THE POWER OF IMAGES

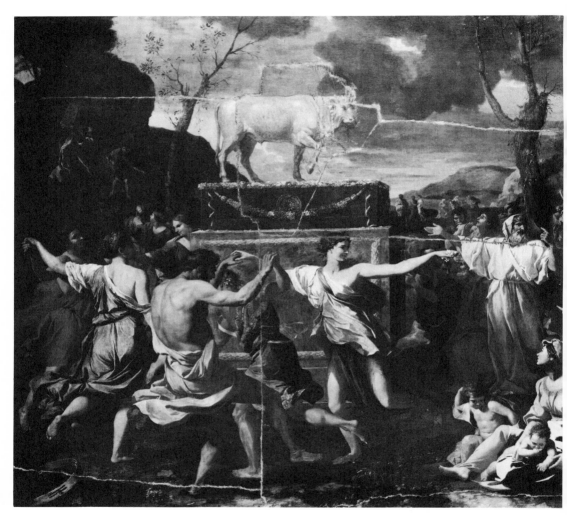

Poussin, *Dance Round the Golden Calf* (detail), as damaged
in 1978. London, National Gallery.

David Freedberg

THE
POWER
OF
IMAGES

Studies in the
History and Theory
of Response

THE UNIVERSITY OF CHICAGO PRESS

Chicago and London

The University of Chicago Press, Chicago 60637
The University of Chicago Press, Ltd., London

10 09 08 07 06 05 04 6 7 8 9

Library of Congress Cataloging-in-Publication Data
Freedberg, David.
The power of images.
Bibliography: p.
Includes index.
1. Art—Psychology. 2. Signs and symbols in art.
N71.F65 1989 701′.1′5 88-27638
ISBN 0-226-26146-8 (paperback)

É grande errore parlare delle cose del mondo
indistintamente e assolutamente, e, per dire così,
per regola; perchè quasi tutte hanno distinzione ed
eccezione per la varietà delle circumstanze, in le quali non si
possono fermare con una medisima misura: e queste
distinzioni e eccezioni non si trovano scritte in
su'libri, ma bisogna lo insegni la discrezione.

—Francesco Guicciardini, *Ricordi*

*

But I must be content with only one more and a
concluding illustration; a remarkable and most significant one,
by which you will not fail to see, that not only
is the most marvellous event in this book
corroborated by plain facts of the present day, but that
these marvels (like all marvels) are mere repetitions
of the ages; so that for the millionth time we say
amen with Solomon—Verily there is nothing
new under the sun.

—Herman Melville, *Moby Dick*

UXORI CARISSIMAE

Contents

List of Illustrations ix
Preface xvii
Introduction xix

1. The Power of Images: Response and Repression 1

2. The God in the Image 27

3. The Value of the Commonplace 41

4. The Myth of Aniconism 54

5. Consecration: Making Images Work 82

6. Image and Pilgrimage 99

7. The Votive Image: Invoking Favor and Giving Thanks 136

8. *Invisibilia per visibilia:* Meditation and the Uses of Theory 161

9. Verisimilitude and Resemblance: From Sacred
 Mountain to Waxworks 192

10. Infamy, Justice, and Witchcraft: Explanation,
 Sympathy, and Magic 246

11. Live Images: The Worth of Visions and Tales 283

12. Arousal by Image 317

13. The Senses and Censorship 345

14. Idolatry and Iconoclasm 378

15. Representation and Reality 429

Abbreviations 443
Notes 445
Bibliography 507
Index 519

Illustrations

1. Brother of the Archconfraternity of San Giovanni Decollato in Rome holding a *tavoletta* 6

2. Annibale Carracci, *A Hanging* (ca. 1599) 7

3. *Tavoletta* showing the Lamentation; a Crucifixion on the obverse (seventeenth century) 7

4. *Tavoletta* showing the beheading of Saint John the Baptist (seventeenth century) 7

5. Fra Angelico, *Lamentation* (ca. 1440) 9

6. Hans Baldung Grien, *Holy Family with Saint Anne* (1511) 14

7. Paolo Veronese, *Holy Family with Saint Barbara and the Infant Saint John* (ca. 1562–65) 15

8. Titian, *Venus of Urbino* (1538) 16

9. Giorgione, *Venus* (ca. 1510) 16

10. Titian, *Venus with an Organist* (ca. 1545–48) 18

11. Édouard Manet, *Olympia* (1863) 20

12. The Madonna of Rocamadour 28

13. Drachm from Ainos; on reverse: enthroned cult image of Hermes Perpheraios (fourth century B.C.) 34

14. Peter Paul Rubens, *Cimon and Pero* (ca. 1635) 48

15. Follower of Jan van Eyck, *Head of Christ* (fifteenth century) 53

16. Basmala in the form of a parrot (Iran; 1250/1834–35) 57

17. Artist's colophon, Kennicott Bible (1476) 57

18. *Aquila,* from Cicero's translation of the *Aratea* (Carolingian) 57

19. German micrographic marginal illustration of Jonah and the Whale, Pentateuch with Targum and Masora (fourteenth century) 58

20. J. [Itzhak] as scribe, micrographic portrait of Rabbi Moses Gaster (ca. 1890) 58

21. Pyramidal *baetylia* on a didrachm and a stater from Caria (fifth century B.C.) 67

22. Assyrian altar with Tukulti Ninurta in adoration before the altar of Nusku (ca. 1240 B.C.) 69

23. Zeus Casios in temple on tetradrachm from Seleucia Pieria (A.D. 222–35) 69

24. The cone of Apollo Agyieus on a drachm from Ambracia (second century B.C.) 69

25. Female statuette from Ephesos (early sixth century B.C.) 71

26. *Hera of Samos* (first half of sixth century B.C.) 71

27. Statue of woman spinning, from Ephesos (late seventh century B.C.) 71

28. Statue of dead woman assimilated to Demeter (fifth century B.C.) 73

29. "Chained" Artemis of Ephesos on imperial cistophoroi (late first and early second century A.D.) 75

30. Statue-reliquary of Sainte Foy (tenth century) 93

31. Reliquary head of Saint Euphrosine (seventeenth century) 93

32. The Morgan Madonna (twelfth century) 95

33. Albrecht Altdorfer, the *Schöne Maria* of Regensburg (ca. 1519–22) 101

34. Michael Ostendorfer, *Pilgrimage to the New Church at Regensburg* (ca. 1519) 102

35. Molds for two pilgrimage badges of the *Schöne Maria* at Regensburg (1519) 103

36. Gaetano Gigante, *The Feast of the Madonna dell'Arco* (1825) 104–5

37. Jacques Callot, *The Fair at Impruneta* (1620) 107

38. After Bruegel, *Saint George's Day Fair* (ca. 1560–70) 108

39. Pilgrimage throngs at Fatima (ca. 1980) 109

40. The interior of the Holy Chapel at Hal, from J. Lipsius, *Diva Virgo Hallensis* (Antwerp, 1616) 111

41. The Virgin of Guadalupe 111

42. Francisco de Zurbarán, *The Miracle at Soriano* (ca. 1626–27) 111

43. *The Virgin of Guadalupe,* from W. Gumppenberg, *Atlas Marianus* (Ingolstadt, 1653) 114

44. *The Virgin of Leon,* from Gumppenberg, *Atlas Marianus* 114

45. *The Virgin of Loudun,* from Gumppenberg, *Atlas Marianus* 114

46. *The Virgin of Rocamadour,* from Gumppenberg, *Atlas Marianus* 114

47. *The Virgin of San Marco,* from [F. Corner,] *Apparitionum et celebriorum imaginum* (Venice, 1760) 116

48. *The Virgin of San Marziale,* from [Corner,] *Apparitionum et celebriorum imaginum* 116

49. *The Virgin of La Celestia,* from [Corner,] *Apparitionum et celebriorum imaginum* 116

50. Anonymous copy of the Passau *Maria-Hilf* by J. C. Loth in the Peterskirche in Munich (eighteenth century) 117

51. J. N. Maag after J. C. Loth, the Passau *Maria-Hilf* (late eighteenth century) 117

52. *The Virgin of Monte Berico,* from [Corner,] *Apparitionum et celebriorum imaginum* 118

53. The Virgin of Monte Berico 118

54. Auda of the Virgin, Seville 119

55. Willem Key (and Quintin Massys?), *Pietà* (sixteenth century) 122

56. Engraving after A. Abondio, *Mutter des Schmerzes und der Leibe,* in the Oratory of the Jesuit Congregatio Minor, Munich (late seventeenth century) 122

57. Anthony van Dyck, *Lamentation* (ca. 1628) 123

58. J. N. Maag, after J. de Pay, after Van Dyck, *Lamentation,* Gnadenbild in the Peterskirche in Munich (late eighteenth century) 123

59. Pilgrimage pennant with Saint Andrew from Balen-Neet (seventeenth century) 125

60. Pilgrimage pennant with Saint Martin from Peutie (seventeenth century) 125

61. Horse wearing pilgrimage pennant 125

62. Silver pilgrimage token, obverse showing the Virgin of Altötting (eighteenth century) 127

63. *The Virgin of Altötting* (fourteenth century) 127

64. Peter Paul Rubens, *Saint Teresa Interceding for Bernardino da Mendoza* (1630s) 127

65. Cornelis Galle after Rubens, *Souls in Purgatory beneath the Monogram of Christ* (seventeenth century) 127

66. The Virgin of Loreto, engraved prayer card (eighteenth century) 128

67. Ampulla with martyr's head (fifth to seventh century) 131

68. Ampulla with cross and apostles (late eighth century) 131

69. Ampulla with the Virgin and Child Enthroned, the Annunciation to the Shepherds, and the Adoration of the Magi (late eighth century) 131

70. *The Hermit in the Desert: The Desert of Religion* (early fifteenth century) 133

71. Lid of the Fieschi Staurotheca (ninth century?) 133

72. Votive image of the *Madonna delle Grazie* in the Appenino Bolognese 139

73. Antonio Floridi da Foligno, the *Madonna dei Bagni* (1657) 139

74. First votive plaque of the *Madonna dei Bagni* (1657) 140

75. Votive plaque of the *Madonna dei Bagni* with a robbery and a knifing incident (1663) 140

76. Votive plaque of the *Madonna dei Bagni* with person falling from tree (late seventeenth century) 140

77. Albrecht Altdorfer, the *Schöne Maria* at Regensburg, colored woodcut, detail without frame (ca. 1519) 143

78. Altdorfer, the *Schöne Maria* at Regensburg, woodcut (ca. 1520) 143

79. *The Holy Chapel at Regensburg,* frontispiece (attributed to Michael Ostendorfer) to the Regensburg Miracle Book of 1522 143

80. Titian, *Pietà,* detail of votive picture (1576) 144

81. Philippe de Champaigne, Ex voto (1662) 144

82. Andrea Mantegna, *Madonna della Vittoria* (1496) 144

83. The *Goldenes Rösse* from the Altötting Treasury (late fourteenth century) 147

84. The altar of the Heiliges Kapelle at Altötting (1645–1730) 147

85. Interior of Santa Maria delle Grazie, Mantua, showing votive images (fifteenth century and later) 150

86. Sala dos Milagros, Nosse Senhor do Bonfim, Salvador (1971) 151

87. School of Raphael, Ex voto of Tommaso Fedra Inghirami (ca. 1508) 152

88. Ex voto of Antonio Peña (Andalucia, 1850) 152

89. Votive panel of Oswolt Dienstl (1501) 158

90. Pilgrims at the tomb of Saint Wolfgang with votive offerings, wing of the Altar of Sankt Wolfgang, Pipping (ca. 1480) 158

91. Hans Weiditz, woodcut depicting Saint Anthony in front of a church hung with votive children, votive limbs, and other votive offerings (early sixteenth century) 158

92. Prisoners' votive figure to Saint Leonard (ca. eighteenth century) 159

93. Mathias Grünewald, *The Crucifixion,* center panel of the Isenheim Altarpiece (ca. 1512–15) 172

94. Grünewald, Isenheim Altarpiece, detail of head of Christ (ca. 1512–15) 173

95. Bernard van Orley(?), *The Mocking of Christ* (ca. 1525–30) 173

96. *Passionis Jesu Christi via contemplationis et meditationis quadruplex,* woodcut broadsheet of the Crucifixion (Augsburg, ca. 1477) 176

97. *The Carrying of the Cross,* from H. Natalis, *Evangelicae historiae imagines* (Antwerp, 1593/1607), pl. 125 182

98. *The Carrying of the Cross,* from Natalis, *Evangelicae historiae imagines,* pl. 126 182

99. *The Nailing to the Cross,* from Natalis, *Evangelicae historiae imagines,* pl. 127 183

100. Title page of the *Orbita Probitatis; The Activity of the Painter as an Allegory of the Imitation of Christ,* from J. David, *Veridicus Christianus* (Antwerp, 1603) 186

101. *Painter Painting at Easel,* from J. Sucquet, *Via vita aeternae* (Antwerp, 1630) 186

102. *Painter Painting Saint,* from Sucquet, *Via vita aeternae* 187

103. *Painter Painting Nativity,* from Sucquet, *Via vita aeternae* 187

104. Piazza dei Tribunali, Varallo, Sacro Monte 194

105. *Adam and Eve,* Varallo, Sacro Monte, first chapel (sixteenth century) 194

106. *The Massacre of the Innocents,* grieving mother and dead baby, Varallo, Sacro Monte, Chapel of the Innocents (1586–94) 195

107. *The Massacre of the Innocents,* detail of dead children, Varallo, Sacro Monte, Chapel of the Innocents 197

108. Giovanni Tabacchetti, *Goitred Tormentor of Christ,* Varallo, Sacro Monte, Chapel of the Road to Calvary (1599–1600) 197

109. Chapel of the Nativity, Varese, Sacro Monte (1605–8) 198

110. Annunciation, Varese, Sacro Monte, first chapel (1605–10) 198

111. Francisco de Zurbarán, *Sudarium* (1635–40) 208

112. Statue of a Roman nobleman with his ancestral busts (late first century B.C.) 214

113. Bust and funerary monument of Caius Julius Helius, shoemaker (late first century A.D.) 214

114. Conrad Meit, "Transi" of Margaret of Austria (1528–32) 217

115. Mannequin of Henry VII 219

116. Mannequin of Charles II 219

117. Hans Sebald Beham, *The Head of Christ, Crowned with Thorns,* state 2 (ca. 1520–30) 221

118. Head of Augustus (late first century B.C.) 221

119. *Georg Wilhelm von Kirchner,* wax figure (ca. 1725–50) 222

120. *Ferdinand IV of Naples,* wax figure (ca. 1750–1800) 222

121. *Picasso,* wax figure 223

122. Wax hands by Anna Morandi (ca. 1750–75) 230

123. Eugene Atget, *Rue Rataud* (March 1909) 233

124. Niccolò dell'Arca, *Lamentation over the Body of Christ* (1463) 238

125. Guido Mazzoni, *Joseph of Arimathea* (1492) 238

126. Juan de Juní, *Lamentation over the Body of Christ* (1541–45) 240

127. Gregorio Fernández, *Dead Christ* (ca. 1625–50) 240–41

128. Pedro da Meña, *Mater Dolorosa* (mid-seventeenth century) 241

129. Juan Martínez Montañés, detail of *Cristo de la Clemencia* (1603). 243

130. Montañés, *Cristo de la Clemencia* 243

131. Montañés, *Jesus de la Pasión* (ca. 1615–18) 244

132. Montañés, *Jesus de la Pasión,* view without garments 244

133. Andrea del Sarto, *A Man Hanging Upside Down* (1530) 252

134. *The Expulsion of the Duke of Athens* (ca. 1360) 256

135. *Execution of an Image of Infamy in Florence,* from A. Poliziano, *Conjurationis pactiane commentarium* (Naples, 1769) 258

136. The hanging of an effigy of President Mitterand of France in Teheran (1987) 258

137. Statuette of a woman with needles driven through it (Egyptian, third or fourth century) 265

138. Zairean nail figure (*n'kondi*) 268

139. Crucifix with moveable arms from Sankt Veit an der Glan, detail (ca. 1510) 287

140. Crucifix with moveable arms from Grancia in Tessin (early sixteenth century) 287

141. Bartolomé Esteban Murillo, *Saint Francis Embracing the Crucified Christ* (1668) 288

142. Francisco Ribalta, *Christ Embracing Saint Bernard* (ca. 1620–25) 289

143. Alonso Cano, *The Vision of Saint Bernard* (ca. 1658–60) 290

144. *The Image of Christ speaking to David and pointing to the Destruction of the Evil Man,* Theodore Psalter (eleventh century) 295

145. *Comment a Toulette . . . ,* from J. Miélot, *Miracles de Notre Dame* (ca. 1456) 295

146. *D'un petit enfant qui donna a mengier . . . ,* from Miélot, *Miracles de Notre Dame* 295

147. Master of the Holy Kinship, *The Mass of Saint Gregory* (ca. 1500) 295

148. Gaspar de Crayer, *Saint Lutgard Embraced by the Crucified Christ* (1653) 296

149. Lucas Cranach the Elder, *Frederick the Wise Adoring the Virgin* (ca. 1516) 298

150. The *Madonna of Czestochowa* 300

151. Gianlorenzo Bernini, *Saint Teresa and the Angel,* detail (1645–52) 323

152. *Hercules Farnese* (early third century A.D.) 328

153. Ascribed to François Clouet, *Diane de Poitiers* (1570) 329

154. Palma Vecchio, *Courtesan* (ca. 1520) 335

155. *Shirin falls in love with Khosrow as a result of looking at his portrait* (sixteenth century) 336

156. Peter Paul Rubens, *Presentation of Portrait of Marie de'Medici to Henri IV,* detail (1625) 336

157. Jean Léon Gérôme, *Pygmalion and Galatea* 341

158. After Fra Bartolomeo, *Saint Sebastian with an Angel* (contemporary copy of original of 1514) 347

159. Eugène Delacroix, *Odalisque* (1857) 351

160. Seated female figure from the Delacroix album (ca. 1853) 351

161. Julien Vallou de Villeneuve, *Standing Nude* 351

162. Gustave Courbet, *Les Baigneuses,* detail (1853) 351

163. *Reclining Nude* (ca. 1854) 354

164. Agostino Carracci, *Satyr and Nymph* from the *Lascivie* (ca. 1590–95) 357

165. Copy after Zoan Andrea, *Couple Embracing* (first half sixteenth century) 363

166. Zoan Andrea, *Couple Embracing,* censored; state 2 363

167. Adamo Scultori after Giulio Romano, *Venus Combing Her Hair,* scratched, state 2 363

168. Marcantonio Raimondi after Giulio Romano, fragments of *I Modi* (1524?) 364

169. Count J. F. M. de Waldeck, copy after one of *I Modi* by Marcantonio after a design by Giulio Romano (mid-nineteenth century) 364

170. Marcantonio after Raphael, *Pan and Syrinx* (ca. 1516) 365

171. Marcantonio, *Pan and Syrinx,* censored 365

172. Enea Vico after Parmigianino, *Mars, Venus, and Vulcan,* state 1 (1543) 366

173. Enea Vico, *Mars, Venus, and Vulcan,* state 2 366

174. Enea Vico, *Mars, Venus, and Vulcan,* state 3 367

175. Giorgio Ghisi, after Teodoro Ghisi, *Venus and Adonis,* state 2 (ca. 1570) 367

176. Giorgio Ghisi, *Venus and Adonis,* censored, state 4 367

177. Lucas van Leyden, *Dance Round the Golden Calf* (ca. 1530) 380–81

178. Nicolas Poussin, *Dance Round the Golden Calf* (ca. 1635) 382–83

179. Removal of the statue of the shah's father, Reza Khan, in Teheran in 1979 391

180. Rembrandt, *The Nightwatch* (1642), as knifed in 1975 408

181. Michelangelo, *Pietà* (1498–99), as broken in 1972 410

182. Rubens, *The Fall of the Damned* (ca. 1618), as damaged by acid in 1959 411

183. Velázquez, *The Rokeby Venus* (ca. 1640–48), as slashed by Mary Richardson in 1914 411

184. Portrait of President Marcos being attacked in Manila in 1986 413

185. Dirk Jacobsz., *The Painter and His Wife* (ca. 1550), detail showing damage before restoration 416

186. Master of Alkmaar, *Polyptych of the Seven Works of Mercy* (1504), detail of *Charity* panel showing damage before restoration 417

187. Rembrandt school, *Seated Old Man* (or *Apostle Thomas*[?]) (1656), as damaged by acid in 1977 417

188. Poussin, *Dance Round the Golden Calf,* as damaged in 1978 421

189. Vincent van Gogh, *Shoes* (1887) 441

Preface

The substance of this book was first outlined in a text drafted between January and March 1980 while I was a visiting member of the Institute for Advanced Study in Princeton. Several topics were developed further in 1983 and presented as the 1984 Slade Lectures in Oxford. The Princeton text was intended to explore the possibilities of outlining an analysis of response to images on the basis of the vast body of historical material relating to recorded and reasonably well-defined responses to images; while the course of Oxford lectures largely eschewed explicit theory in favor of exemplifications and illustrations of particularly striking and apparently recurrent manifestations of response. In its espousal of illustration over theory, it reflected the conventional demands of the lecture format—particularly in the field of art history.

The text that follows may therefore well show some signs of its twofold origins; but without the invitations of Irving Lavin and Francis Haskell, I would have had neither the opportunity of outlining the ideas that lie at its heart, nor the chance of presenting at least some of them in public. Although he will no doubt disagree with large portions of this book, E. H. Gombrich provided encouragement from the very beginning. He made his doubts and disagreements plain, and never ceased to remind me of the groundbreakers in the fields I was tilling again. To him I owe special thanks. Caroline Elam provided much material and offered constant challenges to the thoughts on which this book is based; she, like Kate, Sally, and Victor Ganz, and David Landau, sustained me through the inevitable periods when the going was difficult. So too did the unwavering support of Gary Schwartz. Without the encouragement, interest, and suggestions of Deborah Kahn and Wim Smit, I would never have seen the project through; their devotion to it was more than any author could ask for. They both read a final draft and made crucial suggestions. My research assistants

at Columbia, William Stargard and Tomlyn Barns, went far beyond the call of duty in organizing and helping both writer and book. The members of the graduate seminar in which I presented some of the contents of the book forced me to refine some of its arguments in what seem to me to be critical ways, and to them I am also grateful: Jan Avgikos, Eliot Davies, Jeanne Friedman, Muffet Jones, Sarah Ksiazek, Rebecca Leuchak, John Ravenal, Martha Richler, and Jennifer Taylor. From the earliest stages there have been skeptics; and they have been as helpful as those who provided further examples or suggested refinements. More than anything else I have been encouraged by the broad range of interest in this project. Everyone had one or another instance to offer as yet further testimony to the power of images. At times it was only the force of this abundance of testimony that kept me going (though only a fraction can be presented here). For help, stimulus, information, encouragement, and support in the course of writing this book, I have also to thank Hilary Ballon, Jim Beck, Nicholas and Kristin Belkin, Akeel Bilgrami, David Bindman, Suzanne Blier, Richard Brilliant, Sam Edgerton, Carlo Ginzburg, Anthony Grafton, Anthony Griffiths, John Hay, Julius Held, Judith Herrin, William Hood, Charles Hope, Benjamin Isaac, Jill Kraye, Erika Langmuir, Jean-Michel Massing, Elizabeth Mc-Grath, William Metcalf, Jennifer Montagu, Deborah and Jeffrey Muller, Miyeko Murase, Molly Nesbit, Simon Schama, Leo Steinberg, Peter Parshall, Ben Read, Theodore Reff, Konrad Renger, Amélie Rorty, David Rosand, Charles Rosen, Nicolai Rubinstein, Greg Schmitz, Loekie Schwartz, Andreas Teuber, Nancy Waggoner, Richard Wollheim, and Henri Zerner. At the same time, however, it would be wrong not to acknowledge the names of those colleagues, several of whom I have not met, whose writings—as will frequently be apparent in the text that follows—most substantially influenced both the broad outlines and the detail of the book: Wolfgang Brückner, Ernst Kitzinger, Lenz Kriss-Rettenbeck, and Sixten Ringbom.

To those with whom I discussed the ideas and examples in this book, but whose names I have unwittingly omitted, I apologize; as I do, with less repentance, to those in the list who will protest against the possibility of any responsibility for the ideas that emerge in these pages. Many of them will remain critical of the use to which I have put their information or suggestions. My aim, however, has not been to deflect criticism; it has been to stimulate discussion. I have no doubt that the skeptics will remain; but in taking up their challenge, I hope at least to have reinstated some of the urgency of the history of images.

Introduction

This book is not about the history of art. It is about the relations between images and people in history. It consciously takes within its purview all images, not just those regarded as artistic ones. It is the product of a long-standing commitment to ideas which traditional forms of the history of art—as well as most current ones—seem either to have neglected or to have left inadequately articulated. When I first set out the drafts for this book in 1979, I was much concerned about art history's excessive emphasis on high art at the expense of other elements of visual culture. I doubted the possibility of talking adequately about high art without considering less privileged images as well. But I was concerned, above all, by the failure of art history to deal with the extraordinarily abundant evidence for the ways in which people of all classes and cultures have responded to images. There was occasional enumeration but no analysis. I did not believe the material (nor indeed the whole matter of response) to be too idiosyncratic or too anecdotal to transcend analysis; what is more I believed, as I still do, that it was possible to make some theoretical sense of the historical data. In this respect, I realized I would incur the skepticism of my professional colleagues. If I attempted the necessary survey, they would certainly resist all talk of "people," and allege that I was falling back on some undeveloped and reactionary view of human nature. They would insist that I was neglecting the ways in which context conditions and determines response. To them any book which sought to speak of response in terms which went beyond the purely contextual would seem unhistorical.

But there was never any question of denying the conditioning role of context; the book was simply not to be a case study of a particular one. What I wished to do was to come to terms with responses that seemed to me to be recurrent—or at least to explore the possibilities for analyzing them. I was struck by certain kinds of response—psychological and behav-

ioral responses rather than critical ones—that appeared to have been observed throughout history and across cultures, whether "civilized" or "primitive." They were not usually confronted in the literature because they were unrefined, basic, preintellectual, raw. They were too embarrassing or awkward to write about. But I kept encountering them, by chance and haphazardly, in a wide variety of ethnographic and historical sources, and they seemed to be constantly and consistently figured in commonplaces and metaphors.

But were these kinds of responses not really idiosyncratic ones, which emerged from the dialectic between particular image and particular beholder? Was the only recurrence that which arose from the categorial preconceptions and limitations of the investigator? I realized that I would have to reckon with the possibility that whatever recurrence I detected was no more than a chimera, that I had only chosen to describe the phenomena in such a way that they seemed recurrent, and that the whole thing was more a matter of description than anything about the phenomena themselves. Could it not be, furthermore, that I was simply postulating ideal beholders, and forgetting that responses are forged on the anvil of culture and in the fire of particular history? I hoped to find some level on which to speak more generally, but I realized that the difficulty would be to avoid buckling under the constraints of my own descriptive limits and being misled by the translation of reports, as I sought to assess that which seemed, in some profound sense, to precede context.[1]

Despite such cautions to myself, I could not abandon my belief that it should be within the historian's range to be able to reclaim precisely those kinds of responses that are not usually written about, and that it was possible to do more than leave the apparently haphazard evidence for recurrence as the random detritus of history. So I proceeded. What this meant was that I had to range rather more widely than is usually regarded as legitimate and to be less skeptical than my colleagues usually are about the reclamation of psychology from history. It was clear, furthermore, that in order to deal appropriately with the kind of material I had in mind, I would have to draw on the fields of anthropology and philosophy, and that sociological investigation would at some stage have to become continuous with the historical procedure. The task then seemed immense, and it was not at all clear how I would combine the vast abundance of evidence with the methodological strategies that would best enable me to order it.

In the end I decided that the best way of proceeding would be to set out what seemed to me some of the most dramatic forms of broadly recurrent responses, and to consider these forms in terms of the often meager and sometimes misleading theory that had already been brought to bear on them (if such theory existed at all). The kind of evidence that turned out to be most germane was exactly that which art historians usually avoid in their

concern with more intellectualized forms of response. In thus suppressing the evidence for the power of images, it seems to me, they pass over in silence—usually ignorant, rarely knowing, silence—the relations between images and people that are recorded in history and are plain from anthropology as well as folk psychology. The history of images stands at the crossroads of these disciplines, but the history of art, as traditionally conceived, retreats from the meeting. At the same time, I could not claim that in my raids on neighboring disciplines I have always come away with appropriate booty. The philosophy here is simple, the psychology little more than incipient. Indeed, the psychological and sociological programs have only been outlined, rather proleptically; for their full enumeration other books will be needed.

Although, in setting forth the evidence, it was clear that the basic divisions would have to be by classes of response rather than by classes of images, it soon became just as clear that responses to certain kinds of imagery provided more than usually direct evidence: for example, wax images, funeral effigies, pornographic illustrations and sculptures, and the whole range of billboards and posters. But these were just the kinds of responses that were generally separated from learned and educated response, what one might call high and critical response. The advantage of attending to what were usually regarded as popular attitudes and behavior was simply that felt effects were less often suppressed by the beholder. They seemed to me more dramatic and therefore more easily capable of description and analysis. The assumption may not be correct, but it seemed satisfactorily functional. None of this, it should be emphasized, was to suggest that those versed in talk about high art did not respond in the so-called popular ways. It was just that by calling the responses "popular," they denied precisely what obtained in the case of the refined self as well.

But the issue was not only that of "popular" and "cultivated"; it was—perhaps to an even greater extent—that of "primitive" and Western. As will emerge from the pages that follow, I have striven to counter the still widely current view (whether explicit or implicit) that certain characteristics both of art and of responses to it are solely confined to "primitive" or non-Western societies. Art historians have pretty much overlooked "primitive" behavior in the West, just as they have for so long neglected the evidence in non-Western societies for what has always been assumed to be one of the most sophisticated categories of Western thinking about art—namely, its critical self-consciousness and its development of a critical terminology. Much of what follows deals with the sorts of behavior in the West that rational positivists like to describe as irrational, superstitious, or primitive, only explicable in terms of "magic." I would, in fact, be happy if the long-standing distinction between objects that elicit particular re-

sponses because of imputed "religious" or "magical" powers and those that are supposed to have purely "aesthetic" functions could be collapsed. I do not believe that the distinction is a viable one. Indeed, it seems to me that we should now be prepared to remove the evidence of phenomena like the animism of images from discussions of "magic," and that we should confront more squarely the extent to which such phenomena tell us about the use and function of images themselves and of responses to them.

My final hope for this book is that the material I present should engender a more critical approach to one of the commonest and most unreflectively held assumptions about art. This is the assumption that "in a work of art we overcome the responses which the material or subject matter most readily precipitate."[2] As long as we remain as concerned as we are about the determinants of what we call art, we will not escape from the tyranny that that category imposes on us in our thinking about response.

But if readers expect a specific theory of response to emerge by the end of the book, they will be disappointed, especially if by "theory" is meant a fully explanatory theory, one that will in principle take care of all cases. The aim, instead, has been to develop adequate terms, and to set out the possibilities for the ways in which cognitive theory may be nourished by the evidence of history. But while the more explicit aim will be to work toward an approach to the problems of response (and talk about response) that might lay the ground for theory, it will not escape the reader that much of the material I present (or the way I present it) suggests the possibility of a project for looking. I should add here—to forestall potential misapprehension—that the project is intended to embrace the nonfigurative as well as the figurative, even though far and away the bulk of my examples (the inevitable consequence of a particular education) will involve images that have bodies represented on them.

When, in this book, I use the term "response" I refer—broadly—to the symptoms of the relationship between image and beholder. I use it with regard to all images that exist outside the beholder (though the relevance of mental images will emerge in some chapters). I will consider the active, outwardly markable responses of beholders, as well as the beliefs (insofar as they are capable of being recorded) that motivate them to specific actions and behavior. But such a view of response is predicated on the efficacy and the effectiveness (imputed or otherwise) of images. We must consider not only beholders' symptoms and behavior, but also the effectiveness, efficacy, and vitality of images themselves; not only what beholders do, but also what images appear to do; not only what people do as a result of their relationship with imaged form, but also what they expect imaged form to achieve, and why they have such expectations at all.

The chapters that follow are intended to proceed by exemplification, not

by abstract concept. If anything, the approach is inductive rather than deductive. Instead of gathering together the elements of the arguments about context, criticism, high and low, "magic," function and use—perhaps the main leitmotifs of this book—I have allowed them to appear where the examples demand. The aim has been to suggest the resonance of the subjects in each chapter, in the hope that the possibilities for analysis become cumulatively apparent. Since the subjects I cover are inexhaustible, I have made no effort to be exhaustive. As they proceed, readers will undoubtedly be able to add more examples of their own. The more they do so, the better.

The raw material is vast, diverse, and seemingly incapable of being tamed. Even the selections that I present here raise a great variety of theoretical issues all bearing complexly on the matter of response. At times, therefore, it may seem that a large number of issues are being kept in the air, and that new questions are posed before previous ones are answered. While my aim has not been to settle every theoretical matter, or to resolve every problem (since I have striven, instead, to show their interest), the reader is encouraged to persist to the conclusion, where I attempt to draw together the major threads that run through this book. In the end, I believe that there is indeed a project and—I hope—a reclamation of the many proposals I make and the theoretical tendencies I will be held to espouse.

I begin with examples of response that may seem extremely improbable to us but were once common enough; at the same time, I suggest that we gain some sense of their power if we are frank about our own responses to images which we ourselves regard as of sexual interest. I then outline some of the ways in which the god is in the image; in other words, how it becomes charged with presence. At this point I propose that we take more seriously than we are accustomed those commonplaces, similes, and metaphors which reveal the power of images. In the fourth chapter, I argue that the myth of aniconism arises precisely because of our fear of acknowledging that images are indeed endowed with qualities and forces that seem to transcend the everyday, and that we make up the myth because we cannot bring ourselves to acknowledge that possibility. These qualities are also exemplified by the sensual consequences of the beautiful and artistic, and so the putative lack of images or absence of representation comes to be associated with purity and virtue. If images are invested with power, how then are they made to work? This is the question I address in the fifth chapter.

The next sequence of chapters deals with specific exemplifications of the power of images: from the remarkable drawing-power of pilgrimage images, and the improbable hopes invested in them, through the beliefs that images can somehow act as adequate mediators of thanks for supernatural favors, to the ways in which they can elevate beholders to the heights of empathy and participation. Chapter 10 deals with what might appear to be

some of the most extravagant of all such beliefs and practices, namely, that images could effectively be used to shame or punish those represented on them, or actually to harm them, or to serve as a means of seduction. In the light of responses, uses, and beliefs like these, it seems necessary to take a view of the many medieval tales in which images actually come alive on a less anecdotal and trivial level than has hitherto been the case. Furthermore, since so much of the evidence for live images involves a tacit or explicit sexual relationship, a bridge is provided from religion to sexuality. In the material on arousal by images, one can again begin to understand the problem of fear. If the image is, in some sense, sufficiently alive to arouse desire (or, if not alive, then sufficiently provocative to do just that), then it is more than it seems, and its powers are not what we are willing to allow to dead representation; and so these powers have to be curbed, or what causes them eliminated. Hence the need to censor (and here I draw a parallel with the dangerous and seductive effects ascribed to women). From censorship the move to iconoclasm is clear. What connects all these issues is the power of images and our attempts to come to terms with the evidence for it.

Two final observations about the evidence may be in order. Some readers may be troubled by the lack of an explicit distinction between report and imaginary narrative—and, for that matter, between report and report that forms the basis for imaginative expansion. The issue, for example, may be felt to become crucial in the discussion on live images in chapter 11, and elsewhere too. While there are reflections on the problem throughout the book, I have no doubt that it bears further expansion. But I hope it will not escape the reader, at the same time, that when it comes to the matter of response, it is also possible to make too much of such distinctions—just as it is possible to overemphasize context at the expense of cognition. Similarly, it may be that some will be alarmed at the move from religious imagery, broadly taken (on which the greatest portion of this book concentrates) to secular and erotic imagery. For this I propose even less in the way of mitigation, since the continuum is precisely one which I wish to emphasize. By and large this emphasis is implicit. But in the brief discussion of Gadamer in chapter 4 on aniconism it is more explicit, and it is present, by strong implication, in the analysis of iconoclasm in chapter 14.

I have chosen to concentrate on a number of broad phenomena that seem to me to be capable of being subsumed under general headings without doing excessive harm to internal distinctions and differences. They are all striking and sometimes dramatic phenomena. Each one furnishes more than enough material for abundant books and case studies.[3] No doubt other such topics might have merited attention; above all I am conscious of the absence here of an approach to the problem of figured propaganda and of arousal to political action.[4] The interest of several of the topics dealt with has been

enhanced in recent years (especially since the beginning of the decade) by a spate of publications arising mostly from local pride in the less canonical forms of imagery. To a large extent the interest is folkloristic, but this does not diminish its significance. One has only to consider in particular the number of new publications on ex-votos in Italy, and the now sustained output of material on pilgrimage phenomena and devotionalia in Germany, Austria, and Southern Europe in general. I have not been able to take account of all the newest publications in these areas, since the output grows by the day. The same applies, to a slightly lesser extent, to the once sparse material on wax imagery and the use of pictures and sculptures in judicial contexts.

In other areas, where the existing material is already abundant, I have been arbitrarily selective. Thus, in dealing with idolatry and iconoclasm, I have omitted consideration of the large amount of English material, from texts like the *Pictor in Carmine* and the *Dives and Pauper* through the moments of actual imagebreaking in the fourteenth through seventeenth centuries. But England has finally begun to receive the attention it deserves, while the German pilgrimage problems have shown the study of folklore at its most sophisticated levels. The new abundance, then, as well as the old, highlights the neglect of what is too often regarded as low-level imagery by historians of culture in general and by historians of art in particular. To shift such imagery aside to the levels of folklore alone—especially when that field, in Anglo-Saxon countries at least, has such unjustifiably low standing—is to court the consequences of a narrow and elitist intellectual parochialism. If this book does anything to undermine stances of this kind, then it will have achieved at least one of its aims. It has been intended, above all, to embrace those kinds of response that are too often felt to be at odds with the redemptive nature of art. I have written this book not only to present the evidence, but to lay the phantom of high response to rest.

1

The Power of Images:
Response and Repression

People are sexually aroused by pictures and sculptures; they break pictures and sculptures; they mutilate them, kiss them, cry before them, and go on journeys to them; they are calmed by them, stirred by them, and incited to revolt. They give thanks by means of them, expect to be elevated by them, and are moved to the highest levels of empathy and fear. They have always responded in these ways; they still do. They do so in societies we call primitive and in modern societies; in East and West, in Africa, America, Asia, and Europe. These are the kinds of response that form the subject of this book, not the intellectual constructions of critic and scholar, or the literate sensitivity of the generally cultured. My concern is with those responses that are subject to repression because they are too embarrassing, too blatant, too rude, and too uncultured; because they make us aware of our kinship with the unlettered, the coarse, the primitive, the undeveloped; and because they have psychological roots that we prefer not to acknowledge.

When we read in one Italian writer of 1584 that a painting

Curves are too emotional
PIET MONDRIAN

*

Wir sehen es, aber das tut uns nicht weh.
ABY WARBURG

*

> will cause the beholder to wonder when it wondreth, to desire a beautifull young woman for his wife when he seeth her painted naked; to have a fellow-feeling when it is afflicted; to have an appetite when he seeth it eating of dainties; to fall asleepe at the sight of a sweete sleepinge picture; to be mooved and waxe furious when he beholdeth a battel most lively described; and to be stirred with disdaine and wrath, at the sight of shameful and dishonest actions

or in another of 1587 that

since the eye is the most perfect among the exterior senses, it moves the minds to hatred, love and fear, more than all the other senses . . .; and when the beholders see very grave tortures present and apparently real . . . they are moved to true piety, and thereby drawn to devotion and reverence—all of which are remedies and excellent means for their salvation,

two chief questions arise.[1] Are these both no more than the commonplace repetition of the old idea of the greater susceptibility of the eyes than the other senses? And are they simply to be seen in the context of late-sixteenth-century Italian art theory? Let us begin with some improbable examples.

I

The charming third-century Greek romance by Heliodorus known as the *Aethiopian Tale about Theagenes and Charicleia* has the following account of the birth of its protagonist, Charicleia. Her mother, Persina (who is queen of Ethiopia) writes to her about the palace bedroom, which was "garnished with pictures containing the loves of Perseus and Andromeda."

After Hydaspes had been married to me ten years, and we had never a child, we happened to rest after midday in the summer . . . at which time your father had to do with me . . . and I by and by perceived myself with child. All the time after, until I was delivered, was kept holy, and sacrifices of thanksgiving were offered to the Gods, for that the King hoped to have one now to succeed him in his kingdom. But thou wert born white, which colour is strange among the Ethiopians. I knew the reason, because while my husband had to do with me I looked upon the picture of Andromeda naked . . . and so by mishap engendered presently a thing like to her.[2]

A similar role is ascribed to pictures in another quite different context. In the course of an argument about divine creation in his polemic against the emperor Julian, Saint Augustine cites the medical writer Soranus, who tells of the tyrant Dionysius who,

because he was deformed, did not wish to have children like himself. In sleeping with his wife he used to place a beautiful picture before her, so that by desiring its beauty and in some manner taking it in, she might effectively transmit it to the offspring she conceived.[3]

We may be inclined to regard all this as little more than fictional re-workings of an old notion that goes back to Aristotle and crops up naturally enough in writers like Galen and Pliny: namely, that the child one gives

birth to is somehow impressed with the marks of the parents' imaginings at the moment of conception, but clearly there is more to the notion than just that.[4] We need to examine the role of pictures and sculptures more closely.

At almost exactly the same time as the passage from Augustine was excerpted in Simon Majolus's 1614 encyclopedia, Giulio Mancini was composing his splendid compendium of information about painters and painting, the *Considerazioni sulla pittura*. At the end of a fairly technical discussion of the appropriate locations for pictures, he has this to say about the adornment of bedrooms:

> Lascivious things are to be placed in private rooms, and the father of the family is to keep them covered, and only uncover them when he goes there with his wife, or an intimate who is not too fastidious. And similar lascivious pictures are appropriate for the rooms where one has to do with one's spouse; because once seen they serve to arouse one and to make beautiful, healthy, and charming children . . . not because the imagination imprints itself on the fetus, which is of different material to the mother and father, but because each parent, through seeing the picture, imprints in their seed a similar constitution which has been seen in the object or figure. . . . And so the sight of similar objects and figures, well-made and of the right temper, represented in colour, is of much help on these occasions; but they must nevertheless not be seen by children and old maids, nor by strangers and fastidious people.[5]

For all the attempt to provide a scientific, causal explanation for this belief in the efficacy of pictures (derived from Mancini's own reading of writers like Solinus), to us both the explanation offered and the belief itself seem improbable—if not completely fantastic. But when we encounter the Counter-Reformation view that one should certainly not have pictures in one's bedroom of those of whom one cannot possess the original, we begin to sense that the matter may not be so fantastic after all. If we cannot yet quite share the belief in efficacy, we can at least understand the fear and concern that lies at its basis in writers like Paleotti and Molanus (and there are many like them in the immediate wake of the Council of Trent).

But are these passages no more than testimonies to the repeated use of a commonplace, whose meaning has been drained from it by centuries of hackneyed and unthinking reproduction? For example: are we to dismiss the passages on the grounds that the Counter-Reformation critics of art were simply motivated by a prurient censoriousness; that Heliodorus was writing a pretty romance; that the quotation from Saint Augustine was merely an illustrative aside to a serious theological argument (though its seventeenth-century excerpter used it quite specifically in the context of females and generation); and that Mancini's account cannot be construed as anything

but the incredible repetition of a particular cliché about the power of art? It is worth considering the possibility not only that every one of these writers actually believed such notions, but also that we should take them seriously too.[6]

<center>II</center>

Let us move from the bedroom to the nursery. Part 4 of Giovanni Dominici's *Rule for the Management of Family Care,* written in 1403, is concerned with the upbringing of children. In order for one's offspring to be brought up "for God," the first of Dominici's recommendations is that one should have

> paintings in the house, of holy boys, or young virgins, in which your child when still in swaddling clothes may delight as being like himself, and may be seized upon by the like thing, with actions and signs attractive to infancy. And as I say for paintings, so I say of sculptures. The Virgin Mary is good to have, with the child on her arm and the little bird, or the pomegranate in his fist. A good figure would be Jesus suckling, Jesus sleeping on his mother's lap, Jesus standing politely before her, Jesus making a hem and the mother sewing that hem. In the same way he may mirror himself in the holy Baptist, dressed in camel skin, a small boy entering the desert, playing with birds, sucking on the sweet leaves, sleeping on the ground. It would not harm if he saw Jesus and the Baptist . . . and the murdered innocents, so that the fear of arms and armed men would come over him. And so too little girls should be brought up in the sight of the eleven thousand virgins, discussing, fighting and praying. I would like them to see Agnes with the fat lamb, Cecilia crowned with roses; Elizabeth with many roses, Catherine on the wheel, with other figures that would give them love of virginity with their mother's milk, desire for Christ, hatred of sins, disgust at vanity, shrinking from bad companions, and a beginning through considering the saints, of contemplating the supreme Saint of saints.[7]

How much pictures (and sculptures) could achieve! And what a range of edifying functions they had! This edification was, in fact, one of the three functions explicitly attributed to all religious images throughout the Middle Ages (and for a considerable time after); but the candid faith in what images could do or bring about is very striking in this passage, and it calls out for comment. In what sense did they really have the effects attributed to them here? A view so strongly and attractively asserted must, one supposes, have had some grounding in firm belief, rather than in the straightforward repetition of a topos or of a notion commonly held.

There are several other noteworthy elements within this passage. The enumeration of so charming and various a list of subjects is unusual; and it provides remarkable literary corroboration of the kind of images available at the turn of the fifteenth century. Many of these kinds of pictures, it is true, we already know from our experience of museums; but here is as clear a contemporary description as one could wish of at least one set of functions. It is also a telling and straightforward reminder of the need to consider all possible uses of images, and all possible images, from high use and high art to low use and low art. But in the context of our discussion it has an evidential status that transcends such purely antiquarian and functional issues. Its importance lies in the overall assumption of the effectiveness of images—to the extent that they have the potential to affect even (or perhaps especially) the youngest of viewers, and affect them not just emotionally, but in ways that have long-term behavioral consequences. It is hard to know what to make of the best modern commentator's view that Dominici (who illuminated manuscripts himself) "did not rank painting very high, considering it useful for small children's religious education."[8] We may well ask ourselves on just what basis the commentator *would* have Dominici rank pictures high? Or in what sense the education of small children rates as a baser criterion of status than any other?

Be that as it may, Dominici appears to assume that effectiveness proceeds from a kind of identification between beholder and what is represented by the image. The child delights in the pictures, because they are *"like himself"*; and so he will be seized upon by the like thing, with actions and signs attractive to infancy. He *"mirrors himself* in the Holy Baptist," while girls will acquire girlish virtues by seeing the same qualities exemplified by the appearance and action of female saints. In addition to the problem of identification, two more issues should be noted here: first, the unproblematic equation of painting with sculpture (at any rate with regard to effectiveness); and, second, the apparent belief that contemplation leads first to imitation and then to spiritual ascent. We will return to them, but first let us move from conception and childhood to death and consider responses to pictures not at the beginning of lives but at the end.

III

What comfort could anyone conceivably offer to a man condemned to death, in the moments prior to his execution? Any word or action would seem futile, and it would be as nought beside the inner resources or human weakness of the condemned person. But in Italy between the fourteenth and seventeenth centuries, brotherhoods were set up to offer a kind of solace; and the instruments of consolation were small painted images.[9] A fair

number of these *tavoluccie,* or *tavolette,* as they were alternatively called, survive, and their use is attested by a considerable amount of supplementary visual evidence (cf. figs. 1 and 2). Each *tavoletta* was painted on both sides. On one side was a scene from the Passion of Christ; on the other side, a martyrdom that was more or less relevant to the punishment to be meted out to the prisoner (figs. 3 and 4). This martyrdom the brothers would "relate in some inspirational way to the actual plight of the prisoner as they comforted him in his cell or prison chapel during the night before his morning execution."[10] On the next day, two members of the brotherhood would hold one of the pictures before the condemned man's face all the way to the place of execution. Then, as described in the surviving *Istruzioni* for the Florentine Compagnia di Santa Maria della Croce al Tempio:[11]

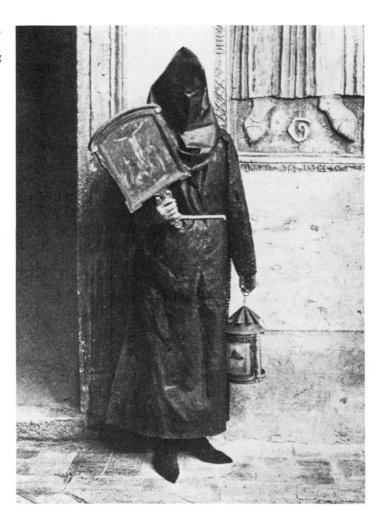

1. Brother of the Archconfraternity of San Giovanni Decollato in Rome holding a *tavoletta* (from Corrado Ricci, *Beatrice Cenci* [Milan, 1923]).

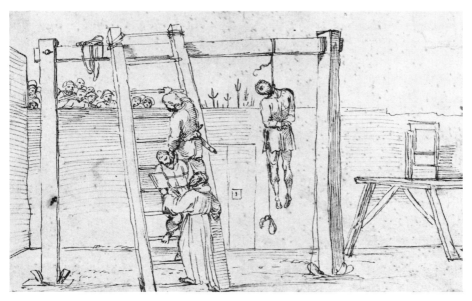

2. Annibale Carracci, *A Hanging* (drawing; ca. 1599). Windsor Castle, Royal Library. Reproduced by gracious permission of Her Majesty the Queen.

3. *Above: Tavoletta* showing the Lamentation; a Crucifixion on the obverse (seventeenth century). Rome, Archconfraternity of San Giovanni Decollato.

4. *Right: Tavoletta* showing the beheading of Saint John the Baptist (seventeenth century). Rome, Archconfraternity of San Giovanni Decollato.

As soon as the *afflitto* arrives at the place of execution, the comforter will permit but not exhort him to say something edifying . . . and when the push is given to him by the executioner, the comforter will pass to the other side of the ladder [see fig. 2]. And keeping always a hand attached to the ladder for security, will maintain the *tavoletta* before the face of the suspended *afflitto* as long as he thinks he has not departed this life. [12]

More edifying words will pass; there will be opportunity for confession; absolution will be given; and the man expires.

Not much benefit would arise from arguing whether words or images were of greater consequence on such an occasion; and one might well feel that the whole business was ineffectual. Certainly one would be justified in maintaining that the practice was clearly institutionalized, and that its roots lay in conventional views of death which were out of touch with its psychological reality—in short, that it served the living better than the imminently dead. One might furthermore insist that the practice is to be seen specifically in the context of the distinctive functions and status of images in fifteenth- and sixteenth-century Italy; but even if that context is narrowly specified, one is still left the problem of effectiveness—even if only imputed.

This is an eyewitness account of the execution of Pietro Pagolo Boscoli, who was condemned to death on 22 February 1512 for his participation in an anti-Medicean plot:

And as he ascended the stair he kept his eyes on the *tavoletta,* and with most loving accent said: Lord thou art my love; I give thee my heart . . . here I am, Lord; I come willingly. . . . And this he said with such tenderness that all who heard him were in tears. . . . And halfway down the stairs he met the Crucifix, and said: What ought I to do? And the friar replied: This is your captain who comes to arm you. Salute Him, honour Him and pray that He gives you strength. . . . And while descending the second flight of stairs, he continued praying, saying: *In manus tua, Domine.* [13]

Could an image really do all this, could it be that affecting and so consoling? Perhaps it is all in the report. One might feel, reading this, that Pago was unusually courageous and stoical in the face of death; that he was clearly an educated and quite learned man; and that the eyewitness may somehow have wished to glamorize his end. But this is not the point. The question is this: Why was it felt that images rather than just words could serve such a function, that they could in any way be effective under such conditions? For the condemned man they may or may not have achieved their supposed purpose, but the institution as a whole was based on a judgment about the

efficacy of images that was predicated upon a belief in their inevitable power. And that social belief cannot merely be regarded as ostensible; it appears to reflect a cognitive reality.

Say we recall the fact that one could receive a papal indulgence for kissing the *tavoletta* (a *Kusstafel* in German); but still we would not have resolved the question: why kiss an image at all? Even if it is a matter of relevant decorum, of a ritualized act, we would persist in wondering about the historical and the nonhistorical origins of such a practice. We still need to know about the fundamental impulses that are institutionalized in these ways. That is the issue at stake—the analysis of the deep end of such practices, not the superficial, ostensible level.

It is worth remembering that a variety of other images may be associated with the kind of function served by the *tavolette,* from Fra Angelico's *Lamentation* (fig. 5), which hung in the little chapel of Santa Maria della Croce al Tempio in Florence (where the condemned man heard his last mass), to the paintings by Benozzo Gozzoli—a *Deposition*—and by several sixteenth-century artists at his last stops before his execution. [14] From the condemned cell, all along the route, and then finally on the scaffold itself, images were provided in the hope that the *afflitto* would—at the very least—be provided with lessons and with solace and comfort. Of course later the provision of such images became habitual; but we cannot simply allow the problem— just as with pictures in bedrooms—to rest there.

5. Fra Angelico, *Lamentation* (ca. 1440). Florence,
Museo San Marco. Photo Alinari.

IV

It is obvious that paintings and sculptures do not and cannot do as much for us now. Or can they? Perhaps we repress such things. But did they ever? Perhaps the cases I have cited are no more than some rather conventional ideas dressed up as empirical reports. If the first answer is correct, then we must examine the matter of repression more closely. If the second answer is correct, then we should consider the relations between convention and belief with greater precision (since most reporters presumably believed what they were reporting).

There is abundant historical and ethnographic evidence for the efficacy of images. But how are we to evaluate the material? What status are we to attach to the reports? Let us say that the evidence for efficacy can only be articulated in terms of cliché and convention, and that we are increasingly ignorant of those clichés and conventions. Some we retain, like the belief that the eyes of a good portrait follow one round the room; others we lose, like the belief that a picture of a fair and naked person in the bedroom will somehow improve the offspring we conceive. This raises another issue: that of the relation between convention and belief, and then behavior. Does a convention become naturalized in a culture, so that clichés about images may actually provoke behavior that meets the terms of the cliché? Repeat an idea often enough, and it can (but need not) form the basis for an action. But how do conventions become naturalized? And what do we mean when we say that they do?

Perhaps images no longer work in the ways I have begun by reporting precisely because contexts are so different. How, then, is one to describe the extent to which context conditions response? If it does, always and wholly, then we must leave behavior and emotion outside the realm of cognition; but before we do so, consider the other side of the coin.

The great iconoclastic movements of the eighth and ninth century in Byzantium, of Reformation Europe, of the French Revolution and of the Russian Revolution have been much studied. From the time of the Old Testament, rulers and public have attempted to do away with images and have assaulted specific paintings and sculptures. Everyone can produce an example of an attacked image; everyone knows of at least one historical period in which iconoclasm was either spontaneous or legitimized. People have smashed images for political reasons and for theological ones; they have destroyed works which have roused their ire or their shame; they have done so spontaneously or because they have been directed to do so. The motives for such acts have been and continue to be endlessly discussed, naturally enough; but in every case we must assume that it is the image—

whether to a greater or lesser degree—that arouses the iconoclast to such ire. This much we can claim, even if we argue that it is because the image is a symbol of something else that it is assailed, smashed, pulled down, destroyed.

Historians of art and of images have been strikingly apprehensive and diffident about assessing the implications for their study of the great iconoclastic movements; and they have been even more reluctant to acknowledge the strain of antagonism that manifests itself on more apparently neurotic levels, as in the increasingly abundant assaults on pictures and statues in museums and public places—to say nothing of the private, unknown act. The response to any inquiry about motive is likely to be one of great caution, even fear, and then to categorize out the motive of the assailant: "The assailant and his motives are wholly uninteresting to us; for one cannot apply normal criteria to the motivations of someone who is mentally disturbed." This is what the director of public relations claims when an object, major or minor, is attacked in his museum.[15]

We easily concur; we do not vent our anger in this way on images in public places. The image—or what is represented on it—may rouse our shame, hostility, or fury; but it would certainly not cause us to wreak violence upon it; and we certainly would not break it. Or would we? No one can answer the question with complete confidence. For whatever reasons—whether directly related to the image or not, to the way it looks, to what it represents, or to the general emotional state in which we may or may not be—we recognize the potential for such a lapse in ourselves. We can all acknowledge the narrowness of the border between the kinds of behavior manifested by the iconoclast and "normal," more restrained, behavior. And although for the most part we absolutely prefer to isolate such deeds, to put them well beyond the psychological pale, still we recognize the dim stirrings of antipathy and involvement that outleaps control in the iconoclast. The issue that presents itself to us is one of repression.

V

Let us briefly return to Giovanni Dominici. The passage in which he insists on the beneficial inculcatory effects of pictures and sculptures concludes—to us a little surprisingly—in a way that speaks to one of the fundamental fears of all art and, indeed, of imagemaking. This takes us one step further, from belief in the power of images to actual response:

> I warn you, if you have paintings in your house for this purpose, beware
> of frames of gold and silver, lest they [your children] become more
> idolatrous than faithful, since, if they see more candles lit and more

hats removed and more kneeling to figures that are gilded and adorned with precious stones than to the old smoky ones, they will only learn to revere gold and jewels, and not the figures, or rather the truths represented by those figures. [16]

Here is the old fear of idolatry, but here too is the neat sociological evidence of history. The fear of idolatry (theoretically outlined over endless centuries) may well not have persisted as acutely as it did if Dominici, like so many others, had not observed the lit candles, the hats removed, the kneeling to figures. To what an endless variety of behavior do images arouse and provoke one! But in Dominici's passage, too, are the rudiments—as elsewhere in the Middle Ages and after—of a strict semiotics of visual signs. Here is the most explicit insistence that one should not focus on the materiality of the sign—the gold and jewels—but on the "figures," or (better still) on "the truths represented by those figures": *alle figure ovvero verità per quelle figure rappresentate.* [17] There could be no clearer way, then as today, of talking about the power of images than by making those necessary distinctions, now codified in the simple Saussurean terms of sign, signifier, and signified. In his avowal of the possibility of the allegorical, Dominici has a clear sense of something that is still beyond (or behind) the signified, and distinguished from it.

For Cardinal Dominici the beneficence of images accrued from the belief that the exemplary beauty and actions of what was represented on them would somehow help assure like qualities in the living young beholder: "If you do not wish to or cannot make your house into a sort of temple, if you have a nurse, have them taken often to church, at a time when there is no crowd, nor any services being said." [18] For writers like Molanus and Cardinal Paleotti, the potential danger of images arose from a similar belief. Have a picture of someone in the bedroom, and you might want to possess that person (adults presumably being more capable of moving from the desire to imitate the admirable to the desire to possess the admirable): that is why it was recommended not to have pictures in one's bedroom of those of whom one could not possess the original. What joins all such writers in their views of the effectiveness (good and bad) of images is the tacit belief that the bodies represented on or in them somehow have the status of living bodies. The issue is absolutely not one of mere reminding (the images do not just remind one—in exemplary or dangerous fashion—of loved or admired figures), for if it were, the paintings or sculptures would not have the effectiveness they do.

It is perhaps in this area more than any other that we may examine the issue of repression most clearly. We fear the body in the image, we refuse to acknowledge our engagement with it, and we deny recognition of those aspects of our own sexuality that it may seem to threaten or reveal. For

example: in the course of the fifteenth and sixteenth centuries, both in Italy and Northern Europe, hundreds of images were produced which showed the infant Christ's genitalia at the center of the composition, or with significant attention focused on them. There are paintings where Christ's legs seem deliberately splayed to reveal his pudenda, where his Mother (or in a few cases Saint Anne) touches them, and where the adoring Magi focus their gaze on his groin (cf. figs. 6 and 7). But as Leo Steinberg has recently and compellingly pointed out (in a discussion of the theological underpinnings of such pictorial emphases), historians have resolutely failed to notice just this aspect of what such pictures show. When he did point out what now seems obvious, the noise of disapproval was very loud, and accusations of frivolity were widely leveled. Either the pictorial facts were blatantly denied, or they were explained away in such contorted and embarrassed ways that the more or less impartial observer could be left in doubt of the extent of the repression.[19]

But this moves some distance from questions of effect and efficacy. It also may seem to demonstrate little more than straight prudishness. With the paintings adduced by Steinberg, it might be claimed, we deal with pictures whose substance touches on too intimate a part of ourselves ever to be dealt with without embarrassment; and so the repression is not so complicated. But the lessons of such pictures (and Steinberg's analysis) go far beyond the simple demonstration of the response that is prudish. It is not only the generations who have failed to notice; it is the attitude of the reviewers who reveal the extent of what they cannot bring themselves to acknowledge.

The same might be said—to take only one further example—of any number of discussions of Titian's *Venus of Urbino* (fig. 8). Either they dwell on the classical beauty of the nude (or some other such ideal standard) or they overextend themselves in complex iconographic interpretations.[20] Twenty-five years ago, it was argued that despite her clearly individualized features this was no particular woman; she was Venus herself. Nor was she the common sensual Venus of classical mythology; she was the celestial— the cosmic—Venus, typifying and celebrating the joys of marital fidelity and domesticity.[21] Some of these interpretations may even have some truth in them, but it is only in recent years that scholars have begun to suggest— or to revive a much older idea—that at least one kind of response (and possibly even the raison d'être of the picture) had to do with male sexual interest in the beautiful female nude that is Titian's Venus, or say, Giorgione's Dresden Venus (fig. 9).[22] It is true that there are sumptuous colors and ravishing paintwork in Titian's picture; there are charming elements like the richly attired lady in the corner and the girl crouching over the chest, the urn, the landscape, and the little dog delightfully curled up at the foot of the bed. We may indeed be charmed by these things, as we may assume many people once were too. But it would be wrong not to admit to

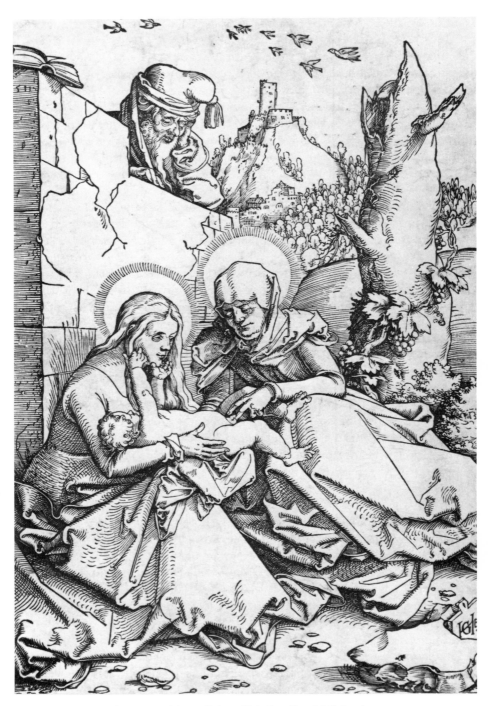

6. Hans Baldung Grien, *Holy Family with Saint Anne*
(1511; Geisberg, 59).

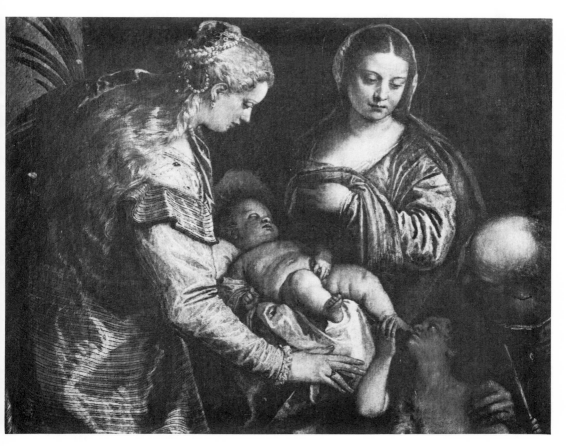

7. Paolo Veronese, *Holy Family with Saint Barbara
and the Infant Saint John* (ca. 1562–65). Florence, Galleria degli
Uffizi. Photo Alinari.

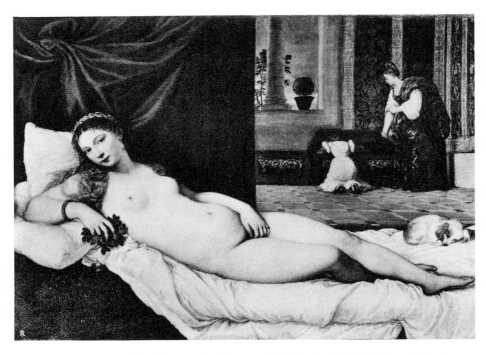

8. Titian, *Venus of Urbino* (1538). Florence, Galleria degli Uffizi. Photo Alinari.

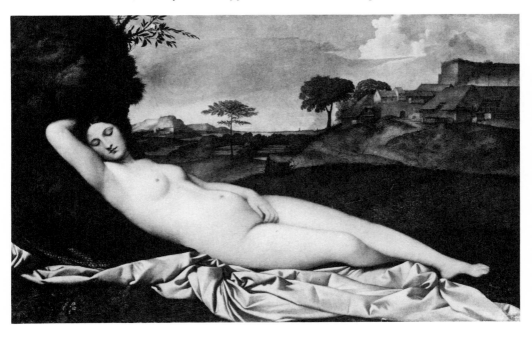

9. Giorgione, *Venus* (ca. 1510). Dresden, Gemäldegalerie.
Photo Alinari.

the possibility of the response that has to do with sexuality, with the love of looking, and with the projection of desire.

A male description of what appears to be the main object of the picture, of what by any reckoning any describer would count as the main focus of attention and (one might suppose) the main focus intended by the painter, could run as follows: a naked young woman looks frankly at the beholder; her chestnut tresses fall over her naked shoulders; her nipples are erect; with her left hand she only half covers her pudenda—she almost toys with them—while the shadow around them suggests (if it does not actually indicate) her pubic hair. She is completely naked except for the ring on her little finger and the bracelet around her wrist. The sensuality of the representation would have been plain to many and may well continue to be so. But not many will admit to this—at least not if they are well schooled. The texts and monographs mostly avoid acknowledging the overt sexuality of such paintings; the obfuscations are extraordinary. Dense iconographic readings and sensitively aesthetic evaluation of form, colors, handling, and composition are the convenient categories of description for pictures like these; but they obscure the analysis of response. They also enable the repression of feelings that pictures such as these may still evoke.

Of course the matter is more complicated than simply evading what some people might conclude to be the "sexual invitation" of pictures like the *Venus of Urbino* or the many versions (e.g., fig. 10) of Venus with a lutenist or organist (usually taken to be Neo-Platonic allegories).[23] It is hard to be sure, in the first place, of the precise nature of the painter's intention—it may, after all, have been mixed. Perhaps he wanted to paint an erotic picture, but he may also have wanted to do the colors well and lusciously. Second, while the sexual element in these pictures can hardly be denied, there may well have been other factors that determined their purchase and that still arouse our appreciative or negative response—such as the artist's skills in making a good painting. But there is a great deal more that we tend to forget, evade, deny, or repress. These are relations that will be hard to define.

All this may be laboring the obvious. It will be held that we have, after all, become increasingly candid about sexual representation and its production and consumption. Perhaps there are very few left who care about or are taken in by the plodding and bookish evasion of meanings and import. But a sufficiently significant number remain, and the cases cited here are extreme examples of a general tendency. We go into a picture gallery, and we have been so schooled in a particular form of aesthetic criticism that we suppress acknowledgment of the basic elements of cognition and appetite, or admit them only with difficulty. Sometimes, it is true, we are so moved that we may be on the verge of tears; but for the rest, when we see a painting we speak of it in terms of color, composition, expression, and the

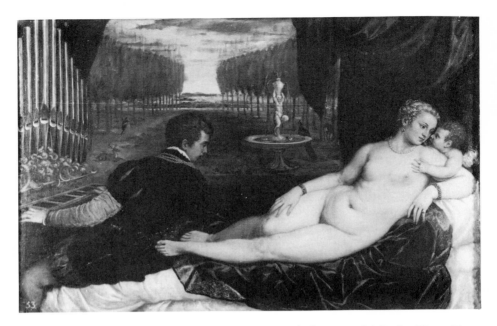

10. Titian, *Venus with an Organist* (ca. 1545–48). Madrid, Museo del Prado. Photo Mas.

means of conveying things like space and movement. It is the cultured layman or intellectual who most readily articulates this kind of response even though occasionally there may be a sneaking feeling that it has deeper psychological roots, which we prefer to keep buried or simply cannot exhume. We refuse, or refuse to admit, those elements of response that are more openly evinced by people who are less schooled. In such cases we are either being psychologically unanalytic, or discomfort with ruder feelings prevents their articulation.

VI

But how do we test these claims—however obvious—about responses to pictures such as the Venuses of Giorgione and Titian, and how do we refine our conclusions? For whatever the seductive pleasures of these images, no one would claim that the modern beholder's response is likely to be the same—or as strong—as that of the sixteenth-century viewer. Let us deal with immediate possibilities first, and then explore others.

We can claim that the very obviousness of the matter provides sufficient evidence—it is a picture of a naked woman and so the male sexual response comes to the fore; it is a beautiful picture of a beautiful naked woman, and so the male sexual response, given male conditioning, is primary. This is to elevate assumptions we automatically make (once freed of repression) to the

status of the evidential; and in some courts that would not be misleading—especially in those courts that must decide on the possibilities of retrieving what is fundamental in the matter of response. Second, we grant a similar status to intuition. We intuit the plausibility of the sexual reading, so do others whom we know, and we accord the judgment intersubjective validity. Third, we collect data from actual beholders and conduct a sociological survey. This is just the course that those skeptical of my claims so far are likely to advocate (the claims are too apodictic; they have a certain air of plausibility; but they are unproven). But for such evidence to be used, one would still need models of psychological and cultural conditioning, of how to take account of varieties of schooling, of differences in the far and obscure corners of one culture, and of the awe that one feels when one enters a museum and sees a picture in an elaborate gilt frame behind the neatly draped scarlet rope (to say nothing of bulletproof glass).

The fourth possibility for testing is continuous with the methodological and ideological predicates of this book. We consider powerful responses and discernable patterns of behavior that we know from people around us or within ourselves. That may mean looking at more everyday forms of imagery or clear forms of historical use (of a kind that sometimes, but not generally, pertains to high or canonical art). Then we seek equivalent models or equivalent contexts from the past or within the realms of art, and we strive to avoid circularity.

Let us return to the case of the *Venus of Urbino*. The picture is plainly erotic, even though *our* perception of its sensuality may be comparatively muted. It is both a truism and a commonplace that the expansion of methods of reproduction—above all of photography—has frequently had the result of turning the shock of first sight into the near-indifference of familiarity. In any case, since 1538 people have become used to still more candid pictures, like Manet's *Olympia,* or the centerfolds of a wide range of magazines (cf. figs. 11 and 163). It is precisely responses to these that one should not neglect in considering images like Titian's Venus. Even now, with a picture like this, we must repress a great deal to avoid admitting to the consequences of scopophilia and the desirous act of looking. It is not extravagantly hypothetical to imagine how much more direct an appeal such a picture must have made to the sexual responses of some sixteenth-century beholders, before Manet, before *Playboy,* before the plenitude of reproductive processes from printmaking to photography. The reason that it is not extravagantly hypothetical will emerge from the abundance of historical evidence I will bring forward. None of this, however, is to claim that modern beholders respond in the same way to sixteenth-century pictures as sixteenth-century beholders did, or that Indian erotic sculptures arouse the same responses in Westerners as in Indians. The aim is to plot responses, and then to consider why images elicit, provoke, or arouse the

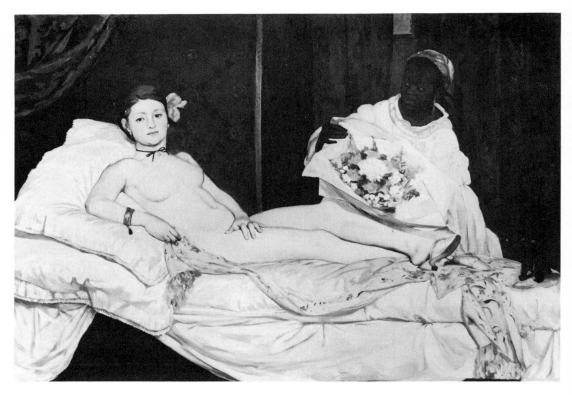

11. Édouard Manet, *Olympia* (1863). Paris, Musée du Louvre.

responses they do; the issue is why behavior that reveals itself in such apparently similar and recurrent ways is awakened by dead form.

But let us not be too guarded in our awareness of the changes of context, both visual and historical. Of course it is possible for a male to gaze upon the revelation of naked female form without being sexually aroused, but even with a picture as ancient as Titian's we count the fact that this is no casual unveiling. Once such forms are presented as paintings, the spectator is invited to dote on the body in the picture and to engage those feelings of possession and fetishism from which, as long as he looks at the picture, he chooses not to escape.

But analysis is complex and difficult. If we are to understand the relations between sixteenth-century paintings such as the *Venus of Urbino* and the sexual feelings of men and women, we have to begin by setting them in the context of a wide variety of related material. Apart from, or in the absence of, written documents, the phenomenological evidence is primary; but a necessary refinement must ensue, and that pertains to the selection of images. We may take the image in the centerfold (the closer in composition and color to the problematic case the better) and consider the phenomenology of scopophilia and arousal; but to this procedure we must join the

historical and contextual one, as we ponder the kinds of response that other forms of apparently erotic imagery may have been capable of arousing. For the sixteenth century, for example, we might take prints such as the *Modi* after Giulio Romano and the *Lascivie* of Agostino Carracci (see figs. 168 and 164 below); but then we are presented with a combination of erotic naked form and strong sexual suggestiveness (or even the sexual act itself). With German nudes of the first part of the sixteenth century the problem is similar. In considering paintings such as those of the Cranachs, we should also turn to the extraordinary erotic prints of Sebald Beham and his circle, where the genital orientation is possibly even more blatant than in the Italian prints, and where the male gaze is even more directly implicated.

Thus we confront the initial complexities of analysis. There are more. Some problems disappear; others persist. Perhaps it might be argued that these prints are not art, but that is hardly the issue: whether or not they are art, they evoke responses that we must take into account when we consider works that *are* regarded as art. Perhaps it will be objected that the prints are reproductive images, on paper, in black and white, lacking the delicious modulations of color of Giorgione and Titian; but then we must ask these questions: What are the consequences of reproduction for the aura of the image? Do we respond more strongly—violently, demonstrably—to the painted picture hung in a public place or to a small print such as one by Sebald Beham, which we can keep with us and produce when we like, doting on it privately? Which gives the greater frisson? It might also be desirable to establish a distinction between the erotic and the pornographic, or at least to devise a sliding scale, beginning with a work that presents the nude cold, as it were, then passing to something that more blatantly suggests sexuality, and terminating with the representation of the sexual act itself. But here we stop ourselves and pause as we recognize the further difficulties that arise from analytic refinement.

For example: The erotic-pornographic distinction may only be semantically real (and intersubjectively variable); we may not need the distinction at all in our analysis of response. After all, it is not uncommon to find that the suggestive turns out to be more provocative than the blatantly descriptive. But with images from the distant past, it may well help to establish the limits of the publicly acceptable and the borderline between that which rouses shame and that which does not.[24] Modern beholders may no longer find the *Venus of Urbino* especially arousing, not only because they have seen so many reproductions of it and many others like it, but because sexual imagery can now go so much further. One has only to consider the vastly greater sexual expressiveness and exposure in popular imagery—from billboards to pornographic magazines—over the past few decades. But even with regard to the sixteenth century, one will still need to know how far Giorgione and Titian pushed beyond the normal conventions of represent-

ing the nude figure. Did they transgress the conventions just sufficiently to arouse the prurient, or much more, or not at all?

VII

Such are the multiplicity of models and controls that inevitably present themselves to the analyst of the history and theory of response. Some questions can only be answered by more historical research, others by more sophisticated phenomenological and psychological techniques. But all are predicated on the examination of as wide a range of imagery as possible, both high and low, both canonical and everyday. Without popular imagery, we can say little about the likely effects of the possible response to other forms of imagery. Here, if anywhere, historians of art acting as historians of images can come into their own, for here they utilize their old skills in assessing the comparative styles of different forms of art and imagery. They see differences and distinction where others may not, and then they may proceed to judge the role of style in engendering particular responses and particular behavior. In doing so they renounce the primacy of the traditional concerns of the history of art: speculation about the genesis of individual works of art, the attempted retrieval of historical-aesthetic categories, the assessment of the status of both creator and object (particularly when it is conceived of as high art), and in general the privileging of the upper end of the scale at the expense of the lower. The ethnography and everyday history that form the subject of this book have, it is true, been raided for the provision of illustrative and comparative material for many of these traditional concerns; but on the whole this kind of material has seemed too complex, too diffuse, and, at the same time, too embarrassingly trenchant to merit any kind of comprehensive analysis or overview.

The obstacles in the way of assessing past responses, indeed of reclaiming them from history, are clear, and I have already alluded to many of them. It will be held that response is dulled as a result of familiarity or reproduction; that the schemata and limits of representation vary and were not the same in the past as they are now; and that the very fact that a work is displayed in a museum, that it is acknowledged and recognized as canonical or as a masterpiece, powerfully conditions response. All this is true, and it may well be the case that in the domain of high art the spontaneous response is indeed the intellectualizing one. Nevertheless, I proceed in the belief that however much we intellectualize, even if that motion is spontaneous, there still remains a basic level of reaction that cuts across historical, social, and other contextual boundaries. It is at precisely this level—which pertains to our psychological, biological, and neurological status as members of the same species—that our cognition of images is allied with that

of all men and women, and it is this still point which we seek. No claim is to be made here that twentieth-century beholders respond to sixteenth-century images in the way sixteenth-century beholders might have (although we well may). But if we attend to our own responses to, say, the centerfold, we may be in a better position to understand contemporary responses to the nudes of Giorgione and Titian (or for that matter of Giulio Romano); and we cannot begin to understand either the motivations for or the effectiveness of, say, the images of traitors painted by Andrea del Sarto on the walls of the Palazzo Vecchio or the fourteenth-century frescoes of the banishment of the duke of Athens before we recall the posters produced by the École des Beaux-Arts in Paris in the spring and summer of 1968.

How, then, should we proceed? The first task must be to proceed as ethnographers and record as much as possible of all sections of society; we must then act as cultural anthropologists, attending to as wide a range of societies as practical. This is not to deny that different classes respond differently and that social and cultural contexts condition response; nor is it to deny that images are encoded in such a way as to communicate specific things to specific cultures or groups (the cultures or groups from which they emerge). But our concern is not primarily with interaction at this level. It is to mine what lies below the overlays of schooling, of class consciousness and conditioning, right down to the reflections and symptoms of cognition.

The scope of this investigation—as I have already insisted—covers all visual imagery, not just art. In order to understand our responses to "high" art we need the general and specific evidence supplied by responses to "low" images.[25] The history of art is thus subsumed by the history of images. There is and always has been a place for the history of what is and has been regarded as art, but that is not the present domain. The history of images takes its own place as a central discipline in the study of men and women; the history of art stands, now a little forlornly, as a subdivision of the history of cultures.

VIII

In the "Epistemo-Critical Prologue" to his youthful *The Origins of German Tragic Drama*, Walter Benjamin recommended an ascetic apprenticeship, whereby the philosophical explorer eschews both the inductive and the deductive approach and immerses himself in the most minute details of subject matter: "The relationship between the minute precision of the work and the proportions of the sculptural or intellectual whole demonstrates that truth content is only to be grasped through immersion in the most minute details of subject matter." This was the only way to save the phe-

nomena, Benjamin platonically insisted. Thus he directed himself to a vigorous attack on induction: "The attempt to define ideas inductively—according to their range—on the basis of popular linguistic usage, in order then to proceed to the investigation of essence can lead nowhere." The attack on induction led him to single out R. M. Meyer for criticism:

> Thus the inductive method of aesthetic investigation reveals its customary murky colouring here too, for the view in question is not the view of the object resolved in the idea, but that of the subjective states of the recipient projected into the work; that is what the empathy which R. M. Meyer regards as the keystone of his method amounts to. This method, which is the opposite of the one to be used in the course of the current investigation, "sees the art-form of the drama, the forms of tragedy or comedy or character of situation, as given facts with which it has to reckon. And its aim is to abstract by means of a comparison of the outstanding representatives of each genre, rules and laws with which to judge the individual product. And by means of a comparison of the genres it seeks to discover general principles which apply to every work of art."[26]

Now this is very astringent, and much of it may seem to apply to the present endeavour. But let it not be thought that this is an "aesthetic investigation." Let no one think that I will seek general principles to apply to every work of art (nor even to "art" in general). I will certainly not seek to abstract genres, however pressing the issue of genre and conventional form may or may not turn out to be. Nevertheless, the process of investigation will indeed be inductive. While I am concerned with fragments and proceed by minutely examining them, as Benjamin recommended, I view the whole of human relations with figured imagery in order to lay out certain aspects of behavior and response that may usefully be seen to be universally and transculturally markable.

There are, of course, plenty of other places where the inductive method is laid to waste. But Benjamin's argument is especially interesting because it is avowedly concerned with the relations between science and art in the analysis of art. This book, it will be seen, is not to be concerned with art above all. It will, however, be concerned with aesthetic issues (but not with issues in the realm of philosophical aesthetics). The enterprise is wholly different from that of Meyer assailed by Benjamin. It is not, to begin with, predicated on the hypostasis of any aesthetic category; indeed it is vigorously opposed to that. A naive assumption may be that it hypostasizes response or particular kinds of responses, but nothing could be farther from the case. It does not set out to determine what responses are or are not, nor, indeed, what response is or is not. It is concerned with the modes of talking about behavior that beholders themselves can recognize, and about behavior

and interaction that cannot take place without the presence of the figured object. It will, of course, also have to concern itself with the "subjective states of the recipient projected onto [if not into] the work." And empathy, as in Meyer, is also at work; but it is a rigorously phenomenological empathy, which may or may not repeat the examples of historical and ethnographic empathy recorded in these pages, and which we will explore philosophically and historically in a number of later chapters.

But have I not, in the outline of examples of efficacy and potential efficacy, and of possible arousal, mixed issues of emotion and cognition? I may seem to have allowed one explicit and one implicit category to overlap too easily (since there has been no claim that this book will deal with the vagaries of emotion.) Athough much in these pages will rouse the disagreement of the author of *Languages of Art,* and although the task is wholly different from his, Nelson Goodman's statements, as he nears the end of that book, may stand for one of the mottoes of this one:

> Most of the troubles that have been plaguing us can, I have suggested, be blamed on the domineering dichotomy between the cognitive and the emotive. On the one side we put sensation, perception, inference, conjecture, all nerveless inspection and investigation, fact and truth; on the other, pleasure, pain, interest, satisfaction, disappointment, all brainless response, liking and loathing. This pretty effectively keeps us from seeing that in aesthetic experience *the emotions function cognitively.* The work of art is apprehended through the feelings as well as through the senses. (Goodman's emphasis)[27]

The only differences are that we might replace the category of "aesthetic experience" with something much broader (say, the apprehension of real images), and that our scope extends beyond "the work of art" to all images. But in his final emphasis, Goodman makes at least one concession in this direction, and the general statement holds. It comes after the claim that "symbolization [i.e., in the broad Goodmanian sense of referring to all images] is to be judged fundamentally by how well it serves the cognitive purpose," and after some diversion down the byway of "aesthetic excellence"

> this subsumption of aesthetic under cognitive excellence calls for one more reminder that the cognitive, while contrasted with both the practical and the passive, does not exclude the sensory or the emotive, that what we know through art is felt in our bones and nerves and muscles as well as grasped by our minds, that all the sensitivity and responsiveness of the organism participates in the interpretation of symbols. [28]

I mean "the interpretation of symbols" in the broader sense; this will not be a book about hermeneutics.

When we think again of the initial examples, we are still left with these problems: What credibility can be attached to such apparently incredible tales? In what senses can images have the effectiveness attributed to them there, and in what ways can we talk about that effectiveness? What are the links between the bedroom tales and the case of responses to imagery seen as erotic; or between the powerfully consoling image and the refinement of emotional sensitivity through concentration? The links have to do with the possibility of arousal and ascent by picture (and by sculpture too, but that, as we shall see, is a slightly different case). Following arousal and ascent, a whole variety of peculiarly symptomatic effects ensue. Why? How? And in what sense that we can still understand? Of course it is not just a matter of sexual arousal or meditative ascent. In the following chapters, I will consider instances of arousal to tears, to militant action, to follow causes, to make long journeys, to make other images like the one that has deeply moved us, to destroy that which disturbs us, as if we acknowledge, in that very act, its power. Without embarking on theories of representation, we must also consider how images are made to work in these ways. But I have begun with specific examples because they pose the following questions most acutely of all: Why do we ignore the evidence for the effectiveness and provocativeness of images? How may we speak about such matters? Why are we aroused by the body in the lifeless image and what do we postulate in its absence? These are the questions to which we must now turn.

2

The God in the Image

On the precipitous slopes of the Alzou Gorge in the town of Rocamadour in Quercy, there is a much venerated statue of the Virgin (fig. 12). A colleague makes a long journey to visit it, just as many pilgrims have done from the Middle Ages to modern times. Some go with the aim of reaching Rocamadour specifically; others make it a stopping point on the road to the great shrine of Compostella. My colleague does not go in the hope of being healed from some disease, but does she still think, as tens of thousands have, that some benefit will accrue from proximity to the little statue of our Lady of Rocamadour? She does not go to pray, but she may go to see what it is about the image that has made it so famous, or perhaps because so many others have done so. We do not know; we cannot precisely unravel such motivations. All we can do is remain alert to the pull of the image. And so my colleague makes the arduous trip and forces her way through the crowds that throng the simple chapel housing it. All she finds—or so she feels—is an apparently insignificant and rather ugly little sculpture. She cannot believe all the powers that have been attributed it. It should look more beautiful, or more imposing. "I could not believe it," she announces on her return, "After so long a journey, all I saw was a small ugly Madonna, with a supercilious look on her face. I was so angry with her!"

Not anger with *it*, but anger with *her*. The issue for the moment is not the disappointment that arises upon realizing that the miraculous is so

276. *It would be very natural for me to describe the photograph in these words "A man with dark hair and a boy with combed-back blond hair are standing by a machine." This is how I would describe the* photograph, *and if someone said that doesn't describe it but the objects that were probably photographed, I could say the picture looks as* though *the hair had been that colour.*

277. *If I were called upon to describe the photograph, I'd do it in these words.*
LUDWIG WITTGENSTEIN,
Remarks on Colour

mundane and unimpressive. With this we are all familiar. What is at issue is the response that is predicated on the assumption of presence, not on the fact of representation. In such cases, what is represented becomes fully present, indeed representation is subsumed by presence: "angry with it," not "angry with her." Now of course when one is irritated, exasperated, or angry, it is sometimes easier to be angry with someone than with something (and in our discussion of iconoclasm, we will see some of the complexity of this psychological field). But still the sign has become the living embodiment of what it signifies. Perhaps it will be suggested that a strong or ingrown belief in the powers of the Virgin easily inclines the believer to see her present, disencumbered of everything that makes her dead representation. Perhaps the suggestion will run that one cannot believe that the Virgin is in the picture—or *is* the picture—unless one believes, to begin with, in the Virgin. Then, wanting her to be there, to exist (because of the love we bear her), we willingly concentrate on the image, and what is represented on it becomes present again. She is, quite literally, re-presented. The slip from representation to presentation is crucial, from seeing a token of the Virgin to seeing her there. What happens? How do we proceed without engaging in the analysis of the propositional status of statements about belief, or the relations between the nature of beliefs and reports about them?

12. The Madonna of Rocamadour. Photo author.

I

In 787 the Second Council of Nicaea brought the first great phase of Byzantine iconoclasm to an end. In order to refute the arguments of the iconoclasts (encapsulated in the decision of the first iconoclastic council of 754), it marshaled a vast body of material in favor of images and image worship. There were complex technical discussions taken from the early Greek fathers as well as from the later Byzantine writers, but there were stories too. Innumerable anecdotes were excerpted from the Apologists and from the Lives of the Saints, all intended to exemplify the advantages and benefits of images. One such tale comes from the life of Saint John the Faster, patriarch of Constantinople (he died in 595), by his disciple Photinus.

The husband of a rich woman was inhabited by an evil demon. Photinus came upon her one evening, and she told him that for three years she had sought help from monks and at shrines, but her efforts were unsuccessful. Finally she went to a venerable hermit, who had instructed her more or less as follows: "Go," he said,

> to the patriarch John, and bring back an image of the Virgin, with his blessing. . . . Set it up in the entrance to your house, making sure that it is turned away from the city. . . . Everyone who lives in your house will be blessed. . . . The spirit will be expelled and put to flight. It will not approach you again, since God will be near at hand.[1]

On the following day, therefore, Photinus took her to the patriarch, but the latter refused to accede to their request. The patriarch was indignant that he, who was also a sinner, should be the instrument of the prospective miracle. This upset the resourceful Photinus, but not for long. He thought of an alternative and provided the woman with an image which looked beautiful and precious enough to have come from the patriarch. The image was fixed to the entrance wall of the house, and the woman's husband was duly cured. The cure was effected, as Photinus put it, by the image, which was "the place—or rather the token—of the Virgin mother."[2]

In this slip of the tongue, which in the Greek is conveyed by a deliberate catachresis—*ho topos ho tupos de mallon tēs parthenou mētros*—lies the nub of the matter. The most distinguished modern commentator on attitudes toward images in the early Byzantine Empire has called it "a last minute withdrawal from the abyss of sheer animism."[3] But to introduce the notion of "animism" here seems to beg a question or two. It is a little premature. The concept of animism remains unanalytic—though we may have a vague idea of what is meant by it.[4] Here the issue itself might be spelled out more plainly.

Clearly Photinus and the woman with the unhappy husband felt that the miracle had been effected by the Virgin, but it was not the Virgin abstractly, or the Virgin purposefully returning to earth to do the specific miracle. It was the Virgin in the image. Photinus knows that the Virgin cannot really be in the image; so he corrects himself and says that the miracle was wrought by the Virgin represented by the image. But the matter is not so easy. Does he mean that the miracle could only have been wrought by the Virgin represented in that particular form—in other words, by that particular token, or conceivably by that particular type? And wrought only because the image had been obtained from a particular source, and only because it had been placed correctly—as the account would seem to suggest? In that case, effectiveness proceeds specifically from the image; the image, rather than the Virgin is believed to work. But of course the image only works because of the fusion of image and prototype, and this is precisely the fusion against which all image theory has always raged. In that needful rage lies tacit acknowledgment of the effectiveness that proceeds from fusion.

We shall spend some time on responses predicated on the perception that what is represented on an image is actually present, or present in it. But perhaps with such responses, it is not that the bodies are present; it is *as though* they were present. When we think, as Photinus did, that the Virgin is in the image, or that the figure in the photo is the living nude, are we only thinking metaphorically? Or metonymically? If that were the case, then the kinds of responses outlined in this book provide proof of the constructive power of metaphorical and metonymic thought, and of the way in which all perception elides representation with reality (perception visually or perception neurologically is not at issue).[5]

But still, just as Photinus stopped himself in time ("on the brink of the abyss of sheer animism"), we know that we do too. We hasten over to the beckoning portrait, we clutch at the dripping blood on the body of Christ, we start at the waxwork murders; and then we remind ourselves that these are only pictures, painted sculptures, wax models. And so, as soon as we outline the consequences of the belief that what is represented on an image is actually present in it, we must at once ask this: When is belief undermined by consciousness that the image is merely the token of what it represents? Perhaps it will be found that belief and response are never thus undermined or enhanced. Perhaps the undermining or enhancement forever remains secondary. We cannot yet decide.

II

A remarkable West African ceremony presents similar issues of fusion and inherence, but at the same time allows us to expand the elements of response still further. Until its suppression by the colonial authorities, the *ndakó gboyá* cult of the Nupe people of Nigeria used a mask that was different from any other in that country.[6] It was not in the slightest anthropomorphic but was made of white cloth, shaped like a cylinder, and was just wide enough to hold a man. This cylindrical shape was suspended from a wheel-shaped bamboo frame fixed to the top of a tall pole, about twelve feet high. It must have made an eerie and terrifying sight as the man inside it moved it forward at varying speeds, "occasionally jumping and running, or inclining the pole this way and that, lifting and lowering it, and making the cloth tube swing and sway."[7] It is not surprising that the *ndakó gboyá* mask should have been used for two purposes: on the one hand to frighten novices and warn youths during the main Nupe initiation ritual known as the *gunnu,* and on the other, to drive out people suspected or convicted of being witches.

After describing the ceremony in this manner, the anthropologist who investigated the *ndakó gboyá* cult most fully before its suppression noted that "once the performer is inside the mask, he is inseparable from the thing he 'represents'; he *is* the *ndakó gboyá* [the "Grandfather" or "Ancestor Gboyá"], the people insist, and no longer so-and-so, whom you know and have talked to." The anthropologist tested this claim, perhaps a little naively: "Once during the ceremonial, I offered food and drink to the 'man in the mask,' suggesting that he must be in need of refreshments after his exhausting performance. My offer was ridiculed, and I was told that 'spirits do not eat.'" There are significant corollaries to all this: "Any person who has not been initiated into the *ndakó gboyá* society or has omitted the preparatory rites would be killed by the mask as he entered it. The mask, of course, is just cloth, and must be cut and tailored; many masks also show patches and signs of repair. But again, once the sacrifice has been performed over them, they are no longer merely a material object, but the thing itself which they signify."[8]

How description beggars perception! "Just cloth," and "merely a material object"—this, of course, is just what the mask is not: it is nothing less than the *ndakó gboyá* itself; and in order for it to be thus invested with the living spirit, it has to look a certain way and be consecrated in a certain way. The case from West Africa is the same as the case from Byzantium. The image, once properly prepared, set up, adorned, and decorated, becomes the locus of the spirit. It becomes what it is taken to represent.

There is a difference, of course: in the African case, the mask—like so many of the masks used in ritual ceremonies in non-Western cultures—is quite literally animated.[9] Spirit, it may be argued, thus passes into material object only through the mediation of some live performer. But whatever the technicalities of mediation, the fact remains that responses to the mask are predicated on the very conflation of sign and signified that we have already noted with images in the West, and effectiveness in all cases depends on just this conflation. But again the matter is apparently not quite so simple. The image seems to acquire its effectiveness only following some act of consecration or another, which invests the "mere" materiality of the mask or image with powers not attributable to the material itself.[10]

The tall plain shape of the *ndakó gboyá* mask is terrifying; it can drive out evil spirits; and its force is such that if appropriate rites are not followed it can kill. If one shows insufficient respect to the mask (and mutatis mutandis, to the *ndakó gboyá* itself), one is likely to pay an awful penalty. Nadel recalls being told of a Yoruba man who "scoffed at the mask and refused to take off his cap (as all onlookers must do)." At once (or so his respondents told him) he was struck down and killed.[11] As soon as the image is consecrated, it has at all times to be properly venerated; insult to the image is insult to what it embodies, represents, or signifies; and terrible punishment is visited on those guilty of such lèse-majesté.

But the African case has been introduced not just because it provides an interesting ethnographic parallel to our Western example of inherence and fusion. The further parallels are striking too, including the notion of respect following—indeed demanded by—consecration. The trouble is that we in the West acknowledge these things very little—if at all. We choose to ignore the kinds of response that transcend cultural and chronological differences, and we refuse to acknowledge those aspects of response to all images that precede detachment and rational observation. Historians of art ignore those symptoms of the power of images that go deeper than more or less anodyne aesthetic attraction and repulsion. *We* may be quite happy to believe that images in primitive cultures are felt to partake of the life of what they represent, or even of the life of things other than what they represent. But we do not like to think this of ourselves, or of our own society. We refuse—or have refused for many decades—to acknowledge the traces of animism in our own perception of and response to images: not necessarily "animism" in the nineteenth-century ethnographic sense of the transference of spirits to inanimate objects, but rather in the sense of the degree of life or liveliness believed to inhere in an image.

The Nupe example has been introduced here for another reason: the mask is of a kind that does not provide the cues to lifelikeness (other than the moving body within it) that would make it easier for us to understand and grasp the assignment of the living qualities of the signified to it. It has

been chosen precisely because of the power of the plain cylindrical shape and the strong responses it seems capable of evoking. The transference of powers to objects with rudimentary and primitive shapes lay at the root of late nineteenth- and early twentieth-century discussions of animism, but what is easily forgotten is the role—and the antiquity—of this phenomenon in Western culture.[12]

<div align="center">III</div>

That black meteoric stones known as *baitulia* were early objects of cult worship in ancient Greece is recorded from the earliest times, and we know from some of the earliest Greek writers that unformed planks, *bretades*, came to serve as the cult statues of particular gods.[13] Even as late as the fourth century, the pro-Christian apologist Arnobius recalled that, before his conversion, whenever he saw one of these stones "anointed and smeared with olive oil," he adored it and addressed himself to it; and he would seek benefits from what he later realized was a senseless stock, "as if some force was present in it."[14] For all their polemical or satirical motivation, one takes these stories and recollections seriously. The archaic wooden image (called a *bretas*) of Hera on Samos was stolen one day by Tyrrhenian pirates. Unfortunately, their ship refused to move; so the pirates made an offering to the image and abandoned it on the seashore. When the Carians of Samos found it there, they believed that it had run away of its own accord, "automatically" (*automatōs apodedrakenai*). In order to prevent it from doing so again, they chained it to a tree trunk (*lugos*) before finally returning it to be fixed on its pedestal in the temple.[15] Plutarch recalls that there was a *bretas* of Artemis at Pellene which was kept covered for most of the year. But on certain days the priestess of Artemis carried it in procession, and on these occasions no one could look directly at the image. Its eyes caused terror and death, and it made trees sterile.[16]

In accounts like these, we find some of the most typical ways in which lively powers are attributed to rudimentary and unformed images. *Baitulia* are invested with the divine and animated by it. Once anointed they even work miracles on behalf of their supplicants. *Bretades* serve as cult images, the holy loci of particular gods. They too are *empsychoi*. They are capable of movement; they can be restrained by chaining; and they are capable of causing harm, particularly if their gaze should fall upon someone at the wrong time or on the wrong occasion. Even these primitive and barely formed objects (if they are formed at all) evince the two primary attributes of life: mobility and sight. Limbs—whether indicated or merely notional—are believed to be capable of motion; eyes glint with the implication of divine reality and divine threat.[17]

13. Drachm from Ainos; on reverse: enthroned cult image of Hermes Perpheraios (fourth century B.C.; May, no. 443). Photo courtesy of the American Numismatic Society, Photographic Services, New York.

The lesson, then, is not to underestimate the affective power of shapes which approximate human (or animal) form only in the most undifferentiated of ways—say, only and solely in terms of their cylindricality or upright rectangularity—and to link this understanding with reports of attributed power. Whether such attributions grow out of a belief in tree divinities is not at issue here.[18] The issue is contained in this question: What is it about perception in history that makes people talk about the origins of images in these ways?

The earliest Greek cult statues that may properly be called statues in the general modern sense were known as *xoana*. They were, by all accounts, made of wood, although there may have been exceptions made of stone. The term appears to be a fairly generic one; very occasionally it seems interchangeable with *kolossos*. No *xoana* survive with any certainty, although a few representations on coins and on vase paintings give us some idea of what the earliest ones must have looked like: planklike stocks, occasionally topped with a sculpted head of the divinity they were supposed to represent (fig. 13).[19] Others appear to have been incised with lines to suggest their limbs, but hands and feet were not actually separated from torso. They were large and blocklike, all the more imposing because of the apparent isolation of the head (it is precisely these heads to which most scholarly attention, significantly, has been devoted).[20] The earliest ones were probably without hands, without feet, and without eyes—*acheiras, apodas, aommatous,* as a comparatively late source puts it.[21] Their primitive quality would probably be more closely conveyed if one called them, from this, unhanded, unfooted, and uneyed.[22]

Like the *baitulia, xoana* are supposed to have fallen from heaven, and this belief may well lie at the root of the perception that they are invested with divine powers. But it may equally be the case that their appearance and setting inspired such a view. They seem archaic and austere, and qualities like these make them so compelling that we call them divine. The problem is encapsulated in a brief account by Pausanias of the origins of a particular cult statue. He tells, in book 10 of his *Guide to Greece,* of certain fishermen of Methymna in Lesbos who caught a face made of olive wood in their nets. "Its appearance," he recalls, "suggested something of the divine"—even though (or perhaps because) it was "outlandish and not like the customary Greek gods."[23] Why, we ask ourselves, did the object suggest "something

of the divine"? Because of its fortuitous discovery (thus connecting it, consciously or subconsciously, with the images that miraculously fell from heaven) or because of its peculiar appearance? The solution of the Methymnans may seem surprising, but it was not entirely unpredictable: "They asked the Pythian priestess of what god or hero the figure was an image (*eikōn*), and she bade them worship Dionysius Phallen. Whereupon the Methymnans kept the wooden image for themselves and worshipped it with sacrifices and prayers."[24] This introduces an issue that may seem entirely new: the issue of naming. But it is not as new as it seems, since one may well want to align naming with consecration, and then conclude that it is only because a statue is *named* as a god, or consecrated as a cult statue, that it partakes of the numinous qualities of the divinity. The problem thus acquires a third element. Is the statue divine because it seems to come from heaven, because it looks venerable and therefore godly, or because it is named as a god?

The third possibility may be discarded, since—as is suggested by the account in Pausanias itself—the object has to have the potential for godly inherence even before it is taken for naming or consecration. Naming or consecration, as we shall see, may make the object work, but first there must at least be something to suggest its divinity. And so we are left with the other elements: that of chance discovery and that of form. Some stones we kick over on the seafront, others we collect—some we even cherish. There was nothing to stop the Methymnan fishermen from throwing away the object they found in their nets, but it looked like a god. In their case at least, form commanded the veneration accorded to a god, and form suggested the magical spell of the numinous.

No one in ancient times seems to have doubted that it was the formal aspect of the *xoana* that inspired this kind of recognition. Like several other writers, Porphyry maintained quite explicitly that even though the *xoana* were only summarily carved, they were regarded as divine. Their simplicity made them more "majesticall" (as an English translation of 1638 appropriately put it) and divine.[25] But if one were to think that Porphyry made the claim only in order to show the retrograde religiosity of the ancient Greeks (who were so inclined to deification that they could even worship stocks), one would be wrong. His next sentence gives the lie to that possibility: Other statues, "though carved with an art that was more refined, and though worthy of admiration, give a lesser idea of their divinity."[26] There seems, in short, to be a direct correlation between the power of the archaic and the immanence of the divinity. The image is arresting because of its archaic form. We cannot tell exactly why, and so it becomes the yet more fitting locus of the divine.

Certainly by the time Porphyry was writing there were many who recognized the archaic as a category, and it is not surprising to find comments on

the reverence inspired by it. (Porphyry himself noted that the oldest sacrificial vessels were regarded as more divine on account of their plain material and the simplicity of their art.) But there is nevertheless a strong consistency about the formal qualities attached to the archaic—rigidity and linearity, the absence of exuberantly decorative elements—and these are just the qualities also to be found in the earliest cult statues of the Greeks. We need not yet worry about the possible circularity of this issue: for even when there appears to be no developed notion of the archaic, images of the kind we have been discussing command the reverence that later appears to be attached to that category. It may well be that very early judgments are less concerned with the idea of the antiquity of the image, but what remains constant is the felt relationship between simple and rudimentary form on the one hand and divine inherence on the other—or perhaps it is rather that qualities of this order give rise to a sense of the divine present in the object.

This by no means exhausts the spell of the archaic, but it is instructive to see how mythical and legendary writing proceeds with the genealogy of images. Every writer who knows about *baitulia, bretades,* and *xoana* also knows about Daedalus, the primal sculptor among humans. It was he who separated and therefore liberated the limbs of statues from their torsos, opened their eyes, and gave them the appearance of life.[27] Fittingly for one who was usually considered a magician, he was also credited with having been responsible for the creation of statues that move, of *automata.* Once Daedalus gave limbs to statues and thereby invested them with the semblance of life, they seemed all the more unearthly and divine. If it were possible to imagine this notional stage in the development of images, the stage where images were still rather blocklike and unformed, but endowed—perhaps—with rudimentary markings, with the beginnings of contours and indentation, then one can also start to understand the sense of Pausanias's remark about Daedalus, *apropos* a naked wooden statue of Herakles at Corinth: "All the works of this artist, though rather uncouth to look at, have something of the divine in them."[28] Here again Pausanias has adumbrated the nature of the conjunction between the rudely sculpted image and the perception of it as godly and supernatural; but instantly the question arises as to whether the image is perceived as numinous because of its lifelike attributes or because of its archaic form. Pausanias may well have chosen the latter, since by the time he wrote, what was lifelike was not regarded as particularly miraculous; it was, indeed, the norm.

For a more precise assessment one turns to the sharper handling of this matter by Diodorus Siculus. A detached and analytic approach is precisely what distinguishes his historical sense from the anecdotalism of Pausanias:

> In the production of statues, [Daedalus] so excelled all other men that later generations preserved a story to the effect that the statues he

created were exactly like living beings: for they say that they could see and walk, and preserved so completely the disposition of the entire body that the statue which was produced by art seemed to be a living being. Having been the first to render the eyes open, and the legs separately, as they are in walking, and also the arms and hands as if stretched out.[29]

At last we can begin to make sense of the circularity of inherent divinity and the perception of liveliness. It is possible that the life-giving source of statuary derives from its divine origins or from its association with the cult of a god or goddess, but Diodorus's claim is that it is *art* that imbues the statues with life (and the claim is not solely motivated by a kind of old antithesis between natural life on the one hand and art on the other). The fact that Daedalus is not a "historical" figure is neither here nor there. In a manner that is central to the whole of Western culture, all talk about Daedalus and all recollections of him, mythical or not, embody a crucial stage in people's thinking about images and the way they respond to them. It is this stage that we conveniently refuse to acknowledge, except to say that when we think like this we are thinking in topos, cliché, and commonplace.[30]

IV

But how seriously are we to take the statements of writers who are, after all, either polemical apologists, perhaps with a specific axe to grind like Arnobius, or satirists like Lucian, or compilers of periegetic anecdotes like Pausanias (*omnium Graeculorum mendacissimus*), and who are spiritually, chronologically, and even geographically divorced from the context of what they describe? Let us be clear about the nature of the evidence sought: no claim will be made for the historical accuracy of the material presented by writers like the above, but substantial claims will be made for the significance of the way in which they speak of responses to images and to art, and for the material they present about this subject.

A Christian apologist is likely to distort—or even to invent—information about responses to pagan idols, in order to clarify Christian attitudes to images and to prove their superiority. (The same applies to the wide range of Jewish writers who adopt apologetic or iconoclastic positions, from Philo to Josephus.) A Lucian or a Juvenal may simply refer to responses to images in order to poke fun at the general absurdity of human behavior. And when it comes to writers like Valerius Maximus and Aelian, perhaps the best that may be said of them is that they are more or less indiscriminate collectors of information (for all the didactic purposes of Valerius), with little

sense of the need to differentiate between old anecdotes and verified facts.

But much of the value of these writers lies in just their lack of scientific pretension. What they say has all the import of the incidental. The most telling information about behavior provided by the rehearsers of jokes, the deployers of sarcasm, and the converted polemicists on behalf of passionately embraced causes is precisely what they do not specifically set out to tell us about. Furthermore, jokes and anger betray the unconscious and suppressed data about human attitudes and behavior that cannot be spelled out in the usual and conventional modes of scientific description. If the aim of this book were to provide a history of responses to images, objections to all such sources on the grounds of tone and time would be serious ones, but the aim is not that. It is to seek ways of speaking about the conditions and elements of response.[31]

For this reason, idiosyncrasy is admitted but omitted. We acknowledge the idiosyncrasy of individual behavior, but we omit it, wherever possible, from the description of behavior. Otherwise description would break up into anecdotalism, and analysis would be thoroughly subverted. We need, therefore, a sufficiently wide range of material to enable the extraction of a reasonably wide variety of random samples. Only on this basis will it be possible to arrive at analytic statements about behavior. That is why a study of this order cannot be confined to the particular case. More than one sample, or group of samples, is necessary to form an adequate basis for the inductive procedure—even though it is clear that some samples permit extrapolation to the general level better than others. The practical range will be small; the ideal range as large as possible. The aim is not to fix constants, as these only arise from the limitations of a particular hermeneutics; it is rather to see what methodological principles arise from an avowedly limited range of historical examples. Although we imply constancy by isolating recurrent phenomena, there is no intention of implying constancy across all cultures. But absence is just as revealing as presence—and never more so than when constancies are postulated. The investigator, then, has to range widely, provided he or she remains aware of the limitations of the particular sources used. There is no reason to exclude the whimsical, the witty, the angry, and the less intelligent. All these may provide more revealing information than the cool reporter.

Nowhere have the problems of evaluating all these kinds of material been more clearly laid out than in the preface to Charly Clerc's almost forgotten book of 1915 on second-century theories about the cult of images. Although he dealt with only a fraction of the evidence which we will allow to be at our disposal, his words about the second century have a striking relevance for our much more general study. He sees the crucial difficulties and sets out the issues so succinctly that his exposition of them merits close attention.

The study of such a problem [i.e., of the cult of images] is risky not only because it deals with past ages and extinct nations. Think of an ethnologist or historian of religion intending to plot the role of images in [popular] piety in Italy or in Spain at the beginning of the twentieth century. Imagine this scholar in the course of his researches, posing himself innumerable questions on the way. Undoubtedly he will learn that in such and such a village a statue has well defined miraculous properties, that on certain occasions another statue is credited with mobility, that a Madonna gathers on her pedestal or in the fold of her garments the written prayers deposited at her feet, that a Black Virgin is regarded as having fallen from heaven, or that it was brought there by angels. It will seem to him that in one place the statue is venerated for its own sake, for its substantive qualities; elsewhere it is the saint who is venerated by way of its icon. For every image whose reputation is known and established, there will be hundreds of others of which there is no mention. And what will he conclude from that? *He will hear old anecdotes, given as miracles and prodigies of the day before.* He will note down carefully the affirmations of 10 or 20 pious people, and will take the surprised silence of the others as agreement. Continually he will risk forgetting that the cult is devoted to "an old idol that one censes by force of habit" (as Montesquieu put it), and that people unconsciously persist in the gestures they have learned. The scholar of whom we are speaking will not lack documents. He will have more than he could wish for, and it will remain for him to put order into this jumble. But I fear that in his conclusions he will only be able to formulate trite reflections, ones already made by other travellers. Each one of them, it is true, will be reinforced by an impressive array of examples: a collection of curious facts, unpublished material, redolent folklore—all of this; but the author still does not achieve his aim. He barely knows more than he did before.[32]

Clerc describes exactly the kinds of phenomena that will feature in these pages, both modern phenomena and those whose roots are deep within the earth of national cultures and folklore, all foreseen by a scholar on the basis of his researches into the second century. Clerc could not, what is more, have put the problems faced by the investigator with greater insight and acuity. He recognizes the full implications of his task and its inductive potential, but he sees, too, the near-impossibility of his task. Indeed, in his very next paragraph, Clerc touches on what is probably the most crucial difficulty of all. How can one say anything at all about popular response and popular attitudes to images in history in the absence of living witnesses? And what is the relation, if any, between reality and the swift judgments and garrulous phrases of those who write about these matters? What

value, we may add, have the belletrists and poetasters for the assessment of belief?

The answers to these questions must lie in the use we make of the material we do have. The issue of the evidential status of the commonplace and of the repeated clichés about response that characterize so much of the writing and the reporting about images must be resolved. The extent to which general judgments about response are predicated on a theory, however tacit, of human nature should be clarified; and a judgment should be made as to whether the reports of (and about) the unschooled—or, say, the primitive—are somehow more telling than the refined judgments of the schooled, of the sophisticated, and of the refined. If one cannot satisfactorily come to terms with any of these issues, then the only recourse available will be to hard sociological data, of the kind examined by Pierre Bourdieu in his two remarkable but unrevealing books *L'Amour de l'art: Les musées d'art européens et leur public* (1969) and *La distinction: Critique sociale du jugement* (1979), which make use of the techniques of social survey and purposively formulated questionnaire. Do we then go out into the subways and museums and ask about responses to images in places like these, or do we develop a theoretical structure that enables us to come to speak in general terms about response and behavior in the presence of all images? This book would founder here if there were no hope of that possibility.

3

The Value of the Commonplace

The following lines occur near the beginning of Nathaniel Hawthorne's short story entitled *The Prophetic Pictures*. The story as a whole contains much about art:

> Pictorial skill being so rare in the colonies, the painter becomes an object of general curiosity. If few or none could appreciate the technical merit of his productions, yet there were points in regard to which the opinion of the crowd was as valuable as the refined judgment of the amateur. He watched the effect that each picture produced on such untutored beholders, and derived profit from their remarks, while they would as soon as thought of instructing Nature herself as him who seemed to rival her. Their admiration, it must be owned, was tinctured with the prejudices of the age and the country. Some deemed it an offence against the Mosaic Law, and even a presumptuous mockery of the Creator, to bring into existence such lively images of his creatures. Others, frightened at the art which could raise phantoms at will, and keep the form of the dead among the living; were inclined to consider the painter as a magician, or perhaps the famous Black Man, of old witch times, plotting mischief in a new guise. These foolish fantasies were then half believed among the mob. Even in superior circles his character was invested with a vague awe, partly rising like smoke wreaths from the popular superstitions, but chiefly caused by the varied knowledge and talents which he made subservient to his profession.[1]

Strangely, though, with progressive loss of its virility as a figure of speech, a metaphor becomes not less but more like literal truth. What vanishes is not its veracity but its vivacity.
NELSON GOODMAN,
Languages of Art

In this passage, Hawthorne announces some of the most crucial issues in the history and ethnography of images. He begins by alluding to the sig-

nificance of the relationship between center and periphery; he is aware of the aura of the imagemakers; he moves on to the dialectic between sensitivity to form and artistic skill on the one hand and, on the other, the kinds of responses which do not appear to be so dependent on formal and technical factors. Then he emphasizes the significance of the effect of pictures, reminds the reader of their peculiar ability to keep the dead among the living (and not only the form of the dead), and he suggests some of the bases for the fear images arouse, and the motives for the constraints people apply to their making. Here too is an awareness of the consequences of perceiving images as lively, and of the presumption of the artist in emulating that sole Being who gives life to form; just as in the Islamic Ḥadith, where the artist, upon reaching heaven, is challenged by God to emulate him by breathing life into his creations, and failing to do so, is cast down and punished.

But most resonant of all is Hawthorne's insistence on that vast area in which "the opinion of the crowd was as valuable as the refined judgment of the amateur." Admittedly he acknowledges the conditioning role of the "prejudices of the age and the country," but he goes further with his description of the parallel with magic. For all that, he clearly does not regard the effects he ascribes to pictures as magical in themselves; it is just that they work in a manner that may be likened to popular perceptions of magic and wizardry. This is the nub of issue: we have yet to see why images are believed to work in ways that transcend the analytic patterns of everyday rationality. And while Hawthorne appears, on the face of it, to relegate the classes of belief he describes to the level of the untutored, the crowd, the mob, there is an undercurrent of awareness that they pertain to the rest of us too. It is an undercurrent that swells, at the beginning, with the acknowledgment of the value of "the opinion of the crowd" and ends, discomfitingly, with the statement that "even in superior circles, his character was invested with a vague awe, rising like smoke wreaths from popular superstitions."

The fact is that Hawthorne knew clearly what I am claiming as one of the underlying principles of this study: that we too have the kinds of beliefs about images that people who have not been educated to repress those beliefs and responses have; and we respond in the same ways. We too feel a "vague awe" at the creative skills of the artist; we too fear the power of the images he makes and their uncanny abilities both to elevate us and to disturb us. They put us in touch with truths about ourselves in a way that can only be described as magical, or they deceive us as if by witchcraft. But because we have been educated to talk and think about images in ways that avoid confronting just these kinds of effects, the only way we can be frank is to attend to the responses and reports of those whom we regard either as simple, unsophisticated, or provincial; or, indeed, to attend to the peoples of Africa, Asia, and America whom anthropologists have thankfully ceased

calling primitive. The term "primitive," however, may still retain its usefulness if we acknowledge it in connection with feelings and emotions that precede the repressive overlay that education in civilized cultures endows us with.

It could perhaps be argued that this is all quite wrong, that the only way in which we can be adequately analytic about the phenomenon of response is by acknowledging the differences between traditional and "primitive" cosmologies and our own modern "scientific" world view. Perhaps we should simply admit that responses based on the attribution of life and lifelike powers to objects are characteristic of societies in which the basic explanatory category is in terms of the gods of a pantheon; we, on the other hand, use science—not religion—as the basic term of explanation. This intellectualist stance may well have a certain analytic utility, but it makes just the distinction I wish to avoid.[2] Even if we take a strictly literalist point of view and accept all explanations of behavior and attitudes at face value, we will find that, once elicited, the reasons given for such behavior differ enormously. But that is not the point. I am less concerned with the explanation of response than with its symptoms and structures and a reasonable means of describing them. By clearly postulating the contrast between traditional cosmologies (whatever they, in general, may be) and a modern scientific world view (whatever that, in general, may be), the investigator may feel better equipped to deal with the problem of the undermining of theory by experience. But such an approach would be artificial, at the very least. A more satisfactory approach would be to take the phenomenological course of building into one's theory and presuppositions acknowledgment of the thesis that experience undermines theory. Otherwise we are likely to sink into a swamp of a prioristic and relativist difficulties about the behavior of others—as much as of the self.

But this acknowledgment does not, of course, resolve every difficulty. Like Hawthorne's colonists, we may find it easier to describe belief in the power of images in terms of fantasy, superstition, and magic; but we know too that such categories are evasive. They seek to be explanatory, but they do not explain enough (or anything). Rather they are telltale signs of our inability to account for the never-ending disruption of natural law that arises from the relations between figured objects and people. That inability is why we invoke them so often.

It is not, for the most part, that the painter is a magician, or even acts like a real magician; it is just that when images are set among us, the dead are kept among the living and inert matter becomes lively—to such an extent that we may even be afraid of it. The role of artistic skill in this process is undeniable. It is most nobly described in Dio Chrysostom's *Olympic Discourse,* where Phidias himself explains the artist's role in ensuring that images work effectively, but there is no need to be mystical about that role.

By its very nature, the lapse into mysticism defies the possibility of analysis. We understand intuitively the effects Dio Chrysostom attributed to Phidias's statue of Zeus, when he said of it that "whoever is sore distressed in soul, having in the course of his life drained the cup of many misfortunes and griefs, not even winning sweet sleep—even this man, I think, if he stood before this image, would forget all the terrors and hardships that fall to our human lot."[3]

Such are the redemptive powers we readily grant to art; but there is more to its effect than the release from alienation. Hawthorne described more than just that when he wrote about the painter in the colonies and the beliefs focused on his creations, and so did Alberti, that most sophisticated of all writers about art, at the beginning of the second book of his remarkable compendium of practical and speculative information about painting, the *De pictura* of 1435. Thus we move from colony to imperial center, from talk about the responses of those unschooled in imagery to talk about those who are refined and educated in art; but the issues involved are not the province and domain of either group.

> Painting possesses a truly divine power in that not only does it make the absent present (as they say of friendship), but it also represents the dead to the living many centuries later, so that they are recognized by spectators with pleasure and deep admiration for the artist. Plutarch tells us that Cassandrus, one of Alexander's commanders, trembled all over at the sight of a portrait of the deceased Alexander, in which he recognized the majesty of his king. He also tells us how Agesilaus the Lacedaemonian, realizing that he was very ugly, refused to allow his likeness to be known to posterity, and so refused to be painted or modelled by anyone. Through painting the faces of the dead go on living for a very long time. Painting is also a great gift to men, in that it represents the gods we worship, for painting has contributed considerably to the piety which binds us to the gods, and to filling our minds with sound religious beliefs. How much painting contributes to the honest pleasures of the mind, and to the beauty of things can be seen in a variety of ways, but especially in the fact that you will find nothing so precious which association with painting does not render far more valuable. Ivory, gems and all other similar precious things are made more valuable by the hand of the painter. Gold too. . . . Even lead, the basest of metals, if formed into some image by Phidias or Praxiteles would be regarded as more precious than unworked silver.[4]

At least five basic points may be reclaimed from this occasionally repetitious passage. Painting makes the absent present and the dead living; it aids memory and recognition; it can inspire awe; it rouses piety; and it transforms the value of unfigured material (just as sculpture does). Its pow-

ers, in short, are such that it can only be described as supernatural and divine. But in what sense divine? Is the claim just an extravagance, a figure of speech that offers a discursive means of coping with the complex powers and effects of images? "Through painting the faces of the dead go on living for a very long time"—"go on living" in what sense? This is the heart of the matter. When we speak of the living faces of the dead, are we again just using a figure? Is the fact that in many languages the same word is used to convey the liveliness of representation and the liveliness of the living being a convenient way of talking imprecisely about a distinction that so resiliently eludes precision? No: for the evidence of the history of images is such that we find that responses are frequently predicated, in high circles as well as low, in refined ones and unrefined, on the perception of dead images as living and as capable of the extensions and intentionality of beings that breathe.

But it is not just a matter of images—at least not for Alberti. Throughout the passage one conviction remains, even when unspoken. This is the conviction that it is art which transforms inert material and enables the realization of its potential. Alberti is perfectly clear about the strong responses images evoke, and he knows that sometimes these are based on the inevitable fulfillment of their potentiality in the beholding—and therefore behaving—spectator, or perhaps in the exchange with the spectator. This realization and fulfillment transcends rationality, and so he fittingly invokes the category of the divine; but there is another level on which he thinks that this applies only to wrought images, and therefore to the skill with which they are made. Sometimes those skills are so transcendent and so far beyond ordinary human capabilities, that here too we are to think of the divine, or—at the very least—to think that the productions of an artist like Phidias are invested with the divine, preternaturally and inexplicably.

In one sense, the matter is simple: Agesilaus won't have his picture painted because he is too ugly. Here it seems that straightforwardly aesthetic factors are at stake; but then Alberti moves on to more complicated consequences of the formation and transformation of objects in the hands of the painter, such as the prolongation of the presence of the already dead, the eliciting and confirmation of piety, and so forth. He cannot explain this: so painting is now said to contribute to the honest (*scilicet* straightforward?) pleasures of the mind, precisely because of its beauty or because of the transforming skills of the artist. These we can easily laud, so that when we do confront that which is discomfiting, we do not have to face the problem of the artist's role in ensuring that as a result of our interchange with his productions we may be moved to tears or destruction, or to war, or to some expression of our sexuality that embarrasses us, in other words, to behave in ways that have little to do with praise and compliment. These are things we cannot understand, even though in a sense it is always easy

to grasp the role of artistic skill, in transforming base ore into noble metal, lead into something as valuable as gold, and gold into something even more valuable than its regular market price.

In another sense, these powers of the artists are divine because they are vastly superior to our own. But it is not in such terms that the matter is especially complicated. The real problem of the divinity of painting arises when pictures manifest their potential. In its very inability to assign art its proper role in this nearly magical and certainly supernatural process, Alberti's passage exemplifies as clearly as one could wish the intricate nexus between the mystical view of the transforming and redemptive virtue[5] of artistic skill and the perplexity of the task of describing the effects that arise from the relations between images and people. We could resolve all this by saying that one issue is that of artistic ability and skill; another that of the "mystique" of art (let us provisionally use that term as a temporary replacement for talk of the divine powers of art). In effect, the distinction is never as clear as this, and we would still be left with the second half of the problem. The mystique of art is discovered by considering the commonplaces in which people speak about art and about all imagery; it is discovered by commonplaces and topoi because it is represented by them—and by metaphor and simile as well. We can return to the question of "as if."

But first we should note this: Despite the fact that Alberti's passage is an example of what Hawthorne would have termed the "refined judgment of the amateur" and that Hawthorne himself concentrates on less refined, more popular beliefs—"the opinion of the crowd"—crowd and amateur share exactly the same judgments about the effects and potential of images. The dead can become alive, people are afraid of pictures, and there is a general, almost mystical, awareness of the transcendent complexities of artistic skill. The difference, of course, is that the amateur somehow has more adequate terms and conventions for expressing such notions, which coarser judges lack. This may make the notions seem more rational, but brief reflection makes it clear that they cannot thus be reclaimed. Say it is just a cliché, or a critical commonplace, that through good painting "the faces of the dead go on living," and that a particular portrait is so good and skillful that it gives a sense of real speaking and moving presence. But we know from just the kind of context described by Hawthorne—to range, for the time being, no farther than that—that people feel just these things about pictures, and respond to them on just those bases.

The potential objection that none of this material is hard sociological evidence thus falls away, and we cannot dismiss Alberti on the grounds that what he provides are simply intellectual versions of literary commonplaces about art. To whatever sociological evidence we may have we must join the subtler kinds of evidence that lie behind the facades of criticism. With Alberti "the refined judgment of the amateur" becomes at least as valuable

as "the opinion of the crowd." It reveals at least as much. Alberti is a sentient human like any other; however clothed in the language of conventional theory and criticism, his insights are the same as the brute and frank reactions of unschooled people. In short, this is the only way in which the schooled and learned come to deal with responses that defy articulation in the critical language to which they have become accustomed. The intellectualizing approach may be to claim that Alberti offers no more than clichés and standard similes; but even if these were indeed no more than conventional topoi, the very fact that they have been repeated so often, at all levels, reinforces the inclination already within us to perceive images in this way. When we see the image come alive, when we start at the flesh that bleeds and the eyes that do, after all, follow us round the room, we may think that our responses are culturally conditioned; but we also know that we cannot, by thinking in this way, wholly subvert or repress the psychological processes that lead us to invest images with powers that make them work, with qualities that make them seem lively, with the ability to rouse us to empathy, incite us to action, and provide us with a mode of articulating the recollection that fades.

Somewhere on the scale between the apparent rudeness of Hawthorne's New Englanders and Alberti's notional sophistication lies Valerius Maximus, that windy and sententious encyclopedist of the first century A.D. His *Facta et dicta memorabilia,* a ragbag collection of moral exempla, remained popular throughout the Middle Ages and well into the seventeenth century. In it he includes an exemplary tale of Roman filial piety, which, unusually, refers to a painting. The tale seems to be made up of a series of the most obvious commonplaces about art. Valerius praises the devotion of Pero in this way:

> When [Pero's] father had succumbed to a similar fate [i.e., to the Roman mother previously mentioned by Valerius] and been cast into prison, she took this man in the last years of old age to her breast and nursed him like a baby. People stop in amazement and cannot take their eyes off this scene when they see the picture of it. As they marvel at what is before them, the situation of that event long ago is brought home to them. In these mute figures they feel they are looking at real and living bodies. This must have its effect on the mind too—and painting is rather more potent in this than literature—in presenting events of old for the edification of people today.[6]

Beside this story, one might consider one of the many paintings of the subject. If one cannot find a modern pictorial parallel (though it no doubt exists), there is at least an earlier one by an artist who knew Valerius at least as well if not better than any other: Rubens (fig. 14). In the combination of the luscious paint so characteristic of the artist, the full breasts of the

14. Peter Paul Rubens, *Cimon and Pero* (ca. 1635). Amsterdam, Rijksmuseum.

girl and the senescent flesh of the old man on the one hand, and the extraordinary story of a daughter giving her father to suck on the other, it is not hard to understand Valerius's claim that people might stop in amazement and be unable to take their eyes off the scene; and there seems little extravagance in the assertion that "in those mute figures people feel they are looking at real and living bodies."

Of course Valerius does not say the figures in the picture *are* living bodies; people feel they are *like* living bodies. He is using a simile; as so often the "as if" is fully implied, if not actually articulated. But one cannot thus dismiss the extent and implications of the innumerable instances where responses are based on the perception of bodies as real, and not merely as if real; where simile is renounced, or even undermined by the need to reconstitute the body. For it is not only a matter of projection or desire. To the observer who strives for detachment, the results of such reconstitution may well seem miraculous or supernatural.

But do not the claims of both Alberti and Valerius Maximus for painting apply equally well to sculpture? Is all this talk of the effects of paintings no more than a characteristic critical downgrading of sculpture, alien, perhaps, to the Greeks, but too much in keeping with Alberti's own argument in favor of painting as "the mistress of all the arts and their principal ornament"? The issue, however, is not that of the old *paragone,* of the relative superiority of one art form over another; it is the relationship between cognition and commonplace. In a straightforward, important, and in some ways old-fashioned sense, painting exemplifies one key aspect of response and effect more strikingly than sculpture: It is less hard to grasp why three-dimensional images, particularly if colored, may seem to be living and why we may want to touch them as if they were real (see, for example, the illustrations to chap. 9). But with painting, depiction is more readily understood as representation; it is irredeemably two-dimensional and thus irredeemably inert. Or so we may think, and yet paintings also seem real, lively; they too demand us to feel them; or, perhaps, to think of them as invested with the kind of animation both painter and public may sense in a picture like Mondrian's *Broadway Boogie Woogie* of 1942–43.

All this may sound dangerously close to the kind of thinking that underlay the notions of tangibility notoriously to be found in Bernard Berenson. It may also sound unduly mystical. But Alberti, just like Hawthorne over four hundred years later, assigned painting a special status precisely because its very lack of three-dimensionality made it seem all the more supernatural, or made the beholder construe it as such. Its powers seemed more mysterious and further beyond the capacities of normal creativity; and so, as Alberti immediately went on to insist after the passage quoted above, "painting was honoured by our ancestors with this special distinction, that whereas all other artists were called craftsmen, the painter alone was not counted among their number." We cannot understand the extraordinary potentiality of painting in terms of natural law. Its operativeness can only be construed in mystical terms, or in terms of categories that pertain to the supernatural; and it must therefore be of a higher order to that sculpted form which makes reality so plain.

For these reasons we need to have recourse to commonplaces. We have no more scientific ways of speaking of the transcendental qualities of imagery that belies the essence of the material of which it is made. There are, indeed, rather less problematic aspects of the potentialities that have traditionally been assigned to painting. In his short and splendidly compressed passage, Valerius Maximus managed to allude to two of them—to the ability of painting to serve as an aid to memory and to its role as an instrument of edification. Common though they are, these too are significant components of response. So is the passing affirmation of the greater effectiveness of painting than literature (which modern scholars will be inclined to light

upon as the main theoretical point—as opposed to the moral and didactic one—of this exemplum).

Perhaps the most paradoxical affirmation of this comparative view of the effectiveness of pictures comes from the trial of *Madame Bovary* in 1857: "Lascivious paintings generally have more influence than dispassionate arguments," says the counsel for the state. "This is not the man," says the counsel for defense, pointing to Flaubert, "whom the Public Ministry, with fifteen or twenty lines bitten off here and there, has represented before you as a maker of lascivious paintings." Of course, the point is that Flaubert has *not* presented dispassionate arguments. He has written passionately and sensuously. But what is significant about the extraordinarily sustained resuscitation of the old parallel between painting and poetry throughout the trial is that the only way in which the danger of Flaubert's passages can properly be presented is by describing them as paintings. His writing is dangerous, as the prosecutor says, because it shows "lascivious *portraits*." It is no less than "the realistic school of painting." "It is indeed the same colour, the same power of brushwork, the same vividness of expression." The whole work is bad because it is not a piece of writing: it is a painting. And it is with "the final *brushstroke*" that Flaubert depicts that terrible—but unacceptable—final moment of Madame Bovary, when "the sheet sagged between her breasts and her knees, and then rose again over her toes."[7]

The parallel between painting and poetry—and the ensuing caution about the danger of that which is represented visually—is to be found everywhere in classical literature and is to be aligned with all the writers from Aristotle and Horace onward who, to this day, have insisted on the deeper effects of pictures than of words. Horace's statement that "what the mind takes in through the ears stimulates it less actively than what is presented to it by the eyes, and what the spectator can see and believe for himself" was, not surprisingly, taken up by many later censors of visual representation.[8] Erasmus, for example, repeated Aristotle's view of the need to regulate paintings and sculptures, on the grounds that "painting is much more eloquent than speech, and often penetrates more deeply into one's heart," in the course of expressing his own concerns about indecent imagery.[9] Leonardo's claim that the vivid reality of the painter's images leads lovers to discourse with portraits of their beloved (as poetry cannot) is to be seen in the context of his extended treatment of the *paragone* and of the superiority of painting in general.[10] But what Valerius does is to account for the greater potency of images. Topos becomes a telling index of belief and behavior, not merely the unthinking repetition of learned or critical commonplace.

And so the historian of response marshals literary and critical texts, however conventional, alongside the evidence he or she gathers for the social use and function of images. The texts corroborate and are corroborated by

the social and historical particularities of response. The chapters that follow will often seem to depend on commonplaces (it would be better to say the resonance of commonplaces); but these, as we shall see, turn out to have real and practical consequences. They recur not because of their place in humanist criticism of the arts, but because they embody fundamental responses. Their articulation as topoi is merely a comfortable way of acknowledging them. Furthermore, they have extraordinarily wide ethnographic implications—so much so that we may risk calling them universal. However sophisticated we may be, we cannot wholly relinquish them. They confirm the topoi that we have begun to examine and underlie almost every other category of response that will be exemplified by specific evidence in these pages. In commonplace and topos we discover the meeting point of sophisticated criticism and folk psychology. By examining them, we understand better why—in the case of witchcraft with images—the closely resembling body of the figure should be so effective from a distance (and not just *felt* to be effective), or why there should be so many accounts of the effectiveness of such images. We will lay bare those elements of response that we dimly recognize in the case of works we call art, but that come dramatically to the fore with functional and popular categories outside that convenient pale. We dimly recognize them, or suppress them, or sublimate them; we talk about them in terms of the topos and commonplace; but we will not acknowledge that they are the same as those which we also conveniently describe as magical or superstitious.

There are some things which we now find very easy to dismiss: the statue that moves, or the eyes that follow one round the room, for example. Critics will have no truck with such judgments. But from ethnography we know repeated instances of the contagiousness of the gaze, and we will see in chapter 5 how it is precisely because of the power of the sculpture's or picture's gaze that the last stage of making an image, and the first stage of making it operative, is—over and over again—the painting in of the eyes. Still later in this book, I refer to some of the other processes which are allied with the painting or opening of the eyes: for example, where images are treated as living, or about to live, from providing them with food to eat (as, above all, with funeral effigies) to speaking to them and expecting them to speak in return. The speaking image is, of course, one of the commonest low-level components in the assessment of the aesthetic success of both paintings and sculptures, just as in the case of the eyes that, as if alive, turn to the beholder wherever he stands. Let us briefly recall the use of this last idea as a profound metaphor for the all-seeing eye of God by the great fifteenth-century theologian Nicholas of Cusa. The preface to his treatise *De visione Dei* opens with an avowal of the need for a suitable "similitude," and he refers to those pictures which seem to look at all around them:

Amongst these are many excellently painted ones, including the archeress at Nürnberg, the most precious picture by the great painter Roger in the Town Hall at Brussels, the picture in my Veronica Chapel at Koblenz, the Angel with the Arms of the Church in the castle at Brixen, and many others elsewhere. Now in case you lack a practical example, I am sending you, dear Brothers, the picture which I have been able to get. It shows the All-Seeing—I call it an icon of God [cf. fig. 15]. This picture you should put up in some place—say the north wall—and you, brothers should stand around it at equal distances from it. Look at it; and each of you will experience that from whatever side you look, it will seem to look at you alone. To the brother who stands in the east it will seem to look eastward, to him in the south, southward, and to him in the west, westward. Therefore at first you will all be amazed at how it gazes at all and each of you; for the imagination of him who stands in the east cannot at all grasp how the gaze of the icon should be turned in another direction, namely west or south. So the brother who was in the east should place himself in the west, and experience the gaze of the icon fixed on him in the west, just as formerly it was in the east. And because he knows the icon is fixed he will wonder at the change of the unchangeable gaze. And even if he keeps his own gaze on the image and then walks from east to west, he will discover that the gaze of the icon goes continuously with him, . . . and still does not leave him.[11]

And so, with extraordinary meticulousness, Nicholas of Cusa goes on to discuss the apparent omnivoyance of the picture.[12]

"I thought I saw the pupils move," said the Sri Lankan villager of a statue of the Virgin outside Saint James Church in Mutwal. "I was not imagining. I was trying to see. It's difficult to gauge a thing like that." A local merchant was confident, despite the skepticism of others. "I saw it," he said, "I saw the eye wink." "Which eye?" "Because I am a cataract patient, I saw only the left eye moving. But my grandchildren, they saw both eyes moving."[13] Everyone has heard of such things.

On the one hand, then, the practical consequences of belief in the context of a low-level object; on the other, with Nicholas of Cusa, response to the work of art as a metaphor, but one which is wholly rooted in experience. The artistic creation, as we shall see, can become threateningly more than just metaphor for the powers and transcendental capability of the divine; but the present interest of Nicholas's passage lies, once again, in the way in which what may seem to be both everyday and highly conventionalized judgment endows the illustration with its full and inescapable force. We cannot dismiss such judgments as merely the topoi of low-level criticism of art. Apart from their phenomenological resonance, they are so deeply in-

grained that they are swiftly transformed from the level of conventional criticism or popular reaction to expectation of and belief in the very phenomena they may seem to imply. For the higher criticism to stand back from those aspects of behavior, belief, and response about which more ordinary people are candid is to deny the truths upon which cliché, topos, and metaphor are founded.

4

The Myth of Aniconism

There is a deep and persistent historiographic myth that provides us with insight into one of the most profound aspects of people's attitudes to all figured imagery. This is the myth that certain cultures, usually monotheistic or primitively pure cultures, have no images at all, or no figurative imagery, or no images of the deity. Abstinence from figuring the deity does occasionally occur, but for the rest the notion of aniconism is wholly untenable. It is clouded in vagueness and has its roots in confusion. We will examine it more closely, not only because it casts light on the roots of our need for images and our fear of them, but because it enables us to start nearer the beginning.

Usage of the term—and therefore the notion itself—veers from implying the absence of imagery *tout court,* to the absence of figurative imagery, and then—in an apparently arbitrary step—to abstinence from figuring what is regarded as spiritual. Thus "aniconism" comes to be taken as an index of the degree of "spirituality" of a culture. Here is the preamble to a discussion of the problem by one of the best-known historians of aesthetic ideas, as set forth in the *Encyclopedia of World Art:* "The more spiritualized religious conceptions—in general the monotheistic religions—tend more or less rigorously to aniconism: the more severely aniconic the attitude, the less anthropomorphic the conception of divinity. [On the other hand] the various forms of polytheism remain iconic in the highest degree."[1] Aside from the a priori assumptions about the nature of spirituality with which this claim is fraught, apart from the equation of spirituality with monotheism, and despite the proviso implicit in "tend more or less rigorously," nothing here is borne out by historical or ethnographic evidence.[2]

Consider the monotheistic religions: theologians and lawgivers may rail against figurative imagery and the canonical traditions balk, but in practice the strictures fail. Of course it is not just a practical matter. For all the prohibitions of the Bible and the condemnations and reservations of the Mishnah, Jewish cultures have, if anything, "tended" to the iconic—from the erection of the brazen calf and all the images of the Bible (idolatrous or not) to the splendid narrative and ornamental decorations of the third-century synagogue at Dura Europos.[3] For all the disapproval (sometimes very severe) of Muhammad and the Ḥadith, both of the main Islamic streams, the Sunnite and the Shiite, have had a wide variety of images, from the earliest days on, as in the abundant paintings of the palace at Quçair Amra and at Samarra.[4] To claim that anthropomorphic imagery was only excluded from sacred (as opposed to secular) contexts would be no counter-argument here, since the impulse to image so often entered those hallowed contexts as well (as, for example, in the case of Dura itself). To point to the featureless faces on certain Persian manuscript paintings and carpets would be to point to the fear of enlivening, not to anything that might be called aniconism.[5] Nor does the fact that almost all but the earliest Islamic coins only have letters and inscriptions on them argue for a generally aniconic view of Islamic culture. Indeed, the early cases are among the most interesting and telling, for we know that prior to 695–96, the caliph ʿAbd al-Malik adapted coins showing himself from the Sassanid coins of King Chosroes, as well as striking later issues based on the image of Justinian II. Of course this had much to do with more general issues of political influence and a variety of assumptions about the relations between politics and economics, but it also demonstrates the rush to figure. It is true that subsequent Islamic opposition to all images of the caliph led to the final replacement of figured coins by ones with religious inscriptions in Arabic. Islam ended this "war of images," as Robin Cormack acutely comments, "by changing the rules of signification."[6] But to change the rules did not mean the exclusion of images at all. On the contrary, it showed the continuing worry about the proper domain for the satisfaction of a need for representation that henceforward continued to reveal itself in other and increasingly more contexts.

Even in cultures (such as Islam and Judaism) with prevailing interdicts against anthropomorphic representation, and an apparent emphasizing of word over image, of the written over the figured, the will to image figuratively—even anthropomorphically—cannot be suppressed. The case is very strong with the adjustments and permutations of refined Arab calligraphy,

where letters, sometimes even the name of Allah, are turned into graceful animals (fig. 16). Then, too, there are the Jewish examples, such as the remarkable but not unprecedented colophon by Joseph ibn Ḥayyim in the late fifteenth-century Kennicott Bible, where animals and naked humans reveal themselves within the letters and as their very armature (fig. 17).[7] Letters are not expanded into figures, but figures contracted into letters. These are the forbidden graven images, but they are letters. The letters *seem* like letters, and so they are. But they turn out to be figured objects too—animals, monsters, people, stars. The fact that the idea may have come from non-Jewish manuscripts is neither here nor there; artistic influence in such cases is merely a symptom of the psychological impulse outlined here. The will to image of which we have been speaking makes use of whatever mode or schema is at hand. In the long traditions of micrography, ranging from the ninth century to the present day, whole constellations of letters are turned into both naturalistic and mystical figures, just as in the calligrams of the West (fig. 18). They occur in places as far apart as sacred texts and modern broadsheets, even (most astonishingly of all) in portraits (figs. 19 and 20).[8] We can say to ourselves that what is on the page is always a text; but it becomes an image. The need for figured representation could not be made plainer than in these subversions of the everyday notion of text as nonrepresentational.[9]

The usual approach, as we have seen, is in terms of polarities: monotheistic is to aniconic as polytheistic is to iconic. But neither the polarities nor their terms are viable. Take the case of Buddhism: in its first century or so, images of Buddha are apparently prohibited. But shortly afterward—if not, indeed, from the beginning—such images are made and worshiped. There is no doubt that images of the Boddhisatvas were tolerated from the start. Already by the Maurya period—especially under Asoka—Buddhist culture is replete with a large range of refined figurative imagery, from the symbols of Buddha to the earliest Yakshis. Objects of worship and veneration are inevitably visualized; such visualizations must then be made real and material; and that in turn reinforces the ever-present impulse to image. The Maori may have refrained from representing the supreme being, but any claim for the absence of anthropomorphic imagery in Maori culture would simply run counter to the material evidence. The Nupe of Western Africa may seem to desist from the manufacture of effigies which might be the loci of supernatural powers, but at least three of their most significant rituals employ masks that are invested with extraordinary powers and the potential of inspiring fear, even terror unto death.[10] The Walbiri of Central Australia tell more or less wordless stories by drawing images in the sand that relate figuratively to what they are supposed to represent, in a systematized and sophisticated manner.[11] If the notion of aniconism cannot include images drawn in the sand, then it becomes even less workable than it

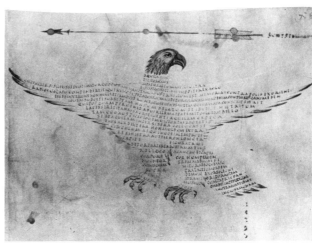

16. *Top:* Basmala in the form of a parrot (Iran, 1250/1834–35). Cincinnati Art Museum, Fanny Bryce Lehmer Fund.

17. *Left:* Artist's colophon, Kennicott Bible, La Coruña (1476). Oxford, Bodleian Library, MS Kennicott I, fol. 447.

18. *Above: Aquila,* from Cicero's translation of the *Aratea* (Carolingian). London, British Library, MS Harley 647, fol. 7 recto. By permission of the British Library.

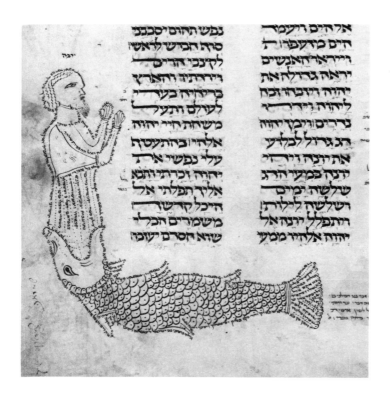

19. German micrographic marginal illustration of Jonah and the Whale, Pentateuch with Targum and Masora (fourteenth century). London, British Library, Add. MS 21160, fol. 292 recto. By permission of the British Library.

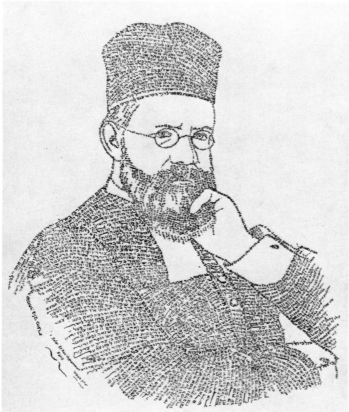

20. J. [Itzhak] as scribe, micrographic portrait of Rabbi Moses Gaster (postcard, ca. 1890). Jerusalem, Israel Museum.

already appears. That Western writers should for so long have purveyed this mythical notion is the real cultural phenomenon we need to examine. Why has this comfortable myth arisen?

For all the undeniable prohibitions against representation, especially of the divinity, the idea of a culture without material images runs counter to both experience and history. There may indeed be cultures which seem to have no figurative imagery; but when we consider such cultures (if there are any at all), then we must rigorously ask ourselves this: What are the criteria for distinguishing between the figurative and the nonfigurative or the ornamental? Surely it cannot be the fact that images and designs do not look figurative to us.[12] E. H. Gombrich has made the convention-bound nature of figurative illusion clear, while Nelson Goodman has even more radically maintained that

> realistic representation depends not upon imitation or illusion or information, but upon inculcation. Almost any picture may represent almost anything; that is, given picture and object there is usually a system of representation, a plan of correlation, under which the picture represents the object. . . . If representation is a matter of choice, and correctness a matter of information, realism is a matter of habit.[13]

This may be a somewhat idealized view about the reality of judgments in such matters; but whichever line we take, we know that we find it difficult to adjust our own schemata for the rendering (and therefore the perception) of lifelike forms to those of the past or of other cultures, so that past or "primitive" forms easily seem to fall short of our criteria for the lifelike depiction of objects and beings. At best we may call the images of primitive or chronologically remote cultures "schematic"; at worst we may misidentify them. We may misidentify them to such an extent that we fail to acknowledge their anthropomorphic or their more generally figurative element. The rudimentary signs in the sand made by the Walbiri storyteller have—if examined more than cursorily—a pictorial logic binding them together with their signifieds. The same may be claimed not only for the isolated images of cultures which may seem to "tend more or less rigorously to the aniconic," but also for sequences of repeated images, for pattern, and for ornament. Nothing could be clearer than the relationship between certain—if not most—ornamental patterns on the one hand and vegetable forms on the other.[14]

What I have been outlining, therefore, are attitudes which insist on the aniconism of cultures and which then, once the images are acknowledged, fail to admit to the consequences of perceiving almost all of them, however dimly, as anthropomorphic or more generally related to particular biological forms. The images or ornaments can then safely be regarded as "merely decorative." Even when we assign them with approval to the category of the

decorative, we clearly mark them off from more compelling psychological categories; we deny to ourselves the possibility of their functioning on any other than the "purely" decorative level. This is true at least with respect to the art of the West. Primitive ornament in other cultures, we more willingly admit, may fulfill fetishistic or totemic functions, possess talismanic or apotropaic powers, or work on levels we call "magical" and therefore "nonaesthetic"—but not our own ornament or images. Only the baser forms of Western art, so the prejudice goes, perform in such ways—as the ease with which we make distinctions between the magical and the purely decorative testifies.[15]

But if in the ornament we sense, consciously or unconsciously, the presence of the living (whether human or plant), we cannot so comfortably assign it the status of the decorative, especially in the way in which we speak of the purely or merely decorative. If, in the end, the referent turns out to be a human form, then the fusion of image and prototype troubles the demands we place upon ourselves for aesthetic detachment and disinterested formal perception, confronting us with the disturbing presence of the animate in the inanimate. That possibility we may comfortably choose to suppress, but to do so is to do violence to cognitive fact.

With this we come closer to accounting for the long-standing valorization of the spiritual over material form. If we can show that our own culture at least began by being aniconic, then our sense of superiority over purportedly less spiritualized cultures is affirmed. But there is an unfortunate hitch if we proceed in this way. Instead of providing evidence *for* aniconism, strictures on image making testify to exactly the opposite, namely the propensity—in many cases, the eagerness and the rush—to make images and icons, and to figure the god in human form. In order to grasp the divinity, man must figure it, and the only appropriate figure he knows is that of man himself, or a glorified image of him: enthroned, anointed, and crowned. All this, at any rate, for Greek and Judaeo-Christian culture, where man is the highest being and is himself the image of God. But at the same time, to acknowledge the similitude of man and divinity is to be filled with apprehension and fear.[16] It would be better to postulate the nonexistence of images, at least in the beginnings. Hence, too, the reports that there were no images of God in the first hundred and seventy years of Rome, hence the tradition that for a century the adherents of Buddha refrained from representing him. Even in such cases, however, it is far more likely that these are historiographical inventions that arise from the need to claim for a particular culture a superior spirituality. Neither the etiology nor the history of images is accurately reflected by the myth of aniconism.

Let us look more closely at the equation between higher thought and the abstinence from images. In his account of the beneficent rule of Numa, Plutarch explains that his ordinances concerning imagery were in harmony with the doctrines of Pythagoras.

> For that philosopher maintained that the first principle of being was beyond sense or feeling, was invisible and uncreated, and discernible only by the mind. And so Numa forbade the Romans to revere an image of God which had the form of man or beast. Nor was there among them in this earlier time any painted or sculpted likeness of Deity, but while for the first hundred and seventy years they were continually building temples and establishing sacred shrines, they made no statues in bodily form for them, convinced that it was impious to liken higher things to lower, and that it was impossible to apprehend Deity except by the intellect. [17]

Although Plutarch was writing about a king who is supposed to have reigned from 715–673 B.C. (and could thus not have been a disciple of Pythagoras), the passage accurately reflects two leitmotifs of early Greek thought that have pervaded the West ever since: first, the devaluation of the senses in favor of the intellect, which finds its greatest exponent in Plato; and second, the closely related notion that the deity cannot be represented in material form, and certainly not anthropomorphically. The latter notion, in particular, has a long and consistent history. In assailing the anthropomorphism of conventional Olympian religion, Xenophanes mocked the fact that people believed that the gods were born, and that they had speech, clothes, and bodies like their own. [18] Heraclitus assessed his fellows' inability to recognize the true nature (not specified) of the gods by remarking that they prayed to their statues, just as if one were to carry on a conversation with a house. [19] Antisthenes the Cynic denied the possibility of any concept that had to do with the divine being represented by a material image, and Zeno the Stoic insisted that anything made from a terrestrial substance or worked by human hands was simply unworthy of the gods. [20]

Along with Plato's suspicion and denigration of materiality, these ideas cover almost the whole range of thought on the subject; they were endlessly and variously expressed even before being taken up by the Christian apologists. For Minucius Felix, one of the distinguishing characteristics of the religion of the Christians (as opposed to that of the Romans) was that it did not figure the deity. Thus was the superiority of Christianity confirmed, at

a time when the whole history of the valuation of the intellect over the senses reached its apogée in the hands of the Neo-Platonists. But the surviving pictorial evidence—from catacomb painting to seals—runs precisely contrary to the claims of the apologists. When it comes to writers like Tertullian and Clement of Alexandria, the keenness of the opposition arises from their discomfort and displeasure with established fact.[21] Christians made images—even of their God—just like everyone else.

It is worth noting that one argument against images, already found in the Pre-Socratics, recurs in every period of Christian history, and particularly in the context of iconoclasm. This is the argument that the divine, being unmaterial and uncircumscribable, cannot be represented in material and circumscribable form. It is to be found in Philo Judaeus,[22] as well as in early Christian writers, from Origen and Clement of Alexandria to the Byzantine critics. It is set out in the aggressive decrees of the iconoclast emperor Constantine V (Christ cannot be depicted because "he who circumscribes that person has plainly circumscribed the divine nature which is incapable of being circumscribed").[23] And it receives its culminating formulation in the arguments of the Iconoclast Council of 754 (since the divine nature is completely uncircumscribable, it cannot be represented by artists in any medium whatsoever).[24] The position is adopted by all the major Reformation figures, from Luther through Zwingli to Calvin and many others.[25] The common cry throughout is that gods cannot be represented by dead objects of wood and stone, worked by human hands—let alone be present in them and worshiped. The Byzantine iconoclastic party and the Protestant writers of the Reformation share with even the most orthodox writers, as they do with the pagan philosophers, a fear of basely materializing the divine, and of contaminating divine prerogative with the efforts of the human hand. It is this fear and this prejudicing of the sensible against the spiritual that lies at the root of the recurrent claim of aniconism.

Associated with the denigration of the senses that lies behind such arguments is an ethical and moral equation, between purity and virtue on the one hand and the absence of images (and not merely images of the gods) on the other. We see the shift in Augustine, who approvingly cites Varro on the old subject of Numa's refusal to have images of the deity:

> If this usage had continued to our own day, says Varro, our worship of the gods would be more devout. In support of this opinion he adduces (among other things) the testimony of the Jewish race; and he ends with the forthright statement that those who first set up images of the gods for people diminished reverence in their cities and added to error. He wisely judged that gods in the shape of senseless images might easily inspire contempt.[26]

From purity of religion we move toward the general virtue of the common-

weal. When Tertullian commented on Numa's injunction against images, he directly associated their absence with the rustic purity of the early republic.[27] Although this position is unsurprising—given Tertullian's own polemical stance—it also reflects the strength of that association among the Romans themselves. Indeed, one of the greatest modern writers on Roman attitudes toward art has claimed that the suspicion of images and art remained endemic throughout Roman history, whatever ambivalence may have been manifested in the making, purchasing, and visiting of works of art.[28]

<div style="text-align:center">III</div>

The images envisaged by the discussion so far are mostly made by human hand, and the majority by artists. They are more or less artistic and more or less beautiful. This brings the ethical connotations of images right to the fore. Ethical issues proceed from two deep-rooted assumptions and prejudices: First, from the Platonic and Neo-Platonic notion—with which we are all to some extent imbued—that the highest form of beauty is spiritual and therefore severed from the earthly and the material; and second, on the grounds that beauty softens and corrupts. The connection between these two ideas takes place in political terms, as we see in this passage from the ancient geographer Strabo: "The ancient Romans did not concern themselves with beauty, preoccupied as they were with larger and more necessary matters."[29] As images (not necessarily images of the deity, and in particular beautiful images) were introduced into Rome, morals began to decline. Ancient virtue and morality were softened and corrupted by art and other decadent customs imported from the outside. The xenophobic strain is significant. Old Rome was pure, manly, and aniconic; it was corrupted by the introduction of foreign art and foreign practices. The main pejorative category of Roman art and style was called the Asian. This had long been associated with the soft and corrupting. After all, it was in Asia, under the permissive leadership of the dictator Sulla (82–79 B.C.), that "an army of the Roman people first learned to indulge in women and drink; to admire statues, paintings and chased vases, to steal them from private houses and public places, to pillage shrines, and to desecrate everything both sacred and profane."[30]

Here, in this neatly compressed assessment, is an epitome of the relationship between art and vice (especially vices involving women and drink) and of the peculiarly complex dialectic between delight in images and hostility toward them. But for the moment let us concentrate on the more general issue of the nexus between awareness of the beauty of art and the slackening of moral fiber. Sallust was not simply using a polemical ploy in

the course of a diatribe against Sulla and Catiline; he was stating what many must then have felt to be obvious. To admire the beauty of a work of art was but one step further down the road of corruption that began with the unsatisfactory but more or less straightforward use of images of the gods.[31] But how easy to shift the blame to other cultures! Rome was pure in its religion and pure in its virtue—at least until the arrival of exotic (and therefore bad) influences from the outside.

One of the charges leveled against the consul Marcellus arose from his spoliation of Syracuse in order to adorn the city of Rome:

> For before this time Rome never had nor even knew about such elegant and exquisite works, nor was there any love for such graceful and subtle art. . . . At a time when the people were accustomed only to war and agriculture, were inexperienced in luxury and ease, and like the Heracles of Euripides were "plain, unadorned, in a great crisis brave and true," he made them idle and full of glib talk about art and artists, so that they spent a great part of the day in such clever disputes. Notwithstanding such censures, Marcellus spoke of this with pride, even to the Greeks, and declared that he taught the ignorant Romans to admire and honour the wonderful and beautiful productions of Greece.[32]

Velleius Paterculus makes perfectly plain the detrimental effects of sensitivity to beauty and talk about art in his comment on the transportation of Corinthian works of art to Italy: "It would have been more useful to the state if Corinthian works of art had remained uncultivated to the present day, than that they should be appreciated to the extent which they now are. The ignorance of those days was more conducive to the public weal than our present artistic knowledge."[33] Little wonder, all in all, that in inveighing against statues imported from Syracuse and against the general praise bestowed on Athenian and Corinthian works of art, Cato the Censor should have insisted that he for one preferred the earthen images of the homegrown Roman gods.[34] That guardian of primitive morality and the rustic and simple virtue of the commonweal could not but have been exasperated with fancy talk about art, and there were umpteen reasons for his concern that it was a symptom—at the least—of a decline from the strong old standards and traditions. The homegrown was better and more conducive to public virtue—and not only for patriotic and nationalistic reasons. Even though sightseers like Livy's Paulus Emilius made special trips to admire famous works of art,[35] and even though Marcellus's importation of statues from Sicily appears to have been part of a program to win over public affection,

it is Cato's sentiment that reflects the basic legislative and philosophical attitudes in Rome toward the potentially corrupting effects of images.

IV

Our discussion has moved from reservations about representing the divinity to reservations about art and what we might call aesthetic sensibility. But the arguments that buttress such reservations are all complexly interrelated, and they serve to suggest something of what is at stake when we encounter claims that certain societies are either free of images or tend to abstain from making them. Such claims are always based on the belief in the moral and ethical superiority of spirituality and of divinity that is abstracted from matter rather than presented in or represented by it. And so the historiographic tradition has suppressed the possibility of iconicity at the beginnings of Greco-Roman culture. The aim has not, of course, been simply to discover what happened in the beginning (nor will that even remotely be our aim here); it has rather been to affirm the value of the spiritual unmitigated by sensual perception. As we have seen, any number of cultures share a belief, more or less articulately stated, that the more spiritually developed a religion is, the less need it has for material objects to serve as a channel to the deity. People should be able to form an adequate relationship with the godhead without the aid of a mediating object.

But unfortunately they cannot. Unless they are superior mystics, most people cannot ascend directly to the plane of the intellect without the aid of perceived objects that may, at least conceivably, act as links between the worshiper and the worshiped, which they represent. Worshipers may as a consequence venerate the object and confuse it with what it stands for. What results is a condensation of the divine in material object—just what everyone wants to avoid. When that object takes human form, then it poses an even greater threat, because the unknowable becomes familiar and knowable; and what is familiarly known cannot be invested with powers that are proper to the sphere of transcendence. If it were to be so invested, we would be unable to distinguish between the divine and the human, between the plane of intellect and the plane of the senses; and we would be sunk in a state of brute sensuality or go about in perpetual fear.

Now we begin to see the depth of our need for images: if we cannot do away with them, then at least we can postulate certain states and certain times when there were no images. Yet from the beginnings of recorded history, people have invested material objects with the divine, as if that were the only way to grasp it. It is this fact—cognitive as well as historical—against which the philosophers have railed.

When Pausanias visited the well-known site of Pharai in Achaia, where about thirty square stones were worshiped as gods, he reflected that "in more ancient times, unworked stones were worshipped by all the Greeks, instead of images of the Gods."[36] Indeed, it is Pausanias who provides us with the fullest range of references to these unworked stones (or *argoi lithoi* as they are called), and to *baitulia,* those meteoric stones, usually black, which fell from heaven—both of them classes of objects unformed by human hand and worshiped as gods.[37] The implication of each reference is etiological—that is to say, from unworked stones people and cultures move to wrought ones. But many of the recorded examples of unworked cult objects actually postdate much more anthropomorphic imagery, such as the cycladic idols of the third and second millennia B.C. Although Pausanias no doubt intended his statements to be taken in a diachronic or evolutionary sense, I will refer to them in terms of a synchronic schema; besides, there is plenty of evidence that the worship of unworked stones continued throughout the greatest centuries of Greek and Roman art. Indeed, his relegation of their veneration to "more ancient times" cannot be substantiated, and the practice seems to have been especially prevalent in Rome, as we learn from the abundant references in writers like Lucretius, Tibullus, and Propertius, right through Apuleius and Prudentius. There are several classes of objects involved, including stone stelae and other more or less hewn markers of boundaries and crossroads. Sometimes erected as memorials, they grew to be cult objects and, reportedly, were worshiped in a variety of ways. The cult of these stones appears to have been particularly prevalent among the lower levels of the populace. Although most of the references are to stones which are likely not to have been in their natural and unhewn state, there were certain stones which were unworked and which become cult objects—and not only among the lower social groups. It is perhaps not surprising that black meteoric stones falling from the sky should have come to be worshiped. Their divine origins were self-evident; they seemed to be sent by specific gods and to be animated by the gods of whom they were a token. Sanchoniathon called them *lithoi empsychoi,* stones with life in them, or simply animated stones.[38]

The famous thirty stones at Pharai, the unworked stone representing Heracles in his temple at Hyettos, the ancient stone of Eros at Thespiai, and the three stones which fell from heaven and were worshiped in the Temple of the Charities at Orchomenos in Boeotia are referred to by many writers.[39] But whether they were really unworked or were in fact rudimentarily shaped and marked, we can never know. It may be that their form

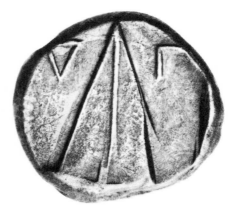

21. Pyramidal *baetylia* on a didrachm and a stater from Caria (fifth century B.C.). Photo courtesy of the American Numismatic Society, Photographic Services, New York.

suggested some kind of inherence. The matter is immensely complicated.

Instances such as the stone found at Antibes with the inscription "I am Terpon, servant of the Goddess Aphrodite" are almost too clear.[40] The stone is found; it is designated as supernatural; it therefore becomes supernatural; and—as the use of the first-person pronoun makes perfectly plain—it is thereby animated. Among the numismatic material there are the all too neglected instances of the mysterious pyramidal *baitulia* shown on a series of mid to late fifth-century Carian coins, where some are plain and others suggestively marked with a single vertical line or central dot (fig. 21).[41] But the possible significance of markings, however rudimentary, is clearly raised by the various imperial *aurei* showing the famous stone of Emessa. At least one of them, that of Elagabalus, shows on the base of the stone the pudendal "mark of Aphrodite."[42] We need not pause here to consider the possible relevance of this particular mark for the attribution of divinity to such stones (nor of the shape of the Indian *lingam*), but we should remind ourselves that the presence of marks may well have been taken as further evidence of the divine origins of such statues rather than of their manufacture.

The issue extends to any number of other cultures. Indeed, the usual ethnographic view is that it was via Crete that the Semitic notion of the divine status of stones from the skies was introduced into Greece. One of the etymologies that has been given for the word *baitulia* even derives it from the place where Jacob, after waking from his dream of the ladder, "took the stone that he had put for his pillows, and set it up for a pillar, and poured oil upon the top of it," naming it Beth-el, the "house of God."[43] Certainly litholatry appears to have been as much a feature of Semitic and other Asiatic cultures as it was in the West.

From the Assyrian altar of Tukulti Ninurta I showing a rite before the square stone of the fire god Nusku to the Ka'abah of Mecca, such stones form the focus of every kind of cultic worship (fig. 22). Of course it is not the Black Stone itself which is worshiped in Mecca (and divine inherence is not usually—and certainly not doctrinally—attributed to it), but there can be no doubt of the existence of litholatric practices in pre-Islamic Arabia and of beliefs that invest stones with divine and supernatural powers. One has only to consider Ibn-al-Kalbi's late eighth-century *Book of Idols*, which provides us with similar kinds of evidence to Pausanias, even though it is written much later than the practices it describes and is rather uncritically antiquarian. Like al-Hamdani's tenth-century compilation the *Antiquities of South Arabia*, it indubitably reflects both thought about images and actual practice, however old. Works like these are not simply to be seen as statements of the superiority of Islamic practices over pre-Islamic ones, just as little as the references to Arabic litholatry in Herodotus, Maximus of Tyre, and Clement of Alexandria are to be taken as indices, implicit or explicit, of the exotic, "heathen" quality of the races concerned. They are still further testimony to behavior that arises in the presence of putatively divine objects, and to the response that attributes to such objects powers which manifest themselves not only in transcendent but also in sensible and familiar ways.

But let us return to the complex and delicate problem of form. As a general rule, the standard discussions of *argoi lithoi* and *baitulia* move from completely unformed stones to ones which are made into simple conic, rectangular, and parallelogrammic shapes. The underlying suggestion is always of an evolution from the crude found object into shapes which increasingly approach the anthropomorphic, but the archaeological evidence is simply too sparse to support such a view.[44] It would be tempting to suppose that in Greece people began by venerating *argoi lithoi*, then made them into conic shapes, incised them with lines to indicate the limbs, and finally separated the limbs from the body. Best of all if this could be made to take place just before the advent of the great sculptures of the fifth century. But this is absolutely not the case. Nor, for that matter, can one trace a similar evolution from tree cults to the planklike cult statues called *bretades*, to *xoana*, to archaic statues of *kouroi* and *kourai*, and finally to Phidias. The fact is that too many of the simpler forms of cult statue exist alongside those of the great artists of later times, and one cannot explain them away in terms of the traces of persistence of earlier modes. The sequence, therefore, is not a chronological but rather a typological one. Our concern is not with origins, either of cult statues or of artistic figuring, and it is not teleological. Instead, we have been looking at some of the historical and archaeological bases for the notion of aniconism. In doing so, we have encountered still further evidence for the kinds of responses that are predi-

cated on the investiture of raw and sometimes unshaped material with supernatural powers, on which people can focus expectation and prayer, and to which they may attribute a greater or lesser degree of animate potentiality. As a result, they may fear what they do, and invent the idea of aniconism. But at the same time, it is precisely these responses and attributions that explain the need for figured imagery and, in the process, the improbability of the invention.

The matter can be taken still further. The fact is that there are very few examples of completely unworked stones that become cult objects. Those that do are all the more telling for that, but most are either enclosed in a shrine, adorned or dressed in one way or another, set into more resplendent settings to emphasize their divine or sacred nature, or shaped. They are conical, rectangular, or square. The Zeus Meilichios of Sicyon is pyramidal; the Zeus Teleios of Tegea in Arcadia, square or rectangular.[45] Coins show the cone-shaped Zeus Casios (Ceraunios) of Seleucia, the frequently encountered tall cone of Apollo Agyieus in Ambracia and the squatter cone of the Venus-Astarte from Paphos (figs. 23 and 24; cf. fig. 21).[46] Herodotus, Maximus of Tyre, and Clement of Alexandria give rectangular examples from Semitic regions.[47] In general (but certainly not always), it would seem that the narrower cone shapes are used in the case of the cults of male gods, while the broader cones represent female deities.[48] It is true that the phallic

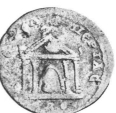

23. Zeus Casios in temple on tetradrachms from Seleucia Pieria (A.D. 222–35). Photo courtesy of the American Numismatic Society, Photographic Services, New York.

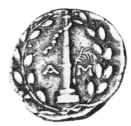

24. The cone of Apollo Agyieus on a drachm from Ambracia (second century B.C.). Photo courtesy of the American Numismatic Society, Photographic Services, New York.

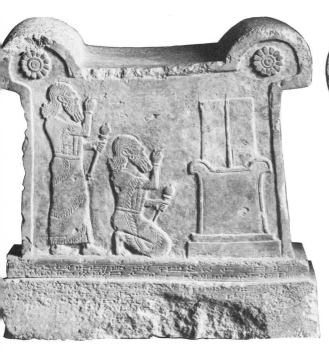

22. Assyrian altar with Tukulti Ninurta in adoration before the altar of Nusku (ca. 1240 B.C.). Berlin, Staatliche Museen Preussischer Kulturbesitz.

and pudendal connotations of both shapes are reasonably clear, but are we entitled to speak of a conscious choice of shapes, as with the phallic *lingams* of Shiva in India? The matter is not as clear as with the association between cubic stones and Cybele, between rectangular ones and Hermes (as in the herms made throughout Greek history, to which, however, carved heads and other attributes were usually attached). In either event, the question is whether symbol determines shape or shape determines symbol, whether connotation is explicit or implicit, imposed or incidental, conventional or, finally, naturalized.

These are just the kind of questions that are virtually impossible to unravel. We have, after all, the apparently arbitrary worship of naturally conic rocks (such as the two underwater stones at Tyre called *petrai ambrosiai*), and it is not difficult to imagine how the natural forms of *baitulia, ceraunia,* and other such objects may have suggested and then determined their subsequent shaping. The same applies to the primitive *bretades* and *xoana* which are so often said to be derived or related in form to the trees which once formed the foci of particular tree cults. Once again there is no need to postulate a specific teleology ("from tree to cult image"), but the typological connection is undeniable. Apart from the fact that the *xoana* were probably of wood (which goes some way to explaining their general disappearance) rather than of stone, there are a series of remarkable statues and coins which make the arboreal connection clear.[49] It may not be so plain on several representations of the famous image of Artemis Orthia, although they are still recognizably treelike (see fig. 25),[50] but in the case of the now unfortunately headless statue from the Heraion at Samos, and in many representations of Artemis of Ephesos and her cult, the connection is most telling. Although the lower half of the Samian statue looks quite remarkably like a tree trunk, it has toes that discreetly peep out from beneath (fig. 26). Head and feet endow the tree with demonstrable proof of the living god, the god that lives because it does so by mechanisms like our own and yet is embedded and fixed in the matrix from which it can never move.[51] Not only do we need material images, we cannot refrain—the process is irresistible—from making a shape we can recognize out of the shape that is merely suggestive; we cannot refrain from filling the blank wall and from enclosing a figure in the empty frame.

But it would be misleading to maintain that the will to form and the need to anthropomorphize in the end transforms all natural objects singled out for cultic or aesthetic attention, or to claim that the impulse to make images turns all found objects—whether marine or meteoric—into shapes and then into statues. The sacred stone of Pessinus (the *agalma diipetēs* as it was tellingly called) is exemplary. In 204 B.C. this small and light black meteorite, which was regarded as the Great Mother, was brought to Rome and, encased in silver, was substituted for the mouth (or face) of the statue

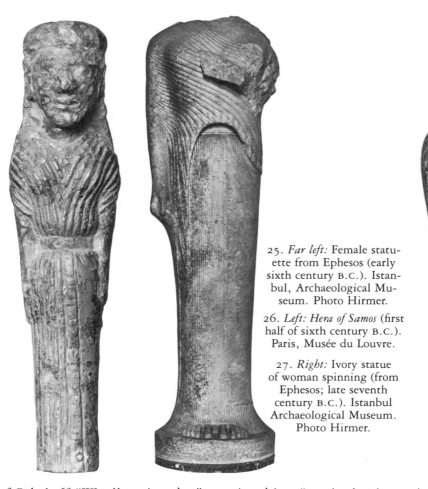

25. *Far left:* Female statuette from Ephesos (early sixth century B.C.). Istanbul, Archaeological Museum. Photo Hirmer.

26. *Left: Hera of Samos* (first half of sixth century B.C.). Paris, Musée du Louvre.

27. *Right:* Ivory statue of woman spinning (from Ephesos; late seventh century B.C.). Istanbul Archaeological Museum. Photo Hirmer.

of Cybele.[52] "We all see it today," says Arnobius, "put in that image instead of a face, rough and unhewn, giving the figure a countenance that is by no means lifelike."[53] Here is an issue that we have not yet dealt with explicitly. This sacred stone, as many others, was deliberately left unworked because it was in that state that its sacredness resided. Shaping it would presumably have deprived it of its sacred content (or, at least, diminished it); the only course left was to have it set in such a way as to emphasize or make plain its divine status. In this instance it was enclosed in silver, in other instances it might have been adorned in a variety of ways. Rather like the care bestowed on framing, setting, or placing found objects today, the status of the image—in the Roman case its cultic status, in the modern one its aesthetic status—is made clear for all to see.

With the cultic examples, the significant element is the divine inherence in the stone itself. In ancient times the sacred stone of Artemis of Perga in Pamphylia used to be garbed in metal (just as the surrounds of Greek and Russian icons of the Virgin are changed according to the occasion) with a

female head above it.[54] In the latter case, the divine is once again anthropo-morphized in order to make it more graspable, but this does not contradict the other cases. In all of them—just as with the Artemis of Perga—it is in the unworked stone itself that the divinity of the image is believed to reside.

The apparently contradictory aspects of this belief can be examined from closer quarters. When the stone is placed in an anthropomorphic setting or when, as in the case of the Pessinus meteorite, it takes the place of that which normally provides us with the most visible testimony to the life of the statue—the face—then we may clearly say that the god resides in that setting too. But the matter can be sharpened further. When we see the remarkable and mysterious fifth-century statue of a woman assimilated either to Demeter or to another god in the Museum at Cyrene (fig. 28), we too are likely to come under its spell.[55] Its face is completely unformed: could it not be that it was intended to convey a particular sense of localized power precisely because of its resemblance to an unformed and unworked stone of some kind? Although we unfortunately lack evidence of the re-sponses it evoked, it does not seem extravagant to suggest that in its origi-nal location it must have been at least as arresting as it seems to us now, per-haps even more so. We find it arresting because our expectation of a face in an otherwise anthropomorphically worked image is thwarted.[56] For fifth-cen-tury beholders that "face" can hardly but have generated an association with the kinds of mysterious powers so often associated with unworked stones.

This example, like that of the Magna Mater of Pessinus, is the morpho-logical opposite of the more usual case, where the unworked or rudimen-tarily shaped trunk is provided with a head in order to make its divine or miraculous status apparent to the human beholder. There is a poem by Callimachus which tells of a *xoanon* of Hermes made by Epeios (the maker of the Trojan horse). It was swept out to sea and caught in the nets of some fishermen near the mouth of the Hebros; but it was not recognized for what it was, and after attempting to destroy it, the fisherman threw it back into the sea. But they caught it again; they realized a god was involved; and they set it up in a sanctuary on the shore. An oracle of Apollo then com-manded them to accept it as one of their gods. This is the story of Hermes Perpheraios of Ainos.[57] It is similar to Pausanias's account of the puzzling discovery of a wooden image by the fishermen of Methymna, who were instructed to worship it as Dionysos Phallen, at the behest of the Pythian priestess.[58] But when we consider the fourth-century B.C. coins of Ainos showing the Hermes Perpheraios (fig. 13), we realize that there is a crucial additional element. Although they show a pretty much unworked *xoanon,* with no arms or legs, it has a clearly depicted bearded head.[59] Whether or not this was Epeios's statue is neither here nor there. The point is that the head makes plain the divine presence already existent (or preexistent) in the otherwise almost completely (if not wholly) unworked *xoanon.* The almost

wholly unmodified stock is seen to be—and deemed to be—of divine origin, and the head serves as a trenchant statement of that fact, as an aid to grasping its divinity.

What is clear from all these cases, then, is that the god in the unworked stone or stock continues to reside in the worked stone or stock. The god in the tree prolongs his stay in those images which still remind their beholders of their arboreal origins. We see this most strikingly in the coin of Eleuthera of Myra showing the goddess appearing directly out of a tree, in the statue of the Hera of Samos dedicated by Cheramyes (fig. 26), and in the several images related to Artemis of Ephesos (cf. figs. 25 and 27).[60] If the god is in the statue, then it is animated, and we treat it as if it were invested with life. The anthropomorphization of an image makes its animate quality both more palpable and more terrifying. It is more palpable because it now looks like what we familiarly know to be invested with life—in this connection one sees exactly the point of Xenophanes' gibe that

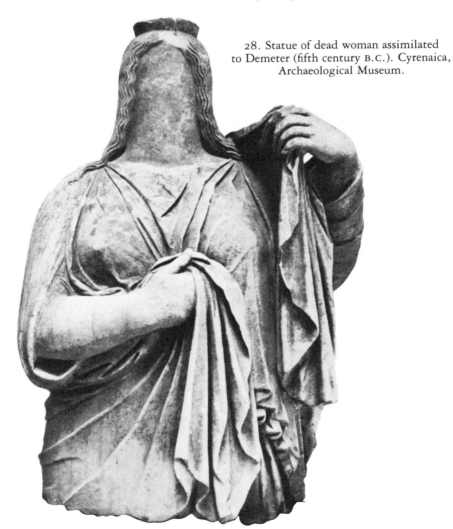

28. Statue of dead woman assimilated to Demeter (fifth century B.C.). Cyrenaica, Archaeological Museum.

"the Ethiopians say that their gods are snub nosed and black, the Thracians that theirs have light blue eyes and red hair"—and more terrifying for two related reasons: its divine powers belie its human appearance, and its animate quality denies its inanimate materiality.[61] The divine power in the object becomes the divine power in the image, and we cannot say that progressive anthropomorphization diminishes it. This assertion bears elaboration, since it is based on an element of response that will feature substantially in the pages to come.

We in the West tend to dismiss the kinds of powers that were once called divine, all the more when we perceive the deployment of artistry and skill in working the object. But we do so because of our cultural prejudices in favor of what we think of as disinterested aesthetic judgment, and not because the god has departed from the image. The fact is that there is nothing in the history of response to suggest the possibility of complete disinterestedness of this kind—even among intellectually sophisticated people. Even if we ignored or played down the evidence of responses to images in which lifelike powers seem to be condensed, and even if we no longer perceived the consequences of this phenomenon in our own responses, we would still have to take into account the burden of the past in shaping them. If images were once, let us say, invested with lifelike and supernatural powers, it would surely be extravagant to suggest that any subsequent perception of a work of art could free itself of this history entirely.

VI

But what is the relation between inherence and animation on the one hand and the concept of artistic achievement on the other? It is a relation that is clearly brought out by the history of the chaining of images.[62] The phenomenon is not a surprising one. If statues are invested with life, or work miracles, or are capable of being dangerous, why should attempts not be made to bind them? They are chained in order to stop them from getting away—either because they can do harm or because they bring good fortune to their owners or to the adherents of their cult (who consequently do not wish to lose them). In the latter case (and there are many examples), there is often some implicit analogy with the famous Wingless Victory, whom the Athenians believed would never desert them because she could not fly away.[63] Statues can also be unchained on a few significant festal occasions during the year, when social bonds and restraints are lifted too.[64] There are abundant stories and representations of the chaining of Ares and Hera, often commemorated by feasts during which their images are briefly chained.[65] In a scholion on Pindar, Polemon simply refers to chained images of Dionysos on Chios and Artemis in Erythraea and concludes that "everywhere

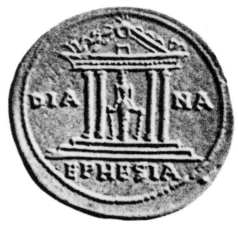

29. "Chained" Artemis of Ephesos on imperial cistophoroi
(from Ephesos and Pergamon; late first and early second century A.D.;
Von Aulocke, nos. 6575 and 6635). Photo courtesy of the American Numismatic
Society, Photographic Services, New York.

we find word of statues which do not stay in one place but often go else-where."[66] No wonder Constantine put the statue of Fortune under lock and key when he built his new city on the Bosphorus.[67] That act we may want to construe as purely symbolic, but can we do so in the case of statues which inspire fear and do harm? After all, the statue of Artemis Orthia in Sparta, known as Lygodesma ("bound with willow") was extremely dangerous, and the two men who found her were smitten with madness simply, some say, as a result of encountering her gaze.[68] Hence the need to keep her in check and to bind her. There are any number of representations of her; in this case as in that of other chained statues, notably those of the Artemis of Ephesos, the archaeological evidence is abundant (fig. 29; cf. fig. 27).[69] Pausanias's account of how the inhabitants of Orchomenos dealt with a ghost (*eidōlon*!) that was ravaging the land is also telling. On the advice of Delphi, they made a bronze likeness of the ghost and fastened it to a rock with iron; Pausanias himself had seen the image tied in this way.[70] We are thus pro-vided not only with another example of fastening, but also with a clear instance of the natural transfer of divine or supernatural efficacity into an image. The fact that some of these stories may be etiological, or even post-factum justification for the representation of bound statues, does nothing to impugn the evidence for treating them this way in order to restrain the living powers in them.[71] Here, as so often, explanation provided by etiol-ogy has its sources in realities of behavior, whether present or past.

But there is one further aspect of the chaining of statues that we have yet to touch upon. Plato himself alludes to the phenomenon in the *Meno*, but he does so with reference to Daedalus. His statues are like opinions, says Socrates, "if they are not fastened up they play truant and run away; but if

fastened, they stay where they are."[72] Aristophanes' play *Daedalus* was specifically about statues by Daedalus which are tied up because of their tendency to run away. There are in fact many other references to the tying up of Daedalic images, and it is not hard to understand why. Daedalus, as we have seen, was the first to make statues which were like living beings; he was the first to show the eyes open, the legs separate, as in walking, and the arms away from the body, as if moving.

Here the issues converge. We have seen the kinds of animation and power with which certain stones and trees are endowed. If images are clearly reminiscent of stone or tree but are worked in such a manner as to suggest limbs or physiognomic features, they may well seem to be capable of running away. Progressive anthropomorphization of the cult image makes the threat even more real; it makes the immanence and imminence of mobility even clearer—even when recollection of the original vitality of tree, *baitulion, bretas,* or *xoanon* has faded. These are the factors that support the ontology of images proposed here. With the mythological and etiological Daedalus, we move from unformed or rudimentarily shaped object to art. It is art that has visibly made the object seem closer to life, but at the same time its productions are animated by supernatural qualities already imputed to the unworked object. The Daedalic tradition provides the clearest evidence that once, at least, there was full awareness of this ontology—prior, one might say, to the intervention of prejudices in favor of aesthetic differentiation.[73] We have lost that tradition, but we should remain aware that the attitudes which crystallize out of those prejudices are, wittingly and unwittingly, philosophical constructs. They are neither fundamental responses nor cognitive realities. The appearance of what we call art, therefore, cannot serve to justify the kind of differentiation that is predicated on the notion of disinterested aesthetic judgment. The final and greatest of the prejudices referred to here is that of aniconism, because it suggests that while we are capable of aesthetic differentiation (in the terms outlined here), "primitive" societies are not. Art brings with it neither the possibility of shelving the animate, nor the right to forget the consequences of making objects look like the figures that live among us.

VII

In order to arrive at a viewpoint that might cover both art and history, Hans-Georg Gadamer took a stand against traditional aesthetics and stressed the importance of examining the "mode of being a picture." For him, as for us, the picture is an ontological event; hence it cannot be properly understood as the object of aesthetic consciousness. Although in *Truth*

and Method he verified the ontology of the picture by means of secular examples, he emphasized that

> only the religious picture shows the full ontological power of the picture. For it is really true of the appearance of the divine that it acquires its pictorial quality only through the word and the picture. Thus the meaning of the religious picture is an exemplary one. In it we can see without doubt that a picture is not a copy of a copied being, but is in ontological communion with what is copied.[74]

A little earlier, Gadamer noted that

> if it is only at the beginning of the history of the picture, in its prehistory as it were, that we find picture magic, which depends on the identity and non-differentiation of picture and what is pictured, still this does not mean that an increasingly differentiated consciousness of the picture that grows further and further away from magical identity can ever detach itself entirely from it. Rather, non-differentiation remains an essential feature of all experience of pictures. . . . Even the sacralization of "art" in the nineteenth century . . . is accounted for.[75]

While we do not go so far as suggest that "picture magic" is naturally associated with the early history of images, and while it is certainly better to abstain from defining identity of the kind spoken of here as "magical," the remaining terms of his formulation are precisely those of the present argument and exactly express the conclusion to which it tends.[76] We may confidently move from images which serve as the foci of cults and whole religions to images which appear to have no connection with such things. What I have been claiming is that we cannot conveniently divorce our responses to religious images from those which are nonreligious, or supposedly "value free" (i.e., which only are supposed to have purely "aesthetic" value) simply on the basis of an ontological distinction between the two classes.

Much of the difficulty in speaking about the ontological status of images in our culture and, even more, in those of the past or in other places arises from a failure to assess the semiotics of the phenomena we have been considering. Gadamer's claims that "a picture is not a copy of a copied being, but is in ontological communication with what is copied," and that picture magic "depends on the identity and non-differentiation of picture and what is pictured," have considerable methodological implications for the problems of identity, inherence, and magic, which are so acute in the case of litholatry. We have seen that just as the god is in the stone, so he is also in the image (of the god). Responses to both classes of object are predicated on the identity of sign and signified, or in the case of images, of the rep-

resented with that which represents it. The historical evidence for this identity is abundant, but to what extent might it apply to present responses too?

With litholatry it may seem unnecessary to suggest that responses are predicated on a belief in the inherence of a deity in the unworked stone: could it not be that the issue is one of denotation rather than inherence, and that the object only serves to denote the deity and the powers associated with it? But very few of these powers—including that of mobility—can be subsumed by any notion of denotation. They are in the object itself and are not simply being referred to by it. The same applies to anthropomorphic imagery, although the consequences of the figuring of matter may manifest themselves in different—and sometimes more affective—ways. What we are still dealing with, however, is not the representation of the signified, but its presentation. It was presumably this factor that underlay Augustine's well-known critique of Varro's defence of the images of the pagans:

> Those who made the images of these gods in human form, says Varro, appear to have been guided by the thought that the mortal mind that is in the human body is very much like the immortal mind. For example, it is as if vessels were set up to denote the gods, and in the temple of Liber a wine-jar were placed to denote wine, the container standing for the thing contained. Thus the image that has a human form signifies the rational soul, since it is in that sort of vessel, so to speak, that the substance is contained of which they wish to imply that the gods consist.[77]

Here Augustine's chief argument was on behalf of the unmaterial transcendence of God, but it also makes very clear the spuriousness of any notion of denotation based on the metonymy or synecdoche of the sign: what the pagans—and all makers of images—have to come to terms with is the phenomenon of presence. And if the deity is present in the image, then it should be bound by the laws of materiality and corruption.

VIII

Two terms, among many others, have clouded almost all discourse about the history of images: "symbolism" and "magic"; and they pertain directly to the evidence so far. When a found object is adored as divine, the arbitrary nature of the sign may seem immediately apparent; but when a relation is perceived between the shape of the object and an attribute of the god it presents, then the notion of connotation suggests itself. Particular shapes, we may say, connote particular qualities of the god in the shape. But in no case is it useful to introduce the notion of symbolism. If there is anything

to be learned from the cult objects and cult images discussed so far, then it is that "symbolic motivations are absolutely not generalizable," as Dan Sperber put it in his attack on the traditional view of the motivation of symbols as the distinguishing factor between them and signs, which are considered to be nonmotivated.[78] "This motivation," he insisted, "is not meta-symbolic, but symbolic. . . . It is not an interpretation of symbols but, on the contrary, must itself be interpreted symbolically. The potentially useful paths for a cryptological view of symbolism to follow (motivation is meta-symbolic, or the motivation is part of interpretation) are therefore both closed."[79] Sperber maintained that "the view that a symbolic phenomenon may be analysed into symbols usually arises from the semiological illusion according to which it is symbols that constitute the *signifiant,* the interpreted message." But this illusion, as he justly observed, "is not only an artifact of theoreticians limited to an academic audience. It often constitutes a cultural phenomenon, a conscious theory of [its] own symbolism."[80] He called the semiological illusion "semiologism," and argued that "the attribution of sense is an essential part of symbolic development in *our* culture. Semiologism is one of the bases of *our* ideology."[81] While no one would deny that symbolic phenomena exist, analysis of such phenomena into symbols would be tautologous or misleading. Symbols are not signs, and they are not paired with their interpretations in a code structure. For this reason a broad but rigorous view of connotation turns out to be more serviceable than the symbolic reading of shapes. *Our* reading may in any case not coincide, either intrepretively or cognitively, with that of the cultures described. This is one lesson to be learned from the history and historiography of litholatry; the other is that the presence of the god in the stone or the image wholly undermines the possibility of symbolic analysis on the basis of a one-to-one relation between symbol and meaning. "Symbolicity is not a property either of objects, or of acts, or of utterances, but of conceptual representations that describe or interpret them."[82] Bearing all this in mind, the most practical approach may be to begin with the analysis of cultural signs as semiological ones and then to see how that analysis is undermined by practical and cognitive phenomena. Sperber's keen identification of semiologism led him to downgrade this possibility. His further, more tendentious proposal was that the basic principles of the "symbolic mechanism," as he termed it, "are not induced from experience but are on the contrary part of the innate mental equipment that makes experience possible."[83] What is not clear is the extent to which this "proto-cognitivist" approach to symbolism allows for the pressures of context or takes care of potentially discomfiting phenomena such as the fusion of image and prototype.

In commenting on the ontological community between the picture and what is copied—indeed, on the identity of the picture and what is pic-

tured—Gadamer fell into the usual prejudice of associating what he called "picture magic" with the prehistory of the picture. Fortunately he could escape the radical consequences of this assessment because of the main direction of his argument, which maintained that the picture can never entirely detach itself from magical identity. This of course is precisely what I have been arguing; but much of the confusion, to which Gadamer himself is briefly a party, arises from an uncritical readiness to subsume the identity spoken of here under the term magic.

If when we speak of magic we imply the activity of a magician, or the performance of a magical rite or rites, in the context of a collective acknowledgment of what constitutes magical activity and magical action—in the sense determined by Marcel Mauss—then, strictly speaking, the term is not relevant to the consequences of the perceived identity between picture and pictured.[84] It can of course be relevant to that identity when images are used for acknowledging magical purposes, as we shall see, and magical effectiveness may also be predicated on this form of identity. But that is another matter. We should be careful to separate out, when we can, magical and nonmagical operativeness, and preserve the distinction. It may be that if we use the term loosely, "magical" may be just the way to describe how all the objects and images I discuss in this chapter and in chapter 10 work, but it is probably best not to use the term in this confusing manner. In any case, "picture magic" in the looser sense is no more characteristic of early or primitive cultures than it is of more advanced or Western ones.

What we might speak of, however, is the supernatural effectiveness of images. This certainly does not mean that we speak of "the supernatural"; though it may mean that we refer to what is regarded as supernatural. When we describe attempts at communicating with or controlling something unmaterial or unearthly, we should beware of construing the supernatural in our own terms, rather than in terms of a particular social group. "The separation of the 'natural' from the 'supernatural' can only have a precise meaning in our own system of thought," and we cannot take it for granted that other cultures—say "primitive" ones—distinguish, for example, between "the sphere of the natural and that of the supernatural, since gods and spirits are just as much a part of the order of nature as men and animals. The dichotomy of the natural and the supernatural implies a scientific epistemology and critical metaphysical sophistication which must not be assumed without indubitable evidence."[85] On the other hand, this need not mean that we should relinquish the attempt to arrive at how, if they do, particular societies define the opposition of natural and supernatural for themselves; and it may even be useful to retain—especially since it may be impossible entirely to eschew—our own conception of the opposition, simply for the purposes of analysis. But this is not really the issue at stake (a full-blown intellectualist stance would both confuse and obscure

distinctions, even when explicit). We have not sought to define the super-natural, nor has such an entity been implicit in our discussion. What we have occasionally described have been instances of supernatural effective-ness, and of ways in which images seem to work supernaturally. And here it does seem possible to generalize. We have been dealing with objects and images that are effective in ways that go far beyond their natural potential. In no culture is it "natural" for a stone or a fixed image to be capable of mobility—unless of course it is propelled by someone else or invested with something that transcends its natural properties. But that these objects work supernaturally is proved by the very fact that in so many cases they do not move or work of their own accord. When they do, we may speak of their supernatural operativeness; otherwise, something has to happen to them before they can operate or become effective. Very often they have to be placed in an appropriate context, or shaped, or worked, or washed, or anointed, or crowned, or made the object of a specific rite and blessed and sanctified in one way or another. How this happens will be the subject of the next chapter; it is not yet time to consider the more direct implications for the images we know more intimately than the stones and stocks of the Greeks.

5

Consecration: Making Images Work

In ancient Egypt as in Babylonia, in Sumer, and in Assyria, the final stage in the making of an image of a god—or of a man, in the case of mummies—consisted of the rite of the Washing and Opening of the Mouth. This is the rite that identified the image with the divinity, and that invested it with the life of that divinity (or, in the case of mummies, the human being). It is the final stage in the making of an image because it is performed as the finishing touches are put on the statue; but it also inaugurates the new status of the image as it is installed in its shrine or other sacred context. Like all consecration rites, it is both a rite of completion and of inauguration; it marks, essentially, the transition from inanimate manmade object to one imbued with life. "In the house of the Craftsmen, where they have fashioned the god," runs the Babylonian rite, "shalt thou sweep the ground and sprinkle holy water; for Ea, Marduk and the God shalt thou place three censers with cypress in them; sesame-wine shalt thou libate; on that God shalt thou perform the Washing and Opening of the Mouth." [1]

The Babylonian rite consisted of at least ten stages: sweeping the ground, anointing, offering, washing and opening the mouth, censing, sprinkling with holy water, pouring libations, offering a meal, arraying with fine linen, and so on. The Egyptian rite consisted of most of these and some additional ones, such as the bestowing of royal insignia. In all these rites, the image is spoken of as the god itself, "so completely is he absorbed in his symbol" says the standard commentator on the Babylonian procedures. [2] His mouth is opened and food is offered to him, and his eyes are turned towards the sunshine. Although all these elements are not always present in every one of the surviving rituals, the function of the rite is abundantly clear. [3] It transforms the manmade image into a sacred one, and invites the divinity to reside in it. Thus in the Babylonian rite, following the incantation "Holy Image that art perfected by a great ritual," the eyes are opened

with a twig of tamarisk (presumably some final adjustment is made to the eyes of the god) and the priest intones, "Image that art born from the holy; Image that art born in heaven."[4] He no longer refers to the earthly makers of the image, but rather to "NIN.ILDU, mighty carpenter of heaven." The priest then takes the hand of the god and intones, "Foot that advanceth, foot that advanceth," and in this manner the image is transferred from workshop to shrine and set up there.[5]

<div align="center">I</div>

When we survey the history of images, we survey the history of consecration. As we multiply the examples, a formula emerges, to this effect: the consecration of an image makes it work, or at the very least, effects a change in the way it works. But we have also seen instances in which objects work, in one sense or another, prior to consecration. How, then, are we to define consecration and its role in making an image effective? Several things are clear. Consecration is never an empty ceremony. It involves at least one process—like washing, anointing, crowning, or blessing—that brings about an intended change in the sacred status of an image. By its very nature consecration is a ritual act, and not merely a ceremonial one, even when it seems to be the simplest of performances. It is usually explicitly physical, but it can also be entirely verbal. The verbal and liturgical elements are never wholly absent, and they are often operative. The notion of consecration can instructively be recalled even in contexts which may no longer be described as sacred, and even when it can no longer, in the strict anthropological sense, be called a rite.[6]

With *argoi lithoi* and other classes of sacred stones, we find evidence of adornment, washing, and anointing with oil often enough.[7] Later writers make fun of and criticize those superstitious people who, among other supposedly irrational things, anoint stones at crossroads and bend the knee to them.[8] The critique, we may suppose, reflects actual practice. Indeed, acts of this kind seem to be associated in a deep and fundamental way with the cultic worship of sacred stones and the more rudimentary forms of anthropomorphic imagery. The process goes beyond mere "superstition." Almost as a matter of course, such images appear to be washed and dedicated before they are set up for reverence and worship. Of the many possible examples, that of the image of Artemis Phakelitis is typical. Like the Spartan Artemis Lygodesma, its origins are to be found in the dangerous image—often called a *bretas* and once a *xoanon*[9]—of Artemis of Tauris. Wrapped in a bundle of sticks, it is said to have been brought by Orestes by Tyndaris in Sicily. There Orestes washed it and dedicated it, and it promptly became the center of a cult.[10] The question that arises, then, is this: Is the stone or

image treated in this manner *because* it is sacred or *in order* to make it sacred? And are acts like anointing, washing, and garlanding acts of homage, inspired by images that are already in some sense operative, or are they rites of consecration?

In the course of a scathing attack on the pagan gods and in mocking the practice of praying to their images, Minucius Felix sarcastically alluded to the fact that a piece of wood, stone, or silver could seem to be a god: "So when," he asked, "does the god come into being? The image is cast, hammered or sculpted: it is not yet a god. It is soldered, put together, and erected; it is still not a god. It is adorned, consecrated, prayed to—and now, finally, it is a god, once man has willed it so and dedicated it."[11] But this is only half the answer. It is important to distinguish between found objects (from meteoric and ceraunic stones to miraculous images discovered in trees or in the ground) and images made specifically for cultic contexts. In the first case, the object works miracles and gives evidence of having been invested with the divine prior to consecration. Consecration only confirms these properties, although sometimes it may also serve as a declaration of the public status of the object. But in the second case, it does seem to be the act of consecration that invests the image with the properties and powers that are either intended for it or are subsequently attributed to it. And so we cannot dismiss Minucius Felix's statement as merely a polemical or apologetic fancy. It amounts to little less than a statement of what is universally believed to happen, and what actually does happen, once an image is consecrated. By means of the proper rites, the deity is induced to inhabit the piece of inanimate matter. Then it becomes an object suitable for worship and capable of bestowing help. "Before its ritual animation, the image is not a fit object of worship; afterwards, it really becomes one of the visible bodies of the god" or a receptacle for that god.[12] This is what happens in Hinduism, on the West Coast of Africa, and among the Maori in New Zealand. It is also what happens in the case of the main monotheistic religions.

II

It is significant that many consecration rites involve the last stages of completing an image and bringing it to life. Even more, perhaps, than the opening of the mouth, the most striking illustration of the relation between consecration and animation is provided by rites which involve the opening of the eyes. The best and most fully documented example may well be the *nētra pinkama* ("eye-ceremony") of the Theravada Buddhists of Ceylon, where the eyes of the all but completed statue of Buddha are at last painted in, the very act by which it is brought to life.[13]

Ronald Knox, an Englishman held prisoner in Ceylon from 1660 to 1679, had this to say about Buddhist images, in a passage that provides a telling parallel with Minucius Felix, but that is nevertheless neither hostile nor misunderstanding: "Before the Eyes are made, it is not accounted a God, but a lump of ordinary metal, and thrown about the shop with no more regard than anything else. . . . The Eyes being formed, it is thence forward a god."[14] In his account of the *nētra pinkama,* Richard Gombrich notes that "the very act of consecration indicates that the statue is being brought to life, for it consists simply [?] in painting in the eyes." The corollary for images that are not consecrated is this: "no ceremony is performed for manufactured images such as the small plastic Buddhas sold everywhere in stalls, or the large cardboard Buddha . . . such images are correspondingly less sacred and more purely decorative."[15] While this may put the relationship between sacrality and decorativeness a little too simplistically, it is clear that consecration marks a conscious elevation in the sacred status of the image, in the amount of sacredness, as it were. Some Christian images may work miracles without being consecrated, but their installation, say in churches, is always preceded by a consecration ritual, as in the transfer of a miracle-working image from grubby street corner to glittering enshrinement in a specially built church or chapel. Consecration either turns the image into a receptacle for the sacred or confirms the sacredness already present by publicly heightening it.

In addition to its intrinsic interest, the *nētra pinkama* has at least three further implications for the themes of this book. It is one of the most dramatic of those many instances from the Chinese painters to Pygmalion where the finishing touches on an image are somehow believed to bring it to life; it makes plain the importance of the eyes in this respect; and it trenchantly illustrates the possibility of contagion, the ultimate consequence of the power that results from the investiture of an image with life.

The ceremony is regarded by its performers as very dangerous and is surrounded with tabus. It is performed by the craftsman who made the statue, after several hours of ceremonies to ensure that no evil will come to him. This evil is imprecisely conceptualized, but results from making mistakes in ritual, violating tabus, or otherwise arousing the malevolent attention of a supernatural being, who usually conveys the evil by a gaze (*bälma*). The craftsman paints in the eyes at an auspicious moment and is left alone in the closed temple with only his colleagues, while everyone else stands clear even of the outer door. Moreover, the craftsman does not dare to look the statue in the face, but keeps his back to it and paints sideways or over his shoulder while looking into a mirror, which catches the gaze of the image he is bringing to life. As soon as the painting is done the craftsman himself has a dangerous

gaze. He is then led out blindfolded and the covering is only removed from his eyes when they will first fall upon something which he then symbolically destroys with a sword stroke. [16]

We deal, therefore, with a completion rite that invests the image with life by putting in that part of the image that is most indicative of life and the quality of being lifelike—the eyes. Among both the Thai and the Cambodian Buddhists, the final stage in the consecration ceremony is represented by a related rite of opening the eyes, where the pupils are pricked with needles. The Hindu consecration ceremony uses a golden needle to perform the rite of the opening of the eyes known as the *nētra mokṣa*. [17] In the Khmer and in many other Buddhist cases, the relationship between the completion of an image by putting in the eyes, the investiture with life, and the possibility of ensuing danger is perfectly exemplified by the consecration rituals. One cannot help recalling the many Chinese tales related to that of the legendary Ku K'ai-chih, who was known for painting in the eyes of the dragons at the end, in order to bring them to life. [18] Chang-Seng-Yu simply refrained from painting in the eyes of his dragons, because he was afraid they would fly away; but one day upon being challenged to do so, he painted in the irises: the walls immediately collapsed, and the painter's creations took life and flew up into the clouds. [19] Wei-Hsieh too did not dare to complete his works by painting in the eyes: he feared that he might see them become animate, and jump out of the canvas. [20]

The act of bringing to life is fraught with danger, for the eye often has a particularly dangerous gaze. But there is another reason for the fear of making animate. It is that the capability for doing so can seem to transcend normal human powers. Animation is the final threat of artistic creativity. I have already noted that one of the grounds for Muslim and sometimes Protestant antipathy toward image making is that the maker of the image arrogates creative powers to himself of which only God is in possession. On the day of resurrection, the image maker will be challenged to breathe life into his images, and he will be tormented until he succeeds in doing so. But then he dares to emulate the divinity and must suffer the consequences of so ultimately vain an attempt. From that fate there can be no escape.

Gombrich draws attention to the salient fact that the Sinhalese monks say the whole consecration ceremony is nonsense, worth preserving only because it is a picturesque tradition. "Many laymen hold the same view, and though they obey orders to keep clear, they do so with indifference. Only the craftsman . . . seems really frightened." [21] But dismissal of a customary action or apparent indifference to it does not diminish its psychological import; if anything, the more explicit the dismissal, the less convincing is the denial of its hold on the emotional and cognitive states implied by responses to the ritual itself. In any case, the fact is that the

ceremony *is* preserved, and the public do keep clear. That they do not necessarily admit to their reasons for doing so is itself a confirmation of the power of these practices. Only if they fell into desuetude would one be entitled to say that the spell is broken; but as long as the custom persists, it stands both as a symptom and as a reinforcement of psychological states that we may want, for whatever reason, to deny, but which cannot in the end be wished away. As long as the practices persist, every dismissal of their effect and every manifestation of partial indifference to them is all the more telling, and serves only to underline their emotional and cognitive significance. It is precisely this form of denial, arising from the conviction that sophisticated cultures do not respond in apparently nonobjective ways to images, and from notional distinctions between magical effects and disinterested aesthetic response, that has for so long stood in the way of the analysis of response and has kept any serious approach based on such analysis from entering the handbooks.

III

Between the second and the fourth century, arguments about the status of images became a central element of the pagan response to Christianity. From the defenders of traditional Roman religion to the Neo-Platonists, from the exponents of theurgy to the practitioners of syncretism, all insisted on the role of images in enabling men and women to perceive and grasp the divine. In doing so, they attributed to images just those qualities most vigorously denied by the Christians, endowing them with powers which, if believed to be real, would have undermined the very basis of the burgeoning faith.

Since the Neo-Platonists believed that one ascended by stages to the realm of pure intellect and spirit, they self-evidently had to make place for material symbols of the divine; and because the intermediate role of images between man and god was most crucially and dramatically seen in theurgical practices, a confusion swiftly arose between Neo-Platonism and theurgy. Properly speaking, theurgy represented the crystallization, often in dramatically explicit ways, of long-standing practices involving the imprisonment of demons and other supernatural beings in statues, and of animating them by prescribed rites.[22] The Neo-Platonists would have abhorred this, but despite their opposition, and that of rationalizing writers like Plutarch who were critical of those who called the statues the gods themselves,[23] theurgical practices flourished for a time.

Theurgy, in the first instance, consisted of actions intended to "animate images of the gods and to endow them with power and motion."[24] In the

second place, it depended on the employment of an entranced medium through which a god could pronounce and prophesy.[25] It is the first branch, known as *theurgia telestikē,* that is of most relevance here. Statues were consecrated and animated, largely in order to obtain oracles from them.[26] *Telein*—from which *telestikē* derives—is used to mean consecration, but its primary sense, significantly, is "to complete." The officiating figure was called a *theourgos,* a term that is variously translated as consecrator or magician. Indeed, the whole practice of theurgy is usually considered in terms of the history of magic, but to do so is to oversimplify or to be misleading. After all, the idea that an image could be given life by a theurgic process derived from a whole variety of sources, not all of which can simply be called magical—unless one groups together under that general rubric a number of different practices without distinguishing clearly between them. The sources range from preclassical Greece, where the installation of statues was accompanied by by their ritual animation, through the so-called Chaldean oracles to the Graeco-Egyptian magical papyri, with their recipes for animating images.[27] But theurgy also has a more illustrious precedent.

In his monumental commentary on Plato's *Timaeus,* Proclus sets the Demiurge among the supreme creators. He is the sculptor of the universe, the inventor of divine names, and the revealer of divine marks by which he consecrates the soul. "For such," he explains, "are the actions of the real consecrators (*telestai*); by means of vivifying signs and names they consecrate images and make them living and moving things."[28] The central theurgic procedure, then, consisted of the concealing of "symbols" (*symbola*) or "tokens" (*synthēmata*) of the god within the statue itself, in order to give it life, or of inscribing certain characters on the image, or of attaching inscribed phylacteries to it, for the same purpose. Later on in his commentary on the *Timaeus,* Proclus states explicitly that it is by means of symbols that the consecrator makes objects of corruptible matter partake of the divine, move of their own accord, and prophesy the future.[29] These symbols and tokens—usually known only to the consecrator—could either be engraved gems or written formulae corresponding to the attributes of the god or gods concerned. But how, more precisely, are they supposed to have worked?

As in the case of ancient lapidaries and herbals, each god was believed to be sympathetically represented by certain plants or stones. The notion of sympathy also extended to names or formulae which were believed to be particularly associated with a god or his attributes.[30] By attaching these to the image by means of the appropriate rites, or by uttering the formulae in the correct way, the image could be endowed with the soul of the god. But it is too easy to invoke the concept of sympathetic "magic" here, since by using the term we explain away—without analyzing—the notion of sympathy itself. What is the relation, one might ask, between identity and imputed sympathy? The problem, again, revolves primarily around why

representation should be effective at all, and why people should go so far as to think that a figured object could be inhabited.[31] It is true that the ritual nature of all these procedures—as with the earlier Egyptian and hermetic rites—is made clear by the need for correct performance. If the rules are not followed, or if they are incorrectly executed, then the rites miscarry or simply fail to achieve their intended effect. But none of this is sufficient to justify the appeal to magic. The term certainly describes and labels the procedures, and provides a category in which to place their supposed or apparent operativeness; but it barely illuminates the cognitive issues at stake.

The relevance of these apparently obscure late antique practices is not only that they are symptomatic of more general features of the ways in which people think about the capabilities of images. Whatever the number of its practitioners and adherents, theurgy raises major issues about the role of consecration in making other kinds of images work or become effective, even with regard to that cult which was so significantly opposed to it—Christianity. The fact that in many Christian contexts the relations between consecration and effectiveness seem so much less clear makes what material there is all the more telling.

IV

An initial survey of the evidence yields poor results; on the face of it, consecration ceremonies do not loom large in Western Christianity. It is true that all altarpieces must receive a blessing before they can officially become the object of devotion and veneration, but what blessings there are seem quite perfunctory. The standard element in the Roman ceremony is as follows:

> Almighty and Everlasting God, vouchsafe, we beseech thee, to bless and sanctify this painting (or sculpture) in memory and honour of your only born son Jesus Christ (or the Virgin or the Apostles or the Martyr or the Saint, as the case may be) and grant that whosoever shall venerate and honour your only begotten Son (or the Blessed Virgin, etc., etc.) may by his merits and intercession obtain from thee grace in this life and eternal glory in the life to come.

And the bishop sprinkles the image with holy water.[32]

No elaborate consecration ritual here, and not much in the way of a claim about the efficacy of the image, either before or after consecration. But the material bears closer reading. The fact is that a form of consecration ceremony does take place; and the ceremony itself clearly implies that before the image is consecrated, it neither merits veneration nor is capable of

providing the channel whereby the intercessory powers of that which is represented by it may be invoked.

The prayer begins with an imploration to bless and sanctify the picture or sculpture of a particular supernatural being (and not just any picture or statue); it concludes with a statement that one should venerate and honor that particular being; and then, somehow, benefits will ensue. It does seem that one has to assume some notion of sympathy in order to make sense of the slide from the call to bless an object to the injunction to venerate, not the object, but what it represents. No wonder that the history of Christianity is punctuated with the allegation that image worshipers (like Catholics) worship the image and not (as they are supposed to) what is represented on it; no wonder that the orthodox continually insist that they venerate the prototype of the image; and no wonder that in practice fusion so often takes place. One can begin to see why the post-Tridentine benediction begins with this disclaimer: "Almighty and Everlasting God, who do not reprove the painting or sculpting of images and effigies of your saints . . ."[33] That in itself, in its extraordinarily apologetic, negative tone, is testimony to the power of images.

This opening invocation immediately continues with a more positive view: "So that whenever we see them with our bodily eyes we may meditate upon them with the eyes of our memory, and imitate their deeds and their holiness."[34] The belief in the ability of images to aid memory and to activate the beholder to imitation, sometimes extravagant and often grim, is found from the earliest days of Christianity. But there are even stronger claims for what images can do in the related group of rites and prayers in many benedictionals—at any rate, once they are activated by consecration. If one devoutly kneels before them to adore and invoke Christ or his saints, one will be liberated from all dangers and deserve to obtain whatever one seeks; if one holds a small image in one's hand or close to one's person, malignant and hostile forces will not dare to approach, and the supplicant will be spared from temptation.[35]

But for all these claims to efficacy, if these blessings in the rituals were the only evidence we had of Christian consecration practices, the yield would be poor beside the rich data from other religions. This might of course be an accurate reflection of the status of such rites within Christianity, but once we move away from codified prescription to actual practice, almost the opposite seems to be the case. There is abundant evidence, for example, of the washing of images, particularly of those which are believed to be miraculous. The manner of procession of the *acheiropoieta*—the miraculous image not made by human hands—of the Lateran Christ from San Giovanni in Laterano to Santa Maria Maggiore on the eve of the Feast of the Assumption is recorded in extraordinary detail in several eleventh- and twelfth-century manuscripts.[36] The picture is preceded by flaming torches

as it is carried in stages from church to church along the route. At Santa Maria Nova it is set down and has its feet washed, while Matins are said inside. A similar footwashing ceremony takes place again at Sant' Adriano; and only when it arrives, finally, at Santa Maria Maggiore does the pope say mass and bless the people. Ernst Kitzinger has brought to the fore a hymn from the year 1000 in which this very *acheiropoieta* was cast in an animate role. In being carried—as Kitzinger suggested—to meet the image of the Virgin from Santa Maria Nova (and later Santa Maria Maggiore), the Christ of the image was said to go to seek the divine pronouncements of his mother.[37] But what is the significance of the footwashing ceremony? Is it to confirm the liveliness of the image in the specific context of the procession, or to activate the image in some further way?

In the absence of the full liturgical apparatus surrounding this procession, these are not questions that can fully be answered. But the footwashing does serve to remind us, in the first instance, of the abundant ethnographic parallels with Christian practices. It is not just pagans or exotic tribes that do such things to images or expect such things from them or, indeed, treat them as if they were alive. The washing of the feet—or, for that matter, any part of the body—clearly constitutes a purification ritual of some kind; but it also provides a mode of stressing the liveliness of an image, or more specifically, its potential for liveliness. This is not to explain the practice by seeking anthropological origins; it is to suggest, once again, the possibility of psychological explanation facilitated by broadening the scope of the ethnography. Very similar issues arise in the case of widespread practices such as the garlanding and crowning of images.[38] It might be argued that all such acts are merely—or even largely—habitual or conventional in nature; but even if this were the case, that would still not sufficiently account for them. People do not garland, wash, or crown images just out of habit; they do so because all such acts are symptoms of a relationship between image and respondent that is clearly predicated on the attribution of powers which transcend the purely material aspect of the object. These are acts that bespeak the transition from human product to sacredly endowed object and from impotent manmade pieces of material to beneficent—or maleficent—representations. The consecration ceremonies in other religions crucially mark the same transition.

V

In a famous letter to Charlemagne on the subject of the *Libri Carolini*—that treatise which attempted to formulate a Western stand on images in response to the conclusions of the Second Nicaean Council—Pope Hadrian I emphasized his support of the Nicaean parallel between images and sacred

vessels, on the ground that both were sanctified by a process of consecration. "It was and is the practice of the Catholic and Apostolic Roman Church," he affirmed, "that when sacred images and histories are painted, they are first anointed with sacred chrism, and then venerated by the faithful."[39] On one level this passage simply provides proof of the survival of the ancient practice of anointing images; on the other it is clear that anointing has to take place before the image is venerated and seen to be capable of efficacity—even though it may not be just any image that is anointed, and even though belief may first be necessary. In addition to noting the continuity with antique practice, one modern commentator has remarked that in this act of anointing, "magical efficacy is bound to the artistic."[40] It is just this kind of statement that obfuscates the analysis of response, belief, and expectation. Some of the issues should be unraveled first. On one definition— the one suggested in most discussions of Neo-Platonic practices as well as that proposed by Marcel Mauss—magic must be effected by a practitioner acknowledged as a magician, in which case one could argue for the continuity between pagan and Christian anointer and officiant. On the other hand, as even the commentator has acknowledged, it may be that the image has a "mysterious" life prior to this form of consecration.[41] In that case the act of consecration is not magical in any useful sense; it sanctifies and possibly enhances qualities already inherent in or attached to the image. How, then, are we to describe such qualities? Surely not as inherently magical. If anything it is this aspect of their history, these prior powers, that transcend rational explanation. To invoke the category of the magical is, once again, to call upon a category of putative explanation that is weakened in too many directions to be helpful.

In one of the few studies devoted to the subject of popular responses to images within a particular period, Cyril Mango has described the widespread belief in Byzantium that pagan images were animated by maleficent demons—in contrast to the fourth-century Neo-Platonists who believed them to be animated by divine presence, and to those Christian writers who emphasized that they were inanimate (though one may be inclined to wonder at the motives for such emphasis).[42] At the same time, statues were also believed to be capable of serving a wider range of useful functions: they could detect unchaste men and women, protect one against bugs, avert calamities, and generally perform in a whole variety of beneficent ways.[43] They received their talismanic powers by means of a rite known as *stoicheiosis,* whereby certain vegetable and mineral substances or vessels filled with sympathetic unguents, inscribed seals, or incense were inserted into the statue in order to make it work. One source for this rite is the eleventh-century writer Michael Psellus, of whom Mango comments that "Psellus himself half-believed this nonsense."[44] Nonsense or not, we have encountered exactly this phenomenon before, where an object or substance is in-

serted in or attached to an image in order to activate it on the basis of a principle of sympathy. Psellus himself may well have been influenced by theurgic practices which operated in the same way.[45] Furthermore, it is no accident—and we can therefore hardly dismiss the whole business as nonsense—that while the rite by which a statue became a talisman was known as *stoicheiosis,* its cognate *stoicheion* was commonly used in Byzantium for a statue, or more precisely, a bewitched statue. In modern Greek, *stoicheio* is the word for a ghost.[46]

There is a related phenomenon within Western Christianity. As early as the fourth century, relics were necessary for the consecration of churches. A classic case relates to the invention of the relics of Saints Gervase and Protase. When the crowd shouted "Consecrate it in the Roman manner!" Ambrose swiftly answered, "I will if I find relics."[47] But for over a thousand years, relics of Christ, the Virgin, or the saints have been placed within images. Many were made specifically in order to contain such relics: for example, there are the great reliquary heads and arms, such as those of Sainte Foy at Conques (fig. 30; cf. fig. 31), and the abundant wooden sculptures with compartments into which appropriate relics were expected

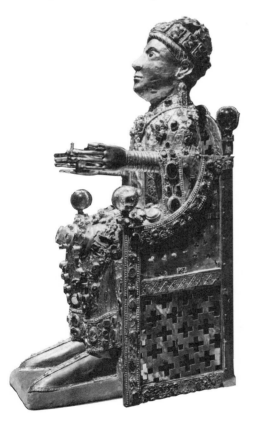

30. *Left:* Statue-reliquary of Sainte Foy (gold and precious stones over a wooden core; French, tenth century). Conques, Ste Foy, Treasury. Photo Werner Neumeister.

31. *Above:* Reliquary head of Saint Euphrosine (Tuscan, seventeenth century). Panzano (Chianti), San Leolino, Centro di Studi Storici Chiantigiani.

to be placed, as in the case of the twelfth- and thirteenth-century wooden images of the Virgin known as the *Thronum Majestatis* (fig. 32). Most altar-pieces (and certainly the reasonably public ones) have a place within them, or within their frames and surrounds, for relics of the particular saint(s) associated with them or with the chapels in which they are set up.

The reason for alluding to this phenomenon must be apparent. Both the insertion of a *symbolon* in the theurgic rites and the insertion of a relic in the Christian images seem to depend on a fundamental sense of the peculiar and specific effectiveness of a substance or object placed within an image and believed to be in sympathy with what it represents. The *symbolon* partakes of the essential nature of the god and can thus make the god work through the image; so too does the relic. This much seems, on the basis of the material we have collected so far, predictable. But consider the problem posed by an account by Hugh of Poitiers of a fire in the Church of La Madeleine at Vézelay sometime between 1160 and 1165. The venerated wooden statue of the Virgin had emerged unscathed, though blackened, from the fire. As a result, a decision was taken to clean and repair it. When it got to the restorer, it was discovered that

> the image had a most secret little door between the shoulders. When he heard this, Giles the prior ordered it to be carried into the sacristy. He called Godfrey the sub-prior, Gervase the sacristan, Gerard the constable, Maurice the sub-cantor, and Lambert the restorer of the image. Then he took a small knife and scraped away the colours. . . . Finally he took a small iron hammer, and tried to detect by ear what all were unable to discover with their eyes. After hearing, as it were, the sound of a hollow, he was happy, hopeful and spurred on. Bold and piously he opened the little door with his own hands, and found a lock of hair of the Immaculate Virgin and a part of the same Mary, Mother of God, and one of the bones of John the Baptist. He also found bones of the blessed Apostles Peter, Paul and Andrew in one bundle; also a bit of the thumb of St. James . . .[an extraordinary number of other relics follows]. For each of the above-mentioned relics, moreover, they found separate little notes, which identified each one of them.[48]

So what made the image work; what gave it its miraculous powers? Was it the insertion of the relics? But that had been forgotten. For a long time the image had performed with no one's knowledge of its status as a reliquary. Was it something else, perhaps the obvious age or venerability of the image, or something about the way it looked? We cannot be certain, especially since it may have continued to work because everyone knew that it always had, even after people had forgotten about the relics. In that case it would have been the relics after all—as seems most plausible—that were the ul-

32. The Morgan Madonna (poly-
chromed oak; Auvergne, twelfth cen-
tury). New York, the Metropolitan Mu-
seum of Art, gift of J. Pierpont
Morgan, 1916 (16.32.194).

timate source of its effectiveness.[49] But once again the matter is not so
simple.

When Gombrich described the Buddhist consecration ceremonies, he did
not attach much significance to the placing of a relic of the Buddha inside
the statue just before the painting of the eyes. He insisted that "by intro-
ducing these relics it appears that the monk is trying to legitimize the
whole proceedings"; after all, "the climax comes when the eyes are painted
in by the craftsman."[50] From the theurgic and the Christian examples, this
is not what one would have expected, and one is left with two different
possibilities. They are not mutually exclusive, but it may be instructive to
formulate them distinctly. Is it the practice of deliberately inserting relics
within images that makes them operative and effective? Or can they be
animated and work independently of relics in the various ways described in
this book?[51] The issue that arises, as Gombrich noted so clearly, is one of
legitimation; and perhaps it is in just these terms that we should read the

passage by Hugh of Poitiers. The discovery of relics within the statue of Vézelay was greeted with joy and admiration precisely because it legitimized and (stronger still) gave authority to the powers that it had already manifested. But not all Romanesque wooden images of the *Sedes Sapientiae* (of which this is one) were reliquary statues, even to begin with. "The reliquary function was a possible adjunct in the late ninth century, not an essential feature," even though "the later association of relics with such images in reliquary statues contributed to the general acceptance, *especially by ecclesiastical authorities*, of all sculpture in the round."[52]

Let us return to the issue of consecration. It seems clear that images can become the objects of devotion, or work miracles, without the kind of sanctification embodied in consecration rites. The images which do miracles, which move their limbs and heads and go from one place to another, do so almost spontaneously.[53] Consecration appears to play little role in their animation. But in an extended sense they are all consecrated—by removing them to shrines (often specially constructed), by washing them, anointing them, crowning them, or garlanding them. This may seem too broad a sense of the notion of consecration to be useful, and many of these acts do not take place prior to the animation or operativeness of the image; but to see it in this way serves to emphasize the continuity between spontaneous action and ritual practice. It is true that on the one hand the liveliness of the image (that is, the perception of it as animate) provokes the action; while on the other hand, ritual activity triggers that liveliness (that is, engenders its animation). This may seem to be a polarity, but both kinds of activity are symptoms of response to the potentiality of the image: in the first case to a potentiality already realized (consecration or the act of homage then ensures its continuation); in the second case to a potential already and always capable of being realized, but yet to be activated by the arousal or engagement of a god working through the image that represents it.

Consecration is nothing in itself. It has an aim, a scope; it envisages. Its consequences are implicit in it. It can only be defined in terms of the way it makes images efficacious. This is not to say that it is consecration that makes an image effective or operational. It may work before consecration, but in a different manner from the way it works after the ceremonies and rites we have broadly grouped under this rubric. The fallacious suggestion that images work only once they have been consecrated arises, perhaps, because they may then seem to do so in ethnographically more interesting or dramatic ways. What, then, is the significance of consecration for a study like this one, and how is it to be connected—if at all—with the role played by relics and the responses that they, in particular, may evoke?

Once again Gadamer's investigations into the ontological status of works of art are useful. Although our concerns are less with "works of art" than with images in general, his observations derive their pertinence from his

distinction between natural and artifical signs. He emphasizes that a work of art (unlike a natural symbol) does not owe its real meaning to an institution like consecration. "The public act of consecration or unveiling which assigns to it its purpose does not give it its significance. Rather it is already a structure with a signifying-function of its own, as a pictorial or non-pictorial representation, before it is given its function as a memorial."[54] Although, as we have seen, consecration certainly does more than assign an image its purpose, and although "significance" is rather too broad a term here, and "signifying" too narrow, what Gadamer does is to establish chronological and philosophical priority for the preconsecration status of a work of art (and mutatis mutandis, of any figured or shaped image). His emphasis on the signifying function of a representation before it is consecrated is decisive for the resolution of a crucial problem that is bound to occur in any discussion which postulates for images a set of functions that transcends their purely material status, and which deals with responses that are not solely predicated on the visual or aesthetic qualities of such images. Is there any difference between responses to miraculous images, say, and to relics? Could it not be said that one might just as well discuss responses to relics as responses to images? Could it not be argued that people respond no differently, at least in any fundamental sense, to an image that is believed to work miraculously than to a relic which does the same? Those who plead the case for similarity would insist that all the images into which relics have been inserted only work because the relic works, and because the relic has been in intimate contact with what was (or has come to be) regarded as divine. Gadamer's point further clarifies the distinction between relic and image. Images work in distinctive ways precisely because they are figured or shaped. That is why the apparently supernatural operativeness of images is a different subject from that of the way in which relics work, though the problems are obviously related.

The role of relics in the genesis of early Christian images has been much argued, and André Grabar has been the foremost exponent of the view that the cult of relics was directly responsible for the rise of the cult of images in the sixth century.[55] Whatever side one takes in this debate, it should now be clear that the origins of figured imagery and of their cult cannot solely be seen in the light of the cult of relics. It is precisely the figural aspect of images that distinguishes them from relics *tout court;* and responses to each group must consequently be predicated on this fundamental difference in their ontology. Perhaps this is all too obvious, but it needs to be stressed because of the all too easy and frequent assumption of the identity of the "magical" qualities of relics and those of images. Indeed, the practices of consecration point the differences. Few if any relics need to be consecrated in order to make them effective; very many images do—at least in order to make them effective in specific and particular ways. This is not

to deny that images work on different levels prior to consecration. It is, simply, to affirm that with relics there is little choice, as it were, about how they work; with images, there is. Their operativeness may be deflected or altered, and that possibility depends entirely on their unique ontological status. This status is in no sense equivalent to that of relics, not even in the few cases where an image is itself a relic.

Our discussion, then, may seem to have taken a surprising and unexpected turn. It began by suggesting that consecration and, sometimes, the related act of inserting relics made images work; now we conclude that this is not, strictly speaking, the case. All images have a signifying and significative function that is prior to institutionalization by means of consecration or any other act or rite. But consecration is a central issue because it so frequently accompanies the activation of images, and in so doing makes abundantly clear the potentiality of all images. Images work *because* they are consecrated, but at the same time they work *before* they are consecrated. They may do so in different ways and on different levels, and response to them may depend in the first instance on the perception of purely aesthetic qualities and in the second instance on apparently supernatural ones. In either event, the phenomenon of consecration fully demonstrates the fact of the potentiality of all images; it dramatically activates that potentiality and realizes it. We have studied consecration here because we still need to seek, in the case of the images around us, its modern equivalents.

6

Image and Pilgrimage

For thousands of years, pilgrimages have formed a cluster of practices around central desires in all people's lives. "Pilgrimage," of course, is a loose term which encompasses a wide range of disparate phenomena and practices, and we are no longer, by and large, intimately acquainted with it. If at all, we know it only in the very loosest sense of going on long journeys to visit the dear or distinguished sick or to see special works of art. But pilgrimage phenomena were once so extensive, chronologically, geographically, and culturally that we can neither relegate them to the level of folklore (as we may be inclined to do if we consider present-day pilgrimage phenomena) nor see them as merely peripheral, idiosyncratic, or obscure. Even if the practices have largely died out, they are not simply part of past cosmologies, so locked in the past that they merit study only because of their intrinsic interest or because of their place in a cultural tradition that terminates in ourselves.[1]

The most thoughtful modern book in English on the subject justly (though somewhat awkwardly) observes that pilgrimage has "shared in the general disregard of the liminal and marginal phenomena of social process and cultural dynamics by those intent either upon the description of orderly institutionalized facts or upon the establishment of the historicity of prestigious unrepeated events."[2] But pilgrimage phenomena are neither prestigious nor unrepeated, and they recur in significantly similar forms and patterns. If anything they are paradigmatic. They tell us about ourselves and how we deal with aspirations and expectations that we are not convinced can wholly be fulfilled by any means on earth, and they illuminate the nature of the mediating role we grant to images in the process of attaining that fulfillment. In other words, they provide further and still stronger testimony to all beliefs about how images work and what they are capable of doing.

99

There is no doubt that many people go on pilgrimage because of social pressure, because it is the thing to do, and because it offers convenient structures for vacationing and fun; but fundamental to every pilgrimage is the element of hope. The focus of every pilgrimage journey is the shrine. Often there are intermediate shrines along the way, but their function is to quicken the pulse of the hope and excitement that is concentrated, expressed, and realized at the shrine at the end. The journeys are undertaken in the expectation, however weak and subliminal that expectation may occasionally be, of physical and spiritual benefit; or they may be undertaken in an attempt to satisfy the need for help otherwise unobtainable on earth.[3] But the aim may also be to give thanks, in one way or another, for answered prayers and benefits received. In every case the main focus is the shrine; and here, as at every stage in this complex process of the manifestation of hope, desire, and gratitude, it is the image that is central, that is regarded as effective and treated as if it were perpetually and transcendently capable of remaining so. We travel to the painting or sculpture; we stop at them on the way; we erect new ones; and we take copies and souvenirs away with us. These images work miracles and record them; they mediate between ourselves and the supernatural; and they fix in our minds the recollection of experience. At every stage the image is indispensable, in all its variety. There is the venerated image at the shrine, often acheiropoietic (it came from heaven; it was not made by human hands), or at least archaic; sometimes it is new; it is always adorned. Along the way are the simpler images, attached to poles and trees; then come the votive images by which thanks are registered; and finally the souvenirs we buy and take away with us. (Examples of each of these forms will be found in the illustrations to this and the next chapter.) No definition of pilgrimage, that vast and disparate phenomenon, can omit to take all of them into account. They are of its essence; without them it is weak, it fails, or is nothing. In the course of this chapter, we must consider not only the way in which the central image of the pilgrimage works and is made to work; how it is consecrated and installed in its splendors and shrines; but also how the lesser images work, differently or similarly, more effectively or less so, and finally the degree to which their efficacity may be dependent on their visual and physical relation with the central image or archetype at the shrine.

I

On 21 February 1519, "the city of Regensburg expelled its large and prosperous community of Jews, which it had been trying to do for some time. The synagogue was razed to the ground and the Jewish cemetery destroyed. A workman engaged in pulling down the synagogue was badly injured but

33. Albrecht Altdorfer, the *Schöne Maria* of Regensburg (ca. 1519–22). Regensburg, Kunstsammlungen des Bistums Regensburg, on loan from the Kollegiatstift St. Johann. Photo Kunstsammlungen des Bistums Regensburg, Domschatzmuseum-Diözesanmuseum.

recovered miraculously; the wonder encouraged contributions for a chapel on the site dedicated to the Virgin."[4] A copy of the already miraculous picture of the Madonna attributed to Saint Luke in the Alte Kapelle was brought here and set up on a marble altar.[5] Albrecht Altdorfer was swiftly commissioned to make further copies (cf. figs. 33, 77, 78). A statue of the Virgin by Erhard Heydenreich, master of works at the cathedral, was also placed on a column outside (in Michael Ostendorfer's great print commemorating this event [fig 34], the forlorn remains of the once beautiful synagogue are portrayed on the right).[6] Already in 1519, over 50,000 people had come to visit the *Schöne Maria* at Regensburg, for both images had begun to work more miracles:[7]

> For instance, clothes that touched the statue were particularly good for curing sick cattle. On 1 June, Pope Leo X issued a bull granting indulgences of a hundred days to properly conducted pilgrimages to the chapel. In 1520 it became more and more the irrational and

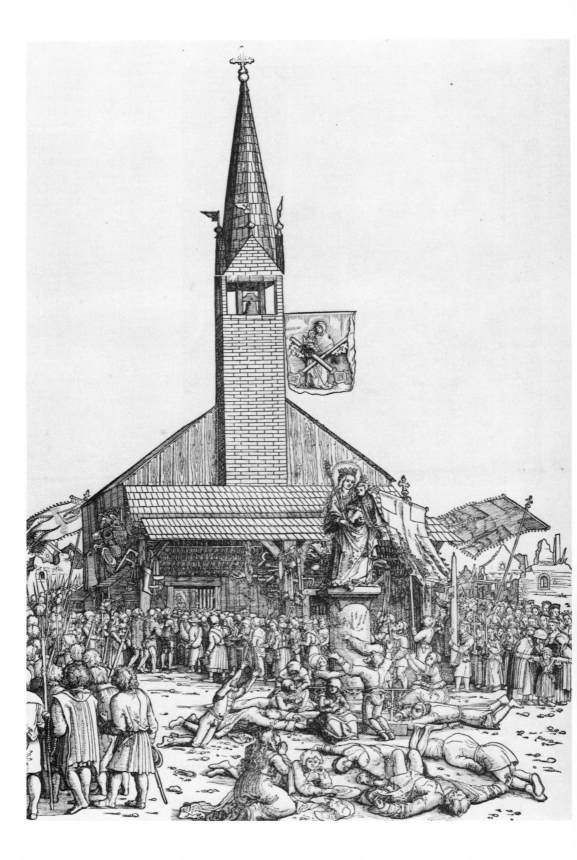

uncontrolled kind of movement that worried contemporary churchmen a great deal. The pilgrims came in thousands, often whole villages together; some elected to come naked, others on their knees; visions and wonders increased. . . . crowds danced howling around the statue.[8]

Although it seems clear that the Regensburg pilgrimage was largely a manipulated affair, initiated by an anti-Semitic priest, the fact remains that "images were a rallying point and a confirmation of deeds done." As on innumerable other occasions, the pilgrimage has its origins in an image that works miracles, or it records gratitude for an apparently miraculous act. The image, whether itself miraculous in origin or not, is placed in a more elevated and appropriate setting; it continues to work miracles; people passionately venerate both it and its copies; they make further copies and take them away with them, or set them up elsewhere; they invest more hope in them; and record their thanks for further favors by bringing still more images, of a kind that we will examine later, to the site of the shrine. In the first tumultuous year of the Regensburg pilgrimage, a contemporary noted that there were not enough tokens to take home, and many people cried and were tearful at having to go back without any.[9] The following year, the surviving accounts testify to the manufacture of 109,108 clay pilgrimage badges, and 9,763 silver ones (cf. fig. 35).[10] Such figures are typical for the great shrines of Europe, especially in Bavaria and Italy.[11]

Enshrinement, adornment, and multiplication: all these are illustrated by Michael Ostendorfer's print of 1519–21 showing the pilgrimage to and

34. *Left:* Michael Ostendorfer, *Pilgrimage to the New Church at Regensburg* (woodcut; ca. 1519; Passavant III, 312.13).

35. *Above:* Molds for two pilgrimage badges of the *Schöne Maria* at Regensburg (black slate; 1519). Munich, Bayerisches Nationalmuseum.

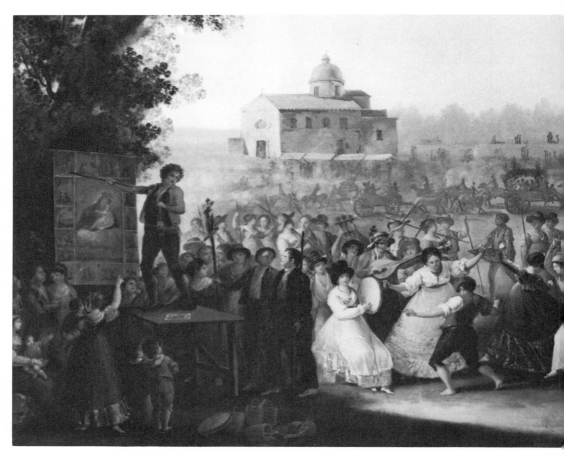

36. Gaetano Gigante, *The Feast of the Madonna dell'Arco* (1825). Naples, Museo Nazionale di San Martino, Soprintendenza per i Beni Artistici e Storici di Napoli.

adoration of the *Schöne Maria* (fig. 34). Representations of the miraculous image feature at least four times in this scene: first, the actual image deep within the church; then the statue in the foreground; then on the huge banner suspended from the tower; and finally on the pennant fluttering by the left-hand side of the church. In the background and from the sides, a great crowd of pilgrims file into the wooden church, while in the foreground a scene of frenzied devotion and supplication takes place before the statue to which still more candles are attached. From the eaves of the church hang a profusion of votive objects, including limbs and implements. The whole scene gives a vivid sense of the extraordinary strength and the extent of the effectiveness of the image at the shrine, and the compulsion to make copies of it. Even though it is itself hidden in the mysterious depth of the shrine, we are left with no doubt of its powerful presence there: the copies alone clamorously testify to that.

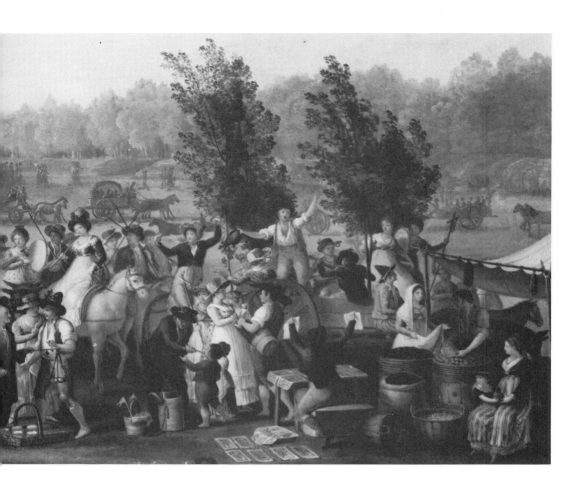

Altogether different from the drama being played out in Ostendorfer's print is the genial event portrayed in Gaetano Gigante's 1825 painting the *Feast of the Madonna dell'Arco* (fig. 36), one of many nineteenth-century pictures showing the festivities associated with the shrine, situated in the sumptuous sanctuary of that name on the road between Naples and Vesuvius. The origins of the cult and enshrinement of this unprepossessing image are characteristically unclear (although she is not at all unprepossessing to her devotees). The earliest records place her in a simple roadside *edicoletta* of the fifteenth century; and the first miracle is supposed to have been this: A young man lost a ball game he was playing and angrily cast the ball at the little shrine. It struck the Madonna on the cheek, and (as with thousands of other such images) she instantly and copiously bled. Whether the story arose simply because of the odd deformation, still visible, of the Virgin's left cheek, we shall never know.

This is supposed to have happened on Easter Monday in 1450 (though some sources place it as late at 1500). From then on people flocked to visit

the miraculous image, and it was placed in a modest church. The next major miracle occurred in 1589–90. A few years before then, a notoriously unattractive and blasphemous woman of the neighborhood called Aurelia del Prete had offered the Virgin some votive limbs in wax in thanks for the cure of a broken leg. Some years later her husband fell ill, and on Easter 1589 she was carrying some votive offerings for him too, but at the same time driving some pigs back to her house. As was customary for that day, a large crowd had gathered at the shrine. The pig took fright, broke loose, and ran away. Violently cursing the Madonna, the evil and blasphemous Aurelia dropped the votive offerings. They broke. Her husband warned her against her blasphemies, but to no avail. Exactly one year later, on the night between Easter and Easter Monday, her legs dropped off.[12] These are the kinds of miracles and wonders associated with any number of shrines throughout Europe, though many are more cheerful.

At the end of the seventeenth century, a sumptuous sanctuary was built for the *Madonna dell'Arco,* its miracles increased, and the throngs annually grew. By the beginning of the nineteenth century, if not for a considerable period before, the pilgrimage to the shrine had taken on a decidedly informal character. Motivation to go to the image seemed to rest less on any belief in what it could achieve than on the structures for rustic social gathering and relaxation it provided, as one may gather from pictures like Gigante's and those of his contemporary Leopold Robert.[13] Even so, one has always to consider the length of folk memory and the recollection in some form or another, however dim and attenuated, of what the *Madonna dell'Arco*—or rather the Virgin acting through the image—could do. In this century, and in the most recent years too, her powers to save from sickness and disaster have been such that the production of votive images has received increased emphasis; and the shrine itself has become of the great votive repositories of Italy, if not of all Europe.[14]

Gigante's picture may seem to do little more than illustrate those aspects of social process and communality in which many have sought to explain the survival of pilgrimage practices. But at the same time, it draws attention to the symptoms of something equally crucial. On the right, an eager vendor of popular prints holds up two examples of his wares; more lie beside the box on which he is seated. They are the kinds of print which show the miraculous image in the church, or the miracles it has effected, or other related subjects of an edifying nature.[15] On the left, shaded by a tree, stands a young man on a makeshift podium, expounding, one may assume, the virtues and miracles of the Madonna dell'Arco herself, as he points to the first of the sixteen scenes that surround the large picture of the Madonna suspended behind him. It is true that while the few people around him attend to his exposition, the rest of the elegantly romanticized participants in the occasion get on with their merrymaking. Presumably it was just this

variety of rustic behavior that provided the main motivation for Gigante's picture rather than any desire to record the drawing-power of image and shrine; but that power is just what this picture, for all its informality, proves. Although it may be felt that the general indifference to the images provides clear testimony, not to their importance, but to their comparative insignificance, caution is called for. As with pilgrimage, so with the rest of life. Just because some people pay no attention to images, walk straight past them, or are generally indifferent to them does not relieve us of the burden of harking to those who do: it were a fine thing if the analysis of response proceeded only from the states of mind of those who concentrate! Whatever the case, it seems certain that without images, without the central image, occasions such as those portrayed by Gigante would have been something else entirely: they are not just country fairs. In the most essential of ways, social process is bound to the archetypal image and to its derivatives. Without the *Madonna dell'Arco,* none of the other prints and pictures here would have existed either; nor, indeed, the abundance of behavioral forms and patterns that is so dependent on its presence. [16]

Exactly the same applies to those many occasions where the image seems to recede almost entirely into the background, and where festive behavior is even more expansive and dominant, as in Callot's great and incomparably detailed etching *The Fair at Impruneta* (fig. 37). The Madonna of Impruneta, enshrined just six miles outside Florence, was chiefly famed for her ability to stave off rain when necessary, but also because she brought the Florentines victory in battle and helped in matters like the plague. [17] Like many

37. Jacques Callot, *The Fair at Impruneta* (etching; 1620; Lieure 478).

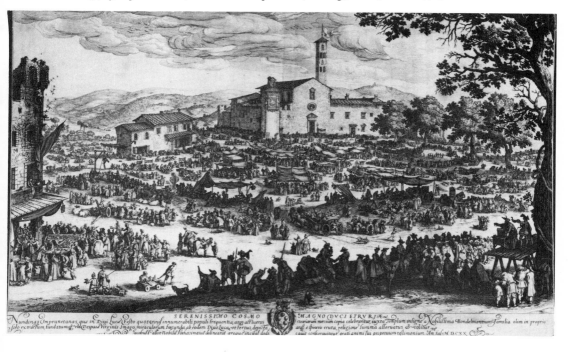

such images, the Madonna was normally kept from view, only to be brought out on those special days when the very fact of display (in its combination of suppression and surprise) released the potential for the multifarious activities seen here. And what all she could achieve! She brought rain, alleviated plagues, memorialized treaties, requested peace, and even inspired the government to correct political courses. Throughout the fifteenth century, her abilities and actions seemed "almost foolproof." [18] But despite the extraordinary potential of the image, and its repeatedly demonstrated efficacity, it could nevertheless be utterly lost, as we see in Callot's work, forgotten amid the vast and excited crowds. Part of the compelling quality of Callot's etching is the search we ourselves are made to undertake for the minutely shown image in front of the church far in the background. Similarly, in Bruegel's *Saint George's Day Fair* (fig. 38), one has to look hard to discover the venerated image being carried in procession, and hence the foreground behavior seems all the more divorced from it. The devices of art meet the haphazard outcomes of social habit in representations like these; and they continue to do so, for example, in the photographs of the massed throngs at Fatima (fig. 39). Collective behavior is what provides the surprise, in all its tremendous scale and variation; but none of that behavior could occur in these benign and expectant forms (especially with Fatima, more than with Impruneta) were it not for the image that is somewhere housed in splendid and often deliberately surprising form. In none of these representations do we see much, if anything, of the veneration of the pilgrimage image; but it is this very suppression, the reduction of so loaded

38. After Bruegel, *Saint George's Day Fair* (etching and engraving; ca. 1560–70; Lebeer 52).

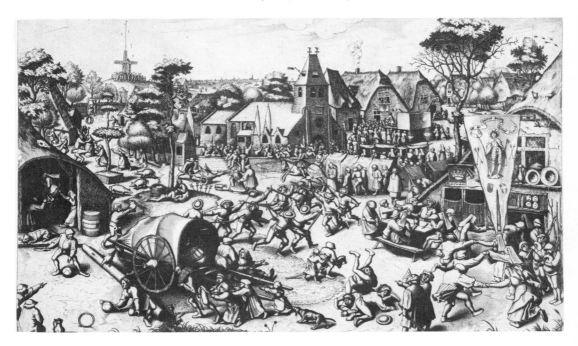

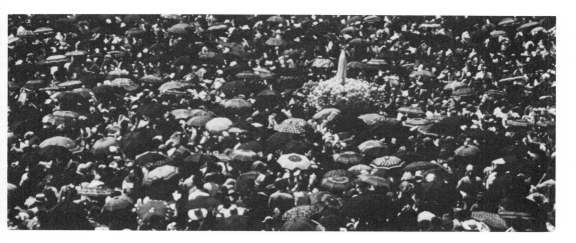

39. Pilgrimage throngs at Fatima (ca. 1980). Photo Magnum.

an act to apparent insignificance, that offers the best proof of the power of the image at the shrine, and of the ultimate burden it carries, however remotely it may do so.

Does it then matter how the images look? Just because men and women do choose to go to particular shrines (rather than any old one) hardly justifies an answer in the affirmative: there are simply too many other factors involved (such as the pleasures of the route).[19] Of course they may make a special effort to see the main image at a particular shrine; but that could be because of its fame or because they want confirmation of having been there, not because there is any perceived relationship between looks and efficacity. On the other hand, they may be so impressed by how the image looks that they are filled with a strengthened belief in what it can achieve. The problem is further complicated by this closely related issue: What—if any—is the role of consecration, particularly with regard to activating the image? The case of the Regensburg pilgrimage exemplifies several aspects of these problems. We cannot, for a start, be entirely certain whether the original miracle was attributed to the painting commissioned from Altdorfer or, as seems much more likely, to an earlier image which it replaced. Nevertheless, it was probably Altdorfer's picture (fig. 33) that was accorded central importance; and the commission (for what is just a version, albeit splendid, of a painting in Santa Maria Maggiore in Rome) went to a recognized artist, one whose place as canonical was even then secure. There can be no doubt that in Regensburg in 1519 considerable concern was shown for the sheerly artistic qualities of the main image. Whether this meant that it came to be more effective can hardly be decided with certainty. My own inclination is that indeed it did, and certainly the commissioning authorities must have felt that it would (even though their motives must also have had to do with the notion of glorifying the Virgin by showing a glorious image of her).

And if one could not start afresh, and make a good artist do the picture, one could always adorn the old image glamorously, or house it in splendor.

Pilgrimage images generally give the impression of being rather rude and rudimentary; but in every case the preoccupation is evidently to ensure that they are aesthetically differentiated, adorned, and specially housed. No one who has been to places like Loreto could possibly doubt that. The simple, unexpectedly miraculous image on the street corner is inevitably removed and put in some fine and holy place. Without such processes, it is plain that the images could have worked no further. At the very least, they would have been infinitely less effective. Now this might seem paradoxical. After all, so many of these images were believed to be of miraculous origin; their very ontology was supernatural. They were miraculous to begin with, so why should they not continue to work miracles? It would not seem necessary for them to be so regularly elevated, adorned, or enshrined (as in figs. 40 or 54) in order to carry out what was, after all, natural to them. They either did miracles because of their miraculous origin or their imputed miraculous origin was a sensible, convenient, and conventional way of explaining an effectiveness that transcended the possibility of normal manufacture.

It is this set of paradoxes that is presented by the vast abundance of acheiropoietic images, ones not believed to be made by human hands. One has only to think of the profusion of those which appeared ex nihilo, as in the image found impressed on the Nahuatl *tilma* before becoming our Lady of Guadalupe; or even the painting of Saint Dominic which the Virgin herself brought to the monastery of Soriano in 1530 (cf. figs. 41 and 42).[20] Then there are those many hundreds claimed to have been painted—or even carved—by Saint Luke; those transported through the air, spontaneously generated, and so on, endlessly. Could one say that apparently rude or plain images—for example, the Madonnas of Loreto or Rocamadour or Hal or Montaigu—work only because of the splendor in which they are housed? Apparently not. We have only to read the abundant accounts, often contemporary with their discovery, of how they work when they are still outside in the cold, hanging on a tree, or pathetically painted on some shabby street corner. They work before the fancy and elevated forms of enshrinement subsequently granted to them. Crowds flock to them; as a result of the ensuing popularity, substantial incomes are generated. Whether manipulated or not, these devotions and these public occasions arise from the attraction, the supernatural charisma one might rightly say, of these simple images. And so the incomes they engender are channeled back to the images themselves, and honor is paid to them in the form of appropriately sumptuous forms of enshrinement. Undeniable practical considerations too lie behind the great buildings of Loreto and Montaigu, and—as much as any-

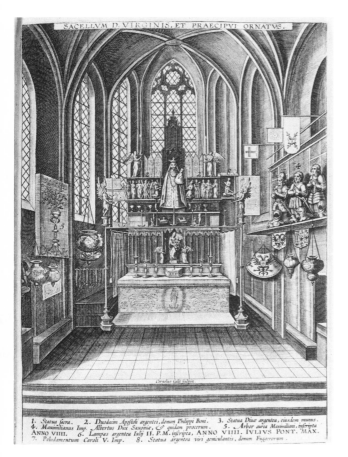

SACELLVM D. VIRGINIS, ET PRAECIPVI ORNATVS.

Cornelius Galle sculpsit

1. *Statua sacra.* 2. *Duodecim Apostoli argentei, domum Philippi Boni.* 3. *Statua Diuae argentea, eiusdem munus.*
4. *Maximilianus Imp. Albertus Dux Saxoniae, & quidam procerum.* 5. *Arbor aurea Maximiliani, inscripta*
ANNO VIIII. 6. *Lampas argentea Iulij II. P.M. inscripta,* ANNO VIIII. IVLIVS PONT. MAX.
7. *Paludamentum Caroli V. Imp.* 8. *Statua argentea viri geniculantis, domum Fuggerorum.*

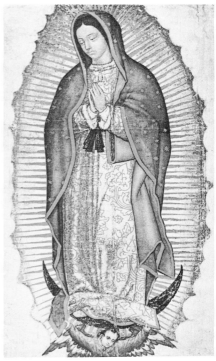

40. *Left:* The interior of the Holy Chapel at Hal (from J. Lipsius, *Diva Virgo Hallensis* [Antwerp, 1616]). Photo author.

41. *Above:* The Virgin of Guadalupe. Photo author.

42. Francisco de Zurbarán, *The Miracle at Soriano* (ca. 1626–27). Madrid, Museo del Prado. Photo Mas.

thing else—they are designed to provide the best means of controlling the vast crowds that daily arrive and of giving most effective access.

But is this a sufficient account? The matter, as I have suggested, is not straightforward. Take the case of Altdorfer's painting in Regensburg (fig. 33). Since it is so clearly derivative, why entrust it to Altdorfer? The answer seems obvious. Although the miraculous powers of that image are at least partly derived from those associated with its famous archetype in Rome, the miracle was special to Regensburg. Hence the need for a special and exclusive image. Perhaps too it was thought, reasonably, that the finer the image the more famous the shrine would be. People might indeed admire it for its art as well as for its other functions. We move closer to an understanding of the need for aesthetic differentiation—though not very much closer to the problem of the relation between imputed effectiveness and perceived aesthetic status. Are we finally going to have to admit that there is no difference between the way a relic works and the way a figured representation does, and that the matter is settled by experiences such as everyone who has been to Lourdes knows? The place may be excruciatingly commercial, with little that is perceptibly elevating in it; and yet its popularity continues and the miracles persist.[21] The Voltairean argument might be this: Belief becomes belief because of the sheer force of convention.

II

In order to explore these issues further, we need to consider the secondary images: not the great archetypal images of Rome, but rather their copies; not the central images of the main shrines, but rather the little images and objects taken away by pilgrims and visitors. They are taken away, these little pictures, these small terracotta and clay reproductions, as souvenirs and to provide solace. The possibilities of motivation when it comes to the images we take home with us are boundless. Does it then matter how they look? They may seem to work—when they do—because they have been in direct contact with the original. Are the powers they have purely the consequences of effective contagion; is it enough for the image to have been in touch with the archetype, or been in touch with something that has touched it (like oil)? What can be said about the role of outward appearance in all this? Again: we may claim that the versions of the Santa Maria Maggiore Madonna only (or even partly) work because they look like the original. But in this case, we will want to know whether a few schematic indications are sufficient to ensure effectiveness; or whether it is enough just to name the object correctly. It is this complex of questions which we must now address in greater detail.

Caution is the first desideratum. Similarity may only seem similarity. It

may seem that most pilgrimage images fall into the same narrow range of categories: either full-length or half-length versions of apparently Byzantine types, to which standard labels have come to be attached: the Hodegetria, in which the Virgin holds the Christ Child to her side while he raises his fingers in blessing; the Nikopoeia, where the Child is brought firmly and frontally before her, as in the solemn medieval statues of the Throne of Wisdom; the Eleiousa, where the Child clings to his mother with greater or lesser affection and brings his cheek to hers; and then the still more intimate Glykophilousa and Galaktrophousa types, where the mother is shown nursing (cf. figs. 43–53). But these are only broad categories. No wonder that scholars have had difficulty in compartmentalizing the huge range of possible variations. They are labels and no more, providing a convenient way of coming to terms with a vast number of permutations (which confound so many classificatory systems).[22] These variations may only seem to be mildly and insignificantly differentiated from each other. But in fact every effort is made at differentiation. The people who produce these images do not set out to ensure that they look like their effective archetypes (although, that in part is what makes them effective); they set out to ensure that they look just a little different. Then, often, the images work better and more distinctively.

Take the extraordinary illustrated compendia of miraculous images of the Virgin that became so popular from the early seventeenth century onward. We may think that one Virgin and Child and one Pietà looks much the same as the other; but the pages of such books make abundantly clear how complex and varied were the adjustments and adornments of an apparently limited range of types. Wilhelm von Gumppenberg's engaging *Atlas Marianus* of 1659, with its one hundred simple illustrations, give us some indication of this variety—despite the roughly schematic quality of the engraving. He himself was especially devoted to the Madonna di Loreto, which he visited in 1632. Between that year and his death in 1675, eighteen Loreto chapels were built in what is now Bavaria alone.[23] No wonder, then, that his *Atlas* should seek both to affirm and to differentiate the tokens of this most famous type.

But consider some of the other variations of the best-known types. The Madonna of Guadalupe is changed almost beyond recognition from one version to the next, and in Gumppenberg's book she is crowned, swathed in a great cone of cloth, and studded with jewels; so is the Child, whom she holds like a doll in her hands (cf. figs. 41 and 43). The Black Virgin of Leon is dressed in a similar way; but she holds the Child to the front, with both hands—just as does the not dissimilar Virgin of Montserrat (fig. 44), who is shown in the glowing center of the sumptuous edifice that contains her. In a volume like Gumppenberg's, we can begin to appreciate something of the extent of adornment, enshrinement, elevation, and variation—

43. *Top, left: The Virgin of Guadalupe* (from W. Gumppenberg, *Atlas Marianus* {Ingolstadt, 1653}). Photo Warburg Institute.

44. *Top, right: The Virgin of Leon* (from W. Gumppenberg, *Atlas Marianus* {Ingolstadt, 1653}). Photo Warburg Institute.

45. *Above, left: The Virgin of Loudun* (from W. Gumppenberg, *Atlas Marianus* {Ingolstadt, 1653}). Photo Warburg Institute.

46. *Above, right: The Virgin of Rocamadour* (from W. Gumppenberg, *Atlas Marianus* {Ingolstadt, 1653}). Photo Warburg Institute.

all in a remarkably short compass. If the Virgin cannot be adequately differentiated, then it is always possible to move the Child around, as in the *Virgen de Los Remedios* from Cordoba, or to tuck him into the Virgin's dress as at Loudon (fig. 45). The scrawny and disappointingly sticklike image of Rocamadour (fig. 12) has here become a somewhat pudgy Virgin encased in a huge cone of plain cloth, while the Child looks even more like a doll than usual, nothing so much as a finger puppet (fig. 46).

All this serves to remind us of the need for caution as we leap to judgment about the comparative lack of differentiation. This kind of leap makes people readier to classify responses that are predicated on miraculous performance as superstitious: we call them that in inverse proportion to the extent to which they have to do with formal and aesthetic factors. But it is clear that if confronted with types that seem very similar, we are not likely to see differences so well; and if confronted with widely differing illustrations or versions of the same type, we would not see their connection with each other. From Rome and Sicily to cold Vilna at the other end of Europe, Gumppenberg's little volumes illustrate the infinity of subtle variations on already subtly varied types, and the magnificently inventive variety of enshrinement and adornment. Sometimes all is profuse and splendid; on other occasions we are left—as at Vilna—with charming dialogues between humble Virgin and crowned Son. The need to make each image special and different could not be clearer.[24] Indeed, it is precisely through simple prints such as these, where economic factors and publishing exigencies are such that artistic skill and display are necessarily exiguous, and the concern with "beauty" limited or negligible, that we may most directly trace—if we attend carefully to each image—the modes of ensuring the proper distinctions between one object and another.

The same observations may be made for many other genres, from the near-universal enterprises to the local collections (such as Placido Samperi's huge *Iconologia* of 1644 on the Madonnas of Messina alone), which further testify to the extraordinary abundance of pilgrimage images and the multiplicity of the powers and capabilities attributed to them, and finally to the prayer cards and other souvenirs taken away from shrines.[25] In the popular Remondini collection of 1760, simply entitled *Historical Accounts of the Apparitions and Celebrated Images of the Virgin in Venice and Her Domains,* for example, the apparent categories are almost wholly subverted by the need for infinite variation.[26] The Virgins of San Marco and of Santa Maria Maggiore in Tarvisio could both be assigned to the Nikopoeia class. But the one image is archaic, simple, and neatly enshrined (fig. 47); the other is more recent, not especially severe, and seems a rather more lavish affair. The Virgins of La Celestia and San Marziale are among the plainest types; what distinguishes them are the differences between their rich enrobement and crowns (figs. 48 and 49). If we survey the prayer cards from Munich or the

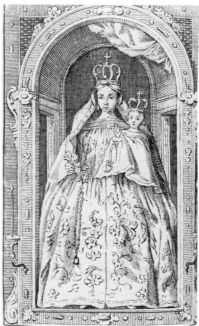

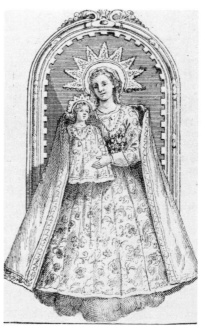

47. *Above: The Virgin of San Marco* (from [F. Corner,] *Apparitionum et celebriorum imaginum* [Venice, 1760]). Photo author.

48. *Above right: The Virgin of San Marziale* (from [F. Corner,] *Apparitionum et celebriorum imaginum* [Venice, 1760]). Photo author.

49. *Right: The Virgin of La Celestia* (from [F. Corner,] *Apparitionum et celebriorum imaginum* [Venice, 1760]). Photo author.

50. *Opposite, left:* Anonymous copy of the Passau *Maria-Hilf* by J. C. Loth in the Peterskirche in Munich (engraving; eighteenth century). Photo Munich, Stadtmuseum.

51. *Opposite, right:* J. N. Maag after J. C. Loth, copy of Passau *Maria-Hilf* in the Peterskirche in Munich, as in its frame by J. F. Canzler designed by J. B. Straub (engraving; late eighteenth century). Photo Munich, Stadt-museum.

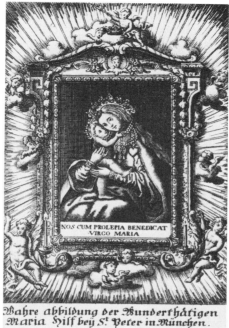

Wahre abbildung der Wunderthätigen
Maria Hilf bey S.ᵗ Peter in München.

Tirol, for example, the same phenomenon emerges: there we find many
versions of the more intimate, so called Eleiousa type. They are particularly
popular in the Munich area. The type obviously catches on, so there cannot
be too great a difference between each one; but once again, even within the
identical type, the need for aesthetic differentiation persists (figs. 50 and
51). At the Peterskirche a brewer's widow commissioned from Johann Carl
Loth a version of the miraculous picture of Passau in 1653; and the adap-
tations swiftly multiplied—especially after the new picture of the Maria
Hilf helped the Elector Max Emanuel win a battle over the Turks just thirty
years later. The result is that in one prayer card, the Virgin is veiled and
surrounded by military banners (fig. 50); in another she is crowned, jew-
eled, and shown in the superb silver frame she received in 1785 (fig. 51);
and so endlessly on.[27] The varieties of Maria Hilf images throughout Mu-
nich are almost without number. And with Vienna, the history of adapta-
tion and variation is perhaps the most fully documented of all—thanks to
generations of researchers who have realized the ethnographic as well as the
spiritual significance of all such objects, whether painted, sculpted, jew-
eled, or clumsily printed on the cheapest of paper.[28]

But there is a still more significant aspect of all this, which we have
already implied. The housing and adornment of each image is often made
to be more distinctive than the image itself. If we think we can distinguish

differences on the printed reproductions, how much more so when we go to the shrines themselves! Each picture and statue is enshrined, set against a more or less gaudy backdrop, bedecked or wrapped in garments that are studded with gems, crowned, and generally bejeweled. This, it would seem, is what makes these pictures and statues effective, and what attracts the crowds. Their age and type seem almost irrelevant. Who, after all, could especially characterize the Virgin of Monte Berico in Vicenza without referring to its enshrinement (fig. 52)? This was a statue that could make the blind see, the crippled walk, the mute speak, the infertile fertile, and in general restore the sick to health. And yet it was so preposterously swathed in a multilayered conical garb that its appearance must seem to have next to nothing to do with all it can achieve. It is worth noting how different the statue looks now (fig. 53). It is full length, it has a vulgar crown and necklace, and an even more vulgar backdrop; and it continues to be effective. It is just this kind of adornment that testifies—if nothing else—to the affection and admiration of those who continue to visit her

52. *The Virgin of Monte Berico* (from [F. Corner,] *Apparitionum et celebriorum imaginum* [Venice, 1760]). Photo author.

53. The Virgin of Monte Berico. Photo author.

54. Auda of the Virgin, Seville. Photo Courtauld Institute.

(even more than it testifies to those who are actively involved in propagating her cult); just as do those alterations in her garments and ornaments in the course of the liturgical year.

The fact is that while one has to recognize the focal images as such, they are often crude, simple, raw, and must always have seemed so, even to the most devoted of guardians and supplicants.[29] This is of course another reason to dress them up, gild and color them blazingly (fig. 54). In strict theological terms—as is so often insisted in the course of Western Christianity—it is the Virgin or saint represented by the image that works the miracles, that arouses veneration, and—for that matter—attracts the crowds. But in every case, the aim is to reinforce the implicit claim that it is this particular image and not another that works in such and such a miraculous or beneficent way. And so one has to ensure that everyone knows

that the miracle is done by the Virgin of the particular place. For example, we read in the *Miracles of Our Lady of Chartres* of a lady of Audignecourt who was cured of a skin disease by praying to the Virgin. When she set off for Notre-Dame de Soissons to give thanks, the Virgin appeared to inform her that it was by Notre-Dame de Chartres that she was healed. There can be little doubt of the commitments of the writers of these collections of miracles. The author of the Coutances collection tells of a Norman called Vitalis who came to the "insipid conclusion" that "the Blessed Mary of Bayeux and the Blessed Mary of Coutances were one and the same person . . . and so the Virgin of Coutances not possibly be more merciful or more powerful than the Virgin of Bayeux." For this the difficult Norman was severely chastized by the Virgin herself. Finally, none other than Saint Thomas More recorded hearing a conversation between pilgrims: The first insists, "'of all Our Ladies, I love best Our Lady of Walsingham'"; and I, saith the other, 'Our Lady of Ipswich.'"[30]

In short, it is not just the Virgin, or Saint Francis or the dead or risen Christ, but rather the Virgin or the Saint Francis or the dead or risen Christ in a specific image to which men and women flock, in which they invest their hopes, and to which they give thanks. And the reason for this has not only to do with local pride or economic good sense: it has, in profound ways, to do with how the images look. Even if these images are considered the adequate mediators between people and what the images represent, they are always highly specified and differentiated mediators: as if their power resided wholly in their visual particularity. But there is a problem. Some pilgrimage images seem to depend at least in part for their effectiveness on the fact that they are evident visual derivatives of well-known miraculous or miracle-working images (say, the *Madonna del Popolo* or the *Madonna di Loreto*).[31] In this case the need has to be to ensure both particularity and identification. The same species of problem arises with the mementos and souvenirs that the pilgrim takes away from the shrine. There everyone knows (both because of adoration and because of adornment) what the effective image is; but when it comes to the lesser images, the reproductions we take away with us, the need for identification becomes more acute. That is why words are invariably added to ensure just that identification, or to encourage the devotion that is inevitably diminished by distance.

These lesser reproductions may be the small mementos of our great journeys, but we also expect them to bring into our lives something of the grace that pertains to the larger images and figures they reproduce, something of the aid and succor they reputedly grant to others. They are protectors of our homes and tokens of the presence of the holy. They are made of paper, lead, tin, pewter, bronze, and silver; of horsehair and silk; of leather; of terracotta, stone, glass; and of every imaginable material. Beaten, pounded, molded, struck, sculptured, and chased, there is hardly a technique by

which they are not made. They are lowly because they are so heavily commercialized; the trade in them is vast and vulgar. This is not to deny that some images in this class are of the utmost refinement. But they are the exceptions. The main task, therefore, must be to consider the extent to which reproduction affects effectiveness, and to reflect on what may be learned from the ordinary and simple examples, whose quality, by any reckoning, is so frequently low.

When we survey the prayer cards, badges, and terracotta tokens—indeed, the whole class of simpler reproduction—we are likely to be struck by just how telling are these adaptations of high and fancy art. Pretty soon we notice how the image is adorned or simplified, embellished or rendered more schematic, made more wooden or more sugary.[32] This in itself provides insight into the aesthetic expectations and preoccupations of the people who buy such images (even though they may well declare that all they want is a reproduction of the image at the shrine). The matter is even more instructive, of course, when it is a modern image that becomes the focus of cultic adoration at a pilgrimage center. The example of the painting by Altdorfer at Regensburg and its derivatives will feature again in these pages; but even if we remain within Southern Bavaria, we find further examples. For instance: from 1635 on, Alessandro Abondio's wax image after the well-known sixteenth-century composition of the Pietà probably designed by Quintin Massys but painted by Willem Key (fig. 55) served as the *Gnadenbild* of the Congregatio Minor of the Munich Jesuits. It was immediately given the characteristic title of *Mutter des Schmerzes und der Liebe,* Mother of Sorrows and of Love (fig. 56).[33] In addition to the Maria Hilf painted by Loth, the Peterskirche also housed the popular Pietà painted around 1640 by the court painter Johann de Pay and taken directly from Van Dyck's *Lamentation* of around 1628 (fig. 57). We may well ponder how and why so recent a picture should be felt to be capable of working in miraculous ways (in 1783, for example, it was frequently reported to have moved its eyes).[34] Exactly the same questions may in turn be asked of the engravings of the Pietà after De Pay (fig. 58). The spread and diffusion of downward transformations of what is regarded as high and canonical and of elements within such archetypes provide evidence not only of the status of the original image from which the reproduction is taken, but also of the kinds of images in general which are capable of purposive function; and the ways the archetypes are abbreviated, expanded, or adorned provide indices to the mechanics of transformation from one function to another. But at the same time, that very change and the adaptation to apparently new uses offers the best possible insight into the potential of the unique original and the variety of responses it is capable of arousing. The study of copies and transformations remains one of the great tasks of the history of images.

But there is another related issue at stake here. When we consider the

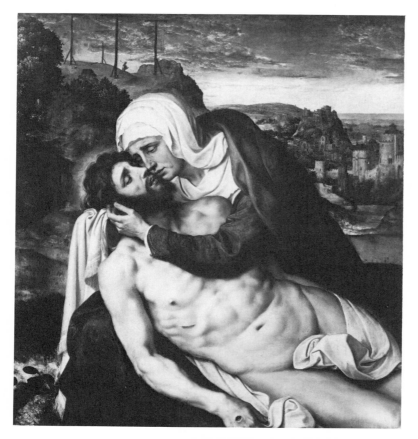

55. Willem Key (and
Quintin Massys?),
Pietà (sixteenth
century). Munich,
Alte Pinakothek.

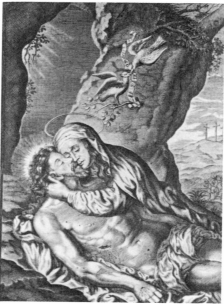

56. Engraving after
A. Abondio, *Mutter des
Schmerzes und der Liebe,*
in the Oratory of the
Jesuit Congregatio Mi-
nor, Munich, after W.
Key. (engraving; late
seventeenth century).
Photo Munich, Stadt-
museum.

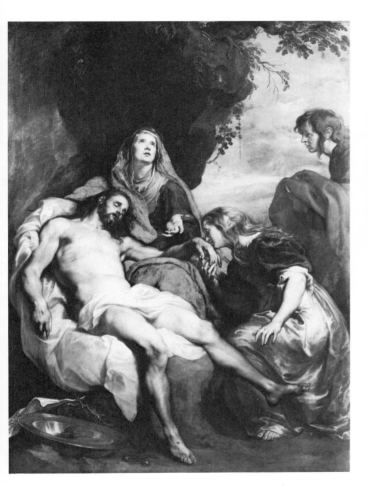

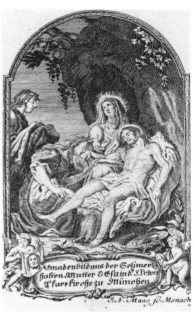

58. J. N. Maag, after J. de Pay, after Van Dyck, *Lamentation,* Gnadenbild in the Peterskirche in Munich (engraving; late eighteenth century). Photo Munich Stadtmuseum.

57. Anthony van Dyck, *Lamentation* (ca. 1628). Antwerp, Koninklijk Museum voor Schone Kunsten. A.C.L.-Brussels.

vast output of secondary imagery associated with shrines (of the kind we have been mentioning), we should also reflect on the implications of the spontaneity, the nonchalance, or the arrested nonchalance with which we regard all the images in this broad class of tokens and souvenirs. What functions are they supposed to perform, what functions do they perform, and what is the relation (if any) to the manner in which they are regarded and handled? These functions vary from that of a more or less simple recollection of the journey and the shrine (what we now would call a souvenir) to that of a fetish, amulet, and talisman. Sometimes such a little picture or sculpture may serve as the reinforcement of a significant memory, in the manner of a holiday photograph; but often it is believed to partake of at least something of the power of the archetype (particularly if it has been in contact with it), and occasionally it is even felt to be an *apotropaion,* capable of warding off evil. Following the prayers for the consecration of images in many benedictionals is the following special prayer for *small* images:

> If any sick or dying person holds this image in his hand, or has it placed on his chest let malignant enemies not dare to approach him, nor harm him with temptations nor beset him with terror by his ghosts. But liberated from the assaults of demons by the virtue of this blessed image, and by the merits of the glorious Virgin, let him thank and do praise to Jesus Christ. [35]

In all such cases, we have again to ask ourselves whether the ways in which the archetype is transformed in reproduction has any significant bearing on its felt effectiveness, or whether it is not again largely a matter of consecration or of power derived from contact.

All these matters are exemplified by class of images which as much as any other remind the investigator of the constant need to attend to the visual modifications of the models they adapt. The Flemish pilgrimage pennants (*bedevaartvaantjes*) began to be produced in large quantities in the latter half of the sixteenth century and continued to enjoy considerable popularity until well into the twentieth. [36] All carry reproductions of key images or saints at the shrines from which they come, or of great public altarpieces by artists like Rubens and Van Dyck (cf. figs. 59 and 60). The quality of their execution varies enormously, and they appear in all kinds of remote, incidental and often apparently insignificant contexts. [37] The horse that accompanies the pilgrims home has one behind his ear in a twentieth-century photograph (fig. 61), while in the print after Bruegel's *Saint George's Day Fair* (where, as we have already seen, the main image is almost entirely suppressed in the background), one of the many revellers has a pennant stuck cavalierly in the folds of his cap (fig. 38). But the pennant is not there just to provide a cheerful visual accent to procession or picture. "Touched by the relics of Saint Elizabeth" reads an inscription on a seventeenth-

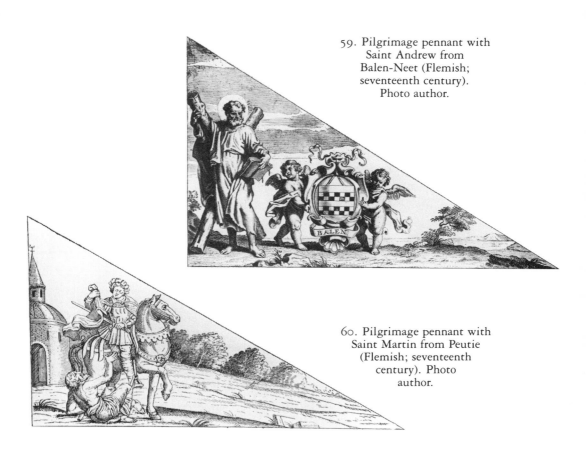

59. Pilgrimage pennant with
Saint Andrew from
Balen-Neet (Flemish;
seventeenth century).
Photo author.

60. Pilgrimage pennant with
Saint Martin from Peutie
(Flemish; seventeenth
century). Photo
author.

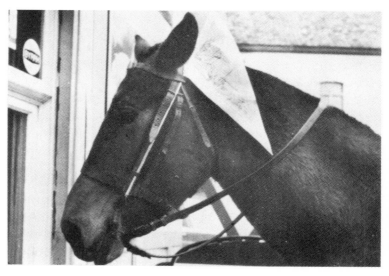

61. Horse wearing pilgrimage pennant (from Philippen, p. 20).

century penant from Zoersel; "this pennant touched the miraculous image of Our Lady at Hal" reads another; "image of Notre Dame of Hal, it miraculously delivers souls from purgatory" asserts an eighteenth-century example; and on a woodcut pennant of 1928, a bold inscription runs: "Cette empreinte a touché à l'image miraculeuse de notre dame aux bois à Braine le Chateau."[38] In cases like these, as with Altdorfer's prints of the *Schöne Maria* at Regensburg, we may well want to revise, critically, Walter Benjamin's otherwise attractive view of the diminution, as a result of reproduction, of the aura of the unique prototype. Adequate reproduction achieves a power and efficacy that may closely approximate that of the image represented; while adornment and enshrinement are likely to enhance it further. This is the prime factor here, not wish-fulfillment, nor projection of one kind or another, nor even contact. It may be felt that the secondary images owe their efficacy to contact, but would this be the whole story? To answer in the affirmative would be to scant the role of reproduction. Reproduction both enables and facilitates repetition; and repetition, sheer repetition— whether in pattern or as evident multiple, whether of motif or of whole visual theme—engenders a new and compelling aura of its own. But "aura" may be too weak to describe that aspect of the repeated motif and the multiplied object that arrests attention and orders the processes of repetition. Finally, these little images that are carried away pose a further question: How and to what extent are their powers determined or altered by downward transformation from the good archetype?

Much the same issues arise in the case of the prayer cards—the *santjes* and *bidprenten* of the Netherlands, the *santini* of Italy, and the aptly named *kleine Andachtsbilder* of Germany—that were also and still are to be had at shrines and at altars generally.[39] Their past is longer and their use more recent than that of the pilgrimage images. The cruder forms are well known, from the small rectangular images of favorite Madonnas and saints, to the innumerable Crucifixions, instruments of the passion, and bleeding hearts. They too are often adapted from well-known paintings or sculptures, or from elements within them; and so they too provide an index to popular forms of consumption and taste, as well as to the deeper aspects of potentiality. The number and kind of reproductive objects—especially of the most favored miraculous images—is beyond measure, and the range of media in which they appear extraordinarily multifarious, from wall-paintings to pocket images, from jeweled pendants to tin badges, from pocket books to sumptuous and learned tomes. The small limewood Virgin of Altötting, for example, appears not only in votive images and in books, but also in drawings, medallions, and in umpteen woodcuts and engravings (figs. 62–63); so does the bottom half of Rubens's picture of Saint Teresa interceding for Saint Bernardino de Mendoza (figs. 64 and 65)—to say nothing of the proliferation of reproductions of, say, the Regensburg *Schöne*

62. *Top, left:* Silver pilgrimage token, obverse showing the Virgin of Altötting (eighteenth century). Munich, Bayerischen Nationalmuseum, Collection Kriss.

63. *Top, right:* The Virgin of Altötting (fourteenth century, with later clothing and crowns. Photo Werner Neumeister.

64. *Above, left:* Peter Paul Rubens, *Saint Teresa Interceding for Bernardino da Mendoza* (1630s). Antwerp, Koninklijk Museum voor Schone Kunsten. A.C.L.-Brussels.

65. *Above:* Cornelis Galle after Rubens, *Souls in Purgatory beneath the Monogram of Christ* (engraving; seventeenth century). Photo author.

66. The Virgin of Loreto
(engraved prayer card;
Bavarian, eighteenth century).
Photo Munich, Stadtmuseum.

Maria, over just a few years, or of the Madonnas of Loreto and Guadalupe over many centuries (e.g., fig. 66; cf. figs. 35 and 43). As souvenirs stuck in caps or behind horses' ears, or passed from generation to generation, or even pasted down in albums, such images may not (one might argue) deeply impress themselves on the imagination; but one should never disregard the possible subliminal consequences of cherishing and fingering the records of some of the central journeys in the lives of vast numbers of people for several centuries. They become surreptitious but insistent reminders of the powers and merits that go well beyond the poor respect we accord them. And then at once, unnoticed, as if by stealth, they are fetishes and become talismanic.

III

Implicit in the use of many of the objects associated with pilgrimages is the possibility of a prophylactic or amuletic function; in other words, the reproduction of a miracle-working image may itself serve as a cure or ward off hostility and evil. But again we should proceed with caution and not make assumptions where analysis is lacking. The problem of defining prophylaxis has arisen most acutely with a group of objects much studied by students of early Christian imagery. Men and women have always carried images of Christ and his saints from pilgrimage sites and burial places, but they have also taken ampullae filled with substances associated with shrines or tombs (usually the oil burning in the lamps around the sacred location); they have taken *encolpia* containing relics; and they have worn medallions of the venerated saint—often living stylites but usually dead martyrs—around their necks. The whole class is known as *eulogia;* almost all have been figured with representations of Christ or the relevant saint; and almost all seem to have served a function that goes beyond that of what would now simply be called a souvenir or memento. We would know this from prayers in the benedictionals alone, leaving all practice aside; but still it is not clear what beliefs attach to objects in this broad class.

There is almost a superfluity of Western evidence for the potency and efficacy of objects and substances that have been in contact with a saint or

with his tomb or shrine. Among the fullest and most graphic are the writings of Gregory of Tours (ca. 540–94). In many places in his *History of the Franks,* but everywhere in his eight *Books of Miracles* (above all in the books on the miracles at the tombs of Saint Julian and Saint Martin), he insistently records the evidence of the healing and other powers of tombs and relics. These powers are manifested not only at the tombs or by the relics themselves, but by almost anything that has been in contact with them, even at one or more stages removed from them. Every kind of illness— from blindness to lameness, deafness and dumbness, from dysentery to boils, cancers, and fractures of every kind—can be cured at the shrine of Saint Martin. Infants on the verge of death are revived; the dead themselves are brought back to life. Although many of these reports are blatantly campanilistic, they nevertheless provide fundamental formulations for the effectiveness of almost every kind of amulet, talisman, *brandeum,* and palladium—to say nothing of the oil, wax, hairs, fibers, and bits of wood that are removed from tombs and shrines and altars. "How could anyone doubt the miracles performed by Saint Martin, when they see the present evidence for the powers at his shrine, when they see the lame made to walk, the blind given sight, demons put to flight, and the curing of every other kind of disease?"[40] Illness, of course, included insanity of various kinds. It is important to note here the strict .elationship between the curing of illness and the expulsion and putting to flight of devils. The two phenomena go together, almost always.

"A little bit of dust from the shrine (*parumper de pulvere basilicae*) is of more use than any medicine; and [they prevail when] consultations with soothsayers are utterly worthless," Gregory says of a Frankish noble whose paralysis of arm and leg, incurred in the course of a hunting accident, was cured after nearly a year's fasting and praying.[41] In short, "who would ever be able to investigate or get to know how many and how constant are the virtues of the dust and the wax [i.e., from the candles] of that place, and which everyone takes away from the tomb?" This is Gregory's apt reflection on the whole phenomenon, as he embarks on a classic tale (one of hundreds) about the desperate attempt of a faithful pilgrim to obtain at least some token of his visit to the shrine of Saint Martin.

> He tried many times, but was never successful, since he did not dare to take anything by day. So he returned at night, and stealthily cut off a particle of the rope used to hoist the banner of Saint Martin. He returned to his home, and from then on cured many sick people, since whoever faithfully kissed the token (*pignus*) of the saint's tomb avoided illness.[42]

Here are least two of the three chief ingredients of effectiveness: a substance from the tomb and devoted attention to it. But what of figuration?

What difference when the substance is placed in a container with an image on it? That the pilgrimage factor is crucial to the effectiveness of the token is abundantly clear from this and many other tales. Gregory concludes this one as follows: "Behold, O Saint, what you show to the faithful who specially seek out your shrine. Through you they are saved, and those who carry away votive tokens with them are cured by the help you then bestow."[43] In the first instance, then, it is faith that is operative, as Gregory himself insists;[44] then too it is the pilgrimage to the shrine; then the substance removed from it; and, finally, devotion to the *pignus,* the votive token.

But if all this were sufficient, why bother with figuration at all? Let us turn to the pilgrimage ampullae of the fourth to the seventh centuries. They fall into several main groups. Most are small and generally of terracotta (fig. 67). The large group with representations of Saint Menas and the majority which come from the Holy Land and Asia Minor appear to have been carried by ordinary pilgrims ("Remain close to the tomb of the martyr; take away the eulogy with you," recommends Saint John Chrysostom, thus reminding one of the issues of contact and proximity);[45] but the celebrated ampullae of the cathedral treasury of Monza are recorded to have been sent by Pope Gregory I to Theodelinde, queen of the Lombards, who built the church of Saint John in that town (figs. 68 and 69). Along with the almost equally famous ampullae from Bobbio, these are certainly the most beautiful of the genre, and they too have inscriptions which vary from the simple identification of scene or sitter to whole sequences of verses. The sixteen surviving Monza ampullae show scenes from the Life and Passion of Christ; the twenty from Bobbio do so too, but with greater concentration on the cross itself.[46]

A constant feature of the scholarly discussion of the ampullae has been the claim that they were intended to serve as apotropaia (or actually did so—the distinction is not always made). Perhaps the claim has been meant to be taken no more strongly than one might, until very recently, have made about neck pendants of Saint Christopher or of other small images held close to the body.[47] But is it only because of leading inscriptions that objects like the late sixth- early seventh-century ampullae from Palestine are said to have been worn round the neck as amulets?[48] Admittedly there are the words "Emmanuel, God with us" and "Blessing of the Lord from the holy places"; but the imputation of talismanic qualities simply on the basis of such plain formulae seems insufficient. What else, in the way of figuration, is on the ampulla, and how the letters are formed must be of equal significance (or nonsignificance). Is the presence of a plain cross, as on many gems and ampullae, sufficient evidence of talismanic power—as every book on amulets would suggest? Certainly, on looking at the Monza and Bobbio ampullae, one cannot help reflecting on the force of the frontally disposed, central element in each piece, whether cross, holy sepulchre,

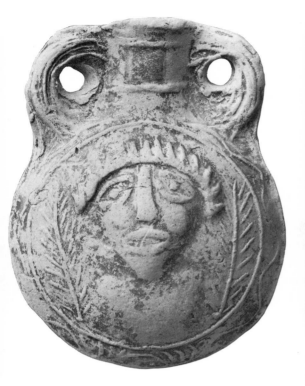

67. *Above:* Ampulla with martyr's head (terracotta; Smyrna; fifth to seventh century). Paris, Musée du Louvre.

68. *Above right:* Ampulla with cross and apostles (silver alloy; late eighth century). Monza, Cathedral Treasury. From Grabar, *Ampoules de Terre Sainte* (Paris: Librairie Klincksieck, 1958), pl. 25. Photo Denise Fourmont.

69. *Right:* Ampulla with the Virgin and Child Enthroned, the Annunciation to the Shepherds, and the Adoration of the Magi (silver alloy; late eighth century). Monza, Cathedral Treasury. Photo Hirmer.

or the dominating and isolated figure of Christ himself (cf. figs. 68 and 69). But that force is difficult to define. One can imagine—intuit—the notional warding off of devils; but why? Because of the force of frontality, symmetry, repetition (in the case of the crosses between the letters), the isolation of the central element, cyclical and circular patterns, or special kinds of framing and adornment? There are any number of possibilities. The lesson is to attend to the visual and figurative (and not just iconographic) dimensions of prophylaxis; and not to rest content with the largely corroborative value of inscriptions.[49] In any event, these are more complicated cases than those instances where accessory elements plainly figure (and therefore embody?) the evil against which Christ or his cross serve to fortify us. One has only to think, for example, of the *Scuta Passionis* in a number of fifteenth-century manuscripts like the English *Deserts of Religion,* with the doglike demons who yap at the hermit monk kneeling under the aegis of the shield with Christ's monogram (on other pages the shield has his bleeding wounds, or the *Arma Christi*) (fig. 70).[50] They cannot get at him because the shield with the powerful symbol wards them off.

But sometimes inscriptions do make the talismanic function (intended and actual) reasonably clear. The famous enameled gold encolpium at Monza has on its reverse some lines from a poem by Gregory of Nazianzus which run more or less as follows:

Flee far from my heart, devious foe, flee fast; retreat from my limbs, leave my life in peace. Thief, reptile who devours like fire, true Belial, perverse and infernal being, insatiable glutton, famished dragon, ferocious beast. You are nothing but darkness, lies, rage, and black chaos; murderous sorcerer, you hurled our first parents into the most frightful ruin, making them taste the fruits of malice and perdition. Christ the King orders you to flee to the bottom of the sea, to cast yourself against the rocks, or among a herd of filthy pigs. Just as formerly with that insensate legion, retreat, if you do not wish me to put you to flight with the cross, the instrument of terror.[51]

There can be no doubt about the intention of such lines; and since they were put so strongly and insistently, one may assume that there was some belief that the object could actually work in this way, or had the potential for doing so. There is also the evidence of Theodoret's classic statement that images of the living stylite Symeon (which he had blessed or had been in contact with) were hung as apotropaia above the doors of craftsmen's workshops in Rome.[52]

But perhaps the apotropaic, talismanic, and prophylactic powers imputed to such objects have less to do with what is figured on them than with other factors. Perhaps their effectiveness is derived from the fact that they contain a substance—say, oil or a relic—that has been in close prox-

70. *Left: The Hermit in the Desert: The Desert of Religion* (North English; early fifteenth century). London, British Library, Add. MS. 37049, fol. 46 recto. By permission of the British Library.

71. *Above:* Lid of the Fieschi Staurotheca, showing the Crucifixion with the Virgin, John the Baptist, and the Apostles (ninth century?). New York, the Metropolitan Museum of Art, gift of J. Pierpont Morgan, 1917 (17.190.715).

imity to the shrine; or derived from the very substance of which they are made, or, as in the case of the representations of the stylites, because they have been in direct contact with the actual source of unearthly efficacity. Similarly, one might insist that the power of a wide range of amulets—pagan as well as Christian—resides wholly in the words written upon them.[53] They can be apotropaic either explicitly or because the apparently incomprehensible jumble of letters somehow entraps the devil or the demon in their inexplicable and inextricable network. If you make the imprecation strong enough and say it long and often enough, in the right way, it might—after all—work; and the amulets themselves might be (or have to be) mystically or magically consecrated, just as are the small images held close to the body or attached to houses referred to in the consecration rituals

in many benedictionals.[54] But the fact remains that most of these objects are figured in one way or another; and so again we confront this question: What is the relation between visual signs—from the cross itself to whole narrative scenes—and the talismanic, apotropaic, and prophylactic? Even if we were to insist on an inherent connection in the case of extremely condensed signs like the cross (and we remember how often it drove away enemies), we would not be entitled to assume that all such figures are talismanic. Just as with objects like the Fieschi Staurotheca, which contained a relic of the true cross (fig. 71), the ampullae from the Holy Land and from Monza have all too readily been supposed to have had such a purpose; but we will never have proof until we are able to be more precise about the reasons for the investiture of visual imagery with a power and efficacy that transcends its status as mere representation.

In late Greek and Roman culture, when a man wished his rival's horse to lose the race, he not only buried a piece of lead with the horse's name on it, but also scratched a crude image of the poor jockey, fettered and nailed and assailed by a fierce serpent.[55] This is one species of the so-called *defixionum tabellae;* others could be used for the purposes of facilitating seduction, while the blackest kind were used to kill not only demons but living enemies as well.[56] Although most were not figured, a few survive which show the enemy entrapped in the coils of snakes or threatened by beasts. As with the prophylactic and related functions ascribed to the ampullae, such phenomena have too often been shifted to the margins or to the putative early roots of the history of art. What is it about the dead reflection—for it is only reflection, at best—of living form that endows it with such force? It cannot simply be because of the felt efficacy of crude form, as with the brute heads of Saint Andrew on the terracotta ampullae from Smyrna and elsewhere in Asia Minor (e.g., fig. 67), nor of the configurations that seem overwhelmingly intricate and subtle, as if such configurations would entrap the evil force, as it certainly would us.[57] Even if we say that it is only because the intensity of our hope, desire, fear, and gratitude forces us to believe in their ultimate efficacy, that they will ultimately work, we still seem to need representation to emphasize, supplement, or condense every such projection. And then we are led to ask again: Does it matter how even the simplest figure looks? Presumably it does. It is from representation that all the objects we have been dealing with gain their full illocutionary force, and come to occupy so profound a place in the systems of intentionality without which all communication and much emotion would fail.

I do not believe that these issues are adequately taken care of by claims for the "sedimentation" of power in objects, as S. J. Tambiah has most recently put it in his discussion of Buddhist amulets.[58] Too often the anthropological and meta-anthropological literature has relied on vague, almost mystical

concepts—"mana" and the like—to account for what is seen by the investigator as the objectification of power in objects and the transfer of charisma, as in the case not only of amulets but also of things like gifts. The latter notion, that of the transfer of charisma, might be seen to some extent to account for the beliefs in the actual powers of objects carried way from pilgrimage shrines, and that may also seem to be a way of describing the apparently magical duplication of the powers of the person or image with which the object was once in contact. But all such notions are really no more than descriptions, or labels, no better at explanation that the notion of magic itself. What we need to examine, in order to see just how unsatisfactory all these notions are, is the precise role of figuration in making the objects effective. Obviously it may be relevant to determine whether the object has been in contact with, or contains some substance that has been in contact with, a powerful or miraculous original; but that cannot be all. It cannot, furthermore, be sufficient to emphasize activation and transmission of charisma alone. Tambiah is no doubt correct to say that "although amulets in the shape of an animal, bird, human or deity have special virtues related to their forms and intrinsic nature, it is the monk and lay specialist who importantly charge them with efficacy";[59] but he then goes on to neglect these so-called special virtues entirely. In his account of what he calls "The Cult of Amulets" (the section is subtitled "The Objectification and Transmission of Charisma"), he concentrates solely on the location and activation of "special powers"—without the barest nod in the direction of what the visual components of effectiveness might be.[60] As almost always in the anthropological literature, the images are indeed described, but the relations between how they look and why they work are almost entirely passed over. It can do no harm to ask oneself, yet again, about the extent to which there is any difference between, say, the efficacy of pilgrimage pennants and the efficacy of *brandea*—those little pieces of cloth taken from the saint's or martyr's tomb or shrine. The *brandea,* by and large, were not figured; as far as we know, it was sufficient that they came from a garment or cloth that had covered the saint's body.[61] The straightforward question, then, is whether figuration on pennants and other souvenirs makes any difference at all when it comes to their miraculous efficacy; or whether the issue is just one of some unexplained impulse simply to decorate. That we cannot, even for a moment, entertain any notion of an impulse "simply to decorate" is, of course, one of the main claims and prejudices of this book.

7

The Votive Image: Invoking Favor and Giving Thanks

*

This subject does not call for lengthy explanation; it is a spontaneous sentiment that expresses itself in the form of a variety of objects. The pagans also showed their acknowledgment to the divinity in this naive form, and it is very likely that the faithful simply transferred to the object of their belief practices that were scarcely different from those which they maintained prior to their initiation. There is no possibility either of imagining or of establishing categories of ex-voto.[1]

H. LECLERCQ,
Dictionnaire d'archéologie chrétienne et de liturgie

*

The practice of making ex-votos is ancient and widespread. It ranges from the *tammata* and *anathēmata* of ancient Greece to the *milagros* of Spain, the *alminhas* of Portugal, and the *wotums* of Poland. It would be futile to attempt to categorize them, so vast is their variety. Excavations at the source of the Seine have brought to light quantities of wooden ex-votos, and the site of a Republican healing-sanctuary at Ponte di Nona near Rome has recently yielded more than 8,000 terracotta ones.[1] Most of the latter represent parts of the body (especially the foot and the hand): thus they anticipate the great agglomerations of wax and metal anatomical parts to be found in thousands of pilgrimage sites throughout the West. Once again, it is in the works of Gregory of Tours that we find many references to this kind of offering, and he mentions the votive use of wooden representations of parts of the body that are sick or cured.[2] An abundance of sources, from the sixth century onward, articulates objections to the whole practice, on the grounds that it is pagan in origin, or simply because it is said to be pointless and ineffectual. In 533 the Synod of Orleans placed restrictions on all offerings made in the hope of or in thanks for cures.[3] And the prohibition of the Council of Auxerre around 587 made at least one of the origins of the custom clear, when it forbade the giving of thanks at sacred or consecrated trees and fountains, and then went on specifically to proscribe the making of wooden ex-votos. Instead it recommended vigils in churches and gifts to the poor.[4] Shortly

afterward, Eligius (d. 661) is recorded as having instructed that the "sacred trees" should be chopped down, and the wooden likenesses of feet (or cattle?) "which were placed at crossroads" burned "wherever they were found." And he briskly forbade them from being made at all.[5]

But the whole practice of giving thanks by means of representations either of the part of the body that was cured or of the event from which the protagonist was saved remained an ineradicable custom. And so it remains even today, in many parts of the world. It is also one which, perhaps more than any other, embraces the very widest range of imagery, from its lowest and most rudimentary forms to the very highest levels. Ex-votos, in short, exemplify yet another aspect of the potentiality of images. They often have to do with pilgrimage, and they force one to consider once again the way in which the relations between high and low determine effectiveness. I have already referred to several instances of their proliferation, in relation to the painting by Altdorfer at Regensburg, for example, but they have not yet been singled out for specific attention.

<div align="center">I</div>

When it comes to the practice of making ex-votos, the central psychological factor is the desire to give thanks; but my concern is not with the giving of thanks in general. It has rather more specifically to do with the recording of gratitude for salvation from disease or disaster by what is perceived as divine intervention. I will not, furthermore, be concerned with the recording of thanks by the erection of buildings or the composition of pieces of music, but rather with the cases in which it is the image that is regarded as (and is seen to be) the effective and adequate vehicle for expressing and giving thanks. The number of potential examples is endless, and the genre has become extremely widely known, especially in recent years, as a result of the publication and resplendent reproduction of the votive images of particular regions and particular sites.[6] It has been much studied, much analyzed, and much exploited, in order to bolster local pride in native image production; and in this manner low images have become higher. But that is not the present point.

The miracles of a particular image are recorded in greater or lesser detail and with more or less completeness at many shrines, but few are documented as extensively as those at the famous site of Altötting in Southern Bavaria. For example: In June 1639 there was a flood at Mannsee in Bavaria. Georg Bürger, a local tanner, had a supply of unslaked lime in his house; but when he and his family could not prevent the water from reaching it, it started burning, there was a sound like shooting, and it began to smell and give off great heat. Whereupon they locked it all up in a room in the

house; and then—their response, for all the concision with which it is recorded, is utterly typical—"we promised to offer a picture and candles to our Lady at Altötting if God protected the house from burning down. And as soon as we made this promise, the lime instantly stopped burning and smoked no longer; and so in praise and thanksgiving to God and the Virgin, we made the offering of candles and a picture."[7] Every element in the votive process is thus pregnantly conveyed.

The family was in danger; they had to make a picture; they knew it would work; and it did. Or perhaps: they knew the Virgin would help if they offered a picture. The records are phrased in such a way as to suggest her susceptibility to such persuasion. To think that she could be persuaded to intervene by means of a picture! In any event, it is clear that by then, the middle of the seventeenth century, the habit of making an image as a mark of thanks had become habitual, so much so that the relationship between salvation and picture- or sculpture-making was perceived as quite direct. This was how one made public one's gratitude to God, and it was felt to be the most straightforward and direct way of doing so. And, in a sense, it absolved one from further demonstrating one's thanks. The picture remained as a perpetual record of gratitude: prayers of thanks would always be transient; one would have to renew them; and if one were rich, one would ensure their renewal after death. It is absolutely significant that the candles were not enough; and for these reasons it is not at all surprising that the main evidence for the whole phenomenon (and therefore for the infinite variety of events to which they testify) should come from the pictures and sculptures themselves.

A few years later, on the other side of the Alps, sometime in 1643–44, the Friar Minor Pietro Bruni was riding from the Colle del Bagno to Perugia. Suddenly he came upon the bottom of a cup lying on the ground. In it was painted an image of the Virgin, facing toward him. He picked it up reverently, kissed it several times, and placed it between the branches of an oak, carefully twisting them together to prevent it from falling (cf. figs. 72, 73). Fra Pietro recited some prayers; and as he left, said to himself, "perhaps one day this sacred image will be able to do miracles." Passers-by venerated the fragment thus enshrined; and even though it repeatedly fell to the ground, and little pieces always seemed to break off, the image nevertheless remained wholly intact.

One day in early 1657, Cristofano di Filippo, peddlar of Casalina, was so moved by devotion that he made the image more secure by affixing it with nails between a pair of forked branches. In March of that year, his wife took gravely ill and was overcome by a terrible fever. He had to go to the market at Deruta, and passing by the Madonna of the Oak, prayed fervently for the restoration of his wife's health. When he returned in the evening,

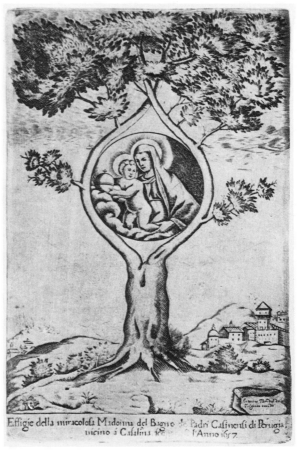

72. *Above:* Votive image of the *Madonna delle Grazie* in the Appenino Bolognese. From Maria Cecchetti, *Targhe devozionali dell'Emilia Romagna* (Faenza: Museo Internazionale delle Ceramiche).

73. *Right:* Antonio Floridi da Foligno, the *Madonna dei Bagni* (engraving; 1657).

Effigie della miracolosa Madonna del Bagno de Padri Casinensi di Perugia, vicino à Casalina &c l'Anno 1657

he found her out of bed, quietly sitting by the fire. And so, in a short time, she completely recovered.[8]

All this is confirmed by the canonical *processo* of September to December 1657, which had been set up to investigate and verify this and other miracles attaching to the Madonna of the Oak.[9] An engraving was promptly made of the miraculous image (fig. 73), and thousands of prints sold; and the image itself was housed in the newly built church of the Madonna dei Bagni at Casalina near Deruta.[10]

From then on, it never stopped working miracles; and just as the first miracle was recorded on a majolica plaque of 1657, so were all the subsequent ones (figs. 74–76). They hang, all 598 of them, in the same church. There could be no better testimony of the variety of miracles such an image could achieve, nor of the ways in which they are recorded and the forms of gratitude thus expressed. Every possible transformation of a single image is presented here, all within a single medium. The Madonna in the Oak saved women in danger of death from childbirth; it effected cures for at least

74. First votive plaque of the *Madonna dei Bagni* (Maiolica, 1657). Casalina near Deruta, Madonna dei Bagni.

75. Votive plaque of the *Madonna dei Bagni* with a robbery and a knifing incident (Maiolica; 1663). Casalina near Deruta, Madonna dei Bagni.

76. Votive plaque of the *Madonna dei Bagni* with person falling from tree (Maiolica; late seventeenth century). Casalina near Deruta, Madonna dei Bagni.

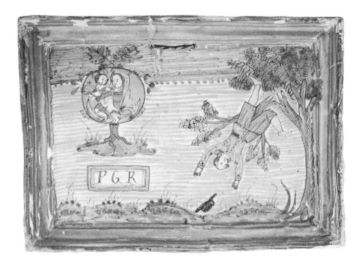

eighteen kinds of illness (this category is by the far the most numerous of all), it saved people from possession by the devil, from attacks by seven kinds of animals, from attacks by robbers and brigands, from a host of watery accidents, from fire, from falls from trees and ladders, from military disasters, from imprisonment and vehicular accidents.[11] Each of these misfortunes is represented by any number of images, over the whole history of the shrine, from its foundation until now. The rude and initially insignificant image found by the Friar Minor, once enshrined, worked all these numerous miracles; and then people felt that the best way of conveying gratitude to the Virgin, to Christ, and the saints (and of course to the Madonna of the Oak herself) was to make a figure of the accident or misfortune and set it beside the representation of the Madonna. All these categories of accident, gratitude, and representation, can be found in the great assemblages of ex-votos at countless shrines throughout the world; but there are few general instances of the genre where the medium is so extraordinarily consistent as at the Madonna dei Bagni.

II

We have begun with what might be called low cases. But simple images can, of course, generate higher ones—even ones that acquire canonical status and come to be called art. The opposite of this, the downward transformation of canonical prototypes, happens even more frequently; but there is also the middle level, where good images—not to refine our qualitative usage any more at this stage—adapted from miraculous archetypes, are transformed first into high art, and then, because of the power of the latter, are infinitely modified down.[12] Take the example of the *Schöne Maria* at Regensburg again.

There the Madonna that lay at the center of the expulsion of the Jews was adapted from the famous image Santa Maria Maggiore in Rome. But it was not the Roman picture itself that generated more images. It was the painting by Altdorfer, commissioned to commemorate the expulsion (fig. 33). Among the many variations spawned by the new picture, one must count Ostendorfer's print itself (fig. 34); the banner that Altdorfer painted and that flutters from the tower of the church in the print; and the woodcut commissioned from him on the occasion of the saving of a woman from drowning. Together with an account of the event, this too was put on display, in a lean-to adjacent to the church. Now a reproductive image is closely involved in the whole process of publicity; it further contributes to the fame of the site; and again, as with pennants and prayer cards, it raises the whole question of the possibilities of the diminution or enhancement of the power of each image.[13] Given the perceived efficacy of the archetype

represented by them, we cannot fail to ask this: What was expected of even the cheap reproductions of the miracle-working image as they were disseminated across a wide and broadly popular field, and how and on what basis were they supposed to work? How did they come to carry the burden of thanksgiving at all, except by extension from commemoration?

At about the same time as his Madonna was completed, Altdorfer's workshop is reported to have produced two panels recording the healing of Cuntz Seytz.[14] One now begins to see the kind of inevitable expansion of votive possibilities that are to be encountered at so many pilgrimage sites. Altdorfer himself did the beautiful drawing now in Berlin, while several other woodcuts by him show the *Schöne Maria* either enthroned on an altar or imagined as the central component of an extraordinary altarpiece, or in a variety of different poses, each a few degrees removed from the original (figs. 77 and 78). The need to reproduce the image popularly and expensively could not be more apparent, and it seems a fairly compulsive need. The *Schöne Maria* becomes a momentary obsession; it is fetishized in its splendors and in its ordinariness (depending on which visual context one considers). But apart from the Altdorfers and their imitations, the Virgin of Regensburg also appeared in Ostendorfer's crude frontispiece to the book of her deeds, the *Wunderbarliche Czaychen* of 1522, on a more sophisticated title page, and as a vision above the tower of the church (fig. 79).[15] Such are the forms by which the whole process of commemoration and thanksgiving by image acquired the extraordinary intensity illustrated by Ostendorfer's own print of 1519–22: every image became a vehicle for thanks, an intimate mediation with God, and the focus of the anxieties against which only the Virgin, acting through *and as* her representation as the *Schöne Maria* of Regensburg could protect.[16]

There are many examples of fine images that may become invested with the emotions that are involved in relief and the giving of thanks. Several of them are to be found in the standard histories. Defined in this way, one may even include works such as Raphael's *Madonna di Foligno* and Titian's great painting for his own tomb, which shows, in the lower right corner the votive image of himself and his son praying to the Pietà (fig. 80).[17] It also shows the (presumably formulaic) inscription required of so many votive pictures, the kind of inscription which seems either to have guaranteed or to have been essential to their felt efficacy. But we have not entirely learned the lessons of Philippe de Champaigne's great and austere painting of 1662 commemorating the miraculous recovery of his own daughter from paralysis (fig. 81), or of Van Dyck's picture the *Madonna del Rosario,* which records gratitude for relief from the plague that swept Palermo in 1624. They are analyzed as high art, but no one asks why and how these pictures should have somehow been thought to be sufficient to give thanks for the genuinely dramatic release from affliction. That they could stand as rich

77. *Above:* Albrecht Altdorfer, the
Schöne Maria at Regensburg (colored
woodcut, detail without frame; ca.
1519; B.8-78-51). Regensburg, Kunst-
sammlungen des Bistums Regensburg,
on loan from the Kollegiatstift St.
Johann. Photo Kunstsammlungen
des Bistums Regensburg. Domschatz-
museum-Diözesanmuseum.

78. *Above right:* Albrecht Altdorfer, the
Schöne Maria at Regensburg (woodcut;
ca. 1520; B.8-77-48).

79. *Right: The Holy Chapel at Regens-
burg,* frontispiece to the Regensburg
Miracle Book of 1522 (woodcut attrib-
uted to Michael Ostendorfer).

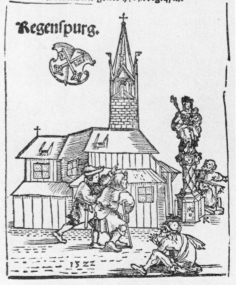

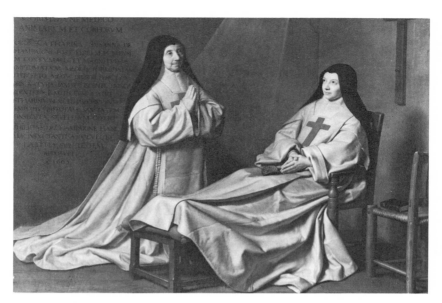

80. *Above:* Titian, *Pietà*, detail of votive picture in lower right of painting (1576). Venice, Accademia. Photo Soprintendenza alle Gallerie, Venice.

81. *Top:* Philippe de Champaigne, Ex voto (1662). Paris, Musée du Louvre.

82. *Right:* Andrea Mantegna, *Madonna della Vittoria* (1496). Paris, Musée du Louvre.

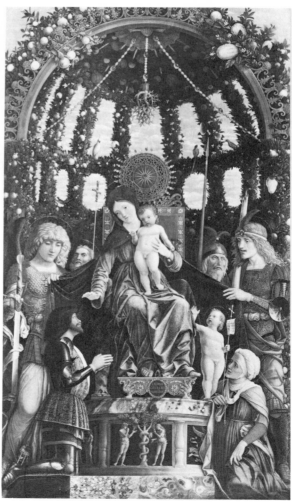

and accomplished gifts to Christ, the Virgin, or some saint would not be adequate explanation, or even description. Philippe de Champaigne's picture, after all, has a similar pictorial formula to many ex-votos showing the patient attended by those who successfully invoked God for a cure (as did Mère Agnès and her sisters at Port-Royal, diligently saying a novena at a time when the young girl was on the brink of death). It even makes room for an elaborate inscription recording the event. Without that inscription, which seems so obviously to shift pictorial attraction aside (in an already stark image), the picture may well have seemed to be less effective as a vehicle for thanks.

Mantegna's *Madonna della Vittoria* (fig. 82) comes from a wholly different area: that of gratitude for victory in battle. These kinds of images are very common indeed; they are at the opposite pole to those which are carried into battle (like Constantine's *labarum*) or invoked before it in the hope of protection and victory. The circumstances around Mantegna's painting further illustrate the rich complexity of this genre. It commemorates the victory of Francesco Gonzaga over the French at the battle of Fornovo in 1495. As in the most popular forms of ex-voto, it shows the figure who has received the benefit adoring the Virgin or the other divine being responsible for bestowing the benefit, while the saints to whom thanks are also appropriate stand by.

The commission for the painting by Mantegna arose from a form of anti-Semitism that is somewhat reminiscent of the much more virulent and hysterical events at Regensburg. In 1493 the Jewish banker Daniele da Norsa bought a house on which there was a figure of the Virgin. He promptly removed it. Although its removal had been authorized by the local ecclesiastical authorities, hostility and disorder ensued. In 1495, about a month after the battle of Fornovo, the Jew was fined 110 ducats. The sum was to be used specifically to commission a replacement by Mantegna.[18] Interestingly, the initial project was for a Madonna della Misericordia protecting Francesco and his family under her mantle. This was perhaps the most explicit way of picturing protection, and it is found in countless ex-votos across Europe. How much one might have wanted shelter in that holy lee.

Exactly one year later, on 6 July 1496, the image was carried in festive procession to San Simone, and set up on a specially decked-out altar in the new chapel next to the church. Within a few hours, people were presenting votive offerings to the Madonna—or rather, to Mantegna's picture—including wax images and candles. Once again the votive archetype swiftly generates votive reproductions, and efficacy spreads contagiously from like to identified like. On the next day, Francesco's secretary Antimaco wrote to him that

there was such a great number of people present as I have never seen in any other procession in this land. . . . I can't tell you what a throng there was in that place from hour to hour. . . . The crowds could never tire of looking at such a worthy work, especially—apart from the image of the Virgin—at the portrait of your illustrious Lordship which moved everyone to tenderness. And they are already starting to offer wax and other images of people brought back to health, and eyes made of silver; so that with this beginning one can imagine that in a few months the place will be privileged with a great and most frequent devotion. Nor will it lack for any suitable ornament.[19]

How right Antimaco was. He knew from experience that the devotion would be popular, that the image would not lack for ornament, and that people would make further ex-votos—especially ones representing sick bodies or parts of bodies now made hale.[20] We cannot now say exactly what needs were then fulfilled, in Mantua in 1495–96, by this wondrous substitute for an old image destroyed by a Jew; but even if people only suspected (or simply hoped) that they could turn to the Virgin for protection, it was to her that Francesco Gonzaga attributed a victory construed as needful and ostensibly beneficial to the commonweal. Then there was the supposed antipathy of the Jew (embodied by his removal of the image) and Mantegna's great picture, substituted for the old and rejected one: no wonder it should be acclaimed and come to be the more than adequate mediator of thanks and the focus of the projection of gratitude and relief. It is the picture, not the Virgin, or any identifiable emotion, that is at the crux of this dialectic. There can be few examples in the history of art of an ex-voto which more beautifully and more sumptuously embellishes and enhances the Virgin, the specific Virgin, from whom favors have been received. It is a far cry from the popular images that lie at the other end of the canonical scale; but if we do not consider them too we lose hold of the very issue that binds this chapter: the efficiency of figuration in the votive image.

III

In places like Altötting in Southern Bavaria, the finest productions of art have been produced along with its lowliest forms. The famous *Goldenes Rössl* of the end of the fourteenth century is there (fig. 83), and so is the magnificent silver dedicatory statue of Crown-Prince Max Joseph (fig. 84). The *Goldenes Rössl,* of gold, pearls, white enamels, studded with jewels, and of the most exquisite Parisian craftsmanship, was taken in 1509 by the Count Palatine Frederick from the Ingolstadt Treasury and given to the Heilige Kapelle in Altötting—just a few years after the miracles of 1490 sparked

83. *Left:* The Goldenes Rössl, from the Altötting Treasury (gold, enamel, precious stones, pearls; late fourteenth century). Altötting, Treasury. Photo Strauss.

84. *Below:* The altar of the Heiliges Kapelle at Altötting (1645–1730). On the right, W. de Groff's silver statue of Max Joseph of Bavaria, 1737; on the left, G. Busch's, of brother Konrad von Parzham. Bischöfliches Administration Altötting. Photo Strauss.

the first great pilgrimages to the place. The silver statue was made in 1736 by Wilhelm de Groff and commissioned in thanks for the miraculous cure of the ten-year-old prince, recorded on the framed sheet of parchment hung above it, in the charming hand of his father Karl-Albrecht, writing on behalf of his son: "Thus your devoted servant Maximilian-Joseph fulfilled his vow with all his heart, the heart given over to Mary."[21] The statue (now accompanied by the 1931 statue of Brother Konrad von Parzham) kneels in adoration before the early fourteenth-century wooden Virgin. She is simply carved, but sumptuously dressed (cf. fig. 63), and surrounded by scores of silver votive images in glass-fronted cabinets that act as wings to the ornate shrine. But each of the pictures and sculptures in the astonishing accumulation of popular votive imagery at Altötting has its own tale of poignant salvation achieved by the simple but much adorned Madonna there.

The numbers of objects at places like these is sometimes breathtaking. Aside from the evidence from the great Asklepeia of ancient Greece, and the huge terracotta dumps of Western Italy, the extant European and American sites are just as telling. In the years between 1656 and 1693, for example, there seems to be evidence for the hanging of over 12,450 paintings at Altötting; and this one can compare with the equally remarkable number of 10,350 silver ex-votos recorded at the tomb of the beloved Carlo Borromeo in Milan in 1610.[22] As in the case of Santissima Annunziata in Florence, the relevant church authorities regularly tried to reduce or banish such vast congeries altogether.[23] But their lack of success (and therefore the resilience of both habit and genre) is conveyed by places like the interior of Santa Maria delle Grazie in Mantua, where the full-length votive images in wax and papier-mâché stand one above the other in serried ranks around the church (fig. 85); or by the Sanctuary of the Madonna dell'Arco between Naples and Vesuvius and that of the Madonna del Monte in Cesena (on which so much has been written); by Vierzehnheiligen in Franconia; by Heiligwasser in the Tyrol; by Tuntenhausen in Upper Bavaria, with its combination of pictures, painted candles, and photographs;[24] and by the American shrines of Nosse Senhor do Bomfim in Salvador in Bahia, with photographs, pictures, and wax limbs everywhere, even suspended from the ceiling (fig. 86), and the bewilderingly packed walls of the Santuario de los Remedios in Mexico City, which has enjoyed unbroken popularity from its foundation in the sixteenth century until our own times. And in almost every image, we see one of the two main figurative formulae that characterize virtually the whole of the genre: either the person who has received the benefit kneels in devotion or admiration before the miraculous image of the Virgin or the accident or illness is shown before her. These are the standard features that bind these great masses of imagery together; but they are by no means the only ones.

It is as well to remember what no one who has been to these shrines

could forget: the range of votive possibilities is seemingly endless. Every conceivable kind of illness or accident is represented in one way or another; and the categories of disaster that are represented range over centuries. Even the most cursory reader of classical literature in the West knows of the antique practice of hanging up tablets, wreaths, or garlands—usually on a tree—after shipwrecks; what varieties of watery disaster are to be found, from Greek icons showing the Madonna of Paraskevi through the umpteen pictures of Saint Nicholas calming the storm, to many wholly local incidents. People fall from trees, and live; they are electrocuted, and live; they are saved from dogs and wild animals; they survive acts of warfare, from banditry to bombing; and so on and so forth. Every modern shrine has its range of vehicular accidents; but the phenomenon is not new. One of the little-known treasures of the genre is Tommaso Fedra Inghirami's votive picture of circa 1508 recording his happy deliverance from the consequences of a fall under a carriage (fig. 87; cf. fig. 88).[25] This was the same cardinal who was the great stage manager and deviser of programs for the *feste* of Leo X, who may also have devised the scheme for Raphael's *Parnassus,* and whose own patronage extended to the well-known portrait of himself by Raphael. Such are the polarities of the need for pictures.

Against acts of hostility to one's person or allegations of crime—here too Christ and the Virgin help. They save people from burglars and robbers. They intervene on behalf of prisoners and otherwise condemned men. Battista Figiovanni was the protonotary of the church of San Lorenzo in Florence. He was condemned to death after having been tortured for his complicity in the pro-Medicean plot of 1517. But he was unexpectedly reprieved, and made the ritual journey to set up an ex-voto in the Madonna delle Carceri at Prato. If we could not figure out what happened from the picture, the inscription would make clear his indebtedness to divine intervention:

> E privo del humano aiuto ricorsi al divino auxilio pregando questa madonna mi liberassi da morte fui exaudito. al laude dell divina maiesta.
>
> And deprived of human aid I had recourse to divine assistance by praying to this Virgin [note: not *the* Virgin] to liberate me from death; and I was heard. In praise of the divine majesty.[26]

The inscription is grateful; but like so many others (which are more regularly standardized), it is almost talismanic itself.

85. *Above:* Interior of Santa Maria delle Grazie, Mantua, showing votive
images (fifteenth century and later), with many votive offerings
of specific parts of the body in silver and other materials.
Photo Werner Neumeister.

86. *Right:* Sala dos Milagros, Nosse Senhor do Bonfim, Salvador,
Bahia, Brazil (1971). Photo from Kriss-Rettenbeck, *Ex Voto,* pl. 21.

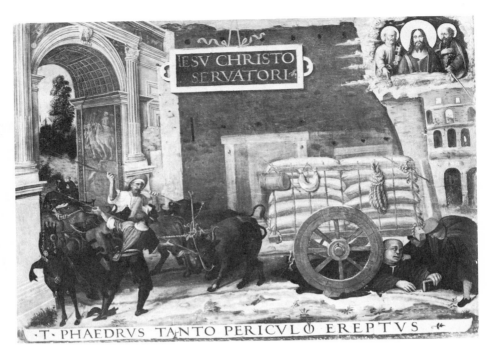

87. School of Raphael, Ex voto of Tommaso Fedra Inghirami (ca. 1508).
Vatican City, Musei Vaticani.

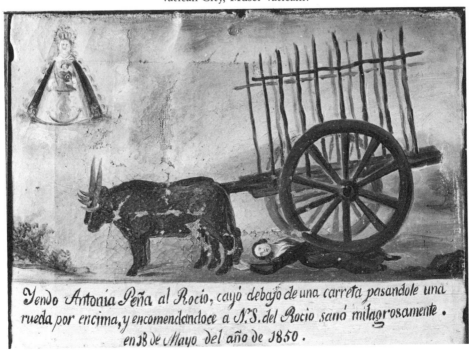

88. Ex voto of Antonio Peña (Andalucia, 1850). Munich, Bayerisches
Nationalmuseum, Collection Kriss.

IV

But is this vast mass of material simply too disparate to warrant general treatment? Does it make any sense to find order or structure within it, and what would be the benefits of doing so? Perhaps to seek order in this genre would be the same as to seek order within the whole genre, say, of monuments. But it does seem that ex-votos are capable of definition as a class, and they do appear to reveal a striking internal consistency. In his great survey of the material, Lenz Kriss-Rettenbeck concluded that "there is probably no comparable form that enjoys the same structural consistency and provides more effectively valid a mode of signification, in terms of its centuries-long use in the most various cultures and language groups, at all social levels of the Catholic world, and at all conceivable aesthetic levels."[27] The observation applies not only to the Catholic word, but to all cultures where representation, mediation, and gratitude are linked.

I have already noted two of the main figurative formulae of the votive genre, but in commenting on what he called the "astonishingly rigid and clear ordering of significant elements" in all votive imagery, Kriss-Rettenbeck suggested a potentially exhaustive classification. These elements take the form of (1) the representation of the heavenly operative, whether miraculous image, divine being, saint, or holy place; (2) the depiction of the figure who turns to the heavenly domain, and of those who present him to it, set him contact with it, or pray for him; (3) the event or condition that was the cause of initial communication between earthly personage and divine person or symbol; and (4) the inscription that records condition, event, or hope.[28] To the second element one might add, significantly, the depiction of those who have reasons, in one way or another, to be grateful for the miraculous preservation of the devotee.

This is all very well, but these structures and formulae do not get us closer to accounting for the popularity and effectiveness of the votive image. Kriss-Rettenbeck himself made a considerable attempt to establish the key factors in the way in which all the images he classified are rendered operative and then effective. In setting out, implicitly, to establish how the votive image comes to work, he categorized at least three of these factors. I have already brought to the fore the process of consecration (whether ritualized or not) whereby images are made operative. Kriss-Rettenbeck's contribution—with regard to votive images at least—is to break down this process into some of its components; and these he sees as progressive.[29]

First, *praesentatio*. Under this heading may be grouped the explanatory and formulaic inscriptions, not only of votive images, but also of objects like the *anathemata* of ancient Greece and Rome. This is the first step of

sacralization, without which the image would not work. The inscription either tells of the miraculous event, more or less concisely, or has one or two of the consistent formulae announcing the status of the object as token and mediator of thanks. The announcement, in the first place, is what defines it thus. Hence *huper euchēs,* VFGA or FGVA (*votum fecit gratiam accepit*), PGR or GR (*per gratia ricevuta*), MGF (*milagro que fez*), and so on and so forth. (That these formulae are but variations of one on the other reveals the consistency of this aspect of the genre.) The insistent recollection of the vow or promise made, as in the phrase *verloben und versprochen,* is often just as formulaic. Without these species of *praesentatio,* the operations and conveyances of thanks are likely to be null.

Kriss-Rettenbeck's next category, *promulgatio,* is possibly still more useful. Strictly speaking, this is the legal term for that process of ceremonial and public announcement of a law before it becomes valid and operative.[30] But in our context, it is extended to include the whole gamut of embellishing, adorning, and garlanding an image; the varieties of enshrinement and placement in an appropriate location; the various ways in which it may be taken *processionaliter* to its sacred locus; the announcement and recording of the events it recalls; and the praise of its effectiveness, from public rhetoric to inclusion in the miracle collections of each shrine. At this stage one may rightly speak of the promulgation of the image. Now it indisputedly works; and everyone acknowledges that it does (or, at the very least, that it could—which is quite sufficient testimony to its potentiality).

Under *dedicatio* Kriss-Rettenbeck discusses those final stages in confirming an image as potentially operative or efficacious. But as this seems to be constituted by the group of formal extensions of the variety of acts already classified under *praesentatio* and *promulgatio,* it is less useful as an instrumental category. Nevertheless, all these acts pertain broadly to the variety of processes by which the image is made to function publicly and privately, and by which belief in potentiality is expressed and then granted demonstrative confirmation.

For all this clarification of process, however, and for all the understanding of the mechanics of effectiveness, we are still left to grapple with questions that may be unanswerable but that will not retreat: What is it about representation in visual form that makes people think that by producing and using it in this way they achieve anything beyond the need to record pictorially? What makes the representation the inevitable and inexorable medium of giving thanks? And how is it that belief in its efficacy comes to be adequately fulfilled? It may seem that these questions are too oriented toward dead images, rather than more directly toward their human respondents. Perhaps one should rather ask what it is about people that makes them want to project feelings, hope, aspirations onto pictures and sculptures, and gives them either the illusion or the reality of satisfaction. People

think they achieve (and do achieve) a variety of psychological satisfactions by making and visiting images, and they respond to them on just this basis. Thus one must still answer in terms of what it is about images that initiates or provokes engagement. The whole phenomenon of votive imagery enables one step toward discovering terms of description, if not explanation.

With votive images of all kinds, one deals with the need to represent the event from which the devotee was saved (or the physical member saved), and to set up such representations as a form of lasting testimony and gratitude at a pilgrimage center or other shrine. In every case, manufacture and figuration is predicated on a strict concept of distinctiveness and accuracy. There may be cases where accuracy and distinctiveness seem to yield to a simpler idea of sufficient denotation, but even in such instances one has a sense of the diminished adequacy of the less true and the less precise.

We have seen the full range of visual imagery deployed as the means of effective thanks and of thanks felt to be adequately expressed and acquitted—from the great paintings by Mantegna, Titian, Van Dyck, De Champaigne, and even Goya (in his extraordinary portrait of Dr. Arrieta) through the *Goldenes Rössl,* right down to the humblest pictures of tin and of glass, and finally to the snapshots pinned to the walls of the massive and poor shrines. There are humbler forms yet, but in every case we encounter the urge to specificity and the need for appropriate forms of verisimilitude. In this respect the photograph is more than usually good, but right from the beginning the concern for accuracy of relevant portrayal and relevant narrative manifests itself.

In 1661, the Wessenberg *Schaffner* Kern recovered from a fall from a horse. A note in the Mariastein archives in Switzerland—probably intended as a label—has the following brief report and stipulation: "Anno 1662 die 19 Octobris solvit votum personaliter et pro pictura dedit 12 1b5. N.B. DZ pferdt muss grauw sein und er einen rotten mantel."[31] With this report, we come closer to understanding the need for figuration and the distinctiveness of formation. For reasons of accuracy and specificity, the inscription is essential: it ensures direct linking with the wonderful event, just in case picturing fails. But it is precisely because the picture can convey that linkage even more assuredly than words that the figured object enjoys its votive supremacy.

Hence the formulaic qualities of format and inscription, along with the repeated specificity of event and the perpetual assertion of the heavenly operative as distinctive and peculiar to the place. In the earliest votive picture from Altötting, dated 1501 (fig. 89), a classic form appears almost fully established, with its crucial elements already present. The scene above graphically represents the illness or event from which the miraculous Virgin provided deliverance; the long inscription below supplements it with all the relevant details. The naked figure of Oswolt Dienstl, burger of Gmünd,

is shown with careful realism, as he lies tucked between the sheets on two charmingly differentiated pillows. Unlike some votive images, where the Virgin or Christ is represented as if participating in an earthly human drama, the Virgin here is shown as a kind of miraculous vision. Both the burger and his praying wife gaze directly at her, while the inscription makes clear the role of both his wife and others (two of whom are represented at the side) in ensuring the cure (presumably by praying specifically to the Virgin of Altötting). It is just these elements, as we now expect, that are to be found in ex-voto after ex-voto throughout Europe. The only difference is that many of the others practically do away with the explanatory inscription, and all that is left is the standard expression of the function of the picture—often simply reduced to the words "ex-voto." That inscription plays a significant role in ensuring that the picture or sculpture works as intended, but of course it is the figuration itself that makes both content and context clear.

Thus in a church like the Madonna dei Bagni outside Deruta, with its six-hundred-odd majolica plaques, the Madonna is always shown in the oak, her image neatly encircled by its branches, just as it was originally found; and the accident or illness is always represented in spare but immediate and telling detail. There are, it is true, any number which show the sick person in bed prior to his or her cure (as with Oswolt Dienstl's picture at Altötting); but at the same time there are many whose insistent specificity draws, from the modern beholder at least, a range of reactions that varies from amusement to deep sympathy. A bull bites a woman's breast; a horse rears and kicks a man in the jaw; a dog bites a lady's finger; five bullets from a robber's gun enter a praying man's back; blood cascades in large drops from a family attacked by a burglar; bullets are shot directly into the eyes of a helpless woman; a tree breaks and collapses upon the woodcutter; people fall from trees, from roofs, into streams; their noses drip ostentatiously; they vomit in large gushes as a result of eating the plant represented behind them (cf. figs. 74–76, 88). In most cases here, the only inscription is the letters PGR.

While there are a number of groups where similarity of accident (say the abundant falls from trees) leads to conventionalized representation, the vast majority aims at visual precision and differentiation. It is not the words that achieve this; it is the fact of figuration. And this happens precisely because pictorial and sculptural representation offer the possibility of transcending the vagueness and generality of convention in a way that words do not.[32] On the other hand, when one considers Francesco Gonzaga's secretary's observation that immediately after the procession of Mantegna's *Madonna della Vittoria* the people started "to offer wax and other images of people brought back to health, and eyes made of silver," a further question arises: Why these assiduous and keen replicas?

Here one moves from accuracy to verism and verisimilitude. Votive objects need not necessarily be pictures or sculptures, or painted glass, or earthenware medallions. Anyone who has even the slightest acquaintance with the phenomenon will be familiar with the small metal limbs, digits, breasts, eyes, ears, noses, and mouths that serve as votive objects—not only in the great votive places of the earth (where they are often as prominent as any other form) but also at more modest shrines and chapels, and even in front of any makeshift shrine, say the picture of the Virgin with a candle before it (cf. figs. 90 and 91).[33] These are mediators of thanks too, thanks for the preservation of the part of the body concerned. Wax is also popular as the medium for making ex-votos of parts of the body, or of infants saved in childbirth; it has the additional advantage of actually looking rather like flesh—especially if tinted (cf. fig. 122 below).

All this remains in the realm of reproduction; but sometimes the votive object has to do with pure reality (and not just realism). Not infrequently the very objects that feature in the salvific event themselves fulfill the votive function: for example, articles of clothing or domestic and agricultural utensils, as in Ostendorfer's print of the pilgrimage at Regensburg. This is what was saved, one can imagine it being ostensively said, and consequently this is what is offered to the Virgin. But mostly one cannot do this, and one has to make do with the reproduction. If it is schematic it will do; but by and large the aim is to make the most exact copy possible—the copy in wax or clay or papier-mâché, the death mask, anything molded from the life.[34] As everyone knows, even the most realistic of paintings and sculptures adhere to schemata of some kind or another; but in fact they strive to avoid schematism and are perceived in just such terms.[35] What is important is the drive to precision, not precision itself (since by now we are all aware of the relativity of representational exactness). There are also objects which represent a reproductive conflation of victim and fate, as, for example, in the striking iron figures that are said to come from a pilgrimage church of Saint Leonard, patron of prisoners (fig. 92). Wax may be used because it looks like flesh; here iron is used for the ex-voto prisoner because it calls forth the association with punishment, imprisonment, and bondage in fetters.[36]

With objects like votive limbs and wax figures, we are alerted to one crucial aspect of all faith in representation: that of the felt efficacy—even if only as a memorial—of the exactly lifelike. We see the sound replica of the body, or of part of it; we respond to it as if it were real; and its soundness (or sometimes its sheer preciousness) reassures us of the fact of healing and of deliverance into safety. This is the justification for the pursuit of verisimilitude that we see in these objects. Their operational effectiveness is perceived as deriving from the closest possible form of realism available to maker and consumer. None of this is to espouse anything like an absolute notion of verisimilitude, however. I certainly do not wish to suggest—as

might naively be thought—that objects we now happen to regard as more successfully realistic or naturalistic are or were more effective as ex-votos; or that a good, and high, Renaissance picture like Mantegna's worked better than a rude and simple one from Santa Maria delle Grazie. What I do wish to underscore is the significance of the attempt to ensure resemblance: resemblance to victim and resemblance to accident, illness, or event. Of course the pictorial devices involved may be schematic, and they may have

89. *Above left:* Votive panel of Oswolt Dienstl from Schwäbisch-Gmünd (1501). Altötting, Heiliges Kapelle. Bischöfliches Administration Altötting. Photo Strauss.

90. *Above:* Pilgrims at the tomb of Saint Wolfgang with votive offerings, wing of the Altar of Sankt Wolfgang, Pipping (ca. 1480). Photo from Kriss-Rettenbeck, *Ex Voto,* pl. 11.

91. *Left:* Hans Weiditz, woodcut depicting Saint Anthony in front of a church hung with votive children, votive limbs, and other votive offerings (early sixteenth century; Geisberg, 1504).

92. Prisoners' votive figure to Saint Leonard (iron and wood; Tirol, ca. eighteenth century). Munich, Bayerisches Nationalmuseum.

to be supplemented by a complex or a formulaic inscription; but what remains fundamental to this genre is the drive to ensure accuracy of representation.[37] And it would be a pity to pass over the felt effectiveness of the truly resembling—like the papier-mâché mold and the wax model—*pace* even the most conventionalist views of similarity and resemblance.

But these may be felt to be claims that have been insufficiently tested. The processes whereby the lifelike is assimilated to the living cannot yet be said to be clear. We have already referred to the issue of the nonchalance or the arrested nonchalance with which we regard the ordinary images of everyday life; we have examined some of the consequences of cherishing, handling, and generally being absorbed in objects that can become fetishes, like pilgrimage imagery and ampullae; and we have attended to the significance of figuration on talismans and amulets. It remains to see how the gaze not only surveys, but enlivens—especially in its concentration. But that is to put the matter too coarsely; vision cannot operate autonomously in this way. It may not be our aim to enter the realm of neurophysiology, but even a moment's reflection on the experience of images would not allow the crude kind of claim that suggests that we simply see and piece together the components of the image. The fact is that we embark, absolutely and instantaneously, on the integration of representation and impression; and we are immediately involved in the dialectical processes that inescapably follow the neurophysiological mechanisms of sight. The issue is not just how perception may make the images alive, but rather the kinds of response that follow on the perception of the image as lifelike. We deal with these matters not because all responses terminate in this way, or even are predi-

cated on this kind of perception. Perception clearly does not turn every image into something that we perceive as lifelike or lively or living, but it does so very often; and in the processes involved there is much that is both instructive and potentially constructive. If this book has any effect on the ways we look at the history of images, it must also alter our view of the status and possibilities of images in the societies we know.

8

Invisibilia per visibilia: Meditation and the Uses of Theory

Old theory has its uses and is instructive. *We may no longer have much leisure to contemplate* the images before us, but people once did; and they turned contemplation into something useful, therapeutic, elevating, consoling, and terrifying. They did so in order to attain a state of empathy; and when we examine how they did so, a brilliant light is cast not only on the function of images but on a potential that for many of us remains to be activated. The core of this chapter consists of the modalities of a practice in which we are no longer versed, but which for hundreds and hundreds of years used real images for directly affective purposes.

My emphasis will be on practice; but as so often, past theory provides a heuristic key that has largely been refused by modern commentators. The practice of image-assisted meditation rests explicitly and avowedly on a massive theoretical network. That in turn embraces and supports a whole range of other practical phenomena. By the early Middle Ages, all the pertinent elements of that theory had been brought together into an articulate and comprehensive whole; and so it too may be tapped not only for the evidence it provides for actual behavior, but also for its assistance as we search for adequate terms with which to approach the cognitive bases of response.

Our concern, then, is not with "meditation" broadly taken, but largely with those forms that depend on real images for the production of mental ones. The aim of this kind of meditation is to grasp that which is absent, whether historical or spiritual. It is predicated on the view that since our

*

The major common feature is the desire for vision. Here Hesychasm and the cult of icons reach a final position in common: Vision both as point of departure and goal of every elevation of the spirit and the source of all religious affect. It is related to the semantic development of the Latin word contemplatio *and even more so to the Greek theoria.*

H. G. BECK, *Von der Fragwürdigkeit der Ikone*

*

minds are labile, meditation profitably begins in concentration. By concentrating on physical images, the natural inclination of the mind to wander is kept in check, and we ascend with increasing intensity to the spiritual and emotional essence of that which is represented in material form before our eyes—our external eyes and not the eyes of the mind.

In most cases we deal with forms of ascent, from the material to the mental, and then to the spiritual; from the gross circumscribed object to that which is uncircumscribable. The repeated theoretical insistence is that we cannot grasp the latter without starting from the former—except, perhaps, in the case of the most superior and refined mystical talents.

There is another closely related form: visualization unassisted and ungenerated by a present figured object, but dependent on recollections of real images and stored knowledge of them. Indeed, from the earliest Christian writing on meditation to the *Spiritual Exercises* of Saint Ignatius Loyola, the act of meditating is conceived of (and publicized) in terms of a specific parallel with actual image making. He who meditates must depict mental scenes in the same way the painter depicts real ones. And then this parallel is taken one stage further. The meditator imitates Christ (for example) just as the painter does his model; and he does so precisely because Christ is made Man, like ourselves.[1] Once again the mystery of the Incarnation has clear implications for what by its very nature transcends the realm of the everyday, the accessible, and what is capable of being represented by gross materiality. But the lessons of meditation go far beyond these specific christological issues.

I

By the middle of the thirteenth century, over a millennium of anxiety and argument about how best to justify the use of images had crystalized. The sometimes lapidary formulations of the time became the basis of all subsequent thought on the subject. The most influential statements occur in the commentaries on the third book of Peter Lombard's *Sentences* by Saints Bonaventure and Thomas Aquinas. Thomas Aquinas's position is more tersely expressed and less fully explored.[2] In his view there was

> a threefold reason for the institution of images in the Church: first, for the instruction of the unlettered, who might learn from them as if from books; second, so that the mystery of the Incarnation and the examples of the saints might remain more firmly in our memory by being daily represented to our eyes; and third, to excite the emotions which are more effectively aroused by things seen than by things heard.[3]

The final phrase simply paraphrases the Horatian dictum that "What the mind takes in through the ears stimulates it less effectively than what is presented to it through the eyes and what the spectator can believe and see for himself.[4]

Bonaventure retained this threefold justification for the introduction and use of images. His position was basically similar to that of Aquinas, but less strictly institutional and more critical for the future. He claimed that images had been introduced on account of the ignorance of simple people, the sluggishness of our emotions, and the lability of our memory. In expanding this, he asserted that we have images (1) so that the illiterate might more clearly be able to read the sacraments of the faith in sculptures and in pictures, as if in books; (2) so that people who are not excited to devotion when they hear of Christ's deeds might at least be excited when they see them in figures and pictures, as if present to our bodily eyes; and (3) so that by seeing them we might remember the benefits wrought for us by the virtuous deeds of the saints (he thus stresses the special need for images in churches).[5]

What faith all this expresses in the potential of images! It would be hard to overestimate the influence and resonance of these formulae. They frequently recur. Sometimes one element of the triad is emphasized, sometimes another. They are to be found in treatises on a whole variety of subjects, and especially in miracle legends involving pictures and sculptures. But while they lie at the heart of medieval thought about the visualization and representation of God, Christ, and the saints, and are mobilized with renewed vigor during the Counter-Reformation, the origins of these much-repeated and infinitely modulated ideas may be traced back to the earliest days of the Church.

The first element of the triad is perhaps the most famous. We need not dwell too much on it here. It is directly based on the statement by Gregory the Great in his letter admonishing Serenus, bishop of Marseilles, for having taken down the images from the churches in his diocese: "Images are to be employed in churches, so that those who are illiterate might at least read by seeing on the walls what they cannot read in books."[6] They are the *libri idiotarum*, the books of the illiterate (as we read already in Gregory of Nyssa two hundred years earlier).[7] Every writer on images from then on insistently reminded his readers of this; but for the significance of the formula, it is the second and third elements of the triad that lie at the root of meditational practice. They pithily bring to the fore the conviction that images are more effective than words in rousing our emotions and in reinforcing our memory.

This is the old Horatian idea again; but what is important for the evolution of the practice of meditation is not the comparatively bland and much used theoretical claim for the greater effectiveness of images than

words, but rather the view of their directly affective possibilities. They do not just stabilize our memory; they excite us to empathy. And since our minds are largely gross and unmystical and incapable of rising to the planes of abstraction and pure spirituality, what better way to understand the full import of Christ's sufferings and deeds than by means of empathic emotion? (His suffering, after all, was predicated on his Incarnation as a man.) We come closer to him and more easily model our lives on his and those of his saints when we suffer with them; and the best way of doing so is by means of images. We attain compassion when we concentrate on images of Christ and his saints and of their sufferings. This is the view that underlies the whole tradition of empathic meditation.[8]

There is one further strand that has no place in the medieval triad, but is at least as important as it is for understanding the use of images in meditation. In a less well known letter by Gregory the Great, dating to 599 and sent to the recluse Secundinus, Gregory touches on aspects of the hermit life before concluding with a reference to the cult of images:

> Your request [for images] pleases us greatly, since you seek with all your heart and all intentness Him, whose picture you wish to have before your eyes, so that, being so accustomed to the daily corporeal sight, when you see an image of Him you are inflamed in your soul with love for Him whose picture you wish to see. We do no harm in wishing to show the invisible by means of the visible.[9]

In this way Gregory makes the case for the use of images in private devotion. The view that by looking constantly and hard at a picture or sculpture we are moved by it underlies all subsequent meditational practice by means of images.[10] But it is the last sentence that is the crucial one. However coolly presented, it is connected to a vastly stronger and more evolved position.

Possibly influenced by the growth of Neo-Platonism, writers like Dio Chrysostom and Maximus of Tyre—and Plutarch too—explicitly justified images on the grounds that man needs material symbols of God precisely because of his inability to ascend directly to the realm of the spiritual.[11] Without images the divine remained inaccessible to ordinary mortals. This is the view that was so firmly resisted by Christian writers like Eusebius and Augustine, but in the long run their resistance was futile.[12] Even in Christianity, images came to be justified on these grounds.

Just a century or so before Gregory wrote, the view of images as a channel by means of which we progress from the visible to the invisible had been put into clear and positively stated anagogical terms by Dionysius the Areopagite (or the Pseudo-Dionysius). Here is a writer whose influence on mystical strains in Western thought was immense, and whose writings are rarely without consequence for later theorists of images; but that his work

also provides a key to the practical effects of images has not always been acknowledged.

> The essences and orders which are above us . . . are incorporeal, and their hierarchy is of the intellect and transcends our world. Our human hierarchy, on the contrary, we see filled with the multiplicity of visible symbols, through which we are led up hierarchically and according to our capacity to the unified Deification, to God, and to divine virtue. . . . We are led up, as far as possible, through visible images to contemplation of the divine. [13]

The best gloss on the implications of this rich passage is provided by Ernst Kitzinger:

> To Pseudo-Dionysius the entire world of the senses in all its variety reflects the world of the spirit. Contemplation of the former serves as a means to elevate ourselves toward the latter. He does not elaborate his theory specifically in the realm of art, but its special applicability in that field was obvious, and enhanced further by his frequent references to the objects which make up the world of the senses as *eikones*. Small wonder, then, that Areopagitic concepts and terms were promptly seized upon by critics anxious to provide a theoretical foundation for the increasing role accorded to images in the life of the Church. [14]

Gregory himself probably did not grasp the full cognitive implications of the last sentence of his letter to Secundinus, but others took up the anagogical formulation of Pseudo-Dionysius almost immediately.

By the time of Bonaventure's famous treatise the *Journey of the Mind towards God* almost seven hundred years later, the anagogical view is more closely analyzed:

> All created things of the sensible world lead the mind of the contemplator and wise man to eternal God. . . . They are the shades, the resonances, the pictures of that efficient, exemplifying, and ordering art; they are the tracks, simulacra, and spectacles; they are divinely given signs set before us for the purpose of seeing God. They are examples, or rather exemplifications (*exemplaria vel potius exemplata*) set before our still unrefined and sense-oriented minds, so that by the sensible things which they see they might be transferred to the intelligible which they cannot see, as if by signs to the signified (*tamquam per signa ad signata*). [15]

For all its expansive detail, this is an unmystical and straightforward attempt to explain the process of ascent from the visible to the invisible. Even the insistent and asyndetic refinement of argument further clarify the nature of the process which Bonaventure has set out to describe. It is true that the

idea that all created things are symbols of God derives from the later Saint Augustine, from Pseudo-Dionysius, and from Duns Scotus;[16] but it was only in the thirteenth century (with writers like Albertus Magnus, Thomas Aquinas, Alan of Lille, and the whole Victorine school) that the terms set out by Bonaventure were elaborated into an all-pervading system of thought about the external world. Here too are the real origins of a general theory of signs.

We can still go further. Since all created things lead the meditative mind to God, all pictures of them must do so too. But at the same time— implicitly in Bonaventure and quite explicitly elsewhere—God's creating can only be grasped in terms of the simile of the creative activity of the artist; and so pictures and sculptures provide even more direct access to understanding him. Furthermore, since the divine is not at all sensible, or susceptible to the normal responses of the senses, but only exists on the level of pure spirit, we can only perceive it by means of objectification in the form of images.[17] What is most clearly revealed by Bonaventure's passage is the widening of the anagogical view by making plain the equation between artistic production and divine production, and by spelling out the divine ontology of all real images. But the issue is not only an ontological one.

In the course of the passage by Bonaventure, we also detect, if only faintly, the initial stages of the collapse of the strictly anagogical view. For what it betokens is not merely the notion that images may usefully lead the mind, by stages, upward to God. It implies, once the usual position has been stated, that ascent is instantaneous. We are with God the moment we see his exemplifications; and these are not just traces of him, *vestigia;* they are *simulacra*—divinely given signs, it is true, but nevertheless real signs.[18]

Although the use of private devotional pictures and sculptures and the exploitation of both these and public imagery for the purposes of meditation occur from the earliest days of the Church, the first clear evidence that the practice is widespread (and not merely sporadic or simply recommended) comes from the thirteenth century. Apart from testimonia like Bonaventure's, the great compilations of miracle legends that flourished in the first decades of the century provide the first extensive reflections of actual practice. From now on, the intimacy of affective relations between image and beholder are brought to the fore with an unparalled sensitivity to the behavioral symptoms of perception. Often it is clear that the more intense the meditation, the more dramatic the response. Time and again it is plain that experience of the miraculous event proceeds directly from the pious attentiveness of the contemplative beholder to the image. "Attentiveness" here does not mean some generalized channeling of the mind to the image, but rather an attentiveness particularized in terms of the intimate experience of

the beholder. In other words, it is not as if the beholder simply concentrates on the image (or on its subject); rather he directs his meditations to those aspects which are most likely to rouse a strong sense of fragility or tragedy. Thus in his fatherly words to a young novice, Aelred of Rievaulx (1109–67) can yoke sensitive emotional description to the metaphor, with which we are now quite familiar, of picture making:

> I feel, my son, I feel the same things, how familiarly, how affectionately, with what tears you seek after Jesus himself in your holy prayers, when this sweet image of the sweet boy appears before the eyes of your heart, when you paint this most lovely face with, as it were, a spiritual imagination, when you feel so keenly how his most lovely and at the same time more gentle eyes radiate charmingly (*iucundius*) at you. [19]

One of the most characteristic elements of all the miracle tales is the dwelling on the human helplessness of the child, the human softness or beauty of the mother, and the tragedy of their subsequent suffering, pictured in terms of drops of blood and tears, weak and friable apprehensiveness, sweating fear, and bruised and welted pain. The relationships generated in this way are of the most intimate kind: they elicit protective feelings of parental love for the child, and a sort of courtly love for the mother—but a love whose links with the more ordinary stages of incipient desire are never entirely submerged. The beholder thinks of the hungry infant, the caressing mother, their sweetly gentle looks; and then moves to dwell on the salvific tragedy of those so innocent.

As a result, what we find in these tales are not generalized descriptions of standard image types, but rather highly particularized descriptions of the tangible and distinctive characteristics of each image. Looks, features, garments, and colors are all described, even the physical condition of the object (so much the better, for example, if it is worm-eaten and neglected). It is not the generalized Mother and Child who feature in these stories, but specific mothers and children; while the saints are ordinary men and women whose very particularity forms the focus of the individual beholder's attention. The more distinctive the better. We do not extend our empathy to humanity at large, nor to the godhead which is intelligible only to the intellect. This is why, even when formulaic, the effort to differentiate is always plain. This is why the miraculous nature of each image, indeed its efficacity too, is directly dependent on the way it looks. "Magical" images are not like magical pieces of wood, since how they work and how effective they are have everything to do with their shape, particular form, and color. In this sense, aesthetic quality is anything but a matter of indifference—as it arguably is in the case of magical beams and stones.

II

While the miracle legends provide abundant evidence for the use of images in meditational processes, they are also to be seen in the light of the rapid expansion, from the second half of the thirteenth century on, of prayer and meditation on the basis of meticulous internal representation. The painter (like the sculptor) was himself, "a professional visualizer of the holy stories. What we now easily forget is that each of his pious public was liable to be an amateur in the same line, practised in spiritual exercises that demanded a high level of visualization of, at least, the central episodes of the lives of Christ and Mary."[20] It was exactly this parallel (with image making itself) that was exploited by Aelred of Rievaulx in his advice to the novice. Visualization took the form of lively, highly vivid, and particularized scenes adapted in such a way as to engage the protective and empathetic emotions of the visualizer. The best example of the mode of such practices is the middle to late thirteenth-century *Meditations on the Life of Christ,* once attributed (not surprisingly) to Bonaventure himself, but now thought to be the work of a Franciscan monk from Tuscany, probably writing for a Poor Clare.[21]

It is worth considering a passage at some length. The detail and direct instruction of the section on the Flight into Egypt are characteristic:

> Finally, reflect on the benignity of the Lord in having to sustain persecution so soon and in such a way. . . . He was carried to Egypt by the very young and tender mother, and by the aged saintly Joseph, along wild roads, obscure, rocky and difficult, through woods and uninhabited places—a very long journey. It is said that couriers would take thirteen or fifteen days; for them it was perhaps two months or longer. They are also said to have gone by the way of the desert, which the children of Israel traversed and in which they stayed forty years. How did they carry food with them? And where did they rest and spend the night? Very seldom did they find a house in that desert. Have pity on them, for it was a very difficult, great and long exertion for them as well as for the Child Jesus {not yet two months old, as the author had just reminded his readers}. Accompany them and help to carry the Child and serve them in every way you can. . . . Here there comes a beautiful and pious, compassionate meditation. . . . Make careful note of the following things. How did they live all this time or did they beg? We read that she provided the necessities for herself, and the Son with spindle and needle; the Lady of the world sewed and spun for money, for love of poverty.[22] . . . What shall we say if at times when He had returned the work and asked for the price, some arrogant,

quarrelsome and talkative or scolding woman replied abusively, taking the finished work and driving Him away without payment, and He had to return home empty-handed. Oh, how many different injuries were done these strangers. . . . These and other things about the boy Jesus you can contemplate. I have given you the occasion and you can enlarge it and follow it as you please. Be a child with the child Jesus! Do not disdain humble things and such as seem childlike in the contemplation of Jesus for they yield devotion, increase love, excite fervor, induce compassion, allow purity and simplicity, nurture the vigor of humility and poverty, preserve familiarity and confirm and raise hope.[23]

Here are the ingredients of all future meditative practices: vivid and graphic description of events and places, in terms of real or easily imaginable acquaintance and experience; careful construction of the scene by stages, and a deliberate intensification, also by stages, of the emotional experience on which successful concentration and meditation depend;[24] empathetic intimacy; encouragement of the free flow of pictorializing imagination; intimation of the divine; and the drawing of appropriate moral and theological lessons. If verbal description of this kind is felt to be capable of provoking responses predicated on empathy—and we must assume that at least on occasion it did so—then how much more effective real images must be. Especially for the illiterate and unschooled, as every writer on images from Gregory the Great on knew. No need to rely on promiscuous and labile imagination to construct the scene, when a clear basis is provided by the picture; no need to worry about the possible wandering of the mind from the appropriate scene.[25] The picture thus restrains the imagination (and suppresses irrelevance) or allows it to be further constructive. Even if we are now by and large not versed in this kind of meditation, it does not require much imagination to conceive of the impact of real images on a public well-versed in (or even remotely acquainted with) the contents of the tracts that echo, rework, and redefine the kinds of material we find in Pseudo-Bonaventure. It was, one might almost say, a public trained to respond in particular ways to particular scenes. Trained it might have been, but that training exploited a potential that is present in everyone. It depended on the potentiality of images to present things that are liable to reconstitution by all beholders.

Passages like the one from Pseudo-Bonaventure provide a context for responses to a wide range of imagery, from narrative scenes of the Life of Christ to representations of the Madonna and Child alone. They indicate the kind of imaginative intensity of which much if not most of the public for all such images were capable. But it was the Passion of Christ that offered the greatest opportunity for expansion of the comparatively meager biblical texts in terms that were most calculated to arouse the empathetic responses necessary for successful meditation. Meditation on the Passion

could engage just those emotions to which we most easily incline: sorrow, compunction, mortification, and horror at the grimness of hurt, pain, and torture. Take an example from the beginning and the height of the meditative tradition. After describing the bruises and blood of Christ's beaten flesh, the nail-by-nail puncturing of his beautiful hands and feet, the author of the *Meditations on the Life of Christ* proceeded thus: "Your patience Lord, is indescribable," and then, turning again to the reader: "Look at Him well, as He goes along, bowed down by the Cross and gasping aloud; feel as much compassion as you can . . . with your whole mind imagine yourself present . . ."[26] Saint Ignatius's *Exercises* three centuries later were not very different from this:

> The first prelude consists of composing the place and to see with the eyes of the imagination the length, breadth and depth of Hell. . . . The first point is to behold in the imagination the vast fires of Hell, and the souls enclosed in their burning bodies; second, to hear the moans, the shouts, the screams and blasphemies coming from there; third to smell the smoke, the sulphur and the putrefying feces; fourth to taste these most bitter things, tears, rancour, the worm of conscience; fifth, somehow to touch the fires by which the souls themselves are burnt; and so, as one speaks all the time with Christ, those souls will present themselves to one's memory, as well as their dreadful punishment, their opprobrious sins.[27]

This kind of inward meditation and comprehensive marshaling of the senses in its service provides the background to large groups of Western imagery, like the *sacri monti* of Northern Italy and the realistic sculpture of Spain. James Marrow has shown how the grim and vivid Netherlandish and German paintings of the Passion in the late Middle Ages are to be seen in the context of the strong arousal of empathy and compassion. This is why the faces of Christ's tormentors are so bestial, the spike-blocks beneath his knees so terrible, his meekness in the face of torments so pronounced; this is why the sores and emissions of his wounds are so appalling in pictures and sculptures by artists from Dürer and Baldung and Grünewald downward (see figs. 93 and 94); in refined prints and in the coarse woodcuts; in public and in private imagery.[28] All these things from the grim end of Christ's life are described in remorseless detail in both the Latin and the vernacular treatises on the Passion.

Now it may well be that not everyone was as pious as the writers of the meditational handbooks had hoped, and only a few may have concentrated as hard as required. But when such habits of seeing were so widespread, and evocation directed in so constitutively powerful a way, then one must reckon with the possibility that even a glance at images like these might have had something of the effect the handbooks postulate. When images

embody the symbolic carriers of all hope of salvation, then even the most skeptical and most distracted will find how readily hope springs to the breast and compassion and consolation come to the fore. The issue at stake here, let it be said once again, is not the extent to which cultural conditions may prepare the well-disposed beholder for these kinds of receptivity, but rather the ways in which the potentiality of images may be tapped.

For this reason the handbooks are instructive, perhaps surprisingly. It is not just that they reflect contemporary practice. The systematization of a method whereby beholders are prepared to respond empathetically to visual images offers insights into behavior and practices that have little or nothing to do with immediate context. What is at stake in the following discussion are practical psychological phenomena as much as aspects of the history of religion or art. The theory is real theory in the sense that it is as much paradigmatic as historical.

Marrow has traced the development of methodical private devotion to the Passion. It seems to start with the Franciscans. Perhaps the most important of the many early Franciscan tracts is the *Little book on the meditation on the Passion of Christ divided according to seven hours of the day* by Pseudo-Bede.[29] "It is necessary," claims the preface, "that when you concentrate on these things in your contemplation, you do so as if you were actually present at the very time when he suffered. And in grieving you should regard yourself as if you had our Lord suffering before your very eyes, and that he was present to receive your prayers."[30] The insistence on actual presence could hardly be more critical. To reinforce it even further, the narrative is regularly broken by interjections predicated on the arousal of compassion:

> What then would you do if you were to see these things? Would you not throw yourself on our Lord and say: "Do not, oh do not do such harm to my God. Here I am, do it to me, and don't inflict such injuries on him." And then you would bend down and embrace your Lord and master and sustain the blows yourself.[31]

The great Latin treatises swiftly follow, from the Pseudo-Bonaventure's *Meditations* to the fourteenth-century *Vita Christi* of Ludolph of Saxony. They are the channels from which such exercises emerge in the great flood of vernacular works of the next centuries. In them Christ's sufferings are characterized in extraordinarily brutal and violent ways. His tormentors are presented as dementedly gruesome, and his sufferings go well beyond the pale of the normally tolerable. The welts and bloody wounds of his body are made septic by the admixture of spit from those who mock him, and are inflamed by the soil rubbed into them; burning eggshells are applied to his face; he is stretched beneath big and heavy tables, squashed by the double pressure of the cross and the tormentors who assail him.[32] All the while the affectionate nature of the beholder's relationship is insisted upon.

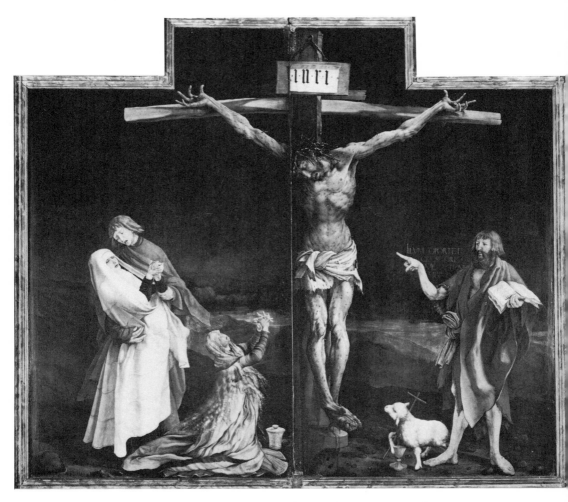

93. *Above:* Mathias Grünewald, *The Crucifixion*, center panel of the Isenheim Altarpiece (ca. 1512–15). Colmar, Musée d'Unterlinden. Photo O. Zimmermann.

94. *Opposite, left:* Mathias Grünewald, Isenheim Altarpiece, detail of the head of Christ (ca. 1512–15). Colmar, Musée d'Unterlinden. Photo Art Resource.

95. *Opposite, right:* Bernard van Orley(?), *The Mocking of Christ* (ca. 1525–30). Tournai, Cathedral. Copyright A.C.L.-Brussels.

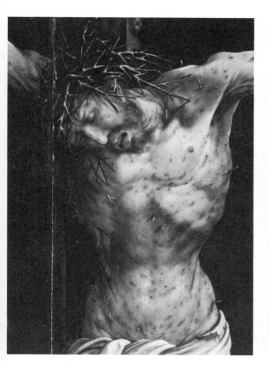
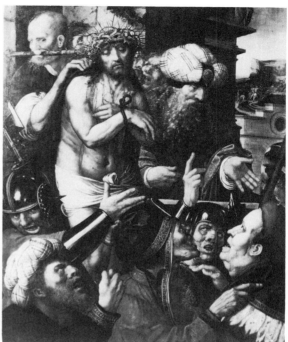

"But he had not the form of a man, because . . . our beloved Lord's holy face was as miserably transformed and disfigured as if he had been a leprous man, because the foul snot and the filthy yellow spit lay baked and dried upon his holy face, and his sacred red blood had thickly overflowed his face, hanging from it in congealed pieces, in such a manner that the Lord appeared as if his face were covered with boils and sores, because he was all full of the bruises," reads one of the Dutch derivations of Ludolph of Saxony's *Vita Christi*.[33] One can imagine the strength—if not the exact content and quality—of the emotions that might have been aroused by pictures that showed this, and what terrible pity (see figs. 93–95).

No wonder that Heinrich Suso (d. 1366), upon contemplating the Passion of Christ, could be roused to such empathy that he felt impelled to carve Christ's initials on his breast and nail a cross to his back. But Suso was a mystic, for whom concentration on texts alone was sufficient to generate this kind of reaction. As Marrow put it: "Spiritual fervour was actively cultivated by many of the mystics; ecstasies were sought after and visions highly prized. For such a disposition, what better focus for compassionate meditation than the sufferings of Christ and his Mother?"[34] But for those who were incapable of reaching the purely spiritual heights which such men and women sought, visual images served as a still more effective vehicle for compassionate meditation.

It would be wrong to overlook the powers of imaginative reconstitution on the basis of the literary tradition, but when that tradition becomes commonplace, the many real representations of the Passion—based on the texts but also supplementing them—will be that much more effective. If Christ in torment is present to us as a result of our reading, we are all the more likely to be inclined to invest present representation with the reality of suffering. Even Suso recalls how devotional images provoked visions that depended directly on what he saw in them. He ascends from real image to the reality of vision; he looks on the lovely bodies of the Virgin and Child, and in an instant, they are present in fleshly form before him, accompanied by singing and rose-strewing angels.[35]

But one further element enters into all this: that of imitation. While the initial vernacular expressions of meditation on the Passion are in German, the Netherlandish tracts that follow hard on them grow out of the late fourteenth- and fifteenth-century movement known as the *devotio moderna,* which laid great emphasis on the idea that the best religious life consisted of the imitation of Christ and his saints. The movement was not predominantly mystical; its piety was down-to-earth. Central to it was private meditation on the Passion of Christ. The meditational programs that emerged influenced vast areas of fifteenth-century culture in the North Netherlands—as we know most movingly from the techniques of Thomas à Kempis. They were substantially practical, since readers and adherents were consistently instructed to transform simple meditation into commitment to the *imitatio Christi*.[36] Christ was a doer, not simply a preacher of abstract parables: even the parables themselves brought abstraction to earth.

It is true that the idea of imitation has already been adumbrated in the earlier Latin texts (as in the passage from Pseudo-Bonaventure); but now it became a raison d'être of meditational practice. Imitation of Christ was taken to have not only personal consequences, but also public ones. We are supposed to demonstrate the same patient and tolerant beneficence as Christ and his saints, and so personal exercises acquire public and ethical implications as well. From now on, even when not specifically stated, even before its massive reinvigoration in the work of Ignatius Loyola, imitation becomes a central recommendation in almost all the treatises and handbooks.

But imitation cannot take place without empathy; and empathy, as we have seen, can most effectively be roused by real images. This yoking of imitation and imagery is most broadly manifested by a genre that may at first seem subsidiary and to raise subsidiary issues. But they are central. By referring to pictures and sculptures, it may be comparatively easy to intuit the arousal of emotion and the kinds of responses that lead to behavioral symptoms; but with printed imagery (especially with multiples, with reproductive imagery in black and white), the strength of response seems considerably less easy to grasp—all other things (like visual content) being

more or less equal. For this reason, it would be wrong to shrink from the evidence that is readily to hand in the case of printed images and their use for meditational and imitative purposes. Not only do they function widely in these contexts, but they seem to function very well indeed. When we examine the problems of analysis as well as the data of response, we come one stage further in our pursuit.

III

If we were to summarize all the instructions to potential meditators in the handbooks, we would find the same basic elements in the way in which the transition from contemplation to emotion was supposed to occur. First, concentration on the story and exclusion of externals; second, careful episodic progression, on the basis of the most analytic, the most complete possible breakdown of the story, into as many separate episodes as possible; and finally, the active engagement and cultivation of ensuing emotions.[37]

This is what we find once the first visual equivalents become widely accessible, as in the German woodcut broadsheet of around 1477, showing the crucified Christ between the Virgin and Saint John (fig. 96). The image in the center is made up of a small number of boldly cut lines; it is forcefully presented; and it could hardly be clearer. It is set against a completely plain background, with no incidentals to speak (or think) of—plain, except for the insistently enumerative inscription schematically arrayed across the sheet. Every line is calculated to fix attention, to force any potential mental digression back to the suffering of Christ. It is, as the heading makes clear, the *Road of Contemplation and Meditation on the Passion of Jesus Christ*. On the extreme left of the sheet, the detailed stages of contemplation are classified into divisions with separate and clear headings. One then reads by shifting back and forth across the central image. The whole process is beneficial (as the final division notes) "because it was by all kinds of men" (extreme left, above) that "he was sold" (far right) . . . "by his own disciple" (immediate left of the cross). He was "abandoned" . . . "by all the apostles"; "betrayed" . . . "by the Priests"; "judged" . . . "by the king"; "beaten" . . . "by the praetor"; "condemned" . . . "by the crowd"; "crucified" . . . "by the soldiers"; and so the system continues. We move then to the next main classification on the far left: It was "by all kinds of elements" that he was "denied" . . . and "taken to fire"; he was "spat" upon . . . "by water and saliva"; "suspended" . . . "in the air"; "covered" . . . "by the earth." Then follow the divisions according to "every kind of pain" ("bloody" . . . "sweat"; "overflowing" . . . "tears"; "loud" . . . "shouting"), "every one of the senses," and "every ignominious form of insult." All this was beneficial and profitable, on account of "the elimination" . . . "of our sins"; "the

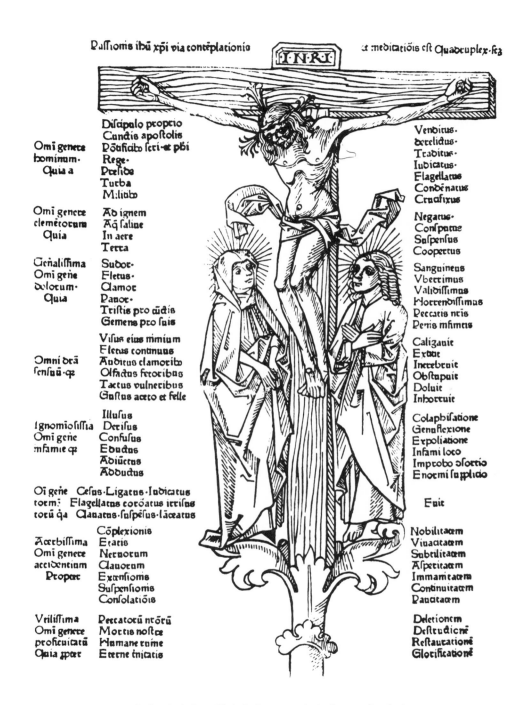

96. *Passionis Jesu Christi via contemplationis et meditationis
quadruplex* (woodcut broadsheet of the Crucifixion [Augsburg (Ludwig
Hohenwang), ca. 1477]; Schreiber 22, 479). Photo author.

destruction" . . . "of our death"; "the restoration" . . . "of human ruin"; and "the glorification" . . . "of the eternal Trinity," that is, the final step in the contemplative ascent. Aside from the rhetorical tricks (which I have largely omitted), what is so effective about all this is the way in which the insistent and particularized description is interrupted by the visual image; the eye is arrested as it passes across the page to the rest of each sentence or phrase (for each set of ellipses above, imagine the real picture); we could not evade that awful image if we wanted to. We are forced to concentrate on it, and to think of all these things, to dwell on the detail of the suffering, the nobility of Christ, and the salvific consequences of his Passion. We could hardly grasp that without being moved to such a pitch of involvement.

The inscription of this broadsheet (and there are plenty of parallels) takes a very similar form of closely detailed analytic enumeration to the textual descriptions and instructions that accompany the illustrations in huge numbers of devotional handbooks later in the Counter-Reformation. In all this the development of woodcut (in the first instance) and printing were crucial. From the middle of the fifteenth century onward, images for meditation reached an incomparably larger audience than ever before; they were cheap and expendable. But above all, they became standardized in undreamt-of ways. No longer was it a matter of painters and sculptors doing their best to adhere to quite specific descriptions of the central figures of Christianity; it now became possible for whole sections of the public to meditate on exactly the same image. Reproduction halts the insistent mutation wrought by convention and freezes it utterly across all those large areas where a single image is available, often for a long time, in hundreds of identical copies. The old difficulties of recognition, the old urgent need for it, now ease; you and I meditate on images of whose identity we may be sure.[38] The look of Christ is standardized more than ever before; he is more than ever recognizable; he is palpably and convincingly ubiquitous. Previously the transition from imaginative conception to recognition would have been hesitant, however fractionally; now it is instantaneous: Christ's presence is immediate and indubitable.

Here is a recommendation by the great Alsatian preacher Geiler von Kaysersberg (1445–1510): "If you cannot read, then take a picture of paper where Mary and Elizabeth are depicted as they meet each other; you buy it for a penny. Look at it and think how happy they had been, and of good things. . . . Thereafter show yourself to them in an outer reveration, kiss the image on the paper, bow in front of it, kneel before it."[39] To us, three-dimensional images and colored paintings are more likely, on the face of it, to seem capable of compelling such forms of outward devotion. We may be inclined to think that beholders are more likely to have invested pictures and especially sculptures with the life of rounded and colored reality in such

a way as to make outward reaction more or less instinctive. Because the illusion of life is probably greater in such cases, we may seem to be more predisposed to respond to them as if they were lively presences—especially, but not only, if Christ, his mother, and his saints are portrayed. But Geiler's cheap print was probably monochromatic (though it is always possible that it was colored); and what we find from this time on—in other words, from the earliest years of printing on—is that behavior in the presence of images takes on not only a variety of new forms, but also exaggerated, more enthusiastic, and more widespread manifestations of the old ones.[40] People can now take exact images away with them; they can go to pilgrimage shrines and take home better and still more compact reproductions of beneficent and favorite paintings and sculptures. There they can privately cherish, as if with them, the images to which they were devoted. Their behavior acquires a new intensity, as a result of the awareness that the absent—which they know to be absent—is really present, and from the recollection of felt experience. The reproductions act as souvenirs do and elicit, in fresh form, the experience of the archetype, as well as, say, the adventures in getting there and the shocks of recognition or surprise. The image becomes like a fetish: it is lovingly cherished, rouses sweet affection or tears, and may be touched and handled as frequently and as fondly as one likes. Sometimes, indeed, images of paper may be pulverized and eaten in expectation of some good effect or another. When such things happen, how intense response must be, and how deeply the process of contemplation and meditation may draw on the wellsprings of private—to say nothing of public—emotion.

But there is a confusion to be avoided. We may respond to a successful reproduction (i.e., a reproduction perceived to be successful) in more or less the same way as we respond to the archetype. In this sense response might be called automatic: the cues to identity are sufficient to cause us to respond as if it were the original.[41] But the invention of the techniques of mass reproduction and the consequent standardization of certain images does not mean that response is independent of the form and quality of those images. It is not: the degree of effectiveness of an image, and the response it evokes, is directly related to its particularity. The transmission of forms of particularization in reproductive imagery may result in the recurrence of certain symptoms on a wider scale and may serve to establish certain correlations between particular accidents of form and appropriate emotion. Such correlations may then acquire more or less regularized cognitive status. But at no stage does response become so automatic as to justify claims for the irrelevance of the conscious and unconscious accidents of form. Awareness of just this fact is never far below the surface of the illustrated manuals of devotion and meditation.

The number of such manuals vastly increased in the course of the sixteenth and seventeenth centuries; it was not to abate until the twentieth.

Unlike the manuscript and illumination manuals, their ownership was not confined to corporate bodies or rich individuals. The use of woodcut and engraving ensured a rapid decline in the cost of books and made them accessible to a larger public than ever before. Often these books were produced in very small formats, so they could be put in the pocket. They were thus readily at the personal disposal of a public whose knowledge of real images had hitherto been confined to a much more limited range of examples. The constant aim of the new form of illustration was the achievement of episodic clarity, in order to ensure that every potentially emotive stage in the scene or sequence of scenes would be plainly accessible to the concentrating beholder and that nothing that might be capable of emotional exploitation would be passed over. The functions of such illustrations are variously stated, but all are conceived with the primary purpose of facilitating the passage of the visualizing imagination to reconstitution, empathy, and imitation.

At the same time, the old habits and patterns of meditation unassisted by real images continue, and unillustrated manuals provide instructions for the inward construction of appropriate mental images. This mode itself comes largely to be conceived in terms of the comparison with real image-making activity: the simplest simile for the image-constructing imagination is now firmly that of the painter or sculptor: one imitates Christ just as the painter imitates his model. At least this seems to be the easiest and by now the most easily grasped model for the whole meditative process.

All these strands are combined with telling effect in the books that follow in the wake of the *Spiritual Exercises* of Saint Ignatius Loyola. That work came at a juncture in the Counter-Reformation that appears to have been particularly auspicious for a meditational practice of the kind it proposed, and its methodical yet robustly sensitive thoroughness still seems compelling: but what one might not entirely have predicted is the extent and manner of its influence on the use of illustrations.

The bulk of the *Exercises* is given over to the enumeration of the details of Christ's Life and Passion in a way that is designed to rouse the empathetic emotions of the beholder, and to enable him to draw appropriate moral and personal lessons; but the meditations proper are preceded by a set of five "exercises" which reveal both the psychological insight and the rigorously methodical basis of the Ignatian scheme. The very first stage (following a preparatory prayer) Ignatius called "composition, seeing the place" (*composición, viendo el lugar / componendi loci*). He explained what he meant:

In contemplation or meditation on visible things, as in contemplating Christ our Lord, who is visible, composition will be to see by the eye of the imagination a physical place where that thing is found which I wish to contemplate. By a physical place I mean, for example, a temple or

mountain, where Jesus Christ, or Our Lady is found, according to that which I wish to contemplate.[42]

Although there are plenty of earlier instances of selecting a physical place like a church or a mountain for the imagining of a scene, the importance of the Ignatian method lies in its unremitting emphasis on making every possible focus of meditation—even invisible things and abstract notions—palpably pictorial. It is significant that Christ himself is here referred to as *visibilis*: this is not the term that most of the earlier treatises would have used. Furthermore, although the Jesuit *Ratio meditandi* itself warned that the imagination is full of trifles and easily capable of being deflected, implicit in Ignatius is the acknowledgment that this freedom of the imagination to construct *ad libitum* could be channeled into a powerfully visualizing force. It was powerfully visualizing precisely because of the richness of stored visual experience and its potential for vivid release. Ignatius himself did not advocate the use of real images to assist meditation, but the potential of his literary images, taken in conjunction with the exercise of "composition, by seeing the place," was swiftly realized in ways that were to influence all subsequent thinking about the uses of art—to say nothing of its influence on art itself.

This is clear even from the unillustrated works. Francis Coster's *Fifty Meditations on the Life and Praise of the Virgin* of 1588 provides an example. In spelling out the correct method of meditation, its preface immediately drew a parallel with the various ways of responding to painted pictures. "Just as it is of great import whether we look at a painting casually or intently, in passing or directly, attentively or thinking of something else, whether we are moved or we admire the art, so it is of great importance that we meditate on the Virgin with a definite method."[43] This method is systematically and precisely exemplified in the body of the text. The subject of each of the fifty meditations is carefully divided into its constituent elements. These are further subdivided according to the various issues they raise: every moment in the event and every emotional juncture is considered, in a strict system of enumeration. Each subdivision begins with the injunction "Consider," followed by a series of numbers. The method (whose origins are to be found both in the handbooks out of Pseudo-Bonaventure and in the practice of meditating on the rosary) demands that the reader call up before himself a specific mental image; and this image then provides the basis for meditation. This is the same function assigned to the *composición viendo el lugar* of the Ignatian exercises. By these means, the work compensates for its lack of physical images; and the system of numbering each division (that is to say, each image) and each subdivision (i.e., each of the thoughts the former arouses) corresponds to the use of letters in the annotated illustrations of the handbooks we must consider next—except that

the use of numbers enables Coster to be still more precise about every component of the meditational process. To some extent, this is necessitated by the very absence of illustrations.[44]

Saint Ignatius's close friend Jerome Nadal (1507–80) played a key role in the next part of this story.[45] Already in 1562 he was encouraging another friend of Saint Ignatius (and of Saint Teresa), Saint Francis Borgia, to write some meditations on the Sunday gospel readings to accompany engravings of the Life of Christ. Over the next four or five years, Francis Borgia did so. In his introduction to the planned work, he wrote:

> In order to achieve greater facility in meditation, one places before
> oneself an image showing the gospel story ["the evangelical mystery"];
> and thus, before commencing the meditation, one will gaze upon the
> image and take especial care in observing that which it has to show, in
> order the better to contemplate it as one meditates, and to derive
> greater benefit from it; because the function of the image is, as it were,
> to give taste and flavour to the food one has to eat, in such a way that
> one is not satisfied until one has eaten it; and also in such a way that
> understanding will reflect upon and work on that which it has to
> meditate, at considerable cost and effort to itself. And this takes place
> with greater certainty, since the image conforms closely to the gospel,
> and because meditating can easily deceive one, as one takes one thing
> for another and leaves out the traces of the Holy Gospel, which one
> should respect both in small and large details, and so should not incline
> either to left or right.[46]

The project was not to be, but almost immediately Nadal himself set to work on a very similar understanding. For the rest of his life, he worked on the book that was to become the great *Annotations and Meditations on the Gospels Read at Holy Mass throughout the Year* and dedicated himself, in Halle, Augsburg, and Rome, to preparing the text and supervising the illustrations. The plates were published on their own in 1593, while the work as a whole appeared in Antwerp in 1595 and 1607 and in several later editions.[47]

In Nadal's work, the Life of Christ was divided into 153 scenes, each illustrated by a print. The prints were grouped together at the end of the text; each was provided with a sequence of between four and six or more letters, each letter placed close to the chief elements in the composition. The captions provided short explanations for each of the letters (figs. 97–99). But it is the correlation with the text that was significant. The text was divided into chapters bearing the same titles as the illustrations. Each chapter (conceived as a *meditatio*) contained, in the first place, a short *adnotatiuncula* corresponding to the caption beneath the relevant print. Then followed a much longer *adnotatio* containing an expanded meditation on

A. Vrgent Principes, vt ducatur
 IESVS.
B. Fert crucem.
C. Peruenitur ad portam veterem.
D. Vident Iudæi IESVM sub

pondere laborare, iubent sub-
sistere.
E. Sequebatur turba, et in hac muli-
eres Hierosolymitanæ, Maria
virgo extra turbam cum suis.

A. Exeuntibus illis cum afflicto IESV,
 occurrit Simon Cyrenensis.
B. Hunc angariant, vt tollat crucem IESV.
A. Respirat paululum IESVS.
C. Sequebantur mulieres Hierosolymitanæ

plorantes.
D. Ex his vna tergit linteo vultum IESV,
 & refert in linteo eius effigiem.
A. Emulantibus mulieribus, ad eas conuersus
 IESVS dixit; Nolite flere, &c.

each of the lettered elements in the print, as well as on the print as whole.[48]

Nadal's book was the first to employ a method of annotation and illustration that was to be adapted in many devotional works from the seventeenth century on. Henceforward such works standardly used the same systematic and enumerative methods of setting out the relationship between text and illustration. The aim was to concentrate the beholder's attention on strategic psychological moments as a means of engaging the processes of meditation more actively and fruitfully. Although Nadal's work was written specifically for a Jesuit audience (and for novices in particular),[49] it received a far wider circulation. The same applies to Coster's handbook of 1588—even though it was originally written for the young members of the Sodality of the Virgin at Douai.[50] Furthermore, both provide evidence of a mode of response that was not restricted to the Latin-reading public. Nor are they unique. Their value derives from their very typicality, particularly when aligned with the rosary devotions and the meditative practices encouraged by other orders and institutions. Many of the works which adopted the same combination of images and sophisticated annotation as Nadal's were written in or translated into the vernacular; and because of the pictures, they reached into the hearts of the illiterate as well as the literate.

In his introduction to the *Meditationes et adnotationes,* Nadal's traveling

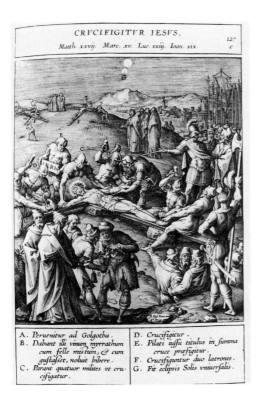

CRVCIFIGITVR IESVS.

Matth. xxvij. Marc. xv. Luc. xxiij. Ioan. xix.

127
c

A. Peruenitur ad Golgotha.
B. Dabant illi vinum, myrrathum cum felle mistum, & cum gustasset, noluit bibere.
C. Parant quatuor milites vt crucifigatur.

D. Crucifigitur.
E. Pilati iussu titulus in summa cruce præfigitur.
F. Crucifiguntur duo latrones.
G. Fit eclipsis Solis vniuersalis.

97. *Far left: The Carrying of the Cross* (from H. Natalis, *Evangelicae historiae imagines* [Antwerp, 1593/1607], pl. 125). Photo author.

98. *Left center: The Carrying of the Cross* (from H. Natalis, *Evangelicae historiae imagines* [Antwerp, 1593/1607], pl. 126). Photo author.

99. *Left: The Nailing to the Cross* (from H. Natalis, *Evangelicae historiae imagines* [Antwerp, 1593/1607], pl. 127). Photo author.

companion Diego Jiménez emphasized the concern that had been displayed for the quality of the illustrations. Deliberate care had been taken that the very multitude of images should not cause boredom. They were to be as skilled, elegant, and attractive as possible, done by the best artists—in order to encourage assiduous meditation.[51] One has come some way from the imageless meditations of the *Spiritual Exercises*. There is even an emphatic statement that quality is crucial: no fear here of the snares of beauty or refinement, or of potential distraction by "purely" aesthetic factors. Nor is this merely an affirmation of the role of art at a time when its validity and purposes were constantly subjected to severe criticism, and when pictorial imagery was consistently underplayed in favor of a renewed emphasis on words and texts. It is as clear as possible an acknowledgment of the role of aesthetic differentiation in engaging an empathy that, seemingly spontaneous and autogenous, may be directed and controlled—despite the free flow of imagination and sense.

A similar system of illustration and annotation by careful use of letters and numbers is adopted in a whole series of devotional emblem books, beginning with Johannes David's *Veridicus Christianus* (1601–3).[52] Despite the difference in genre (the illustrations are allegorical and emblematic, not historical), these books are specifically meditational, and the instructions to

the reader/beholder are presented, again, in terms of the kinds of emotion that each element in the pictures properly or most deeply arouse. One could hardly overestimate the importance of this system in fixing the mind that wanders to aesthesis and fails to be firmly constitutive. But the interest of this particular genre lies in two of the major conceptual constants of most of the works it embraces: first, the conception of the imitative empathetic mind in terms of actual artistic activity; and second, the specific and insistent concern for the quality of the illustrations. The two conceptions are combined in extraordinary ways.

The section of David's book entitled *Orbita probitatis ad Christi imitationem* has its own title page, showing Christ carrying the cross, raised on mound and surrounded by nine painters seated at their easels (fig. 100). They paint, "with the appropriate colours" as David pointedly notes, a variety of scenes from the life of Christ.[53] In the center is the most important picture of all—that of Christ carrying the cross. The only exception in the cycle is the bad imitator of Christ, who paints the devil in the guise of women and beasts.[54] The proemium explains: "Just as famous and outstanding painters must do their best to represent after the life that which they have chosen to imitate by art, so Christians must imitate Christ in their lives and relations with others, as well as in their deeds, until they show Christ in themselves, as if depicted after the life."[55] Here the reader is referred back to an earlier passage reflecting on the fact that in imitating Christ we all become painters and portraitists: "Imagine that you see many painters all sitting at work, casting their eyes on Christ as the model, and painting him, praying in the garden, tormented."[56] "And in this representation of Christ," says the proemium to the *Orbita probitatis,* "everything that helps us to lead a Christian and virtuous life helps us likewise to represent in ourselves Christ as the prototype, as if copying and portraying him on a painting."[57] These passages amount to a full statement of artistic activity as a metaphor both for the virtuous Christian life and for the meditative process; and it is all represented by pictures—indeed by pictures of pictures.

Antonius Sucquet's enormously popular *Road of Eternal Life* offers one further example out of many.[58] It too has the annotated kind of illustration with which we are now familiar; each chapter provides precise, steplike guidance on how to meditate and exactly how to benefit from each meditation; and it brings to the fore a succession of specific emotions, each calculated to bring the reader/beholder to the appropriate state of absorption and re-creation. Each meditation begins with instructions on how to form the *compositio loci;* and this is often simply described by referring to the relevant illustration, *ut in imagine proponitur, qualis in imagine adumbrentur,* and so on. Pictures are more eloquent than words and more concise; so in places like this they may replace much verbal description.

"What, then, is meditation?" Sucquet asks at one stage in the book. "To

meditate is to consider in one's mind, and as it were, to paint in one's heart, the mystery or some doctrine of the Life of Christ, or even the perfection of God, by [representing] the circumstances: people, actions, words, place, and time."[59] The annotated prints graphically illustrate the point, with several interesting variations of the imitative theme (figs. 101–3). Straightforwardly, a painter seated at his easel paints a picture (D) of Christ carrying his cross, shown on the hill beyond (C). In doing so he is supervised by two angelic figures representing Scripture and Virtue (A and B) (fig. 101). But in an earlier illustration (fig. 102), while one painter portrays a saint (A), another is pulled away from his easel with a picture of the Madonna on it (D) by a devil (B). Distraction of heart and imagination could hardly be better represented. In figure 103, the painter who stands before a scene of the Nativity (A) paints an annotated and compartmentalized heart (D: *Quis*, the infant Christ; E: *Quid? Quomodo?* the Nativity; F: *Ubi Quando?* the manger; G: *Cur?* a soul saved from Purgatory, etc.).[60] And always, as if the mind could not properly be relied on to do so itself, the text expands and constrains, point by point; until emphasis, repetition, and evocation ensure, first, the involvement that is empathy and then the presence that results.[61]

In the key chapter "On the method of meditating, by which the mind ascends from terrestial things to God," Sucquet builds up his argument about the relations between function and form:

> These [images] will be able to help everyone, since the mind is arid and dull; but it will especially help simpler folk to concentrate their attention and to meditate more usefully. For he who uses this method will easily overcome those two things which tend to make meditation difficult and even fruitless. The first is the instability of the imagination: after the sin of Adam it became wholly unbridled; the unstable mind was made to wander over the whole course of the earth, and was not allowed to stick to pious thoughts. In order to restrain it, it seemed appropriate to fix it, as it were, by means of pious cogitations and by images. The blessed Ignatius approved of just this when he wrote to Nadal that he should publish the Life of Christ represented by beautiful images, for the specific convenience of the meditator. Experience teaches us how true this is; and the Holy Church, which makes considerable use of images, confirms this by its authority."[62]

By the second decade of the century, a conclusion that had long been looming, implicitly and explicitly, was fully realized. Real images could be yoked to mental ones in more systematic ways than had ever seemed possible. Although Sucquet's conclusion justifying practice in terms of tradition and authority was inevitable—given the Tridentine formulations he and everyone else knew so well—its real point lies in the antecedent claim

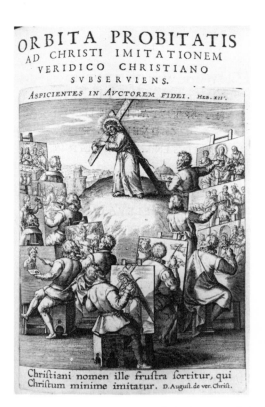

100. *Left:* Title page of the *Orbita Probitatis; The Activity of the Painter as an Allegory of the Imitation of Christ* (from J. David, *Veridicus Christianus* [Antwerp, 1603]). Photo author.

101. *Right: Painter Painting at Easel* (from J. Sucquet, *Via vita aeternae* [Antwerp, 1630]). Photo author.

about cognition. It is a claim that had never been far from the surface of thought about the imagination, but its particular context, in writers like Sucquet, gives it a new and trenchant pertinence. If the imagination is unstable and liable to roam, one must rely on the allurements of form to attract its attention and to halt its free flow. Once fixed, however momentarily, the restraint thus placed on it may be progressively reinforced. It can be controlled and guided along the required paths, and at every stage in its course concentration may be strengthened by blocking off and removing from the inner scene all side roads and byways. Naturally there may be other ways of attracting, bridling, and directing the imagination, but only now is the primacy of sense perception in this process fully realized. The results of this realization become commonplace, and are acknowledged in every passing remark: "In order that they should attract all the more, the images have been designed and engraved by those who are counted among the best in the Netherlands," runs a line in the introduction to one of the most popular illustrated devotional books of the seventeenth century, Ju-

 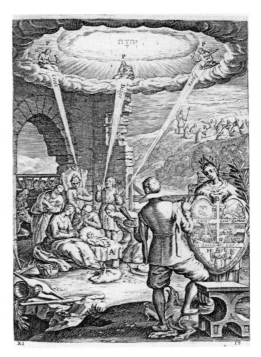

102. *Left: Painter Painting Saint* (from J. Sucquet, *Via vita aeternae* [Antwerp, 1630]). Photo author.

103. *Right: Painter Painting Nativity* (from J. Sucquet, *Via vita aeternae* [Antwerp, 1630]). Photo author.

docus Andries's *Necessary Knowledge for Salvation*—and it is not just a commercial boast designed to attract art-loving buyers.[63]

But a danger lurks in this yoking of imagination and sense perception. Real images may attract and guide the imagination more immediately and effectively than mental ones; but if it is their formal qualities that serve as the means of attraction, what guarantee is there that imagination will not remain with the pleasures of sense, and tarry at that easy juncture, instead of passing on to the next stages of concentration and reconstitution? This is the tension that forms the basis of much suspicion of visual imagery, from early Christian reservations to Protestant critiques. It may be that instead of hurrying to their wordly business, men and women linger in churches, drawn by pictures of Christ and his saints; but what if pleasure in form undermines or suppresses thought of them—the very thought that might not have been generated without the image? What if the lingering is occasioned by color, line, and pleasure in anatomy, and not by reflections of sacred history and dogma? It is only when we align ourselves with those

who feel or express reservations of this kind that the full import of the systems of annotated illustration I have been describing becomes apparent. The letters on the pictures not only draw attention to that which otherwise might escape us, they insistently draw the mind away from the attractive sign to the meaningful signified; they prevent our dwelling on quality and form by the fact that they refer back to the signified. And then the letters take the beholder away from that which he or she has reconstituted: whereupon the signified takes on its originally absent and disembodied quality. Annotation by letter or number reminds us that the sign is not merely a pointer back to the necessarily notional archetype: for a moment we grasp the illogicality of presence, as the mechanics of the relationship between sign and signified are laid bare. In practice, of course, fusion is unavoidable; but every word, letter, or number on an image represents the beginnings of an analysis that can never be completed, an analysis into the wholly abstract and the fully materialized. The visual image on the page is not merely a signpost (in a significant sense the letters and numbers and words are); it forces a synthesis that obliterates abstraction and the logic of differentiation. Taken together with their illustrations, the passages from the devotional handbooks thus lay bare the very tensions which make images compelling, and which give them their hold on the imagination: on the one hand the rational perception of separateness; on the other the inescapable elisions of the mind that only grasps through the experience of bodies seen.

IV

Both the practice and the theory of meditation demonstrate the ways in which we grasp the notional by drawing on the stock of our visual experiences—experiences not only of natural things seen, but also of more or less conventionalized forms of representation. In our minds we construct images on the basis of our memory of things seen, in order to grasp the unseen. With real images, of course, the task is that much easier, even though they allow greater scope for cherishing that which is purely formal, at the expense of the prescribed object of our thoughts.

But whether we have an image before us or not, the mind can only grasp the invisible by means of, or with reference to, the visible. This then amounts not merely to a theoretical recommendation, a device for drawing the mind upward; it amounts, in the theories, to the acknowledgment of a cognitive fact. Either we remain on the level of pure feeling or we constitute the notional in the clear terms of that which can only be grasped visually. With a real image before us, there may be little difficulty; without one, we draw with greater or lesser difficulty on forms with which we are acquainted. Meditation—unless it consistently fails—forces upon the medi-

tator the discovery of the mind's potential for pictorial visualization. And it is in the meditator that we most clearly see how easily the mind has recourse to the construction of mental pictures based on experience, when it sets itself the task of grasping and dwelling upon the absent and the notional. We can discern how swiftly and inevitably it assembles fragments of visual experience and orders them into clear and apparently coherent pictures on which the mind's eye may focus and come to rest.[64] Why it should do so and what the consequences are for individual conceptions of the constituting and enlivening powers of the mind emerge, once again, from old theory.

This is how some of the third-century Neo-Platonists resolved a problem that was already then a matter of concern to Christian communities, and that was to have an extraordinarily long life:

> Do not think that philosophers revere stones and images (*eidōla*) as gods. For since we living beings are not able to attain perception and feeling of incorporeal and non-material forces and powers, images of them were invented to serve as remembrances, so that those who see such things and venerate them might arrive at a conception of incorporeal and non-material forces.[65]

This characteristic view should be set beside the much more famous exposition in Dio Chrysostom's great *Olympic Discourse* of approximately a hundred years earlier. The discourse is "On Man's First Conception of God," and none other than Phidias is brought on to account for *his* representation of the divine. He is firmly questioned:

> But was the shape you produced by your artistry appropriate to a god; and was its form worthy of the divine nature? Not only did you use a material which gives delight, you also presented a human form of extraordinary beauty and size.[66]

The questioner continues with the issue of superior art:

> In the past we had no clear knowledge: each person had a different idea, and according to his capacity and nature, conceived a likeness for every divine thing, and fashioned such likenesses in his dreams.[67] If we do perhaps collect any small and insignificant likenesses by earlier artists, we do not trust them much, nor pay them much attention. But you by the power of your art . . . showed such a marvelous and dazzling conception (*thespesion kai lampron doxan*) that none of those who have beheld it could any longer easily form a different one.[68]

This is how Phidias replies:

> My fellow Greeks, the issue is the greatest that has ever arisen. For it concerns the God who governs the universe and the way I have

represented him. No sculptor or painter will ever be able to represent mind and intelligence, for all men are utterly incapable of observing such attributes with their eyes or learning them by inquiry. But as for that in which this intelligence manifests itself, men have no inkling thereof except from actual knowledge, to which they fly for refuge; and, since they lack a better illustration, they attribute to God a human body, as a vessel to contain intelligence and rationality. In their perplexity they seek to indicate that which is invisible and unportrayable by means of something portrayable and visible, using the force of symbol (*symbolou dynamei chromenoi*), and thus do no better than the barbarians who are said to represent the divine by means of animals, using as their starting point symbols which are trivial and absurd. . . . For certainly no one could maintain that it would be better if no statue or picture of gods were exhibited among men, on the grounds that one should only look at the heavens. . . . All men have a strong yearning to honour and worship the deity from close at hand, and to approach and lay hold of him, persuading him and offering him sacrifices and crowning him with garlands. For just as infants when torn away from father or mother are filled with terrible longing and desire, and often stretch out their hands to their absent parents in their dreams, so also do men to the gods, rightly loving them for their beneficence, and eager in every possible way to be with them and to converse with them.[69]

There are few more profound or moving passages on the complex relations between superior art, creator, and beholder, but its significance here lies in the clear and forceful articulation, first of the need to shape the divine in the form best and most intimately known to us, that of human form; and second, of the affective consequences of actually doing so. Its interest is not confined to the exposition of the problem of representing the invisible and unportrayable god (that problem is, in any case, simply paradigmatic: all representation, by its very nature, visually articulates the invisible). It also forces us to address this question: On what bases do we respond to represented forms that we recognize from experience, and in particular, experience and knowledge of human form?

<div align="center">V</div>

When Freud sought to justify the tendency to attribute life to inanimate objects (in his discussion of animism in *Totem and Taboo*), he quoted the following passage from the third section of Hume's *Natural History of Religion:* "There is an universal tendency among mankind to conceive all beings like themselves, and to transfer to every object those qualities with which they are familiarly acquainted, and of which they are intimately con-

scious."[70] But these words apply not only to inanimate objects; they point to, indeed they emphasize, the way in which we spontaneously and inexorably seek to invest representation with the marks of the familiar. It is because of this that we behave in the manner so movingly described by Dio Chrysostom, and it is in these terms that we should probably understand all behavior in the presence of images. This is why the meditational manuals insist on the intimate and familiar (throughout their pages we note the desire to level off description to that which is ascertainably familiar). This is why the legends about miracle-working images so frequently have at their center images with traits or behavioral predispositions that are self-consciously low-level, intimate, and everyday.

But to perceive an image in terms of the intimate and familiar depends, in the first instance, on the perception of similitude. However mistaken we may be in that perception,[71] we empathize with an image because it has or shows a body like the ourselves; we feel close to it because of its similarity to our own physique and that of our neighbors; we suffer with it because it bears the marks of suffering. The dead Christ rouses our grief all the more because it shows death in terms and forms most of us know. If we are forced to concentrate on the image, or if the signs of life and torment are forced upon us (as in the case of the close-up or half-length image), empathy may be all the more direct and strong. When we have no image before us, we can only be compassionate by reforming mental images on the basis of what we have seen and known. The mind has no choice: it lapses into visualization in order to grasp all but the purely ecstatic, syllogistic, and arithmetical (and even then it is hard to postulate the complete abandonment of visualization of this kind). Seeing an image arrests that descent, because a substitute is provided for the attempt at inward visual construction. But because we know that the construction is based on the deposits of experience, when we see the affective image before us, we respond to it in terms that to a greater or lesser extent can only be grasped on the basis of the kinds of lively reality that are layered in the imagination. The lesson of meditation is that it shows us, in the first instance, *how* we visualize; and in the second, what effectively may happen when we are confronted with real images. The exploitation, by programmatic meditation, of all possible elements of the physical and emotional existence of the form represented reveals, more clearly than anyone nowadays might expect, the affective consequences of the elision of sign and signified. It also makes plain the nature of that elision. This is why I have chosen to dwell on practices that are now largely forgotten and whose extent it is difficult to measure. And to these we may relate those many forms of behavior that so embarrass historians of art that they choose to suppress them in favor of anodyne descriptions of the foundations (at best) and the symptoms (at worst) of an effectiveness that is made to appear as "purely aesthetic." As if that were possible.

9

Verisimilitude and Resemblance: From Sacred Mountain to Waxworks

High above the town of Varallo in Piedmont, overlooking the upper reaches of the Sesia, is the earliest site of what may properly be called a *sacro monte*. Here, in the last quarter of the fifteenth century, the Friar Minor Bernardino Caimi decided to erect a number of chapels containing scenes that were intended to replicate the most famous sites of the Holy Land. His aim was to evoke, in a natural setting, the holy places which he himself had visited, Bethlehem, Nazareth, Mount Tabor, and Jerusalem, and especially the various sites of the Passion—Gethsemane, Mount Sion, and Golgotha.[1] Caimi thus took the recommendations of contemporary books like the Venetian *Zardino de oration* one significant stage further:

> The better to impress the story of the Passion on your mind . . . it is helpful and necessary to fix the people and places in your mind: a city, for example, which will be the city of Jerusalem—taking for this purpose a city that is well known to you. In this city find the principal places in which all the episodes of the Passion would have taken place—for instance a palace with the supper room where Christ had the Last Supper . . . and that of Caiaphas . . . and the room where he was brought before Caiaphas and mocked and beaten. Also the residence of Pilate . . . also the site of Mount Calvary, where he was put on the Cross and other like places. . . .
>
> And then too you must shape in your mind some people, people well-known to you, to represent for you the people involved in the Passion . . . every one of whom you will fashion in your mind.
>
> When you have done all this, putting all your imagination into it, then go into your chamber. Alone and solitary, excluding every external thought from your mind, start thinking of the beginning of the Passion, starting with how Jesus entered Jerusalem on the ass. Moving

192

slowly from episode to episode, meditate on each one, dwelling on each single stage and step of the story. And if at any point you feel a sensation of piety, stop: do not pass on as long as that sweet and devout sentiment lasts.[2]

At Varallo the principles of familiarity and particularization were to be exemplified and expanded, not in the interiorized way of this and the other meditational handbooks, but on a public level. It is in the light of passages like these that we must imagine the progress of travelers and pilgrims from chapel to chapel.

In 1486 Caimi obtained papal permission for his plan. It was encouraged by Carlo Borromeo, who frequently visited the "New Jerusalem," as he called the site. After completion of the first three chapels by 1493, there followed a period of intense activity between 1510 and 1610. Work was entrusted to a number of the most distinguished artists of the region, beginning with the participation of Gaudenzio Ferrari in all three branches of the arts deployed there—painting, sculpture, and architecture.[3] More chapels were built and adorned in the eighteenth and nineteenth centuries; so like the lengthy and piecemeal construction of all the *sacri monti,* with the exception of Varese (to which we shall shortly turn), the huge number of painted and sculpted figures provide, apart from anything else, extraordinary evidence of the continuity and transformation of images that were to serve exactly the same purposes for hundreds of years. The visitor now has to make a tour of forty-five chapels containing scenes that begin with Original Sin and the Annunciation and culminate in a fully expanded version of the Passion. The architecture of the earlier chapels is rudimentary in the extreme, but later they become graceful scenographic evocations, as in the Piazza dei Tribunali, with its palaces of Caiaphas and of Pilate, from which Christ was shown to the people (fig. 104).

In the first chapel at Varallo, Adam and Eve stand amid an Edenic assemblage of animals in front of a rather unluxuriant tree; the nineteenth-century frescoes in the background are so bland and wooden that to most of us now the scene will not seem especially involving (fig. 105). But this is only a beginning. When we get to the charming scenes of the Dream of Saint Joseph nearby, and the Procession of the Magi, with their stuffed horses and matted coifs, the cumulative spell of the polychrome sculptures, which begin to merge with the painting of the background and sides, sets to work. With the chapel of the Massacre of the Innocents, the effect is irresistible. The figure of Herod may be wholly unconvincing, but we soon forget him as we perceive the horror of the rest of the scene. Here is a terrified mother with real hair and everyday beads: she sheds mucid tears as she exposes her fractured nipple beside the cruel and scarred executioner (fig. 106). The other grief-stricken mothers strain their heads back in an-

104. *Top:* Piazza dei Tribunali, Varallo, Sacro Monte. Photo author.

105. *Above: Adam and Eve,* Varallo, Sacro Monte, first chapel (1565–66; statues, 1594–98). Photo author.

106. *Opposite: The Massacre of the Innocents,* grieving mother and dead baby, Varallo, Sacro Monte, Chapel of the Innocents (1586–94).

guish; while the vivid but violated bodies of the massacred babes relentlessly insist on the living grimness of the moment (figs. 107). This pitch of involvement is maintained in scenes like Giovanni d'Enrico's *Crowning with Thorns* and his and Morazzone's *Ecce Homo*. Such is the raw power of Christ's bloodied body, the poignancy of his downcast gaze, and his clotted hair, such is our shock at the cruel executioners with their bulging veins and terrifyingly goitered necks (fig. 108), that the perception of living presence extends to the painted figures in the background as well. By the time we come upon the final scenes of the Passion and the Burial, we grieve with the Marys and the Josephs, the John the Evangelist and the Nicodemus; they are sentient beings like ourselves; their pain is our own. And always the grilles prevent the ultimate verification of their fleshliness: but the suspension of final proof and the urge to verify makes the perception of the body as real still more acute.

No other class of Western imagery—except perhaps the large-scale waxworks which we will discuss below and sculptures such as those by Kienholz—offers the same deployment of every conceivable device to particularize, familiarize, and make vivid as do the sculptures of the *sacri monti;* few others have been so continuously and extensively preserved in settings of such unparalleled evocativeness; none provide such constant evidence of a function that has changed little over five centuries.

Sanctuaries similar to the one at Varallo sprang up all over the upper reaches of the Lake District of North Italy, particularly at the end of the sixteenth century and the beginning of the seventeenth, and many continued to be expanded in the subsequent two centuries as well. They are not all devoted to the same subjects—at Varallo it is the Life and Passion of Christ, at Oropa the Life of the Virgin, at Orta San Giulio the Life of Saint Francis, at Varese the Fifteen Mysteries of the Rosary—but they are all on mountainous sites, often notably beautiful, and all are composed of a series of chapels containing statues and paintings of the most lifelike quality.[4] At Varallo there are over 600 statues and 4,000 painted figures. The striving for verisimilitude that is the subject of this chapter is nowhere seen as clearly as in the *sacri monti,* nor on so grand a scale. The statues are all painted in full color, with attention not only to the realism of clothing, as one might expect, but to the eyes and to other physiognomic features. Often, though by no means always, the hair was not just painted, it was real (or of a similarly fibrous substance). Faces grimace with exaggerated expressions; wounds and blood are vividly shown. The aim, of course, was to engage the spectator in a directly empathetic relation with the scene; and this is just what these shrines—which are devoid of relics or other such attractions—continue to do, as they always have for those who flocked to them.

From the busy town of Varese, the road stretches upward into the high

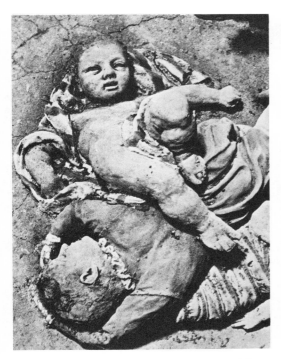

107. *Left: The Massacre of the Innocents,* detail of dead children, Varallo, Sacro Monte, Chapel of the Innocents.

108. *Right:* Giovanni Tabacchetti, *Goitred Tormenter of Christ,* Varallo, Sacro Monte, Chapel of the Road to Calvary (1599–1600).

hills overlooking a blue lake. After a gradual climb of about six kilometers, one comes to a shaded inn where one may eat and drink. There is a corner, some steps, and then, in a clearing, the great triumphal arch surmounted by a statue of the Virgin. This is how the ascent of the Sacred Mountain of Varese begins.

The way is open and verdant, with ever-changing views of the lake, the Lombard plain, and the mountains beyond. Fourteen small chapels, each one charming and different from the other, punctuate the route; built by Giuseppe Bernascone starting in 1604 they are devoted to the mysteries of the rosary (fig. 109).[5] The traveler and pilgrim stops at the simple first chapel and sees the most vivid possible enactment of the first of the mysteries (fig. 110). Here the Annunciation takes place, in a combination of painted setting, polychrome sculpture with real hair and glass eyes, real furniture, and simple clothing. This is no longer the representation of the scene, but the presentation. Only the grille prevents the spectator from moving among these actors and from discoursing with them; but that interposition, that barrier, only serves to heighten the sense of realism. One cannot get in to prove that they are just stuffed or wooden figures; one must

109. Chapel of
the Nativity,
Varese,
Sacro Monte (1605–8).
Photo author.

110. Annunciation,
Varese,
Sacro Monte, first
chapel
(1605–10).

believe, and one does believe, that they are real, however much one may wonder at the kind of craftsmanship that makes the figures appear so vivid. They are beings like us, and we are like them.

This is how Samuel Butler described and commented on the chapel of the Annunciation in his charming *Alps and Sanctuaries* of 1881:

> The Virgin had a real washing stand, with a basin and jug, and a piece of real soap. Her slippers were neatly disposed under the bed, so also were her shoes, and, if I remember rightly, there was everything else that Messrs Heal and Co. would send for the furnishing of a lady's bedroom. . . . The object is to bring the scene as vividly as possible before people who have not had the opportunity to realise it to themselves, through travel or general cultivation of the imaginative faculties. How can an Italian peasant realize to himself the Annunciation so well as by seeing such a chapel . . . ? Common sense says, either tell the peasant nothing about the Annunciation, or put every facility in his way by the help of which he will be able to conceive the idea with some definiteness.

Not only the peasant, but also the "generally cultivated," is the only qualification one would want to make here. Butler goes on:

> We stuff the dead bodies of birds and animals which we think it worth while to put into our museums. We put them in the most life-like attitudes we can, with bits of grass and bush, and painted landscape behind them. By doing this we give people who have never seen the actual animals, a more vivid idea concerning them than we know how to give by any other means. . . . Each bird or animal is so stuffed as to make it look as much alive as the stuffer can make it,—even to the insertion of glass eyes. . . . Over and above the desire to help the masses to realize the events in Christ's life more vividly, something is doubtless due to the wish to attract people by giving them what they like. . . . For the people delight in these graven images. Listen to the hushed "oh bel" which falls from them as they peep through grating after grating; and the more tawdry a chapel is, the better as a general rule they are contented. They like them as our own people like Madame Tussaud's. . . . But how pray can we avoid worshipping images? or loving images. The actual living form of Christ on earth was still not Christ, it was but the image under which his disciples saw him; nor can we see more of any of those we love than a certain more versatile and warmer presentment of them than an artist can counterfeit.[6]

It is true that there is a patronizing quality in all Butler's references to "the people" and their taste, in his implicitly superior stance to Catholic image-worship, in the general sense of cultural superiority that he cannot avoid

betraying; but at the same time, he seems clearly to acknowledge the implications of all this for more general attitudes and involvements; and so, in this charming passage, he has managed to compress a number of key issues. The parallel with Madame Tussaud's is most apt. Of course the beholder is capable of aesthetically distancing himself from the scene before him, of avoiding involvement and simply admiring the art and artifice with which it is made. But at the same time, the fusion of image and prototype is powerfully facilitated by the deployment of every possible device: from polychromy and real hair to the actual trappings of everyday life. The spectator sees living beings, animate, not ones rendered mortal by history, but ones which are like him, of (apparently) the same breath, blood, and flesh.

Everything about the tableaux in this and the other *sacri monti* encourage this mode of involvement, to such a degree that even the two-dimensional paintings in the background acquire a presence that we perceive and respond to as living.[7] We see the tender eight-year-old Christ surrounded by the hateful Pharisees, and the Massacre of the Innocents, again, where we spontaneously draw back from the bloodied bodies of the infants, and where the pain that registers on the faces of the distraught mothers becomes, perhaps only momentarily, the pain we feel ourselves. The distancing that results in aesthesis gives way to immersion in the plight of these others. Such empathy was the goal of meditation with the aid of images, but the scenes of the *sacri monti,* so explicitly bodied forth, are infinitely suggestive of the possibility of such responses. Perhaps it is only skilled practitioners, only the most faithful, who may feel this way with (for example) engravings of the Crucifixion; but we do not have to be especially pious to be horrified at the puncturing of flesh that yields and bursts like our own.

The journey to the last of the chapels and the sanctuary in the little town at the summit of the mountain becomes increasingly compelling, the views ever more ravishing; and by the end every possible emotion has been engaged in the course of our participation in what, on the face of it, may seem mere representation. It might be argued that it is the natural beauty of all these sites that in the first place inclines the mind to contemplation, and prepares it for the kind of attention described here. But one should not mistake a necessary preliminary stage for that which actually produces the effect. While the splendor and isolation of the sites plays an undoubted role in inducing the receptive mind to pious repose, it is the images themselves and their verisimilitude that actually channels attention and activates emotional engagement. The effects, of course, are cumulative, but they are directly the consequence of the sustained and continuing realism of the individual scenes. Only the most intellectual of people will have attempted to resist the automatic transition from seeing to empathy and involvement—and they will have resisted and attempted to deny some of the most

fundamentally spontaneous elements of the relations between feeling and perception.

<div style="text-align:center">I</div>

Concern with verisimilitude haunts the reproduction of the living. Produce again, not reflect, illustrate, portray, or image. The striving for resemblance marks our attempts to make the absent present and the dead alive. Symbolic tokens, what Edward Sapir once called "condensed symbols," may commemorate the dead or suggest the living; but only the figure resembling human form enables the reconstitution of life.[8] We see the familiar anatomy and invest it with familiar sentiments; and then alien materiality can breathe, bleed, and feel. Perhaps we remind ourselves of the inert substance of figured form; but like the emerging and vanishing shapes of an optical illusion, all sense of that substance disappears; to be replaced by the insistent and living reality of the figure—of the figure itself, and not merely the recollection of the figure resembled.

The issue is the striving for resemblance—not, it is to be emphasized, the attainment of it; not whether or not it can objectively be said to be achieved.[9] For how could we measure, by any absolute standard, its successful attainment? The great investigations and experiments of E. H. Gombrich have demonstrated the convention-bound nature of the perception of resemblance and the illusion of reality; and Nelson Goodman has brought the full force of his philosophical skepticism to bear on the possibility of resemblance, similarity, and realism. It may be that to speak of the illusion of reality is to deploy an essential heuristic category; but in this chapter we must begin our assessment of the problem of the reconstitution of living reality by the beholder of figured form. The process whereby this happens has almost always been "explained" by the employment of some generalized notion of magic, or magical thinking. The time has come to put paid to such strategies, and to suggest their inadequacy as appropriate explanatory categories.

"In certain circumstances," Kris and Kurz irrefragably observe, "men are inclined to equate the picture and the original it depicts."[10] But this is how they go on: "Such conditions are more easily found among primitive peoples than among people who have reached our level of civilization, though in our culture they do occur in the wake of mental illness or in situations that are charged with intense emotions; they evolve more readily in crowds than in an individual; they occur more frequently in children than in adults."[11] How convenient this relegation of behavior to primitives, to neurotics and psychotics, to crowds and children. Kris and Kurz perfectly exemplify the reluctance to admit to "our level of civilization" a propensity which they

themselves identify; and this reluctance—and fear—remains one of the greatest obstacles to the proper analysis of response. It shifts the level of explanation to something other, to primitive, pathological, and infantile states. As usual, the possibility that we ourselves may equate picture and original (or, indeed, that we may choose not to acknowledge the equation) is entirely suppressed; and it is done in an inadvertently deceptive way. Of course Kris and Kurz have a neat explanation to hand. They decide that "magic" is involved (which is naturally not part of of "our" culture) and that that explains what happens. They refer to the Chinese tradition according to which the painter avoided putting eyes in his portrait to prevent it coming to life: "The idea that the artist would thereby retain control over his creation—by denying it full vitality as it were—is rooted in magical beliefs." [12] Now if we insist on claiming that such traditions "shed light on the attitude of the artist to his work" (rather than confronting the issues of response), then we may have to have recourse to an unanalytic concept of magic; but in this and all such cases we are not merely dealing with the "functions" of the image broadly taken, but quite specifically with the constitutive response of the beholder.

There is nothing magical about the correlation of the completion of an image by painting in the eyes with the attribution of life to it. Either the phenomenon exists on the level of pure metaphor or it has a perfectly deducible reality for the beholder. Eyes, as we have repeatedly seen (and will continue to see), provide the most immediate testimony of life in living beings; in images—where substance, at the first level, excludes the possibility of movement—they are even more powerfully capable of doing so. If an image is perceived as particularly lifelike, then the absence of the eyes may inspire terror. [13] Their presence enables the mental leap to an assumption of liveliness that may not, in the first instance, be predicated on similarity or on the skill of the artist of craftsman. Hence the perceived liveliness of images with eyes, or the acquisition of vitality by acts of completion involving the insertion of eyes. [14]

Kris and Kurz reinforce their intellectualist and solipsistic position by claiming that "the 'stronger' the belief in the magic function of the image, in the identity of picture and depicted, the less important is the nature of that image." [15] They do not make the basis for this assertion clear, or what exactly is meant by the latter part of the phrase; but they go on to maintain that "whenever a high degree of magic power is attributed to an object—whether this be the fetish of primitive man or the miracle-working ritual of civilized man—its resemblance to nature is rarely of decisive importance." [16] Their assertions thus become wholly a prioristic; and one wonders, again, on what basis the judgments about magic are made. One can imagine proceeding the other way round.

Furthermore, although the hypothesis about the comparative unimpor-

tance of the nature of an object and its resemblance to nature may seem attractive, by what standards do Kris and Kurz judge "resemblance to nature"? By their own. The history of images does not, in fact, provide much to corroborate the claim that the efficacy of magical images (whatever they may be) has little to do with their resemblance to nature. The unspoken assumption here is that magical images are "primitive," and that "primitive" images are only rudimentarily shaped, or somehow distanced from nature; but that assessment only reveals the limits of our standards. It has nothing whatsoever to do with the conception of resemblance possessed by the makers or consumers of those images.

Kris and Kurz enlist the aid of Heinrich Gomperz: "Where the belief in the identity of picture and depicted is in decline, a new bond makes its appearance to link the two, namely similarity or likeness."[17] But the basis for measuring such "decline" could not be more uncertain. All such writers have to go on are their preconceptions about the progress away from magical beliefs, and their own perceptions of similarity and likeness. There are two spurious postulates here. The first is the equation of the identity of picture and depicted with magical beliefs; the second is the correlation of similarity and likeness with the attenuation and disappearance of such beliefs. What these writers mean, of course, is that images which to *us* seem lifelike can no longer be regarded as magical—that is, as subject to the conflation of image and prototype. So Kris and Kurz go on to insist: "At the dawn of Greek art, when the belief in the identity of picture and depicted was prevalent, there was little or no concern with making the work of art as lifelike as possible."[18] It may be that if they insist hard enough, these ideas will gain acceptance; but the claim is a fanciful invention with no apparent basis in fact. It is, for reasons I have already outlined, a pseudo-anthropological view of the beginnings of art.

But perhaps their idea is that magic (of the kind they identify) is predicated, somehow, on the free flow of imagination. It is an appealing notion, because of its simplicity. But the correlative implication—that similarity and resemblance restrict the limits of imagination—does not bear a moment's examination. There are genuinely important issues at stake here, but they are clouded by preconceptions. Let us consider these issues—and some of the related evidence, omitted by or unknown to Kris and Kurz—in different terms and in greater detail.

The artist who is deemed to have successfully conveyed the illusion of living reality may acquire godly or demiurgic status; but the status thus acquired is a metaphorical one. There is no question of magic here. Few people, if any, think that the artist is actually a god or demiurge (of course it may occasionally be believed that a work is genuinely of divine origin, but that is a different matter). We know, after all, who they, the gods and demiurges, really are. When the artist or craftsman makes an image that

seems alive, he seems to emulate the god, to be like him in his creative powers; he can make the dead substance alive. But since we know that the artist is not, in fact, a god, the process of aesthetic distancing and differentiation supervene with some clarity. What then happens when the act of more or less self-conscious differentiation is suspended? What subverts the clues to inert materiality? It is precisely the perception of similarity; and when the final subversion occurs—say the painting in of the eyes—we can no longer deny the life of the image.

All this is clumsily to make a claim about cognition. The lack of adequate discursive terminology for the processes whereby we respond to the visual imagery that affects us powerfully makes us fall back on the more emotive and sentimental categories of spontaneity, instantaneity, and helplessness. But in none of this is there, nor need there be, any place for magic.

It now becomes easier to account for the fact that sometimes the fear of images occurs more acutely in the case of painting than of sculpture. A painting provides fewer material and physical clues to the illusion of liveliness, so that when the beholder does reflect on his own suspension of belief in that illusion, he is likely to be even more embarrassed or afraid than in the case of figures already in the round. These are old topics, but they are neither fanciful nor pure inventions. Their psychological bases survive the test of self-examination. We modern beholders may indeed stop ourselves and engage in some process of differentiation, but the historical burden of all looking staves off the successful attainment of that process. For too long we have been accustomed to suspend differentiation; so that even with contemporary images, most of us cannot engage it without prior discipline and practice.

Consider the impulse to represent the dead. In ancient Egypt the *ka* was regarded as a species of soul, which exactly reproduced the form of the individual to which it belonged. On the death of a particular person, an image of him or her would serve as appropriate receptacle for the *ka:* hence the living powers attributed to Egyptian funerary images—or so one explanation goes. [19] If this account is correct, it does not seem difficult to explain movement and other vital forces, or the striving for resemblance; but where concepts of the soul are less explicit, or where metempsychosis is taken as sufficient explanation (or a substitute for it), the matter is more complicated.

"Represented by the skillful hands of craftsmen," says the grieving Admetus to his dying wife, Alcestis, "your body will be stretched out on the bed; and I shall fall down beside it and throw my arms around it, call your name, and think I hold my dear wife in my arms—even though I do not hold her. Vain gladness [lit. cold enjoyment] then, but still it would lighten the heaviness of my soul." [20] Perhaps it is not surprising that one might be aroused to passion by an image of a dead lover or spouse. It is the

suggestive substitute for the lost body; it fills the lacuna that cannot yet be replaced by another; and so it looks as much like the departed as possible. But implicit in the words Euripides gives Admetus is the correlation between resemblance and efficacity. If the solace Admetus seeks could be provided by a mere symbol of, say, one or more of his wife's qualities, then he would not need to speak of the skillful craftsman; but he wants to embrace an image that reproduces her as she was, as if she were alive. The only substitute for the dead, in instances like this, is resemblance to the living. When Admetus embraces the skillfully wrought image, he can imagine her there. The closer the resemblance, the more successful the imagining, and not—as Kris and Kurz would have it—the other way round.

But perhaps it will be argued that the case of Admetus is exceptional. His beloved was on the verge of death, and he was in a fractured and labile state. He might reach out to embrace that mute image; he might want to clasp anything, let alone the figure of the woman of whom he had so freshly been deprived. But would we, in more normal and levelheaded states? Even Admetus admits that the solace of the image is just illusory. But could it not be that overwrought and neurotic behavior in itself provides clues to more normal responses? In such cases, it might be argued that the unbridling of emotion reveals exactly the propensity which we are normally able to restrain or suppress. Indeed, if we consider the functions of portraiture, it seems clear that all this is not solely a matter of disturbed states of mind. With portraiture it is only resemblance to the lost dead or the absent friend, or lover, or suitor, that enables it to function successfully. Hence the striving for accuracy of representation and accuracy of attribute. An unsophisticated criterion of success might be the perception that the eyes follow one round the room, since in this way one can acknowledge both skill of representation and its corollary, successful functioning. But let us pursue the historical evidence for the concern with verisimilitude further.

II

A common allegation of the Reformation critics of images was that it was ridiculous to suppose that images of Christ and the apostles actually looked like Christ and the apostles. Charges like these were bound to arise in response to the continued claims on behalf of the historical accuracy of surviving images of Christ, the apostles, and the saints. After all, the Catholic defenders of images argued, it was still possible to see images dating from apostolic times, such as the many images reputedly painted by Saint Luke. Of course, as everyone knew, he could not possibly have painted so many himself; but that was hardly the point. Nevertheless, the survival of a considerable number of images supposedly painted by Saint Luke, or dat-

ing from apostolic times, or of apparently divine origin, was used, in the first instance, as a means of justifying the antiquity of the practice of making images in the service of the Church.

The claim that pictures of Christ survived from apostolic times never ceased to be repeated,[21] along with the suggestion that such images provided an accurate source for all subsequent representation. Hence the Protestant skepticism. But if the strong claims for verisimilitude and accuracy had not been made, the charges that arose from this skepticism could easily have been defused; and they never were. Verisimilitude is not and was not a necessary adjunct to the function of images as an aid to memory. The orthodox apologists themselves knew that.[22] Why did they not simply maintain that no matter what images looked like, they could still serve—with appropriate indications—as tokens or symbols of what they were supposed to represent?[23] Such a position would have been perfectly consistent with the dogmatic ontology of images in general; but it would have undermined one of the cornerstones of the whole apologetic and defensive structure: that certain antique images provided secure evidence of how Christ and his saints looked, and that that factor justified their continued representation.

It might be thought, at this stage, that these are different issues. "Accuracy of portrayal" might roughly be taken to imply the accurate representation (or what passes for accurate representation) of the individual features of a physiognomy. The striving for verisimilitude, on the other hand, might be understood to imply the striving toward reproduction of total reality. "Accuracy" then is predicated on the differentiated perception of the portrayal as close reflection of reality; "verisimilitude" not merely on the illusion of real life, but on its substantively substitutional quality. It is possible that the best way of understanding the nature and complexity of the link between accuracy as a reflective category (i.e., the accuracy that mirrors) and constitutive verisimilitude (i.e., a resemblance that re-produces) is provided by the case of images of Christ. Here theology is ontologically exemplary.

The Christian doctrine of the Incarnation holds that Christ is at once fully God and fully man. His divine nature is not circumscribable, but his human nature is. That embattled article of faith exemplifies the problem of representation. How can one represent the humanity of Christ without impairing the integrity and permanence of his divine nature, as the doctrine of the Incarnation demands? To symbolize Christ by means of a cross or fish or lamb may leave his divinity unimpaired, but the only way to grasp his human nature is to represent him as man.[24] The form of man, however, is vitiated by a whole variety of accidents—even though he is an image of God. Yet how else can one know Christ? Let us consider the consequences of so fundamental a tension. We will stay with Christian theology, though

closely similar questions arise in the case of images of Buddha. It may be, for example, that to symbolize Buddha by means of a wheel leaves his divinity unimpaired; why introduce the signs of earthly presence in the shape of recognizable human forms? But representation of Buddha then also takes on the marks of humanity, and accuracy supervenes. The tension remains.[25]

By the end of the third century, Eusebius of Caesarea had already recorded the presence of a Christian sculpture at Paneas. It showed Christ healing the woman with the issue of blood (the Hemorrhoissa of the gospels).[26] In introduces an untidy nexus of stories that illuminate these issues. When Eusebius tells of it, he notes that "it is not surprising that Gentiles who received such benefits from our Saviour should have expressed their gratitude thus, for the features of Peter and Paul, and indeed of Christ himself, have been preserved in coloured portraits which I have examined."[27] According to Macarius of Magnesia and other fourth-century writers, the group (possibly a Hellenistic sculpture of another subject entirely) was supposed to have been set up by the Hemorrhoissa herself.[28] At about the same time, she was identified as Bernice or Veronica in a version of the apocryphal Acts of Pilate. By the seventh century, the Hemorrhoissa/Veronica tradition underwent a crucial change. Veronica is supposed to have gone to a painter for a picture of Christ. "When my Lord was going about preaching I was deprived of His presence, much against my will. For that reason I wanted to have His picture painted for me, so that, when He was not present with me, the figure of His picture might at least afford me consolation."[29] On her way she met Christ himself. He took the cloth from her, pressed it to his face, and left an impression of his features on it.

So two traditions emerge. The first, less important, one is that the Christ of Paneas was based on this direct (and therefore impeccably accurate) image. The second is more significant. By the twelfth century the *sudarium* with which Christ wiped his perspiring and bloodied face on the road to Calvary, again leaving his features imprinted upon it, is supposed to have been in Saint Peter's in Rome.[30] This object was called the Veronica (cf. *vera eikon*), and so the most popular of all these legends arose from a conflation of the events recounted here. A woman from Jerusalem named Veronica offered her headcloth to the Lord to wipe the blood and sweat from his face on the way to Calvary, and he returned it to her with his features impressed upon it (fig. 111; cf. figs. 15 and 117).[31]

But this is not all. To the confusing Veronica tradition—in which the factor of fidelity to Christ's actual features is just about the only constant—must be added the group of stories around the famous mandylion of Edessa.[32] Again it is Eusebius who gives the kernel of the story, taken from the correspondence between Abgar V of Edessa and Jesus himself—a correspondence supposed to have been preserved in the Edessene archives.

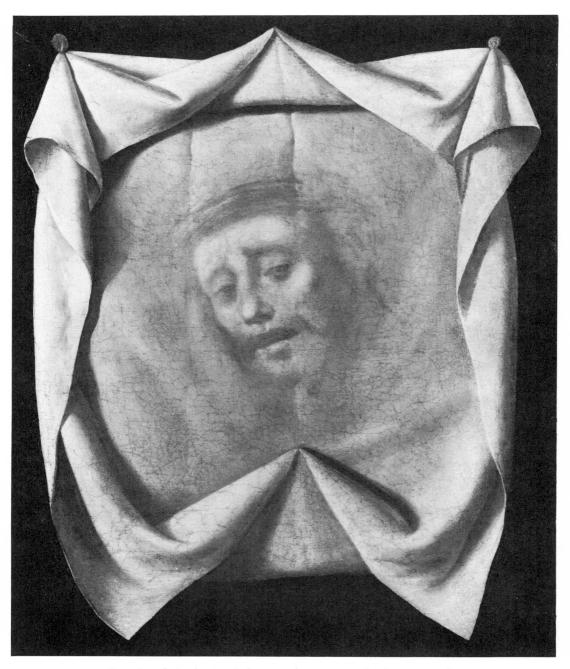

111. Francisco de Zurbarán, *Sudarium* (1635–40). Stockholm, Nationalmuseum.
Photo Statens Kunstmuseet.

Abgar was suffering an incurable disease. He wanted Jesus to come to cure him; but Jesus, being busy, had to send his disciple Thaddeus instead, and he effected the cure. Thaddeus is sometimes said to have come from Paneas.[33] In an addition to this legend, Abgar's archivist and court painter took the king's letter to Jesus and there, "in choice paints," made a portrait of him. This he brought back to the grateful king.[34] Still another addition, in the sixth- or seventh-century *Acts of Thaddeus,* records that the image was not made by human hands and therefore had healing powers. This image—just like that of Veronica—was supposed to be a miraculous impression of Christ's face on canvas or towel, and it was this, the so-called mandylion, which Thaddeus held up before his forehead as he entered the room in which the king was seated.

> Abgar saw him coming from a distance, and thought he saw a light shining from his face which no eye could stand. This was produced by the portrait which Thaddeus had before him. Abgar was dumbfounded by the unbearable brightness; and forgetting his ailments and long paralysis of his legs, at once got up and compelled himself to run.[35]

One could hardly wish for a more explicit account of the power of that accurate image. Evagrius in the sixth century also described its use as a palladium. In 944 it was transferred to Constantinople with fitting pomp and devotion.[36] There it remained until the sack of 1204; but its subsequent fate is unclear, with various towns claiming it, including Paris, Rome, and Genoa. The Parisian exemplar, predictably, was burned in 1790.

Whether they considered the image to be that of Veronica or that of Edessa—or a conflation of both—artists could thus refer to an absolutely authentic representation of Christ's features. The Shroud of Turin has, naturally enough, been repeatedly identified with the Edessene mandylion, even though the mandylion is never supposed to have originated as the shroud in which Christ was wrapped on his burial, and even though the recorded history of the shroud that survives in Turin can really not be pushed back much beyond the fourteenth century.[37] But it is sufficient to emphasize that at least from the fourteenth century on, we have an available image that is reputed to have been impressed with Christ's living features and which thus provided authority for his representation. Then there is the image which seems to have been at Rome since the eighth century, and was transferred by Boniface VIII to Saint Peter's in 1297, and which provided the basis for the extraordinary number of representations of the *sudarium,* culminating in their great popularity during the seventeenth century. There are also a large number of other images not made by human hand, most notably the apparently sixth-century picture which is the object of all those people who ascend the Scala Sancta in the Lateran.[38] All provide additional

authority for representations of Christ. So do the umpteen images of Christ and the Virgin, from Rome and Tivoli to Regensburg and Brussels, reputed to have been painted by Saint Luke—and they are the basis for thousands of copies. Finally, there are the copies made from the fifteenth-century on, of a profile portrait which appeared on an emerald seal given by the Sultan Bajazid II as a ransom for his brother to Innocent VIII. Such is the hunger for accurate images of Christ (as if only accuracy could guarantee efficacy) that a medal cast from this gem provides the source for the "authentic portrait of our Saviour" that is still sold in photographic, engraved, and other forms of reproduction at fairs and other special occasions throughout Southern Europe.

Given prototypes like these, then, it may seem surprising that worry about how Christ actually looked should have persisted. But how can we be sure that the human hand is capable of representing him, not just correctly, but in all his perfection? And if the results fall short—as they must—how can we be sure of his divinity or, indeed, of his divine incarnation as man? Questions like these present conflicting exigencies; and they are reflected in the centuries of discussion about how Christ really looked. On the one hand, we find highly idealized reports; on the other, insistence on the putative realities of the way he appeared on earth.

The fullest supposedly authentic account is the so-called Lentulus description. Although it probably dates to no earlier than the thirteenth century, it purports to be of apostolic origin. Its influence on actual representation was to be substantial. The best version takes the form of a letter, prefaced by lines that assert its historical validity:

A certain Lentulus, a Roman, being an official for the Romans in the province of Judaea in the time of Tiberius Caesar, upon seeing Christ and noting his wonderful works, his preaching, his endless miracles . . . wrote thus to the Roman senate:

There hath appeared in these times, and still is, a man of great power named Jesus Christ. . . . A man in stature middling, tall, and comely, having a reverend countenance . . . having hair of the hue of an unripe hazel nut and smooth almost down to his ears, but from the ears in curling locks somewhat darker and more shining, waving over from his shoulders; having a parting at the middle of the head . . . a brow smooth and very calm, with a face without wrinkle or blemish, which a moderate colour [red] makes beautiful; . . . having a full beard the colour of his hair, not long, but a little forked at the chin . . . the eyes grey, glancing and clear; in rebuke terrible, in admonition kind and lovable, cheerful yet keeping gravity; sometimes he hath wept but never laughed; in stature of body tall and straight, with hands and arms fair.[39]

The tension between detail and idealization could hardly be clearer. Nevertheless, as M. R. James noted, rather wryly: "This follows the traditional portraits closely, and was no doubt written in the presence of one. The Greeks, it may be added, had similar minute descriptions of the apostles and the Virgin—just as they had of the heroes of Troy."[40] But this, of course, is not the point. The purported authenticity of the description is, the authenticity that allowed it to form the basis of a huge range of fifteenth-century images, including ones like the famous and much-copied picture by Jan van Eyck (cf. fig. 15). A Dutch diptych from the end of the fifteenth century in Utrecht contains the face of Christ on the right and the Lentulus description in the vernacular on the left. Then there are the lower genres, where the need to reassure the beholder of authenticity and accuracy is bound up with the implication that to diminish these qualities would diminish efficacy (as in the case of pilgrimage contexts): an Italian woodcut Virgin and Child of around 1500 has a Dutch inscription on the reverse, asserting that "this is the likeness of the image of our Lady and her blessed son in their [exact] features and clothes; it was made after the image painted by Saint Luke in the Church of Santa Maria Maggiore in Rome."[41]

The Lentulus description is an unreservedly ideal one. While purporting to be a first-hand account of Christ's appearance, it leaves little scope for confusion with the likenesses of everyday flawed humanity. The same may be said of the many pictures and sculptures based on this description. Yet as early as the second century, Christian apologists began to be aware of the kinds of problem that might arise from just this notion of idealization-as-resemblance. Justin Martyr insisted that Christ was not at all beautiful or good looking.[42] This he held to be in fulfillment of Old Testament prophecy such as that of Isaiah 52:14 and 53:2—3: "His visage was marked more than any man . . . he hath no form or comeliness . . . and when we see him there is no beauty that we should desire him." Clement of Alexandria, Tertullian, Cyprian, and several other Church fathers all insist on this aspect of the way Christ looked, in other words, on his putative ugliness.[43] But why?

Aside from the constant but here unconscious fear of desire, the clearest reason is articulated by Clement of Alexandria: admiration for Christ's looks would detract from his words. This is neither the first nor the last time that we find the valuation of spoken word over visual form, nor the fear that visual pleasure might somehow displace spiritual content. But there is another reason for the insistence on the unattractiveness of Christ's visage. It is to differentiate his representation from the frank beauty of Greco-Roman imagery and, mutatis mutandis, of the classical gods. This is why Theodore the Lector could hold that the type of Christ with short, frizzy hair was more authentic than the long-haired one, which looked like Zeus (which might in any case, according to Theodore, seem to be more in keeping with

Jesus' Jewish origins). One could hardly wish for a more trenchant example of the tension between authenticity and idealization.[44]

But is not the case of images of Christ a special one, made so by virtue of his unique incarnation? That miracle gives rise to the particular problems of representation outlined here, and to the unique potentiality of all images of him, not just of the archetypal *acheiropoietai*. One might argue that it enables all images of him to seem capable of behaving or performing in ways that transcend their materiality. But other images also behave and perform thus (always depending, of course, on the constitutive response of the beholder). I take the case of Christ's images to be wholly paradigmatic.

We can only know Christ if he is incarnate as man; and so we must be able to represent him. But if we represent him—rather than symbolize him—then he can only be represented in the most accurate possible way. Otherwise we impugn his divine wholeness and unity. One class of images allows for no inaccuracy—the direct impressions of his face, or of his body (as in the occasional case of the imprinted shroud or *epitaphios*). But all other images must strive toward the greatest possible verisimilitude. Then we will have not merely an image of Christ; we will have an image that so closely mirrors the miracle of the Incarnation that absence becomes presence and representation reality.

But this is precisely the consequence of all instances of perfect verisimilitude. Of course we can never attain it, but it is in the belief that reproduction of this kind is possible that we strive so desperately toward achieving the exactly mirroring resemblance of reality. Hence the parallel between the desires of Veronica and Admetus. Each wants an image that can provide consolation for absence; but only in Veronica's case is desire completely fulfilled by the happy substitution of a direct impression of Christ's face—instead of a representation that is merely painted. But what if Admetus had asked for a wax cast? Let us make one major distinction before we proceed. While the direct impressions of Christ's face are always miraculous and acknowledged to be so, direct impressions of anyone else's face are not. The miracle for Admetus would have consisted precisely in the artistic attainment of total and perfect resemblance, without resort to a mode of direct mechanical reproduction. How does the photograph that consoles work? Let us consider the matter of resemblance in the context of other classes of imagery.

III

Nothing is more amazing that when we pour cold plaster of paris over the dead—and even the living—and carve it, having smeared oil over it, or plaster of paris, or paper [i.e., papier-mâché], or clay, and thus make a man, with the result that the image differs from a man in no

way except in terms of colour and in the fact that it does not breathe. But in truth they carefully deal with this matter too: having shaved the beard and cut the hair of the dead man, they stick hair to the image; then they add colour and thus make a living image. I saw an image of this kind of the recently deceased François Ier at the home of the illustrious Cardinal de Tournon. For art could not have made anything more like a man than that image, nor more like the living. Then it was carried out to the funeral.[45]

In these words the great sixteenth-century investigator Hieronymus Cardanus commented on Jean Clouet's wax bust of François Ier or a replica in the possession of the Cardinal de Tournon.[46] Let us now examine the tradition of making deliberately lifelike images—usually in wax—and consider the functions to which they were put. Besides the modern wax museum, their use falls into six main contexts, namely: in funeral ceremonies, as ancestor portraits, in votive and judicial contexts, in witchcraft, and as aids to anatomical study.

The ancestral and funerary contexts are obviously related; but while it is difficult to find references to the use of ancestral portraits before the fourth century B.C., the funerary context is very much earlier. One of the main prerogatives of the Roman nobility was the so-called *ius imaginum,* the right to have images "for the sake of memory and posterity."[47] Such images were displayed in the atrium; all, but most obviously those of wax, show an overt concern with verisimilitude, as a means of ensuring an adequate record for posterity (figs. 112 and 113).[48] Later on reservations arose: while one might accept verisimilitude as more or less sufficient for the representation of appearance, was it not, potentially at least, in conflict with the need to provide an adequate record of virtue?

Polybius describes what happens after the burial of the corpse. The portrait, according to him, is placed

in the most prominent part of the house, and enclosed in a wooden shrine. This image is made to be as close as possible to the appearance of the dead man, both in its form and according to the inscription beneath it. Such images are also carried round in public ceremonies, and are adorned as beautifully as possible. But when a prominent member of the family dies, they carry it in the funeral procession, and clothe it according to his standing and status.[49]

Julius von Schlosser, the greatest historian of wax images, offered the following apt comment: "The Gallery of Ancestors is therefore only secondary; the most important aspect of this development is the portraiture of the dead, intended to preserve his personality beyond the grave."[50] He then went on to ascribe this function of the lifelike portrait to some vaguely

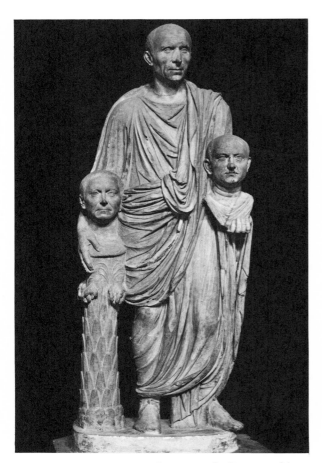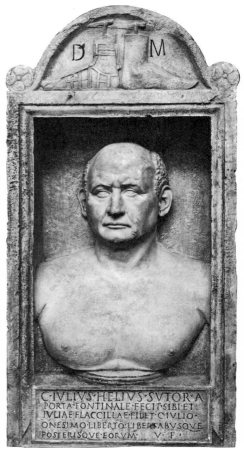

112. *Left:* Statue of a Roman nobleman with his ancestral busts (late first century B.C.). Rome, Palazzo dei Conservatori. Photo Alinari.

113. *Right:* Bust and funerary monument of Caius Julius Helius, shoemaker (late first century A.D.). Rome, Palazzo dei Conservatori. Photo Alinari.

magical process, and has rightly been criticized by Wolfgang Brückner for his repeated recourse to such categories.[51] Brückner calls attention to the obvious fact that increasing verisimilitude has as much to do with artistic skill as with some form of magic or another.[52] Or has it? Where, we may be inclined to ask, does artistic skill enter into the taking of casts from the living or recently deceased model, and how much art goes into the making of wax images? (Or so we may have been inclined to ask until very recently). Let us consider two further aspects of the passage from Polybius.

On the one hand, he refers to the similarity between the appearance of the image and that of the dead person; on the other, he observes that similarity is underscored by the presence of an inscription. Is this tantamount to admitting that the task of ensuring likeness might fail, or is it there

simply because some beholders may never have seen the model? Again we are on the borderline between the accurate portrayal of specific features and the convincing representation of features, not necessarily specific ones. But how far is it between accuracy and conviction? The claims of accuracy may be such as to shift the generalized schemata of representation much closer to the forms of reproduction and reproductivity. It does seem clear from Polybius's passage that the aim is to make the image look exactly like the dead man (and, we are to understand, to make it so similar that it seems living) in order to convey his character (and mutatis mutandis, his virtues) as closely as possible. The link between likeness and personality could hardly be more clearly put; and so the aim is a state beyond accuracy and closer to reality, to what we may rightly call the greatest possible verisimilitude. Every one of the early sources expresses this aim. Especially from the fourteenth century onward, all means are employed to ensure its achievement, from coloring the image as appositely as possible to providing it with real hair and real clothing. No class of images is more suitable for such purposes than those made in wax.

Since Schlosser's profound investigations in 1911, wax images have been neglected by art historians—presumably because of the (comparatively late) prejudices against verisimilitude. As it becomes more accurate, and then more like the reality of the signified, the image comes to be regarded as more "mechanical," and therefore as less artistic. But attitudes are changing again, and the intrusion or extension of "mechanics" into "art" is perceived as less troublesome altogether.

The Western *locus classicus* for the making of wax images occurs in Pliny the Elder. According to him, Lysistratus of Sicyon

> was the first to obtain portraits by making a plaster mould of the actual features, and introduced the practice of taking from the plaster a wax cast on which he made the final corrections. He also first rendered likenesses with exactitude, for previous artists had only tried to make them as beautiful as possible.[52]

In the explicit opposition between exactitude and beauty may be seen the origins of that attitude which, in the end, led to the denigration of the aesthetic quality of exact images in wax. But more common in Pliny's time was the allegation that however exact an image, it could never render the real personality of the sitter. Yet verisimilitude remained an imperative because only by means of it could an image substitute for the living and the dead. Although Pliny does not mention the funerary context, a host of other antique sources do.[54] One of the fullest accounts is Appian's description of the exequies of Julius Caesar. A wax statue which could be turned to all sides *ek mechanēs* showed the twenty-three wounds of the deceased emperor on all parts of his body, including his face. The crowd was so

moved by this sight that they wailed loudly and burned down the Senate.[55]

It might perhaps be argued that the use of wax images for funerary purposes from the fourteenth to the eighteenth centuries is simply to be seen as a corollary of the continuing practice of mummification, and as a solution to the problem of preservation that inevitably arises with such processes. Instead of presenting the embalmed body, recourse was had to a still more permanent form. The substitute had thus to look as much like the real (embalmed) body as possible. This may be sufficient explanation for the striving for close naturalism and for the evolution of the wax effigy. But the matter, once again, is not quite as straightforward as this.

Schlosser gives several fourteenth-century Italian examples, where the body of the deceased is represented, not lying down, but sitting up; there are antique and Byzantine precedents for this too. In the same passage as the one cited earlier, Polybius specifically noted that the body was more often shown upright than lying down.[56] It is significant that in several accounts an apparently miraculous event occurs, where a body laid out one day is found to be sitting up on the next—or is actually seen to sit up.[52] As in the Roman imperial cases as well, the image usually carries the full insignia of status or office. When it comes to the well-documented use of wax effigies and wax masks in French royal funerals of the next century, Brückner aptly observes that "the intention is not [to make] a copy of nature, but rather to show the physically wasted king in a state of complete health."[58] Here again one encounters the tension between idealization and resemblance; here again accuracy moves to realism.

The earliest recorded instance of this use in France occurs in connection with the exequies of Charles VI in 1422, when "Maistre François d'Orleans, peintre et varlet de chambre dudit feu Seigneur" was charged with painting the head and face of the king "après le vif le plus proprement que on a peu."[53] There are frequent sixteenth-century references to a *pourtraicte* or a *pourtraicture* made "au plus près du vif que faire on peult." It is worth noting that the task of preparing the death masks and effigies so that they look as lifelike as possible falls in almost all cases to a distinguished painter. On the other hand, the practice of taking wax effigies from the body itself meant that the chief artist did not always have to be present, in the first instance at least. Thus in the important case of the effigy of Charles VII in 1461, it did not matter that Jean Fouquet was not present in Mehun-sur-Yèvre at the time of the king's death. After all, the mold could be made and immediately sent to Paris to be painted by Fouquet "comme au vif." Pierre de Hennes, the sculptor (who together with Colas d'Amiens and Jacob Lichtemont of Bourges, had made the death mask and effigy), took the mold there as swiftly as possible. The head was then fixed onto the trunk of the effigy which was being prepared by tailors.[60] This leather effigy clothed in the robes of the dead king served, according to the old custom,

114. Conrad Meit, "Transi" of Margaret of Austria (1528–32).
Brou, Abbey Church. Photo Courtauld Institute.

for the funeral celebrations and the translation of the body to Saint-Denis.[61]
A similar phenomenon occured in the case of the queens and members of
the upper nobility as well. The realism of the wax effigies then became de
rigeur in other media too, as much as they would allow: the most spectac-
ular instances are provided, perhaps, by Conrad Meit's astonishing statues
of Philibert le Beau and Marguerite of Austria in Brou (fig. 114). He also
prepared the *personnaige de la representation au vif,* the funeral effigy, of each
of the couple in 1526. But developments in the history of stone and wood
sculpture are part of another story.[62]

A contemporary account of the obsequies of Charles IX in 1574 enables
us to extend our perception of the function of the funeral effigy:

> While the body *in effigie* lay in this hall, at the hours of dinner and
> supper the forms and manners of serving were respected and observed
> exactly as one was accustomed to do during the lifetime of his Lordship,
> the table having been laid by officers, the service was brought by
> *gentilshommes, servents, panetier, echanson & ecuyer tranchant, l'huissier*
> *marchant devant eux* [and then when the meal was ready] the table was

blessed by a cardinal or prelate . . . all with the same form, ceremony, and *essais* as they would have done in the life of the said Seigneur.[63]

This is entirely typical, at least after the funeral of Anne of Brittany in 1514.[64] The effigy of the dead king is treated exactly as if it had been the living king. When Cèsar de Vendome was embalmed in 1665, he lay in state for three days and continued to be served with his meals—but the provision of meals for the dead is found in the antiquity of cultures ranging as widely as Etruria, Egypt, and China.[65]

It might, of course, be argued that the ritualized performance of such ceremonies simply testifies to the need to demonstrate the preservation of appropriate continuity. Presumably all present would have been well aware that the exact execution of mealtime ritual was no more than that, and that the effigy was just as dead as the king. The king was dead; the ceremonies survived. But why then strive for such realism in the presentation of the body? Why go to such lengths to mask whatever is seen and thought of as schematic? Every care is taken to ensure that the body looks exactly as the king did in his lifetime, usually when he was in the peak of health, always with his distinguishing insignia and costume. The ceremonies demand an effigy which has to be treated as if it were still a living participant, and so it has to look that way.

When wax is not used, other media and forms, as we have seen, may be adopted; but the aim always remains the same. There are instances of the use of papier-mâché, of a mixture of boiled leather, and even of wood, often with moveable limbs.[66] Wood and a plaster, canvas, and hay mixture are used for the English funeral effigies (often referred to simply as a "picture"). Their use closely parallels French practice. But these wooden effigies all have faces and hands of extreme precision, often of wax, or modeled on wax death masks and then colored; and particular attention is always paid to the garments in which they are clothed (figs. 115 and 116). After visiting the tombs in Westminster Abbey, to see the array of such effigies that are lined up in the Undercroft is to be reminded of the modern wax museum.[67]

But there are other developments too that culminate in the wax museum, especially in the field of realistic portraiture. To begin with, it should be recalled that the use of wax masks and wax images of the dead was not only confined to the aristocracy. There are whole classes of commemorative imagery, utilized over a wide social range, outside the funerary context. A famous passage in Vasari on Andrea da Verrochio is pertinent here:

Andrea was very fond of making plaster casts, the material being a soft stone excavated at Volterra, Siena, and many other places in Italy. This stone, baked in the fire, and made into a paste with tepid water may then be fashioned as desired, and being afterwards dried, becomes hard, so that whole figures may be cast in it. Andrea used it to form natural

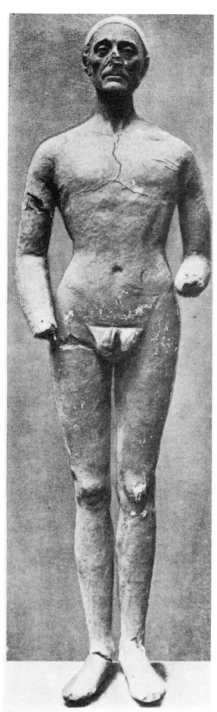

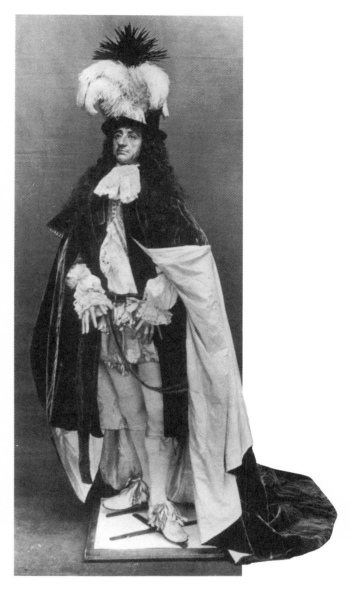

115. *Left:* Mannequin of Henry VII (canvas and hay over wooden core and plaster). London, Westminster Abbey, Undercroft Museum. Photo from St John Hope, *Archaeologia* 60, no. 2 (1907), pl. 61.

116. *Above:* Mannequin of Charles II (wax head and hands, stuffed body over wood and iron core, hair, garments, etc.). London, Westminster Abbey, Undercroft Museum. Photo from Tanner and Nicholson, *Archaeologia* 85 (1935), pl. 55.

objects, so that he might have them before him and imitate them, such as hands, feet, knees, legs, arms, and busts. Later on in his life men began to make at slight cost death masks of those who died, so that a number of these lifelike portraits may seen in every house in Florence, over chimney pieces, doors, windows and cornices. This practice has been continued to our own time, and has proved of great advantage in obtaining many of the portraits introduced into the scenes in the palace of Duke Cosimo. For this a great debt is due to Andrea, who was one of the first to make use of it.[68]

And Vasari goes on to outline the evolution of wax portraiture in Florence, in a passage that we will cite shortly.

Schlosser had already noted in 1911 that this frequently cited passage was clearly based on Pliny's account of Lysistratos's discovery of the means of making natural casts.[69] Certainly the practice of making death masks and effigies was far earlier than Verrocchio, even in Florence.[70] But the further development of realistic commemorative portraiture, often busts, is worth pursuing. Two late seventeenth-century historians illustrate it.

In describing Pietro Tacca's life-size wax bust of Archduke Cosimo (d. 1621), with its natural hair and eyes of crystal, Baldinucci recorded that it was so deceptively naturalistic that when the duke's bereaved mother came to see in it Tacca's studio she was unable to bear the sight of it and had to leave.[71] It may be that this is little more than a retrospective eulogy on the skillful naturalism of the bust, and it might be argued that the response can be sufficiently understood in terms of the emotions of a mother at the reminder of her departed son; but this kind of response is compounded of other factors as well. The first has to do with the eyes: these are the features that are most capable of eliciting emotion in us. This is why the images that trouble us most are those in which the gaze of the represented most actively engages our attention. One has only to consider, for example, those arresting woodcuts of Christ's face where the gaze is so powerfully directed at us that we seem unable to evade it (fig. 117). I claim no more than empirical status for this observation, but it does seem to be borne out by experience. Most beholders of classical statuary will admit to being more than expectedly disturbed by statues in which the eyes are still painted in, or in which they are represented by flickering inserts of metal or crystal (fig. 118)—although the peculiarly realistic waxwork without eyes may be just as deeply troubling as the statues with colored or crystalline eyes, precisely because where we fully expect eyes to be, they are awfully absent.[72]

While this factor may account for the strength of our response to wax images such as the eighteenth-century busts illustrated in figs. 119 and 120, works like these suggest a disturbance that may well occur on a deeper cognitive level. We suspect the inertia of the material of which the image is

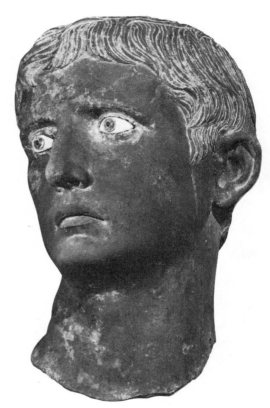

117. *Left:* Hans Sebald Beham, *The Head of Christ, Crowned with Thorns,* state 2 (woodcut; ca. 1520–30; Pauli 829 IIa).

118. *Right:* Head of Augustus (bronze, late first century B.C.). London, British Library. By permission of the British Library.

made, but we cannot discard the impression of liveliness that it makes. The tension implicit in such a perception may, at the very least, cause anxiety; at the most it may cause a terror that is not assuaged by the consciousness of the manmade status of the image or object.[73] Of course we may marvel at the skill of the maker, at mechanical contrivance, and the artistry that makes objects seem real; but at the same time, fear of the lifelike haunts the warring perceptions of the image as reflection and the image as reality. That tension may reach its peak in images of Christ, where his very representation is predicated on his Incarnation; but it is also engaged when we enter the wax museum. Indeed, it is here where we may most easily test all these empirical observations, for in such places we are now accustomed—as we are not always—to suspend aesthetic judgment or to discard it altogether; and thus we remove the restraints of detachment demanded by the a priori assessment of an object as art. In the realism of the waxworks we are still made to confront our fear of the lifelike (fig. 121).[74]

119. *Left: Georg Wilhelm von Kirchner* (wax figure; ca.
1725–50; Schlosser, pl. 22). Breitenfurth near Vienna, Parish Church.
Vienna, Bundesdenkmalamt.

120. *Right: Ferdinand IV of Naples* (wax figure, ca. 1750–1800;
Schlosser, pl. 21). Vienna, Fideikommissbibliothek der Österreichischen
Nationalbibliothek.

It is in these terms too that we should consider the order of response
exploited by the late seventeenth-century makers of automata. In his 1675
treatise on painting architecture, and sculpture, Joachim van Sandrart de-
scribed the work of the wax-sculptor Daniel Neuberger (d. 1660), who
made a particularly good representation of Ferdinand III, "life-size and in
his everyday clothing."[75]

Its head and eyes moved around, and indeed the whole body could sit
itself down and stand up again by means of its internal clockwork. It
was all so natural, that once the Hungarian Chancellor and Bishop of
Neutra was being shown round the royal treasury and came into the
room where this royal image was sitting. It then rose at his arrival, and
moved its head and the eyes this way and that. He was so startled at

121. *Picasso* (wax figure). London, Madame Tussaud's Wax Exhibition.
Courtesy Madame Tussaud's, London.

this unexpected royal presence that he fell to his knees and begged forgiveness for having entered uncommanded; and thus he remained kneeling for a long time, until the *Schatzmeister* raised him up, laughed, and revealed the deceit.[76]

But there is a clear difference between responses to automated sculptures and to ones which are not. The poor ambassador who was so startled to see his king before him was able to laugh upon being made aware of the machinery of the object.[77] Awareness of the mechanics of mobility makes us relegate automata closer to the level of curiosa, and it is that relegation that always hovers on the horizon of our perception of the wax image too. When the mechanics of reproduction are made too obvious, all we may be left with is delight at inventiveness.[78] For this reason, it may be that the constant alternation, even vacillation, between these two different kinds of response is what makes the waxworks work as entertainment more than anything else, why only a few images in Madame Tussaud's impress themselves with any felt permanence or effect on the imagination. The transition from funerary imagery to public waxworks takes place at precisely the same time as the accounts of Baldinucci and Sandrart; and it is a transition to which we should devote some attention.

Already in 1611 the sculptor Michel Bourdin appears to have commercially exploited his wax bust of the assassinated Henri IV by putting a replica on public display, under the management of one François de Béchefer, secretary of the Prince de Conti.[79] The assassination of Henri was still fresh in everyone's memory. We can still imagine the transference of the frisson of horror from the gruesome slaying by Ravaillac to the realistic sculpture of the just-buried king. But it was only in the second half of the century that the commercial exploitation of wax images really got under way. In 1667 Abraham Bosse praised the talents of Antoine Benoist, "ecuyer, peintre du roy et son unique sculpteur en cire colorée." In the following year, Benoist received a royal privilege to make wax portraits of high-ranking personages in Paris and elsewhere, and to display them publicly. A series of subsequent privileges (the last one was in 1718 and was to last for twenty years) extend and confirm this right.[80] But already by 1688 La Bruyère could call him a "montreur des marionettes." We can thus locate, with some precision, the period in which esteem for the achievement of naturalism gives way to denigration, in which closely realistic images are increasingly declassified from the status of works of art. A similar phenomenon occurs in the Netherlands, from the 1660s on.[81] But it is not my aim to pursue the story into the eighteenth century, nor to explore its ramifications into the widening fields of popular entertainment, since that story has been told often enough elsewhere.

Hanging from the ceiling, encumbering the galleries, and ranged against the walls are the wax and papier-mâché images that, by their quantity alone, overwhelm the spectator upon entering the Church of Santa Maria delle Grazie in Mantua (fig. 85). Such vast congeries of images are only to be found in the greatest votive centers, in every continent (cf. fig. 86). When Schlosser discussed the origins of the waxworks cabinet and museum, he pithily noted that just as churches were the oldest museums, so they were also the oldest sites of the "Panoptikon."[82] He went on to comment on the secularization of what had, after all, been a religious phenomenon; and, as we shall see, their contents were swiftly to be, quite literally, *pro-fana,* outside the temples.

Immediately following the passage on Verrochio's development of the technique of making casts of living bodies and the faces of the dead, Vasari turns to describing his contribution to another closely related genre:

> From Andrea comes the greater perfection in images, not only in Florence, but in all places where there are devotions, and where persons assemble to offer such votive objects miracles as they are called, for having received some favour (*per alcuna grazia ricevuta*). These were first only made small in silver, or small painted panels, or very rudely moulded in wax; but in Andrea's time they began to be made in a much better manner. For being in very close contact with Orsino, a worker in wax, . . . Andrea began to show him how he could make himself excellent in this. An opportunity came with the death of Giuliano de' Medici, and the wounding of his brother Lorenzo in S. Maria del Fiore [in the Pazzi conspiracy of 1478]. It was described by the friends and relations of Lorenzo that images of him should be made in several places, rendering thanks to God for his preservation. So with the assistance and advice of Andrea, Orsino [*sc.* Benintendi] made three life-size wax figures, the framework being of wood, covered with split canes, over which cloth was stretched and waxed over, with beautiful folds and so suitably that there could be nothing better or more lifelike. He made the heads, hands, and feet of coarser wax, hollow inside, portrayed after the life, and painted in oil, with the hair and other things, as was necessary, all so natural and well-made that they no longer represented men of wax but the most vivid people. All three figures may still be seen, one being in the church of thé nuns of Chiarito in the via di S. Gallo, opposite the crucifix which works miracles. This figure is dressed exactly as Lorenzo was when wounded in the throat, and showed himself at the windows of his house, all

bandaged, to be seen by the people, who wished to know whether he was alive. . . . The second figure is in a gown, a civil habit worn by the Florentine, and this is in the church of the Servites at the Nunziata, above the lesser door, beside the desk where the candles are sold. The third was sent to S. Maria degli Angeli at Assisi and placed before that Madonna.[83]

Aside from the information it provides about the Benintendi family of waxworkers (or *fallimmagini,* as they were significantly called), and the manner of the construction of the images of Lorenzo de'Medici, this passage encapsulates several of the major anthropological issues at stake in the analysis of response. First, there is the clear exposition of the desire to show thanks by means of an image of the figure saved (and the belief in the adequacy of that means); second, the implicit judgment that effectiveness is somehow related to verisimilitude (one notes both the apparently haphazard "as was necessary" and the claim that the first figure was dressed exactly as Lorenzo was when he was alive, at the critical juncture); and third, the collocation of these images, one with a miracle-working crucifix, the next with a desk where candles were sold, and the last before the Madonna herself.

But the way the passage begins is itself of the greatest interest. Verrochio's contribution was to "the greater perfection of images," not only in Florence but in "all places where there are devotions and where persons assemble to offer such votive objects for some favour received, *miracles as they are called*" (my italics). One could hardly wish for a more concise assessment of votive practice. It is followed by a brief developmental account of the genre—from "small in silver," through small paintings, to wax; and then follows the marvelously sustained exposition of the importance of lifelikeness in all this. The passage ends rather poignantly: "All are of extreme beauty and very few have equalled them. The art has been maintained until our own days, though in a somewhat declining condition, through lack of devotion or from some other cause."[84] Here is a story to tell.

Writers on wax portraiture—whether votive or not—have argued that its use and development are attributable to the cheapness of the medium and therefore to its popular accessibility. But this is only partly true. While the practices, especially votive ones, that make use of wax imagery range from the lowest ends of the social spectrum, they also occur in places like Or San Michele and Santissima Annunziata in Florence, where use is quite severely and deliberately restricted to the highest social levels. The issue is not simply the relationship between technique and function. Crucially at stake are the further implications of working in a medium that enables verisimilitude far more easily and effectively than most other media. Lorenzo de' Medici certainly had no need to reduce his costs when he had a

votive image made in thanks for his happy deliverance from the Pazzi conspiracy. By using wax (or related substances like papier-mâché and boiled leather), one could achieve the closest possible approximation of real flesh. When real hair was added to the wax image, the illusion of tangible fleshly reality could still further be enhanced. Wax also enabled the most exact possible modeling of physical features, with a comparatively limited amount of effort. But why the need for such verisimilitude in the case of votive imagery?

The answer surely lies in the need to represent the saved body in its full wholeness and soundness. The only means of testifying to its deliverance from danger or illness, or of having attempted to secure such deliverance, is by presenting it thus. But at the same time, the degree of soundness required can only be demonstrated on a body that is exactly like that of the supplicant or giver of thanks. The closer the resemblance to the supplicant, the more adequate the act, for it enables the visual formulation of the salubriousness or preservation of the specific body. Furthermore, the divinity which is thanked or supplicated—say, the Virgin or Christ—is enabled to recognize, beyond doubt, the maker of the supplication or the giver of thanks. But it is not only a matter of recognition: by being present in substitution the body seen as real can be treated as real. By being present in its wholeness, it is away from all danger; continuity between present and past (or expected) salubriousness is ensured.[85]

But what of images like the first one described by Vasari, which showed Lorenzo "wounded in the throat and . . . all bandaged"? In such cases the need for verisimilitude is even greater; the more exact the representation; the keener the awareness of the danger averted. The image can then be used not only as an emotive reminder of the threatened body in all its specificity; it also serves as the most acute realization of the physiological implications of the danger. We fully appreciate the threat to life only by seeing it present as exactly as possible. To eschew verisimilitude would be to render both gratitude and plea ineffective. We do not give thanks in these cases by presenting another object, or some symbolic token: we present the substituted body. While social and economic factors inevitably determine the formal and material status of the objects in the great assemblages of ex-votos, and while the emulation of social equivalents or superiors, or the simpler requirements of fashion, have an incalculable and complex effect on the way such images looked, none of these factors are sufficient to mitigate the aims and functions of verisimilitude.

Aside from the great assemblages noted in chapter 7, there is one further repository that deserves closer examination. Already in 1260 the Servite chronicle of Santissima Annunziata referred to the presence of a life-size votive image of Pope Alexander IV;[86] but the largest Florentine collection of wax votive imagery at that time remained Or San Michele, in the vicinity

of the shops and stalls of the waxworkers, and the *ceraiuoli*. A few other local churches also had wax images; but soon Santissima Annunziata came to be the main location. By 1447 the *boti* had begun to present a danger: as soon as people found no more space to place them on the ground, they started to hang them from the beams.[87] In his 109th *novella*, Francesco Sacchetti (whose works contain several further references to these kinds of images) mocks the whole practice:

> Every day they are making *boti* like these, which are more idolatry than the Christian faith. And I have even seen a man who, having lost a cat, vowed that if he found it, he would send it in wax to Our Lady of Or San Michele.[88]

By the beginning of the next century, the number of *boti* in Santissima Annunziata had already grown out of hand, and the Signoria made a rule restricting their use to the upper administrative classes. Soon, as Aby Warburg noted, the Church might be called a *Wachsfigurenkabinett,* no more and no less. On one side were the votive images of the great Florentines; on the other the life-size images of foreign notables, left behind, as Warburg put it, as gigantic visiting cards, to be shown to other visitors with particular pride.

But it would still not be entirely right to speak of the dilution of the original function of the *boti*. While they had undeniably become a tourist attraction, and while they may have been set up as a mark of status, the practice of making votive images continued to be considered effective. There is the extraordinary case of the Turkish pasha, a Muslim, who dedicated a votive image of himself to the Madonna of the Annunziata in order to ensure a safe return home.[89] Other cultural and psychological considerations evidently come into play here, but the belief in the potential effectiveness of the resembling image remains.

Nevertheless, serious objections to the clutter and the blocking of the view in the church emerged with increasing frequency in the course of the century; and by the beginning of the sixteenth, the weight of the images hanging from the roof was so great that the walls had to be strengthened. From now onward, the signs of the change of status in the genre become much clearer. Soon the Via de' Servi itself, the road leading to the church, came to be crowded with shops selling votive limbs of wax and papier-mâché; and the tension between votive function and aesthetic status emerged with still greater clarity. When the sensitive painter Ludovico Cardi, il Cigoli, had to get to Santissima Annunziata, he preferred to make a detour rather than to have to walk past the shops that so offended his pride in the status of his own art, that of painting.[90] In 1588 this is what the Dutch traveler Arnout van Buchell had to say about the images in the church itself:

There is such an infinitude of votive statues and painting that when you first enter the church you would think you were entering a field of cadavers. For there are the statues and effigies (with which the church is over-full), life-like and life-size, of wood, of stone and of wax. There one sees the suspended statues of Leo and Clement in their pontifical habits, and of several kings and princes, and around them other statues of armed soldiers, horsemen and infantry. . . . Here hang almost completely rusted swords, there helmets, lances, bows, arrows, indeed every kind of armour. In another part we see the wounded, the hanged, the tortured, the shipwrecked, the imprisoned, the sick, the pregnant lying in bed, all represented by statues.[91]

It was a marvelous sight; but it was a curiosity rather than an assemblage of artistic note, remarkable rather than awe-inspiring. By 1630 the authorities seem already to have begun to remove such images, but even in that year there were still 600 life-size images in the church, 22,000 votive images of papier-mâché, and (incidentally) 3,600 images with the miracles of the Santissima Annunziata.[92] When the church was modernized in 1665, its great encumbrance of wax images was removed to the small cloister, and that, as Schlosser remarked, "was the beginning of the end." The final remains were destroyed under the enlightened Archduke Leopold. But similar "church museums" of wax and papier-mâché images have remained until our own times all over Europe, from Santa Maria delle Grazie in Mantua to Sankt Wolfgang am Abersee in the Salzkammergut and the great Franconian pilgrimage church of Vierzehnheiligen.

These are the main stages in the developments that culminate in the evolution of the modern wax museum. There are others, too, including the assemblages of portrait busts (from Roman antiquity down to the wax busts of famous men and children that proliferate in the eighteenth century) and the great collections of anatomical figures such as are still to be found in places like the Anatomical Institute in the University of Bologna (e.g., fig. 122) and in La Specola, the astonishing and terrifying Zoological Museum of Florence University, which opened in 1775.[93] Their role in the commercialization of the waxworks in the late eighteenth century should not be forgotten either. It is not so surprising that both the most important of the early waxworks entrepreneurs, Madame Tussaud (1760–1850), and the most inventive and accomplished of the Bolognese modelers, Anna Morandi (1716–74), should have been women; and that their great skills should have been devoted to genres that are not generally regarded as art. But what conclusions—aside from this proleptic one—may we draw from all such developments?

Take the wax and papier-mâché images, the "ragged regiment" in the Undercroft Museum in Westminster Abbey (see figs. 115 and 116 above).

122. Wax hands by Anna Morandi (ca. 1750–75). Bologna, Università, Istituto di Anatomia Humana.

For several hundred years now, effigies which once served particular funerary functions have been gathered together, often enshrined in glass cases and presented as a tourist attraction. Indeed, it is likely that the later images in the collection, such as that of Nelson, were made more as additions to what was already then a museum than to serve any specific commemorative purpose. Again it seems appropriate to speak of the dilution—or, if not that, the transformation—of function. The original impact of the image has been lost, we may like to think; and in a sense it unquestionably has. Context inevitably erodes one kind of impact; but it always produces another, often one which is demonstrably related to the first: sometimes identically, otherwise at several and various removes.

How do we respond when we visit the Westminster effigies or Madame Tussaud's? These places are museums in the modern generic sense. We are no longer presented with living reconstitutions of the dead, but with dead displays, preserved like archaeological specimens for study, or frozen for the wonderment of posterity. Frozen or embalmed, dead birds stuffed. The images we see arouse our admiration precisely because of our conviction that they are not alive; and yet the artist has been able to make of the obviously dead substance images which are so lifelike that they seem to come within a feather's breadth of breathing. Our amazement, then, is fundamentally predicated on the awareness that the images are dead; if it were not, then we would not be aroused to wonder at the skill of the artist in approximating life so closely. If the images were alive, there would, after all, be no question of skill. But is the matter as simple as this?

Most readers will have little doubt—if any at all—of the qualitative differences between responses to the greatest images, to the canonical images of our time, in art galleries and museums, and responses to images in waxwork museums. We have learned to resist the attribution to such images of anything like rewarding or satisfying aesthetic status. But consider again our visits to the waxworks. As soon as we reflect, we realize that wonder and admiration are not as simply predicated as suggested in the preceding paragraph. We are arrested by these images at least partly out of fear that they might just come alive, just open their mouths, just begin to move. We fear the lifelike because the dead substance of which the object is made may yet come alive. If not fear, then another complicated emotion; for we ourselves still have little difficulty in recognizing the activation of emotion in the crowd that saw the effigy of the wounded Caesar. If we see an image that looks as if it were alive, then the appearance of suffering— say as a result of wounds, emaciation, or even tears—provokes empathy. It is for this reason that it is misleading to think that the images in wax museums provoke wholly dispassionate responses, of the kind that consists of admiration for manual skill, or amazement at the heights of such skill. The history of wax images does not culminate in responses that are based on aesthetic differentiation; and at no stage are their effects simply to be regarded as magical—except as a figure of speech.

Our argument, then, is not complex: just as in the case of wax images we need to treat the claim of aesthetic differentiation with caution, so too in the case of all other images, even those we regard as the greatest works of art. It is not an argument that will find favor, because we like to think of aesthetic judgment in terms of detachment from emotional and empathetic considerations of the kind we have been outlining. It may be thought that the argument is engendered by too deep a grounding in Mosaic fears, and in centuries of polemic about images, which no living being can altogether shake off—those polemics, prohibitions, and concatenations of reasoning in which apprehension about the effects of images and the effects of art have been so consistently and so variously voiced. There is a further paradigmatic case that we should consider before rejecting the argument on grounds like these. It is the case of the photograph.

V

There is a simple everyday sense in which we may also speak of the verisimilitude of the photograph and of film. The figures are there, apparently—to most of us—exactly as they are; they are reproduced exactly as if in reality. Or so we think when we look at films and photographs that are not made specifically to subvert the claims of realism or to be elevated into

the genres that transcend everyday reflection. But we do not imagine, by and large, that response is predicated on reconstitution of the living object, at least not in the same way as with wax images. This may all be rough-and-ready, but it is just this rough-and-readiness that high theory excludes from its considerations and which this book is intended to reinstate, not as replacement for theory, but for inclusion in it. It might, broadly again, be said that the photograph is two-dimensional, that we know it from its bitonal origins, that it can never attain the degree of substitutional reality achieved by the wax image, precisely because it has no hair, no tangibly fleshly quality, even in the case of the colored photograph. But the problem lies deeper than this, and it has nowhere been more eloquently clarified than in Walter Benjamin's now famous essay on the work of art in the age of mechanical reproduction. It would be hard to overestimate the pertinence of Benjamin's essay for the student of response, and it will continue to feature in these pages; but here we must concern ourselves with a notion that is central to it and is of direct application to the history of wax images and the lessons we have drawn from that history: the thesis on the diminution of aura of the reproductive image.

Benjamin's argument was based on experience of the photograph and the film, but its validity extends backward as well, and it suggests one of the key problems in discourse about response to lifelike images of the kind we have been considering. Although he primarily envisaged the reproduction of one image by another (or many others) rather than the resembling reproduction of a living object, his argument applies especially to and is exemplified by the fate of wax images (notably cases such as that illustrated by the history of Santissima Annunziata). "That which withers in the age of mechanical reproduction," he observed, "is the aura of a work of art"; and have we not been observing just this, the withering of the aura of the wax image?

This argument provides a twofold insight. First, in terms of reproduction: "The whole sphere of authenticity is outside technical—and of course not only technical—reproducibility." Once detached from its original context, once its historical testimony was thus affected, the authority of the object was jeopardized; and the eliminated element Benjamin subsumed under the term "aura." The second insight comes in terms of the detachment of the image from its ritual function. Benjamin argued from the preceding that "the unique value of the 'authentic' work of art has its basis in the ritual, the location of its original use value," and he maintained that with the coming of the age of mechanical reproduction the work of art was emancipated from its dependence on ritual.[94] Although he claimed that this happened for the first time with photography, he also recognized that "with the emancipation of the various art practices from ritual go increasing opportunities for the exhibition of their products"; and that seems directly

applicable, again, to the history of the waxworks. "By the absolute emphasis on its exhibition value the work of art becomes a creation with entirely new functions, among which the one we are conscious of, the artistic function, later may be recognized as incidental."[95]

The next step Benjamin took in this argument is of even greater significance. He noted that

> it is no accident that the portrait was the focal point of early
> photography. The cult of remembrance of loved ones, absent or dead,
> offers a last refuge for the cult value of the picture. For the last time the
> aura emanates from the early photographers in the fleeing expression of
> a human face. . . . But as man withdraws from the photographic
> image, the exhibition value for the first time shows its superiority to
> the ritual value. To have pinpointed this new stage constitutes the
> incomparable significance of Atget, who around 1900, took
> photographs of deserted Paris streets [cf. fig. 123].[96]

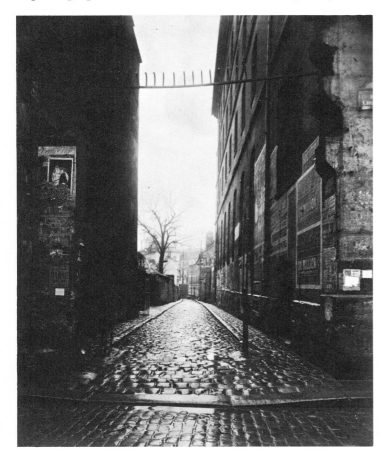

123. Eugène Atget, *Rue Rataud* (photograph, March 1909). Collection, the Museum of Modern Art, New York; the Abbott-Levy Collection; partial gift of Shirley C. Burden.

Here Benjamin seems to acknowledge the association between the representation of human face or form and the aura of an image, but this too he felt to be mitigated by replication. In moving on to his powerful argument about film, he maintained that "for the first time . . . man has to operate with his whole living person yet forgoing its aura. For aura is held to his presence; there can be no replica of it."[97] The formulation is compelling, but it invites modification on the basis of our analysis of the history of the resembling wax image.

Let us take stock of the implications of this rapid summary of Benjamin's essay. Its larger argument is about the consequences of the mass reproduction of images for popular consumption and for response. It brilliantly suggests how mechanical reproduction actually changes what Benjamin calls "the reaction of the masses" toward art, and how it affects the politics of artistic production and perception. But most germane in our context is its pointer to the nature of the distinction between responses to lifelike images which are not replicated on any significant scale, and responses to replicated (or replicable) images like photographs. What diminishes the aura of the photograph is not, we thus realize, the perception of it as realistic, but the fact that it is capable of replication (a less confusing word in our context than "reproduction") on a grand scale.[98] But what are we to make of the claim that in film "man has to operate with his whole living person" yet forgoes its aura, since there can be no replica of the aura of its presence? On the one hand the argument seems wholly axiomatic; on the other it is misleading—and it is here that we must make our modification.

We have seen how the reconstitution of living presence occurs in the case of images perceived to be realistic, and I have suggested some of the cognitive and psychological consequences that arise as a result. We may choose to suppress the consequences of that perception, but nothing in experience suggests the complete dissipation or disappearance of what Benjamin calls aura. The aura of the living presence can never be wholly dispelled in the case of the resembling image. Of course the aura of its authenticity may be diminished, or even wholly yield; but we are negligent about the symptoms of cognition if we take the realistic image to be wholly without aura. While replication may mitigate the consequences of verisimilitude, it cannot wholly eradicate them. Photographs of living beings have the same potentiality as realistic wax images, even though it may be less frequently fully realized. Film, clearly enough, is a different phenomenon: here Benjamin is justified in speaking of the way in which it forgoes the aura of living presence; but that results less from replication than from the fact that the film moves on. We cannot hold to the image in a film in the way we do with still images. The imprisonment of presence in representation gives the fixed image its potentiality; then it may be cherished or become a fetish. At the very least it remains unchanged and ever ready for reconstitution,

and that takes us unawares. Reconstitution begins even before we deny and suppress it.

But there is another aspect of fixed image representation that arrests our attention and contributes to the aura of the image; and that arises, as I have shown, from the dialectic of acknowledgment and denial in the process of perceiving the realistic image: we cannot escape from reconstitution, but we tell ourselves that the image is only artifice. We deny that it lives by acknowledging that it is art, but we still reconstitute. In one of his most famous passages, Benjamin observed that in the case of film "the equipment-free aspect of reality has become the height of artifice; the sight of immediate reality has become an orchid in the land of technology."[99] I have already referred to the rejection of realistic images on the grounds that they are mechanical and therefore not art, but at the same time the realism of the image supersedes all thought of mechanics. The tension between acknowledging the orchid and realizing that it is grown in the hothouse of technology, on the one hand, and the preceding suppression of all thought of technology, on the other, is precisely what constitutes the aura of verisimilitude.

VI

It may seem that by the time the images in Santissima Annunziata were banished to an outer cloister they had become indifferent objects; but at least one of the chroniclers of these events knew differently. For all the multiplication of votive imagery, and for all their detachment from their authentic context—indeed, for all the appearance of undifferentiated replication already remarked by Vasari—Del Migliore expressed regret at the banishment of the images in the following terms:

> I do not know what those Fathers had in mind when they stripped the church of such a rich decoration of votive images, at the risk of diminishing and enfeebling devotion . . . since, as our intellect cannot arrive so easily at knowing the causes of the production of effects, a most effective means is provided by the things relating to votive images, by the pictures and other external matters sufficient for every illiterate person to derive from them a greater increase in spirit, and a more lively hope and faith in the intercession of the saints; whence it is no small matter that the people regretted these events and regarded the church as deprived of a most beautiful *memoria*.[100]

The chronicler speaks of the effects of these images in terms of the Gregorian dictum that paintings are the books of the illiterate, in other words, in terms that were easily accessible to him. But underlying this is the

awareness of a cognitive relation that transcends class categories, and that is the relation of figured material object to psychological effect. The mind ascends more easily to attention and devotion in the presence of material images, and more particularly—as I have been striving to show in this chapter—in images that are arresting because of their verisimilitude. This is why we began with the *sacri monti,* and this is why we should briefly turn, before concluding, to one other genre that is rather less frequently denied the status of "art" and is usually placed higher on a putative scale of aesthetic evaluation than waxworks.

The status of all such genres, it is true, may sometimes seem ambiguous, and they may seem to hover on the borderline between the aesthetically indifferent and what is acceptably and conventionally regarded as art. But the discomfiture we experience in assigning them appropriate status is precisely what throws into high relief the transition between what we classify as "not art" and what we regard as fully or satisfyingly artistic.

Thus the *sacri monti* have until recently been neglected by historians of art largely because they have seemed to be of limited artistic worth. But they can also acquire comparatively high status, usually as a result of the intervention of a named artist (such as Gaudenzio Ferrari at Varallo). This phenomenon—the elevation in status of an object because it has an authorial name attached to it—has considerable resonance in the history and historiography of art; but here it serves to alert us to the way in which this particular genre is open to a range of aesthetic categorization, and not merely on the grounds that in cases like the *sacri monti* and the waxworks certain objects are notionally "better" than others.

There is one further aspect of the *sacri monti* that should detain us briefly. Despite the fact that the chapels on most of the sites were built over long periods, of anything up to four centuries, the sculptures display an extraordinary stylistic unity. This is not simply a matter of gross rather than fine calibration on the part of the investigator, of insensitivity to smaller changes than usual, or of an inability to deal with seemingly coarse rather than seemingly refined modes (the implicit counterargument being that we see change more easily in fine art than in crude). Obviously there are fluctuations in style, which depend on the variety of artists involved or on local requirements and traditions. Obviously, too, the apparent unity may be attributable to the strength of favored regional traditions; but no one who visits the sites can escape the impression of the lack of appreciable stylistic differentiation—or even development—from period to period.[101] What does seem inescapable is that physiognomic and physical realism appears to be less subject to convention and schematization that most other modes of representation. The funerary sculptures and waxworks that we have already discussed are often dependent on the taking of death masks from the actual body, and this leaves little room for schematization. The images of the *sacri*

monti are inconceivable without such precedents, where realism is heightened by the use of real hair and actual garments. Of course various tricks and schemata are used in the painting of the sculptures, but these are not sufficient to alleviate the impression of constancy rather than idiosyncrasy—however many minor idiosyncrasies we may detect. But even if a skillful relativist could prove that we merely overlook the conventions and schemata of representation in the *sacri monti,* we would still have a cognitive lesson to learn; and that is that the perception of an object as realistic (we are absolutely not discussing whether it is—or was—realistic or not) makes it seem to be little subject to the common laws of stylistic change.

In other words, to the beholder realism suppresses awareness of changing conventions of representation and stylistic idiosyncrasy.[102] The most modern sculptures of the *sacri monti* may indeed be the ones that make us most aware of change and difference, but the impression of the unity of centuries of figuration in these places in itself provides sufficient demonstration of the inability to suspend involvement with verisimilitude in favor of differentiated aesthetic assessment. The case is somewhat different with paintings, where it might be argued that change is more readily perceived; but I have already commented on the easy transition from sculpture to painting in these places. Here the paintings acquire the same reality as the statues, and the consequent involvement in them results in a like suspension of aesthetic distancing—at the cost of the detachment necessary for judgments about aesthetic difference.

VII

Among the closest parallels for the realism of the *sacri monti,* and among their most immediate precedents, are the series of groups of painted terracotta sculptures from the areas just north of Bologna, dating from the 1460s on. The chief artists, initially, were Niccolò dell'Arca and the extremely popular Guido Mazzoni (figs. 124 and 125). These freestanding groups, almost always of the Nativity or the Bewailing of the Body of Christ, evince a striving for verisimilitude that is very close to that of the *sacri monti*—although gestures, especially in Niccolò dell'Arca, are often heightened to an exaggerated extent. But the chief difference with the *sacri monti* is that these sculptures do not form part of a narrative sequence, and therefore serve more clearly devotional purposes; they are not placed against illusionistic backdrops and are not so frequently separated from the viewer by means of a grille. There is little opportunity here for the beholder to move on to the next stage of the sequence, in a state of diffused but constantly heightened emotional excitement and engagement; here he must give himself over to devotion, in rapt and pious concentration on the particular group.

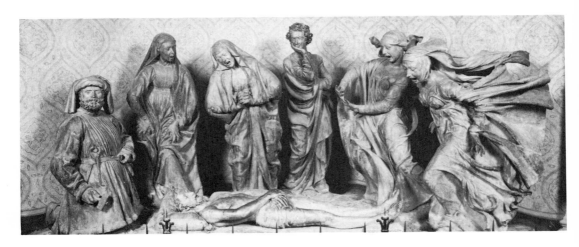

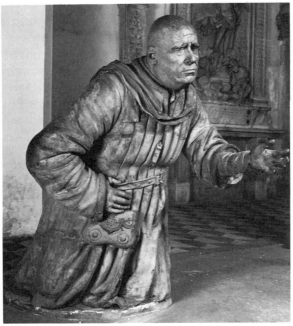

124. *Above:* Niccolò dell'Arca, *Lamentation over the Body of Christ* (1463). Bologna, Santa Maria della Vita. Photo Courtauld Institute.

125. *Left:* Guido Mazzoni, *Joseph of Arimathea,* from Lamentation group (1492). Naples, Sant'Anna dei Lombardi, Oratorio del Santo Sepolcro. Photo Courtauld Institute.

The realism of a sculptor like Mazzoni, it has been pointed out,

was based on the acceptance of life casts or death casts as raw material for art. Vasari's biography of Verrochio, vague enough in other respects, must be respected for its circumstantial description of studio properties that included life casts not just of faces but of hands, feet, legs, and even torsoes. . . . What Mazzoni accomplished was to move the effect of absolute likeness into the realm of the illusion of life. [103]

I have already commented on the connection between life (and death) casts

and the wax *boti* of the late fifteenth century; the significance of Mazzoni's sculptures consists, among other things, in the transition they mark from a realism dependent on life masks to a category of objects that are regarded as art. The influence of his works and those of his school radiate south to Naples and east to France; but swiftly the need for such explicitness manifests itself in less explicit modes. Once the lesson of verisimilitude has been drawn, art may supervene, not relinquishing it by any means, but applying the rules of restraint and suggestiveness that the higher intellectual realm requires. "Towards the beginning of the series," notes a standard authority on fifteenth-century Italian sculpture, Mazzoni's sculpted groups "have a marked dependence on life-casts for hands and faces, and they even use glass in the representation of the eyes. Later a freer parallel to the mask with greater emphasis on emotional expression, was evolved. . . . The genre continued into the sixteenth century, but with inevitably lessening of impact on the mainstream of sculpture in Italy."[104] In that "even" lies all the prejudice that is implicit in the very pattern of taste the commentator charts. It may adequately plot certain developments in the history of taste and reception; but about response it is inevitably and unwittingly silent. Thus to dismiss the material of realism, and to ignore the lessons of involvement that follow, is to become an accomplice in the kind of repression about which this book seeks to be more candid.

The kinds of sculpture represented in high form by Mazzoni may rapidly diminish in canonical status in the course of the sixteenth century in Italy (when critical talk about status and rank is abundant); but in Spain we see the vigorous rise of a similar genre. Spanish polychrome wood and stone sculpture provides us with continuing instances of the perceived continuity between liveliness and the quality of being lifelike. The greatest of the Spanish sculptors in this mode is Juan Martínez Montañés (1568–1649); and it is from the history of his commissions that we may draw our last set of illustrative examples (figs. 129–32 below).

The sculpture of Montañés—and to a lesser extent that of his near-contemporary Gregorio Fernández (ca. 1576–1636)—represents the apogée of the mode that relies on meticulously veristic anatomical modeling in combination with rich polychromatic treatment for its considerable illusionistic effect. Not only are garments painted in a manner that suggests every stitch in the brocade of a bishop and the rough textures of the cloak of John the Baptist, but the technique of painting the flesh is perfected in such a way as to convey the feel of palpitating veins, tense or rippling muscles beneath a skin that is soft, taut, or wrinkled according to the age and condition of the figure represented (figs. 126–31). Splendor of impression is sought, but so is the ordinary physicality of human frames subjected to the events and crises of individual Christian lives. Never again were bodies and the clothes that garb them to be shown with the same sensitivity

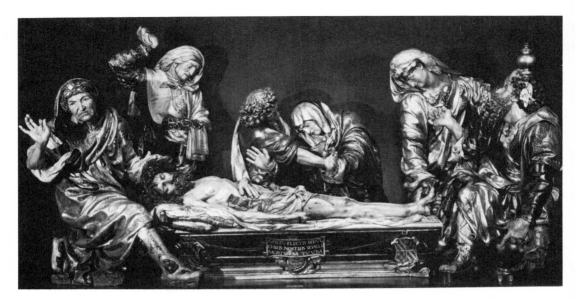

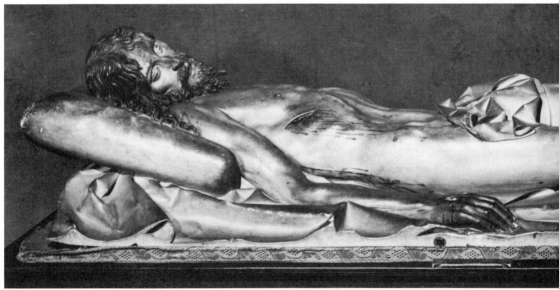

126. *Top:* Juan de Juní, *Lamentation over the Body of Christ* (1541–45).
Valladolid, Museo Nacional de Escultura.

127. *Above:* Gregorio Fernández, *Dead Christ* (ca. 1625–50). Valladolid,
Museo Nacional de Escultura.

128. *Opposite, right:* Pedro da Meña, *Mater Dolorosa* (mid-seventeenth century).
London, Victoria and Albert Museum.

to every minute and gross accident of substance and surface and texture. Sometimes actual garments were draped over the sculptures, or real attributes—say, flowers or bejeweled crowns—fitted to appropriate hollows or sockets in them; but more often it was the rich and multifold layers of polychromy that gave the effect of a present and breathing life, for that is what these sculptures were intended to convey. It was not only the overwrought expressions of pain and emotion that engaged the spectator, but rather the impression of being able to realize in oneself something of the quality of suffering and presence—as in Juan de Juni's famous *Lamentation over the Body of Christ* (fig. 126), where the stark gestures of grief would have been much less effective were it not for the boniness of the exposed body and the amazing palpability of the flesh, over which the polychromers are known to have striven especially.[105] If anything, the many versions by Gregorio Fernández of the *Dead Christ* (e.g., fig. 127) are still more shocking. It is not too difficult, here, to imagine spectators catching their breath

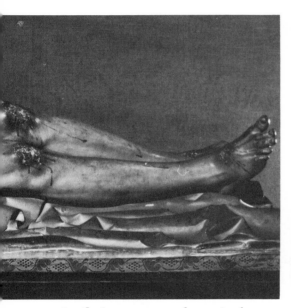

at the flesh torn away from the kneecaps, at the coagulating blood, at the half-open mouth—and again one recalls how those who saw Pythagoras of Rhegion's sculpture of a limping man are said to have felt the pain of his ulcer. On the other hand, Pedro da Meña's sweet but dolorous Virgins (fig. 128), recall the intimations of affection and mild compassion that we find in writers from Pseudo-Bonaventure to Jerome Nadal.

In 1603 Mateo Vázquez de Leca, archdeacon of Carmona, ordered from Montañés a crucifix for the Carthusian Monastery of Santa Maria de las Cuevas and stipulated that Christ was to be

alive, before He had died, with the head inclined to the right, looking down to any person who might be praying at the foot of the Crucifix, as if Christ himself were speaking to him, and reproaching him because what He is suffering for is the person who is praying; and therefore the eyes and face have a rather severe expression and the eyes must be completely open.[106]

Now it may indeed be that the rigors of Carthusian piety and devotion prepared the monks to be more susceptible than usual to the kind of relationship spelled out here; but once again we encounter the old requirements of the figure that must appear to speak and the eyes that are supposed to engender and engage attention; once again we deal with the mobilization of metaphor that is more than metaphor (cf. fig. 129). Almost thirteen years earlier, Montañés had been asked to carve eight Virgins of the Rosary for export to Chile; each of their faces "had to have such an expression that it seems to look at all those near who may be praying to her."[107] "To be alive" . . . "looking at those near" . . . "with his eyes open" . . . "as if speaking" . . . "reproaching him [for his] suffering"—metaphors like those betoken more than anything else the way in which response is based on attempted reconstitution of the life of represented form.

The crucifix commissioned by Vázquez de Leca is now in Seville Cathedral. It is known as the *Cristo de la Clemencia;* and the effect of the open eyes, with their fleshy upper lids and arched brown eyebrows, and the half-open mouth is startling, if nothing else (fig. 129); and it is sufficient to engage us to dwell more deeply yet on the blood that streams over the gleaming and otherwise perfect torso of Christ the Savior (fig. 130).

Aside from the convincing effects of polychromy and the realistic garments, one could go further and employ gestural and other technical devices to enhance the effects of verisimilitude.[108] Most of the sculptures seem to have had little need for the mechanical tricks which were so often alleged or actually used, but even within the oeuvre of Montañés they too were occasionally deployed.[109] The two largest Virgins of the Rosary destined for the Dominican monasteries in Chile, for example, were to be

beautiful in the extreme . . . serene and devout . . . the Child . . .
with the fingers so arranged that rosaries can be placed on them, so that
He seems to be bestowing them. The right hand of Our Lady has to be
extended in proportion and made to serve two purposes, first to have
in the upper fingers a hollow in which flowers can be fitted, and the
other fingers with such grace and in such a position that she can hold
rosaries in them.[110]

As in Vázquez de Leca's stipulation, the central and final requirement has to do with the eyes, and the document explicitly acknowledges their

129. Juan Martínez Montañés, detail of *Cristo de la Clemencia* (1603). Seville, Cathedral. Photo Mas.

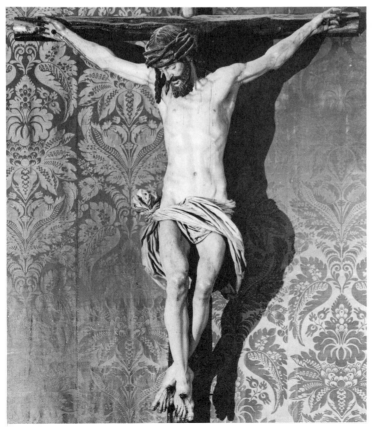

130. Juan Martínez Montañés, *Cristo de la Clemencia* (1603). Seville, Cathedral. Photo Mas.

131. Juan Martínez Montañés, *Jesus de la Pasión* (ca. 1615–18). Seville, El Salvador. Photo Mas.

132. Juan Martínez Montañés, *Jesus de la Pasión* (ca. 1615–18), view without garments. Seville, El Salvador.

role as the ultimate measure of living presence. But in this early commission the need for verisimilitude is great enough to override the artistic skills of which we know Montañés was capable and was soon to evince: recourse was had to a device which combined artistic re-creation and real object— in this case, the flowers and rosaries. Such objects bridged the feared gulf between representation and reality in obvious ways. The magnificent statue (ca. 1619) of Christ bearing the Cross in the Sevillan church of El Salvador is clothed in real cloth, bound with a knotted and tasseled cord (fig. 131); but beneath the cloak the torso is little more than blocked out, and the

upper limbs are jointed in a manner that recalls the crucifixes with moveable arms that one encounters so abundantly throughout Europe from the thirteenth century on (fig. 132; cf. figs. 139–40).

Now it is not as if Montañés were unable to carve a robe that gave the illusion of reality, or that he could not model the body in such a way as to imply convincing movement. The recourse to real garments and jointed limbs demonstrates, finally, the insistent impulse to merge living qualities with inert substance. We may argue as hard as we like that all realism is relative, that resemblance and similarity is always arbitrary and conventional, and that resemblance to nature cannot be absolutely determined; but the history of all the images that have been considered in this chapter makes it clear that they were intended to be as realistic as possible, and that they were and continue to be capable of being perceived as living presence, with awareness of the category—art or image—into which they may appropriately fall being suspended, at least momentarily.

The images in this chapter are not usually classified in the mainstream of what we call art. Earlier I indicated a reluctance to engage in the matter of such classification and suggested the spuriousness of such an endeavor. But for the objects which come under the more favored rubric, a plain lesson is to be drawn from the images discussed here. To spell it out requires more than usual tact. Almost every image provides its beholders with clues to the organic presences registered upon it. When those clues are so abundant and exact that they combine to form what is regarded as an unusually lifelike image, then responses to it are predicated on a sense of its living reality. But when the clues are less exact and less abundant, we still seek to reconstitute the reality of the signified in the sign. Sign fuses with signified to become the only present reality. The smallest number of clues suffices to precipitate the search for more. Response to all images, and not only ones perceived as being more or less realistic, is predicated on the progressive reconstitution of material object as living. We respond with empathetic horror to the bleeding wax image or the sculpture polychromed in colors that convey bruising and welting; but when it comes to painted or printed images of bleeding figures, we may like to think that our response is more detached. Indeed it may be. But to deny our inclination to lapse into empathy before all images that even hint at the lively quality of what they represent is to deny the inescapable progression toward reconstitution of the living body demonstrated by the lifelike images at the core of this chapter. This is the lesson from non-art to art, from figurative form to abstraction; and this is the lesson that more fully than most others points to the fluidity and ultimately the arbitrariness of that shifting boundary-line between what we regard as canonical and what seems less sophisticated, more everyday, and beyond the pale of high aesthetic categorization.

10

Infamy, Justice, and Witchcraft: Explanation, Sympathy, and Magic

What is the historian of images to make of the following event recorded in the *Commentaries* of Pope Pius II, Aeneas Sylvius Piccolomini? In 1462, Sigismondo Malatesta, tyrant of Rimini and bitter enemy of Pius, was tried in absentia, and

> found guilty of treason against the Pope and of having dared to make impious assertions about the Christian religion. . . . He was deprived of the vicariate, stripped of every dignity and honor, and subjected to those punishments which the laws of men have decreed for heretics and traitors.

Then followed condign punishment:

> In front of the steps of St. Peter's a huge pyre of dry material was built. On top of it they placed an effigy of Sigismondo, so exactly rendering the man's features and dress that it seemed more him in person rather than an image. But lest anyone still be misled, an inscription issued from the mouth of the image, reading "I am Sigismondo Malatesta, son of Pandolfo, king of traitors, dangerous to God and men, condemned to fire by vote of the Holy senate." This writing was read by many. Then while the people stood by, fire was applied to the pyre and the image, which at once blazed up. Such was the mark branded on the impious house of Malatesta by Pius.[1]

The passage cannot by any means be said to have gone uncommented—especially in the light of Pius's reputation as a comparatively enlightened and humanist pope—but the tendency has been to see the punishment as an unusually ostentatious revival of practices that were more common in the preceding century or as some kind of magical phenomenon more characteristic of primitive cultures.[2] There has been some attempt, therefore, at

246

classifying the event, but little close analysis of this form of punishment. What exactly, we may ask ourselves, was it supposed to achieve? Was it felt that Sigismondo would in some way be affected if his effigy was burned in his absence; or is the action merely a symbolic one, ceremoniously embodying the public removal of his status and dignity? And what is the significance of burning his effigy—rather than some less resembling token—and of ensuring identification by the inscription issuing from his mouth? The temptation is to invoke some notion of sympathy in order to explain how the punishment worked or was supposed to work; or to attribute its operation—putative or real—to some concept of magic or superstition.[3] Two classes of imagery (often but not always of wax) must now occupy us: on the one hand, images used in judicial and public defamatory contexts, and on the other, those used in the more private contexts of witchcraft.

Recently, and periodically in the past, scholars have strenuously denied any inherent connection between these classes. Some have gone still further and insisted on category distinctions within each of them. The grounds have been the perfectly sensible ones of the ontological differences between the classes and categories. But if one takes them together, useful analytic similarities do emerge in terms of function, use, and response.

The division into classes is not wholly arbitrary either. One class has reasonably clear legal and political aims; the other has murkier telestic functions. The first has a broadly public dimension, the second a largely private one. The first is open to reasonably impartial investigation; the second has been subject to suspicion and surmise at every stage of its history. From the Inquisitors and orthodox commentators who first look into allegations of image magic, to the historians and anthropologists who annex the terrain, motives have been assigned and practices imputed on the basis of slender and supposititious evidence, often elaborated for the sake of forensic or exegetic convenience. The first class has received less attention; the second has received almost clamorous interest. But in neither case has the actual use of images and the function they served received more than passing analysis.[4] In the effort to see all such phenomena in terms of wider historical currents and disturbances, their very center has been neglected.

Let us say we shame the miscreant in our midst by displaying an image of him. Sometimes a straightforward depiction will do, but more often greater of lesser marks of odium are indicated or attached to it. Punish the absent miscreant by punishing his representation in our midst; visit odium upon it it by public disfigurement, mutilation, or hanging. In both cases the action of making, displaying, and disfiguring the image may be spontaneous, or it may fall within established and official structures of disapproval and sentencing. The great majority of what are usually called "images of infamy" (the Italian *immagini infamanti* or the German *Schandbilder* are both better terms) fall into these two main subdivisions. The officially

sanctioned forensic use of such images form the bulk of genuinely documented examples; but one also has to take into consideration the spontaneous public practices which, on the one hand, lie at the psychological root of the legal practices and, on the other, mirror them. The interaction between private inclination to wreak public vengeance in this way and official (and therefore public) manipulation of private feeling reinforces the effectiveness of all such cases.[5]

The instances of the desecration of enemies of the commonweal described by the Roman historians, and the destruction of statues of those posthumously declared to be enemies of the state, properly fall under the rubric of iconoclasm; but they—and all cases of the *damnatio memoriae*—should be borne in mind as we begin to consider what it is that people think they achieve when they punish an image, and how they think such punishment may be effective.[6] Of course it can appear to be little more than a spontaneously angry gesture. The gesture itself may be sufficient to assuage anger, and there may be no further assumption of effectiveness—but what is it about the attacking of an image that allows or helps such anger then to be assuaged? The question will not be closed until after our consideration of iconoclasm in chapter 14.

The use of images of infamy within an officially sanctioned statutory framework begins in Italy in the late thirteenth century. The additions to the Parma civic statues of 1255 (approved in 1261) contain the following:

> *Item:* it is decreed and ordained that anyone who does anything against the preceding [statutes] should be painted on the Palazzo Communale, by the Commune and at the expense of the Commune; and that his name, forename and the charge [against him] should be inscribed beneath him in large letters.[7]

Here, *in nuce,* is the first record for the substance of a punishment that was soon to become very widespread indeed in Northern Italy. The two main groups punished in this way were those guilty of political crimes (e.g., treachery, rebellion, banditry) and those whose crimes were of a more clearly defined civil nature, usually financial offenses like bankruptcy and embezzlement. The forensic distinction was between *infamia facti* (or *vulgaris* or *popularis*) and *infamia iuris* (*legalis*). The legal aim in both cases was the deprivation or impugning of reputation and status, the *privatio vel commaculatio famae.*[8] Men found guilty of the statutory crimes were to be painted on the walls of prominent civic places; details of name, condition, and crime were usually inscribed there too. The punishment was perhaps most often applied to those who had fled, either because of their political treachery or misdemeanor, or with the money of their creditors.

The evidence is richer and more varied than one might expect; it is also of considerably greater relevance to the history of the use and effect of im-

ages than has generally been acknowledged.[9] To say this is not to make any assumptions about the possibility of an internal history of images isolated from the specific legal and political factors that may at certain periods have generated or encouraged the practices we are about to consider.

I

The use of images of infamy was concentrated in Emilia and Tuscany, but swiftly spread out to neighboring areas, with the notable exceptions of the Romagna (despite its proximity to the area of concentration) and the Veneto. There do not appear to have been examples in towns like Ferrara, Venice, Ravenna, Turin or Forlì.[10] The reasons for this anomalous distribution are not entirely clear. In any event, the diffusion from Parma in 1261 and from Bologna and San Gimignano in 1274 (where the next instances are recorded) was very rapid indeed. By the end of the century, images of infamy were used in at least twelve cities. The period of the greatest use appears to be the following hundred-odd years, which was also notable for an obsessive concern with images associated with witchcraft. In the fifteenth century, use was sustained, but by no means as concentrated; and there then followed a period of gradual desuetude, with some last but very striking examples in Florence in the 1530s. It is from just about this time onward, that one can pinpoint the increasing use of the *executio in effigie*, not only in Italy but throughout the rest of Europe too.

Let us turn to the practice itself. There is one (apparently tentative) case in San Gimignano in 1274, where a Ghibelline leader was punished for having slain the leader of the Guelph party: a representation of his "enorme et habominabile maleficium" was painted on the *pieve*, to serve as perpetual reminder of that hateful deed.[11] But the richest supply of early evidence comes from Bologna (and not Florence, as is popularly supposed).[12] Also in 1274, three notaries are recorded as having been expelled from their corporation for fraud, and painted on the wall of the Palazzo communale, "quia infamis et falsarius et propterea depictus in palatio."[13] The evidence begins to speak for itself, and there is no need to go into all the instances that rapidly follow. In 1283 five men were punished by means of *immagini infamanti:* three communal officials received and sold corn and wheat; a civic notary changed the text of a source; and the fifth man was responsible for forging a document. So far, then, we have 8 instances; by 1301, there were 108, in Bologna alone.[14]

Although not a single image that can unqualifiedly be said to fall within this category survives, the names of many of the painters who made them are recorded; and they are by no means all insignificant names. In Bologna, to begin with, the task seems to have fallen to some undesirable characters.

Between 1286 and 1289 one Antonio (or Antolino) di Rolando, called Cicogna, painted eleven images of infamy, in the very years in which he was involved in a number of cases of violent assault. The Gerardino Bernardi who painted 36 such images between 1290 and 1299 appears in a case of armed robbery in 1300. But it is the overall statistic that is most revealing: of the 112 paintings of criminals between 1274 and 1303, 59 were done by painters accused of attempted homicide.[15]

The historian who has most recently chronicled these facts circumspectly refrains from drawing firm conclusions from them, but at least one imposes itself. Even at this early stage, the aura of shame attaching to such images was so great that the task of producing them fell to painters whose own moral status bore some relation to that of the transgressor they painted. Their involvement, furthermore, in the production of such images must *pari passu* have reinforced the degradation and disgrace implicit in this particular form of punishment. It is perhaps worth recalling here that one of the constants of theological stipulations about the arts is that the artist should be of sound moral standing. This is a recommendation that could hardly be more widespread: we find it in Clement of Alexandria, in John of Damascus, in the Ḥadith, and in the decrees of the Russian Stoglav at the end of the sixteenth century. What an aura of turpitude must then have been felt to pass from characters like Cicogna to the images he made, and what shame must then, inevitably, have been passed back from image of infamy to maker! Such a stigma attached to the job that no painter of sound morals could be seen to be associated with it. No wonder that when it came to painting the men who had attempted to rob the Cassa del Camera del Commune in Florence in 1292, Fino di Tedaldo had to be forced to carry out the task; and Vasari records that half a century or so later, Giottino had to be similarly conscripted to paint the image of the banished duke of Athens (cf. fig. 134 below).[16]

These stories continue. At the beginning of his career in 1440, Andrea del Castagno painted the Albizzi and their accomplices on the façade of the Florentine Palazzo del Podestà, after their treachery at the Battle of Anghiari. Swiftly he acquired the cognomen *degli impiccati*. The shame inherent in that reputation even confused the historiographers. Vasari himself derived Andrea's nickname from the painting of the Pazzi conspirators in 1478; but that task went, in fact, to Botticelli—who painted the three traitors hanging by their feet.[17] And when a similar task was assigned to Andrea del Sarto in 1530, he accepted it only with reluctance, and apparently with considerable circumspection: "He said he would do it; but in order not to acquire, like Andrea del Castagno, the cognomen *degli impiccati,* he let it be understood that he had handed over the work to an apprentice of his called Bernardo del Buda." He took the further precaution of literally covering himself by "constructing a large shed into which he went

in and out at night and where he painted the figures himself and made them seem alive."[18] The preparatory drawings by Andrea del Sarto are among the very few surviving visual documents for this class of imagery (fig. 133); and perhaps it was Bernardo del Buda after all who went into that shed to do the actual painting of the images of infamy on the basis of the drawings supplied by Andrea.[19]

One could hardly overemphasize the shame of this form of punishment. In addition to the evidence of the attitudes of painters, a number of sources from the period of greatest use in Italy testify to its superior effectiveness. People in positions of power strained to have the images of relatives or political allies removed; and men condemned in this way sometimes preferred to submit to what to us would appear severer punishment—in at least one case, that of hanging—than to have their names and reputation so visibly and publicly besmirched.

When punishments were meted out to those who had treacherously treated with Gian Galeazzo Visconti in 1389, the Bolognese elder and chronicler Matteo Griffoni succeeded in preventing Alberto Galluzzi from being painted as a traitor. One of Griffoni's relatives had also been involved in the plot, and he probably wanted to avoid so public and emphatic a commemoration of the events. But as soon as Griffoni left office, the defamatory image of Galeazzo was set up as required. A glossator notes beside the reference to the image in Griffoni's text that it was set up "against the will of the said Matteo, who had wished that Galluzzi should be hanged and not painted."[20]

Not quite eighty years later, in 1465, a section of the Florentine council worried about the growing laxity in applying this punishment: "The said statute had an excellent basis, because it had been found that many people abstained from this form of bankruptcy [i.e., fraudulent bankruptcy] on account of the fear of being painted, rather than for any other reason."[21] Such a powerful degree of shame was invested in images of infamy that it frequently radiated outward from its intended focus. The case of Matteo Griffoni is a good example; but the reasons given in 1396 for the removal of all public images of infamy in Milan, and for the firm prohibition of their further use, are still more striking:

Concerning the removal of pictures of infamy on the walls of the palazzo and the registration of the names of the defamed. Since certain images are painted on the walls of the Palazzo Nuovo of the commune of Milan, representing false witnesses and corrupt notaries, merchants and money changers, and although they seem to be made for the purpose of confounding and defaming frauds, yet they disgrace and defame not only the authors of the deceits themselves, but also the whole of the city in the eyes of visitors and foreigners; for when the latter see these images, they

133. Andrea del Sarto, *A Man Hanging Upside Down* (drawing, 1530). Florence, Galleria degli Uffizi, Gabinetto disegni e stampe. Photo Alinari.

imagine and are almost convinced that the majority of citizens can barely be trusted, and are involved in great falsehoods; and so it is decreed that all these pictures be removed, and that no one should be painted in future. Rather, let him be strictly and firmly punished; and as for those who are already painted, and those who will in future be condemned for falsehood—let them be registered in a book in the Communal Chamber of Milan.[22]

Less discredit, it might be thought, to the condemned; but less shame upon the city as a whole—or so, clearly, it was felt. When the Florentine council of 1329, after the death of Charles of Calabria and the restoration of civil liberties, forbade the painting on public buildings or at the town gates of arms or pictures of persons other than Christ, the Virgin, the Roman Church, the king of France, and Charles of Anjou, the restriction is not simply to be seen as an aspect of the need to keep the province of painting and its subject matter reasonably pure (although this factor is usually over-looked). It is rather, as Helene Wieruszowski noted, to be thought of in the context of civic concern about the ways in which the *pittura infamante* had been used as a strong weapon in the fights between the democratic government and its enemies. The images had come to be seen as a negative reflection on the people of the city and its government.[23]

II

We take for granted the relation between shame and public representation. The former seems to follow without difficulty from the latter. We deal with an established frame of reference for such degradation; what need, then, to inquire into the relation between odium and other forms of representation? Display, not form, may seem to be a sufficient guarantor of effectiveness; all the more so with statutory display, where the context of punishment is publicly acknowledged. But why in that case is mere inscription not sufficient? Why do most records tell of images and symbols of the condemned and his crime, in addition to the great letters in which miscreant and misdemeanor are so often described? The shame that must accrue from a coat of arms soiled by an adjacent animal needs no explanation; but what is it about representation in public that generates and focuses odium? Can it only be a matter of public and significantly permanent reminder? Can the felt effectiveness of such punishments be simply attributable to the jealousy with which unsullied name and reputation are guarded? If that were the case, it would not be clear why form of representation played so significant a role in so many of the documents recording these particular condemnations.

No commune can have wanted to expend too large a sum on their images of infamy, and the 1301 report that the Bolognese commune expected the painter Bartolomeo di Maestro Gerardino to complete two images the day after he was paid for them must represent a fairly typical demand.[24] Painters probably worked at some speed, and a degree of greater than usual schematization in the representation of features may be assumed. "Rapidity rather than aesthetic quality seems to have been the determining factor," says the historian.[25] Generally speaking, one could refer to the images as stereotypical: who would worry about precision in the portrayal of the face of a hanged man? And yet one had to be able to recognize crime and criminal; indeed, closeness of resemblance became an essential aim of these images.

Some reasons are obvious. If the criminal had fled, then he had to be made present for odium to be actively visited upon him; his return had to be prevented by ensuring that he would be recognized if he did come back; and the full force of disgrace depended on his memory and the memory of his deed being kept vivid. If the miscreant was still within the community, then he would nowhere escape recognition, he would not be able to hide his shame as long as the accurate image remained. The presence of identifying inscriptions or didascalia on these images would not have obviated the need to ensure this. One would strive for accuracy of representation and avoid undue schematization and stereotypification because individual distinctiveness had to be maintained. The criminal remains present among us, but his crime sets him outside the bonds of communality; we acknowledge his distinctiveness but perceive his human similarity with ourselves. That is why the quality of shame depends, in the end, on the perception of the image as a present and distinctive body.

The records of sentences and the chronicles that describe their implementation yield a considerable amount of information about how these images looked. Those of bankrupts and frauds were not usually very closely described, aside from the references to whether or not the miscreants were shown hanged (or whether or not they actually were hanged); but those of the traitors and other political miscreants were. In 1315, for example, the Council of Reggio nell'Emilia took a series of severe measures against the dalla Palude. They were banished, stripped of their rights, and deprived of their goods and possessions. On top of all this, it was decreed that

> the said Lords Jacopino and Goffredo and their sons, both legitimate and natural, and the others banished on the occasion of the robbery *Bergenzoni et Corvarie* were to be painted on the exterior wall of the old Palace of the Commune, and their names and surnames inscribed in large letters, so that they could clearly be read and understood; and let the people of Reggio be painted, and the way they destroyed their

castle; and let the army and the siege machines be painted; and let it also be written how the above-mentioned rebels were banished from the commune of Reggio, for robbery, treachery, rebellion, arson and other great crimes; and let it be described how the Reggian army stood, and how the commune and people first sent 1,300 infantrymen and a hundred cavalry . . . so that the wickedness, the treachery and the arrogance of the Dalla Palude family might be seen and be read by all.[26]

Again we find the requirement of a bold inscription—but it was clearly not regarded as sufficient. The details of the events had to be visually described, in a way that they could be recognized by everyone. It seems clear that it was visual description above all that was regarded as the operative shaming factor. From records like these, it does appear that shame would not reach (or even touch) the offenders if the events at issue were not portrayed in a manner that made them visually graspable and recognizable.

The Reggian case introduces a new element into the tradition we have been discussing. Instead of simply showing the miscreants and their crimes, the picture showed the retribution and punishment wrought upon them. In this respect it is like one of the classic examples—the fresco of the expulsion from Florence in 1343 of the famous and briefly popular despot Walter of Brienne, duke of Athens (cf. fig. 134).[27]

This is the work which Vasari supposed to have been painted by Giottino, and which later writers have given, without much conviction, to Maso di Bianco. (Characteristically, as Vasari records, Giottino had to be "forced [to do the work] by the twelve Reformers of the State, and especially by the prayers of Agnolo Acciaiuoli," the archbishop of Florence).[28] The original fresco from the wall of the Palazzo del Podestà showed the flight of the duke with his most prominent followers in the guise of wild animals, which alluded to their personal qualities. Lampoons were attached to each of these figures. The fresco is lost, but a version from the Stinche Vecchie, the city prison, survives, showing the duke with a fearful expression on his face being expelled from the city by a wrathful angel (fig. 134). In his hand he holds a half-human monster, and the sword and balance of Justice are trampled underfoot. Dominating the left side of the work is Saint Anne, on whose name and day the resistance against the duke was successful, and to whom an altar was then dedicated in Or San Michele. She protects the Palazzo Vecchio and hands out banners to the knights representing the various quarters of the city.[29]

Although the collocation of Saint Anne and the fleeing duke is unequivocally condemnatory, the only explicitly shaming aspect of the representation of the duke is the inclusion of the devil and his animal-like associates. Bad enough, perhaps, but at least he was spared the besmirching of his coat of arms beneath the anus of an animal, as one finds in a number of other

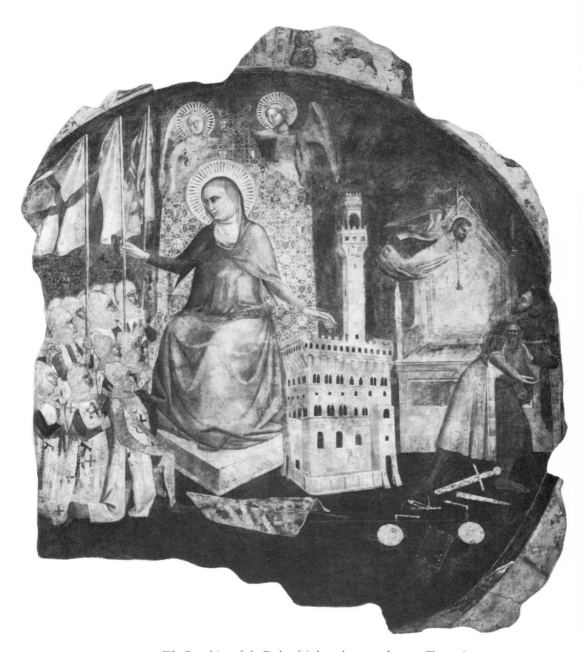

134. *The Expulsion of the Duke of Athens,* by an unknown Florentine
artist (ca. 1360). Florence, Palazzo Vecchio. Photo Alinari.

cases. The devil, indeed, is just about the only element that it shares with
the image recorded in 1377 in the case of Rodolfo da Varano, lord of Cam-
erino. The records of this picture give some idea of just how visually de-
grading such images could be. Rodolfo had been captain-general of the

Florentine republic in the recent War of the Eight Saints; but he went over to the side of the pope, to whose forces he had once belonged. For this act of treachery he was painted on the façade of the Palazzo del Podestà. He was shown hanged from the gallows by his left foot. On either side of him were a siren and a basilisk. He wore a miter on his head, while a devil gripped him by his throat; and his arms were splayed as he directed an obscene gesture at the Church and at the Commune: "e fa la fica alla Chiesa e al Comune de Firenze, com'egli à tradito il Papa e 'l Comune di Firenze." The final act of treason made the first seem reprehensible too. Thus was his double treachery made plain to all.[30]

Just over ten years later, Bonaccorso di Lapo Di Giovanni was painted hanging upside down from a chain, with a miter on his head and surrounded by devils, for having treacherously plotted with Gian Galeazzo Visconti.[31] The practice of representing excommunicated figures in the company of devils remained a common ecclesiastical practice until the sixteenth century. They were shown in this way on the bills of excommunication attached to a variety of public places but especially to church doors.

The inclusion of devils and other monsters in such images may seem to require no further comment. They are a conventional means of representing evil, and as such may be understood as simple indications of the quality of the traitor's or heretic's mind and actions. But they must also have been perceived as objectifications of the shame that is wished or visited upon the figures portrayed. In this sense they allow the enactment of degradation without the responsibility of individual participation. They become the crystalization of a violence that is now deflected but that in other cases erupts on both a personal and collective level. The time has come to examine such cases.

III

Frauds and traitors, as we have seen, may be represented as hanged.[32] But a further step could also be taken: the images themselves (both two- and three-dimensional) could be hanged (cf. figs. 135 and 136). Finally, the whole apparatus of execution could be employed upon images, not only in hanging, but also in pillorying, burning, quartering, and decapitating them. Naturally, all images of infamy were often subjected to personal demonstrations of hatred by these and other means; but the punishment of images by individuals—who often made them specifically for such puposes—falls into another category. Here we must consider the instances of public and formalized desecration of the absent body. Such actions help to bring us one step closer to discovering the limits of discourse about how such images were supposed to work.

135. *Above: Execution of an Image
of Infamy in Florence* (from A.
Poliziano, *Conjurationis pactiane
commentarium* [Naples, 1769],
p. 140).

136. *Right:* The hanging of an ef-
figy of President Mitterand of
France in Teheran (1987). Photo
Reuters/Bettmann Newsphotos.

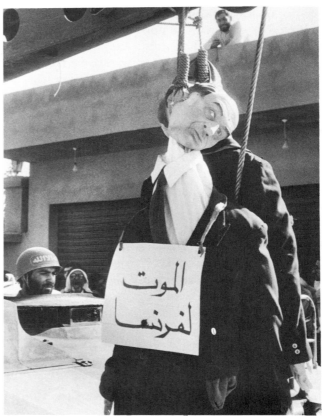

Schlosser made much of a new form of *iniuria* recorded by Trebellius Pollio. It was visited upon the usurper Celsus: "His image was lifted onto a cross, and the crowd jeered, as if Celsus himself were affixed to the gallows."[33] But Brückner noted that the circumstances surrounding this isolated case are not at all clear.[34] There are several Roman examples of the destruction of statues of posthumously declared enemies of the state and, in the early Middle Ages both in Rome and in the North, of the desecration of the body of an enemy (as, for example, in the case of Pope Stephen IV's trial and subsequent drowning in the Tiber of the exhumed body of his bitter opponent Formosus in 897).[35] But for actual examples of *executiones in effigie,* where an effigy is set up for more or less formalized public execution, one has to wait until after the Middle Ages.

Brückner's sophisticated and pioneering study made fine but important distinctions between a wide variety of related examples. In specifying their legal-historical contexts, he also refrained from grouping them all together under the rubric of magic. Then he firmly noted that the legal institution of images of infamy in frescoes and on documents dated from the thirteenth to, at the latest, the seventeenth century, while the *executio in effigie* was only applied in cases of *lèse majesté* from the seventeenth century on (with its origin, perhaps in the fifteenth century).[36] It was almost always applied to dead persons only. The latter punishment has related forms in military codes and punishments for dueling right up until the nineteenth century.[37]

But our aim is not to classify the historical examples. It is rather to assess the significance for response of all punishments visited upon images. For this reason one has to group together a representative variety of examples that may be different legal phenomena but that all have in common the hanging and execution of an actual image or effigy. Thus, for instance, there is the case of the *Meier* of Rijmenam who deliberately set free an imprisoned thief in Mechlin in 1490: he was then required himself to set up the gallows, at his own expense, upon which a portrait of the thief was hung.[38] Brückner is almost certainly justified in claiming that this cannot be regarded as a case of *executio in effigie,* but rather as a statement of the power and authority of the local Vierschaar, which had been infringed by the Meier in letting the thief go free.[39] For the present, however, the question is not just the classificatory one. It is above all this: Why should an image feature in the penal satisfaction of the crime at all? Let us look at some of the other examples of penal practices involving images.

In 1575, Pierre Ayrault, the earliest French writer on crime to deal with the *executio in effigie,* wrote that "certes si on peult estre honoré par effigie, apposition et erection d'image: on peult bien aussi y recevoir de la punition et de la honte."[40] The parallel between honor and punishment could hardly have been more apt. All such punishment may be seen, on the simplest level, to proceed from the assumption—whether articulated or not—that

if one could be honored by means of an image, one could also be dishonored by one. This seems reasonably clear; why then resort to the extreme of burning or executing an image? Why did the lawmakers not regard it as sufficient to keep the image present for the venting of antipathy, anger, or disgust? One reason must be that the formalized *executio in effigie* asserts, through reenactment, the power of the legal instruments of justice. It stands for a social and visual statement of the legal means at the disposal of those who dispense and execute the law. In its ideal state it makes clear the role of legal authority in transcending private antipathy, or in controlling it. This allows spontaneous individual feelings to give way to formalized structures and expressions of control—although of course it may also be seen as a channeling or a crystalization of widespread feelings of anger. But quite frequently it may not; it may serve as an attempt by authority to give form to unformed attitudes, or to allow people to focus upon them. In this respect, then, the *executio in effigie* is a symbolic statement. It exemplifies the kind of punishment the miscreant would have received had he been present or alive; or it even exaggerates it. We need not then be puzzled about the execution of the image of an already dead man. But if we consider the matter in terms of the cognition of such forms of punishment, then we must grant them an affective component as well. Let us remain alert, as we consider the historical examples, to the kinds of factors that may have to be taken into account in assessing their effectiveness.

One practice not yet mentioned must be regarded as a significant antecedent of the public execution of images: the execution and burning of corpses of criminals and heretics by civil and ecclesiastical authorities. Although it clearly antedates the full-blown *executio in effigie,* it continues beside the latter well into the eighteenth century and even beyond. As in the case of funerary ceremonies, then, the use of images and effigies replaces the use of the actual body; and we may postulate the same requirements of resemblance and presence (and not merely substitution). The punishment of corpses became widespread in the sixteenth century, received much discussion in the criminological treatises, and was frequently employed by the Inquisition. But already by the end of the century, doubts about its use began to be expressed—first on the grounds that a corpse ought not to be punished (it should rather be hanged) and second as to whether it should be employed at all.[41] The rise of the practice of punishing and executing an image cannot wholly be attributed to the decline of the earlier practice, but the relationship should not be ignored. We have, in fact, to wait until the seventeenth century before it is possible to trace a significantly wide range of instances of *executio in effigie* for the *crimen laesae majestatis,* for heresy, and for a variety of lesser offences, including dueling.

Although François Ier had already introduced execution *par figure* into military law, and Robert Etienne was thus punished after his flight from

Geneva in 1551, it was Louis XIII, Mazarin, and Louis XIV who put it to more extensive use. There are many recorded examples from elsewhere in Europe as well.[42] The practice seems rarer in Southern than in Northern Europe, although we may record the use of a portrait "that might be seen and recognized by all" in the posthumous execution of Marcantonio de' Dominis, the former archbishop of Spalato who, after becoming an Anglican and then returning to the Catholic Church, was finally tried for heresy under Urban VIII. (He died in 1624 before the completion of his trial.)[43] In glossing this and related events, Brückner has observed that the burning of the effigies of absent (or deceased) men does not constitute—to retain the legal terminology—a *vera executio*. In cases of the absence of the suspected, the Inquisition did not have the legal authority to corroborate accusation, and it therefore could not administer the full sentence that would have been required had the case been proven. The burning of effigies by the secular arm of the Inquisition tribunals must thus be regarded not as the formal carrying out of a sentence, but as a "show for the people."

This may indeed be the appropriate definition of the punishment, but it brings us no closer to understanding its use. We have to examine not only statutory and near-statutory uses, but also those in which we clearly see the phasing-off from legalized to mock forms. The examples from Northern Europe are striking. In 1660 images of Cromwell and Bradshaw were set up in Dorset:

> The judges asked the senseless images whether they would submit themselves to the judgment of the court; and when these did not reply, they were accused of High Treason because of the murder of Charles I. The surrounding crowd shouted Justice! Justice! . . . whereupon they were condemned to hang on two gallows, each forty feet high.[44]

Even before they were up on the gallows, the people stormed the images with pikes, daggers, halberds, and other weapons, and tore them apart.[46]

One year later in Copenhagen, Kai Lykke was convicted of high treason. Since he was out of the country, the judges decreed a full-blown *executio in effigie,* along the lines of the by then refined French practice. But in the illusion of reality it went much further. The wax effigy, which had a moveable wooden framework, was made to resemble Lykke as closely as possible. It was provided with a perruque and a full set of clothing—right down to the white gloves. The effigy was taken from the Blue Tower to the place of execution, where four hundred musketeers and two hundred cavalry were waiting. It was made to kneel in the sand, its necktie was removed, a blindfold placed over its eyes, and the hair tucked beneath it. Then the figure was decapitated, and the executioner's assistant held up the head by its hair. The parts of the body were dragged past the royal palace while heads and hands were nailed to the pillory in the marketplace. Before finally

burying it beneath the gallows, the executioner kept the torso for several days, in order to show it to the public upon payment of an adequate admission fee.[45]

Such an episode clearly exemplifies the relationship between shame and the pursuit of verisimilitude. Once again the image is in wax; and the ritualized reenactment of a grim sentence on a body that is perceived as realistic, if not actually real, evokes the same kind of sympathetic horror, resisting detachment, that often occurs in the case of the public waxworks. If this kind of punishment is predicated on collective assumptions about its deterrent value, then it is not hard to imagine its cognitive effectiveness. Just two years after the execution of the substitute body (the German *Scheinleib* is a better word here) of Kai Lykke, the same resources were deployed in an even more grisly fashion, when Christian IV's chancellor, Count Cortiz Uhlfeldt, was condemned to death in absentia by Frederick III—"das nächste Schauspiel gleich perfektionierter Regie," Brückner rightly calls it.[46] After the cutting off of head and hands, the body was quartered to reveal the animal innards with which the effigy had been filled. Head and hands remained nailed to the wall of the town hall for sixty-five years afterward, before being destroyed in the great fire of Copenhagen in 1728.[47]

If instances of the *executio in effigie* were limited to the punishment and execution of three-dimensional representations in the round, then one might accessibly explain their use and persistence in terms of their derivation from the punishment first of living bodies, and then of actual corpses. Their substitutional role would thus seem to provide the basis for explanation. But the cognitive issues are thrown into sharper relief by the use of paintings for this purpose as well, just as in the case of the *pitture infamanti*. A few examples may suffice.

In 1673 the French general (and son-in-law of Grotius) Jean Barton de Montbas, was charged, in his absence, with the *crimen laesae majestatis;* and in this case a life-size painting was used, with his name inscribed in large letters across it. Barely had it been strung up when a mob of youths attacked it with stones, as if it were not so much a picture, says the chronicle, but a body made of flesh and blood. Not content with this, they set upon it with their own hands, and tore it apart, each one making off with a piece of the picture.[48] Mere lynching, or pelting it like a snowman, as boys are wont to do? Perhaps. But it is precisely this kind of response that ought not to be neglected as one considers the charge and the power of representation.

The question that now imposes itself is this: In what terms may one speak of and assess the mental processes that are engaged when people execute or attack the image of an enemy of a miscreant? Here one has to turn to the use of images in the context of witchcraft and other magic practices. It is true that a separation between these two forms is often insisted upon,

rightly so. The juridical form is formally institutionalized; the other, by and large, is not. The first begins with socially controlled manifestations; the second is either more idiosyncratic and individualized or bound up in a complex of more or less formalized ritual processes. But if we think in terms of the not infrequent venting of spontaneous and individualized forms of antipathy on juridicial images, it is possible to discern at least some analytic continuity from institutionalized to personal forms; from the legally tolerated, indeed, the legally encouraged, to the wholly illicit. In the case of legal images we rarely know anything about the imputed effectiveness; in the case of *envoûtement* we do. In most instances one specific aim or another is acknowledged. If one asked those who stoned a defaced legal image what they hoped to achieve thereby, they would reply in bewilderment or answer confusedly; in cases of *envoûtement,* they would answer with considerable clarity.

IV

In the great mid-twelfth-century compendium about courtly and political life, the *Policraticus,* John of Salisbury defined those who practice *envoûtement* as people "who, in order to affect the minds and bodies of others, make effigies in a softish material like wax or earth of those whom they wish to undo (*eorum quos pervertere nituntur*)."[49] This straightforward definition would have satisfied everyone who practiced what has usually been called, in English, image magic. It would have been taken as a clear enough statement of the aim of making an image and treating it in such a way as to affect the person whom it was supposed to represent. It may also stand as a succinct formulation of the phenomena we are about to describe—except in one respect. Although "a softish material" is generally employed, there are instances in which firmer substances are used; and it is not clear whether John of Salisbury would have assumed in his definition the drawing and making of images of an intended victim in the sand—but the latter two must also come under our rubric.

The practice of *envoûtement* has long been a favorite subject of ethnographers, anthropologists, folklorists, and all those interested in magical phenomena and witchcraft. It is not difficult to see why. The practice is found from the earliest times in Western culture until our own day, as well as in an extraordinary range of other cultures.[50] Every North American child has heard about it, whether in tales about early New England, or in putative reports about voodoo in Haiti. People seem always to have made images in a variety of substances, and then pierced, pulverized, mutilated, and destroyed them in order to do harm to those whom the image represents or—with seemingly lesser frequency—to make them behave in ways desired by

the practitioners. It would be futile even to begin a listing of confirmed examples, and Frazer made the phenomenon a centerpiece of his immensely influential discussion of sympathetic magic. The classical poets contain many references; so do many later writers.[51] Ovid described Hypsipylus's allegation that Medea, having been spurned in love, tried to kill by this means. Thus she combined two of the commonest motives at stake in such cases: "She curses absent men, and makes wax effigies, and plunges thin needles into the wretched man's liver."[52] It is hard, at the same time, not to recall again the legendary Ku K'ai-chih. When he was enamored of a local girl, the stories run, he painted her on the wall and stuck a nail into her heart.[53] The general literary and anecdotal evidence is overwhelming. But what of the material and documentary evidence?

We may begin with the antique practice of *defixio*. It stands as an early and comparatively rudimentary form. Here the name of the victim was scratched on a lead tablet; it was then buried, along with appropriate incantations and ceremonies. The practice received its name from the latin *defigo,* "I bind fast" (in Greek *katadō*), which was often added to the inscription. The aim was to affect someone by ceremoniously cursing or harming an object clearly identified with him. One could add invocations to the gods of the underworld, as is to be found in many of surviving *defixionum tabellae;* one could drive a nail through the tablets; sometimes one might even engrave a representation of the victim; and one could bury images of him along with the tablet.[54] The need to ensure identity could hardly be more fully realized—except by making different kinds of things altogether.

In his classic article of 1902, Wünsch described his discovery of a small leaden image (about 6 cm. high) of a youth, which he judged to have come from a third-century B.C. Attic grave. Its head appeared to have been deliberately and violently cut off. Although it is not impossible that this loss was due simply to the passage of time, the remaining aspects of the image were unmistakable and suggested a clear kinship with the tablets of defixion (most of which date from the third century too). Hands and feet were bent back and bound with tight leaden bands, while two iron nails were driven through the body—one though the chest and one almost directly through the navel (cf. fig. 137).[55] Wünsch reminded his readers of a miracle described in Sophronios's life of Saints Cyrus and John. The pious Theophilus suddenly became inexplicably paralyzed in both hands and feet. When Theophilos appealed to them, the saints instructed him to make a sea voyage. Following their further instructions, a net was cast. It dredged up a basket containing a bronze figure that looked exactly like Theophilos. Its feet and hands were pierced by nails; and when the nails were removed, Theophilos regained full control of all his limbs.[56]

This, then, is a classic case of *envoûtement,* and Wünsch's find provided material evidence for its particularities. Only one element usually found in

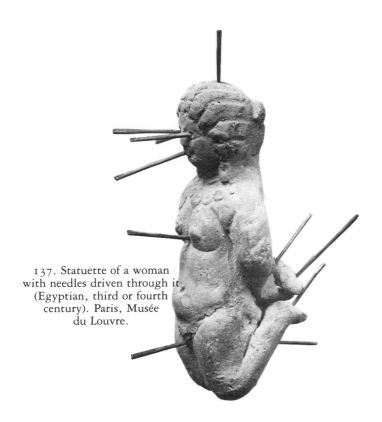

137. Statuette of a woman
with needles driven through it
(Egyptian, third or fourth
century). Paris, Musée
du Louvre.

such cases was missing from these dovetailing pieces of evidence: the baptism or ritualized consecration of the image. We may make a figure of the party we wish to harm, who is thus in our power. By identifying it as that party, we can treat it in such a manner as physically to effect the living person represented by it. But we must anoint, baptize, make an incantation, invoke gods, cast a spell, or perform a prescribed rite in order to set the desired process into operation.

In the case of the third- or fourth-century Egyptian statuette of a woman pierced by eleven needles now in the Louvre (fig. 137), we do have evidence of its use, in the inscription on the lead tablet originally buried with it.[57] It is a love charm. Sarapammon, son of Area, appealed to the spirit of a dead man and several infernal deities, to help him win the love of Ptolemais, daughter of Aias and Origenes. More specifically, he called to the dead man's spirit to rouse itself and go and look for Ptolemais and to prevent her from eating, drinking, sleeping, indeed from having any pleasure, including the pleasure of love, until she fell in love with him.[58] This practice is further corroborated by a magical papyrus now in the Louvre containing a recipe for gaining the same effect, and several inscriptions similar to that of the lead tablet are preserved in Cairo and Cologne.[59]

All these elements, and more, are to be found in abundance in the extraordinarily extensive documents pertaining to witchcraft from the fourteenth century on.[60] We find, in particular, a great many references to practices involving images that date from the first half of the fourteenth century. It will be recalled that this is precisely the period of the establishment and flourishing of the use of images for juridical purposes. The fact that the functions of pictures and effigies expand in so remarkable a way at this time is one of the great unexplored phenomena in the history of art, and the historical factors concerned in this expansion have largely remained unanalyzed. No broad explanation can be offered here, but two events, even if not strictly causal, may be taken as especially resonant; and they involve figures as well-known as anyone could possibly then have been.

In 1309 Phillip the Fair arranged for the trial of Boniface VIII, six years after his death. The eighth of the twenty-nine charges against him was very serious indeed. It accused him of idolatry, not only because he put up silver sculptures of himself in churches, but also because he had marble sculptures erected in places—above city gates, for example—"where of old there were accustomed to be idols" (i.e., the statues of pagan antiquity).[61]

It is true that Boniface seems to have set up a quite unusual number of images of himself in public places.[62] In most quarters this would have seemed perfectly in keeping with a character widely regarded as overweeningly proud and arrogant; but Philip was also making cunning use of a suspicion of visual imagery that was widely articulated not only in theological writing but also in civic practice. Only twenty years later, as we have noted, the Florentine council was to forbid the painting of pictures representing families or persons other than Christ, the Virgin, the Church, the king of France, and Charles of Anjou, either at seats of office or on town gates. Images had come again to be no mere *adiaphora,* but highly charged reconstitutions of the people they represented; and the bond between representation and represented was drawing unusually close.

The second event is even more telling. It too involves a pope and a well-known public figure. It also involves, quite specifically, an allegation of image magic. In 1320 Matteo and Galeazzo Visconti, like Louis of Bavaria just a few years later, were accused, in a trial that was to continue to reverberate throughout the history of such phenomena, of having tried to kill John XXII. They are supposed to have made a silver statuette reproducing his features and bearing his name, which they then exposed to the elements for seventy-two nights.[63] And this at the very heart of a period in which *envoûtement* provided the surest, most inescapable proof of witchcraft. Indeed it was precisely in this year that John issued the second of his two bulls directing prelates to deal with the growing problems of heresy and witchcraft; and it is as a result of this that most of our evidence for image magic comes to the fore. Seventeen years later, Benedict XII was still hav-

ing to look into allegations that certain members of both the clergy and the laity in the diocese of Béziers had attempted to kill John XXII by using "some baptized images of wax."[64]

Although Inquisitors in Southern France had already been instructed around 1270 to ensure that those suspected of idolatry or witchcraft had not made trial of images or baptized objects like coins,[65] one of the fullest early formulae for the recanting of crimes like these comes from Toulouse some fifty years later:

> I . . . fully abjure all error and heresy . . . and specifically and expressly abjure all baptizing of images and other irrational things. . . . Also I abjure the art and manner of making images of lead, or of wax or—indeed—of any other material.[66]

A special form of public degradation was reserved for priests who were guilty of the offence, a degradation which served as a deterrent "in detestationem factionis ymaginum."[67]

The practice of *envoûtement* continued to occur all over Western Europe until well after the end of the seventeenth century. Many of the allegations no doubt were fabricated (the imputed discovery of a wax image in the home of one suspected of witchcraft was enough to secure a conviction), and there were plenty of possible motivations for the trumping-up of such easy charges. Nevertheless, the fact that images were believed to work in the ways described in the trials means that we must attend to what is said to happen in each case.

The earliest secure English instance dates from 1324–25. In November 1324, Master John de Notingham, a necromancer of Coventry, was accused with twenty-seven of his clients of having made seven wax figures of the king and courtiers, against whom the twenty-seven harbored a variety of grievances. In order to put the efficacy of the images to the test, they had apparently randomly chosen one courtier, Richard de Sowe. The necromancer made a likeness of him and struck a lead pin through its forehead. Sowe immediately became frenzied and died three days later.[68]

Stories of this kind abounded, and not only in England. Images of wax and lead were made; pins were driven through them; or they were pulverized or buried. But not only wax was used. Images were painted on canvas or parchment or paper, or carved and engraved on wood. They were colored, baked, or left to waste.[69]

But it would be wrong to think that the use of this class of imagery was solely confined to harming a second party. If that were the case, then our evidence for the imputed efficacy of the images would be undermined by the conventionality of motive and effect. There are, in fact, other kinds of use that provide still clearer examples of the ways in which images were supposed to be operative. Take for instance the lengthy investigation or-

dered by Benedict XII into allegations of magical practices in the diocese of Mirepoix. Several clerics and monks of the Cistercian monastery of Boulbonne were supposed to have an image of wax in order to help them find and "extract" a hidden treasure. No mention is made of how the image actually looked, but further relevant information emerges from the investigation conducted by the abbot, Durandus. The image was taken to the monastery and placed above the altar in the chapel of Saint Catherine. There it remained unnoticed for several days, even while mass was being celebrated. One would have thought this would be sufficient to constitute a "consecration" of the image, but it was taken back to the home of one Pierre Garaud, who asked whether it had been baptized or not. Upon receiving a negative reply, one of the members of the group stuck nine needles into the image; and a book was produced "in which was written the traditional form of the sacrament of baptism."[70]

How this sort of thing was supposed to help in the search for the treasure is not made clear; but it does seem that in instances like this the practice of *envoûtement* was somehow supposed to activate the image to the benefit of the group involved. Belief in the possibility of activating an image in this way is not uncommon outside Europe, as every anthropologist knows. In the case of the so-called nail fetishes of Bas-Zaire, for example (fig. 138),

138. Zairean nail figure (*n'kondi*) (wood with screws, nails, cowrie shells, and other materials). Detroit, Institute of Arts, Founders Society Purchase, Eleanor Clay Fund for African Art.

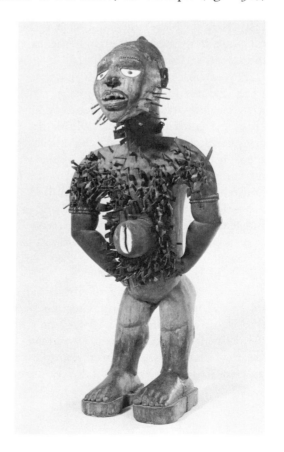

the object is used not only in juridical procedures: it can be made to render special services and is challenged into action by having a nail driven into it.[71] This is the very converse of the withdrawal of sharp objects or the removal of bonds from maleficent images.

A comparatively common allegation against those accused of being witches provides yet another view of the potentiality of images used in *envoûtement*. This is the allegation that images were used as means of seduction. As so often in all these cases, women are usually supposed to have been the chief exponents; but not always. Two documents may be regarded as representative.

In 1375, one Monna Caterina di Agostino, "a woman of the most evil life, condition, and reputation," was condemned by the Florentine court following an accusation brought against her by Vieri di Michele Rondinelli:

> Motivated by a diabolical spirit, Caterina committed numerous and various acts of sorcery and magic. She also invoked demons in order that the chaste souls of men, and particularly the soul of Paolo di Michele Rondinelli, of the parish of San Lorenzo in Florence, an honest and honourable man, might engage in libidinous acts with her. In order to attract Paolo to her, and to render him incompetent, so that she might extort money from him, Caterina placed a wax figure of a man . . . in a bed in her house to which she had led Paolo. . . . Into that figure she had stuck several iron pins. And in that bed to which he was drawn by those acts of magic and sorcery and by numerous other acts and incantations, he had intercourse with her on several occasions. As a result of this, Paolo—an honest and serious man of 45 years of age and over—deviated and continues to deviate from every right path, and he left his wife, children and business, and all his affairs to involve himself with that evil woman Caterina.[72]

A textbok case; and our sympathies rest entirely with the woman, who was sentenced (in absentia, fortunately, having fled) to be burned at the stake. The trumped-up nature of the charge, as in so many other cases of witchcraft, seems reasonably obvious. It is even more apparent in the concluding portion of the document, which blames Caterina for Paolo's gifts to her, for the disgrace to the family, and for the "disorder, tumult, and scandal" that seems particularly to have arisen among Paolo's relatives.[73] But it is not our task to assess the truth of the evidence; it is to consider the role of the image in the events brought forward in testimony like this.

A number of other cases confirm this use of images. An allegation brought before the Courtrai court in 1472 refers to an unusual (but not unprecedented) type of image:

> A certain priest [of Tournai] wished to seduce a young girl. In order to achieve his aim, he baptized an image painted in chalk on a tile, using

the form of baptism and sprinkling holy water on it in the name of the young girl. Then he similarly baptized a wax image, and subsequently made conjurations and invocations of devils, using unknown names, which he had written out on a piece of paper. These are contained more fully in some book or another, which he had excerpted on a piece of paper and written out himself.[74]

An accomplice called Egidius was accused along with him, since it was he who had counseled the baptism of images and had provided instructions for both their making and their consecration, along the lines prescribed in some books said to describe the *dampnatas scientias*. The case is barely different from that of Sarapammon of Antinooupolis.

Most of these examples of image magic and images of infamy come from the fourteenth century. This is indeed the period, particularly in Central Europe and Italy, of a notable expansion in the functions of images in general; but it should not be forgotten that the great age of *executiones in effigie,* particularly in Northern and Western Europe, was the sixteenth and seventeenth centuries, and the great bulk of witchcraft trials involving images in England ran from the late sixteenth to the late seventeenth centuries. These were all periods, it is true, when the status of the image seemed peculiarly embattled. In the fourteenth century, criticism of the expanding use of images in churches and public places crystallized; in the sixteenth and seventeenth centuries, criticism led to iconoclasm. No wonder, then, that degradatory and illicit use should reach such heights or should be so sensitively detected and recorded. Nevertheless, the periods I have chosen to dwell upon do no more than dramatize and expose for analysis practices which extend far more widely than the limited range of examples presented here suggest. What, then, are the terms of explanation for images which are believed to have the power of affecting those whom they represent— whether physically harming individuals or simply shaming them?

<center>V</center>

Discussions of the use of images in the context of witchcraft ("image magic," as it is always called) have very often followed references to the juridical use of images for purposes of shaming and degradation. Once again, it is Wolfgang Brückner who has most rigorously insisted on fundamental distinctions between these forms of use. At the very center, "the innermost nerve," of practices involving the mutilation and execution of juridical images, he places the "defamatory moment."[75] He emphasizes this moment at the expense of explanations by way of magic. The practices cannot be seen, he insists, as "later rationalizations of ancient magical de-

sires and primitive anxieties", nor should any comparisons be drawn with the practice of *envoûtement*. Here he maintains that "magical efficacy does not derive from the representational status of the images, but is rather dependent on many other components within a traditional magical system."[76]

All this may be true, and it is certainly significant that the most effective instances of *envoûtement* occur quite specifically in the context of a witch, necromancer, or anyone else alleged or acknowledged to be a magician. But simply to invoke concepts or structures of magic does not go very far in explaining why such images are supposed to effective, and often are so. Brückner rightly criticized Schlosser for including the Florentine images of infamy in the category of images which are thought to work across distance (*fernwirksam gedachteten Bildnisse* is the useful German phrase), since their use was predicated upon impugning, quite specifically, the legal status of the person represented, rather than somehow causing damage from afar.[77] All this we may grant, but what we cannot escape is the one belief that underlies all the phenomena we have described; that the use of an image in a certain prescribed way can affect the person it represents in one way or another. It has long been acknowledged that this assumption and this belief presents an acute problem of explanation.

By the time Kittredge wrote his wide-ranging compilation of material *Witchcraft in Old and New England* in 1928, he could begin his chapter "Image Magic and the Like" in this majestic and magisterial way:

> No department of witchcraft affords more convincing evidence of
> continuity than Image Magic, technically termed *invultuacio* or
> *envoûtement*. From remote periods of history in Egypt, Assyria,
> Babylonia and India, from Classic times and lands, from the Middle
> Ages, and so on down to the present day, the practice of image magic
> has been prevalent, and it is still common the world over, among
> savage men and civilized. *It depends, of course, on the doctrine of sympathy.*[78]

Even when Wünsch wrote his much-cited article on the discovery of a statuette which provided such important early material evidence for *envoûtement,* he could take the notion of sympathy for granted: "In countless peoples the notion remains from a time of primitive culture that the representation of a man whose name has been bestowed on the image is connected with the prototype [*originale*] by the magical bond of sympathy, which is mediated by the mysterious power of the personal name common to both."[79] But what (leaving aside the invocation of "mysterious" powers and "primitive" states) is gained by this hypostasized notion of sympathy that is so taken for granted? Clearly some explanation of the imputed efficacy of all such images is required; but as is apparent from these two quo-

tations alone, explanation is in fact elided with the easy employment of the wholly unexplained notion of sympathy.

This is the notion that received its most compelling formulation in Frazer's chapter on sympathetic magic at the beginning of *The Golden Bough*. It began in this way:

> If we analyze the principles of thought on which magic is based, they will probably be found to resolve themselves into two: first, that like produces like, or that an effect resembles its cause; and second, that things which have once been in contact with each other continue to act on each other at a distance after the physical contact has been severed. The former principle may be called the Law of Similarity, the latter the Law of Contact or Contagion. From the first of these principles, namely the Law of Similarity, the magician infers that he can produce any effect he desires merely by imitating it.[80]

It is this "law" which is evidently of most relevance to the treatments of images discussed in this chapter. "Charms based on the Law of Similarity may be called Homeopathic or Imitative Magic," Frazer notes, and then he embarks on his great pages of specific illustration, with this introduction:

> Perhaps the most familiar application of the principle that like produces like is the attempt which has been made by many peoples in many ages to injure or destroy an enemy by injuring or destroying an image of him, in the belief that, just as the image suffers, so does the man, that when it perishes he must die.[81]

We need hardly remind ourselves that the apodictic confidence with which Frazer pronounces on "the principles of thought on which magic is based" can never be reclaimed. It is not surprising that his discussion of the principles of magic in general should since have been superseded by many other analyses of the subject, most notably that of Marcel Mauss. But the idea of sympathy has never been entirely relinquished, and Frazer's "principles of thought" on which magic is based do seem to have at least some acceptable empirical basis, even though we need not elevate them into "laws" or be prepared to accept only two such principles. It is true that he begins with an a priori assumption of a hypostasized concept of magic; but he does not go on to claim baldly that images of the kind we have been considering worked, simply, by magic. The subtle discussion which follows his introduction is worth our attention because it acutely and helpfully raises the problem of explanation.

Frazer acknowledges that "the primitive magician knows magic only on its practical side; he never analyzes the mental processes on which his practice is based, never reflects on the abstract principles involved in his actions"; but the urge to explanation carries Frazer forward: "It is for the

philosophic student . . . to discern the spurious science behind the bastard art."[82]

The frame of reference could not be more clearly delineated. We may not share it, and yet we too know that we cannot abandon analysis simply because the people who made images and expected them work, and saw them do so, never—or rarely—articulated the abstract principles involved in their actions. It is, of course, not only the primitive or the magician who is thus "inarticulate." Nor do we proceed simply for the sake of being philosophical. We are confronted with a large body of evidence about the operation of images. They are clearly, in some sense or another, efficacious. We decide not to claim that they are efficacious by magic; how then do we describe the way in which they work? It cannot merely be a matter of putting into words what is left inarticulate by those most intimately involved in the practices. It is an attempt to establish adequate terms, avoiding a priori assumptions as far as possible, for describing the relationship between images and people that is engaged in the operation of the phenomena we have been discussing.

Not content, then, with explanation by way of an unanalyzed notion of magic, Frazer has recourse to what he regards, again, as a fundamental process:

> If my analysis of the magician's logic is correct, its two great principles turn out to be merely two different misapplications of the association of ideas. Homeopathic magic is founded on the association of ideas by similarity; contagious magic is founded on the association of ideas by contiguity. Homeopathic magic commits the mistake of assuming that things which resemble each other are the same: contagious magic commits the mistake that things which have once been in contact with each other are always in contact. But in practice the two branches are often combined.[83]

With what sure-footedness Frazer treads these thorny paths! How simple it seems to identify those "mistakes"! Now we see why he spoke of "the spurious science behind the bastard art." Its application was based "merely" on mistaken inductions from the association of ideas.

But is the association of ideas a sufficient basis for explanation of the way in which images used in juridical contexts and in witchcraft were believed and seen to work? Is it not just a philosophic student's rationalization of what he firmly regards as primitive beliefs? The intellectualist description in terms of mistakes—of a single big mistake, one might say—clearly calls for an answer in the affirmative. Let us see if we can proceed with greater precision, reflecting on the Western cases presented in this chapter, which may be used to complement the array of examples set out by Frazer. We should try to proceed without invoking the notions of sympathy or

operation by magic, without reducing the operative image to the status of the symbol, without resorting to some theory of identification, and without suggesting that belief in efficacy rests on some epistemological mistake. Our examples—both the images of defamation and those in the context of witchcraft—and the "primitive" or "traditional" ones cited by Frazer and others suggest a mode of analysis and a set of conclusions that seem to have a more plausible cognitive basis than the a prioristic explanations hitherto offered.

<div align="center">

VI

</div>

When an image of infamy is defamed, soiled, or otherwise insulted, when a wax or earthen image is pierced, burned, or buried, the victim suffers or is believed to suffer. This much is clear. If we say that he suffers because of the sympathetic relation between sign and signified, then we must assume that the operation is by magic, that the image is capable of working from afar. But there is little in the evidence to suggest that this is the way the images were perceived to work. Efficacy is generally believed to be more or less instantaneous. Of course we do not always believe the represented to be present since aesthetic differentiation may well intervene. But in the case of the images dealt with in this chapter, the procedures of production and action upon them are inescapably predicated on the effort to ensure presence and life. It is for this reason that the way in which the image is made is neither indifferent nor simply a matter of symbolic constitution.

In an important assault on Frazer's two forms of sympathetic magic—homeopathic and contagious—John Skorupski has argued that the efficacy of the image depends purely on its symbolic relation with what it represents. In this respect, the position coincides with that of Nelson Goodman on likeness. While admitting that it seems essential that the image should be an image of the enemy, Skorupski goes on to argue that

> it is the symbolic relation between image and the person which is directly relevant, and the likeness only insofar as it contributes to the function of the symbol: that of making the goal object present and actable upon. For if it is simply the likeness which is believed to underlie the efficacy of the rite, then why should the rite not have the same effect on many other persons to whom the effigy is equally similar (such magical images typically have a highly schematized character)? [84]

Parenthetical comment notwithstanding, the answer to Skorupski's question is clear: the rite does not affect another person to whom the effigy is equally similar, precisely because there can be no question of it being equally similar to anyone else. In every case, more or less elaborate steps

are taken to ensure that the image is precisely that of the victim and no one else. That too is why the images are invariably clearly named or dubbed. But could this not in itself be taken to support the next stage of Skorupski's argument, in which he claims that "while there *may* be some underlying appropriateness which gives the magical object its connexion with the goal object, there need not be: the only essential is that it should be taken as representing it."[85] That claim is wholly undermined by the persistent effort to ensure that the image actually represents the victim rather than simply being taken as a symbol of him or her.

Nothing in the host of available examples of defamatory images and those used in witchcraft serves to corroborate views like these, which Skorupski expands as follows:

> While a symbol may often have some natural appropriateness which fits it to the object represented, this characteristic is not constitutive of its semantic status as symbol: what is essential for this is simply that it is taken as standing for an object. . . . There are many bases on which an object might be selected as an appropriate symbol for another . . . but it is also true that there need be no basis of appropriateness to link the symbol and its object at all.[86]

All the evidence suggests otherwise. Of course it might be argued that everything depends on what is meant by "appropriateness": In whose eyes? One might ask. In any case, it is not at all clear how "natural" is here taken to qualify "appropriateness"; but if there is one conclusion that may be drawn from all the cases we have gathered together, it is that appropriateness, and often anthropomorphic appropriateness, is exactly what is constitutive of the semantic status of the efficacious images that come under the rubric of this chapter.

Nor is the similitude which comes into play "quite conventional," as Marcel Mauss claimed:

> The only thing the image and the victim have in common is the convention which associates the two. The image, the doll or the drawing is a very schematic representation, a poorly executed ideogram. Any resemblance is purely theoretical or abstract.[87]

Again the theorist is misled by the uncritical assumption of schematization; for what do we mean when we call an image "schematic"? Do we mean that the mode of representation seems "schematic" to us, or that various forms of shorthand schemata are employed in the depiction of various elements within the image? There can be no argument about the use of schemata in the latter sense; but Mauss's—and *mutatis mutandis* Skorupski's—argument implies apparent schematization in the first sense. They *are* conventional in that conventional schemata may be used in individuating representations,

but they are not merely conventional in Mauss's sense that any resemblance is purely theoretical or abstract, or in terms of Skorupski's understanding of their status as conventionally taken symbols. The fact is that each individual and each group that makes an image strives precisely to avoid the schematic—however poorly ideogrammatic it may seem to us. The image is particularized in strategic ways, even if the mode of particularization and individuation itself may sometimes be termed schematic. In order to make the image resemble the party we wish to affect, we must individuate it; and we ensure that leveling-off by way of schematization does not occur. There should be no possibility of confusion with a further party. In short, to call any of the images we have been considering conventional symbols is to overlook the close attention that is paid, in all cases, to how they look.

When we see the resembling image, we elide it with the living prototype it represents, unless (as I have already suggested) aesthetic differentiation by way of attention and abstraction supervenes. This tendency to elision does not happen by some kind of magical process. It is part of cognition and it lies at the root of the belief in the efficacy of "magical" images. Aware of the supervening tendency to abstract and differentiate, makers of defamatory or magical images encourage the elision, and set out to preempt the move to differentiation. Not only do they use hair and nails of living beings; there is often an insistence that the images be made according to quite specific rules in order for them to work properly, or to be made of certain materials in order that they should work more effectively.

This is not only a matter of the conventional use of appropriate rites; it is predicated on our empirical knowledge of how things work. We do not have to invoke the concept of magic to explain the effectiveness of images made according to rules. The terms we require are not those of a priori conceptions of how things work. They must be ones which we can recognize from experience; and a little imagination is all that is required to provide the clue to the effectiveness of defamatory and other "magically" operative images. We need, as it were, to engage in a phenomenological quest for the socially determined parameters of cognition. Everything that we make has to be made properly in order for it to work properly. If the model on which we base our reproduction works, then the reproduction must be made according to a similar set of rules. Just as the reproduction of a machine will work if we reproduce it and its measurements faithfully, so too the exact reproduction of an image should be capable of operation, on a similar but sometimes diminished or attenuated scale. There is no need for further explanation by way of magic. In the same terms we may invest reproductions of living beings with life, provided we adhere to the appropriate requirements, and engage in an act—of consecration, say, or baptism—that may inspirit it.

When, therefore, we have an image of a living being in our possession,

we have too that being itself in our possession, and we may affect that person more or less as we wish. If we want to affect certain parts of this being, then we must be sure to affect—or afflict—the exactly appropriate part, as is made clear by those abundant documents concerning the use of images by witches and sorcerers. The image will not be effective if it is not specifically identified with the third party; otherwise we will not thus be able to possess him or her. But we cannot speak of the image being a mere symbol of the third party. It becomes the third party—however temporarily or fleetingly. It is on this basis that images that "work from afar" operate and are effective.

Nor can one reclaim explanation on the grounds of symbolic linkage, or in terms of the evocative resonance of symbols, as has recently been suggested. Perhaps, it might be argued, all that magical images do is to create widening circles of evocation which enable the impugning of one or other evoked componet. Such a line of reasoning fails to take into account the elision of reproduction and prototype.

Skorupski's account of magic rests on two foundations. He argues (1) that a good deal of magic rests on symbolism, and (2) that its "ultimate logic" is that of identification. But these explanations, as he fully acknowledges, can only be maintained by what he calls the intellectualist position: only by looking at "magical" phenomena from a standpoint outside that of the socially shared consciousness in which they play an accepted role are we in a position to assess the notion of a real identity between symbol and symbolized, which, according to him, "runs counter to the categorical framework within which we (at least officially) interpret the world."[88]

In that concessionary clause—"at least officially"—lies the nub of the matter. "Officially" we may now, of course, be able to identify the fusion of the elements that are combined in identification, but cognitively we cannot: fusion precedes analytic suspension. There is no magic here. Skorupski finally admits that "symbolic identification is no longer seen as a purely conventional identity: the symbol in some sense *is* or participates in the reality it represents."[89] But if we speak thus of identity, what need for the notion of the image or object as symbol? "Symbol" implies polarity, and the polarity, as we have seen, falls away in the case of all efficacious images. Identification itself depends on an assumption of polarity, and so we must qualify that notion too, or admit that in the process of identification the image or object instantaneously loses its symbolic quality. But Skorupski's careful argument does have the merit of moving the discussion safely and properly away from the notion of a "double" (where the efficacious image is taken to be a double of the prototype, a position usually held with respect to Egyptian images of the dead), and thus away from its concomitant requirements of the analytic concepts of sympathy, association of ideas, and latterly, of evocation.[90]

Galland's memoir of Napoleon's expedition to Egypt gives this account of an attempt to paint the chief of a Nubian caravan recently arrived in Cairo:

> At first the Nubian appeared to be satisfied with the sketch in chalk: he pointed to the features corresponding to his own and exclaimed: "*Tayeb*—good!" But when the painter began to apply the colours the man threw himself backwards and shouted frightfully. It was impossible to calm him, and he fled, telling everyone that he had come from a place where they had taken his head and half of his body.[91]

For the next century and more, anthropologists gathered further instances of the belief that the body (or some part of it) went to the picture that represented it, and that it could thus dry out, or perish, or be subject to any number of accidents.[92] Everywhere they found evidence of the fear of being portrayed and of resistance to it.

When Frazer wrote about this in 1911, he began with a brief explanation in terms of the capture of the soul. The portrait, he claimed (as in the case of shadows and reflections), was believed to contain the soul of the person portrayed, and so "people who hold this belief are naturally loth to have their likeness taken: for if the portrait is the soul, or at least a vital part of the person portrayed, whoever possesses the portrait will be able to exercise a fatal influence on the original."[93] This "explanation" naturally seemed appealing to those who thought they found evidence, as in the case of ancient Egypt, of a belief that the soul was somehow a "double," that is, a mimetic representation of an individual's physical form. But here a certain agnosticism is called for. It is probably superfluous to invoke a fundamental notion of the transference of a soul from person to portrait in order to explain the belief that a portrait somehow gives its owner or maker possession, power or control—even potentially fatal control—over the person portrayed. We could never get to the bottom of the matter in these terms, since beliefs about the status of the soul, or indeed, of the mind, are very likely to differ from instance to instance. Instead, at this stage, of seeking blanket explanations, or attempting to pry apart the shell of first-level belief in order to attain some putatively deeper notion of the reproduction and transference of the soul, let us stay, for the moment, with just those first-level beliefs.

From the Inuit Eskimos of the Bering Strait to the Canelos Indians of Ecuador and the Araucanians of Chile, from the Yao on the shores of Lake Nyasa (Malawi) to the Bara of Madagascar, from Sikkim to Celebes and Borneo, anthropologists have recorded people's fear of being portrayed on the grounds that they might thereby fall into the possession and control of

others.[94] The Mandan Indians thought they would die if someone get hold of their portrait—"they wished at least to have the artist's picture as a hostage"—and the Araucanians believed that anyone who had pictures of them could injure them. It is in the case of photography, not surprisingly, that the belief finds its most striking manifestation. As soon as explorers and anthropologists started taking photographs they encountered it. The Tepehuanes of Mexico were afraid of the camera because they believed the photographer would be able to devour them in his spare time. When James Thompson tried to photograph the Wateita of East Africa, they felt that if he got their likeness, "they would be entirely at his mercy" (imagining, according to Frazer, that he was a magician trying to get possession of their souls). In Sikkim the early photographers encountered the view that the owner of their photographs would be able to cast spells on them—indeed, they maintained that a picture likewise blighted the landscape—and so the examples can be multiplied.[95] The fact that in certain cases, the "primitive" subjects of photographs have some difficulty, at least initially, in recognizing themselves or in understanding what the photographers represented does not mitigate the relevance of these beliefs in the power to damage or control—the power that arises with the portrait that is acknowledged to be both vital representation and vital presence of the portrayed or of his soul.[96]

But it may be worth singling out a few instances of "operation from a distance" that put one in mind even more directly of the Western material. The Yao dreaded the camera. It was felt that the transference of the shadow or portrait (both called *chiwilili*) to the photograph would result in the disease or death of the shadeless body. A Yao chief, it was early reported, allowed himself to be photographed, on condition that the picture be sent out of the country as soon as possible, lest some local ill-wisher be able to bewitch him. When, shortly afterward, he fell ill, the illness was attributed to some supposed accident to the plate in England. The reluctance of the chiefs of Minahassa in Celebes to be photographed arose from similar fears: if their photographs were lost they believed that whatever injury the finder chose to do to the portrait the person whom it represented would be equally affected. Throughout central Borneo, explorers had difficulty in photographing local people, since they felt that if the explorer possessed their likeness he would be able to work on the originals at a distance by means of "magic art," in Frazer's term.[97]

"Magic art" or not, what every one of these examples illustrates is the relation between the perceived likeness (and, usually, the perceived realism) of the portrait and some assumption, by the portrait, of the living person portrayed. That is why, on any level, that person may be affected if his or her representation is similarly affected. The closer the perceived likeness (for this is the lesson of the example of photography), the more likely the belief in the transference, the attenuation, or even the deprivation of the

living qualities associated with the original. But it is as well to remember, as Marcel Mauss would have insisted with regard to both magical persons and objects, that these are more social than experimental facts.[98] Social and not experimental with respect both to the object itself and to its imputed efficacy. We need not test whether images are exactly as efficacious as they are said or seen to be: it is enough that they are believed or proven to work in their particular circumstances. This is not, however, to say that they are arbitrarily chosen.

This, in fact, is just what Mauss himself went on to claim, when he commented on what he called "the idea of magical efficacy." "These value judgements [i.e., those of magic]," he properly remarked, "are not those of individual spirits. They are the expression of social sentiments which are formed with regard to certain things, chosen for the most part, in arbitrary fashion."[99] But we have repeatedly seen that the latter is not the case at all, and that the efficacy of such things—but above all visual representations—depends precisely on the specific care with which they are chosen or made. Once that fact is grasped, we have no further need for recourse to the categorization as magic. The "value judgments" at issue are indeed the expression of social sentiments; but they are predicated, in their turns, on the cognitive relation between resembling object and living body portrayed. The "expression of a social sentiment" by no means precludes, as Mauss's argument may conceivably be taken to imply, the symptoms of cognition; nor does it undermine the possibility of psychological generality lying at the root of behavioral variation, or a generality that is subject, as are all such generalities, to the pressures of social and cultural context.

VIII

I have surveyed a series of non-Western responses to portraits, and especially photographic portraits, in order to illuminate the instances of the efficacity of the classes of Western imagery on which this chapter has concentrated; but most readers will also have encountered examples of the resistance to being photographed in the societies they know, in circumstances with which they are intimately acquainted. Of course such resistance may be based on "aesthetic" grounds, or on a feeling that the picture can never live up to the true quality of the original (as often, in old criticism, with painted portraits); or perhaps more deeply, it may be predicated on an apparently moralizing concern over the vanity of reproducing one's own features. But even this is related to the kinds of fear upon which all such resistance is predicated. And that, in the end, has cognitive bases at least as much as social ones.

When we see an image we strive to constitute it according to some grasp-

able form with which we are already visually acquainted; when we see an image resembling a living being, we supplement the clues it already provides with further visual points of reference, in order that it may thus acquire substantive and recognizable vitality. In thus seeking to reconstitute the living being before ourselves, we take away from the vitality of the actual being thus represented. Hence metaphor upon metaphor of the living presence of represented form; hence the slow erosion of metaphor in favor of a transferred reality, until, in some cases, reality becomes present and actual. Signified is thus diminished and reconstituted more graspably and comprehensibly in the signifier before us. It would be straining the limits of our own understanding of how we perceive if I were to suggest that we always reconstitute living presence thus, for we are too convinced of our ability to perceive signifier as signifier, to perceive what we call the "aesthetic" aspects of the sign as sufficient demarcation from the living reality of the body signified.

But does demarcation occur as clearly and as frequently as we now like to think; and how sure can we be of the constancy and strength of our ability to differentiate sign from signified? How do we know that when we see an image there is no moment of suspension, no moment when striving to reconstitute resembling form as resembled reality obliterates all awareness of the signified being as a thing apart, a presence elsewhere? Not even the keenest exponents of the view that we have become fully acculturated to see object as object, to accept image as representation, could claim that. It may be thought that the evolution and acknowledgment of a canon ensures differentiation: we see the canonical object specifically as art, and not, somehow, as partaking of the nature of life of what it represents. That, however, is the comfortable art historical view. But if we, or our predecessors, or our ancestors, or our fellows in more or less related cultures—albeit more "primitive," albeit less sophisticated—elide living being with represented form in the case of images not specifically called art, then we cannot be sure of an abrupt, indeed a harsh change of perceptual modes upon the intervention of awareness of aesthetic qualities that, on the face of it, seem to encourage differentiation. Perhaps we should be more relaxed about this in the case of art too. We cannot suppress all vestiges of the tendency to elide prototype and image, and to invest the latter with the qualities of the former. In doing so, we too may feel the stirrings of fear, or sexual arousal, or emotions so strong that they threaten to arouse us to visible behavior; and in the case of portraits of ourselves, the beginnings, remote though they may be, of a feeling akin to resentment (to assess the emotional disturbance at no more than that) at the transference of some part of ourselves to the representation of ourselves.

No history of art can afford to ignore these lessons of a history of images more widely conceived. That it has so far largely done so is a shortcoming

that can only properly be made good by closer and more candid attention to the evidence of responses that we have come largely to suppress. To say as much is not to restrict the pleasures of aesthesis, but to allow the expansion of response to its more natural limits. The perception and analysis even of canonical forms can only be enhanced by this freer and less alienated awareness of how we may conceivably be moved by them. Acknowledgment of this may be disturbing; but if the candor of analysis does not threaten the equilibrium upon which it is supposed to be predicated, then it remains on the level of insistent and self-deluding reinforcement. The pleasures of a formalist aesthetics deny both the fears and the pleasures that otherwise sustain us—because it springs from an alienation that both clouds analysis and denies our natures. A history of art that stands back from the natural symptoms of response merely toys with the small change of intellectualism.

11

Live Images: The Worth of Visions and Tales

When a third-century apologist for Christianity writes in defence of the new religion, he also has to point out, with all the fervor of the newly converted, the cracks in the edifice of the old. The mocking of inconsistencies in the old Roman religious practices becomes a polemical imperative—we have already seen it in the case of Minucius Felix and we see it again in Lactantius, at the end of the first book of his great treatise, the *Divine Institutions* of 304–11. In taking this line he quotes a passage from Lucilius, who had himself satirized and mocked the stupidity of people who thought that the statues of the gods were the gods themselves.

But if we had to name anything which is the life of the sign we should have to say that it was its use.
WITTGENSTEIN,
The Blue Book

> As for scarecrows and witches which our Fauns and Numa Pompiliuses established, they [i.e., the ignorant] tremble at them, and think that they are all-important. Just as little children believe that all bronze statues are alive and are men, so they think that the fictions of dreams are real, and believe that bronze statues have hearts and souls in them. But these things are the painter's gallery, nothing real, all fiction and make-believe." [1]

It is peasants and children, then, who think these things; this is how we comfortably relegate orders of belief that make us uncomfortable and deny or upset our education. Peasants, children, and crazy people. But can we be sure that beliefs of this kind do not extend more widely; and if they do, how are we to talk about such beliefs? Lucilius's vivid formulation implies that intelligent and sophisticated people (and adherents of Christianity) do not conflate image and prototype, and do not think that statues are (or could become) alive: only the ignorant lapse into such errors. This is not

283

only the implication of the original passage in Lucilius and the point of its reappearance in Lactantius; it is also the basis of modern self-consciousness—where it exists—about responses to images.

Anthropologists and folklorists used to devote a great deal of energy—far more than they do now—to two related phenomena: first, the belief that inert objects were (or could be) invested with souls or inhabited by spirits (either good or bad); and second, the tendency to attribute living character to what appear to most of us to be inanimate objects. Sometimes a distinction would be made between the two phenomena: the first was identified as animism, the second as a preanimistic stage called animatism. But the latter term was never widely used, and all such beliefs and tendencies came to be grouped together under the general rubric of animism.[2] Not surprisingly, the term gave rise to much difficulty. It was used as a catch-all to provide a kind of generalized explanatory link between constantly recurring accounts of images that manifested their liveliness in one sense or another. "Animism" acquired a life of its own, and came to be something which was thought to be capable of definition as an abstract universal. Even the ethnographers, who were in full possession of the contextual and material determinants of the beliefs involved, sought to define its essential nature. Convenient though it may have been as a classificatory mode, it blurred the distinctions between a wide variety of phenomena. Even when animism was not regarded as one of the *Urideen* of all religious systems, argument about it remained unpragmatically idealist, instead of being rooted—in principle at least—in the realities of history and context, and in the dialectical relationship between object and perceiver. Nowadays the term—and the whole endeavor it implies—is scrupulously avoided.

Just because we have discarded the concept does not mean that we should overlook the abundant evidence that forms its basis; but analysis has almost always been distorted by the need to associate the material with a further concept, that of the primitive. As a result, the Western evidence concerning images invested with life has been largely neglected by the sociologists, anthropologists, and psychologists to whom it should have been of most interest. Yet Western writing contains an extraordinary number of references to paintings and statues that demonstrate their vitality in any number of ways. They perspire, bleed when struck, and distill oil and other healing substances. Their eyes engage the attention of the spectator, or follow him around a room. In short, they belie their inert nature by appearing to be animated.[3] What are the implications of this great body of material for the history of response?

That the material has not been a major concern of historians of art and culture is hardly surprising. It seems almost wholly literary, bearing little definable relation to actual experience. It is felt to be an embarrassment, too childish or trivial to merit serious attention. It does not appear to reveal

very much—if anything at all—about artistic processes, or even about how men and women respond to images. What are we to make of passages like the following? A novice reflects after a monk reminds him of a miraculous image at Floreffe and of another which hit a nun on the jaw when she tried to run to her lover: "I am overcome by amazement," he says, "when I hear a voice speaking in the wood, a hand raised to strike, the body bending over, raising itself, sitting down, with the other vital movements. I am more astonished by this than the ass's speech to Balaam—for that was a living and moving being; but in wood, stone and metal there is no living spirit."[4] Do we dismiss this passage—and the many others like it—on the grounds that the speaker is impossibly simpleminded (as novices are wont to be); or that he is only talking in topoi; or that he really is perfectly well aware of the distinction between inert signifier and lively signified (with the apparent conflation a more or less conscious indicator of just what was constitutive of the miraculous nature of the image)? This indeed is what the text of the conversation suggests. Or should we take the novice's response more seriously still?

Before proceeding to a closer examination of the Western material, two issues should be clarified. The first is this. On the one hand there are practices which only imply the life (in the sense of the *anima*) of the image; on the other hand the image may actually come to life, or seem to do so. It is important to remain aware of the difference between offering something to an image or placing a garland on its head (as if it could respond in the way a human—or an anthropomorphized god—would) and actually seeing it come alive. Of course, the answer to the question of whether people actually believe that images can come alive at all, and whether they really perceive them as though they were, depends wholly on the construction we put on those two adverbs: is it really possible to distinguish between actually believing something and thinking one believes something? Or is the implicit distinction a spurious one? But the aim is not to answer questions like these; it is to consider the implications of the repeated insistence that such things do happen.

Second, unlike the anthropologists who unearthed animism, my main concern is with the attribution of life to images and not to other kinds of inanimate objects, except when these are directly relevant. If we thought that the formal qualities of objects had nothing to do with the way they worked, then much of the argument would be seriously undermined; but I will again choose to suggest the centrality of the relation between the formal quality and the efficacity of objects.

Even the Sacri Monti of Northern Italy and the polychrome sculpture of the Iberian peninsula do not have devices such as those which serve to animate the fourteenth- to sixteenth-century crucifixes with moveable arms and heads. In 1969 Gesine and Johannes Taubert cataloged thirty-five surviving examples—and five documented ones—from both Northern and Southern Europe.[5] Since the devices are often covered by garments or some other mask of realism, one may safely assume that there are many more. Some of the surviving works are by superior artists, like the one ascribed to Donatello in Santa Croce in Florence and Giovanni di Balduccio's early fourteenth-century crucifix in the Baptistery there; but for the most part they show a wide and uneven range of artistic skill. Although not all are made in the same way, the head is usually moveable, and so are the arms. They are attached to the torso by means of ball and socket joints, which in turn may be covered by painted linen (see figs. 139 and 140). Sometimes the hair is natural, and a vessel connected to the chest wound is affixed to the back, so that while head and limbs move, the wound in the side is enabled to bleed.[6] One can imagine the opportunities they offered to unscrupulous clergy willing to exploit the credulity (and therefore the pockets) of their congregations.[7] But here we must ask how and in what context these crucifixes were used.

From the early to the high Middle Ages, their main function was to play a specific role in the course of the liturgical dramas of the Easter period. Both people and images actively participated in these dramas. On Good Friday the crucifix was carried round in solemn procession. Homage was rendered to it—in the course of the *Adoratio Crucis*—during which it would be directly addressed. Then, in front of everyone, Christ was taken down from the cross, and his arms placed by his side (fig. 140). He was wrapped in a shroud and placed in or on the altar serving the Holy Sepulchre (the *Depositio*); until on Easter Sunday the shroud was unwound and Christ would rise from his grave (the *Elevatio*). It is not hard to see how suited the crucifixes with moveable arms were to such ceremonies.[8]

The earliest account of this liturgical ceremony involving a crucifix with moveable arms comes from the convent of Benedictine nuns in Barking in Essex and dates from 1370, but the fullest account is the *Ordo* of around 1489 from the Benedictine Abbey of Pruefening near Regensburg. What should be emphasized (and what the accounts make clear) is the joint involvement of both living actors and these images. It was not unusual to find monks or even lay people actually playing the roles of Joseph of Arimathea, Nicodemus, and an attendant as they took the wooden image of Christ from the cross and placed in the lap of the man who played the Virgin Mary.[9] Sculptures like these could thus replace the actors who had

139. *Left:* Crucifix with moveable arms from Sankt Veit an der Glan, detail (ca. 1510). Klagenfurt, Diözesanmuseum.

140. *Right:* Crucifix with moveable arms from Grancia in Tessin (early sixteenth century). Zurich, Schweizerisches Landesmuseum.

earlier played and elsewhere continued to play Christ himself; and if some images could really move, who is to say that others might not too?

Such examples cast in a new light all those representations of Christ coming down from the cross and embracing the living historical personage beside him, as in the early sixteenth-century sculpture of Christ leaning forward to embrace Saint Bernard in Oberschönfeld, or in Murillo's extraordinary picture *Saint Francis Embracing the Crucified Christ* (who puts one arm round the saint), or Ribalta's still more intimate *Christ Embracing Saint Bernard* (figs. 141 and 142).[10] There were also the coarser pictures presented to the *afflitto* just before their being condemned to hang—as well as the

141. *Right:* Bartolomé Esteban Murillo, *Saint Francis Embracing the Crucified Christ* (1668). Seville, Museo Provincial. Photo Mas.

142. *Opposite:* Francisco Ribalta, *Christ Embracing Saint Bernard* (ca. 1620–25). Madrid, Museo del Prado. Photo Mas.

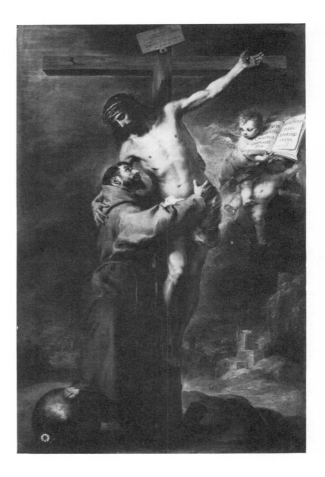

many images of the Virgin ejecting her milk into the mouth of Saint Bernard (fig. 143).[11] The vision on which this immensely popular scene was based (and it was nowhere more popular than in Spain in the seventeenth century) took place, significantly, before a real statue of the Virgin.[12]

But while many of the crucifixes with moveable arms may still seem reasonably lifelike to us, most of the sculptures of the Virgin and Child known as the Throne of Wisdom now seem solemn and immobile (fig. 32). If we find them arresting at all, it is because of their seemingly archaic and austere formality. And yet these were the statues that were most frequently used in the Epiphany drama of the *Officium Stellae.* We have a text from as early as the eleventh century. It comes from Nevers and sets out how three clerics were to dress up as the Magi, advance to Herod and then to the midwives, and ask for the Christ Child. "Here is the Child whom you seek, *Ecce puer adest quem quaeritis,*" respond the midwives, pointing to him. Small wonder that to many the Child would then seem to move or bend his head![13]

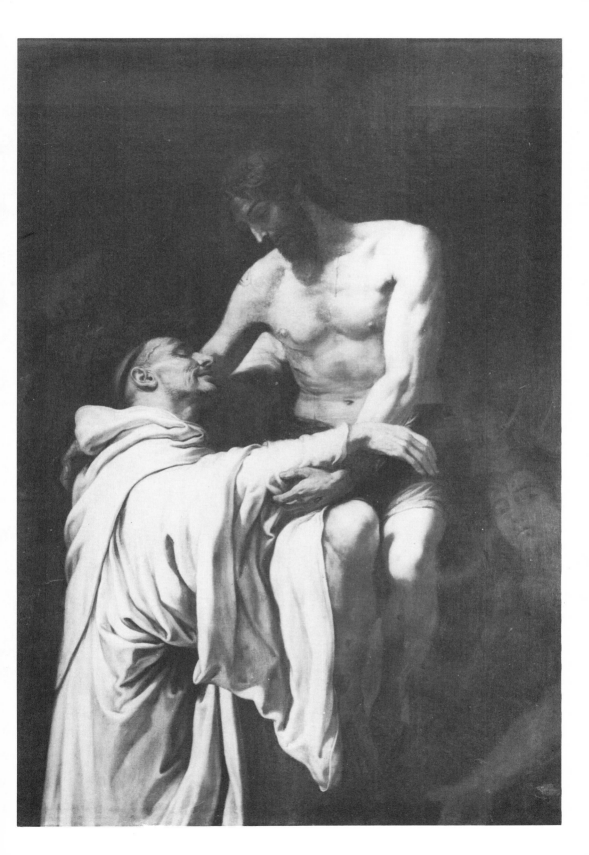

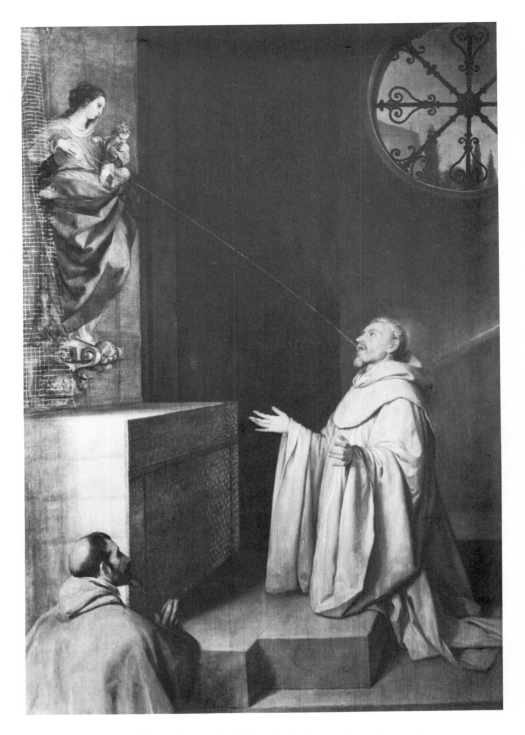

143. Alonso Cano, *The Vision of Saint Bernard* (ca. 1658–60).
Madrid, Museo del Prado, Photo Mas.

In Aurillac, Bernard of Angers described the *Majesty* of Saint Gerald made of the purest gold and the costliest gems (cf. fig. 30); but for all its craftsmanship and splendor, it still seemed so similar to human form that "the peasants in prayer before it believed that it saw and encouraged them through its expressive gaze. It listened to their petitions, and they even imagined that the figure nodded to them in answer."[14] Now this is not simply a case of a learned and elitist writer attributing to the lower classes species of behavior, belief, and sentiment that suited the polemical or dogmatic thrust of his arguments; they cannot be dismissed as pure invention. If anything it is more likely that, however silently, Bernard recognized in himself similar forms of behavior, belief, and sentiment; but like so many after him, felt more comfortable if he could relegate such apparently irrational and inexplicable things to people with less education and who were by implication less critically thoughtful. We cannot precisely know, but we can also not be dismissive. Once we think of the surviving images themselves, and the functions to which they were put, we can begin to hear the resonance of those countless miracle legends in which images are said to move, speak, weep, strike out, and eat. This is not merely folk psychology—although it is certainly and significantly that too—it is historical testimony to cognitive fact. These are not just quaint practices and charmingly iterative tales: they tell us about the constitutive powers of men and women. It is in this that their relevance lies, at least as much as in the internal history of drama, of literature, and of the rise and development of figured objects.

II

It will be recalled that the classical legends around Daedalus are of two kinds: one tradition simply records that he was the first to liberate the limbs from statues and make statues so lifelike that they appeared to move, even to run away; the other has it that he made statues, like automata, which were capable of movement. The latter tradition is consistent with and reinforced by Daedalus's reputation as an inventor, and it presumably grew out of the first; but the whole congeries of tales makes clear, from an early stage, the relationship between the perception of an object as lifelike and the attribution of lively powers to it. Swiftly we encounter a convention of compliment that occurs throughout Graeco-Roman culture, and thus enters the mainstream of Western writing and thinking about art. If one measures the skill of the artist in terms of his success in conveying the illusion of reality, then one pays tribute to that skill by describing his productions as being so lifelike that they appear to be on the verge of movement or speech, or—better yet—that they are actually alive.[15] But is one dealing simply

with conventionalized compliment, or has convention once again become an index of cognition?

There are many examples of the troping of compliment in the Greek Anthology; but they hardly ever occur more frequently than in the epigrams on the statues by Myron, especially his famous Heifer.[16] The following two pithy lines are entirely representative: "If you saw the heifer of Myron you would swiftly cry out: is this lifeless nature, or art filled with life?" The other epigrams in this group all work variations on the same theme. "I think the heifer will low. Truly it is not Prometheus alone who moulds living creatures; it is you too, Myron."[17] This is fairly restrained in its eulogistic tone; but as soon as the idea of lowing is elaborated, literary extravagance sets in. "Calf, why do you approach my flanks, and why do you low? The artist put no milk in my udder."[18] Are all these lines nothing else than literary tropes? Although they seem to be very little more than that, they do show remarkable affinities with the apparently unsophisticated beliefs in animated images that we have already outlined and will continue to explore in greater detail. But first let us see how the notion of the speaking image is developed and expanded in these literary contexts.

The opening of Christodorus of Thebes's poem on a statue of Homer is more restrained than some of the farfetched witticisms about Myron's Heifer, but it ingeniously turns the idea on its head, in a way that has become one of the clichés of lowish-level descriptive writing about art. "Homer's statue seemed alive, not lacking thought and intellect, but only, it would seem, his ambrosial voice."[19] Here, in what may seem a rather uninteresting couplet, the conventionalized compliment works two ways, in a manner that we encounter again and again, until well after the seventeenth century.[20] The statue is praiseworthily illusionistic, but how can one ever capture the essence of Homer—his voice? The special irony with an image of Homer, of course, is that he was blind; and in this case it would have been impossible to employ that other form of recurrent compliment, the praise which turns not on the movement of limbs or the potential for speech, but on the vitality of the eyes.

No less a writer than Pliny has this to say about a picture by Famulus, who lived, presumably, in the reign of Nero: "He painted an Athena, whose eyes are turned to the spectator from whatever side he may be looking."[21] Few comments about images—whether paintings or sculptures—could be commoner than this. The convention of making this form of compliment had even then become so thoroughly ingrained that there was no further need to refer to the painting's closeness to reality (although this may be one of the reasons why it has been suggested that some mechanical device is implied in the passage about Famulus).[22] We need not detain ourselves by rehearsing the many other descriptions of this kind in Pliny, since his abun-

dant proofs of the skillful deceptiveness of works by artists like Apelles have entered the mainstream of high culture in the West.

The time has come to confront the issue posed by this antique material more directly. It seems entirely literary. What then, one might ask, can it have to do with the actuality of behavior and response, except glancingly? And even if people do respond in ways suggested by the literary material, could it not simply be a matter of just that, of the literature suggesting a response? That in itself would be sufficient to merit attention; but there is still more to these repeated themes in the common critical literature about art. If the material does reflect actual response, it may seem to be on just this level of greater or lesser sophistication in the judgment of specific works, and thus all the more distant from natural or spontaneous behavior.

Perhaps we incline to the view that passages such as the ones cited so far do not reflect actual experience; that they are merely descriptive, merely literary clichés, merely conventional metaphors for artistic skill. Once again, the issue revolves round "merely." Implicit in the attention I have devoted to this kind of writing (and talk) about art is that it cannot be dismissed on the grounds that it is catachrestic, and on the grounds that when people refer to living or lively images in such contexts they really mean to refer to images which look *as if* they were alive.[23] It strains credulity and begs too many questions to assume that constant talk about living images has no resonance beyond providing a convenient handle for saying something purely descriptive about an image. One may argue that no intelligent person ever really thought that a statue was alive, and that whatever muddles might have arisen only did so in popular contexts. But that is not the point; in the first place because even if the intelligent person had only a suspicion that it was alive, the suspicion itself would count; in the second place because the intellectualist distinction here looks to be entirely spurious ("ordinary" people are just as likely, if not more so, to see through a convention which describes inert matter as "alive"); and finally because one must assume that conventionalized discourse, including critical discourse, plays at least some role in plotting the boundaries of cognition. That, in the end, is the significance of the use of single words like *zōon* (primarily "living thing") for statue, *zōgraphos* for painter (with which one may compare the even more explicit Egyptian word for sculptor, *s'ankh,* "he who makes live/alive"), and *andrias* (from *anēr,* "a man") for statues primarily of the human male—however diluted their etymological significance may ultimately become.[24]

But if the evidence for the description and perception of images were limited to these particular words or the particular form of discourse I have been alluding to, there would not, admittedly, be much to go by. There is in fact a much larger body of material that is neither critical nor theoretical,

but bears directly on the kinds of relationship between persistent metaphor and cognition that we have begun to sketch. Often it is almost as conventionalized as the art-critical talk, but for the most part it consists of what are supposed to be reports and descriptions of actual experience. It differs from the critical, "aesthetic," and ekphrastic talk in that it frequently seems to have its roots in experience and in observed behavior in the presence of images. Let us turn our attention to the reports of images that come alive and focus on how the image itself seems to perform.

<center>III</center>

First, however, consider the illustrations in figs. 144–47. In a number of the Byzantine books of the ninth to the fourteenth centuries known as the "marginal psalters," an image of Christ extends a hand beyond the frame to believers or, most often, to David; or appears to be in conversation with them; or actively blesses them. In the so-called Theodore Psalter in the British Museum, Christ often reaches from an icon representing him to bless or speak to a figure before him, or to point to an event such as the destruction by an angel of an evil man (fig. 144).[25] In a fifteenth-century French manuscript of the miracles of the Virgin, the Virgin emerges from behind the retable to speak to the Christians of Toledo (fig. 145); this is the only way in which the artist can convey the speaking powers of the image. On another page, a winsome boy hands an apple to the Christ child in a painting, who stretches forward from his Mother's lap to receive it (fig. 146); on a third a painter is shown putting the finishing touches to a devil who subsequently pushes him off his scaffolding.[26] Documents like these, just like the texts that form their basis, have been neglected because they have seemed too childish and insignificant (except perhaps in terms of the skill with which they were done). One of the commonest representations in Western devotional painting from the fourteenth to the sixteenth century is the Mystic Mass of Saint Gregory, where Christ himself, as the Man of Sorrows, appears in all his suffering above the altar before which Gregory kneels in prayer (fig. 147). From the seventeenth century we have such remarkable images as that of Christ reaching forward from the crucifix to place his arm protectively round the shoulders of the adoring Saint Lutgard (fig. 148), while there are any number of paintings showing Christ bending forward from the cross to embrace Saint Francis. And this is to omit those many pictures, sculptures, and prints which show the visionary appearance of the apparently living Christ, Virgin, or one or more of the saints.

At stake in all these representations is not only the narrative or doctrinal source—their textual bases—but also the apparently powerful motive, in many of them, for showing the central figure as palpably lifelike. This

144. *Left:* The Image of Christ speaking to David and
pointing to the Destruction of the Evil Man,
Theodore Psalter (Byzantine; eleventh century).
London, British Library, Add. MS 19352, fol. 15 verso.
By permission of the British Library.

145. *Below: Comment a Toulette . . .* (from J. Miélot, *Miracles de Notre Dame*; ca. 1456). Oxford, Bodleian Library
MS Douce 374, fol. 12 recto.

146. *Bottom, left: D'un petit enfant qui donna a mengier . . .*
(from J. Miélot, *Miracles de Notre Dame*; ca. 1456). Paris,
Bibliothèque Nationale, MS fr. 9199, fol. 28 verso.

147. *Right:* Master of the Holy Kinship, *The Mass
of Saint Gregory* (Cologne; ca. 1500). Brussels, Musées Royaux des Beaux-Arts. Photo A.C.L.-
Brussels.

148. Gaspar de Crayer, *Saint Lutgard Embraced by the Crucified Christ* (1653). Antwerp, Zwartzusters. Photo Rubenianum, Antwerp.

cannot only be increasing skill at naturalistic representation; it is a matter of absolutely conscious and sometimes extreme diligence in making the living qualities of the dead image present. "Dead image" in two ways, for it will not have escaped notice that the examples fall into two categories: the first consists of representations of images that come alive or are made animate; in the second the representation itself—or part of it at least— seems to be living. In each case there is a beholder, either the one within the representation, or the implied one outside it, upon whose response the quality of being animate is wholly predicated.

Furthermore, as in the abundant illustrations in both manuscripts and panels of the Mass of Saint Gregory, the place on the altar where we would expect a painting or sculpture of the Man of Sorrows is occupied by the living Man of Sorrows (fig. 147). Representations like these are always obviously like a painting or sculpture, but they are also made to seem palpable and alive, just as the story dictates. In the course of saying mass, Gregory the Great saw the host transform itself into the Man of Sorrows himself. Now it is true that this was a vision; and that it was the host and no picture that became the visible Christ (since this particular transformation is inherently more likely). But we have only to ponder for a moment to appreciate the consequences of seeing what is in effect a representation of Christ as the Man of Sorrows but knowing that it is the fleshly, suffering, compassionate Man of Sorrows himself. What is striking, indeed, about almost all the depictions of the Mass of Saint Gregory is the great pains the artist has taken to make sure that the Christ is perceived, not as representation, but as real; and after that we should consider all those many instances of votive imagery where a living historical being prays before a vision of Christ or the Virgin (e.g., fig. 149).[27] The nature of the vision is such that we must imagine the real Virgin, and yet she is painted. After so many centuries of this variety of experience, how unavoidable it must have been to invest inert figured material with life.

This too is the lesson of topos and of standardized metaphor. The ultimate tribute to artistic excellence may be to say the work is so excellently crafted, so lively, that it seems to move or speak. These are the convenient conventions of compliment; but if they are repeated often enough, if they are inevitably to hand, then convention itself is likely to condition response. We become ready to perceive the image in this way. The merest suggestion of living potentiality will trigger the process whereby the trope becomes cognitive reality.

Let us look at the textual counterparts of all this. How may they be said to begin and then to grow? Again there is an instructive manner of attempting an answer. Although ekphrastic writing never ceased to include and elaborate the classical theme of the image that is so skillfully wrought that it seems alive, the new doctrines of Christianity gave the theme new point

149. Lucas Cranach the Elder, *Frederick the Wise Adoring the Virgin* (ca. 1516). Karlsruhe, Staatliche Kunsthalle.

and substance. If images of Christ could be justified on the grounds that his Incarnation as a man enabled the representation of the divine as human, then images of him had to appear human too. But images of the Virgin and all the saints also frequently demonstrated their vitality; and in order to understand this we must invoke another factor: the need to render the divine accessible by making it seem familiar, recognizable, able to be grasped. It also had to be seen in these ways; hence the attribution of human sentiment and emotion to so many images from the early centuries of the Christian era until our own times.

In Byzantium the evidence comes not only from the kinds of ekphrastic and eulogistic talk we have already considered from classical antiquity. Much of it is more direct and less apparently metaphorical, as in the eighth-century *Parastaseis syntomoi chronikai:* it is concerned with the inhabitation of images, by good or bad spirits. In this respect it is more wide-ranging and more obviously popular than the Greco-Roman material; and it seems

to reflect popular attitudes and practices much more directly than the literary sources. Finally there is the matter of miracles, not only in Byzantium, but all across the West, from the advent of Christianity on. Images which come alive are taken to be further instances of the kind of miraculous event that supports the verity of the Christian faith and justifies the practices of its adherents. From early on the bulk of the material, when it is not of the purely literary and ekphrastic category, occurs in collections of miracles. Many of the stories that occur throughout the Middle Ages—whether or not adapted to local concerns—are to be found in the Byzantine guidebooks and in the lives of saints and holy men. Furthermore, the origins of particular cult statues and the devotions surrounding them are justified by increasingly elaborate accounts of the miracles they worked and continued to work; and a high proportion of such miracles consist, unsurprisingly, of the ways in which they transcend their inert material nature by the demonstration of human and living qualities. All this is to be found with increasing frequency and in many variations from the fourth century right until our own; and most of the stories that we encounter from then on contain a kernel that provides a clue to their earlier origins.

There are stories about the statues at particular shrines and there are abundant ones about crucifixes, but most are about images of the Virgin. Examples of all kinds occur in Peter Damian (988–1072), who writes about them in his letters and in the *De apparitionibus et miraculis,* as well as in Sigebert of Gembloux's *De gloria martyrum* (before 1112). With him and with Guibert of Nogent's *De laude S. Maria* and the *De pignoribus sanctorum,* we move into the first half of the twelfth century, a crucial period which has such writers as Gautier of Cluny, Honorius Augustodunensis, and Peter the Venerable chief among those who make frequent mention of miraculous images. By the end of the century the material has started to expand rapidly and also comes to be very repetitive. It is at about this time that we see the earliest of the great collections. The very earliest seem to be of English origin, most notably those of the younger Anselm (who came from Normandy to England around 1120) and William of Malmesbury (who died in 1143); but by the middle of the thirteenth century they had taken all of Europe by storm.[28] The greatest of all the compilations are probably those of Caesarius of Heisterbach (1180–1240) and Gautier de Coinci (1177–1236), but almost simultaneously many of the stories are included in the exempla of sermon writers like Jacques de Vitry (1181–1240).[29] They are taken up in the treatises on a whole variety of subjects by Etienne de Bourbon (d. ca.1261), Umberto de Romans (d. 1270), in the *Liber Mariae* of Gil de Zamora (1282) and the *Scala coeli* of Jean Gobi de Alais (1301), to say nothing of a whole variety of anonymous sermons and treatises, and marvelous vernacular pieces such as the *Cantigas* of Alfonso X of Castile (d. 1281) and the Middle High German *Altes Passional.* Vincent of Beauvais

150. *The Madonna of Czestochowa.* Photo Werner Neumeister.

(1190–1264) included many legends in his great encyclopedia known as the *Speculum Maius,* and so, not at all surprisingly, did Jacobus de Voragine in the *Legenda Aurea.* The names alone give some idea of the extent and geographical range before the end of the thirteenth century.[30]

The vogue continues throughout the fourteenth, in high and low literature. We find stories of miraculous images in Dante and Ruteboeuf, in the engaging *exempla* of Johannes Herolt (d. 1418), and in the mystical effusions of Heinrich Suso. Increasingly the tales are illustrated, notably in the mid

fifteenth-century manuscripts composed and probably supervised by Jean Miélot, secretary of Philip the Good of Burgundy. But by then, as we have already noted, there are reflections in panel painting and in sculpture too. The stories have become firmly rooted in Western culture and recur throughout the sixteenth and seventeenth centuries, with a particular following, it would seem, in the hundred or so years immediately after the Council of Trent. Wichmans writes his great *Brabantia Mariana* (1632) for that province alone, packed with tales of the lively and miraculous images at almost every shrine; from Venice comes Felice Astolfi's abundant *Historia universale delle imagini miracolose del Gran Madre di Dio* (1624); and out of Ingolstadt there appears the immensely useful *Atlas Marianus* by the Jesuit Wilhelm von Gumppenberg, with a pronounced bias to the major shrines of Central Europe (1659).[31] The aim of all such books, than which one can imagine few more compendious (Gumppenberg's book has one of the greatest indexes in all history), is to bring together as many accounts as can be found of the miracles associated with particular shrines and particular cults. Toward the end of the eighteenth century, a pronounced official skepticism sets in; but the stories continue to be revived, often in surprisingly but still recognizably metamorphosed forms. By the end of the nineteenth century they became somewhat more peripheral; but their influence may still be detected in the accounts of many pilgrimage shrines and popular cults. In any event, all these stories are still to be had in the umpteen guidebooks and in every piece of local and national propaganda, from those about the tiny carving of Saint Wenceslas on a tree stump in Nove Sobotak in the Tatra Mountains to the great Black Madonna of Czestochowa in Poland (cf. fig. 150); or in the reports from a small Sri Lankan village about the statue of the Virgin that moves its eyes; or the icon in an Albanian church in Chicago, which 5,000 people a day streamed to see when it emitted an oily substance from its eyes and hands in 1986.[32]

<div align="center">IV</div>

Caesarius of Heisterbach was a Cistercian monk in the abbey of that name near Cologne. Despite the abundant evidence to the contrary, it used to be held that the Cistercians were unsympathetic to art—largely on the basis of Saint Bernard's famous letter to Abbot William of Saint Thierry. That letter, however, provides no evidence whatsoever of thoroughgoing opposition; it is rather a warning against excessive luxuriousness in the adornment of churches, and a clear moral insistence that one keep the matter of poverty and expenditure on art in proportion: in other words, that money was better spent on the poor (the living images of God) than on superfluous decoration.[33] This attitude hardens somewhat in the subsequent decisions

of the chapter general in Citeaux, but as Meyer Schapiro, among others, has tellingly demonstrated, there is little if any evidence to suggest a general blunting of aesthetic sensibility among the Cistercians in the twelfth century.[34] Indeed, if one needed further material to show just how untenable this position was, one would only have to turn to the *Dialogue on Miracles* and the other writings of Caesarius of Heisterbach.[35] It is full of the most detailed accounts of art and imagery. At least part of its value for us is the intense awareness it demonstrates of the specific visual characteristics of the images that are the center of his tales. But more than that, the more intense the experience of the aesthetic qualities of the image, the more readily, one realizes after reading several of the stories, it appears to have powers that transcend its inanimate nature. That alone would give the lie to the easy view that the miracle legends are of little interest for the historian of images, and that the lack of apparent specificity in many of the writers means that the legends are not good evidence of response or responsiveness.

But Caesarius, of all people, has been almost wholly neglected by historians of art.[36] His tales may often be derivative, but even when they are, they are usually elaborated in terms of specific images which he himself knew, or had directly heard of. For Caesarius, part of the proof of the miracles he describes consists of the very specificity of the images at their core. And not only that: he takes pains to enumerate the place, circumstances, and protagonists of the events at issue.[37] It is these details that give them considerable ethnographic interest; and we should allow them some space to resonate here, before embarking on more general analysis and their relationship with other writing of this order.

In the seventy-sixth chapter of the eighth book of the *Dialogue on Miracles*, Caesarius describes a portrait of Saint Nicholas in the monastery of Burscheid near Aachen. It was about a foot and a half high, "the face in the picture long and emaciated, very earnest and venerable, the brow bold, the hair and beard quite white." It was of especial benefit to women in childbirth. One day it was carried to the house of a pregnant noblewoman, "and at the season when she was delivered, in the sight of all who were present, the picture turned its face to the wall, as though to avoid seeing the woman in labour."[38]

The account is, of course, of extraordinary psychological and sociological interest; but here we must concern ourselves with its other implications. The event it outlines may be capable of several rational explanations, say in terms of the physical displacement of the image by a human agent, or in terms of a symbolic crystallization of the polarity between holy image and mundane event. But the point is just that no such explanation is even hinted at here. It is taken as given that images can move; so why should there be any need to rationalize? Certainly an explanation in logical terms

would be entirely superfluous. An enabling mode has arisen whereby images move naturally. It has become part of their nature to transcend their physical properties.

Seven chapters on, the same phenomenon recurs, but this time more dramatically. There was a wooden sculpture of Saint Catherine on the altar of Saint Linthild in the abbey of Hovene.

> One day an honourable matron named Alice, the wife of Wiric, knight of Guzene, was standing in prayer before her, with her attendant present. Now this image had, by carelessness, I think been so placed that its face was turned almost wholly to the wall. But while the women were looking on, it turned round very morosely; and the servant cried out: "Look, Lady, look, this image is turning round." Her mistress replied: "Yes I see." Some other women who were standing there also saw this. It is barely a year now since this wonderful vision (*visio*) took place.[39]

All this detail may seem a little excessive, but of course Caesarius was intent on making absolutely sure that no one should doubt the historical veracity of the miraculous event. That much is to be admitted; the motivation is clear. But we note, once again, that he is not content only to describe the movement of the image. He also attributes emotions and sentiments to it, and so do many of the other writers and compilers of such tales. With the story of the pregnant woman of Aachen, the indignation of the statue is only implicit; but here the same sentiment is perfectly explicit: the statue of Saint Catherine turns round "very morosely" (*multum morose*). It would be wrong to see this simply as a literary flourish. Beholders, in the twelfth and thirteenth centuries at least, were quite capable of seeing images as endowed with a full emotional and expressive range. The whole passage is entirely consistent with the tendency to invest the image not only with the physical attributes of liveliness, but also with emotion. And if we must avoid dismissing such descriptions as purely literary, so too—if we go beyond that—would it be wrong to attempt an explanation of such phenomena as psychological projections of the viewer or on the grounds of his or her intentionality. If these notions about the movement and emotion of the image occur often enough, even in varied form, they are likely to acquire the status of belief; and this easing of anecdote and topos into the realities of perception can only have been enhanced by the increasing multiplication of actual representations of events such as those described by Caesarius and the others.

But we note that the second story from Caesarius is referred to as a vision; and the eighth book, from which both tales come, is actually entitled "Of Divers Visions." Indeed, many of the events retold in the other books are called visions, and would even be called that now, by any reckoning. Let us

return to the issue. Even if one did not wish to insist on the distinction between "real" and "visionary" experiences in order to suggest a difference in quality of experience, one might still wish to reclaim that distinction in terms of levels of reality. One kind of story has images which do move or are reported to move; the other specifically records that the perception of an image of Christ, the Virgin, or his saints takes place within the context of a vision or a dream (here I am not referring to a third order, where Christ, the Virgin, or the saints themselves appear in the vision or dream). Both, one might say, have their own reality. Furthermore, there are enough stories to suggest that the visions and dreams are based on actual or reported experience (just as one might expect, on the grounds of common sense). It would be a fairly straightforward task to trace the influence of real paintings and sculptures on the accounts of visions and dreams; indeed this is the subject of the only available treatment of Caesarius of Heisterbach and art. But the evidential status of dreams and visions is considerably higher than this. While it may be clear that conscious and waking experiences, and things seen while walking, can determine the substance of visions and dreams, it may be less easy to grasp how these in turn influence perceptions of and responses to nonvisionary and waking reality—particularly once they have entered popular lore or become a literary genre (as, say, with Caesarius).

More may be possible in a dream than in reality, but such accounts and recollections of them are likely to expand the potentiality of everyday experience (as well as its repertoire). They serve as an index of the imputed potentiality of images; in almost every one of these accounts the vision or dream is inspired by a real image: and if we know that the image may come alive, move, and speak in a dream, how can we be sure that it will not do so in our waking hours as well? If we hear or read about dreams of moving images often enough, then we may well accord that potentiality to actual images too. In any event, who will be ready to claim that the visionary experience is any less real than the waking one? Certainly it would be no objection to claim that many of the stories retell visionary experiences. Visions and dreams involving images which move, speak, suffer, or act beneficently provide strong illustrations—all the better because they are unconscious—of the ways in which people think of the potentiality of images, and therefore of the ways in which they respond to them.

The stories so far have as their center an image which turns round, but movement is often more dramatically formulated and plays a more active role in affecting the beholder. The commonest examples are provided by images which incline their heads toward particularly pious beholders or passersby, or toward anyone else singled out for favor for one reason or another. A crucifix bows its head to a knight who had spared his enemy for the love of Christ. Saint Irmgard of Zutphen is hailed and greeted by a crucifix upon entering Saint Peter's in Cologne, and so on.[40] Such images—

like those which bleed when struck—play a crucial role in conversion, from the beginnings of Christianity on; and it is worth recalling that Caesarius put together his compendia barely a few years after Saint Francis underwent his profound conversion after a series of events involving a crucifix, including the occasion on which he saw the lips of Christ move when the crucifix spoke to him.[41] Since the stories around Saint Francis—and Saint Francis himself—won such swift renown, it may not be surprising that similar ones should so soon have abounded; nor indeed that men and women should have had more and more visions like his and Saint Clare's. But it would be wrong to see them only in terms of fashion and convention.

The stories of Saint Catherine that arose in the later twelfth century but grew especially popular in the fifteenth century (and then came to be illustrated with increasing frequency) exemplify the further links between convention, meditation, and visions. When Catherine was still a young girl, she asked a holy hermit how she might best see Christ and the Virgin. The hermit gave her an icon of the Madonna and advised her to contemplate it and pray to Mary to show her her Son. During the night the Virgin appeared, but Catherine was not yet deemed worthy to see the face of Christ. The hermit duly instructed her further, and she then had a further vision in which Christ "sweetly turned his glorious countenance towards her."[42]

Already in the century before Saint Francis, Saint Bernard had similar experiences; and the accounts of these became at least as popular. He prayed before an image of the crucified Christ, who then leaned forward to embrace him (fig. 142).[43] This is the scene that was so favored in seventeenth-century painting, where it influenced a wide variety of other representations showing a devotee being embraced by a figure of Christ detaching himself to a greater or lesser extent from the cross (figs. 141–42, 148).

But there is another story involving Saint Bernard and an image; and it brings the implications of physicality and comfort even closer to the fore. After praying more fervently than usual before a statue of the Virgin, she pressed milk from her breasts to comfort, succor, and nourish him (fig. 143).[44] This aspect of the Virgin's qualities also featured prominently in the tale found in several of the writers about the conversion of a Saracen and his fellows.

> There was once a Saracen who had an image of the Virgin, very nicely (*decentissime*) painted on a small panel; and even though he was a heathen, he really loved that picture very much indeed. He venerated it so much that he never allowed it to be even the slightest bit dirty or dusty. He carefully and often wiped it down; and every day he adored it on bent knees and with joined hands.

Soon, however, he began to have doubts: how could God have sprung from a Virgin? How could God be man?

> And as he was pondering these things, suddenly he saw two beautiful
> breasts arise from the image . . . and he saw oil flow from them, as
> from a spring.[45]

Much of the story seems pure propaganda, of the order of fairy tale. But it remains, for all that, yet another telling index of the potentiality that rises from the interaction between attentive or fetishizing beholder and an image regarded as attractive in one way or another.[46]

Caesarius has several chapters in which precisely the same experience as Saint Bernard before the cross is recounted; and on at least one occasion the account laconically exploits the sexual implications not only of the event described, but also of a relationship that is deeply embedded in Christian tradition. Thus, tersely: "The Lord Jesus Christ, who is the Spouse of his whole church, appeared visibly to another nun of our order, whose name I do not wish to give, at a time when she was grievously tempted, and by his embrace changed all her trouble into the greatest peace."[47] It is true that no image is mentioned here; but one can easily imagine how effectively a similar psychological nexus might come into play with an attractive/ beautiful/affecting physical representation of a handsome or pathetic Jesus. Thus, in a similar context of temptation, the details of the action of embracing are spelled out more carefully than usual: a monk of Hemmenrode named Peter ("who came from Coblenz," Caesarius adds, making sure, as always, of historical precision) was accustomed to meditate with special intensity on the Passion of Christ. One day he fell to his knees under the lamp of the altar of the lay brethren, and

> behold there stood before him the Lord Jesus himself—or rather, Lord
> Jesus as if he were hanging upon the cross. Then He withdrew his most
> merciful arms from the cross, embraced his servant, drawing him to his
> breast as one being dear to him, in sign of mutual friendship. He
> clasped him close; and by that embrace destroyed his strongest
> temptations.[48]

It is hard not to recall the crucifixes with moveable arms as one reads such an account. I have already commented on those occasions which feature the interaction of image and living actor in such a way that they will now seem to represent the dramaturgic exploitation of the kind of relationship only adumbrated in the miracle legends. Thus, in addition to the dramatic liturgical moments described earlier in this chapter, on Good Friday in the abbey of Lambach near Wels, a male actor representing the Virgin Mary clasped an image of Christ to his breasts, saying "Awe Kindt," while similar treatment was accorded to a wooden statue in Regensburg.[49]

If the phenomena we have been considering only involved crucifixes they would not, perhaps, appear particularly significant for the history and

theory of response. Crucifixes, it might be argued, had for so long been the centrally ardent focus of all believers' attention that they had become fetishistic objects to a much greater extent than all other images, and their form was therefore more or less irrelevant to the kinds of response they engendered. Perhaps too they were more like amulets and talismans, in the general sense, than like most other images. But apart from the fact that it never seems possible to make hypothetical claims of "aesthetic indifference," even in the case of amulets and talismans, the miracle legends frequently have as their focus other kinds of images as well. They are often carefully described; and when they come to be illustrated, a whole range of material imagery is quite naturally chosen for depiction.

Let us progress from the kinds of movement we have dealt with so far. There are still more dramatic and explicit forms, and they provide further insight into the kinds of emotional object-relations which lie at the psychological center of these accounts. Aside from crucifixes, the commonest stories concern images of the Virgin, which move, speak, or behave in ways that betoken the liveliness of which they are capable. This is not wholly surprising in the light of the proliferation of cult images throughout Europe which were supposed to perform or behave miraculously. One of the most improbable tales occurs with comparative frequency in several fourteenth- and fifteenth-century writers, including Vincent of Beauvais, and is charmingly retold in Jean Miélot's great adaptation of Gautier de Coinci, the *Miracles de Notre Dame.*

There was once an abbey of our Lady,

> which was beautifully adorned with paintings and sculptures. Facing on to the road was a painted portal which people often used to stop and look at. A monk of the order took great trouble in painting it *car il estoit moult expert en entailleure.* He had already painted the Virgin and Child in the centre of the portal; and above it he painted a Last Judgement. When he came to paint the devil in the hell scene he made him so hideous that no painting or sculpture was ever so ugly. In a fit of pique the devil pushed him off the scaffolding, but as he fell, the Madonna stretched out her right arm, and with the help of her child prevented him from falling. Everyone came to look at the miracle, the monk climbed down a ladder, and having let him safely go on his way, the Virgin returned her arm to its original place.[50]

This is one of the most extravagant accounts of the actions of an enlivened image, and however delightful, it seems more than usually childish. But it does call attention, once again, to the problem of the relationship between felt effectiveness and the way the image was made and fashioned. There is an even greater insistence than usual on the aesthetic aspect of the image—"people stopped to look," the expert sculptor "took great trouble," the devil

was "so hideous and ugly," and so on. In this respect the tenor of the passage is even more refined than Caesarius; but it is worth reminding ourselves that Gautier, unlike Caesarius, wrote in the vernacular, and that most of his tales came from identifiable earlier sources. While Caesarius's Latin was certainly not elevated or complex, writers like Gautier and his adapters like Jean Miélot provide still further evidence of the extension of this material into every segment of society. And they all remain concerned with the specificities not only of history but also of appearance and form.

This not only ensures the necessary veracity, it also reveals one aspect of the attentiveness that seems to lie at the intersection of beholding and fusion or reconstitution. The other aspect has to do with the relation between meditation and the perception of an image as capable of movement. In cases such as the Virgin who emerges from behind the retable to speak to the Christians of Toledo (fig. 145), there is always an element of devotion to the image.[51] But there are still more striking examples of the consequences of intensifying devotion by concentration and meditation. In Miélot's adaptation of another tale from Gautier de Coinci, we find one of the most affecting formulations of a story which occurs in picturesque form in almost all the collections, from the Middle High German *Altes Passional,* to the mystic Heinrich Suso and the Dominican preacher Johannes Herolt:

> A young and chaste monk who was devoted to the Virgin kept a beautiful image of her in his cell. Every day he would place a garland of roses on the image, and whenever he did so, the Virgin seemed to incline her head towards him. But when the season of roses was over, he became sad and melancholy: where was he now to find the flowers to adorn his beloved image? Observing his distress, his abbot bade him say a daily prayer of twenty-five *Ave Marias* before the work, and when he did so, he saw that at each *Ave* the Virgin herself produced a red rose, until, on the twenty-fifth *Ave,* she had completed the garland.[52]

One could wish for no clearer example of the relation between devoted attentiveness to a work and the fusion of image and prototype; but there are a number of other stories where meditation plays little apparent role.

Whole images may move; or individual figures detach themselves from their material matrix; or they may alter—beyond mere illusion—their positions in relation to other figures within the same image. Caesarius records the vision of a carpenter in the recently founded (ca. 1216) convent of Essen near Groningen. During the reading of the gospel lesson in the mass, the Christ Child rose from his Mother's lap in a picture, took the crown from her head, and placed it on his own. But when the priest came to the words "Et factus homo" in the creed, the Child restored the crown to his Mother's head.[53]

Of course the story has a doctrinal undertone, and Caesarius himself,

after telling it, offers an interpretation in terms of appropriate texts; but none of this mitigates the force of the formulation of the vision in terms of a specific image that does specific lively things. There were other ways of making exactly the same doctrinal point; why so frequently in terms of the lively image? The point of Caesarius's interpretation is not that the image moves, but that it moves as soon as the words "Et factus homo" are pronounced; and while that may serve to emphasize the miraculous fact of the Incarnation, it is not an explanation of movement, nor is it even proffered as such.

At least as germane is the apparently humorous group of stories involving an image which gives a recalcitrant man or woman a chastising blow on the head or box on the ear. These tales are repeated with great frequency until the eighteenth century. The most extended account given by Caesarius is of a nun driven by desire for a clerk. Instead of retiring to her dormitory at night—as she should—she tries to leave the church. At each exit the door is blocked by the crucified Christ; and when she finally takes cognizance of her sinfulness, she seeks pardon at an image of the Virgin. Whereupon

> the image smote her on the jaw with her hand, and said, "Whither, O mad woman, do you want to go? Go back to your own dormitory." So violent was the blow that she fell to the ground and lay there till morning. [But] although it was a grievous blow, she was at least delivered by it from all temptation; for a grievous disease requires harsh medicine.[54]

Now it might be easy to see in this anecdote nothing more than a moralizing rationalization of a naughty nun's collision with an image; nothing more, in other words, than a rationalization of an accident. But the very nonchalance of the combination of moralizing and humor provides, at this humdrum level of response, an all the more telling indication of the ease of the fusion of signified and signifier—all the more telling, that is, than some putatively explanatory mode. But let us move away from these forms to the more overtly serious; and range, before we conclude, from those cases where the image is invested with powers that go beyond ones we normally ascribe to human actors to those instances where the functions of testified physicality (like bleeding) go well beyond the rousing of conjoint pain.

There is one kind of movement that we do not find in Caesarius but which occurs in many of the other compilations, as well as in the accretions that have grown around particular cult images. This is the belief that an image is capable of being transported, or of transporting itself, from one place to another—*velut aliquod volatile animale,* "as if some flying animal," as a French manuscript of the fifteenth century puts it in describing the way an image which Pope Sergius had taken from Santa Maria in Templo

flew back to its original location.[55] There are many other stories of this order, the most famous, perhaps, being one that involves not an image but a whole building, the Casa Santa of Loreto, which the Virgin herself helped transport from Nazareth to Loreto, and where—needless to say—it was housed in extraordinary splendor.[56]

But this particular case should alert us to the difference between stories like these and the ones we have referred to so far. The movement which we are now considering transcends that which even humans are capable of (as the descriptive phrase *velut aliquod animale* itself makes clear); and we deal, therefore, with miraculous events of an entirely different order. There are images whose miraculousness does not depend on their transcending their inert quality to become animate in the way humans do. They behave in extraordinarily locomotive ways because they must fulfill a wholly assertive function, that of making their divinity transparent—not by being like ourselves, but by being unlike ourselves. This is just the context in which one must consider the images claimed to have been made by Saint Luke (like the one which Pope Sergius stole).[57] They are of divine or near divine origin; and so they can transcend not only their material earthbound quality, but also all normal human quality. With most of the stories in Caesarius (and practically all the other compilers) the point is that the capabilities of the image are those of a human being. The image is assimilated to the human or is endowed with qualities with which we are familiarly and intimately acquainted. It is not only locomotion, but feeling—sentiment, pain, and emotion—that is transferred to that which looks like ourselves or like people we know.

A similar distinction is required by another large groups of tales. I have already, on several occasions, alluded to the compassionate and empathetic relations that ensue from intense concentration and meditation on images of Christ suffering on the cross; and it is in this kind of context that the frequent visions of bleeding crucifixes are to be placed. But the many examples of images which manifest their distress at being struck, mutilated, or broken provide a rather different case (e.g., fig. 150). And with the accounts of such things, just as with the instances of intimacy that we must shortly consider, we come to some of the most profound and difficult aspects of response.

As we know from the circumstances surrounding the commission of Mantegna's *Madonna della Vittoria,* Jews pay for mistreating Christian images. But it is only when we go through the hundreds of similar accounts that we can begin to appreciate the impact and resonance of such circumstances. The story that most frequently recurs is that of the Jew at Constantinople who stole a painting of Christ, struck it, and took it to his home to burn it; whereupon it issued blood from the place where it had been struck. The story is found in the earliest sources, from Gregory of Tours onward,

and it then is expanded, elaborated, or transformed in all the subsequent compilations, including Caesarius and Gautier de Coinci.[58] Caesarius characteristically notes that the picture was one which was transfixed by a sword in Hagia Sophia in Constantinople and could still be seen in his own time.[59]

Another key tale, to be found in both Gautier and Caesarius, is that of the well-known image of Sardenai in Damascus, which issued oil from its wound. The story becomes traditional; it is recalled at every possible opportunity; the more recent parallels are eagerly brought to the fore. In his heated defence of the verity of the miracle of Sardenai, Gautier reminds his readers of the mutilated and bleeding image of Chateauroux, one of the many images that bleed, whether as a result of a blow from a Jew or Saracen or not.[60] All the stories of images that bleed or issue other substances have strong moralizing components: the iconoclast is confounded by the issuing of real blood from the inflicted wound; the Jew or pagan is converted by the miraculous event. The motive is usually very clear.[61]

But effectiveness of motive depends on belief—real or supposititious—in the miracle. This is why such tales somehow reinforce the kinds of elision we have been examining against the claims of insistent rationalism. When Vincent of Beauvais, a few years after Gautier, tells of a Brabançon who threw a stone at a statue of the Virgin and Child, he says that the blood flowed from Christ's arms *ac si esset hominis viventis,* "as if he were a living man."[62] Such a phrase suggests quite clearly that Vincent was perfectly aware that the statue was not alive but that it only behaved *as if* it were. The miracle consisted in just this fact. The reporter, unlike the beholder, remains aware of the distinction between image and prototype. But this is after the event, and it is important for the reporter to insist on the distinction. If images were considered as fundamentally partaking of life in any normal and everyday sense, then the issuing of blood and other substances might not be considered miraculous or thus capable of converting disbelievers. But once again we see that these miracles happen and are described so frequently that in many cases it is likely that the awareness of the distinction, implied by the simile, between inert object and living being is suspended. Thus it may be that the familiarity with which some images are approached betokens an attempt to bring the transcendent representation on the image, or the transcendent operativeness of the image, within the limits of human experience. But the attribution of sentiment and sensibility to an image, and the articulation of the possibility of a personal relationship, are often entirely successful: it brings the transcendent to earth and the supernatural down to the realms of everyday experience. But that brings its own disturbances.

The soothing effects of images of the Virgin that offer their breasts to the troubled beholder have already been described; and we can begin to see the

connection with all these stories involving the distillation or flow of bodily substances, whether easy or as the result of effort or pain. Already in Pliny and Plutarch accounts of images that perspire are sufficiently frequent to be counted as topoi. An image of the Virgin sweats so violently ("for fear of divine judgement," says Caesarius) that the bystanders wonder greatly; and some matrons present are spurred to wipe off the drops with their veils.[63] But more often the secreted substances, especially oil from breasts, turn out (once collected) to have healing powers.[64] Here cognition meets with the psychology of desire. One has only to consider the words of Miélot's re-working of an older tale.

A monk was especially devoted to an image of the Virgin, before which he was accustomed to say his prayers. One day he fell ill and developed a terrible growth on his throat. He could not talk; he was pallid and dolo-rous. At the height of his pain he had a vision in which the Virgin appeared especially beautiful; and then, having wiped his wounds with a cloth, she withdrew her breast from her bosom and placed it within his mouth, "et puis en arousa toutes ses playes."[65] The sexual basis of the vision, just as with the less explicit account of Saint Bernard receiving the ejected milk of the Virgin's breast into his mouth, could not be clearer.

Of course we deal with a vision, not a real image. But again what is significant is the direct collocation of image and vision, with the clear im-plication, as so often, that the monk's attention to his image stimulated the vision. One begins to grasp still more clearly why clerics who wished im-ages in their churches and monasteries to acquire cultic status—often for purposes of financial gain—should devise mechanical tricks whereby the image concerned would distill a liquid of some kind or another. And this liquid would, in turn, naturally be capable of effecting cures. Even if the majority of allegations of this kind were false (and they were by no means always), one has no difficulty in understanding the imputation that such things were done. The results were too plainly effective.

V

There is an unusual passage in Caesarius which purports to recall the re-sponse of a certain woman to an old image of the Virgin in the chapel of Veldenz near Bernkastel. She took one look at it and "indignant with the sculpture" cried out: "Why's this old load of rubbish standing here?" (*Ut quid hic stat vetus haec rumbula?*).[66] The fact that the woman swiftly received condign punishment for such cheek is of less interest to us here than Cae-sarius's formulation of the context of this story. It begins with the assertion that although certainly not well wrought, the image was, characteristically, "endowed with much virtue."[67] What we have, then, is consciousness of

the aesthetic status of the image, such as we find throughout the miracle legends, set in apparent opposition to belief in its inherent potentiality. The passage thus embodies two major issues.

The first seems clear. As I have been claiming, conception of the image in familiar terms (in this case in the terms of familiar contempt) makes it accessible (and in this case deprives it wholly—or is believed to deprive it wholly—of its transcendent potentiality). But the second issue is more problematic. Although Caesarius seems to be in no danger of conflating image and prototype (in this story it is clearly but an image of the Virgin, and by no stretch of interpretation the Virgin herself), the image is none-theless endowed with virtue. What are we to make of this? And is there really any relation at all between perceived aesthetic quality and efficacity? The easy answer to the latter question is that there is not; but it may be too easy.

Precisely because they describe processes that are evidently not idiosyn-cratic, these texts and reports cannot be dismissed on the grounds that they are not, by and large, first-hand accounts of individual behavioral processes. Indeed, they enable behavior (the fact that the genre is often not a specifi-cally popular one is neither here nor there). The correlations between the stories and observable behavior on the one hand and surviving classes and types of imagery on the other are sufficient to substantiate this claim. In addition to the illustrations of the legends—which have themselves been all too neglected—there are the many representations of the Mass of Saint Gregory, and the whole variety of subjects showing Christ leaning forward from the cross to embrace an adoring saint. They are fondly represented for long periods. Like the widely circulated images of bleeding Crucifixions, Men of Sorrows, and Dolorous Virgins, they ensure the long and easy cur-rency of belief in all such possibilities. And the survival of objects like the crucifixes with moveable arms testifies to the exploitation of psychological reserves that the Church has sporadically and scholars have always tried to suppress.

But the questions may continue to be worrisome. Have we not been dealing with literary elaborations of a limited range of stock themes whose connection with real events is at best remote? Perhaps one might argue that it was only for dogmatic or propagandistic reasons that the same miracles were repeated over and over again. And to what extent do any of the ac-counts actually reflect popular behavior? Do people really believe that im-ages come alive? "Real belief" has rightly proved to be an elusive category to define; but it does seem right to be somewhat agnostic—at the very least—about the distinction between what people say they believe and what they actually believe, assuming that they do not set out to deceive. The pursuit of such a distinction may well turn out to be an anthropological chimera.

On the other hand, it could hardly be denied that what others say about one's beliefs and behavior is likely to have a far lower level of correlation with the reality of these categories. But here the grounds for empirical generalization are too shifting: the reports by others of my visionary experience could be more objective than my own, or at least have an empirical validity that is superior to the phenomenological one. But even if we were to define the chimera and lay hold of it, even if we turned the phenomenological creature into an apparently clearer and more comfortable empirical one, the miracle legends would remain ethnographically relevant. And even if the beliefs involved turned out to be wholly unreal, the abundance of material about them would be sociologically significant.

The stories emerge from and inform popular behavior, whatever their audience. They are both the ingredients and the precipitate of behavioral constants, not of idiosyncratic responses. They are not, in any case, the exclusive property of social segments that are especially privileged, whether materially or culturally. These claims may stand, whatever functions the stories may have served or been intended to serve in securing the dogmatic foundations of practices which involved some of the most striking objectifications of the material power of the Church. Indeed, one of the most satisfyingly clear aspects of these tales is the fact that their consumers come from all social classes. Moreover, they reflect practices which have their origins in an equally wide range of classes. If one were to hypostasize high culture and popular culture as more or less independent entities, in the way that has recently been fashionable, then these tales would exemplify a continuum between high and low. If one dismissed them on the grounds that they are high crystallizations of low practices, or "high" readings of "popular" phenomena, then one would wholly be missing their rich evidential status. And that, by and large, has been precisely their fate. Everywhere there is evidence of the downward percolation of these stories, as they enter popular lore, up to our own day; but at the same time, many if not most of them have their origins in the behavior and responses of the most unlettered classes. It is exactly in this rich dialectic of content and consumption that the value of these stories lies for the student of response. Beyond this we should perhaps not labor the point.

VI

But two questions still remain. The first is this: Should we not distinguish more clearly between fusion and reconstitution? In the course of this book I have variously referred to the elision and conflation of sign and signified, and have occasionally had recourse to talk of the ways in which we (and all beholders) reconstitute the image as living, and transfer qualities with

which we are familiar and most intimate to that which looks like ourselves. But at stake are neither semantic differences nor the description of different processes or different realms; the question is more fundamental than this.

I have not attempted to arrive at the kind of psychological theory that is concerned, for example, with the ways of reconstitution, nor with the provision of specific examples and test cases of how beholders light on significant cues (and reject others) that may or may not trigger (or thwart) reconstitution. If this were my aim, then I would have had to provide a textbook for the analysis of perception; and we would still be left with the problem of responses predicated on the reading and instantiation of images as alive and living. In a significant sense no explanation of reconstitution could ever be final, nor would it be possible to provide a tabulation and scheme of the kinds of cues whereby we reconstitute. What we do finally and definitely know is the history of responses (including our own) to dead images taken to be living. The impossibility of formulation has nowhere more beautifully been put than in Roland Barthes's search for the being of his mother in his favorite (but never reproduced) photograph of her. In the end it is all frustration: "I live in the illusion that it suffices to clean the surface of the image in order to accede to what is behind: to scrutinize means to turn the photograph over, to enter into the paper's depth, to reach its other side (what is hidden is for us Westerners more "true" than what is visible). Alas, however hard I look, I discover nothing: if I enlarge, I see nothing but the grain of the paper."[68]

It may be asserted that Barthes is here talking about being not body, about the knowing of essence, not the grasping of substance. But the acknowledgment, in this passage, of "Westerners' truth" reaches into the depths of the varieties of repression to which I have so constantly been referring. Now finally it should be possible to admit the truth of what is visible as body. The history and ethnography of images provides all the evidence we need, as the criticism of art does not. But in all this lies— hidden perhaps, but never too deeply—the final question of this chapter. Do responses of the kind I have described in this chapter and taken from old books have anything to do with responses now, with the art and the images around us?

The facts are plain: talk about live images continues and men and women persist in responses that arise from believing, assuming, and feeling that living and lively qualities inhere in the figured object. "Figured object" broadly taken, not just figurative imagery, or religious imagery working in simple or traditionally religious cultures. To investigate how nonfigurative imagery is seen to be lively and to be animated or fleshly would, of course, require a different ethnography, but not a significantly different mode of description. No great sophistry would, or should, be required to establish just such responses: if it did, then the claim for cognition would fall away.

But even if the specific claim for the perception of images as lively and for responses predicated on that perception were to meet with skepticism, one would still be unable to deny or to argue away the force of the long history and the strong and wide ethnography that tells of such responses. The force lies precisely in the residue, in the fact that however much we might like to say modern responses are never like old ones, or like those of different cultures, we could not begin to forget those old and different ones; or to suppress the ways in which they have entered every thought we have about images, every motion we have toward them, and every category into which we place them. How exactly the eddying of history enters the mainstream of our thinking is the most difficult of all to detect clearly; but we cannot postulate a simple damming; or a termination of responses that have persisted for so long. There is no reason they should suddenly end now—least of all because some images no longer seem to look like the bodies with which we are familiar. But now our talk is more innocuous; we no longer think we are party to responses that make of images so much more than they really are—plain wood and stone, paper and canvas. If we were, we would not allow them. Once and for a long time the reports of live images and responses to them were quite dramatic; but now we have taken their strength away from them and consider them loud and vulgar. Our own way of talking about images, we think, is more sophisticated; we turn to a formalism that drains images of their effect, their impact, and whatever is significant about their meaning. Or we admit, with some wryness, to certain vulgarities in our responses. It would do no harm to think and speak more openly about the life in the image, and sometimes, even, to consider reclaiming the body.

12

Arousal by Image

W hat if every conscious act of looking were part of the intentionality of desire? And if the desire to gaze on representation were like the desire to gaze on the object: and the drive to do so, in the West at least, were masculine? What then would be the implications for the investigator of response?

Say the issue is one of possession: but is the reference then to possession of what is represented or of the representation itself? If we think that the range is simply signified and sign, then we play down the extent of the search for domination and possession. It is in this region that the gender orientation arises. If we concentrate on mere signifier, then we enter the realms of fetishism; and the semiotic range is inadequate. But why the centrality of possession? Because possession of what is imaged reveals the erotic basis of true understanding. The hermeneutic quest is always founded on the repression and perversion of desire; the objects of understanding are always bare. The long gaze fetishizes, and so too, unequivocally, does the handling of the object that signifies. All lingering over what is not the body itself, or plain understanding, is the attempt to eroticize that which is not replete with meaning. For example: the need to explicate form and to articulate the collocation of colors brings one closer to an acceptable pornography of discourse. But this is not to say that in shape, and form, and color, and in every way representation and represented seem, we do not

*

If the psychologist teaches us, "There are people who see," we can then ask him: "And what do you call 'people who see'?" The answer to that would have to be: "People who behave so and so under such-and-such circumstances."
WITTGENSTEIN, *Remarks on Colour*, 1.88

*

Cette femme n'est pas une creature, c'est une creation.
FRENHOFER IN THE 1837 EDITION OF BALZAC'S *Le chef d'oeuvre inconnu*

*

Cette femme n'est pas une creation, c'est une creature!
FRENHOFER IN THE 1831 PERIODICAL VERSION OF BALZAC'S *Le chef d'oeuvre inconnu*

*

317

find the precise locus of particular desire and particular response. Or that every expression and every symptom of response is predicated, directly, stringently, and immutably, on how representation looks.

The problem, then, is to theorize a history that has become—if it was not always—the ideology of men. Nothing would now be served if the history were a partial one.[1] The first question of method is posed by a decision of the kind that acknowledges male conditioning (or the inescapability of the investigator's position at its present apex) in all talk of arousal by image. Say all viewing in the West has been through male eyes, because it has been largely through the eyes of males possessing or wishing to possess women. But can one, with such acknowledgment, dispense with the crucial a prioristic problems? To answer affirmatively would be too simple an answer—though by no means wholly illegitimate within the terms of response history.

In chapter 1, I alluded to readings of pictures like Titian's *Venus of Urbino* and of prints like Hans Baldung Grien's *Holy Family with Saint Anne* which were repressive because they evaded the more direct and immediate responses of which one might have assumed the people who wrote about them to have been capable. This was not to say that the readings were illegitimate; it was just that they took no account of response, except of the most remote and secondhand kind. Indeed, it may be that the present project should be to evolve notions of reading that implicate response rather more deeply than is customary. But in fact the project is simpler: it is to develop a mode of discourse about arousal by image that bears on the general relations between images and people, and on cognition—not on conditioning. If we concluded that the only thing that could be said about the sexual responses postulated in the case of the picture known as the *Venus of Urbino* was that they were the product of male conditioning, male determining, and male possession, then the overall project would be threatened. But even that case, if admitted, would exemplify the issue of repression; for we could not thus explain the persistent and striking and wholly unnoticed avoidance of readings that excluded the centrality of those aspects of the image that pertained to sexuality. The matter is by no means just that of arousal; it is of the failure to see that grows from the acknowledgment of effectiveness. We repress as if in tacit but tormented denial of the potential and effectiveness of figuration.

A key issue in this book has been the fusion and elision of image and prototype. But when one deals with responses to images that seem to be not just images, but rather the bodies or objects or things they represent, then the problem of possession arises with great clarity. In this chapter I do not intend, in any substantial or explicit sense, to speak of the inevitable *commodity* fetishism that arises with the need to possess either the picture itself or the picture of something—say, the picture of a bowl of fruit. I do,

however, intend to speak of the arousal that may or may not proceed from attempted or imagined possession of the body in the picture, or even of the picture or sculpture itself. Arousal may proceed from the latter as well; but in all cases we should be aware of the drive to understanding, possession, and domination. The pivotal question is not whether understanding precedes possession, but whether we need to possess in order to understand at all. Not every stage may occur, and frustration is also likely to feature. When we reconsider the matter of fusion, and when we postulate possession as male, then the claim that all Western looking has been through male eyes makes a kind of sense that we may provisionally accept before volunteering the necessary and potentially adequate qualifiers.

The thread that runs from repression to fusion winds its way through the problem of live images. Here we find abundant exemplification of acquiescent and complicit or palpably resistant responses to images that are believed to be alive, or to be awesomely, unexpectedly and miraculously like living bodies. Dead wood not only performed miraculously, in ways that ran exactly counter to what one might possibly have anticipated of its materiality, it also became vulnerable flesh; and it became sentient, emotional, and sympathetic. We saw images of the Virgin Mother of Christ come alive or offer their soft breasts to allay the wounds of monks and sometimes nuns; and Saint Bernard (who wrote one of the greatest sustained commentaries on the most erotic book of the Bible, the Song of Songs) had a celebrated vision in which he received in his mouth a jet of milk from the breasts of a particular statue of the Mother and Bride of Christ with whom he, like umpteen others, identified the comely mistress of Solomon.

Now the psychosexual implications of most of this is clear. Indeed it seems especially easy so to judge the issue at the end of the twentieth century. The Virgin offered the most concentrated possible combination of motherhood and youthful sexuality. She was the fair sister and spouse of the Song of Songs, and the Mother who could turn the anger of a judgmental Son by reminding him of the breasts that nourished him in his infancy.[2] Everyone knew these iterated aspects of the Virgin, and so she naturally became the intense focus of the full gamut of sexual attention. The desire for sexual relations with females of this world was conveniently displaced onto her.[3] It would not be difficult to develop an analysis of all these manifestations of arousal by image in terms of the psychology and eristics of gender relations; but to phrase the issues in these ways is likely to appear anachronistic. We may compound anachronism by remaining attentive to our inability to express anything at all in this arena except in terms of the language of male dominance. But we cannot dispense with anachronism if we are to come closer to the terms of cognition. Thus we confront the old intellectualist divide: How can the historically and ethnographically responsible investigator declare anything at all without relinquishing the per-

fectly abundant but always culture-bound terms provided by the object of his investigation? The gender issue and the viciousness of the hermeneutic circle intersect at this very point. I will return to it later; but what further is at stake?

When we think of the example of images that come alive, we recall that the relationship with them always arose from concentrated gazing, from attentive prayer, and from sustained devotion of one kind or another—in other words, from plain fetishization of the painted or sculpted work. In many cases the image came alive because the beholder wanted it to do so. This intentionality provides full justification for a psychology of behavior in the presence of images; but what we must seek to achieve is the move from culture-bound psychology to a more general description of the forms of arousal that necessarily occur because the interaction is precisely with a figured object (and not—precisely—with some woman or man). And then the question must arise about the extent to which arousal is dependent on what the image represents, or whether it proceeds from a specific form of seeking to grasp the consequences of figuring an object or of making a figure of it. In speaking of figuration here I use the notion in its broadest sense; I absolutely do not imply anthropomorphic representation, except incidentally.

I

"On the Sunday before Easter they brought the miracle-working icon of the Vladimirskaya Virgin from the Oransky Monastery to our town," recalls Gorky of his boyhood days (just before his apprenticeship to an icon painter),

> She'll probably cause my arms to wither for carrying her with dirty
> hands. I loved the Virgin . . . and when the time came to kiss her, I
> tremblingly pressed my lips to her mouth, not noticing how the
> grownups did it. Someone's strong arm hurled me into the corner by
> the door. . . . You simpleton! said my master in a mild rebuke. . . .
> For several days I waited like one condemned. First I had grasped the
> Virgin with dirty hands, then I had kissed her in the wrong way. . . .
> But apparently the Virgin forgave my involuntary sins.[4]

Gorky had responded to the image of the Virgin in the wrong way. He behaved to her—impetuously and immaturely—as if she were some mortal woman, of the kind he knew, and not as some divine unknowable being. To her and not to it. Gorky's "sin" consisted in acting spontaneously on that basis. The sin was involuntary (a crucial term in our present context) because of the overwhelming strength of his conditioning. We may suppose

that he, like everyone else in his culture, was accustomed to think of the Virgin as the most beautiful of all women; and so, instead of wanting to kiss her chastely, he kissed her more intimately, even wantonly; or perhaps—to take the strongest element in the conditioning—as a mother. For that is what the Virgin endlessly was: the most beautiful of all women on earth and the ultimate exemplar of motherhood. Furthermore, the image was a miracle-working one; so she could come alive; she could be like flesh; she was fleshly and beautiful; and so she could impel the young Gorky thus to deliver his kiss. Let us briefly consider the further implications of his "involuntary" act.

Gorky was impelled to kiss the picture of the Virgin in the way he did because he had been conditioned to view women in a certain way, and especially women regarded as beautiful. But what is central in the whole action is that he could only thus be moved if he perceived that particular image of Our Lady of Vladimir as a particular mortal (and not as the Virgin generalized by the picture); and so he responded to it as if it were living, and inclined to whatever passions—including sexual ones—that living forms normally induce. No claim is here being made for the kinds of images which are regarded as lifelike, nor do I make any tacit offer to help with determining what kinds of form are or are not capable of being regarded as that (for that must remain the task of a pure cognitive psychology). The only claim is that once images are regarded as lifelike, then we are liable to respond to them in the ways that we do to the living (or incline to do, or repress if we are not young and simple and full of ardor, like Gorky).

This is all very well; but say the argument is made that this sort of response is primarily—if not exclusively—male? The ontology of the religious picture argues otherwise; and so does the immense power of the kind of conditioning of which I have been speaking. Who is there in the Western world who could not point, first, to instances of response to the Virgin, Christ, or his saints that arise from grasping them as real (and therefore as mortals)? And second, who does not know that women respond in affective and sexual modes to beautiful Virgins and Magdalens too? In the absence of reports of the kind provided by Gorky, we cannot be quite as certain, it is true, about the possible responses of young girls to images of the Virgin; we do not know that they would yet have learned to kiss them in the wrong way. But just as we may *think* that they would not have handled the image with dirty hands either, so too we must acknowledge, first, the force of the stereotype that is wrong, and second, the extraordinary dominance of male ways of perceiving women, to such an extent that women as much as men may be roused by the sight of conventional beauty or conventionally seductive nakedness.

In any event, all of this would be taken care of, analytically, by an adequate theory of male ways of looking or—better still—one based on the

proposal that all looking in the West has precisely this gender orientation. It would certainly also cover with ease the neater cases such as the one recounted by Caesarius of Heisterbach, where the embrace of "Christ the Lord Jesus, who is the spouse of the whole Church changed all the trouble of a nun, who was grievously tempted, to the greatest peace."[5] But when, with pictures like the *Venus of Urbino,* or Manet's *Olympia,* or with the general representation of female bodies made visually available in ways that meet with prevailingly male conventions of eroticism, we find evidence of female enjoyment too, the matter becomes more complicated. It is not just that the conventions become (or are) female too. We may then have to provide a further theory of possession, where, say, the idea of male possession of the female body offers the possibility of female sexual arousal. But such a theory would be only partial. Aside from the element of argument from androgynity that it may or may not require, it would not incorporate any sense that to gaze on the representation itself (and not merely to imagine the body as present) partakes of the intentionality of desire. And not only the gaze; but the force of the combination of the act of looking and the insistent presence of figured image, the presence that cannot go away unless we turn away from it. It is the whole exchange that evokes, elicits, and is the very product of desire.

But we should not yet leave the problem of the relations between convention and arousal. Vasari tells the story of a Florentine citizen who one day went to the overclever puppet painter Toto del Nunziata and asked him for a Madonna which would be modest and not an incitement to desire. So Toto painted him one with a beard. Now it is true that Vasari goes on to tell of another man (a simpleton, according to Vasari) who asked Toto for "a crucifix for the summer"; whereupon he painted him one in breeches.[6] But the tale about the unlascivious Madonna has implications that go beyond that of a joke. First of all it points to what we already know: that an image of the Virgin can be so attractive that it rouses desire. Second, it alerts us to the fear of such arousal—a fear (as we shall see) that does not simply arise from the need to keep profane and sacred apart. And third, it emphasizes, implicitly but with great and concise force, the power of conventionality in the evocation of arousal.

The Virgin, as everyone knew, was supposed to be a beautiful woman (from the earliest days of Christianity she had been likened to one); and she therefore had to be seen as such. The only way to show her, then, was against the prevailing standards applied to living women. But if one took as one's model the most beautiful women of the day, a woman who corresponded most closely to Solomon's bride, one could hardly be surprised by the allegation that the Virgin was too lascivious—at least in the eyes of the prudish and prurient. Furthermore, she is supposed to be ultimately and perfectly chaste; to how can we respond to her as such, when she is made

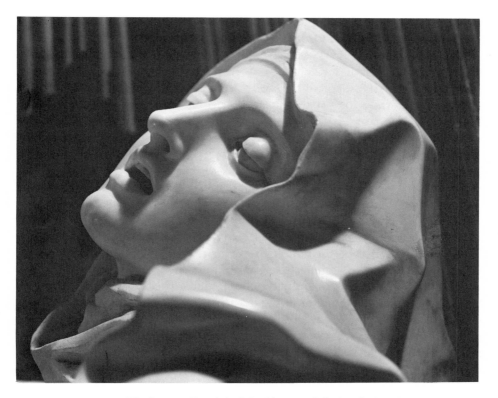

151. Gianlorenzo Bernini, *Saint Teresa and the Angel,* detail
(1645–52). Rome, Sta Maria della Vittoria. Photo Istituto Centrale
per il Catalogo e La Documentazione, Rome.

to look like those to whom we are prone to respond in the very opposite of
ways? Of course the fact that we are encouraged by religion to adore and to
love the Virgin played an additional role in the arousal of such feelings. As
it is we may have difficulty in distinguishing between erotic and spiritual
love (and everyone would agree how perfectly this is illustrated by a sculp-
ture such as Bernini's *Saint Teresa* (fig. 151), or his *Blessed Ludovica Albertoni,*
for that matter). But how nearly impossible to make that distinction when
the Virgin looks like a living model of beauty. The problem recurs countless
times in the history of art.

So we admit the great force of convention in all this. We acknowledge
the different sensitivities of different cultures. We recall that the Chinese
were apparently revolted by the first images they saw of the crucified Christ,
and that they took offence at the early missionaries' pictures of female
saints, on the grounds of their excessively large feet.[7] We find other stories
from still other cultures, such as one that comes from ancient Iran. A man
was inflamed with passion by the figure of a female cupbearer (supposedly
that of Shirin, the mistress of King Abarwiz) in the Grotto of Tâq i Bustân

at the western end of the famous mountain of Bisutun, near Kirmanshahan; so its nose was struck off in order to prevent this from happening again.

But convention does not seem an entirely sufficient category of explanation. It is problematic for at least two reasons. The first is that it does not adequately allay the suspicion, however much we acknowledge the patriarchality of our thinking, that some conventions are more widespread than others; and at what point does convention leave the particular and historical terms of context for the inclusive and embracing forms of cognition? When we read in a protocol of the Strasbourg archives for 25 April 1511 (not so long after the reported case of Toto del Nunziata) that the Council was concerned that "Jost, painter in the Oberstrasse," painted "scandalous pictures of the Virgin"; and that they decided they should send someone, knowledgeable in art, to go and look at the pictures; and that if he found that the pictures of the Virgin were painted scandalously and with bare breasts, Jost should be forbidden to do them[9]—when we read of such an incident, as we may of many others in the history of European art, we consult ourselves and can only conclude that either we fully accept the theory that all looking in the West is the expression of male desire (or the fear of it) or we make it culture-specific only if we embed it in some larger view. Then we proceed from diffident acknowledgment of context, site-specificity, and the way in which conditioning is structured by particular convention to the more difficult task of inducing a general but more liberating theory. One might attempt something along these lines (and we begin with the second difficulty incurred by the argument from convention):

However much one argued for the place of small feet in sexual contexts in China, or other anatomical features elsewhere, it would be futile wholly to argue away the psychosexual dimension of the bare female breast in all cultures, or of the exposed genitalia, male or female. The exact limits of the resonance of the breast in the psychopathology of everyday life may vary from one culture to another, but the limits are only somewhat variable, certainly not so much so that they never intersect. The same applies to its sexual resonance. For women that resonance may or may not be different from men; but again—leaving aside the maternal and mothering aspect—we must postulate the kinds of arousal that may spring from female awareness of the sexual implications of the breast for men. And so for particular kinds of exposure of the body: especially those which seem to make it available or open; or which set the beholder, teasingly, in search of the sexual organs.

It may of course be that the whole of Western representation (and, I suspect, most representation across the world) is patriarchally determined, since it is clear that female bodies are presented sexually considerably more frequently than male ones; but this does not affect the general position taken here at all. There are of course certain kinds of presentation of the

male body that show the male sexual organ; and so sexual interest—or the fear of it—may arise here too. There is no reason to suggest that it was only in Catholic and Counter-Reformation Europe that cases such as the naked Christ Child would have caused anxiety. Or naked Satyrs and Hercules figures either—though there is no disputing that some people would have been more blasé than others. But the elements of sexuality that lie beneath sophisticated indifference should not be forgotten.

But even if all this were quite wrong, even if one were to insist that arousal could not enter into the case of pictures regarded as ugly (or representations of people regarded as ugly), and that ugliness was not only a matter of convention but also wholly relative—even so that would not affect the more general course of this argument. Its aim is not to define precisely that which arouses and that which does not, or to set up appropriate rules and criteria for making such a distinction. It is to examine the historical evidence for actual response, and to assess the ways in which such evidence might illuminate the modes of cognition and the behavioral patterns that terminate in arousal by image. In order to do this, we need not only to continue our pursuit of history, but also to consider more deeply the way in which the act of looking itself enters into the problem of arousal.

I have postulated that once we perceive the body as real and living (or once we wish to perceive it as real and living, or to reconstitute forms with some such result), we invest it with life and respond to it accordingly. When, mutatis mutandis, we find ourselves responding to an image as if it were real, it seems at that moment no mere signifier but the living signified itself. Then, once the body is perceived as real and living, we are also capable of being roused by it. The issue is not one of context, since to claim this much is not to attempt to achieve terms of definition for what is or is not seen to be lifelike, or real, or living in particular cultures or contexts. It is rather to suggest that there is a cognitive relation between looking and enlivening; and between looking hard, not turning away, concentrating, and enjoying on the one hand, and possession and arousal on the other. The argument from convention then becomes irrelevant in that it is insufficient, although it is evidently not wrong. It is, as I have claimed, only part of the story.

Kris and Kurz justly comment of the story of the sculpture of Shirin that it is "noteworthy in two respects; the statue was believed to be alive not only by the man who offered his love to it, but also by those who mutilated it to prevent others from falling in love with it," but we should not be misled into thinking it a tale about the convention-bound nature of sexual appeal.[10] It is much more than that. It provides still further demonstration of the way in which we acknowledge the response that arises from the perception of the body in the image; and of how, by disrupting the object of the fetishizing gaze, we may subvert desire. The point, of course, lies in

the tautology that arousal by sight of picture is not simply a matter of arousal by sight of a particular alignment of features, or long legs, or slender neck, or large muscles; but precisely a matter of arousal by sight of picture.

II

Once we invoke convention and conditioning we must speak of horizons of expectation and thresholds of shame; we need to know the limits of what is both privately and socially acceptable in terms of picturing the sexual and the sensual.[11] Only then can we move to assessing the relations between arousal and individual perception of the transgression of boundaries and limits. As we know, these limits may sometimes be pushed far back, and sometimes move forward; as far as we know, individual arousal may depend both on a sense of substantial transgression and only of being on its limits. In short, this approach to arousal seems almost wholly unamenable to analysis, because the social boundaries are so variable and the personal ones so idiosyncratic. But to search for anything more general forces one to fall back on specific instances from the past; even the psychologist who examined arousal by picture would need to analyze context and conditioning first—since his examples would wholly depend on the relations between beholder-context and representational convention.

These are the provisions we accept as we fall back, as indeed we must, on the historical cases. We accept them not only because they seem self-evident; but also because, in terms of the argument of this book, they are beside the point. Much more crucial, as with so much history writing, is the constant lack of authentic female voices. The construction of history has remained agressively inattentive to—because willfully neglectful of—female report; and so it remains one of the essential structures of male power. But it may be possible to acknowledge all this and start coarsely in the hope that a bonus may nonetheless accrue. In some instances one may even go a little beyond these needful provisos. Take the issue exemplified by a story in one of Girolamo Morlini's highly scurrilous novellas of 1520.[12] For once it has something to say about a specifically female response, even though it is told by a man and is plainly scopophilic; and even though it may be assumed to be predicated not only on a prevailing literary genre but also on the assumption of male enjoyment of the disclosure of female arousal (Morlini's book makes special capital of this). We may read it wholly in that spirit too; but while the matter of the arousal that springs from looking must remain problematic and therefore problematized, there is a sense, here, in which the matter is altogether direct.

One evening a woman whose husband had gone away set out for church,

as she mistook the light of the full moon for the breaking dawn. But when she came to the market place, with its statue of a nude man "intentum arcum habens", she was suddenly seized with a longing for her distant husband. Swiftly she made a pile of stones and climbed up to kiss the statue; but when she felt "erectus ille priapus" against her, she was so filled with passion that she removed her clothes and copulated with it. Her lust was so great that she could not remove herself, and so she remained clinging to the statue until the morning crowds gathered to gape at her. [13]

This is all—must all have been—very titillating, especially for the male readers for whom the tale was presumably intended. Indeed there are several other details in Morlini's story which are still more explicit but are simply further evidence of the pornographic genre to which it belongs. Once again, however, the problem is not chiefly one of genre; nor indeed the further issue, however interesting, of the relation between fantasy and evocative presence. The problem remains general and not conventional.

A statue with a penis always offers this kind of potential. But the issue at stake is the degree of preparedness thus to engage it; or the degree of arousal that has proceeded not only from imagining and from fantasy about things unrelated to the object (say, here, the absent husband), but from the gaze, from the evocation of fantasy engendered by the object itself and by fetishization fed and heightened by looking. Before elaborating the case, let us look at two more instances that we may presume—or intuit—to have an application that extends beyond the confines of genre. The first is similarly direct, even though it masks its directness with a semisophisti-cated and disingenuously coy prurience. It comes from a part of Brantôme's *Vies des dames galantes* that belongs, in many respects, to the same literary genre as Morlini's novella. Its immediate literary context is an imaginary and thoroughly scatological conversation about the problems posed by the supposed fact that women desire large penises and men small vaginas. It also happens, incidentally but significantly, to underscore something of the sexual significance of the collection of antique statues amassed by François Ier and about which many art historians are still coy or evasive.

One day a "grand dame" at the court was looking and gazing at ("regar-dant et contemplant") the great bronze of the Hercules Farnese at Fontai-nebleau together with an "honneste gentilhomme." After commenting on the fact that the statue was well made, she noted a shortcoming. The pro-portions of his limbs were not quite right, because of the discrepancy be-tween "son grand colosse de corps" and that part of him which corresponded so little to it (cf. fig. 152). And the predictable dirty joke follows (women in those days were not so big, replies the gentleman). [14]

The case looks very trivial, and it seems wholly consistent with the slightly overheated fetishistic context of the Fontainebleau court. Here male fetishism and male fantasy brought forth pictures like the very many

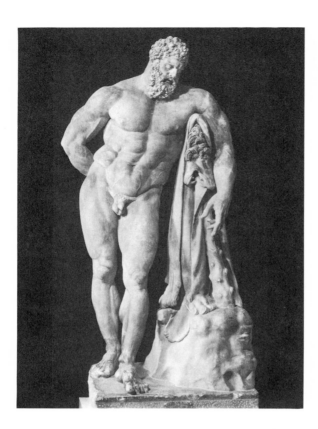

152. *Hercules Farnese,*
after a Lysippean original
(early third century A.D.).
Naples, Museo Nazionale.
Photo Alinari.

versions of Venus/Diane de Poitiers in the bath (fig. 153); and there are
even some indications of the way in which female enjoyment of female
nudity was exploited. The Estense emissary Teofilo Calcagnino tells of how
François took the Duchesse d'Etampes to look at a statue of Venus, to show
her "come ella era di bel corpo perfettamente formata." She smiled, and
turned and went to warm herself with the other ladies of the court; while
the king, naturally, remained with his courtier to enjoy his statues—"al
quanto a divisare di quelle figure." [15] The *sous-entendus* here are hardly bear-
able; but lines like these, just as those from Brantôme, have considerable
indexical weight. They are also, for all their archness, unusually candid
about plain responses to nude sculptures. None of this material should be
dismissed as simply contextual or conventionalized.

It may be that we have an adequate context for the kinds of remark
engendered by the famous bronze Hercules of Fontainebleau, as well as for
the more than usual attention to female responses to naked form; but that
would not take us very far in terms of the questions posed here. Nor would
any attempt to subvert the historicity of sexual responses by reflecting,
however troubledly, on the odd sense we have of a kinship between Belli-

fontainish responses and those that we immediately recognize as contemporary, or even our own. We do not at this stage need the phenomenological test. What we do need is an understanding of the full implications of the way in which talk of the kind we find in Brantôme (and reports of such talk) are legitimated by the fact that it is all about a statue, a work of art. One would hardly—certainly infrequently—talk about a real person in this way. The issue goes beyond one of simple decorum, and it has several correlates.

The first is that images arouse—or, in the broadest sense, elicit sexual interest—because of looking and gazing. Even with the trivial remark of Brantôme's "grand' dame," the narrator stresses its origin "regardant et contemplant." The strong response is engendered by allowing the eye to linger over the surfaces of the object, to caress them lovingly, troubledly to traverse them, or visually to engage with its accidents. All this is emphatically no hypothesis from sight to touch; it is the initiation of the second correlate. Visual attention—the gaze, look, or stare—proceeds from the ontology of images in general; not just, as everyone knows, from art. But everyone knows too that with art we are more self-conscious in what we say about

153. Ascribed to François Clouet, *Diane de Poitiers* (1570). Washington, D.C., National Gallery, Samuel H. Kress Collection.

looking, or even in what we think about. Once we deal with art, we know we are not dealing with life; and so the third correlate is pure paradox. With the image that is not art, we can talk openly about sex and arousal. It allows us to do so frankly and in more or less full acknowledgment of the sublimation involved. Decadent bourgeois sophisitication, say, tolerates talk about pornographic imagery that it would never tolerate if the responses were directly implicated in life. But with the image that is art—say, that we recognize as art—we incline to denial. Such responses, we know, consciously and in our bones, detract from art. We can only talk about low-level imagery in these ways; if it really is art, especially great art, then we have to think of and speak of response in a different way. We do not fully acknowledge the sexual, or the sexual response. We talk about colors and form. If we suspect arousal we deny it or—at best and most liberated—are mildly ashamed. This may be the pure paradox of looking, but there is—as so often—a further paradox. We have, clearly, to look more closely at the ways and implications of repression; but at the same time we realize fully the possibility that there is no arousal without repression. And when that does happen we may need rationalization.

For all the conventional aspect of the tale from Morlini, and for all the caveats we enter because of its genre and its patriarchal archness, it is unusually direct about arousal; and its chief actor (for whatever reasons) is female. When we turn back to antiquity (where, of course, we find the sources for all such stories), there is no shortage of accounts of young men who are aroused by images and overtly express their desire. The most famous case is that of the young man of Cnidos who was so roused by the famous Venus of that place that he stole there by night and copulated with the statue, leaving behind the actual traces of his lust.[16] So blatant (and oft-repeated) a case is of less relevance here than that of a woman who features in the Byzantine life of Saint Andrew the Fool.[17] In considering it, it is as well to remember how, not only in Byzantium but throughout the Middle Ages and later, classical statues were suspect—not only because they were not Christian but because their sensuality was the very mark of their pagan orgin. The Byzantine lives of the saints are full of stories of hostility to statues that seemed to be unchaste or to be directly capable of rousing desire. They were too beautiful; they showed the body naked. These two elements together were too much, and they could thus arouse the adulterous thought and action. But as we know even from other kinds of statues—and not only sensual ones—images such as those which came from Greece and Rome were effective and potentially active because they were believed to be inhabited by demons. Or they could be activated by specially magical processes (called *stoicheiosis*). This, it must always be remembered, provided the chief and most satisfactory rationale for the power of images. What it meant was that one could deprive images of their pow-

ers, within an acceptable category of rationality, by magical means or—if this did not work, or if the demons were too strong—by breaking them. This is the context for our tale and the context for a particular kind of rationalization—and again we have something that is usefully and trenchantly indexical.

The problem was the husband: he was given to dissipation. But with the aid of a magician he was brought to heel. Unfortunately the woman then started to have bad dreams. In some she saw herself pursued by Ethiopians and huge black dogs; in others she was standing in the Hippodrome, embracing the statues there—"urged," according to the chronicler, "by an impure desire of having intercourse with them." The saint was called in and he managed to drive the demons from the woman's head by expelling the demons of the statue. When Mango recounts this story in his excellent summary of Byzantine attitudes toward antique statuary, he notes, quite rightly, that "it is not surprising that the nude statues of the Hippodrome should have been inhabited by demons of concupiscence."[18]

The fact that the story is of a dream does not diminish its evidential status. If anything, by virtue of the unconsciousness of dreams, it indicates very clearly the response that easily elides image and prototype. And however common—say "normal"—it may have been to account for all powers of statues and pictures by the assumption of a demonic or magical presence, we are still dealing with one of the varieties of rationalization.[19] Indeed, this applies not only to Byzantium, but to Greece and Rome as well— above all to the fourth to sixth centuries when Neo-Platonic views and telestic functions combined, and where it could unexceptionably be claimed (as it regularly was) that the "reason" the image was alive was because it was inhabited by demons. But we too, now as then, incline to rationalization, especially in this broad area. The process has a twofold scope: first, the image that is, becomes, or seems alive; and second, the denial or defusing of the response that is sexual, in one way or another. The reasons for rationalization thus lie close to the center of what writers about art habitually, characteristically, and deliberately fail to acknowledge about art.

There are some cases where the actual sexual engagement is straightforward, as with the young man of Cnidos. The story is repeated in Lucian, in the Greek Anthology, and in several others.[20] It can be compared with tales in the comedian Alexis, and after him Philemon, which describe how a young man (this time of Samos) becomes enamored of a statue of a woman and shuts himself up with it;[21] or with Aelian's vignette of the youth who fell desperately in love with a statue on the Prytaneion, not a statue of Venus or Eros, but of Fortune. He embraced and kissed it; he wanted to buy it; the City refused; and so all he could do was adorn it with ribbons and garlands.[22] The mistake, once again, would be to dismiss stories like these as clichés. While their repetition may seem to diminish the possibility

of historical truth, it is just this repetition that emphasizes rather than impugns the cognitive relation between image and intentional beholder.

Then there are the cases where sexual interaction takes place in a vision or dream. They range from the woman and her problem with the statues in the Hippodrome to the later medieval instances where—for example—Bernard is confirmed in his faith by his vision of the lactating breast of a statue of the Virgin, and where the carnal temptations of monks and nuns are deflected by their all-too-sentient visions of the physical embrace of Christ or of statues of him. Here it may be worth expanding the summary of the case of the novice whose cancer was cured by the appearance of the Virgin whom he knew from the image upon which he meditated in his cell. She took pity on him, appearing to him "plus blanche et plus fleurie que la fleur de l'aube espine . . . et la rosée de may"; she approached him, wiped his wounds with a towel whiter than snow, and without delay (as we have seen) "ella tira hors de son savoureux sain sa douce mamelle, et luy bouta dens la bouche, et puis en arousa toutes ses playes."[23]

Of course this kind of language may itself be arousing, and one may wish to align it as a kind of religious and medieval equivalent of the sort of thing to be found in France under François Ier; but it still provides a sharp outline of some of the psychopathological motives that may underlie the need to invest an image with a life that is specifically capable of sexuality.[24] We may now pretend to be wiser and to see through the motivation, indeed the raison d'être of the story—just as we may insist on the significance of the psychological context of the Hippodrome case (the woman had the dreams because of jealousy of her husband's dissipation and because of the need for sublimation, etc.); and of Saint Bernard (denial of sexuality by contextualizing as conversion and the requisite chastity, etc.); and of the tormented monks and nuns (sex with Christ replacing the need for sex with someone of this world, etc.). But although it may be as well to remind oneself of the forms and varieties of rationalization, none of these "explanations" are needful here. The problem with the reminder is that greater wisdom (say, in identifying rationalization) does violence to the historical integrity of the deeds and events described—however much such violence may be in the nature of every act of historical investigation. Be all this as it may, the present significance of all such tales is rather simpler, and (in my belief) rather greater than all explanations along these lines imply.

III

Let us leave rationalization aside and take the cases as they come. The image seems to be or simply comes alive; and more or less overt sexual relations ensue. Or—mutatis mutandis again—the image gives rise to more or less

sexual feelings; and so it can only be construed as living. Once we rationalize, we are on the borders of art; and with that we prefer to admit to other kinds of responses, preferably predicated on nothing too lively or, at best, on metaphors and similes of liveliness. The portrait "seems to" speak; the eyes "seem to" follow one round the room. It behaves "as if" it were alive. But a problem arises with beautiful images, or rather, with images for whose beauty the artist is evidently responsible. What happens when we see the image as beautiful, when we see it knowingly as image and not as body, when the stirrings have to do with nothing recognizably human—or even organic? That is the long-term question here; for the time being, one more example from the great body of medieval image-lore may be considered.

It comes from a large group of variations, dating from the twelfth century, on the theme "Young Man Betrothed to a Statue."[25] The young man puts his marriage ring on the finger of a statue of Venus and then discovers that the statue takes him seriously: she prevents him from embracing his earthly bride. These stories are in turn to be related to those about the young man who similarly betrothes himself to a statue of the Virgin (not just to the Virgin herself). When he goes to bed with his wife, the Virgin of the image comes between them and prevents their mortal embraces.[26] Of course the Virgin's role as spouse of Christ was so well known that we can immediately identify the literary contamination, to say nothing of how easily that role could give rise to just this imagined intervention in a marriage bed.

As always, situations which seem perfectly plausible need rationalization; and this is exactly what one finds in this group of stories as well. The *Kaiserchronik* of around 1140–50 tells that a herb was placed under the statue involved in order to make those who looked upon it fall in love with it. In the end the statue was reconsecrated and dedicated to Saint Michael.[27] More often it is the ring that fulfills the crucial, almost talismanic function; and we think, just as in the *Kaiserchronik* story, of *stoicheiosis* all over again. The act which enlivens the statue of the Venus or the Virgin is the giving of the ring; and that, even outside the realm of Freudian symbolism, is implicitly sexual (because it implies marriage, and therefore the marriage bed). The Virgins bend their fingers to receive the ring; they are therefore alive; and so they can come between the real lovers. Or—and how closely related this case is to the ones about temptation in the miracle legends—a young priest who is tempted by the flesh is commanded by the pope to go to an altar where there is a beautifully painted picture of Saint Agnes, "ubi picta est Agnetis ymago formosa," and ask her hand in marriage. The image then stretches out its/her hand for the ring, and all the young man's temptation disappears.[28] It has, one may rightly say, been transferred to the picture. And so we have moved back from actual intercourse to what is, in

effect, the subject of this chapter—arousal by image; and we move from making love in the newest sense to the broader, more old-fashioned sense.

Along with the many stories of the ring placed on the statue of the Virgin so popular from the thirteenth century on, the Saint Agnes account stands at the distant origins of the endless romantic tales in Eichendorff, in Merimée, in William Morris, and in many others about the situation of the bridegroom who is pursued by a jealous divinity on the finger of whose image he has slipped a marriage ring.[29] With this we embark on the whole topic of "Love by Sight of Image," as Stith Thompson entered it in his *Motif Index of Folk Literature.* His examples came from every continent, from Japan to the British Isles, from China to Finland, and from Iceland to Missouri, to say nothing of their occurrence in Indian and Arabic literatures.[30] The basic aspect of the topic is extremely close to that of the "Young Man Betrothed to a Statue"—someone falls in love with the image on a picture—only here the issue is even more crucial to the course of our investigation. The statue or picture is not used for overtly sexual purposes; there is no question, usually, of sexual intervention or sexual engagement. The question remains fundamentally one of looking—however much we may discern the projection of desire in feeling thus about a picture.[31]

This very last difficulty clarifies itself somewhat once we note the clear distinction within this body of tales. On the one hand, the image represents someone the beholder already knows; and this reinforces him or her in love, devotion, memory and so on. On the other hand, men and women fall in love with the images of people they have not seen except on the image. Sometimes and significantly they are moved to love by images of people who have not been seen before except in dreams; but this we must align with the first group. Into it falls Proteus's plea to Silvia in *The Two Gentlemen of Verona* (act 4, scene 2, lines 116–22):

> Madam: if your heart be so obdurate,
> Vouchsafe me yet your picture for my love,
> The picture that is hanging in your chamber;
> To that I'll speak, to that I'll sigh and weep;
> For since the substance of your perfect self
> Is else devoted, I am but a shadow;
> And to your shadow will I make true love.

For all the talk of shadows (which places these lines in one of the most venerable of all traditions of thought about imagery), the point, of course, is that Proteus says he wants to talk and weep to the image as if it were the real Silvia, neither image nor shadow.[32]

The equally typical verses penned by Leonardo Giustinian (1388–1446) almost two centuries earlier are more straightforward. He writes to his lover in a poem that begins, long before Marvell, with the perfectly standardized

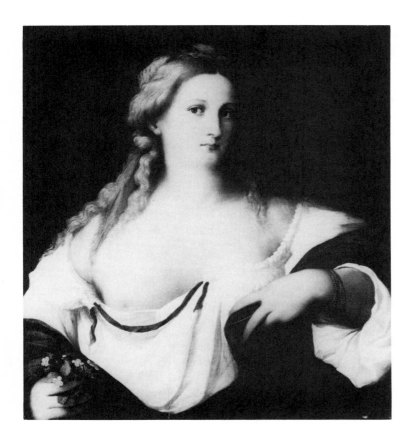

exhortation not to lose time: "Non perder, Donna, il dolce tempo c'hai/
 Deh non lassar diletto per durezza": After the usual sentiments about the
impossibility of recovering lost time and the impermanence of beauty, the
third stanza runs as follows:

> I have painted you on a small piece of card
> As if you were one of God's saints.
> When I rise in the sweet morning,
> I throw myself on my knees with desire.
> Thus I adore you, and then I say, O clear star
> When will you make my heart content?
> Next I kiss you and caress you tenderly;
> Then I go and take myself to Mass.[33]

And so he talks quite naturally to the image as if it were alive; he kisses
and caresses it. The reference to God's saints may not be entirely noncha-
lant, not entirely a way of eulogizing the qualities of the lover. In a context
like this, the lover becomes as adorable as an image of a saint notoriously

could be. It is as if the writer knows that the image can—almost idolatrously—be treated just as saints' images were, as if endowed with something magical, or at any rate with the presence that has so often been called magical.[34]

The second group takes us one step further away from such projections onto the image of desire for the person one already knows and wants. Again the variations are endless. The subject recurs many times in Arabic literature, particularly in the *Thousand and One Nights,* in the Turkish *Parrot Book,* the *Tuti Nameh,* and in the epic poems of the twelfth-century Persian poet Nizami and the fifteenth-century Timurid poet Djami—to give only a few examples.[35] Men see an alluring representation of a woman in paintings and in books; filled with desire they set out to find her—often in charmingly complicated ways, as the genre requires. Thus in the *Thousand and One*

155. *Shirin falls in love with Khosrow as a result of looking at his portrait* (Persian; sixteenth century). From a miscellany written for Jalal al Din Iskandar Ibn 'Umar Shaikh; copied in 1410–11 by Muhammad al Halva'i and Nasir al Katib. London, British Library, Add. MS 27261, fol. 38. By permission of the British Library.

156. *Right:* Peter Paul Rubens, *Presentation of Portrait of Marie de'Medici to Henri IV,* detail (1625). Paris, Musée du Louvre.

Nights, Ibrahim, the son of the Wazir of Egypt, stops at a bookseller on his way home from prayers. In one of the books he sees a picture of the most beautiful woman he can imagine. He pays a hundred dinars for it and falls to gazing upon it and weeping day and night, neither eating nor sleeping. He makes a desperate attempt to find her, the prototype of the image; but he discovers (as in many of these tales) that she is deeply hostile to men, "a virago of viragoes."[36] Women too cannot rest until they have found the living archetype of the handsome representation. So, for example, in the complex and intricate account of the role of pictures (and sculptures) in the love of Shirin and Khosrow in Nizami's *Khamseh,* Khosrow's confidante Shapur paints no less than three pictures of the Persian prince.[37] When Shirin sees the first one hanging from a tree in a hot and delightful meadow (fig. 155), she "holds it in her hands and gazes at the handsome Prince [whom she has never seen]. Her heart dissolves with joy and she embraces the portrait." But her handmaidens are afraid at her trembling, and in the kind of move that one could almost anticipate, they "destroy the image and burn rue to stop the spell. Only then does Shirin recover her senses." The next morning practically the same thing happens again, but now the maids do not even bring the picture to her. On the third day, Shapur makes yet another portrait. The Armenian princess catches sight of it, snatches it from the branch, and "worships it as if it were an idol. In its homage she drank wine, and with every sip she kissed the ground." And so she falls desperately and endlessly in love with Khosrow Parviz, whom, from early on, she was destined to marry.[38]

But the example of "Love by Sight of Image" that will come most readily to readers' minds is that of Tamino's aria in the first act of *The Magic Flute.* "Dies Bildnis ist bezaubernd schön," he begins:

> This portrait is bewitchingly beautiful,
> Such as no eyes have ever seen before.
> I feel how this divine image
> Fills my heart with a new stirring.
> This something I can scarcely name,
> Yet I feel it burning here like a fire.
> Can this sensation be love?
> O yes, it is love alone.
> If only I could find her
> O if only she just stood here before me!
> I would . . . I would warmly and purely . . .
> What would I do?
> Full of enchantment I would
> Press her to my ardent breast,
> And then she would eternally be mine!

The basic thematic structure of the aria could hardly be clearer; it is developed around the main elements of the theme we have been considering so far. But it also describes in extraordinary detail something of the mental movements that one can imagine accompanying the revelation of the picture. Tamino's heart is stirred, and then more powerfully so; he cannot name the emotion; he calls it love. Thus identified, the sentiment grows stronger; he moves from beautiful picture to the beautiful woman represented on it. Tamino is overwhelmed with a sense of her potential presence, her potential liveliness. He speaks of pressing her to his breast, and he wants to possess her forever.

There is one more telling aspect of these verses, and that is the reference to the picture as divine. Tamino himself calls it a *Götterbild,* but this is no idle trope. Both Mozart and Schikaneder knew in their bones that only a *Götterbild* could have such an effect and make the absent present; or induce such terrible desire, following veneration, for that which an image represented. But at the same time they knew that all images, once discovered or gazed upon with such attentiveness, partook of the quality of divine images. The ontology of the religious picture, as Hans-Georg Gadamer—like some new Sarastro—has reminded us, is exemplary for all pictures.

IV

I have strayed far from looking, repression, and rationalization. The moment has come to consider these terms more closely, but within the full embarrassment of their equivocal ideological implications and their awkwardness for the kind of history that is supposed to speak for itself.

What we learn most clearly from "Love by Sight of Image," and indeed, from almost every one of the cases we have considered so far, is how the wish, the desire, and the need to make alive actually enlivens the dead image. It may be held that this is an inaccurate—or at least inadequate—way of saying that the desire to make what the image represents alive is what, in the end, makes it seem alive; or that by the projective act we bring forward the signified wholly to replace the sign (rather than, say, to fuse the signified and signifier). This refinement would possibly make the role of attentive beholder rather clearer and remove—rightly, it might be argued—the quality of liveliness from the ontology of the image. Liveliness in itself is a coarse term; its metaphorical aspect merges easily and closely with its literal one. But the coarseness may be useful and should alert us to the problem of seeking refinement in this area. We begin to see how the general and apparently vague formulation with which this paragraph opened may in fact be more revealing, once we realize that it may be profitable to dispense with semiosis as we consider the investment with life and

liveliness. An even more radical step would be deliberately to eschew any attempt to distinguish between the transitive and intransitive senses of investment or—at best—to conceive of the problem of arousal in terms of the dialectic between its active and passive modes. Excessive emphasis on the active mode of investment is likely to lead into the dead end (into which all our examples may seem to head) where all arousal has to do with figuration. It may not; it may have as much to do with the cognition of correspondences between feeling and the liveliness of shape, form, contour, and color, surface. Taken *grosso modo,* such a formulation serves the relations between arousal and what is nonfigurative too.

On the other hand, the danger with the approach adumbrated here is that it may seem to lead to mysticism or to absurdly sexist views of arousal. Toward the very start of his introduction to *The Florentine Painters,* Berenson embarked on the outline of a now famous theory. The theory, such as it is, admittedly came after a statement about the Florentine preoccupation with figure painting; but the idea had and has much more general implications. As we follow it, we follow too a path of ideas that starts with a view of how the beholder invests the image with life; that then shows a sense of the dialectic at stake; and that ends, as so often with so much art history, utterly intransitively, though ostensibly predicated on the action of the painter and his or her activation of the object.

> Psychology has ascertained that sight alone gives us no accurate sense of
> the third dimension . . . although it remains true that every time our
> eyes recognize reality, we are, as a matter of fact, giving tactile values
> to retinal impressions. . . . [The painter] can accomplish his task only
> as we accomplish ours, by giving tactile values to retinal impressions.
> His first business, therefore, is to rouse the tactile sense, for I must
> have the illusion of being able to touch a figure . . . before I shall take
> it for granted as real, and let it affect me lastingly. It follows that the
> essential in the art of painting—as distinguished from the art of
> colouring—is somehow to stimulate our consciousness of tactile values,
> so that the picture shall have at least as much power as the object
> represented, to appeal to our tactile imagination. . . . [We] no longer
> find [Giotto's] paintings more than lifelike; but we still feel them to be
> intensely real in the sense that they powerfully appeal to our tactile
> imagination, thereby compelling us, as do all things that stimulate our
> sense of touch while they present themselves to our eyes, to take their
> existence for granted. And it is only when we can take for granted the
> existence of the object painted that it can begin to give us pleasure that
> is genuinely artistic, as separated from the interest we feel in symbols.[39]

And the passage goes on to discuss the matter of pleasure. It is true that for Berenson it is not—explicitly or in any sense—a matter of sexual plea-

sure; but the argument that relates tactility to the assumption of the existence of what is represented in the picture derives quite clearly from the kinds of tales we have been considering. This is to make no claim for the psychological validity of the Berensonian view; nor do I propose to test it. What is telling is the move that Berenson immediately makes to the "genuinely artistic," as becomes abundantly apparent in the next stages of his essay. For him it is precisely because of art that we take greater pleasure in the object painted than in itself. Giotto's pictures were great—and ipso facto give greater pleasure—because they convey "a keener sense of reality, of lifelikeness than the objects themselves." The opportunity to consider the forms of arousal (even "pleasure" in the Berensonian sense) that are consequent on the internal life of the constitutive components of the painted or sculptured object (irrespective of whether they show organic figures) has been utterly lost. Instead it is art that gives life, arouses, and is pleasurable. Art becomes, mystically and slightly absurdly, "life-enhancing"; and, because it is art, it will never descend from the vague and the mystical.

"Others," according to the *New York Times Magazine* on David Salle's pictures, "such as Philip Johnson, contend that 'sex should be in pictures—why not? That slight tumescence that you feel sometimes is part of seeing.'"[40] In sentiment as well as in tone, the statement is as much of our times as Berenson's were of the 1890s. On the face of it, it seems perfectly to encapsulate the position suggested at the beginning of this chapter: that desire is implicit in seeing and that (in the West at least) all looking is male (since "tumescence" in Johnson's statement can hardly be taken to be meant as anything but masculine). But the fact is that the tone of this claim is entirely characteristic of the prison-house of late twentieth-century talk about art. It appears to be open, candid, and free of repression; but in its glib dispassion, in the archness of the adverb that modifies "tumescence," and in the vagueness of "sex should be in pictures" (presumably good ones, as in Berenson), it passes by the very core of the disturbances that arise from the relations between looking and what is in the image. We have learned—just as Foucault has shown in his long meditation on the history of sexuality—to seem to talk about that which we cannot or refuse to talk about.[41]

V

Everyone knows the story of Pygmalion; by now it will have come to the mind of every reader of this book. It tells of how a sculptor falls in love with his creation, which then turns into a real being (fig. 157).[42] It seems so peculiarly apt for illustration that one can only wonder that its vogue—before the nineteenth century at least—was not greater. Then, in the nineteenth century, it also had its most important (and possibly most inven-

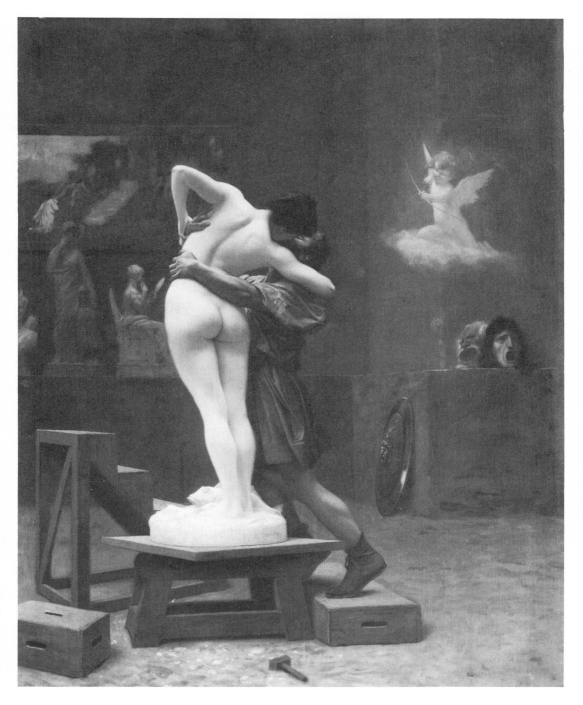

157. Jean Léon Gérôme, *Pygmalion and Galatea*.
New York, Metropolitan Museum of Art, gift of Louis C. Raegner,
1927 (27.200).

tively interesting) literary influence, above all in the great stories of Balzac and Zola—*Le chef d'oeuvre inconnu* and *L'oeuvre*. The significant difference between the tales collected by Baum (where a dead image comes alive and somehow interpolates itself between the main character and another living being) and the story of Pygmalion is that the protagonist is now the creator of the image himself; so the act of re-creation by love becomes the hallmark of the powers of artistic creation itself. But Ovid's account of Pygmalion and his statue provides so extraordinary a gloss on the stages in the enlivening of an image, and the substitution of living body for dead material, that it is worth pondering in almost all its compelling detail.

One should suspend, for a moment, the inclination to overpsychologize the opening of the tale as an explanation for what happens in the rest of it; rather, the whole should be read in the light of the other anecdotes and tales in this chapter.

> When Pygmalion saw these women, living such wicked lives, he was revolted by the many faults which Nature had given to the female sex, and long lived a bachelor existence, without any wife, to share his home. With marvellous artistry he skilfully carved a snowy ivory statue. He made it lovelier than any woman born, and fell in love with his own creation. The statue had all the appearance of a real girl, so that it seemed to be alive, to want to move, did not modesty forbid. So cleverly did his art conceal its art. Pygmalion gazed in wonder, and in his heart there rose a passionate love for this image of a human form. Often he ran his hands over the work, feeling it to see whether it was flesh or ivory, and he would not yet admit that ivory was all it was.[43] He kissed the statue, and imagined that it kissed him back, spoke to it and embraced it, and thought he felt his fingers sink into the limbs he touched, so that he was afraid lest a bruise appear when he had pressed the flesh. Sometimes he addressed it in flattering speeches, sometimes brought the kind of presents that girls enjoy. . . . He dressed the limbs of his statue in woman's robes, and put rings on its fingers, long necklaces round its neck. Pearls hung from its ears, and chains were looped upon its breast. All this finery became the image well, but it was no less lovely naked. Pygmalion then placed the statue on a couch that was covered with cloths of Tyrian purple, laid its head to rest on soft down pillows, as if she could appreciate them and called it his bedfellow.
>
> The festival of Venus . . . was now in progress when Pygmalion, having made his offering, stood by the altar and timidly prayed, saying "If you gods can give all things, may I have as my wife, I pray"—he did not dare to say "the ivory maiden," but finished, "one like the ivory maid." However golden Venus, present at her festival in person,

understood what his prayers meant. . . . When Pygmalion returned home, he made straight for the statue of the girl he loved, leaned over the couch, and kissed her. She seemed warm: he laid his lips on hers again, and touched her breast with his hands—at his touch the ivory lost its hardness and grew soft: his fingers made an imprint on the yielding surface, just as wax of Hymettus melts in the sun and, worked by men's fingers, is fashioned into many different shapes, and made fit for use by being used. The lover stood, amazed, afraid of being mistaken, his joy tempered with doubt, and again and again stroked the object of his prayers. It was a body; he could feel the veins as he pressed them with his thumb.[44]

We recognize almost every element in the tale, at least in its first part. The sculptor falls in love with the image; he wishes it to be alive. He speaks to it and hopes to be spoken to; he wants to possess the statue as if alive. With hope and great passion he wishes the statue to come alive, and it does. We may be tempted to read the tale in the light of Freudian psychology, say in terms of the initial description of Pygmalion's misogyny and celibacy, and thereby explain the whole course of events, from the carving of an unimaginably beautiful woman to using it first as a substitute body and then as a real one. But Ovid did not, of course, intend his tale as a psychological document in anything like this sense. It would be grossly fallacious to read it in terms of this sort of psychological reduction. On the other hand, his marvelously detailed description is utterly paradigmatic in its account of arousal by image.

It begins with repression (celibacy) and moves through sublimation in the form of artistic creativity. Repression follows again (it is only art; it is not real; it cannot be sexual). But creation implies life: the statue is not only lifelike, it comes alive by the very miracle of creation, and sexual liberation follows.

But note how intricately Ovid has managed to weave in the strands of art and looking. There could be no more gripping formulation of the repression that implies arousal and the need for possession. The statue is so beautiful that it threatens to come alive; it threatens no longer to be art, but life. Here is the final paradox. It *is* art; but, as Ovid puts it, "his art concealed its art." It had to do that, because once it came alive, it could no longer be art. It was art, because it "seemed to be" alive and—like all good art—to want to speak and move. But if it did that, one would be ashamed; and so it remained locked into its skillfully artistic but always artisanal matrix.

Then, however, Pygmalion stood back from it and "gazed at it in wonder." The phrase is Mary Innes's extremely deft translation of the Latin *miratur,* which at once combines exactly the two elements that constitute

the fetishization of the object. Passion for it follows. Pygmalion kisses it; he decks it out. Finally he lays it on his bed, on the softest of pillows, and calls it his bedfellow—exactly as if it were alive. The poet makes it perfectly clear that Pygmalion expected the statue to feel the softness of the bed.

Then Pygmalion goes to the festival of Venus, and the miracle happens. Perhaps the most brilliant part of the passage is the description of the artist's self-consciousness about just what was happening in his thoughts as he prayed. He asks to have—to possess—as his wife the ivory statue itself; but he knows it is still art. He stops himself, just in time, and asks for one "*like* the ivory statue." But Venus understands him, and the statue turns into a living being. It is no longer art but life; but it has been enlivened by looking, by a looking that could only have happened because of the beauty of the statue. The fetishization of the beautiful object follows, and the eager beholder is aroused. The great paradox and the great tragedy that lies in making the protagonist an artist is that the object he made was only beautiful because of his skills, because it was art; but as soon as it came alive, it was no longer a piece of art at all. It was indeed, and no less, the body itself.

The extraordinary thing about Ovid's Pygmalion passage is that it also adumbrates two deep fears: in the first place that of the real body, and in the second, that of making an image come alive. The second is always a danger with artistic creativity. We are reminded again of the Islamic strictures against image making, where the artist suffers dire consequences for his ultimately fruitless (and temerarious) efforts to emulate God's own creativity—since it is only God who can make truly living images.[45] It is hard not to reflect on the irony of the repeated presence of stories such as those around the topic of "Love by Sight of Image" in a culture where the tradition (though, as we know, not the practice) evinced such grave misgivings about the portrayal of the living—to such an extent that Aisha, the ten-year-old wife of the Prophet, was only allowed to play with dolls on condition that they did not resemble people.[46] Indeed, there are several manuscripts of Nizami's *Khamseh,* where the faces of the protagonists and all the other figures are rendered without features. But the fear of making alive is, in the end, less difficult to grasp, since it is not hard to understand that we should want our creations to remain inert; it is we who should remain masters of what we make, and not have them turn into phantoms that seem dangerously to be like ourselves, and therefore both equal and stronger. We must now proceed to the first fear, that of the body itself, because it attaches to one of the most fundamental fears of all images (namely, that they appeal to the senses), and because it forms the basis of the innumerable reservations that terminate in censorship.

13

The Senses and Censorship

On 31 March 1864, Swinburne wrote frankly to his friend Milnes—who had just been created Lord Houghton—about the *Venus of Urbino*. He was writing from Florence, and after commenting on various works of art described Titian's painting:

> As for Titian's Venus—Sappho and Anactoria in one—four lazy fingers buried dans les fleurs de son jardin—how any creature can be decently virtuous within thirty square miles of it passes of my comprehension. I think with her Tannhauser need not have been bored—even until the end of the world: but who knows?[1]

Now the passage may be more an index of Swinburne's rather febrile sexual sensibility than of any particular candor, more frivolous than frank perhaps; but it is not as overtly hostile as the remarks of Mark Twain about exactly this picture less than twenty years later:

> You enter [the Uffizi] and proceed to that most-visited little gallery that exists in the world—the Tribune—and there, against the wall, without obstructing rag or leaf, you may look your fill upon the foulest, the vilest, the obscenest picture the world possesses—Titian's Venus. It isn't that she is naked and stretched out on a bed—no, it is the attitude of one of her arms and hand. If I ventured to describe that attitude there would be a fine howl—but there the Venus lies for anybody to gloat over that wants to—and there she has a right to lie, for she is a work of art, and art has its privileges. I saw a young girl stealing furtive glances at her; I saw young men gazing long and absorbedly at her; I saw aged infirm men hang upon her charms with a pathetic interest. How I should like to describe her—just to see what a holy indignation I could stir up in the world . . . yet the world is willing to

let its sons and its daughters and itself look at Titian's beast, but won't stand a description of it in words. . . . There are pictures of nude women which suggest no impure thought—I am well aware of that. I am not railing at such. What I am trying to emphasize is the fact that Titian's Venus is very far from being one of that sort. Without any question it was painted for a bagnio and it was probably refused because it was a trifle too strong. In truth, it is a trifle too strong for any place but a public art gallery.[2]

"Look your fill" is exactly the kind of looking that fetishizes the object, that makes it seem to be alive and makes one respond to it as if it were. That it becomes an object of great sexual interest is evident from the fetishistic symptoms of this looking; this happens as soon as looking at *it* becomes looking at *her*. And not only that: "anybody" gloats; girls steal furtive glances at her; young men gaze long and absorbedly at her; aged men hang upon her charms with pathetic interest. We have already noted the keen relationship between looking and enlivening; but the passage now introduces a crucial issue: censorship. It also reminds us, once again, of the relations between repression and art. The picture is too strong even for a "bagnio." Indeed the only place it could hang—as Twain's final, sarcastic lapse into philistinism makes clear—is in a public art gallery. Equally telling is the repeated insistence that such a representation would not be tolerated in words.

A brief passage in Vasari reveals another facet of the relations between sexual arousal and what is regarded as art. It also happens to be one of the few places in the classic historiography of Western art to refer to a specifically female response of this general order. He tells of how Fra Bartolomeo responded to the frequent taunt (which upset him) that he was unable to paint nudes: he did a Saint Sebastian (as the pendant to a lifesize Saint Mark) "with very good flesh colouring, of sweet aspect and great personal beauty" (fig. 158). But while the picture was on display in the church (San Marco in Florence), "the friars found out by the confessional that women had sinned in looking at it, because of the comely and lascivious realism with which Fra Bartolomeo had endowed it." So they decided to remove it to the chapter house (where it would only be seen by men) before finally selling it to the king of France.[3]

It was not only that the chapter house was an all-male preserve and that the provocative nude would thus be sequestered from the sight of women. By taking it into the chapter house, the picture was removed one stage further from a religious context. Keeping it anywhere in the church implied acknowledgment of its functional affectiveness; taking it outside—even to the chapter house—not only distanced it, at least somewhat, from the arena of arousal and sexuality. It made it more a work of art, something to be

158. After Fra Bartolomeo,
*Saint Sebastian with an
Angel,* from San Marco
(contemporary copy of
original of 1514).
Fiesole, San Francesco.
Photo Alinari.

displayed and admired (as in a museum) for precisely the qualities that
Vasari extols—certainly less liable to cause sin, more to be praised, inter-
preted, and understood than to be felt. In being sold off to the king of
France its status as a work of art could finally be confirmed. It entered his
collections precisely because it was a work of art, and not because of its
erotic power (though we know perfectly well how François Ier could respond
to the objects in his collection).

When Vasari reflects on the "colour very similar to flesh, sweet air and
great beauty" of Fra Bartolomeo's *Saint Sebastian,* he adds that, as a result,
the painter-friar "won great praise among artists."[4] Women might sin in
regarding it; but what Vasari had to ensure was that neither his responses

nor those of his readers should seem to be predicated on anything other than purely artistic criteria. Repressive talk about art has its beginnings in the earliest forms of criticism of art. When Vasari alerts us to the qualities of the picture, he does so in a way that does not draw attention to the dangerous power of its effects. But at least he does report on them, even a little pointedly.

When we turn to modern art historical writing—as with that on the *Venus of Urbino*—the effects of the picture are turned into something as unthreatening and undangerous as possible. Thus the standard monographic treatment of Fra Bartolomeo's *Saint Sebastian* and its pendant mentions nothing of the women of San Marco.[5] Indeed, it even takes issue with Vasari's explanation of the genesis of the picture in terms of the taunt that Fra Bartolomeo was unable to do nudes. In calling this explanation a rationalization, the writer insists instead that the novelty of both pictures "is explicable by their dependence on contemporary monumental sculpture."[6] And there follows a long art historical account of the influence of contemporary sculpture on the pictures, and of Fra Bartolomeo's involvement with it. Not a word of the effects of the picture recorded by Vasari. These, so one might assume such writers to imply, have nothing to do with art history; or they are not thought to be suitable for academic discussion.[7] Thus art history deprives objects of their most violent effects, and of the strongest responses to them. Thus it makes them anodyne. In doing so it ensures that the objects remain as art. But when we suspect that there might be a better word for this deprivation of the powers of an object—when, in short, we say that art history *emasculates* objects like these—we become immediately aware of the profound gender issues.

There is at least one further aspect of Vasari's life of Fra Bartolomeo that is germane here. This is where he describes the terrible and famous *bruciamenti* instigated by Savonarola on Shrove Tuesday 1496. "Stirred up by the preacher, the people brought numbers of profane paintings and sculptures, many of them the work of great masters, with books, lutes and collections of love songs. This was most unfortunate, especially in the case of paintings."[8] But who was it who brought his own studies of the nude to be burned? None other, of course, than Fra Bartolomeo (then still called Baccio). Less than thirty years later, the zealot who had encouraged other painters, including Lorenzo di Credi, to follow his example, and who shortly thereafter become a Dominican monk, painted the abundantly sweet and handsome nude that inspired women to sin.

Of all people, then, Fra Bartolomeo must have been aware of the powers of art (and from an early age); thirty years earlier the way of rendering art ineffectual could only be to destroy it altogether. Religious pictures were allowed to be powerful, but only in certain ways. If their powers implicated the overtly or explicitly sexual, they could be shifted into the realm of the

more purely artistic, into the realm of the profane. But if they still had effects of the strength that we might just tolerate with religious imagery, then—according to the thought of Savonarola and his followers, as with Calvin and the sixteenth-century iconoclasts—they had to be destroyed.

But there were other ways of dealing with the problem of the arousal of the senses. They have to do with censorship, rather than with the ultimate act of destruction. The paradox of censorship is that while it may destroy part of an image, indeed damage its artistic qualities, it allows the image to remain within the category of art. It does so with the aim of depriving the work of qualities that engage the senses too deeply and too intimately. But this is also characteristic of the censorship of all images, not just artistic ones.

Let us ponder more closely the analytic relationship between the assignment of the label which says "art" and the arousal that springs from looking and gazing at any image, whether we call it art or not. The issue comes acutely to the fore in the case of photography. Indeed, it might be argued that the history of photography begins with and is a result of the gaze that fetishizes; and that the tension between the need to classify as art and the need to arouse and be aroused is what inspires its origins.

Let us also use the term pornographic. It is no part of my intention in this book to define what is or is not pornographic; or to attempt to establish the boundaries between the sensual, the erotic, and the pornographic. These may indeed shift according to context; if anything such definitions and such boundaries are among the most liable to change. I use the term as an expedient one for the purposes of argument.

I

We are all as familiar with the variety of ways in which images are somehow made "respectable" by allowing them to fall into the canonical category of art as we are with the ways in which we explain away discomfort or embarrassment by thus elevating their status. If an image is pornographic, it either cannot be allowed as art; or (we assert) it is not art. If it is pornographic, then it must be low-level and crude—"crude" in both senses of the word. It is vulgar (again in both senses) and not high. These are the commonplace positions of repression, and it is true that they are changing. Notions of canonicity, now, seem to expand; but however much we (as sophisticated critics and consumers of art) may be pleased with the processes of liberalization and liberation, it is clear that the dismissal of artists who represent subjects commonly subsumed under the category of pornography is predicated on just the position that the images are not art but pornography. On the other hand, we sophisticates deal with our greater or lesser

discomfort in perceiving the images as straightforwardly erotic by putting them into a loftier category, by granting them the higher status of art. Hang them in galleries and exhibit them in the art museum.

The relations between what we define as art and what we call arousing or erotic or pornographic appear—to say it again but more bluntly—in the earliest history of photography.[9] We need not examine here the abundant and well-documented ways in which the photograph was used as a vehicle for pornography, nor the way in which its subjects were often seen as pornographic.[10] There are plenty of contemporary parallels to the many late-nineteenth century raids on photographic dealers, and to the petty bourgeois moral positioning represented by the letter to the London *Photographic News* in 1860 expressing the view "that a man who takes a walk with his wife and daughters dare not venture to look at the windows of many of our photographic publishers."[11] On the other hand, when we reflect on the confiscation of photographic reproductions of the *Venus of Urbino* and other famous paintings (cf. fig. 163 below), such as that documented in Hamburg in 1880, we come closer to the issue at hand.[12] And when we recall the huge public success of the move that Julien Vallou de Villeneuve made from erotic lithography to erotic photographs in the early 1840s—to say nothing of their use in the work of Courbet—then it is clear that the matter merits further exploration.

The use of early photographs by both Delacroix and Courbet is well known. It is not surprising that they should have taken realistic photographs of female nudes and added to them. They did so in a variety of ways, and they turned them into easel pictures. Delacroix, broadly, idealized the photographic images he had made or collected in his album. He made them less ugly and generally more suitable for the more beautiful and decorous medium of painting (figs. 159 and 160).[13] Taking nudes such as those produced by Villeneuve, Courbet made them still fleshier, still more replete with the accidents, dimples, and bumps of nature (figs. 161 and 162).[14] We know that the photograph was realistic because it was called that. It was called realistic because it was regarded as being too close to nature. That is precisely why it was not art. Art improved on nature; it was not so bluntly realistic; it made it more beautiful.[15] As Aaron Scharf put it in his excellent summary of these issues: "Realism was the new enemy of art and it was believed that it had been nurtured and sustained by photography."[16] It is hard not to reflect on how the prosecution condemned *Madame Bovary* at the trial of 1857 on the grounds that it belonged to "the realistic school of painting."

The implications of the constant insistence on the categorial distinction between art and photography, and on the need to keep the boundary between them absolutely firm are now clear. Arousal by image (whether pornographic or not) only occurs in context: in the context of the individual

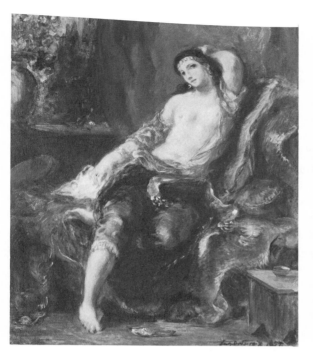

159. Eugène Delacroix, *Odalisque* (1857). Stavros S. Niarchos Collection.

160. Seated female figure from the Delacroix album (photograph; ca. 1853). Paris, Bibliothèque Nationale.

161. *Above:* Julien Vallou de Villeneuve, *Standing Nude* (photograph). Paris, Bibliothèque Nationale.

162. *Right:* Gustave Courbet, *Les Baigneuses,* detail (1853). Montpellier, Musée Fabre.

beholder's conditioning, and, as it were, of his preparation for seeing the arousing, erotic, or pornographic image. It is dependent on the prior availability of images and prevailing boundaries of shame. If one has not seen too many images of a particular kind before, and if the particular image infringes some preconception of what should not be or is not usually exposed (to the gaze), then the image may well turn out to be arousing.[17]

All this may be irrefragably true, and one may well want to argue thus. But it is only part of the story, and it does not take care of the particular and peculiar case of the photograph. It is only half an account. The fact is that the early photographs were seen as realistic and arousing, and they were both used and censored for that reason. Moreover, they were seen and used as arousing *because* they were realistic. The conjunction was always made by the censors; and it could be quite plainly expressed, as in the English court case of 1861, initiated because "provocative and too real photographs" were displayed in public places.[18] But the concern was not only that they were realistic; it was that they were available to the crowd. Of course the censors might have been equally concerned with private misuse; but once again the connection between realism and the vulgar (in the sense of popular and low-level) could not be plainer.

But perhaps it is possible to be less elliptical about these connections and about the relations between realism and arousal. The gaze, as we have seen, fetishizes. We fall in love with the represented object; or feel—possibly—some species of physical sympathy with swirling lines, or with large sculptures that make us want to move to see or feel their end. We look and gaze, like Tamino. Like him, and even more like Pygmalion, we want the image to be alive—to be real. It has to be real because we do not wish it any longer to remain as lifeless material, or as two-dimensional. It has to be real so that we can properly possess it. The perceived realism of photography springs from this kind of fetishization; and it is always pregnant with the possibility of arousal. The basic fact about art, at least in those days, was that it was not as real as the photograph and could not be so—because otherwise it would arouse.

Art, of course, was also more beautiful than anything that realistically reproduced nature. Courbet had more trouble with this attitude than anyone else. His *Burial at Ornans* was regarded as ugly because it was too realistic, and it was belittled by comparing it with a photographic image. "In that scene," wrote Delécluze, "which one might mistake for a faulty daguerrotype, there is the natural coarseness which one always gets in taking nature as it is, and in reproducing it just as it is seen."[19] And it had a commonplace subject too. But Courbet also exploited this attitude, and in doing so he knew exactly what he was about (as when he used Villeneuve's photographs as the basis for his own, often more abundant, female nudes). The whole issue may seem to be entirely of the nineteenth century; but it

is not. In recounting the fate of Fra Bartolomeo's *Saint Sebastian,* Vasari observed that the women of the congregation sinned in looking at it because of the realistic skill of Fra Bartolomeo. Thus he established the direct connection between arousal and realism that—consciously or unconsciously—continued to alarm the demarcators between art and photography.

But there is still another lesson in all this. If the makers and purveyors of pornography (and realism) want to make their pornography acceptable; if they are aware of the need for its consumption and its uses for purposes of arousal, then they can and do make their pornography seem like art. Especially if the society which consumes it is sunk in its bourgeois repression. It is no surprise, nor any consequence of the old idea that nature follows art, that even Villeneuve's nude females—even the ones used by Courbet—look so artistic. They are posed in artistic ways, with artistic trappings, in ways that Villeneuve learned from that high and canonical category. There are the archer, or more abandoned, or coyer adaptations—by Villeneuve himself and many others—of Titian's *Venus of Urbino* (swiftly destined to be turned into Manet's *Olympia* [fig. 11], a picture that carries with it the full consciousness of every issue discussed in this chapter); there are the robust/delicious/plain/peasant-like studies related to Ingres's *Odalisques* (pictures which to many must have seemed erotic enough but which could not be carried around with one for private consumption); and finally there were the multitudinous derivations from Velazquez's *Rokeby Venus,* each one emphasizing or changing those parts of the picture assumed to be of sexual interest by their makers (e.g., fig. 163). But now, because they were photographs, the pictures were realistic, and therefore both uglier and more arousing. In most of these adaptations the increasing fetishization of breasts and buttocks is easily identified.[20] In any event, once photographs like all of these make their kinship with art apparent, they seem to be safer; they may be bought by the widest of markets; and fetishization of the body becomes large-scale commodity fetishism at every level of image consumption.

But there is a brute fact that subverts the categories and the pigeonholes of a bourgeoisie that so blatantly makes capital of repression (or allows the exploiters of these categories to do so). It is this: As soon as the photographic image is seen as too threatening it does not qualify as art; nor is it perceived as such. Its threat is too plain. Then, of course, it can be censored—or kept under covers, or appropriately, in the bedroom, and certainly away from children and old maids)—it *must* be censored. We begin to come closer to the relationship between realism and censorhip. What is realistic is ugly and vulgar. Art is beautiful and high. The photograph is realistic; it is vulgar; it elicits natural and realistic responses. In art, nudity is beautiful and ideal; in the photograph (unless it has acquired the status of art), it is ugly and (therefore?) provocative. In 1862 the photographer

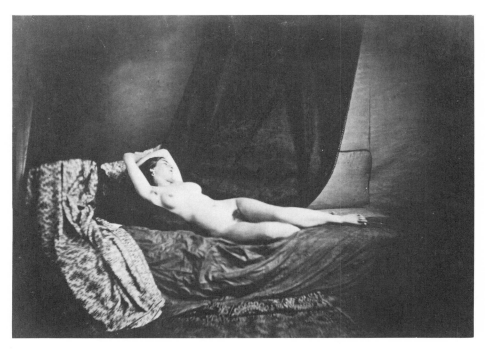

163. *Reclining Nude* (photograph; ca. 1854). Paris, Bibliothèque Nationale.

André Disderi complained about the abundance of obscene photographs in his time by referring to "those sad nudities which display with a desperate truth all the physical and moral ugliness of the models paid by the session."[21] Once again Scharf provides the most appropriate of glosses to this attitude: "The crudities of actuality in photographs of nudes especially did not blend very elegantly with the antique, and photographs of this kind were an effrontery to men and women of good taste."[22]

In the phenomenon of censorship we see most clearly the convergence of good taste and the fear of realism. The covering of genitals (probably the commonest form of censorship) is the ultimate acknowledgment of the relations between realism and offence. When we cover or remove them (or when we cover the breast that nourishes or the parts of the body that excrete, or even when we cover feet or other physical features regarded as sexual), we take away the profoundest marks and criteria of realism. The provision of fig leaves—as now seems obvious—registers a fear of the consequences that the artistic and ideal work may somehow not be so ideal after all; it reveals to the gaze that which, were it real, would be the most realistic proof of its sexuality. Herein lies the true subversiveness of the beautiful: it traps the enlivening and therefore dangerous gaze. That is why art may be censored as much as non-art, and sometimes even more so.

I have omitted one reason for the opposition of photography to art (or,

at the very least, the worry about whether it qualifies as such). Photography is reproductive; art is unique. Almost everyone can own or have access to a photograph; but art, being high, is reserved for the few. The crowd responds in basic and crude ways to reproductive imagery; but art only yields its secrets, as if hermetically, to the select people who are trained to understand it or are born into the culture that financially enables it.[23]

One final aspect of the kinds of photographs that we have been considering may be too obvious to merit special comment, but it is so telling an aspect of the nature of Western looking and arousal that it cannot be emphasized enough. It is also directly implicit in every issue in this section: from art and non-art, to looking, gazing, fetishization, enlivening, arousal, and possession, through to the vulgarity of reproduction and the commonplace promiscuity it implies. I refer to the fact that the majority of the photographs called obscene or erotic are of the female nude. Of course there are some that are male, and when they exist they are probably censored in equal proportion; but erotic and arousing and pornographic photographs of the female nude crucially and vastly outweigh those of the male. One could not say that the situation now is substantially different—even with the elevation into art of photographs such as those by Robert Mapplethorpe.

When we turn to the sixteenth-century prints that were subject to censorship, we find that a smaller proportion were devoted to the female nude alone. Overall there seems less concentration on the female body and more on the illustration and suggestion of the sexual act itself. There is certainly a larger proportion of erect penises in the sixteenth-century prints than in the nineteenth-century photographs. Differences like this may largely be cultural and contextual. But as much as one may want to plead this, or (I would say irrelevantly) that the genre is different and that the photographs are not narratives—or are less narratival than the sixteenth-century prints—such differences force upon us the consideration of matters that I have so far left insufficiently explored.

II

Even though it has not been my aim to define what is pornographic or not, one thing seems clear: much that is pornographic is not arousing. The photograph—or the engraving—that shows blatant sexual engagement is likely to fail: it fails because there is none of the frisson, the tension, or the still stronger arousal that arises from a sense of the image being on the borderline of what is art (or what is tasteful, decorous, fashionable) and what is not art (or tasteful, decorous, fashionable, etc.). It is art, so it should not be arousing; it is publicly acceptable as art, and yet it transgresses—just—the limits of the admissible and the tolerable. This border-

line position is what gives so many of these images their sexual potential. Once again the issue is one of demarcation. When the objects are too blatant, the demarcation between art and non-art becomes too clear; and the effects, though they may be interesting and curious, are not likely to be terribly stimulating or provocative. Of course there are images that are plainly not artistic, but are still arousing. This, however, is not what is at issue; the inefficacy of the blatant is.

The inefficacy of the blatant is at issue because it allows us to return directly to the problem of the arousal that springs from looking. With the phallic representations or scenes of intercourse on Greek vases, on Roman lamps, and on Pompeian wall paintings; in the small phallic jade sculptures of China and in K'ang-Hsi silk paintings; in the stone Shinto penises and in Ukiyo-e pornography; and in the extraordinary sculptures of Khajuraho, representation and narration is all too obvious. We do not need to pause for long or to concentrate to see what is happening. We see the penis and the vulva; we scan cursorily and get the point. The scene is all too obvious and plain, writ in large letters, as it were, before us. We do not need to look very hard. Indeed we may even be too embarrassed to do so; and embarrassment is not conducive to arousal.

For all this, the difficulty of establishing definite terms for the pornographic remains clear. What is called pornographic remains wholly contextual; there can be no hope of deriving the term transcontextually or on anything remotely approaching a transcultural base. Indeed, when we consider the fact that prints like the *Modi* after Giulio Romano or the *Lascivie* of Agostino Carracci (fig 164; also fig. 170 below), which we might think would fall into exactly the same class as the Chinese, Japanese, and Indian pornographic illustrations, were themselves censored, we cannot be entirely certain that the censors were just being prudish. We can all too easily see why they might have been worried about the potentially wide circulation of reproductive images like these. We can easily understand their fear because we can imagine any number of circumstances where they might indeed have been arousing. If confronted, the censors might have insisted that the basis of their worry was that such images might fall into the wrong hands. The schooled in art could perhaps enjoy them without danger, but what about the others? The answer was to censor or to restrict circulation— but then, even the more sophisticated viewers might lapse and be seduced into arousal.

It may be impossible to say what arouses and what does not, but we can at least come closer to accounting for the fear of arousal. As we do so, and as we tap the old sources that know that the beautiful is dangerous and that it is wise to control it, we may begin to understand better not only why all images are capable of working in the ways that the critics of art maintain, but also why the addition of beauty may make them additionally subversive.

164. Agostino Carracci, *Satyr and Nymph* from the *Lascivie* (engraving; ca. 1590–95; B.18-109-134).

We do not know what the images that Henry Peacham wrote about in *The Gentlemen's Exercise* of 1612 looked like, but he conveys a clear if censorious sense of what their effects might be. Lewd art from Italy and Flanders, he alleged, was "oftener enquired after in the shops than any other . . . wax pictures of Curtizans in Rome and Venice being drawn naked, and sold up and down as *Libidinis Fomenta.*"[24] Although it is true that the sense of foreignness and the exotic may well have added something of the frisson that accrues with the evident infringements of borders—here a simple geographic one—one cannot simply account for this passage in terms of the common nationalistic fear of the corrupting effects of foreign art which we find in all the late Roman writers from Sallust to Velleius Paterculus, and above all in Plutarch's life of Marcellus.[25] Passages like the one from Peacham provide contemporary corroboration of the possible effectiveness of those pictures of courtesans that we know used to adorn brothels or bedrooms. We have already seen many examples of the enlivening potential of the lingering, doting, and desiring gaze; and this is why we cannot simply

dismiss harangues such as Clement of Alexandria's in terms of the high moral indignation that may well account for them. Clement, after referring to those who "lying upon the bed, while still in the midst of their own embraces, fix their gaze upon naked Aphrodite," goes on thus: "Your ears are prostituted and your eyes have fornicated. . . . Your looks commit adultery [with] reclining Venuses, little figures of Pan and naked girls."[26] Nor are such criticisms simply indices of the frequent early Christian hostility to the luxurious and lascivious otherness of pagan statues. They are that too; but their heated tone belies the cool facts of cognition upon which they are based. All strictures like these provide clear acknowledgment of the fact that images do work in such a way as to incite desire.

But it is not only the critics who pass over or evade the rude facts. This is the kind of response that perhaps more than any other we ourselves choose to suppress. We prefer not to acknowledge it, and we willingly forgo the responsibility of articulating it. Outside the groves of the academy and the world of high art criticism, people are generally franker about such things. And sometimes it even gives them pleasure to talk about effects of this order. But here our concern is with the other side of exactly the same coin: the way in which people evince their fear of the possibility of arousal by image, and the ways in which they suppress, censor, or wholly reject those aspects and those classes of images which are felt or believed to excite.

III

The issue is the fear and suspicion of images on the grounds that they force upon us the mobilization of our senses. From Clement of Alexandria (with all his antipathy to images) to Bernard Berenson (with all his love of them), the eyes are the channel to the other senses. These are what are dangerous, or enlivening, or both—touch above all. Once our eyes are arrested by an image, so the argument more or less runs from Plato onward, we can no longer resist the engagement of emotion and feeling. (Of course our eyes must be detained by something attractive, striking, beautiful—the very criteria of art). We may be moved; we strive to touch the unliving object before us. Whether inevitable processes or merely inclinations, these are what detract from the purity of mental operations *tout court*. That higher side of our beings that sets us apart from animals, the realm of intellect and spirit, is brought down and sullied. Each time this happens, we are endangered and threatened—all because of the dominance of the senses, because we are labile, not strong enough to control their motions and impulses.

If we must have images at all, then we must ensure not so much that they do not bring us down to the level of the senses, but that they lift us to higher planes; that they assist us in proceeding from the material to the

spiritual; and that they offer us mortals enwrapped in our senses the possibility of mediation—at least with the divine. And so the image, ideally, is sacred; it should not be impugned by the possibility of baseness. This is why the production of images—and craft activities in general—are so often accompanied by dietary and sexual prohibitions. The act of creation rivals divine creation and is accordingly sacred; so must the image be itself. This is usually said to be the case in what are called traditional cultures; but there are, in fact, any number of Western injunctions that insist on the morality of the artist, from the apologists for images in Byzantium to the decrees of the Russian Stoglav in the sixteenth century.[27] The process of the production of images must be undertaken by those of the highest moral standards; their personal lives should be free from blame; they should not paint on Sundays or fast days; and so on. Everyone has heard the recurrent allegation that artists sleep with their models; and that allegation embodies all the fears of waywardness and promiscuity against which injunctions of this kind are to be set. It is hard not to forget Clement's explicit allusion to the promiscuity of the eyes.

Once an image is perceived as capable of arousing sexual feelings, or actually does so, it is liable to be regulated by law, restricted, or censored.[28] The image is regarded as offensive in one way or another. But why? After all, it is only inert matter. Perhaps one of the most extraordinary things about Ovid's Pygmalion narrative is that its very structure adumbrates two of the deepest fears that converge in the mistrust of the senses: in the first place the fear of the real body; and in the second that of making an image come alive. Hence Pygmalion's prolonged hesitation and elaborate preparations—Ovid's account may engender extreme impatience in the reader—before taking the final step that would make the image do just that, come alive. As we remember most acutely from the Islamic strictures against image making, this is always the danger with artistic creativity.

But the enlivening of the image is most dangerous because it always implicates the first of the two fears, that of the body itself. The two come together in the West at least as much as anywhere else. This is what gives the passage from Valerius Maximus about the effects of the painting of Cimon and Pero its exemplary value.[29] If its interest lay solely in the fact that it provided a colorful instance of a particular literary genre, or an extra insight into the Roman concept of virtue, then we would not need to pursue it further. But it does not just constitute, as we have seen, a commonplace exemplum of Roman virtue (however colorful), or a more or less trivial repetition of the standard view that pictures are more effective than words.

"People stop in amazement and cannot take their eyes off the scene when they see the picture" of the beautiful young Pero giving her naked breast to her father to suck, precisely because, as Valerius himself notes, "in those mute figures they feel they are looking at real and living bodies."[30] No

doubt it was no part of Valerius's intention to make a statement about the relations between cognition and sexual engagement; but when we consider more closely the content of this particular exemplum (and, perhaps, by considering Rubens's treatment of it), we can see just how powerful a statement of this order it happens to be (cf. fig. 14). The attention of the spectator is arrested by the unusual subject, and by the sight of a part of the body associated with sex and sensuality; the gaze is not withdrawn, but lingers on the picture; the spectator dwells on it, perhaps additionally drawn by the beauty with which it is painted; and concentration and doting proceeds to the desire for possession and enlivenment. Although Valerius wishes to stress that the effect of such pictures is edifying, it is not difficult to imagine that the moral point might have been lost or obscured, or a very different lesson drawn. Of the strength of its effect there could be no doubt, and that strength in itself might give rise to the gravest of misgivings. The picture is (as we see from Rubens and Baburen and Fragonard) art: it should pertain to our highest and most spiritual faculties. Instead it blatantly, almost palpably, arouses the senses. Furthermore, it does so sexually, or at the very minimum *could* do so. Who are so pure that when they see a painting like Rubens's *Cimon and Pero* (to say nothing of the Behams' prints of the subject) they will only draw the virtuous lesson—especially when, as Valerius put it, "in those mute figures the spectator feels he is looking at real and living bodies"? Of course one could always remove the painting from sight, or order a less attractively painted one, or attempt to distance father and daughter, or cover the breasts . . .

The tension lies precisely in the fact that although the images are inert, dead, or of divine beings, when we look at them with the gaze that enlivens, our responses are likely to be akin to, if not identical to, the responses that would arise with ordinary human beings. Indeed, any suggestion of the sexual, or any perception of sexual potential, is likely to enhance the strain to enlivenment and possession. This is the tension that underlies the concerns of the censors and that troubles the rest of us. One way, then, of attempting to deny the possibility of conflation and illusion is by eliminating the possibility of the sexual response. Hence the suspicion of nudity that prevails so widely in Western culture; hence too its constant appearance in the context of the old parallel between painting and poetry—because it is in exactly this area that the figurative and representational arts distinguish themselves from texts. It is plainly and evidently the area where images are more effective than words. Thus, when Poggio Bracciolini, in the 1420s, gently reproaches his friend Panormita about the indecent poems in the latter's *Hermaphroditas,* he does so not only in terms of the sense of demarcation but also (and concomitantly, as always) in terms of the allowable: "Even though painters are allowed to do anything, just as poets are, still when they paint a naked woman—even though they are following

nature as their guide—they cover the obscene parts of her body, or if the picture contains anything that is lewd, they keep it well out of sight."[31] The implications are several; two should be reemphasized. Poetry, altogether significantly, is generally allowed more than painting, because painting is potentially more dangerous; and as we saw with photography, nature has its shortcomings as a model for true art, because nature (or its realistic representation) appeals to something rather baser than the ideals of art should strictly allow.

There are plenty of instances in the history of art where pictures of nudes are kept away from old maids or children and where they are kept in the most private or sequestered parts of the house, just as Poggio recommends.[32] Implicit in all such recommendations and implementations is the acknowledgment that pictures and sculptures of this kind are indeed capable of arousing the flesh. But perhaps even deeper than worry about erotic arousal *tout court* is the concern that we should not respond to images of divine beings, say, Christ or the Virgin, as if they were ordinary beings— let alone in the base ways that sexual response implies in the West. From this follow not only the proscriptions on pagan and secular imagery, but also on religious imagery. There is a telling passage in Leonardo's notes on the *Paragone*—the context of the greater effectiveness of painting than poetry is again significant—that reminds one both of Gorky's childhood "sin" and of Toto's lascivious Madonnas. "The painter," says Leonardo,

can even induce men to fall in love with a picture which does not portray any living woman. It once happened to me that I made a picture representing a sacred subject which was bought by one who loved it—and then wished to remove the symbols of divinity in order that he might kiss her without misgivings. Finally his conscience prevailed over his lust and he . . . removed the picture from his house altogether.[33]

<center>IV</center>

The censorship of sixteenth-century prints with erotic subjects offers further lessons. Prints, like photographs, are reproductive; they can be widely disseminated; they are potentially vulgar because they can get into the hands of the *vulgus,* the crowd; they are therefore not like art, which is unique and in principle restricted in the access it offers to its audience. Even in a museum it does not allow intimate access. In any event, one cannot possibly control into whose hands printed imagery might fall—perhaps even children's and the ignorant lay person's—and so the need for censorship of the engraved plate itself becomes critical. (At the same time, the censor's access

to the plate grants him a rather more authoritarian and powerful position from which to act than the censor of pictures, which is why attempted censorship of pictures often takes more violent and overtly iconoclastic forms.)

The history of this particular episode ranges from the change in Zoan Andreas's plate of a pair of lovers, where the hand on the breast was rather maladroitly made to seem as if it rested on instead of inside the woman's bodice (figs. 165 and 166), to Leo XIII's wholesale intervention in the Chalcografia Camerale in 1823. Hundreds of the sixteenth-century plates surviving there (and some later ones) were broken and sent to be melted down in the foundry at Tivoli. Others were horribly and irreparably mutilated by being scratched through, as in the plate of the generously endowed—one might almost say Courbet-like—*Venus Combing Her Hair* by Adamo Scultori (fig. 167). Many, like Scultori's *Hercules and Antaeus* and any number of other Herculean prints, had the decorous fig leaf added to them, just as with so many nineteenth-century photographs of men—to say nothing of the usual treatment of antique nude statues. Quality of image and quality of engraving technique made no difference to the frantic efforts at this time.[34]

Nor did it in the later sixteenth century, when there was a constant tension between the desire for erotic prints on the one hand and official disapproval—especially in the wake of the Council of Trent—on the other. In this too there are obvious parallels with the early days of photography, where production of erotic imagery went hand in hand with the outcry against them. But of course there are some more rigorous periods than others, and they are all instructive. The case of Clement VII's anger with Giulio Romano and Aretino and Marcantonio over the publication of the very explicit *Modi* is well known.[35] He sent Marcantonio to prison and ordered all impressions to be destroyed.[36] So successful was he in his aim that all that now remains of the originals are the nine pathetic fragments in the British Museum so diligently collected by Mariette (fig. 168)—although the original compositions are preserved in woodcut in at least one early sixteenth-century book, in several engravings by Gérard, and in the more evidently scabrous drawings by Count J.-F.-M. de Waldeck (fig. 169).[37] What one censor does not get another will. While Marcantonio's *Pan and Syrinx* (sometimes attributed to Marco Dente) seems to have survived Clement's anger, it too was eventually adjusted, with a bunch of leaves covering Pan's erection and the removal of most of the indication of Syrinx's pubic hair (figs. 170 and 171). The fate of Enea Vico's *Mars, Venus, and Vulcan* is equally instructive, except that here adjustment took place in a more progressive way than usual, as we may see from impressions taken with each newly adjusted state: the first (fig. 172) shows the naked lovers copulating, with Mars ensconced between Venus's raised legs; the second

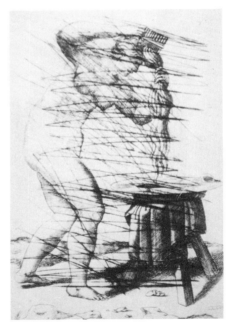

165. *Above:* Copy after Zoan Andrea, *Couple Embracing* (engraving; first half sixteenth century).

166. *Above, right:* Zoan Andrea, *Couple Embracing,* censored, state 2 (engraving).

167. *Right:* Adamo Scultori after Giulio Romano, *Venus Combing Her Hair,* scratched, state 2 (engraving).

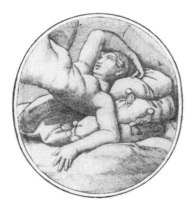

168. *Above:* Marcantonio Raimondi after Giulio Romano, fragments of *I Modi* (engravings; 1524[?]; B.14-187-231). London, British Library.

169. *Right:* Count J. F. M. de Waldeck, after one of *I Modi* by Marcantonio after a design by Giulio Romano (black chalk copy; mid-nineteenth century). London, British Library.

170. *Left:* Marcantonio Raimondi after Raphael, *Pan and Syrinx* (engraving; ca. 1516; B.14-245-325).

171. *Right:* Marcantonio Raimondi after Raphael, *Pan and Syrinx,* censored (engraving; ca. 1516; B.14-245-325).

(fig. 173) shows that whole area of the plate obliterated; while the third (fig. 174) has Venus restored, but whereas she previously was shown actively embracing Mars, her head is now slumped in sleep, Mars is absent altogether, and her right leg, instead of being raised, is now more or less decently down, with her hand and a substantial drape turning her into a much more proper Venus Pudica.

Such are the changes that are likely to have taken place during the papacy of the next Clement (1592–1605). He was also the pope who was only just prevented from destroying the whole of Michelangelo's *Last Judgment* because of his objections to its indecent nudes (as opposed to those of his predecessors and successors who, though worried about this aspect of both the *Last Judgment* and the Sistine ceiling, contented themselves with the painting of some modest veils and loincloths).[38] He issued even more severe decrees, and it was probably during his papacy that prints like the *Sacrifice to Priapus* by the Master of the Die and Giorgio Ghisi's *Venus and Adonis* were made more respectable by a complete covering of the demigod's chief

172. Enea Vico after Parmigianino, *Mars, Venus, and Vulcan,*
state 1 (engraving; 1543; B. 15-294-27).

173. Enea Vico after Parmigianino, *Mars, Venus, and Vulcan,*
state 2 (engraving; 1543; B. 15-294-27).

174. Enea Vico after Parmigianino, *Mars, Venus, and Vulcan,*
state 3 (engraving; 1543; B.15-294-27).

175. *Left:* Giorgio Ghisi, after Teodoro Ghisi, *Venus and Adonis,*
state 2 (engraving; ca. 1570; B.15-402-42).

176. *Right:* Giorgio Ghisi, after Teodoro Ghisi, *Venus and Adonis,*
state 4, censored (engraving; ca. 1570; B.15-402-42).

attribute and by a drape extended decorously but still suggestively over Venus's full buttocks (figs. 175 and 176).

The next major case of the censorship of prints took place in the late eighteenth century when the erotic prints in the collection bequeathed by Benedict XIV to his native town of Bologna were similarly treated. It may well be to this period that we should date the "improvement" of many of the impressions of Agostino Carracci's *Lascivie*, which had already earned the scolding rebuke of Clement VIII for their immodesty.[39] Here, as always, one cannot help reflecting that if these were the ways in which prints were kept pure, how much more sensitive the matter must have seemed when it came to paintings, colored like flesh, and sculptures, modeled and shaped like bodies. On the other hand, neither paintings nor sculptures could be widely circulated. The issue is at least as much social control as sexual control.

<div align="center">V</div>

The ideological bases for the second of the main concerns about nudity are in some ways even clearer. This is the concern that arises from the need to keep the divine and the everyday clearly separate, to ensure that the divine remains unimpugned by sensual feeling, just as in the passage from Leonardo.[40] When we read Valerius Maximus's description of the picture of Cimon and Pero, we may be inclined to recall the similarities with the vision of Saint Bernard, or with other visions, such as that of the monk whose cancer was cured when the Virgin placed her "douce mamelle" in his mouth. But with Saint Bernard, and with the other accounts of visions, the imaginative possibilities are pushed one stage further: there could never be acknowledgment in a writer like Valerius of similar imaginings on the part of the spectator. Christian apologists, however, easily conceived of such possibilities. Aside from their concerns with chastity, they were all too aware of the power of images—which they persisted in construing as negative, as long as it remained outside the strict service of Christian dogma and doctrine.

The classic test period for this whole complex of issues—the need to keep the spiritual uncontaminated by the fleshly (indeed, by anything corporeal or material), and the need to ensure the strict separation of divine and everyday—remains the sixteenth century. The full gamut of restrictive positions is expressed by the Reformation writers, while Catholic attitudes are codified and canonized by the Tridentine decrees on painting. The bases for restrictiveness and censorship are surprisingly similar on both sides. The views of both are predicated on a sense of the danger that arises from the ability of images to engage our ever-unstable senses. Luther and Zwingli,

for example, allowed images in churches as long as they took the form of historical narrative (though naked Venuses and Lucretias could remain at home).[41] For the Catholic apologists our senses were so prone to excitement by art—which in any case can instruct, edify, and aid the memory—that the strictest measures had to be taken to ensure that it did not arouse the wrong ones (so naked Venuses and Lucretias should not be allowed anywhere, and certainly not at home, where, after all, they might be seen by old maids and young children). Thus one of the few specific elements in the Tridentine decree of 1563 was its insistence that all lasciviousness was to be avoided in the sacred use of images. Significantly, this meant not only the proscription of lascivious imagery, but also the prohibition of the association between sensual behavior (e.g., drunkeness, which made the senses still more labile) and occasions when sacred images were carried around in procession. Everything in the way of new imagery was to be regulated by ecclesiastical visitors, and finally by the upper clergy.[42]

There is no need to rehearse again the many attempts to cover up the more offending parts of Michelangelo's Sistine ceiling and *Last Judgment* or to remove it altogether.[43] The arguments about the chapel, which had started with Hadrian VI, reached their greatest pitch in the decade or so following the last session of the Council of Trent when the decree on images was passed (3–4 December 1563); but this was also the period immediately following the great outburst of iconoclasm in the Netherlands in 1566. In the wake of that event—the resonance of which was pan-European—a great spate of Catholic writers attempted to construct systems of justification for the use of imagery, but of imagery purified of its threats and dangers.[44] Thus purified, it might be less vulnerable to attack. So they devised systems of regulation and proscription, lest anything go wrong, lest the power of images serve the wrong domain. The chief of these writers, whose book on religious imagery was printed over and over again, and who provided the model for many others, was Johannes Molanus, Philip of Spain's censor in the Netherlands.[45] Molanus objected to the representation of the naked Christ Child in a chapter that set forth all the traditional arguments against nudity.[46] But the most exact articulation of the problem came in a quotation from Ambrosius Catharinus: "The most disgusting aspect of this age," Catharinus harangued, "is the fact that one comes across pictures of gross indecency in the greatest churches and chapels, so that one can look at there all the bodily shames that nature has concealed—with the effect of arousing not devotion but every lust of the corrupt flesh."[47]

Already at the beginning of the fourteenth century, the authoritative and influential writer on church ornaments, Durandus, had insisted that the infant Christ be represented only from the navel up (and this recommendation he no doubt learned, in turn, from a number of Byzantine writers).[48] Indeed, there were recurrent worries, on similar grounds to these, about

the nakedness of the crucified Christ. Several writers suggested that Christ covered himself with his left hand—as in many representations of the Crucifixion—because of his own shame at being thus exposed.[49] The fact that restrictions like these often had little effect is another testimony to the power, not only of tradition, but of the force of representation itself.

No one would want to claim that breasts, buttocks, and genitalia are similarly threatening or are likely to arouse the same sensitivities in other cultures. I have already noted the anxieties caused by other parts of the body in China and Persia, and further instances will occur to the ethnographically minded reader. But when we recall Kris and Kurz's reflection on the removal of the nose of an image in order to prevent it from inflaming further passions—"the statue was believed to be alive not only by the man who offered his love to it, but also by those who mutilated it to prevent others from falling in love with it"—we see the force of the paradigm.[50] By censoring or destroying an image, we acknowledge the response that arises from the perception of the body in the image; and thus we subvert desire. The case, because of the long history of figuration, pertains to the figurative; but extrapolation to the nonfigurative need not be complex.

These two factors, then—erotic arousal by secular or pagan imagery and the threat posed to religion (Christianity in particular) by the awakening of the flesh—come together in the history of attitudes toward pagan sculpture. The lives of the Byzantine saints until around 600 are full of references to the destruction of pagan statues, and of stories like the following. The nude statue of Aphrodite in the Marneion at Gaza was an object of great veneration. When, in 1402, bishops surrounded by Christians bearing crosses approached this statue, "the demon who inhabited the statue, being unable to contemplate the terrible sign, departed from the marble with great tumult, and as he did so threw the statue down."[51] The story is obviously meant to be testimony to the power of the single most important sign of Christianity, but it also brings us closer to the basis for the impulse to iconoclasm. Here again the fear of arousal is implicit, even though the triumph of Christianity over paganism is the explicit motif.

The same may be said of the legendary destruction of images by Gregory the Great at the end of the sixth century; but with Gregory motivation is rooted in that still broader spectrum of fear that is so close to the center of this chapter: the inevitably seductive and ultimately corrupting effects of beautiful form.[52] Gregory is reported to have "ordered that all the most beautiful statues . . . should be thrown into the Tiber so that men, captivated by their beauty, should not be led astray from a religion that was still fresh and recent."[53] Humanists like Andrea Fulvio may have felt they had to deny such reports as inaccurate, but their revival in the fraught first half of the sixteenth century (when religion might perhaps be said to have weakened again) is not surprising at all. In fact, in the very years after the

Protestant iconoclasm, both Pius V (1566–72) and Sixtus V (1585–90) attempted to remove and destroy ancient statues, or to convert them to Christian uses.[54] Needless to say, they were supported in this by many of the theological writers on art, including Andrea Possevino, who in the course of his 1595 treatise insisting on the proper domains of painting and poetry (and on what was allowable in images) claimed that the sight of pagan statues was hateful to the saints in heaven.[55] Molanus, who was as broadminded as any of the apologist-critics, believed that pagan statues should not please Christians, although those that taught a good moral (and Christian) lesson might usefully be preserved.

It is hard to imagine a more threatening situation for images; but it is a situation that bears stark and exemplary witness to the fundamental fear from which we cannot escape unless we admit frankly to the potential upon which it is based. This is the potential for arousal that immediately and irresistably accrues from the interaction between images and people. Once we stop to look, we may be trapped; we might want to escape, but we cannot. Even if we walk away in discomfort, we only transform effect into denial. That is why in hypersensitive or neurotic states men and women may want to extricate themselves entirely by doing away with the image that works on them in the manner of an insidious, opposing, and uncompliant mortal. If it were alive it would be more compliant; irritation turns to anger, and anger to the impulse to remove or destroy. But if it is alive— or even makes us seem more alive—it has no business doing so, because it should be lifeless, dead, and inert.

VI

The previous chapter began with the problem of the extent to which all looking in the West might, in the drive to possession, be masculine; it then traversed the broader problem of the gaze that desires and enlivens. At the center of much of the evidence and discussion stood presentations of the female body, and in particular the female nude. I attempted to wrest cognition from the narrower relations of context and convention, and finally in this chapter I set the issue of censorship not only in terms of the fear of sensibilia (and the consequent impugning of the intellectual and spiritual) but also in terms of the separation of divine and unearthly from everyday and profane. Throughout I have attended to the apophantic and analytic status of repression and fetishization; and, increasingly, to the tension that arises from a sense of boundary—a sense but no precise knowledge. I have already described some of the ways in which good love for images may turn to bad, or to love of the wrong ones; and it is this that is most often called idolatry.

The classic writer on the proper domains of the visual arts and poetry remains Gotthold Ephraim Lessing. It is in the *Laocoon* of 1766 that he exercised himself, with great erudition, wit, and no little profundity, on the problem of boundaries: on what limits poetry and the visual arts should set themselves, and on what each genre may fittingly and becomingly set out to do. The issue, as W. J. T. Mitchell has recently affirmed, is not ontological but prescriptive. Lessing's famous distinction between poetry as the art of time and painting and sculpture as that of space arose from a fear of transgressing the boundaries appropriate to each.

But this will not immediately seem relevant to the argument so far. Let us extract from Lessing a key passage that *is* relevant, and centrally so. It comes early on in his book, where he begins to set out the relations between the beauty appropriate to art and the inevitable necessity for making it subject to law. But the passage hardly seems to be about that; instead it deals with one aspect of the effect of images that seems, as I noted in the opening chapter, to be wholly out of keeping with modern rationality. It seems if not utterly improbable, at least primitive. Lessing begins by observing that "if beautiful men are the cause of beautiful statues, the latter on the other hand have reacted upon the former, and the state has to thank beautiful statues for beautiful men."[56] Once again we also note the moral position (a sense that good art requires good men); but as Lessing proceeds to a far more dramatic illustration of the power of images, he not only sets up the opposition with the modern, he makes a crucial gender shift:

> With us the tender imagination of the mother appears to express itself only in monsters. From this point of view I believe that in certain ancient legends, which are generally thrown aside as untrue, there is some truth to be found. The mother[s] of Aristomenes, Aristadaemos, Alexander the Great, Scipio, Augustus, Galerius, all dreamt during their pregnancy that their husband was a snake. The snake was the sign of godhead, and the beautiful statues of a Bacchus, Apollo, a Mercury, a Hercules, were seldom without snakes. These honourable wives had in the day-time fed their eyes on the god, and the bewildering dream awakened the form of the wild beast. This is how I read the dream, despite the explanation which was given by the pride of sires, and the shamelessness of flatterers: for certainly there must have been one reason why the adulterous fancy always took the form of a snake.[57]

"Indeed there must have been," comments Mitchell on a passage which animadverts to almost every one of the issues I have been emphasizing, "and Lessing has no need of Freud's analysis of fetishism and phallicism to see what it is."[58] What is at stake is precisely "the irrational unconscious power of images, their ability to provoke 'adulterous fancy,'" and it is this aspect of the visual arts that demands regulation and the attention of the law.

Mitchell is right in his perception here, except that we have no longer any need of the reference to the "irrational." The irrational has become irrelevant—except that it is just this that the lawgivers may wish to curb.

But let us not move so swiftly to the matter of control. The train of Lessing's thought is astonishingly rich in its implications and development. With great brilliance Mitchell notes how it unfolds, but even he does not quite grasp its significance for the act of looking. In his eagerness to deny the traditional distinctions between images and words in Western culture, Mitchell underplays just this aspect of Lessing's thought; but at the considerable gain of seeing the deep ideological and, specifically, the gender orientations of the old need for these distinctions.[59]

In the same place that Lessing enunciates his first principles (painting employs figures and colors in space; poetry articulates sounds in time), he also insists that bodies with their visible forms are the proper objects of painting (though obviously painting can show actions by means of bodies, and poetry can describe bodies existing in time). Then he goes on to outline the implications of these principles. At first they seem almost tautologous—except that they are now described from the point of view of the beholder. We know them well, at first: "The details, which the eye takes in at a glance, [the poet] enumerates slowly one by one [but] when we look at an object the various parts are always present to the eye. It can run over them again and again."[60] In this last sentence, so easily passed over, Lessing touches on exactly that aspect of the visual sign which makes it so fraught that it requires regulation and control. By looking in this way we are placed in the object's thrall; it is always there for us to engage with, in whatever way we like. Through looking we make it into a fetish. The ear, on the other hand, loses details; it can only reclaim them with the help of erratic memory. Words pass on; we cannot linger with them. In fact, it costs great pains and effort (*Mühe* and *Anstrengung* are Lessing's words) to recall them and to form the proper "picture."[61]

But what happens when the object is beautiful? It may make men more beautiful, as it did, apparently, in antiquity; but imagine how much more seductive it then is, and how much more likely to detain the gaze. Yet it has to be beautiful in order to produce beautiful men, like those of Greece; otherwise we find the monsters produced by "the susceptible imagination of mothers." The issues seem perplexing and contradictory. There is no question that they are simpler with poetry, which presents far lesser dangers—even when it infringes on the proper domain of painting. There is also no question of Lessing's ideological preferences. Poetry somehow appeals to the spiritual, painting to the beauty that is corporeal. Men made beautiful art in the past and were beautiful; now women have the susceptible imagination—and that produces monsters.

It is only when Lessing begins to write in characteristically enlightened

terms about the distinction between art and religion that matters become a little clearer. The more beauty, the greater the art, so the commonplace might run. Of all commonplaces, this has been among the greatest inconveniences to clear judgment about images and art. It has contaminated the whole range of modern thought that concerns itself with the question of whether an image is artistic or not. For all his profundity, Lessing has the same prejudice in great measure, and his view of beauty seems absolutely to require it. "Among the antiques that have been unburied," he insists, "we should discriminate and call only those works of art which are the handiwork of the artist purely as artist. . . . All the rest, all that show an evident religious tendency, are unworthy to be called works of art. In them art was not working for its own sake but was simply the tool of Religion, having symbolic representations forced upon it with more regard to their significance than their beauty."[62]

Once again Mitchell's gloss is illuminating. He comments: "Religion fetters painting by removing it from its proper vocation, the representation of beautiful bodies in space, and enslaves it to a foreign concern, the expression of 'significance' through 'symbolic representation,' concerns that are proper to temporal forms like discourse or narrative."[63] No wonder, then, that Lessing himself should have approved of the *fromme Zerstörer,* the pious iconoclasts, who destroyed ancient works of art that carried symbolic attributes (such as the horns of Bacchus), and for sparing only those that were "unpolluted by being an object of worship." The opposition is astonishing: "It was only the free artist who did not sculpture his Bacchus for any temple, who could leave out this symbol." The fact is, according to Lessing, that "superstition overloaded the gods with emblems."[64] Remove the emblems, he seems to be saying, and the imagination can dwell on beauty, not on the fancies that produce monsters. Beauty comes only from the artist who precisely does not make the idols of religion. Images that are associated with religion are idols, not art.

The oppositions do seem clear: art is opposed to religion, beauty to symbolic significance. Unfortunately they do not hold. If anything is evident from every effort to control images or subject them to laws it is that all images work as religious images, including beautiful and artistic ones. All visual representation must be held in check—as the ancients knew, and as Lessing would have been the first to acknowledge—because of its strong ability to involve the beholder and to transcend natural law. It is dead but it can come alive; it is mute but has a presence that can move and speak; and it has such a hold on the imagination that it informs dreams and produces fancies that are adulterous. To those who fear the relations between form and looking, this may all seem to be irrational; and it is an irrationality that a rational society must keep in check.

These are the fears that lie at the root of Lessing's genre distinctions.

They are also the fears that go hand in hand with love of art. But let us attend still more closely to the ideological burden that suppresses the effects of all figured form, and makes us silent about the troublesome facts of cognition. We have observed that it is improbable in the extreme to suppose that images would have none of the effects feared by Lessing (and by all those who love art) if they were beautiful or if they fell into that assuring category. Every image that detained us or were in the slightest alluring would have to be censored if one wanted to prevent honorable people—and not only women—from feasting their eyes on it and thus being drawn into it. Art is not supposed to have this dangerous effect; but the unfortunate paradox (unfortunate, at least, for this view) is that anything that has to do with form is likely to be subversive—anything, indeed, that has to do with space, in the broad terms conceived by Lessing. Form in space, presented to our visual faculties, is subversive in the way women are subversive, profoundly and fundamentally.

"The decorum of the arts," Mitchell notes, "at bottom has to do with proper sex roles. . . . Paintings, like women, are ideally silent, beautiful creatures designed for the gratification of the eye, in contrast to the sublime eloquence proper to the manly art of poetry. Paintings are confined to the narrow sphere of external display of their bodies and of the space which they ornament" (they are ornaments and should not be useful, we might add), and so on.[65] We need not follow all of Mitchell's arguments—he quotes Blake's wonderfully succinct "Time is a Man, Space is a Woman"[66]—to grasp their measure and import, since we have already seen precisely what happens once paintings do speak and break from their confines. We may enjoy these effects but they are also dangerous: they move us to love and adultery; they arouse the flesh; and they must therefore be censored.

We now begin to see the deeper relevance of the theme of "Love by Sight of Image." It becomes paradigmatic, as I have already suggested, in the very way Lessing himself appositely observed of the passage with which I began this section: "From this point of view I believe that in certain ancient legends, which are generally thrown aside as untrue, there is some truth to be found."[67] We can fall in love with a picture, or—as with the example provided by Valerius Maximus—we can be so arrested by some aspect of it that the mute forms it shows can seem like real and living bodies, all the more dangerous because we then have presented to our senses those parts of the body that drew our adulterous fancy to the picture in the first place. It is no accident at all that immediately following his comment on the living reality of the figures in the Roman picture, Valerius should have added that "this must have its effect on the mind too—and painting is rather more potent in this than literature."[68] Nor is it accidental that this apparently theoretical gloss has until now been the only area of interest in the passage to historians of art, as they continue to repress the power of images and the

problem of effect; nor similarly, that Poggio should set his censoriousness in exactly the same context: "Even though painters are allowed to do anything—just as poets are—still when they paint a naked woman, they should cover the obscene parts of her body . . . or keep it well out of sight."[69]

The danger of course is that looking enlivens and causes the adulterous fancy—and then we become real idolaters. This is exactly what Shakespeare's Sylvia knew when she responded to Proteus's desperate request, "Vouchsafe me yet your picture for my love, /The picture that is hanging in your chamber: / To that I'll speak, to that I'll sigh and weep." Her firm response is this: "I am very loth to be your idol, sir."[70] We may define the term exactly as Mitchell does: "An idol, technically speaking, is simply an image which has an unwarranted irrational power over somebody; it has become an object of worship, a repository of powers which someone has projected into it, but which in fact it does not possess."[71]

Irrationality is associated with religion and superstition; but it is not just religious objects, images used in religious contexts, that are idolatrous, that are fetishes, that lie beneath the surface of divine emblems like the snake.[72] We feast our eyes not only on images of God but on images of man (or, better, of woman). They are, paradoxically, not the images of the true God but of the false one. They are essentially and fundamentally deceptive and illusory, as the Islamic tradition so squarely maintained. It is for this reason that those who cannot tolerate the power of images may want to show them up as idols (certainly not as art), and to do away with them. They are just aesthetic objects, art; they are safe. If they have powers, they are not art. But it is precisely because of their art that they may be effective and the cause of adulterous fancies.[73] This is the helpless circularity of a category than can longer be serviceable.

We may not need the gender orientation so acutely proposed by Mitchell and derived from Lacan, nor the explanation in terms of gender ideology; but it does serve to bring us closer than ever before to an understanding of the persistent failure in Western culture to acknowledge the sexual implications of the relations between images and looking. It is not the looking, so much, that is the product of culture, but rather the repression. The very inclination to repress has left this aspect of the power of images unanalyzed (though it is repression that makes analysis possible at all). Most telling, however, is the fear that leads to the adulteration and destruction of images; and while we may usually channel our responses along safer and more fertile courses, we continue to shift that which troubles us into the neater and safer categories of art and beautiful or successful form. We may sophisticatedly acknowledge that art is supposed to disturb, not soothe us in our complacency, or fit our categorial preconceptions; and we may want to do away with the very distinctions and boundaries that have clouded Western

thought about imagery since the days of Simonides of Ceos; but until we admit the full extent of the ways in which we love images, the activities of the censor will pave the way to iconoclasm. That they will indeed continue to do so need not interrupt the course of analysis.

14

Idolatry and Iconoclasm

Consider two paintings of *The Dance Round the Golden Calf:* the first done around 1530 by Lucas van Leyden, the second just a century later, around 1634, by Nicolas Poussin (figs. 177 and 178). The subject, as each picture makes plain, is the ultimate idolatry: a false image, made in the teeth of the prohibition against graven images, is surrounded by visible evidence of the debauched sensuality into which men and women fell as a result of their adoration of the artistic, manmade, golden substitute for the God they could never see. In each case debauchery and unbridled sensuality is chiefly represented by dancing, though in the Lucas it is further underscored by drunkenness and the lustful activity of the men and women on the wings of the triptych. Poussin brings both Golden Calf and dancing to the foreground. In this and in every respect they are depicted with considerably greater prominence than usual. Prior to this it was common to show the false idol as much less significant in scale, as in the Lucas and as in Poussin's own more immediate precedents, like the scene on the vault of the Vatican *loggie.*

Of Poussin's dancing figures it has justly been remarked that in them he "attempted something that is very rare in his work, the depiction of figures in violent movement."[1] In the atmosphere of gratitude, joy, and abandon that Poussin has so carefully depicted, the figures might be said—at least in terms of what we know about the limits of his art—to let themselves go. This is how he set out to convey the freedom from the restrictive repression of the senses demanded by the strict God of the Israelites. In her abandonment to the dance, the sleeve of the woman in the foreground on the left has slipped down her arm, to reveal the alluring expanse of her shoulder; while the drape of the woman on the right of the group, who seems to exhort the adoring people to join the dance, has similarly fallen away to reveal much of her breast.[2]

In the painting by Lucas van Leyden, the dance in the background is still wilder. It seems to follow no measure at all. The reign of the senses is further conveyed by the eating and drinking and lounging in the foreground, with much lovemaking on the side panels. In 1604, van Mander said this about it: "Amidst the festivities and banqueting one sees the dissolute nature of the people depicted very realistically, and the unchaste lust shining forth from their eyes."[3] Once again the notion of realism and the provocation of the senses are yoked together. But that, of course, is not the point of the myth as represented in these pictures: it is that the erection and invocation of a material image invariably engages the senses. When the true unseen God is abandoned, people fall into dissoluteness. The image that unleashes such responses must be cast down, and so will the evidence of God's word that has in any case—by these very events—already been symbolically smashed.

In Exodus 20, God insisted "Thou shalt have no other gods before me. Thou shalt not make unto thee any graven image, or any likeness of anything that is in heaven above, or that is in the earth beneath, or that is in the water under the earth."[4] The prohibition was made; but Moses delayed to come down from Mount Sinai with the completed law; and so

> the people gathered themselves together unto Aaron, and said unto him, Up, make us gods, which shall go before us; for as for this Moses . . . we wot not what is become of him. And Aaron said unto them, Break off the golden earrings, which are in the ears of your wives, of your sons, and of your daughters, and bring them unto me. And all the people brake off the golden earrings which were in their ears. . . . And he received them at their hand, and fashioned it with a graving tool, after he had made it a molten calf: and they said, These be thy gods, O Israel. . . . And when Aaron saw it, he built an altar before it. . . . And they rose up early on the morrow, and offered burnt offerings and brought peace offerings; and the people sat down to eat and to drink, and rose up to play. (Exodus 32.1–6).

Apart from the emphasis on bad behavior, one could hardly wish for a more explicit statement of the crass and cold materialism that brings forth the idol that (once fashioned) is worshipped.

Moses then descends from the mountain, having been warned by God that the people have corrupted themselves; he descends in a rage and smashes the tables of the law when he sees the people dancing. Thus he breaks the verbal icons of the divine word; but he also "took the calf which they had made, and burnt it in the fire, and ground it into powder, and strawed it upon the water, and made the children of Israel drink of it" (Exodus 32.20).

As if aware of the extraordinary gravity of these events, the chronicle is

remarkably full and repetitive. When Aaron himself tells Moses what happened, the story is supplemented with close details of how the people asked for another god, and how he had made the calf of the gold from their earrings. And then, as if to emphasize the connection between idolatry, iconoclasm, and sensuality, the people's sin is made explicit: "Moses saw that the people were naked; for Aaron had made them naked unto their shame among their enemies" (Exodus 32.25). The core of shame that attaches to all arousal could not be more emphatically put.[5]

Few retellings of this great myth include the terrible punishment that Moses then visits upon the Israelites in the wilderness. This is how he

177. Lucas van Leyden,
Dance Round the Golden Calf
(ca. 1530). Amsterdam,
Rijksmuseum.

instructs the children of Levi: "Put every man his sword by his side, and go in and out from gate to gate throughout the camp, and slay every man his brother, every man his companion and every man his neighbour . . . and there fell that day about three thousand men" (Exodus 32.27–28). Except for the black cloud from which Moses descends in the background of both, neither picture gives any inkling of this horror; but in their portrayal of the relations between abandoned sensuality and idolatry they could not be more eloquent.

The central figure in Poussin's painting is Aaron. He is placed opposite the calf and alone among the participants is dressed in white. Even though

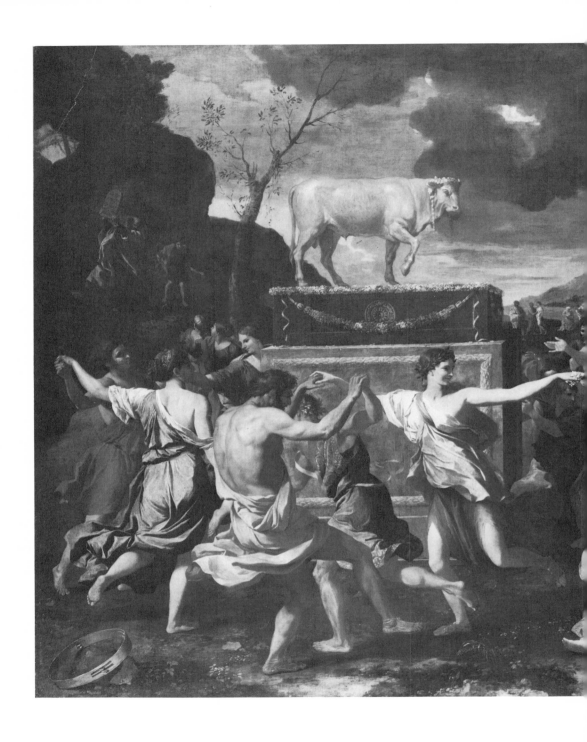

178. Nicolas Poussin,
Dance Round the Golden Calf
(ca. 1635). London,
National Gallery.

the whiteness is appropriate to his priestly status, it also serves as a commentary on the gaudy allurements of the colors in which the idolatrous Israelites are dressed. But there is an even more powerful statement by Poussin about the implications of the scene, one that we should not pass over. Aaron's is one of those extraordinarily pregnant gestures by an artist who above all others worried about gesture. With one hand Aaron gestures toward the calf; with the other he seems to point to his eyes. Nothing in a picture could more definitively make plain that sense by which we are undone. Through sight we fall into idolatry—and what follows is the unleashing of the other senses. The calf is made of gold, and it rests on a pedestal that is crowned and garlanded by myriads of tiny flowers. We may feast our eyes on them and delight our senses, even imagined ones like smell and touch.

There is, of course, a deep irony in all this. We admire—adore would not be entirely incorrect—a picture which has as its subject the epitome of the negative consequences of looking, admiring, and adoring. The commentary and the irony is even deeper in the case of Lucas van Leyden's triptych. For a start, the painting has the form of an altarpiece. It looks like a traditional devotional image, but it has a plainly narrative subject, at a time when narrative and secular subjects were comparatively rare in painting in Northern Europe. In every sense it seems a nonreligious picture, almost pagan, in the guise of a Christian and religious one. There can be little question that Lucas was also attempting to show off his skills as a landscape painter, as a painter of people in action, as a glorious painter of stuffs, and so on. For us, as for the sixteenth century (as one can assume from van Mander's passage alone), the painting's virtues are purely visual—certainly not devotional. But what subject did Lucas choose to show? The very subject which proved how wrong it was to feast one's eyes on rich material idols.

Lucas's painting was done at a time when the various arguments about images were reaching a new pitch and when the old issues about the rightness of having material images in the service of the Church were raised all over again. Lucas cannot but have been *au courant* with these arguments, at least in their broad and clear directions. But is his picture a statement that it was wrong to have devotional images at all, that material objects like paintings could not be adequate mediators between man and God, and that if one did have them, one was simply being idolatrous; or is it more a statement that pictures could and should have narrative histories from the Old Testament, as both Luther and Zwingli allowed?[6] These are complex questions and they cannot be resolved in the present state of knowledge about this particular picture and its circumstances. Certainly the subject of the Golden Calf featured endlessly in the literature against religious images. It was constantly used to bolster arguments against images altogether,

but it was also used as an example of their bad use. After all, it was idolatrous, sinful, and ultimately destructive.[7] And in the 1520s there can hardly have been a soul in Christendom who remained unaware of the view—if he or she did not feel it anyway—that wealth was better spent on the living images of God, the poor, and that substantial expense on material imagery got one nowhere, except further into fleshly corruption.

<center>I</center>

Whatever their position within this complex dialectic, these two paintings bracket one of the greatest episodes of iconoclasm in Western history: the determined and violent wave of image-breaking that swept almost every town and village in the Netherlands during the extraordinarily intense last quarter of 1566. The movement was prepared by a variety of social, economic, and religious motives; but in the historiography of the subject, it has often been forgotten that the immediate target of the violent events of August, September, and October of that year were images.[8] It was exactly at this time that long-standing arguments about the use and validity of images, both in churches and outside them, came to a sudden and threatening head. The images which were cast down were regarded as no less than idols—or, at the very least, so tainted with one or another species of idolatry or idolatrous behavior that they had to be melted down or smashed. If not actually killed, the priests of the cult of images were martyred and expelled. Those responsible for these acts were the true bearers of the word of God, justified by the acts of Moses.

The Netherlandish movement did not, needless to say, arise ex nihilo. It was well prepared for, and its antecedents are not hard to detect. For a very long time images had been regarded as an aspect of the corruption of the Church. The earliest Church Fathers had written about image problems; and the reformers were able to tap them to a greater or lesser extent, sometimes honestly and sometimes speciously. By 1530 the main lines of the controversy about images that was to torment the whole of Europe for the rest of the century were firmly drawn. Its consequences had their epicenter, it is true, in the Netherlands; but the rumblings and tremors would be felt in areas that covered a vast radius, from the northernmost reaches of Scandinavia to the straits of Gibraltar and Messina, from the British isles in the West to Magyar Hungary and onward into the Balkans in the East.

There were plenty of factors other than the many theoretical and dogmatic ones. No one, for example, could pretend that Henry VIII's dissolution of the monasteries and his stripping of their wealth between 1536 and 1540 were rooted in theological unease—or even dismay—about the use of images. The great Reformation centers like Nuremberg and Zurich

would have provided good precedents for the systematic removal of images. In places like these, one has also to reckon with more spontaneous behavior and with the triggering of individual anger and resentments. The whole question of the relations between organized behavior and individual, spontaneous action is one which all historians of iconoclasm must deal with; and so must those who bring its psychological and cognitive issues to the fore. In considering the sixteenth-century events, however, it should be noted that there were sporadic outbursts, sometimes quite violent, all over the continent. Indeed, in the years just before the Netherlandish upheaval, there were so many troubling instances of iconoclasm in France that the Church authorities there had sought to refine the official standing of images, in an attempt to defuse at least some of the anxiety about them.[9] The bases for anxiety are what must occupy us in this chapter, rather than the immediate political and social factors that naturally played a role in the stripping of the churches and the casting out of idols.[10]

To tell of the desperation into which many people fell in the winter of 1565–66, and of how they hearkened to the field preachers who could easily point to the wealth of the Church as embodied by images (as well as insisting on their own spiritual places, for the word of God alone, in which Protestants could worship), would be to tell an oft-repeated tale.[11] To tell of how the organized bands, as well as individuals, assailed images would make no less exciting and disturbing a history; so would the many stories of the hysterical and bad-tempered destruction of images—as well as the cool, deliberate, and sober (if not downright cold and vengeful) acts of iconoclasm.[12] One could do the same for the ever-increasing number of individual assaults on painting and sculptures in recent years.[13] If nothing else, such an examination would illustrate a surprisingly unstudied aspect of everyday psychopathology and everyday violence—or perhaps of the sublimation and enhancement of emotions that otherwise might be or would be suppressed. But illustration alone would be insufficient. It used to be thought that the theoretical background to iconoclasm, at least in sixteenth-century Europe (and possibly in Byzantium), was irrelevant to what actually happened; but this can no longer be held to be the case.

II

The Netherlandish episode was one in which the arguments for and against images were brought to the fore with greater density, repetitiveness, and sophistication than ever before. The number and complexity of the arguments are stupefying, in their pedantry, profundity, scope and—above all—in their quantity. Everyone then had some idea of the major arguments, and although we have forgotten their origins, they have profoundly

entered the mainstream of all Western thinking about images. But they embody ideas which were present in antiquity, evolved in the hands of significant movements like Neo-Platonism in later antiquity, merged with Judaeo-Christian currents, and came to the fore again in the astonishing episodes of Byzantine iconoclasm between 726 and 787 and 815 and 843— by which time Islamic thinking about images could also join the ever-broadening stream.[14] The anxiety about images continued throughout the Middle Ages, stimulated and enhanced by thinkers and authorities who ranged from Saint Bernard to Saint Thomas Aquinas. Saint Thomas may have justified images as a means for the instruction and edification of the uneducated faithful and as an aid to memory; but he also was only too aware of the dangers of the emotional involvement that springs from sight. Bernard was much more critical. Images were too splendid and too irrelevant: why beasts in churches; why demons on floors, devils on capitals, animals everywhere? The money spent on adornment was better spent on the poor.[15]

After a few centuries of comparative quietness—despite the development and proliferation of forms like panel-painting and increasingly lifelike sculpture—European iconoclasm flared up again, fiercely, in the sixteenth century. Combined with the early Christian and Byzantine strains, the medieval ideas came to a head in the Reformation polemic. In the seventeenth century, England succumbed again, thanks to parliamentary and Puritan reaction to the Catholic inclinations and aesthetic excesses of a negligent king (Charles notoriously devoted excessive time and money to his magnificent collections of high art). For all the specific context it is both striking and wholly unsurprising to notice the recurrence of some of the oldest arguments in a country by now well insulated from Catholic thought. Perhaps not so much old argument as action based on old concept. Or on satire? In a remarkable inversion of the deeds performed by Gregory the Great as destroyer of pagan idols, the West Cheap Cross in London (which had already been assaulted by iconoclasts in 1581) was replaced with something utterly pagan: a pyramid instead of the finial cross, and a half-naked statue of Diana instead of the Virgin. A recent commentator has suggested that this was done in order to make the monument "safe" in Puritan eyes; more likely an acerbic parallel was intended to be drawn between heathen goddess and Blessed Virgin.[16]

During the French Revolution the Virgins were thrown out too. They had to be, since they shored up the symbols of royalty. The new symbols came from a variety of sources; but Diana was present again, with her companions from classical antiquity. Indeed, in the Feasts of Reason that replaced the old feast days of the Church, image destruction led to an inventive new iconography, in which, among its other aspects, the themes from classical "pagan" history were reclaimed from the realm of the adiaphoristic secular into which they had been relegated by the Reformation

critics. The advent of Neo-Classicism—for style was theme and theme style—was not adventitious. With the Russian Revolution the statues of the czars went, and were in due course replaced by those of the heroes of the revolution. Neo-Classicism came to symbolize the old order, especially in its architectural monuments; and so it gave way to more modern styles, and finally to ones self-consciously of the future—until a more repressive order prevailed again. Indeed, in the fascist regimes of the twentieth century, such styles are visual proof of the authoritarianism that appeals to purity. But this is another story.

With Nazi Germany we come full circle to a central paradox. The lovers of art are the destroyers of art. The collecting impulses of the Nazi leaders were directed toward objects which had acquired the status of the highest art and toward the life-enhancing returns of fetishism. The art they encouraged was an art of crass representationality, of a vulgarly evident realism that stipulated careful reflection of the portrayed object or being, healthy bodies in a dull technique, bodies that must rouse and produce the ideal Aryan creature: do we speak of the perfection of the best Greek statues or of Lessing's monsters? That which cannot engender the perfect being is corrupt. In Weimar Germany and in the early years of the Nazi regime, there were still many forms which disrupted the easy transition from life to art. These were the forms that could be seen in the great displays of *Entartete Kunst* of the 1930s, especially 1937.[17] Once one had got rid of degenerate art, then one could seek out the degenerate artists too. The old notion that pure art can only be produced by pure artists is once again in the vested interests of authority, and of regimes that would keep their government pure and their people undistracted by the wrong things. The work of degenerate artists, even if their art conforms, must go. As for the Jews, who should not be making art anyway, their fat and golden calves must be the first of all idols to be melted down and strewn upon the waters.

Even in these briefest of summaries we see some of the deep paradoxes of iconoclasm. We love art and hate it; we cherish it and are afraid; we know of its powers. They are powers that, when we do not destroy, we call redemptive. If they are too troubling they are the powers of *images,* not of art (except in the newspeak of criticism, to which we will return). It is true that no general account of iconoclasm in the West could cover every one of its episodes, particularly when one considers how frequent are the isolated, apparently individualized acts—especially now, when art and images are more widespread and accessible than ever before. But although most educated people in the West have heard of each of the events and periods I have swiftly surveyed, art historians have shied away from the evidence they provide of the relations between images and people; and in so doing they reveal yet another aspect of the way in which we repress what is most troubling about images.

For all its brevity, my survey will have conveyed some sense at least of the varieties of iconoclasm. I have omitted the Egyptian episodes, the Greek, Chinese, Islamic, and many others. In ancient Egypt we know, for example, of Old Kingdom cases where the names and images of private individuals and rulers were destroyed to prevent them from living after their death; of Thutmosis III's destruction of the statues and cartouches of Queen Hatshepsut and her followers; of Akhenaten's destruction of all images of Amun, to replace them with those of Aten; of Tutankhamun's own iconoclastic reinstatement of Amun, and so on. From Greece there are even more instances, though often more localized, ranging from the destruction of the statues of Hipparchos Charmidou at the time of Peisistratos's ostracization, through the mutilation of the herms on the eve of the Peloponnesian War, to the many attempts to control luxury and excess, from Solon's rules of the early sixth century B.C. about the adornment of tombs onward.[18] In Rome the *damnatio memoriae* more often than not involved the destruction or mutilation of objects, and in China the periodic attempts to suppress Buddhism from the fifth through the ninth centuries were generally accompanied by the removal or destruction of Buddhist statues and temples, culminating in the Hui-Chang suppression of 845.[19] Muhammad himself removed the idols of the pre-Islamic Arabs from the Ka'abah in Mecca (having first attempted to strike out their eyes with his bow). Indeed, the whole question of *aṣnam* continued to trouble Islam for several centuries.

But to attempt a global history of iconoclasm would be to write a different book. What is significant here is that with the exception of idiosyncratic moments and attitudes—say, for example, the extensive eradication of the names (equated with the soul) in Egypt, or the Jewish reluctance to tolerate sculpted (including embossed) images but willingness to accept flat or engraved ones—the issues that are raised everywhere also occur in the West. These may all be very different phenomena, with different motivations; but it would be wrong to overlook the cognitive issues embedded in almost all the polemics and in all the approaches to iconoclasm. To claim this is not to deny that we see all cultures through Western eyes; it is rather to suggest the heuristic use of the Western examples, or at least to announce the intention of using them heuristically. Then, once the loci of cognitive interest in the polemics have been determined, one may turn again to individual psychopathologies.

III

It may be objected that I have not taken sufficient account of one important distinction that arises with regard to iconoclast motivation. On some oc-

casions, iconoclasm may seem chiefly to spring from a general concern about the nature and status of images, about their ontology, and about their function (or, indeed, the possibility of function). On other occasions, one might claim, there seems to be less concern about ontology (except, of course, among the artists), as in the French and Russian revolutions. In other words, the motivation seems much more clearly political. The aim is to pull down whatever symbolizes—stands for—the old and usually repressive order, the order which one wishes to replace with a new and better one. One removes the visible vestiges of the bad past. To pull down the images of a rejected order or an authoritarian and hated one is to wipe the slate clean and inaugurate the promise of utopia.

Even within single iconoclastic episodes this distinction is to be made. For example, following the general iconoclasm of August 1566 in Antwerp, in which motivation had at least partly to do with religious issues broadly taken and with image doctrine in particular, the statue of the much-hated duke of Alva was pulled down with great fervor and celebration. The great funerary monuments of the English aristocracy suffered during the Commonwealth and immediately before it (though less, perhaps, than one might expect); the statues of Napoleon III were pulled down by the Commune; and the destruction of monuments during the Russian Revolution and after the fall of Stalin had very clear political purposes. This form of iconoclasm is one of the oldest as well as the newest: it is found in Egypt and Byzantium and in the Anabaptist Utopia of Münster in 1534–35, but also in all those countries which wish to shuffle off the imperialist yoke or cast it off more vigorously: as in the Philippines in 1986, Iran in the years from the fall of the Shah until the present, and any number of other countries which perceive themselves to be the victims, in one way or another, of American imperialism (fig. 179, see also fig. 184 below).

But when we consider the forms destruction takes, and the violence with which individual images are assaulted; or when we consider, say, the burning of crude and satirical effigies, the deeper psychological issues surface again and the broadly political act becomes allied with the idiosyncratic, neurotic one. Of course one could always argue—as the purely empirical historians are inclined to do when they consider the circumstances of each event—that iconoclasm is never any more than the removal of the symbols of a hated order. Any more than? Even if one were to take this view in a rigorously positivist way, insisting that this whole class of iconoclasm proceeded from *Staatsträson* and that its dimensions were purely political, it would be hard to deny the possibility of reclaiming the cognitive aspects of the responses that constitute it. To look at illustrations of individual assaults on images (see figs. 180–83, 185–88 below), or to hear the testimony of participants in iconoclastic movements, or the testimony of perpetrators of isolated acts, is sufficient to suggest that possibility.

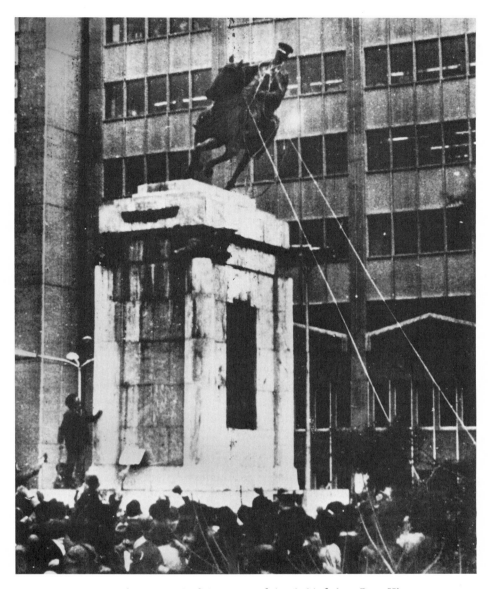

179. *Right:* Removal of the statue of the shah's father, Reza Khan, in Teheran in 1979. Photo UPI-Bettmann Newsphoto.

Or again, is it simply that, once removed, the signs of the hated or replaced order are no longer there to remind the beholder—the ordinary all-too-susceptible citizen—of their erstwhile authority, to exhort him or her to rebellion? This would fit nicely with the old Thomist and Bonaventuran view of the function of religious imagery—to instruct, edify and encourage, and to aid memory. But there seems to be more to this kind of removal. Could it be that by assailing the dead images, getting rid of them, one was assailing the very men and women they represented? And if so, were they there in their images, or did the hostile act somehow carry over to the signified by a kind of magical transference or contagion? These are much deeper issues, and we cannot hope to resolve them. But in the old controversies, especially in Byzantium, we find help once again. The earliest Christian writers in Latin, as well as the Greek Byzantine writers, touch on almost every issue that is ever raised again; and each problem is dealt with so sustainedly and so variously, with such a determined exploitation of the linguistic and semantic possibilities of every single formulation, that the psychology to be extracted is never raw.

Take the problem of the meaning of the removal of symbols of the king or emperor or dictator. When the image of the emperor went round in the Byzantine cities and provinces, he was there too: he was present in his image.[20] One could imagine no more effective act for diminishing his living power than by destroying his image. When Athanasius of Alexandria (328–73) sought to illustrate the nature of the union of Father and Son in the Trinity and ended by noting that "he who has seen the Son has seen the Father," he had a clear and concrete parallel to hand, and he provided what was to become a key formulation:

> In the image [of the emperor] there is the idea (*eidos*) and form (*morphē*) of the emperor. . . . The emperor's likeness is unchanged in the image,[21] so that who sees the image sees the emperor in it, and again who sees the emperor, recognizes him to be the one in the image. . . . The image might well say: "I and the emperor are one." "I am in him and he is in me."[22] . . . Who therefore adores the image adores in it also the emperor. For the image is the form of the latter and his idea.[23]

"Kindred examples could be multiplied. The underlying idea is always the same: that in so far as an image is similar to the original, it is *equal, identical* with it."[24] This is Ladner's just comment, as he adds his own emphasis to the equation between similarity and identity. The implications for iconoclasm are clear: if the similar image is perceived as identical, and if hostility to what it represents is sufficient, then the motion to mutilate, destroy, ruin, or cripple is likely to come to the fore. The equation occurs with great frequency in the context of references to images of the emperor—whatever its motivation, and however politically expedient.

Embedded in all this, and in the recurrent simile of images of the emperor, is a profound consciousness of two of the most crucial problems in the analysis of response: that of the extent to which response is predicated on identity and likeness, and of the comparative roles of sign and signified in engendering it.

Of course, it may be objected that Athanasius's statement is chiefly about a theological problem, and that it is intended as an illustration of a hotly disputed christological point. We should therefore not be misled into exaggerating its evidential status (although the very incidentality of the illustration gives it added weight). After all, one can hardly help noting that its very terms are determined by the point it seeks to prove, since the words attributed to the image are an obvious parallel to the gospel of John: "I and my Father are one" and "I am in the Father and the Father in me" (John 10.30, 14.10). In other words this passage, like so many others, was not intended as a doctrinal—let alone an ontological—statement about images. It was evidently an attempt to clarify the nature of the Godhead in the Trinity. But when we consider how frequently the great defenders of images like John of Damascus (675–749) reasserted the Pauline doctrine that Christ was the image (*eikōn*) of God, we begin to understand something of the extraordinary resonance of the Byzantine theological arguments: not only their historical resonance, but also in terms of the nature of figured imagery.[25]

For example, the Pauline views helped to make clear the crucial distinction between the honor due to God in the form of worship and the honor due to images in the form of veneration, in other words between *latreia* (or *proskynēsis latreutikē*) and *proskynesis* (or *proskynēsis timetikē*). The distinction was crucial because it was used against the repeated iconoclastic objection that in worshiping images we worshiped not God, Christ and his saints, but mere blocks of wood and stone. The standard rebuttal of this objection was in terms of Saint Basil's famous assertion that the honor paid to an image passes to its prototype: *Hē tēs eikonos timē epi to prōtotypon diabainei.*[26] No single passage was more important for the course of Byzantine iconoclasm and no single passage was used more frequently by the defenders of images in every iconoclastic period up till the seventeenth century. But it too was originally used in another context, one that we might by now have expected: the context of illustrating the unifying image relation of the Son to the Father in the divine Trinity.[27] John of Damascus could take this whole nexus of argumentation further and use it, crudely but directly, against the iconoclastic position: since the Son was venerated as the image of the Father, those who did not venerate images also failed to venerate the Son of God.[28] But it hardly seems surprising that the iconoclasts should have insisted that the only true icon of Christ was the Eucharist.[29]

We could not now begin to unravel the complex technical arguments

about the distinction between images by nature (*physikōs*/*kata phusin*)—which were also images by generation (*gennetōs*) and in their ontological essence (*kat'ousian*)—and images as imitation, *mimēma*, by art.[30] But at least some of their implications for the study of material imagery must be considered, and they loom very large in the general stances of two of the greatest defenders of images in the Byzantine iconoclastic controversy, John of Damascus and Theodore the Studite.[31]

First we hear John of Damascus, in his first oration on images, written just after the outbreak of iconoclasm in 726:

> As painters transfer the human forms to their pictures by means of certain colours, applying to their work of imitation (*mimēma*) the proper and corresponding tints, so that the archetypal beauty may be transferred exactly to the likeness (*homoiōsis*), thus it would seem to me that our Maker also with certain tints as it were, by putting on virtues, paints the image, with various colours according to his own beauty.[32]

Images, then, are not only justified in terms of Christ as *eikōn* of God; here their justification is in terms of the oldest book of the Bible, the opening chapter of Genesis where God makes man in his own image. The brilliant metaphors and similes of early Christian and Byzantine christological discourse continue to be exactly those ontological predicates upon which the responses that terminate in iconoclasm—both the social and the individual act—depend. Just as in the case of the description of images of the emperor, where the ontology of images became the metaphor for the nature of God, so here the formation of images is the metaphor for those aspects of man's nature that are divine—couched in terms of the making of an artistic image.

But passages like John's have a resonance that exceed and transcend the retelling. Its implications for the actual status of images become clearer if we consider Theodore the Studite necessary clarification of the relationship between Christ and images of him. The clarification is utterly necessary because of the convergence of the arguments that Christ was the *eikōn* of God and so was man. Of course such convergence was christologically essential. Christ was Christ precisely because of his Incarnation, because he was God made Flesh. But the complexities of the relation between representation as reflection and representation as embodiment and presence emerges most powerfully in just these interminable debates about Christ and man as the *eikōn* of God. Some resolution, at least in terms of the relation between image and prototype, is to be found in the work of Theodore the Studite. We have, after all, found ourselves in the position where Christ and man are said to be the likenesses of God, but in a way that is more direct and essential than mere likeness would seem to imply. Image has become vastly more than likeness.

Theodore develops the notion of identity—*tautotēs*—at some length. The identity of image and prototype has nothing to do with the image in its being (*kat'ousian*) or nature (*kata phusin*). For him images of Christ are identical with Christ in his hypostasis: it is an identity of the hypostasis, a *tautotēs tēs hypostasis*. Christ can be portrayed only according to it, *kat'hypostasin*.[33] This seems the desired clarification; but it is problematic because it places at risk the orthodox Chalcedonian view of the Incarnation, where Christ is rather more essentially the image of God, homoioetically. And so Theodore declares that images are related to the hypostasized prototype in terms of the individual features—the *idiōmata*, the *notae individuantes*—of the latter.[34] We now begin to see the tremendous importance of the need for verisimilitude and authenticity. How can we be certain that the image appears according to the individual characteristics of the prototype? Only if it is accurate and authentic. And how to guarantee that? We can only be sure if the images are not made by human hand, if they have fallen directly from heaven, if they were painted by Saint Luke, or if they received the direct imprint of Christ's body or face. (Conversely, images that are proven imprints or good descendants of images taken in Christ's own lifetime provide paradigmatic justification). And so all the many legends that pertain to *acheiropoietai* become an utterly integral part of the iconodule defence; and since that defence provides the most profound ontological statements about the nature and effects of figured imagery, the legends are integral to our own argument.

IV

It is entirely characteristic that the bulk of the main evidence for the Byzantine iconoclastic arguments should have come from the defenders of images. Image defence and image cherishing, as we have so frequently seen, contains within it every element that seeks to destroy. This, of course, is both a theoretical issue and a telling psychological dialectic; but its interest lies equally and considerably in terms of praxis. The fact is that it was precisely with legends about miraculous images that the defenders of images, every minor iconodule—or even doubting—bishop and monk, came armed to the great Council of Nicaea (787) that was called to put an end to the first wave of Byzantine iconoclasm. Not for them the grand theoretical debates! From their own dioceses and monasteries they brought tales of *acheiropoietai* or miracles wrought by favored icons, icons which had been in touch with some favored saint or bestowed directly by him. Everyone had a tale of a private or public cult image that worked, successfully and preternaturally. These miracles are what justified the cult of images. This

is what ordinary people understood and wanted. The intellectuals might strive to work out a complex resolution of the wide-ranging theoretical arguments; but the true and most evident justification for images lay within their own practical experience. The final Nicaean canon in favor of images may have avoided the basic theoretical questions for complicated political reasons, but it may also have done so because of the very indefinability of the powers attributed to images and recorded by the great mass of delegates.[35] These were the powers that justified the cult; and these, of course, were what the simpler folk knew and could understand. These were the powers that reinforced their faith. No wonder that the decree did not—could not—formulate an official stance vis-á-vis the authentic and miracle-working images.[36] The theologians, the real intellectuals, were too embarrassed by the power of images to acknowledge it.

But again this is a two-edged sword. In a masterful summary of the cult of images before iconoclasm, Ernst Kitzinger pointed to the proliferation of miracle-working images, of magical amulets, of palladia, *brandea, eulogia,* apotropaia, ampullae, and talismans in general, all of which were felt to work in "magical" ways, in ways that transcended the usual explanatory categories (except in terms of their investment with the divine). It was precisely these properties, especially of figured form, which the opponents of images objected to, and which they regarded as idolatrous.

The time has come to consider the arguments that were brought to bear against the images before iconoclasm, from the early days of Christianity on. Naturally the old Platonic fears that images, especially when artistic, appealed to the all-too labile senses subsisted; but by and large, as H. G. Beck has shown, the issues were less theoretical, in the first six centuries, than direct and substantially pragmatic—at least on the surface.

In the first place there was the Old Testament prohibition against graven images: "Thou shall not make unto thee any graven image, or any likeness of anything that is in heaven above, or that is in the earth beneath, or that is in the water under the earth." However much the later iconoclasts may have insisted on the general breadth of its scope, that prohibition was made in the context of a jealous God's exclusion of false gods: "Thou shalt have no other gods before me. . . . Thou shalt not bow down thyself to them, nor serve them" (Exodus 20.3–5).[37] The deepest fear was of the lapse into idolatry. The writings of the earliest Church fathers are shot through with it. The best images of God, as Origen put it, were in the heart, formed (of course) by the Word of God.[38] A similar view is found in Epiphanius of Salamis's possibly spurious *Treatise against those who make images of Christ, the Virgin and Saints "after the fashion of idols",* quoted in the iconoclastic council of 815.[39] For Tertullian (ca. 160–225), whose writings provide some of the most extensive assaults against idolatry, both real and metaphorical, idolatry was the *principale crimen generis humani, summus seculi reatus, tota causa*

iudicii. That, in fact, is the wonderfully apodictic opening to his treatise entitled *De idololatria. Latreia* of idols was the antithesis of *latreia* of God, just as both great and small reformed writers of the sixteenth century opposed *Götzendienst* to *Götterdienst.* The convenience was that everyone could understand the metaphorical sense of idols; and so it was easy to make the attack on literal ones sound convincing.

But there were other pre-Byzantine concerns and allegations, as Beck has noted. When Eusebius wrote to Constantia (in a possibly apocryphal letter) against her private use of images, he formulated another critique: The colors of artists—man-created, therefore—could in no way match the brilliant glory of Christ.[40] (And here we will recall John of Damascus's later use of the metaphor of the artist's coloring of images to describe the creation of man.)[41] Furthermore, art was not becoming to Christians, because it was the domain of pagan antiquity. It was its very hallmark. Non-Christians and heathen, Romans and Greeks, all those given to sensual pleasure trafficked in it. Finally there was the whole gamut of mistrust of everything that was art or artistic. The creative impulse appropriated that which was within God's power alone; or rather, it presumptuously sought to emulate it. The beauty of manmade objects could only seduce and corrupt the senses, and usurp the role of the spiritual and intellectual. It is hard not to recall Poussin's picture in this context. Even as we wonder at its rigor and ponder its self-conscious classicism and its reminiscences of antiquity, we realize that no image could better formulate the seductive and corrupting but wholly inevitable idolatry that is counterposed to the God hidden from view. This is the God that should be present in the heart but is obscured, like the cloud on the mountain, while the people dance.

The people: but specifically the women. Eusebius formulated his attack on the use of images, the kind of use that exceeded the bounds of propriety, in his letter to the Christian emperor's wife. And when Tertullian, that greatest of all assailants of idolatry, broached the matter of colors in relation to the idolatrous use of material imagery, he did so in the context of the adornment of women. In the eighth chapter of *De cultu feminarum,* he railed against the means (make-up, dress, etc.) whereby women make themselves seductive. Again the issue of legitimacy arises, and he uses as an example of the illegitimate use of colors the case of pictures on walls.

> God is not pleased by what he himself did not produce. We cannot suppose that God was unable to produce sheep with purple or sky-blue fleeces. If he was able, then he chose not to do it, and what God refused to do certainly cannot be lawful for people to make. . . . Hence they must be understood to be from the Devil, who is the corrupter of nature. . . . Those things which are not of God must be of his rival.[42]

The move to corruption is inevitable, and so is the next step—to idolatry:

Now even if the material out of which something is made is from God, it does not therefore follow that every way of enjoying these things is also of God. . . . For it is clear that all those profane pleasures of worldly spectacles, and even idolatry itself, derive their material from the creatures of God. But that is no reason why a Christian should devote himself to the madness of the circus, the cruelties of the arena, or the foulness of the theater, just because God created horses, panthers, and the human voice; any more than he can commit idolatry with impunity. . . . Thus, then, with regard to the use of the material substances too; that use is falsely justified on the basis of their origin from God, since it is alien to God, and is tainted with worldly glory.[43]

The fact is that material images, colored withal, are temerarious creations, and therefore idolatrous. In this sense, whatever they are made of, they are not of God, but of the devil. Their glory is worldly, and they seduce. They attract, directly, like the cruel spectacles of the arena and the common and cheap appeals of the theater. Their attractiveness, in short, is like that of women—with respect to whom Tertullian naturally proceeds to advise moderation and caution. But who are the people who are seduced by the obviousness of colors and materiality? Not, of course, those for whom God is the Word, nor the intellectuals who live in—or aspire to—so spiritual a realm that they do not need the crutch of the senses or of material sensuality in general. Rather, it is women themselves, and the large body of ignorant people—the illiterate above all. They are the ones to whom the seductive charms and pleasures of material images are most likely, and are supposed most directly, to appeal.

This whole context is clearly negative, but from bad seductiveness to good effectiveness is no great distance. If simple people were so easily attracted by images, might images not have a good purpose too, a purpose that was more direct and effective than those of words alone? It is in just these terms that we should see Gregory the Great's famous response of October 600 to Serenus after the destruction of the images in his diocese. Serenus had written asking whether he was justified in breaking the images. No, replied Gregory; while one could approve—indeed praise—the view that one should not adore images, to break them was wrong.

It is one thing to adore a picture, another to learn from the history [i.e., the subject] of the picture what is to be adored. For what scripture shows to those who read, a picture shows to the illiterate people as they see it; because in it the ignorant see what they ought to imitate, they who do not know letters can read it.[44]

Paintings were truly the books of the illiterate.

It would be impossible to overrate the resonance of this much-quoted

passage. It was exploited over and over again both by Catholics and Prot-estants at the time of the great image controversy of the sixteenth century. Pictures were justified because they were the books of the illiterate, because they caused the simple folk to linger in the churches—they were attracted, of course, by the pretty colors—and writers like Luther (and to some extent Zwingli and Calvin too) emphasized the value of pictures which showed histories and were not cult images of Christ and the Virgin. Histories, in the broad sense, meant pictures and sculptures with narrative subjects from the Bible. The reformers, of course, tended to prefer narrative subjects from the Old Testament.

Nevertheless, the notion of justifying images in terms of their value to the ignorant, the simple, and the illiterate clearly evaded many of the on-tological issues that had been raised. It is also patronizing, and has some-thing inconsistent about it. None of the writers, from Gregory to Luther, approved of the adoration of miracle-working images or cult images gen-erally; but these were exactly the kinds of images that lay at the center of the religiosity of simple folk. One begins to see the necessity for arbiters and censors, to ensure that people use only the "right" images. The better class of people have no need for the gaudy attractions of images. They, after all, can read and learn the truth from books. The poor and simple, on the other hand, being unlettered, need help and can at least learn the truth from the right pictures.

But could it be that the formulators of this position also sense that visual images are indeed more effective than writing and that their appeal is more direct? Perhaps they simply cannot acknowledge that this might apply to themselves as much as to the uneducated and unlettered. Once again we find that as soon as the profound effectiveness of paintings and sculptures is acknowledged, the blame—as it were—is shifted to the lower classes. *They* are the ones who are susceptible to the effectiveness of pictures; not us. With us there is no danger of adoration of pictures, or of fetishization, or of being misled by bad subjects. This seems to have been the party line for hundreds and hundreds of years. No wonder that when the Council of Trent came to pass its feeble justification of images a few days before Christmas in 1563, it could barely do so except in terms of emphasizing the old Thomistic triad of edification, instruction—especially of the unlettered—and reinforcement of memory.[45] All it could do was insist that the honor paid to an image passes to its prototype, and attempt to ensure that there were no images of false doctrine or ones which might furnish ordinary people—the *rudes*—with the opportunity for error.[46] Again it is the rude and simple people who err and whose error is likely to be sufficiently grave to necessitate supervision and, ultimately, censorship.

But the them/us view had already appeared in full clarity in the century before Gregory. This is how Hypatios, archbishop of Ephesus (531–38),

replied to his suffragan bishop, Julian of Atramytion, who had evidently written to Hypatios suggesting that since images were contrary to the Scriptures they should be destroyed.

> We ordain that the inexpressible and incomprehensible love of God for us men and the sacred patterns set by the Saints be celebrated in holy writings since so far as we are concerned we take no pleasure at all in sculpture or painting. But we permit simpler people, as they are less perfect, to learn by way of initiation about such things by the sense of sight which is more appropriate to their natural development. . . . For these reasons we too, allow even material adornment in the sanctuaries, not because we believe that God considers gold and silver and silken vestments and gem-studded vessels venerable and sacred, but because we permit each order of the faithful to be guided and led up to the divine being in a matter appropriate to it.[47]

The explicit point is made that we intellectuals do not need the sense of sight to be led up to the inexpressible divine; but simpler people, "who are less perfect," do. Writers like Hypatios may have avoided the question of idolatry by shifting the elements of justification so that they appeared in terms of the unlettered others; but his call for material splendor and sumptuousness to help them also sounds suspiciously idolatrous. How, then, could one redeem the consequences of the divide?

One had somehow to reduce the old superiority of the ear over the eyes, of words over images. For that there were always Christ's words to the apostles: "Blessed are your eyes for they see, and your ears for they hear" (Matthew 13.16). Here at least there was some equality between the two channels to revelation, and it clearly did not depend on one's degree of letteredness. But unfortunately, one could also adduce Christ's words to Thomas after his incredulity: "Blessed are they that have not seen and yet have believed" (John 20.29). By and large there were not too many arguments that could be brought to bear against the superior spiritual position of words and texts; the same applies to the Reformation debate. Not only were there the repeated classical statements, but also the many New Testament passages expressing the view most concisely put by John in his letter to the Hebrews: "Now faith is the substance of things hoped for, the evidence of things not seen" (Hebrews 11.1). The one decisive Byzantine critique of the whole word-oriented position was formulated by the patriarch Nicephoros, who defended images against the third iconoclastic emperor, Leo V.[48] Nicephoros noted that the problem with words was that thought was required to make sense of them. Words could lead to doubt, indecisiveness, and equivocation. Sight, on the other hand, provided for much more direct perception. Holy images were *less* prone to misinterpretation than sermons (or holy texts), and in this sense were less threatening to

faith.[49] They could, therefore, provide at least as convincing a proof of faith.[50] The notion of the direct appeal and effectiveness of images thus significantly democratizes their rationale. According to reasoning such as Nicephoros's, they were just as needful and just as useful for those who could read, and read well—if not more so.

For John of Damascus the priority of seeing was a necessary part of his argument against those who denied the cult of images. It is indeed in the Damascene that the whole position with regard to high and low, to sight and hearing, and to the consequent importance of splendor and artistic crafting is most fully set out. Instead of regarding the role of the senses as some kind of failure, he admits their susceptibility; and the response of the illiterate becomes the most direct index of the effectiveness of images. For him, as we have remarked, those who denied the cult of images denied God himself (since the very proof of his existence rests on the visible evidence of his Son as image of him as archetype, and of man, who was also created in God's image). Not for the Damascene the weaker kind of argument such as that set out in the seventh century by Bishop Leontios of Neapolis in Cyprus, who noted that one could have images in the same way that the Old Testament tolerated the cherubim and lions' heads of the ark.[51] In one of the fullest statements about these matters in his famous first oration on images against the iconoclasts, John ties them all together. Though ostensibly pro-image, it contains every element of the twofold response that cherishes and destroys:

> When we set up an image of Christ in any place, we appeal to the senses, and indeed we sanctify the sense of sight, which is the highest among the perceptive senses, just as by sacred speech we sanctify the sense of hearing. An image is, after all, a reminder: it is to the illiterate what a book is to the literate, and what the word is to hearing, the image is to sight. All this is the approach through the senses; but it is with the mind that we lay hold on the image. We remember that God ordered that a vessel be made from wood that would not rot, gilded inside and out, and that the tables of the law should be placed in it, and the staff and the golden vessels containing the manna—all this for a reminder of what had taken place. What was this but a visual image, more compelling than any sermon? And this sacred thing was not placed in some obscure corner of the tabernacle; it was displayed in full view of the people, so that whenever they looked at it they would give honour and worship to the God who had through its contents made known his design to them. They were of course not worshipping the things themselves, they were being led through them to recall the wonderful works of God, and to adore him whose works they had witnessed.[52]

Whether or not the image was more compelling because it had something sacred placed in it (the law, the manna), and thereby acquired something akin to mana or charisma (in this respect perhaps like a reliquary), is not raised by John of Damascus. In fact the point would be irrelevant: what is being stressed, in the first place, is the role of sight in the arousal of the senses (even though, predictably, he argues that it is with the mind that we lay hold on the image). This is what gives adornment and splendor—enshrinement in short—their justification. But it is the final claim that is most telling. While we might grasp God by the mind, we are led up to him by the splendid material object, the object that is the image of the prototype it represents: *Abbild* is not identical with *Urbild.* Certainly it was not the things themselves that the faithful worshiped; it was what they represented.

This takes us to the ontological heart of the problem. When we consider how frequently the fusion of image and prototype occurs, we realize that the issue goes considerably deeper than a simple distinction. Even though the theologian may only be seeking to ensure that worship in the form of *latreia* be reserved for God alone, and that veneration in the form of *dulia* be extended to the images that show God or his representatives, and even though he may be making capital of this view for the whole theory of images, are we not dealing once more with a case in which the theologians insist on one thing—the separation of image and prototype—and where the opposite frequently and palpably occurs? Does the effectiveness of images not depend *most of all* on the possibility of fusion? If it does, then one supposes that theologians will again start speaking of the simple and unlettered masses. They are the ones, after all, who believe in the miraculousness of cult images; and this miraculousness is almost always predicated, if not on fusion, then on a kind of sacred contagion that is itself constituted by the notion of duplication of the powers of the original body. The miraculous object has an effectiveness that proceeds as if the original body were present; but the difficulty lies in cognitively grasping that "as if." Again we are left to assimilate the processes of fusion.

V

There is one final element in the early Christian and Byzantine arguments that informs all subsequent Christian thought and has a bearing on the ontological issue. It revolves round the Incarnation of Christ, and it pertains to religious imagery. The problem, simply put, is this: If God is divine, not material and uncircumscribable, how is it possible—indeed, how can it be legitimate—to represent him in material and circumscribed form? This is the argument used by all those who are hostile to images; but the

counterargument depends on the fact that Christ, the image of his Father, was made incarnate as man. That is not only how he is to be grasped, it is the only way to apprehend his divinity in his fleshly, visible, and material presence. This not only justifies images of Christ (again one can understand the need for accuracy and verisimilitude) but also all images of the absent and unknowable signified. It also explains why the argument about the *vera ikon* of Christ lies at the center of so many discussions of the validity of images.

Once again the exemplary and indexical issues lie at the center of the Byzantine iconoclastic debate. It was not difficult, after so many centuries of argument about the divine nature of God and Christ, to arrive at the ontological part of the iconoclastic canon of the Council of 754, which condemned the artist "for having attempted to delineate the incomprehensible and uncircumscribable divine nature of Christ" and for having "confused the unconfusable union of the uncircumscribable Godhead in the circumscription of created flesh."[53] The decree made it perfectly clear that unless this was acknowledged, the artist would fall either into the heresy that claims that the divine and human natures of Christ are separate or into that which holds that there is only one nature in Christ.[54]

This position belies the fear that the artist may indeed be able to circumscribe the divine (or even present the divine in the image). The christological issue becomes the fundamental issue of representation in material form, and it presents the problem of inherence in its full and blinding force. The problem of inherence, of course, must be evaded by the high defenders of images, in one way or another, but the problem of circumscribing the divine is skillfully extended by writers like John of Damascus, in his rebuttal of Tertullian's disdain for the adulteration of God-given material by human hand. This extension of the dogma of Incarnation and this rebuttal of the critique of materiality is combined in book 2 of the *Oratio de imaginibus,* in the most explicit possible formulation of the position assailed by the iconoclastic councils. In emphasizing the relevance of the advent and Incarnation of Christ, it also takes care of the Old Testament prohibition:

> Of old God the incorporeal and uncircumscribed was not depicted at
> all. But now that God has appeared in the flesh and lived among men,
> I make an image of the God who can be seen. I do not worship matter
> but the creator of matter, who for my sake became material and
> deigned to dwell in matter, who through matter achieved my salvation.
> I will not cease from worshipping [the matter] through which my
> salvation has been effected.[55]

No wonder the Reformation critics were not satisfied with the old insistences that in worshiping images men and women were not just worshiping blocks of wood and stone. Later on in John the point about materiality is

put very bluntly; but then he has to import some notion of consecration and some idea of investiture with the sacred:

> It is clear to all that flesh is material. Therefore I adore, worship and venerate the material by which my salvation was gained. I worship it not as God but as full of divine grace and efficacity. Is not the wood of the Cross most blessed and most happy? Is the sacred and venerable mount, the place of Calvary, not material? Is not the lifegiving stone . . . ? Are not the ink and paper of the Gospels material? Are not the body and blood of our Lord material? Either remove all worship and adoration of these things, or allow, according to the tradition of the Church, the veneration of images dedicated to the name of God and his friends the saints, because they are in the shadow of the Holy Spirit.[56]

This, of course, skirts the very problems posed by the means by which images acquire their force, their power, their solemn and terrifying effectiveness. If one admitted *these,* one would be lapsing into idolatry; and when John again takes up the issue of idolatry, he comes as close as he ever does to understanding that force. It has to do with the epiphanic nature of representation. The image declares and makes present that which is absent, hidden, and which we cannot possibly know—but then do. This is the distinction between representation as image, on the one hand, and the concise and condensed referentiality of symbols on the other.

> These injunctions [against idols] were given to the Jews on account of their proneness to idolatry. We, on the contrary, are no longer children. . . . How depict the invisible? How picture the inconceivable? How give expression to the limitless, the immeasureable, the invisible? . . . When the invisible becomes visible in flesh you may then draw a likeness of his visible form. When he who is without form or limitation, immeasurable in the boundlessness of his own nature, existing as God, takes upon himself the form of a servant in substance and stature, and a body of flesh, then you may draw his likeness and show it to anyone willing to contemplate it.[57]

The real, apparently graspable image pictures the inconceivable. What cannot be conceived is—inconceivably—grasped in the painting or sculpture. But if anyone still doubts the application by extension of the christological issue to the possibility of representation, John himself provides a counter in the final book of the *Oratio:*

> Secondly, what is the purpose of an image? Every image is declarative and indicative of something hidden. I mean the following: inasmuch as man has no direct knowledge of the invisible (his soul being covered by a body), or of the future, or of things that are severed and distant from

him in space, being as he is circumscribed by place and time, the image has been invented for the sake of guiding knowledge and manifesting publicly that which is concealed.[58]

In specifying the iconicity of the image (in the Peircean sense) there still remains a strong emphasis on the differentiation between image and prototype (as John himself declares openly in his immediately preceding section); but that emphasis does not detract from the power that proceeds from the revelation of the unknowable and invisible. How does one come to grasp the inconceivable at all, let alone by means of the graspable, apprehensible image? The proposal of purpose—"secondly, what is the purpose of an image?" he asks—is also unanalytic, in its failure to consider the full consequences of picturing the invisible: the consequences which lead to the perception of signification as perception of inherence and presence. But it is not for us to pass anachronistic judgment on the endless circling around the same arguments in the Byzantine writers, even in those as thoughtful as John of Damascus. It was not for him to go beyond the christological proofs of imagery to the powers that arise when the limitless is perceived in the circumscribed object.

VI

These complicated texts are rich in their implications and dense—and sometimes confused—in the arguments they set out. But let it not be thought that these are "merely" theological problems with no practical bearing, or divorced from action. In cases like the image breaking in the Netherlands in 1566, everyone—from aristocrat to townsman to peasant—had some idea of the major theological issues at stake. Indeed, they are issues that had in some form or another become commonplace. One heard them passed round, from sermons in church to simple country preachers, from bookish people to those with the merest smattering of learning; and they passed even further down (Carlo Ginzburg's miller from the Friuli derived his admittedly odd cosmology from bits of the highest learning floating around in his vicinity).[59] But all this is hardly surprising. The claim that in many cases the theories discussed here constitute incipient—if not occasionally fully-fledged—theories of cognition implies exactly this; and so the theories lie at the very roots of both the love and the fear of images. They are not, except incidentally and accidentally, culturebound. This is absolutely not to disclaim their ideological component.

For the love and fear of images, as the Byzantine arguments show so clearly, are indeed two sides of one coin. The arguments all rage round the same issues: the superior spiritual status of the word; the need for images

to provide a channel for the more susceptible sense of sight, so that the mind can ascend to that which it otherwise could not grasp; the awareness throughout of the possibility—and the danger—of the fusion of image and prototype, of perceiving the prototype in the image and the image as the prototype itself. Indeed, that danger is sensed even by the most strenuous defenders of images, in every period. The texts make clear the real threat of conflation and fusion; but they also make clear the consequences of the ineffable presentation in hard, visual, knowable form of the wholly unknowable and limitless form. That is what is both wondrous and frightening. Because awareness of the power that arises from fusion may be sublimated into the love and cherishing of images, the theologians are always embarrassed by the phenomenon of cult and miraculous images. Here the realization of inherence can scarcely be avoided, and so to insist on the separation of sign and signified only serves to enervate and etiolate exactly that which inspires devotion in the minds of the beholders (especially, as we have seen, simple beholders). This is also why, despite the strong defences of images we have seen, there is so little about images as part of the apparatus of worship in the Byzantine liturgy but so many images, such a huge abundance of them, in every Byzantine church.

This is a real disjunction. It is seen not only in the Eastern Church but also in the Western one, where there is almost as little in the way of references to images and blessings for them in the Latin rite and the Latin books of the liturgy, and almost as many images hanging in every church.[60] In a more negative way we see the same disjunction across many cultures, as in Islam. The lawgivers may rail, but the images remain, multiply, and persist. But it should be remembered that the prohibitions (say in Islam) and the embarrassment (say by the theologians of the eighth and ninth centuries) spring from high theory; and it is this intellectual failure to acknowledge the logic of the gaze and the needs it engenders that we must still pursue further.

Imagine the consequences of fusion. The body in the image loses its status as representation; image is the body itself. Arousal ensues, positive or negative. This is not to say that the loss of independent prototypical status is inevitable. Often—if not most of the time—we remain aware of the status of the image as representation. But the case of the iconoclast dramatizes these issues. He sees the image before him. It represents a body to which, for whatever reason, he is hostile. Either he sees it as living, or he treats it as living. Or—perhaps frighteningly—what should be absent (or unknown) is present (or known). In either event, it is on these bases that he feels he can somehow diminish the power of the represented by destroying the representation or by mutilating it.

Of course there is a difference between organized and orchestrated iconoclasm, as in the Netherlands in 1566 or in the Russian Revolution, and the

individual or idiosyncratic or neurotic act. But there is a continuum too. Who is to say what individual feelings of antipathy are unleashed or legitimated by group activity or by orchestrated encouragement? Of course political or religious motives may come more significantly to the fore with large-scale iconoclastic movements; of course highly idiosyncratic motives may determine the actions of a man or woman who attacks an image in a museum with a knife or with acid. But both ends of the spectrum exemplify the need for a view—and a theory—of response that goes deeper than the obviously determining constraints of context. At the same time—ideally— the theory will need to look to the ideologies that determine its boundaries.

VII

"The assailant and his motives are wholly uninteresting to us; for one cannot apply normal criteria to the motivations of someone who is mentally disturbed." This is what the director of public relations at the Rijksmuseum in Amsterdam is reported to have declared after the knife attack on Rembrandt's *Nightwatch* on 14 September, 1975.[61] It was the third attack on the picture in the century. Aside from the evident psychological interest of all such cases, and aside from the odd confusion of the second half of the statement[62], the most telling aspect of this claim is the vehemence of its denial. Someone who responds so powerfully to the picture that he assaults it is here held to be uninteresting (at least to the museum official). He is not interesting, one gathers, because he tests the limits of normality. This is how we lay aside and suppress that with which we cannot deal. Such a claim is all too characteristic; what it amounts to is an expression of the fear of plumbing psychopathological depths that we prefer not to acknowledge—not only because we are frightened by the behavior of others, but because we recognize the roots of and the potential for such behavior in ourselves. The whole framework of denial is of a piece with the massive fortifications of repression with which we seek to protect ourselves from the powerful emotions and the distracting and troubling behavior that we sometimes experience in the presence of images: especially ones we strongly like and strongly hate. Sometimes those fortifications are so strong that they are never breached, and we feel well protected.

Consider some examples of individual iconoclasm in the twentieth century.[63] A man attacks *The Nightwatch* in 1911 with a pocket knife because (he says) he is disaffected with the state (he has been laid off from his job as a cook in the navy). So when he walks into the Rijksmuseum one afternoon and sees the state's most prized possession—*The Nightwatch*—anger wells up in him and he attacks it.[64] In 1975 a man again attacks *The Nightwatch*, with a knife he has stolen from a restaurant in which he just lunched. The

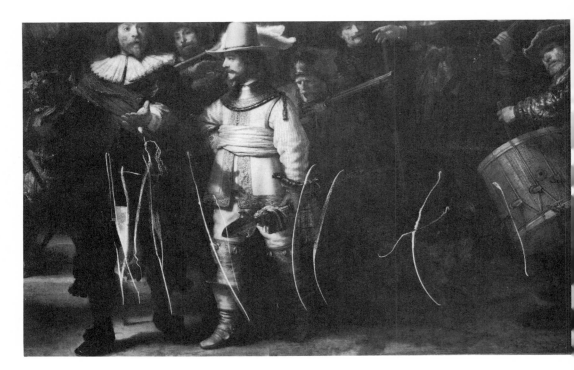

180. Rembrandt, *The Nightwatch* (1642), as knifed in
1975. Amsterdam, Rijksmuseum.

museum officials profess to be uninterested in his motives. But the news-
papers discover that he had been acting in an odd manner just previously
(especially in church the weekend before) and had gone about declaring that
he would shortly make front-page news and be on the television. As in so
many other cases like this one, he is institutionalized shortly thereafter.[65]

Closer examination of the damage he wrought, however, suggests that
his attack was not entirely wild (fig. 180). The slashes seem to be more de-
liberately directed than that would imply. It transpires that he felt (or said
he felt) that Banning Cocq, at whom he directed most of his slashes, was
the personification of the devil (Cocq was dressed in black), while Ruyten-
burgh, dressed in yellow and gold, was the angel.[66] The man may have been
completely beyond the pale, but he was not completely out of control. The
deliberate element in such apparently spontaneous or crazed acts should give
one pause for thought. It happens more frequently than one might think.

But there is also the messianic aspect of the man's claims. When he
created the disruption in the church the weekend before, he maintained
that he was Jesus Christ and that God had commanded him to do the deed,
and that he had been called by the Lord to save the world.[67] The messianic
impulse is shared by many attackers of images. They claim that they are
Jesus Christ, the Lord, or the Messiah, come to save the world. Such delu-

sions were voiced by the man who struck off the arm and nose of Michelangelo's *Pietà* with a hammer in 1972 (fig. 181). They were also voiced by the author of a series of pornographic booklets who, when apprehended for throwing acid at Rubens's *Fall of the Damned* in 1959 (fig. 182), insisted that he had been subject to a systematic campaign of literary suppression and that his aim was to bring peace to the world and to end all wars.[68] The impulse may be deluded and seriously pathological, but we may pause again to reflect on the appropriateness of the subject of the picture he assaulted. It cannot be accidental, given the little we know of his biography, that he should have chosen to throw acid at a picture of the damnation of one of the greatest and most brilliant assemblages of lusciously naked flesh in all of Western art.[69]

All iconoclasts are aware of the greater or lesser publicity that will accrue from their acts. They know of the financial and cultural and symbolic value of the work they assault. The work has been adored and fetishized: the fact that it hangs in a museum is sufficient testimony to that, just as the hanging of pictures in churches is testimony to religious forms (or less overtly secular forms) of adoration, worship, and fetishization. Furthermore—especially in the twentieth century—the better the art, the greater the commodity fetishism. So destruction is especially shocking to those normal people who adore art and art objects. When Eratostratos burned down the great temple of Diana at Ephesus, he did so specifically in order to ensure that posterity would not forget his name; and all attempts to erase it from history failed, since someone, in the end, leaked it.[70] Both the 1911 assailant of *The Nightwatch* and the man who threw acid at a series of paintings throughout Germany in 1977 declared that they had to destroy what other people cherished.[71] Like latter-day Eratostratoses, each of them also made grandiose claims about their need to be famous, to appear in the newspapers, and to be the Messiah who had come to save the world.

In 1914 a young suffragette—subsequently known as "Slasher Mary"—hacked at Velazquez's *Rokeby Venus* in the National Gallery in London in order to draw attention to the women's cause in general and to the plight of the suffragettes in Holloway Prison in particular (fig. 183). "The most beautiful woman on canvas was as nothing compared to the death of one woman in prison," Mary Richardson claimed in a 1952 interview, speaking of Emmeline Pankhurst.[72] Such motivation, of course, is an activist extension of the egocentric desire for publicity. To attack a well-known picture may bring immediate notoriety to the attacker, but he or she is usually forgotten. More long-lasting and more immediately clamorous is the publicity that attaches to a cause when a well-known image, one which has become totemic in one sense or another, is attacked, mutilated, or even stolen. Hence the many instances where the letters of political organizations are incised, scratched, inscribed, and chalked on pictures, sculptures, and

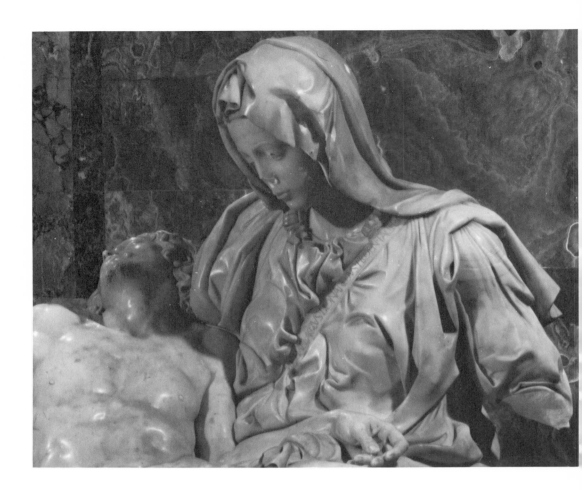

murals. Such actions go beyond the publicity that accrues from inscription or emblazonment on the waiting space.

Once again, though, the subject of the picture assailed by the suffragette seems peculiarly fitting. It is not entirely surprising that when Mary Richardson reflected on her youthful deed some forty years later, she added, "I didn't like the way men visitors gaped at it all day long."[73] Indeed not; and indeed they might have. Moralizing disapproval is thus joined to political motivation, but it is also coupled with fear of the senses. This is the basis for countless attacks on images, from the earliest times on—from Louis of Orleans's terrible mutilation of Correggio's *Leda and the Swan* to the destruction in 1987 of posters of overly revealing bathing suits on bus shelters in Israel. Of course such actions have their private roots, or their religious motivations; but the underlying similarities are undeniable, and they are not factitious. Such examples occur with increasing frequency in our own times, as images multiply and as their mutilation becomes more or less legitimized and current.

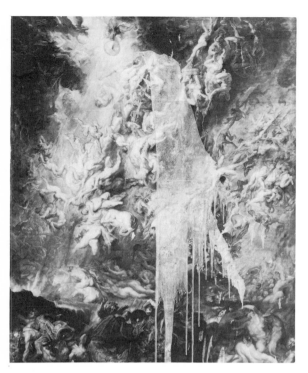

181. *Opposite, left:* Michelangelo, *Pietà* (1498–99), as broken in 1972. Rome, Saint Peters. Photo Musei Vaticani.

182. *Left:* Rubens, *The Fall of the Damned* (ca. 1618), as damaged by acid in 1959. Munich, Alte Pinakothek.

183. *Below:* Velázquez, *The Rokeby Venus* (ca. 1640–48), as slashed by Mary Richardson in 1914. London, National Gallery.

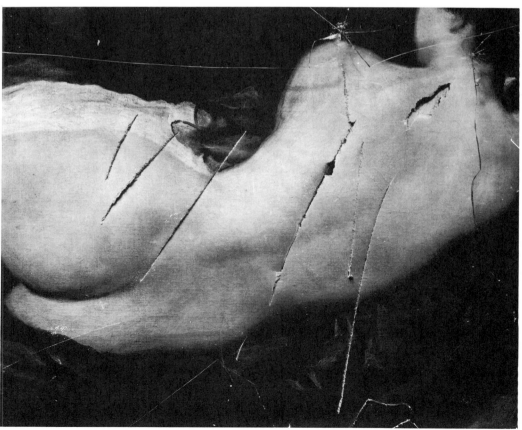

But there are further implications that were brought to the fore in the public response to the affair of the *Rokeby Venus*. The *Times* of that year was obsessed with the rise in the value of the picture and its consequent reduction after the assault. To the list of the actual figures it had at its disposal—such as the purchase price of the painting—it added figures of its own purporting to give an indication of the drop in value. The drop is always notional. The same happened with *The Nightwatch* in 1911. This kind of assessment of the putative financial implications has now become commonplace.[74] It is clear that to reduce the possibility of object fetishism is significantly to impugn its status as a commodity fetish. Fortunately the magic of the picture restorers will do something to reinstate its former value—though not all of it.

The general rubric for all such cases is the moralizing fear of sensibilia. Fear of the possibility of arousal stands at one pole; exasperation with the vanity of what is represented, or of the sign itself, stands at the other. People may think that a subject showing too much finery or a woman looking at herself in a mirror is not fit for public display (as with the man who broke off a mirror held by a rather voluptuous figure of Juno in the garden of the Rijksmuseum);[75] or as with religious art, they may take offence at the expenditure of money on objects of art (conceived as frippery) when it might better have been spent on the poor. And so we attend to the modulations of given reason and possible motive, of ostensible claim and the real trauma that the sufferer consciously or subconsciously obscures. Who knows what individual frustrations, disappointments, and resentments are masked by the commonplaces of image critique? And who could establish the extent to which image critique, formulated by the most sophisticated writers, legitimates the unleashing of private emotions that culminate in attack? We, of course, if we feel impelled to hostility, are likely to prefer to attack with words.

Then there are the cases where personal disappointment is turned quite specifically into anger at the success of others. In unusual cases the artist who feels that his own work has received inadequate recognition assaults the work of the publicly acknowledged or rewarded artist, as with the 1953 attack on Reg Butler's *Unknown Political Prisoner* in the Tate Gallery, or the attempted burning in 1983—by a young designer who could not contain his jealousy—of a pile of tires dubbed a submarine which had received a public subsidy in London and was then displayed beside the Thames in front of the Royal Festival Hall. The designer may have attempted also to immolate himself in the process (the reports in this respect, as so often, are either garbled or sensationalist).[76]

More frequently and more revealingly, this kind of hostility is simply visited on images of those who are successful in general; and once again, as with images of political leaders, we deal with the feeling, unexpressed

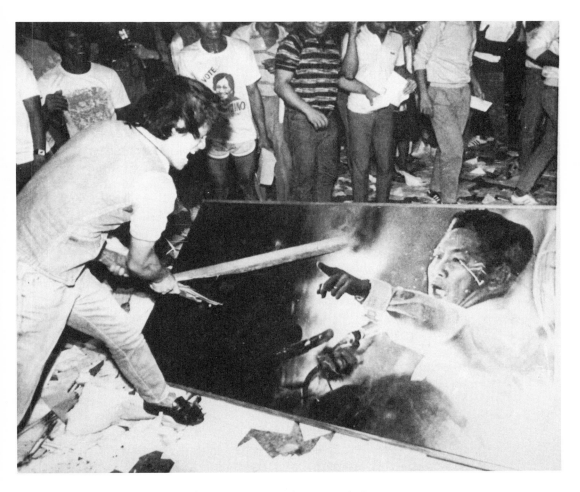

184. Portrait of President Marcos being attacked in Manila
in 1986. Photo AP/Wide World Photos.

though it may be, that by damaging the representation one damages the
person whom it represents. At the very least, something of the disgrace of
mutilation or destruction is felt to pass on to the person represented. That
feeling could not be more graphically demonstrated than in the destruction
of the portrait of President Marcos immediately following his overthrow in
the Phillipines in February 1986 (fig. 184). Anger with him becomes anger
with the picture, as if the president were present in his picture—exactly as
the emperor was supposed to be in the pre-Justinianic empire and for a long
time afterward in Byzantium.

In this particular case the press photograph makes the cognitive founda-
tions of response even clearer than usual. Still more than in most pictures
that seem unusually lifelike, the president in the assaulted portrait seems
to look straight at the spectator, as if directly challenging him. No wonder

the iconoclast gestures with peculiar fierceness and hatred. It is no longer a picture; it is the imperious president present. He must be able to see the hostile adversary and to feel the force of his hatred. All this applies equally to the extraordinary recent proliferation of attacks on portraits of Western and Saudi leaders in the Islamic Republic of Iran (cf. fig. 136).

In 1981 a hole was ripped in a portrait of the newly married Princess of Wales displayed in the National Portrait Gallery in London. In this instance, as often, a variety of factors in the relations between public and private, neurotic and less neurotic, are seen to converge. The young man who attacked the picture seemed disturbed, but he had a political motive. He wished to draw attention to the plight of Northern Ireland, and to Belfast in particular. So he attacked the image of Princess Diana. The young man knew that the fact that the picture was of a royal personage (and a particularly popular one at that time) would have given the gesture even greater publicity. He explained all these things at his trial, emphasizing that he had decided to bring to the attention of London what he felt about the social deprivation of Belfast.[77] Once again private feeling found justification in the public domain for the way it has expressed itself; once again a picture became a vehicle for a political statement, though no message was scrawled across it. The motivation for publicity, of whatever kind, is clear. And once again we are reminded of old theory.

When we see an image of the king—to put it in the classical imperial terms—we respond, or are inclined to respond, as if the king himself were present.[78] This is both theory and reality; and it is not surprising that every theologian and every justifier of images is aware of the more or less easy elision of image and prototype. But the matter is not quite so clear-cut. One can always stand back, take hold of oneself, aesthetically differentiate, and argue with oneself against that elision. We see a picture, a framed object, a cold and bloodless statue; and so we rally at least part of our thoughts against the conflation, which we sense to be inevitable, of signifier and signifed. At least those of us who are aware and in control of such impulses. The young man knew perfectly well that by attacking the image of Princess Diana somehow the dishonor would accrue to her as well, that public response to this act would have at least as much to do with the fact that it was she who was represented as with the damage to an expensive object in a public place. But he must also have known that he would not really be damaging her person; and so the violent act could somehow and quite evidently be relegated to a second order of harm, but one which would have gained a much lower level of publicity if it had not involved an image, and certainly not an image of royalty. In any event, it is we who generally refuse to see that to destroy the figuration or representation of such a personage is often, somehow, to respect that person's life at the cost of dis-

respecting or destroying the object. Unless, of course, we deal with help-lessness and rage at the inaccessibility, the absence, or the actual death of the person represented by it. To call such a position simply the justification of a wrong deed would be cruel and impatient—and it would confirm that one was smug in one's superiority and self-control and love of art.

For all that, it is perfectly clear that any number of assaults of images—if not the large majority of them—are predicated in one way or another on the attribution of life to the figure represented, or on the related assumption that the sign is in fact the signified, that image is prototype, that the dishonor paid to the image—to invert Saint Basil's famous dictum—does not simply pass to its prototype, but actually damages the prototype. The evident corollary is that we respond to the image as if it were alive, real. We have observed this often enough as the basis for positive arousal, and for sexual arousal. Hence the effectiveness of mutilation by those who wish to deprive the picture of something of its sexual energy. But hence, so very frequently, the destruction of the eyes. These are the clearest and most obvious indications of the vitality of the represented figure. The livelier the eyes seem, the livelier the body. Take away the eyes and remove the signs of life. It is not hard to understand why the unknown assailant should have struck out the eyes of the extraordinarily vivid picture—a picture that to modern beholders will seem to have more than usual presence, to use the entirely appropriate metaphor—of Jacob Cornelis van Oostsanen and his wife by their son Dirck Jacobsz. (fig. 185).[79] Nor is it difficult to imagine why the soldiers in Matteo di Giovanni's *Massacre of the Innocents* in Naples might have had their eyes scored out too; or the executioner in the *Martyr-dom of Saint James* by Mantegna in the Ovetari Chapel in the Eremitani in Padua. In the first case, as with Dürer's *Self-Portrait* in Munich, which also had its eyes blotted out, it may be the vividness of the gaze within the picture that is alarming (with the Dürer it also may be a sense of the emu-lation of Christ that the portrait conveys). With the Mantegna and the Matteo di Giovanni, on the other hand, the mutilations represent the at-tempt to deprive the bad powers embodied by the soldiers and the execu-tioners of their vitality by directing the attack at the eyes. This case too is common enough. But how greatly such motivations, even if only dimly sensed, play their role in group iconoclasm. When image breakers run wild, they often rest content with scratching out the eyes (or faces) of the images. One has only to recall the fact that the bestowers of charity (espe-cially offensive to Protestants) had their eyes grimly gouged out, along with much else, in the great early sixteenth-century polyptych by the Master of Alkmaar, probably in the second wave of iconoclasm that struck the Neth-erlands in 1581–82 (fig. 186).[80] We may assume that destruction here would fall under the correct rubric of group iconoclasm, but we should also

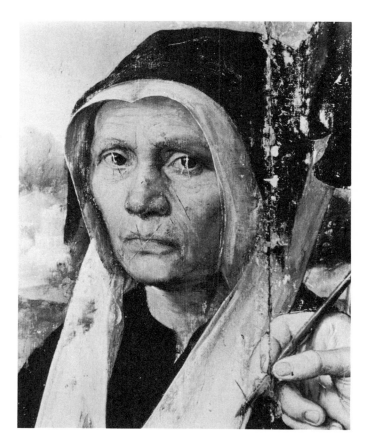

185. Dirk Jacobsz.,
The Painter and His Wife
(ca. 1550), detail showing
damage before restoration.
Toledo, Ohio, Museum of Art,
gift of Edward Drummond
Libbey.

see the need to invoke the idiosyncratic and spontaneous act. Everyone senses that to deprive the image of its eyes, in particular, is to deprive it effectively of its life.

When we consider all these cases we understand, too, something more about our own reaction when we contemplate a photograph such as the one of the portrait of the Archduke Albert by Rubens almost ruined by the 1977 acid thrower in Düsseldorf, with acid all but obliterating the face, or the similarly ruined picture in Kassel (fig. 187); we understand much more clearly why our horror is much greater at this obliteration than if the representation of any limb had suffered similarly.[81]

And so we may assess the continuities. The idiosyncrasies and peculiar neuroses of individual psychologies are engaged by group iconoclasm; the group activates and legitimates that which would normally be suppressed. At the same time, it should now be clearer that outbreaks of widespread social iconoclasm, while evidently determined by social, political, and theological pressures, have as their bases those aspects of the relations between images and people that we have brought to the fore. There are strong and essential continuities between the individual act and the group act, but

186. Master of Alkmaar,
*Polyptych of the Seven Works
of Mercy* (1504), detail of
Charity panel showing damage
before restoration.
Amsterdam, Rijksmuseum.

187. Rembrandt school, *Seated
Old Man* (or *Apostle Thomas*[?])
(1656), as damaged by acid in
1977. Kassel, Staatliche Kunst-
sammlungen, Gemäldegalerie
Alte Meister.

there are also clear continuities between one individual act and another. What is idiosyncratic turns out not to be psychological motivation, but—axiomatically—the idiosyncratic external pressures brought to bear on cognition.

When, however, we insert the apparently neurotic deed into the continuity between individual and group act, attacks on abstract art may be most instructive of all. It seems easier to understand the inclination to destroy the figurative, to assail something that appears to have life and that might be deprived of it, or to attack what is clearly symbolic of something we dislike and that might, on such grounds, in whatever way, elicit anger. This may not seem to apply to overtly abstract representations. But consider some of the motives that prevail: violent frustration at being unable to make figurative sense of the nonfigurative; rage at the temerity of even attempting the abstract in material form; the feeling that anyone could have done better (especially if the work has been financially or publicly rewarded); the notion that the object is not really art at all; or the conviction (if one is an artist) that one is really doing better or more difficult things oneself and that one therefore deserves equivalent public recognition. It may seem that the disappointment of the artist who destroys has no more general lesson to teach us beyond the extent to which disappointment may turn to anger and hostility. But all the apparently random, idiosyncratic, and spontaneous cases show signs of an inner logic we can grasp; all show elements that feature in the outbreaks of group iconoclasm.

One has only to think of the particular response to Barnett Newman's *Who's Afraid of Red, Yellow and Blue,* attacked in Berlin in 1982.[82] As with the apparently random attacks on other images, there is more purposiveness than one might expect. With the attack on the Newman, we find the most direct conceivable response to the challenge posed by the given title of the picture. The people who assail images do so in order to make clear that they are not afraid of them, and thereby prove their fear. It is not simply fear of what is represented; it is fear of the object itself. One hardly needs to add that when the *Berliner Zeitung* of 22 September of that year reported the attack, it did so under the headline "Das hätte jede Lehrling malen können."

In addition to confessing to his direct response to the title, the student who attacked the painting by Barnett Newman also claimed that the picture was a perversion of the German flag, and that it represented an unjustified waste of public funds. The last factor again comes to the fore in an incident that occurred in the Dutch town of Apeldoorn in 1983. On the night of 1 September, over a hundred local inhabitants tore 49 rectangular stele-like sculptures by Evert Strobos from their bases. Along with 114 other such sculptures which still had to be set up, they had been bought by the town government for 180,000 florins. Money had been squandered not only

on art, but on abstract art. Journalists attended and photographed the event, while the local police abstained from intervening on the grounds that intervention might provoke an escalation of violence.[83] How comforting to have fellow image breakers to legitimate one's impulses, and how encouraging to have the chroniclers there, with the forces of order standing by in silence. All this could easily have taken place in any Dutch town in the last quarter of 1566. To see the links between private motive and public act, between modern event and past event, is not to force the issue; it arises from consideration of the power of the exchange between the seeing spectator and the object that speaks to those who see, that gazes at those who speak.

Of course one can find social and political motives for each of the individual acts described here. Of course they may be rooted in the psychopathology of each of the individuals concerned, who are usually judged to be deranged in one way or another. We, on the other hand, do not seek to take out our vengeance on the state in this way, to destroy what disturbs our libido, or to gain massive publicity on the scale envisaged by several of the iconoclasts. Usually we keep such disturbances and such ambitions under control; we keep them vastly more modest. If they exist (so the usual account would run), we more profitably and beneficially sublimate such psychological motions.

There is no denying the political, the social, or the psychopathological background to the motivations for each of these acts. Nor can it be gainsaid that many iconoclasts are bitterly disappointed individuals, and that they seek to draw attention to their unfair plight by violently attacking objects which are admired by the rest of society and are regarded as of great financial, social, or cultural value.[84] There is no question that there are many other psychological factors mixed up in all the delusions and impulses that are predicated on perceiving the object as a present body, as the living leader, as the embodiment of unfairly spent wealth, as a temerarious creation. Who is to say what exactly these disappointments and senses of failure or delusions of grandeur might be? It would be wholly presumptuous to unravel such factors, and it has not been my purpose to do so.

The theorist and the individual may object to a picture or sculpture and may even censor or assault it on the grounds that it is a distraction from higher things, an intolerable and offensive vanity. Such an objection may rationalize another motivation altogether, but it nevertheless provides further testimony to the fear of the senses that arises from the fetishizing gaze. Even if only rationalization, it amounts to theoretical acknowledgment— at the least—that this is what happens with paintings or sculptures. The sailor who attacks *The Nightwatch* realizes the commodity fetishism on which the value of works of art are based, so he attacks the most valuable work he knows. The attacker of a picture like Rubens's *Fall of the Damned* realizes the fetishism that turns the picture into something that is threat-

ening to his libido, so he subverts the possibility of fetishism by destroying, mutilating, or otherwise ruining it.

The slashing of representations of nudes provides further evidence of the investiture with life as the basis of response. What would the danger be of leaving it whole if it were simply dead to begin with? It would be easy to answer by claiming that the fear is that the representation is suggestive. There is nothing wrong with this answer; it is just that it is incomplete. Suggestive it may be, but the imagination that lingers is the imagination that reconstitutes, and reconstitution is constantly referred back to the representation and projected onto it, so that the mind not only sees the mental image but strives toward materiality and the investment with life. Similarly, whatever the symbolic component of an iconoclastic act may be held to be, one would be evading the realities of action if one only had recourse to notions of pure or conventional symbolicity.

The Virgin of Michelangelo's *Pietà* looks too beautiful, so the man, for all his messianic impulses, breaks those parts which make her beautiful and therefore make her seem desirable. He destroys her face by breaking her nose (fig. 181), in the same way that the image of Shirin in the grotto of Tâq-i-Bustân was disfigured. Not only does she threaten the senses, she is also the Mother of God. She should not rouse carnality in the ways ordinary women do, the women of this earth. Again one encounters the old resistance to confusing profane and sacred, which also lies at the root of the recurrent objections to confusing the everyday with the sacred. Here it is important to reemphasize not only the aspect of the neurotic's motivation that can be considered under the rational heading, but also his avowed messianism. This too has its parallels in the messianic and soteriological motives of reform movements that purify their houses of representations of the genuinely unknowable Messiah, whom they alone can make known to the world. Their word (and sometimes their images) will replace "false" images of the real Messiah. The awareness of the publicity that accrues from the destruction of a cherished object in its turn constitutes a part of the social glamor of iconoclasm and part of the motivation for the organizers and instigators of group iconoclasm.

In these ways we insert the individual act into its social context; thus we engage the interest of the deed that is generally regarded as beyond the pale, and thus we see the truth that lies within the apparently crazed deed of the isolated iconoclast. It is not hard to understand why we should want to repress our kinship with such people, or why we should want to repress the disturbances that images cause and that, in their turn, make us understand why the iconoclast might behave the way he or she does. If we grasp *that,* and if we accept the disturbances, we may then begin to talk about the power of images—even at the cost of reshuffling our preconceptions about the role and status of art in our lives, or of deriving illumination from

the dark acts of those whom we dismiss as deranged and incalculably more troubled than we are. The aim is to seek the calculable.

VIII

There can be no excuse, then, for the historian of visual cultures to disclaim interest in the acts that destroy what is generally respected or cherished. Such disclaimers arise from the ignorance that is the consequence of repression—because in this case lack of interest is the same as repression. In order to learn, we cannot simply dismiss the acts as those of madmen, as being of no interest to normal people. They illuminate our own responses and are continuous with them. There are many cases where the blows may seem wild, but they turn out to be purposive, methodical, or systematic, and where the choice of subject is not at all accidental.

In 1978 a man attacked Poussin's *Dance Round the Golden Calf* in the National Gallery in London (fig. 178). As the photograph taken after the attack shows, he concentrated his efforts on the representation of the Golden Calf itself (fig. 188). No one seems to have made anything of this. No statement about his motivation is recorded, other than his declaration,

188. Poussin, *Dance Round the Golden Calf,* as damaged
in 1978. London, National Gallery.

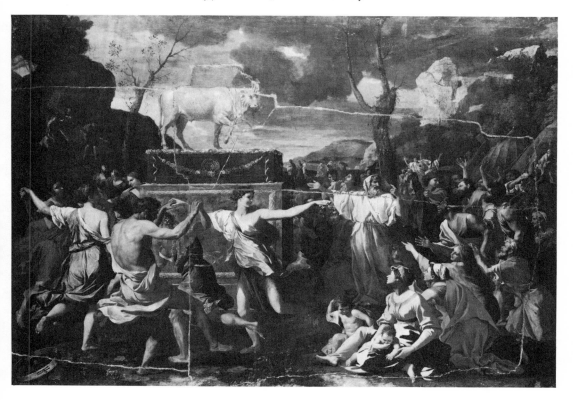

upon being imprisoned for two years, that "it pleased me to do it" (almost exactly the words of the man who threw acid at twenty-three paintings across North Germany the year before).[85] The psychiatrist who examined him declared him to be schizophrenic, and appropriate institutionalization was recommended. That would seem to be the end of the story.

But might one not ask in such cases why this picture rather than any other was attacked, and why it was attacked in such and such a way? As we have already discovered, questions like these can yield fairly specific answers. In this instance it is difficult to resist answering them in terms of the issues raised at the beginning of this chapter. The story of the Golden Calf is one of the *loci classici* of idolatrous image worship. It has been adduced as such, and as one of the indices of the sudden moral descent of the Israelites in the Wilderness, ever since men and women began to worry about the validity and use of figured imagery. Something of all this must have entered the assailant's head, or at the very least, been known to him, in however vague or diminished a form. What more convincing reason for the singling out of this work and for the way in which it was attacked? It shows a subject that must seem to carry with it its doom. It is by any modern reckoning a beautiful picture, a picture of the kind that leads to exactly the sensuality embodied by the dance in the foreground, and that leads to awareness of the flesh: the flesh that distracts from the Word, the true Word, the Word of God.

But consider some of the public responses to the action. In referring to the picture, the *Liverpool Daily Post* expressed its puzzlement about why it of all pictures should have been knifed: "It is not offensive. It just depicts the Israelites dancing round the Golden Calf."[86] Such a view may be thought to be naive or at least defective in its memory of the Bible; but in London there was puzzlement too, and there ignorance was most revealing of all. This is what the public relations officer of the National Gallery declared a few days after the episode: "We cannot think of any reasons why this particular painting should be attacked. It is, in fact, a very beautiful painting."[87]

Thus we come to the crux of the matter. The beautiful work of art does not—or should not—give cause for disturbance; and so we conveniently repress as many of the ways in which it is troublesome as we possibly can. If it is too troublesome, it is not worthy of enshrinement in a museum or is not a work of art. The implications are considerable, but we should confront them.

First note the indices of repression. In almost every iconoclastic period in which there is any debate at all about images, we learn about the arguments of the iconoclasts from those of their opponents, the iconodules. Either the iconoclasts' own arguments are changed or etiolated, or they are set in a firm context of disapprobation. But some of these arguments are so

effective and so striking that it seems they cannot be gainsaid. Over and over again, the councils and other bodies that are called upon in order to pronounce favorably upon images fail to deal with the basic issues. They fail to refute the ontological arguments of the iconoclasts and fail to provide substantive arguments in favor of images. Most of the pro-image positions adopt the stance that images are not so corrupting after all, that they are only bad when they are misused, and that they are of help to the simpler people who are more likely to be misled.[88] The theologians and iconodule thinkers take weak positions. Of the power of images that arises from inherence and that gives them their miraculous and miracle-working qualities there is rarely a breath. When images *do* have such powers, the theologians and thinkers are simply embarrassed. Magic and irrationalism are invoked as sufficient explanations for problems like authenticity and identity. It hardly comes as a surprise to note the frequent disjunction between theory and practice, as when the churches are thick with images but the liturgy thin, and when the painted manuscripts are full of the images that the canon forbids.

But there are many more overtly secular indices too. Museum officials may not wish to speak of iconoclasm at all; but the newspapers, when such things happen, are full of it. Both the serious and the popular press are replete with the details.[89] There is an evident relish for the grimmer minutiae of each attack: what kind of weapon, how much acid, how many slashes. Photos are provided to elicit horror (and indeed we start at the sight of the damaged icon). There is little reluctance to classify the assailant as mad, violent, or abnormally inclined to vandalism. One can hardly wonder at the success of at least one element in the motivation of many of the iconoclasts: the desire to gain attention and publicity. The restorers work magic in returning the picture to its former beauty and therefore to its former value, or something like its former value. The museum conservators hide the details from posterity or refuse to talk about them—because they do not wish to put ideas into peoples' heads.[90] They claim that the actions of deranged people are of no interest to normal people like ourselves.

The further indices, then, go much deeper. The iconoclastic deed is called *einmalig,* unique, the assailant deranged and beyond the pale. We, on the other hand, are healthy. We are complacent in our self-control and in our love of art. We might be corrupted, as the curators and others note, if we hear (too much) talk about iconoclasm. Beneath this concern lies the strong fear that to reveal such things in others might somehow expose and legitimate that which lies deep within ourselves. We cannot bring ourselves to analyze—or even to confront—the actions of those who appear to be mentally disturbed; yet all of us know the experience of powerful but indefinable emotions in the presence of figured objects. With us (we think and constantly assert) those emotions—of catharsis, of warmth, of calm, of

difficulty, even of frustration—are channeled, however inexplicably, along safe and generally rewarding lines. We too may be disturbed and troubled by specific images; but can it be that such feelings, which we know how to sublimate or transmute, often beneficially, are somehow akin to the over-demonstrative, violent, and ultimately damaging behavior of the image breakers? At this point an answer in the affirmative seems called for; yet we continue to insist that this is not the case, that we, after all, do not destroy. But how do we deal with the knowledge which we suppress, and what are the consequences of the ways in which we deal with the kinship to which we will not admit?

In the first place, we compartmentalize out those who we think do not respond in the way we do: madmen, women, children, and less educated people generally (especially the primitive and illiterate). They are all more susceptible to the base and easy charms of images, to their powers and their seductiveness. The case of the madman has already occupied us sufficiently; but it is worth recalling how deeply the associated ideas run. Only women and ordinary folk are seduced by cheap beauty (vulgar colors, adornments, fripperies, and the overly emotional aspects of representation in general), not mature male beholders. Women, moreover, embody the essence of arousal of the senses; as a result they distract from the higher functions of the mind and impede its upward strivings. This is exactly what happens in the case of material images, especially the gaudy ones. But not only them: we have now to be wary of the seductive pleasures of the ascetic and the austere too, of the cold and monotonous varieties of formalism.

In the second place, as this account of hegemonic positions must already have implied, it is children and simple peasants who conflate image and prototype, or who are most liable to do so. It is they who attribute to images powers which only living beings could properly have. Who are they who so frequently go on pilgrimages, who invest the kind of faith in images that holds them as miraculous, and who have them perform wondrous things that transcend their earthbound and inert materiality, if not the broad mass of uneducated people? It is only these groups who use images as books and who are likely to linger longer because they cannot read at all, or because they trust more to the more susceptible sense of the eyes—the one faculty, as we have seen, that provides the straightest channel to the lower senses and rouses them.

For us, on the other hand, art is that which elevates the mind, and which we perceive chiefly by means of our intellect. It is here that the pleasures of art lie (or are supposed to lie). The best of art we put in the museums. Or to put the notion at its most extreme, once it is in the museum it is need-fully art. Art is certainly not the image that troubles or is disturbing. The image that rouses us powerfully, that disturbs us deeply, has no place in the museum. It is either pornography, or a cult image, or a miracle-working

image, or a poster, or advertisement. The images that are most effective turn out to be excluded from museums. They are the most effective precisely for the ways in which they engage our apparently lower senses. None of this is to deny the possibility of the tearful response before the picture in the museum. It is simply to note that tears in museums are provoked by purely artistic, "aesthetic," factors. Such are the means whereby we turn the troubling image into something we can safely call art.

For these reasons too the iconoclastic act is so frightening. It opens realms of power and fear that we may sense but cannot quite grasp. When the iconoclast reacts with violence to the image and vehemently and dramatically attempts to break its hold on him or her, then we begin to have some sense of its potential—if we do not perceive it in the flash of light that blinds us, finally, to its art. But these days we have become more sophisticated, and thereby more confused. We allow that art can be troubling too, and we come full circle. We have learned to turn the troubling image into something we can safely call art. Thus we refute our parents who want their art to be soothing, pleasant, harmonious; not the art of ugly textures, murky colors, garish or random lines, wild graffito-like scratchings. They do not call these things art, but we do. In the process we anesthetize their real strength and powers.

The next step, and the logical position for those of us who assert our catholicity, who expect to be shocked and to install the shocking in the canon and then in the museums, who expect to see the troubling in museums and call it art (for we must call it art), is to deny the impossibly upsetting powers that arise from conflation. Otherwise we would not be able to cope with the disturbances, or face the threat of destruction. For these reasons we attempt to strip the image of all reference, except the reference to its own marks. We attempt to say that the sign *is* the signified; that the mark is nothing more than the mark itself. Of course, when we speak of stripping the sign of all reference we mean, *grosso modo,* reference to nature; and that leads us to the last of our questions from ideology. What are the implications in terms of social class, first, of the need to reconstitute the world in a picture or sculpture; and second, of the wish, the desire, and the simple ability, to see the sign as constituting nothing but itself?

To pose the latter question is not to admit its possibility. Indeed, from William IX of Aquitaine who sang, "I will make a *vers* about downright nothing:/ Not about myself or anyone else,/ Not about love or youth,/ nor about anything at all;/ I've just written it sleeping on my horse," to Jackson Pollock, whose avowed aim was to find a means of signifying and ordering experience other than by some parasitic dependence on likeness to nature, we encounter the attempt to make art out of something other than the accepted ways of making sense of the external world.[91] But these efforts to deny the kinds of referentiality that the nonruminative (at least) recognize

as persuasive, evident, and logical are hardly democratic in any sense: they are inevitably the products of elite culture, and they obfuscate the very bases from which the evolution of such sophistication springs—however rewarding the results may be. It is not part of my proposal to take away from such rewards; it is simply to point yet again to the consistent folly of making images safe by ranking them as art. What we do when we respond positively (say simply with enthusiasm) to the large blocks of clearly divided color in Barnett Newman goes deeper than the mere pleasure in color or form; the iconoclast—however deranged, whatever the personal axe he has to grind—recognizes the profound reordering of experience that springs from the acknowledgment that the image is not just art. He recognizes it, even if he does not articulate it. Even now it would be presumptuous and misleading to do so.

But the cases of Pollock and Newman—among many others—raise a further problem. It is one which demands a closer examination of some of the premises which may appear to have been staked out so far. Say, with Pollock, that despite the avowed intentions of the painter, the viewer looks for the body in the picture, or for the Gothic forms suggested by the title; say, upon seeing the painting by Barnett Newman entitled *Vir Heroicus Sublimis,* the spectator inevitably goes in search of that great man, and upon not finding him, is so frustrated that image fetishism gets the better of him. Perhaps he cannot give up his search to extract the figure from the picture, but when he does not find it, responds with dissatisfied violence, unafraid. Or goes away shrugging his shoulders in the contentment that it is just art, that at least in museums figures do not lurk in abstract pictures, insisting on the need to possess them.

It may be that reconstitution needs to be located more precisely in its historical, social, and ideological context, before we can be clearer about the bases for cognition. To locate it fully would require other books; here we may be schematic. However provisional, this will at least provide a start in the indexing of self-reflectiveness. If, schematically, we assume that ordinary people happen to conflate, while elite segments deliberately strive to avoid the compulsion of referentiality, what are we to make of the ways in which we find ourselves attempting to make sense of the picture by reconstituting that which is or which we want to be within it? Is it only in late bourgeois society that we do so, that we feel compelled to make sense of nature in terms that we can visually recognize, that we colonize alien nature by incorporating it directly into the art on which we thrive? Is the whole of Western art practice and theory predicated on the need to know nature thus, and on the tacit but profound belief that knowledge only comes from possession (and therefore, with nature, from what one might call colonization)? Of course it will be argued that the same might be said for other cultures, for the relations between nature and art in all of Chinese culture,

for example. The question, then, is not so much whether or not the need to reconstitute is cognitive; but rather why it has become so deep an issue in the West.

It has become so deep an issue because of the inseparability of the iconoclast and the iconodule positions. Both are predicated on the possibility of reconstitution and fusion. Both are based on the cherishing that turns to fear. We see, we gaze, and we create the false idols we must destroy; we see, we gaze, and we create lively parallels for the existence of the true God. That is the only way to know the divine or to ascend to it. The sense of sight is also the most direct channel to the labile senses, vastly more direct than words. But for both iconodules and iconoclasts, words are less distracting—and simply higher—channels to the divine. Both need images and admit to their power, and in so doing need to control them. Calvin, as we know, violently disapproved of the old Christian uses of images: how could material images possibly circumscribe the unmaterial and invisible divine? He would not have any truck with the visual symbolization of the divine, beyond the Eucharist. To make material images of the uncircumscribable all-creating Creator, when the real images were already around us (in the form of our fellow beings and in the manifestation of Christ as flesh), was terrible idolatry. One could only represent *quorum sint capaces oculi:* those things which the eye was capable [of seeing].[92] What Calvin meant by this was that one could paint everything that could be seen; not that which could not be seen, not the invisible or the hidden God. Hence the great premium on realism; hence the fact that we know what we mean by realism (the old arguments against it are vain obfuscations; the issue is no longer the obvious and accepted one of changing conventions of realism and illusion). If representation is not to be an infringement of divine law, indeed of the capacities of human nature, then it must show things recognizably as they are; and if we cannot find them, then no wonder we strive, even if in vain, to reconstitute. Without reconstitution there can be no God at all, because the graspable representation of things which are around us reassures us of the presence of that which cannot be pictured or sculpted. And once we do picture that which cannot be pictured, we impugn the sole right of God to breathe life into beings and things.[93]

It may be that the assertive humanism of E. H. Gombrich has led him into positions in which reconstitution of representation into forms we recognize is seen as part of human nature; and it may be that such a view fails to acknowledge the ideological implications of its own bases. But why the fierceness of the rebuttals, since Gombrich himself insists on the firm contextual constraints on recognition and resemblance? Why the rigorous insistence by Nelson Goodman that resemblance is nothing but inculcation, that likeness is not merely but wholly conventional and symbolic? Why Pollock's intense belief that he could somehow paint pictures which were

stripped of their referentiality to nature and to the order and experience of nature? Why the profound attractiveness—at least for a while—of Clement Greenberg's conception of the fruitfulness of painting that does not go in search of the world beyond painting for its subject matter? Because, as I have implied throughout this chapter, of fear.

To suggest that the answer lies in the realm of fear is not to espouse any view of the superiority of the reference to nature, to the human body, or to organic form. What the position implies—requires—is an attentiveness to the bases upon which we rank things as art and non-art, and to the self-deceptions upon which such distinctions occur. They are not, of course, self-deceptions if the questions are purely ones of personal enjoyment; but they are indeed self-deceptions if there is ever to be the possibility of any analysis of effect, power, and the success or failure of images. For that, in the end, however relativist we may claim ourselves to be, is what we talk about.

15

Representation and Reality

L et us consider the way forward. I have covered a wide range of topics. What connects them is the power of images and our attempts to come to terms with—or refuse—the evidence. But what conclusions may be drawn from the vastness of the material?

I set out to show that the power of images is much greater than is generally admitted. My first aim was simply to lay bare the evidence. But I was also concerned to show that the kind of responses I described could not just be relegated to the past or to backward or provincial places. I knew perfectly well that the objection would be that while all the material might or might not be of historical interest, it pertained only to the past (or to fantasy). Thus my aim acquired a polemical edge. I hoped that anyone reading the chapters would swiftly realize that many of the elements of response described in them did indeed obtain in the present, and that they were ones which modern readers would recognize in themselves, even if reluctantly. Hence too—given the temper of our times—the demonstration in sexual as well as religious contexts.

My claim, then, was that we repress the evidence of responses clearly revealed by past behavior because we are too embarrassed by it, and—just as in the past—because we fear the strength of the effects of images on ourselves. But I also anticipated the objection that the kinds of responses I described only arose in the case of low imagery, certainly not in the case of the high, the canonical, and what we call art. It was here that the polemical edge of my arguments was intended to be sharpest. Indeed, it was against precisely this view that I set out to write this book, as well as against the related view that such responses are not only those of the past, but of more primitive people and more primitive societies. Much of our sophisticated talk about art is simply an evasion. We take refuge in such talk when, say, we discourse about formal qualities, or when we rigorously historicize the

work, because we are afraid to come to terms with our responses—or, at the very least, with a significant part of them. We have lost touch with them, so we repress them and do not study the kinds of material I have presented—or, if we do, we fail to draw out their full implications.

What are these implications? Some of the most important ones are spelled out in Roland Barthes's beautiful and searing essay on photography, in which he admitted that he began by trying to find the essence of photography, but discovered that he could only talk—only wanted to talk—about response. After a series of semiotic claims about responses to the photograph, Barthes concluded that in order to see the photograph in all its fullness, he had to combine two voices: "the voice of banality (to say what everyone sees and knows) and the voice of singularity (to replenish such banality with all the élan of an emotion which belongs only to myself)." [1] This is precisely what I have advocated not only for photographs but for all images. We survey the banal and commonplace evidence, the evidence we all know, and supplement it—flesh it out—by looking more deeply into ourselves. It is not easy to do this, because of repression. But while we cannot entirely rid ourselves of the inclination to repress (since it is an inescapable part of all looking, and of all the excitement of looking), we can at least admit to it. We have, in a sense, to try to lose our education (at the same time acknowledging that we never can) and become "primitive" and crazy in the way Barthes proposes: "Mad or tame? Photography can be one or the other: tame if its realism remains relative, tempered by aesthetic or empirical habits; mad if this realism is absolute, and, so to speak, original. . . . The choice is mine: to subject its spectacle to the civilized code of perfect illusions, or to confront in it the wakening of intractable reality." [2] He had just been even more explicit: "Society is concerned to tame the Photograph, to temper the madness which keeps threatening to explode in the face of whoever looks at it." [3]

This is strong language, but it does serve to emphasize the chief obstacle in the way of understanding response and learning from history. The obstacle is our reluctance to reinstate emotion as a part of cognition, as Nelson Goodman, for one, has so eloquently argued. [4] This reluctance runs deep, but never more so than when we talk about art. We have the ready means of high talk always to hand, or we set out to learn it. We who are educated look and behave in detached ways, we become high formalists, and we deny the wellsprings of the power inside and outside ourselves. We also omit those aspects of feeling and emotion that are usually left outside cognition and are considered so fine-grained and distinctive that they cannot be held by anything but the most anecdotal procedures in history. These too are what I reclaim—in spite of the refusal of academic history and much aesthetic theory—both for cognition and for history.

The two chief means modern viewers have at their disposal for talking

about art thus fail us. I have alluded to both already: the first is high critical talk; the second is that which is too strictly based on reclamation of context. Both enable evasion and allow one to talk in terms from which the untidiness of emotion is necessarily excluded. The first entirely suppresses the elements of emotion, appetite, and behavior that I have sketched. The second acknowledges such things, to a certain degree, but only historically. It resolutely refuses to allow the integration of ourselves into the past, or—to put it less sentimentally—to allow the lessons we learn from our own responses to inform our judgments about the past. This approach is only rigorously historicizing in principle, but that is precisely what its practitioners too often forget.

The approach to art that sets out to reclaim original context, or (as in the case of what has come to be called inferential criticism) to reclaim appropriately contextual critical terms,[5] is often adopted not only by those who are dissatisfied with the strategies of high formalism but also by those who are skeptical of all views of the redemptive possibilities of art (and of great art in particular). It is also held by people who claim that we somehow appreciate and enjoy a work of art more when we see it "in its own terms." The trouble with all this—both with the sophisticated practice of inferential criticism and with the "own terms" school—is that we cannot thus purify ourselves either of our past or of the insistent present. We have seen and learned too much; we cannot see with old eyes. History does not give us that possibility—and so the question still remains whether we have any other resource for grasping the power that is constrained by context, event, and idiosyncrasy.

I have often noted that there are also means of thinking about response in contexts where superior terms are less articulated; and that the attempt to recover such contexts may in turn illuminate those kinds of response that are not described by the terms recovered by inferential criticism. I have also remarked on the difficulty of thinking analytically about responses to art without considering responses to all other imagery in particular visual cultures. It is true that at least some exponents of the inferential and historicizing approach will concur, at least notionally; but in practice the examination of low responses or responses to low imagery (let us keep that hypostasized category for the moment) is avoided.[6] In short, to limit the description of response in these severely historicizing ways and thus to define the "causes" of response (for that is what is implicit in the endeavor) is often to restrict the audience for art in a manner unsupported by historical fact. It is also an impoverishment of our own relations with art and, for that matter, with all images. No such procedure can reclaim anything but the data thrown up by a misguidedly positivist approach to history; nor can it tell the full story, unless it also retains a strict sense of that which is omitted and repressed. I speak not only of what may be left unrecorded by

the documents of commission and criticism but also of supposition based on experiential categories solely bounded by the data of history. The kinds of research espoused by practitioners of these forms of art history give us a history that cannot tell us enough about response because it does not begin to comprehend the relations between sentiment and sensation on the one hand and knowledge on the other.

The alternative to all this is to seek what is, might, or would be liberating: not just for the sake of the enhancement of pleasure, but also for the enhancement of analysis and theory. The issue of pleasure (or terror) cannot neatly be shifted aside as not pertaining to the historical endeavor; it is integral to it. We do not need to embark on mystical proposals of the value of art or images, or on suggestions of how images or art might better lives and enhance feelings. Nor is it simply a matter of the intellectual pleasures that may accrue from the satisfying practice of history. It is, instead, a matter of endorsing acknowledgment and description of sensations and emotions as part of the experience which history takes within its sphere. By this I do not mean the curious or amused recording of random emotion and sensation as they feature in anecdotal history, or the elevation of anecdote to indexical status, as is now the fashion. I mean recognition of the deep cognitive potential that arises from the relations between looking—looking hard—and figured material object.

But how can we liberate ourselves so that we can recognize this potential in any form prior to its re-formation by values, codes, even by anything that might be subsumed under the heading of the collective unconscious? How can we achieve that liberation, admitting our position in history and remaining as aware as we can of the fullness of our cognitive stock, but still granting the image its force? It would be impossible to do so completely. The project, as I have' said, must be twofold: in the first place we must survey the banality of responses to all imagery; and in the second place we must look more deeply inward. It need not mean the acceptance of formalism, of historicism, or of the way we generally think about the canon and exclusions from it.

All this may seem to suggest a high skepticism on my part about the interest of high art. On the contrary. Although the traditions of talk about art may be so strong that we do indeed derive profound intellectual pleasures from high formalism, we also know that we can go into a gallery and be moved beyond words, even to tears. We recognize the possibilities when we go into a museum and see a great picture or sculpture. We see the object and feel that history and common judgment have rightly sanctioned its status in the canon: we feel no doubt whatsoever of its presence; we feel the fullness of its aura and its great force. Most readers of this book will recognize some kind of feeling along these lines, however much they may also sense that they have been set up by installation or museological trick (just

as display was and still is manipulated at many shrines). The aura of the picture or sculpture in a museum may even approach something of the force of its original aura, notwithstanding the abating effects of reproduction and removal from original context. There is nothing like this repleteness with billboards or with the vast bulk of everyday imagery—not usually.[7] But what do we forbid ourselves in the street? And what do we deny in museums? In other words: we can begin to reclaim aura by being aware of its possibilities (such as I have tried to sketch in this book); and that awareness can only come from admitting force—even if it is only to reject it, and not submit to it.

But here we should proceed with caution. By aura I do not mean something vague, mystical, or unanalytic, or some mysterious quotient or residue of energy within a painting or a sculpture. Aura is that which liberates response from the exigencies of convention. And while I suggest that we may reclaim the power of images by attending to the forceful effects of some great works, I do not wish to propose that we need great art for that. Nor indeed, to rank at all. Once again Nelson Goodman (who certainly would not deny the pleasures of high aesthesis) is eloquent on the subject: "Works of art are not racehorses and picking a winner is not the primary goal. . . . Estimates of excellence are among the minor aids to insight. Judging the excellence of works of art or the goodness of people is not the best way of understanding them."[8]

The fact is that ranking has become a hallmark of Western and much Oriental thought about art, and it goes along with repression—though I do not deny for a moment that some works are inexplicably more beautiful than others. The problem with ranking is that it is of a piece with the position that assumes a radical disjunction between high and low images and high and low response. To continue to hold to these radical disjunctions is to stand in the way of allowing the emotions described by Barthes a fuller place in our thinking about all imagery, whether high or low, primitive or modern. In a sense, then, the aim is to democratize response.

The same lessons may be drawn from our detours into the ethnographic collections. We need ethnography not to reclaim original function, but to sense the roots of admiration, awe, terror, and desire—indeed, to understand the very fact of function itself, not historical function but the functions predicated on the integration of feeling into cognition. When we see the powerful images of primitive art in a museum we pause in horror and amazement, struck to our core. We recognize what we miss in the generality of conventional response. But this is not to claim that only the art we continue to call primitive has these effects: whether the flayed figure is by Ligier Richier or from Aztec Mexico, we still start back in natural horror. It is simply that we recognize such responses more frequently and with greater clarity when we go into those rooms where the imagery is so dis-

tinctly other, and where the relations between function and response seem, intuitively, so much plainer than in the traditions in which we are drenched, or know too well. Furthermore, while we may have every reason to be grateful for adequate or enhancing housing in a museum, all such images could not more strikingly evince the uselessness of the category of art. They are images integrated into life; they are not art. When we respond to them in museums we sense immediately the effectiveness of their functionality. Of course there are many images from primitive cultures that were made as art too, and there is by now plenty of anthropological literature to testify to the richness of artistic terminology within particular cultures, for example and most famously, the Yoruba.[9] But it is hard to escape the fact that the functionality of the works depends on factors that, in many cases, do not require the notion of art or of ranking. Nevertheless, we should be careful to remember that for images to be beyond art or ranking (in the sense that such notions are irrelevant to their function), or to precede such categorization, we do not have to claim that artistic criteria did not enter into their making, or that such criteria do not have a great deal to do with their effectiveness. But the effects of great size, flayed skin, hollow or glistening eyes, mouthlessness, or any form of dismemberment are not to be forgotten as factors which do not easily fall into the tidiness of most other (if any) "aesthetic" criteria.

It is true that from our responses to "primitive art" we learn that we are not or need not be too concerned with how to respond, or with what our culture may regard as the appropriate, decorous, or conventional way of responding. In other words, we are less likely to feel compelled to pay court to the terms of formalist or historicist discourse when it comes to description of response or feeling; though of course there will always be some who will feel obliged to force their responses into appropriate systems of criticism. On the one hand, it may be argued that by refusing to apply the terms we apply to Western art to that of other cultures we are guilty of blind cultural superiority; on the other hand, it may be felt that the liberal position is too repressed, as it seeks to apply good formalist terms to responses that powerfully precede the sense of what such terms seek to describe. Neither position is relevant here. All I claim is the need to integrate the experience of reality into our experience of imagery in general, and into the terms of critical discourse about imagery and about art. If we do not do so, we lapse into the categorial preconceptions and the ideological narrowness against which this book has set itself.

The strong lessons, then, sometimes come from our responses to that which we recognize as a (Western) masterpiece and to that which we call primitive. Indeed, "primitive" is frequently used as synonymous with powerful, strong, effective; and it is not unusual to find ourselves using, as the final term of approbation for a non-Western or non-Oriental work, the term

"masterpiece," in a nearly explicit acknowledgment of the way in which we measure primitive art by Western or refined Oriental standards.

But there is a third broad category which provides some of the strongest lessons of all: the art that is hung in the modern and contemporary museums. Here the irony will be plain, since it is around just this broad category that the most refined kinds of formal criticism and the most developed vocabularies have developed. Already the democratic exponents of such criticism will be alleging that they wish to have nothing to do with the generalizing of an art which they confess to be fundamentally elitist. They will maintain that we should simply admit that our concerns are high level, and not everyday or ordinary or of interest to those not concerned with art in the first place. [10] That position is not one to be argued out here, though it has always seemed specious to me. I have no wish now to make claims for the liberalization of good modern art; what I do wish to suggest is that once again we who look at it attend rather more closely to our responses than the conventional terms allow. For within our own experience of modern art, unsurprisingly, we find further clues to the relations between looking and figured object that we normally repress and that I am here seeking to reintegrate into discourse about imagery in general and art in particular.

The modern museum is useful precisely because there we need not be misled by figuration or iconography. And even if there are both, they are often less distracting than in earlier art. We are arrested by size or color or the suggestion of smell, or nauseous agglomeration of surface texture. It might be felt that to describe such things calls for the terms of formalist criticism, but that would be to diminish and etiolate such responses. To allow them their full role is, again, to acknowledge the role of sensation in knowledge. We see jagged edges, spikes, texture, flakiness, and we respond in more visceral ways than refined criticism is usually capable of being articulate about. Although it often implicitly acknowledges such sensation, it never explicitly articulates it. But this is no call for better description or better criticism. It is a summons to expand the possibilities of a better understanding of response.

I have suggested, often enough, that a history of response can only commence by taking into consideration as wide a range of imagery as possible. It must do so on the basis of admitting the fundamental role of repression in all feeling about images. It acknowledges the consequences of the ideological pressures—from which it does seem possible to escape—to rank and classify, not only as art, but as high and low, and as that which pertains to the higher faculties on the one hand and that which must be excluded because it rouses the lower ones on the other. The kinds of responses that have chiefly interested me here are precisely those which all too often give way to other ones, to fine "aesthetic" ones, to the kinds usually engaged

in the weak criticism that is either formalist or purely historicizing.[11] We need not be ashamed to see the image come alive; indeed, we should speak of it.

But what does all this entail? A conclusion is suggested by one aspect of my arguments; but it is one that may have generated misunderstanding. Readers may have felt that I have overemphasized the search for the figure, and that in having had such frequent recourse to the notion of reconstitution, I have taken too dominantly a figurative or illusion-oriented view of art. I would hope that my references to different and more immediate responses lay this potential misunderstanding to rest: I allow the full weight of responses that originate in a sense of enjoyment in multifold, random line, in paint, line, size, extravagance, minuteness, absence, large areas of flat color. I emphasized the problem of reconstitution because it is one aspect of response that we are most prone to suppress. Indeed, if there is anything that illuminates the mechanisms of suppression it is the search for the figure, for parts of the body, even the *membra disjecta*, for signs of biological form. We may not find such forms, but then we must reckon with the consequences of failing in our search as an aspect of response. This is not to suggest that everyone responds to biological form in similar ways; it is to take one kind of response that we can recognize without too much effort and to suggest that we be more relaxed about our inclination to elide and conflate the appearance of visual forms with reality.

A radical conclusion thus imposes itself. It is that we reconsider the whole insistence in Western art theory—as, perhaps, in Western philosophy as a whole—on the radical disjunction between the reality of the art object and reality itself.[12] This is not to argue for a revision of the philosophical and ontological view; it is to propose that we will only come to understand response if we acknowledge more fully the ways in which the disjunction lapses when we stand in the presence of images. However much we may strive to do so, we can never entirely extract ourselves from our sense of the signified in the sign; and our responses are irrevocably informed by that.

It may be—though it is debatable—that our commitment to seeing pictures and sculptures differently from the way we see the world around us became fixed, even ossified, at the end of the seventeenth century. Theory had long tended this way, and was consistently infected by the measuring of the effect of representational works against the effect of their perceived equivalents in the real world. It has rightly been remarked by Thomas Puttfarken in his excellent book on Roger de Piles (1635–1709) that one of the fundamental problems of depiction, and of the specifically visual effectiveness of representational painting, was (for de Piles) that of "distinguishing between the way we perceive pictures (and the effect they have on us)

and the way we perceive and are affected by the real world around us."[13] This is the problem that continues to hamper our project.

It was, in short, Roger de Piles who set out the terms for the important modern distinction between the artificial order and the natural or imitative order of painting which some modern critics may feel I have wrongly conflated. They would be right in thinking that I have suggested that the two orders may be usefully collapsed. By no longer using nature (out there) and representation (as reflection) as the criteria by which we measure successful imitation, and therefore successful effect, we may avoid the old dead ends into which even De Piles drove himself. Imitation falls away as a criterion of success, though it remains a factor in response. But we need no longer worry that "if represented objects and their qualities were not of intrinsic interest in painting, how could painting avoid the ancient accusation of being of interest merely for its feat of imitation, irrespective of what it showed?"[14] We need no longer worry because that is not only no longer relevant, it is not the way the question is posed by the student of response. The issue is precisely how we respond to the uninteresting represented object (if the painting is indeed representational). Response does not only hang on how it is painted, nor, indeed, on how successfully imitative it is—as if our response to the shoes Van Gogh painted (fig. 189) only referred to the quality of the brushstroke or, for that matter, to the charming accidents on the surface of worn and weathered leather! The old insistence that "the conditions under which we see a depicted world, painted in material colours on a flat surface surrounded by a limiting frame, are fundamentally different than those under which we see the real world" thus becomes irrelevant, and so does the conclusion that "this limits the illusion of depiction in a number of important ways but also gives to painting its powerful uniquely pictorial effectiveness."[15] And it is by no means only a matter of painting. It is as much a matter of sculpture.

The project, in the first instance, must be to see the consequences of easing the disjunction between the image (bounded in whatever way) and the real world around us. To see the consequences is to enable the kinds of historical analysis that have been impeded by the evidence, over vast tracts of time and regions, of resolute conflation. To do so is also to free seeing now from the burden of the need to assign—to assign pictures, sculptures, and other forms of art and imagery to appropriate contexts, shrines, and canons. What clouds our perception is exactly the compulsion to establish whether an object is art or not, and whether it belongs in a museum or not. Such clouds may be dispelled; though it has hardly to be said (however much it should still, for precaution's sake, be repeated) that much image making goes on in the full awareness of just that need and its historical force. Instead, then, of seeing the disjunctions, the time has come to see

the picture and sculpture as more continuous with whatever we call reality than we have been accustomed to, and to reintegrate figuration and imitation into reality (or rather, into our experience of reality). That is to say, the time has come to acknowledge the possibility that our responses to images may be of the same order as our responses to reality; and that if we are to measure response in any way at all, then it is to be seen and judged on just this basis.

The further implication is that when we talk about art we should more freely use the terms we apply to that which exists before and beyond the world of images and of art—unless we specifically wish to engage in artful or artificial discourse, and to make the new forms that are criticism but are generally weaker than art forms. I make the proposal because such talk would then correspond more closely—more completely—to how we actually respond, or to the bases of response. In order to avoid the kinds of misunderstanding which such a proposal might generate, let me emphasize that such talk is not to be confused with old talk about the relations between nature and art. I do not wish to suggest that response should be based on the perception of representation as the more or less successful imitation or illusion of nature—even though sometimes it undoubtedly is, and even though such a criterion stood for millennia as the crucial basis for response and, at the same time, for the success or failure of a work of art. No wonder there was such anxiety about the emulation of the altogether beautiful and original creation of God, of the truly divine. Everything else was either (temerarious or aspiring) imitation—or mere illusion, "mere" however full of art and skill. But I do not here speak of imitation and illusion, except incidentally.

Such are the reasons for giving all images their full weight as reality and not merely (simply, old-fashionedly) as representation. We have been fortified by generations of theorists in the view that the wonder and illusion of representation is different from the wonder and illusions of reality. In this respect representation is exactly the opposite of what it has always been supposed to be. Representation is miraculous because it deceives us into thinking it is realistic, but it is only miraculous because it is something other than what it represents. The great deceptiveness of the central theories of representation to which I have alluded in this section has been this: it has made us measure response (and success of making) in terms of the absolute distinction between representation and reality. But everything about the picture and the sculpture demands that we see both it and what it represents as a piece of reality: it is on this basis that we respond. To respond to a picture or sculpture "as if" it were real is little different from responding to reality as real. [16]

For all the return to what critics may want to call representational art, one of the lessons of art and of image making now (and over the last fifty

years) is that much of it cannot by many means be called representational—at least in any useful sense. ("Figurational" might be better, but that remains to be seen.) Representationality remains as problematic a concept, in terms of visual theory, as "realism," "reality," and "nature"; and it may be that we should be as prepared to renounce it as we are in the case of these other terms; or to cease invoking it. I have implied—and the time may have come to state it explicitly—that when I speak of the integration of art and image making into reality, I do not just mean that we do so by reconstituting, or that we make art part of life, as it might crudely be put, by "seeing as," by seeing something as something else. It is of course possible to integrate by seeing the image as an affective object of colors, shapes (internal), and forms (external). This is what we learn from modern art as well as from primitive imagery, where we intuit and feel that effectiveness of function proceeds directly from affectiveness of form, color, mouth- and eyelessness. But in asserting this lesson we do not and should not deny the full import of subject matter, of imputed realism, or of the success of illusion in the object (as, extremely, with Zeuxis' grapes; with Hoogstraten, Harnett, Peto; with *sacri monti,* Kienholz, and Duane Hanson).

The burden of history lies heavy on cognition. We can renounce neither history nor context, not even when we respond on the basis of our sense of the imminent collapse of the object, of its weight, colors, and textures. But while we can hypostasize nothing that precedes context, the danger of a strict and unthinking contextualism is that it fails to take into account the ways in which individuality is pressured by history and context; it assumes the very position of generality that it ostensibly seeks to avoid. It is precisely the possibilities of individuality prior to their inflection by context that I have tried to reassert. There is nothing to be identified except the failure to acknowledge the extent of repression.

And as we have surrendered talk about imagery to the conventionalists and only tolerated that which we think the generality of our peers can know and tolerate, so we have relinquished the hard, brute, and sweet reality of the image. Barthes loved the reality of the photograph because in it he saw the death of his mother transcended. In his gazing at it, she was not just restored; she existed again. The reality of the image does not lie, as we might like to think, in the associations it calls forth; it lies in something more authentic, more real, and infinitely more graspable and verifiable than association. "The photograph," we remember Barthes saying, "does not call up the past (nothing Proustian in a photograph). The effect it produces upon me is not to restore what has been abolished (by time, by distance) but to attest that what I see has indeed existed." However Proustian a painting—and it may indeed be more so than a photo—Barthes's statement about it is full if implication for all imagery in the modern world. He goes on: "Perhaps this astonishment (produced by the photograph), this persist-

ence reaches down into the religious substance out of which I am molded; nothing for it: Photography has something to do with resurrection: might we not say of it what the Byzantines said of the image of Christ which impregnated St. Veronica's napkin: that it was not made by the hand of man, *acheiropoietos?*" [17]

So much for the magnificent fullness of the photograph. It transcends death and peculiarly replenishes the lost being. What is lost or absent seems present, but we cannot know why. As soon as we strive to grasp that presence in all its fullness, we either fail or set out to tame or destroy it. We see the image: "There she is; she's really there," we exclaim, as Barthes does. [18] But there is nothing on the other side of the paper, or even within the wood or stone (unless some priest hides within it). "Alas," says Barthes, "however hard I look, I discover nothing: if I enlarge I see nothing but the grain of the paper." [19] We think we can escape bad dreams by talking about art, even about the grain of the medium; but the dreams return to haunt us because we have not dealt with reality, only illusion.

Perhaps we must admit that it is in this transcendence of death wrought by the form that should not have been capable of being made by human hand, that *should* not be made by it—that it is in this that the redemptive power of images lies. It may be thought that all my arguments for the power of images are invalidated by the fact of reproduction, by the fact that images have become weaker as they have become generalized, banalized, made infinitely sociable. [20] But at the same time, what has also changed is that however much the photo may wilt and fade, however much it may be attacked by humidity and light—those remorseless phenomena of nature which also attack images of bronze and stone—the photograph is not mortal. It is not mortal because it is reproductive and reproducible. It is alive, present, and real. For these reasons Barthes's observations apply not just to the photograph but to all the images we know and are likely to know. First as a result of the woodcut and the printing press, then with the development of engraving, but finally and conclusively with the advent of the photograph, all images have become irrevocably reproducible. Away with the monuments of stone! We need them no longer. Because of the fact of reproduction, every image has become reality and is a witness of what is, what has been, and therefore of what will always remain. Even if the images we now hold in our hands go and are lost, the technology of reproduction takes away from every reality and makes it into a possible picture; we know that instantly. The picture is reality; it is not bad, or misleading, or deceiving, or even weak copy. It need not lose its aura, provided we see that its poetry or its clumsy prose lies not in its distance from the real, but rather in the possibility it offers for the integration of the unashamed creativity of the eye with the blunt receptiveness of the senses. A history of response that takes all this into account may begin its task of reclamation.

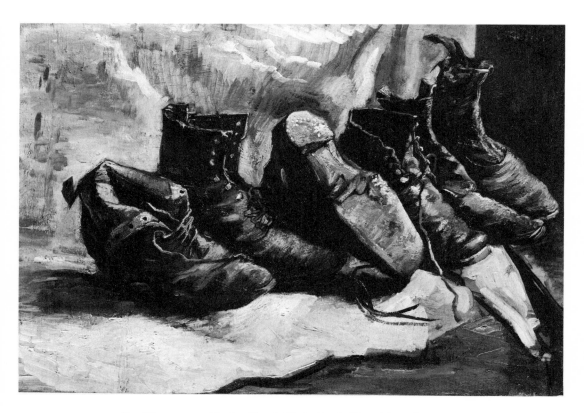

189. Vincent van Gogh, *Shoes* (1887). Cambridge, Massachusetts, Fogg Art Museum, Collection of Maurice Wertheim.

Abbreviations

AB	*Art Bulletin*
AA.SS.	*Acta Sanctorum.* Antwerp, 1643ff.
B	A. Bartsch. *Le peintre-graveur.* 21 vols. Vienna, 1802–21.
BM	*Burlington Magazine*
COD	J. Alberigo et al., eds. *Conciliorum Oecumenicorum Decreta.* 3d ed. Bologna, 1973.
DA	C. Daremberg and E. Saglio, eds. *Dictionnaire des antiquités grecques et romaines.* 5 vols. in 10. Paris, 1877–1919.
DACL	F. Cabrol and H. Leclercq, eds. *Dictionnaire d'archéologie chrétienne et de liturgie.* 15 vols. Paris, 1907–53.
DOP	*Dumbarton Oaks Papers*
DThC	A. Vacant, E. Mangenot, and E. Amman, eds. *Dictionnaire de théologie catholique.* 15 vols. Paris, 1909–50.
EWA	*Encyclopedia of World Art.* 15 vols. New York, Toronto, London, 1959–68 (*Enciclopedia universale dell'arte.* Venice and Rome, 1958).
GCS	*Die griechischen christlichen Schriftsteller der ersten drei Jahrhunderte.* Leipzig, 1897–1941; Berlin and Leipzig, 1953; Berlin 1954ff.
Madonna dei Bagni	*Gli ex-voto in maiolica della Chiesa della Madonna dei Bagni a Casalina presso Deruta.* Le classi Popolari nell'Italia centrale 9, A. Cataloghi e repertori, 8. Florence, 1983 (Catalog of an exhibition held in Spoleto, 22 June–10 July 1983, with contributions by G. Guaitini and T. Seppilli et al.).

Mansi	J. D. Mansi, ed. *Sacrorum conciliorum nova et amplissima collectio.* 31 vols. Florence and Venice, 1759–98.
Manuale	*Manuale selectissimarum . . . ex diversis ritualibus & auctoribus collectum.* . . . Ex Ducali Campidonensi Typographia (Kempten), 1780.
MGH	Monumenta Germaniae Historica
PG	J. P. Migne, ed. *Patrologia Graeca.* 162 vols. Paris, 1857–66.
PL	J. Migne, ed. *Patrologia Latina.* 221 vols. Paris, 1844–64.
RE	G. Wissowa et al., eds. *Pauly's Real Encyclopädie der classischen Altertumswissenschaft, Neue Bearbeitung.* Stuttgart, 1894–1968.
Vasari-Milanesi	G. Vasari. *Le Vite de' più eccellenti pittori ed architettori* (1568). Ed. G. Milanesi. 9 vols. Florence, 1878–85.

Notes

1. I should perhaps add that I do not believe that to seek cognitive identities and psychological constants is to suggest that history is undifferentiated, continuous, or unchanging, in any sense. I have no disagreement whatever, for example, with Peter Brown's eloquent strictures on "popular belief," and specifically on the view that the cult of saints—indeed the whole of late antique "popular religion—"was a monolithic structure, presenting a "vista of seemingly unbroken continuity—*plus ça change . . .*" Brown quite rightly observes that "the cult of saints involved imaginative changes that seem, at least, congruent to changing patterns of human relations in late-Roman society at large" (Brown 1981, p. 21).

2. The phrase is Michael Podro's in *The Critical Historians of Art* (New Haven and London, 1982), p. 14, justly commenting on the position eloquently set forth in Schiller's *Letters on the Aesthetic Education of Man*.

3. A good example is provided by the case of pilgrimage. See, for instance, the great catalogs and essays as well as the books produced on the occasion of the 1984 Munich exhibition entitled *Wallfahrt kennt keine Grenzen* (see also Kriss-Rettenbeck and Möhler 1984), four years after the earlier drafts of my chapter on this subject were written. Endless case studies of particular pilgrimage shrines continue to be published, but I have chosen not to cover them in this book, or even to allude to them. I have selected, in this chapter and in the others on large subjects, salient and illustrative examples—though I might no doubt have chosen any number of others.

4. See now, for example, C. Arvidsson and L. E. Blomquist, eds., *Symbols of Power: The Aesthetics of Political Legitimation in the Soviet Union and Eastern Europe* (Stockholm, 1987).

1. THE POWER OF IMAGES

1. The first quotation is from G. P. Lomazzo, *Trattato dell'arte della pittura, scultura, et architettura* (Milan, 1584), lib. 2, cap. 1, in G. P. Lomazzo, *Scritti sulle arti,* ed. R. P. Ciardi, Raccolta Pisana di Saggi e Studi, 34 (Florence, 1974), pp. 95–96. The translation is that of R. Haydocke, *A tracte containing the artes of curious painting, carvinge, buildinge* (Oxford, 1598), book 2, pp. 1–2 (Aa i–Aa i verso). The second is from G. B. Armenini, *De' veri precetti della pittura* (Ravenna, 1587), p. 34. Unless noted otherwise, subsequent translations are my own.

2. Heliodorus, *Aethiopica,* 4.8. This translation slightly adapted from the Under-downe translation, *An Aethiopian Historie* (London, 1587).

3. The original is more blatantly sexual: "Nam Dionysium Tyrannum narrat, eo, quod ipse deformis esset, nec tales filios habere vellet, uxori suae in concubitu formo-sam proponere solere picturam, cuius pulchritudinem concupiscendo, quodam modo raperet & in prolem, quam concipiebat, afficiendo transmitteret" (Augustine, *Against Julian,* book 5, chap. 9, cited in the remarkable discussion of these and related matters in a section on MULIER (the third after METEORA and HOMO in Simon Majolus, *Dies caniculares* [Mainz, 1614], p. 55).

4. The most famous literary example is perhaps that of the daughter conceived by Eduard and Charlotte in Goethe's *Die Wahlverwandschaften;* but here the issue is as much the relationship between child conceived and moment of gaze as the conse-quences of extramarital love and the desire for adultery.

5. Giulio Mancini, *Considerazioni sulla pittura,* edited by A. Marucchi, with com-mentary by L. Salerno, (I Rome, 1956), 1:143. See also note 7 below.

6. There is no need to comment on the long history—of which everyone is aware—of the use of images to stimulate sexual arousal, from Tiberius's use of pictures to assist him in his orgies (Suetonius, *Tiberius,* 43–44) to its contemporary equivalents—whether milder in their libidinous range or not. Of course the question of *why* looking at pictures should engender such arousal at all is one of the central issues of this book. See chapter 12 below.

7. Dominici 1860, pp. 131–32. This translation largely similar to Gilbert 1980, pp. 145–46. For an outstanding discussion of the use of sculpted *bambini* of the infant Jesus (and sometimes of saints) in fifteenth-century Florence, see C. Klapisch-Zuber, "Holy Dolls: Play and Piety in Quattrocento Florence," in *Women, Family, and Ritual in Renaissance Italy,* ed. L. Cochrane (Chicago: University of Chicago Press, 1985), pp. 310–29. Here Klapisch-Zuber gives an account of the use of these religious "dolls" (several of which were after a famous prototype by Desiderio da Settignano) not only by children but also by adults—and not solely for purposes of edification and medi-tation. The sculpted *bambini* were often given as part of middle- and upper-class mar-riage trousseaus. They could be bathed and dressed and may have been thought to help in the production of good-looking children, if looked at in the course of preg-nancy (ibid., pp. 317–19, for a negative view of the latter possibility).

8. Gilbert 1980, p. 145.

9. For an extended discussion of this usage, see Edgerton 1979, pp. 45–61, and Edgerton 1985, pp. 165–92.

10. Edgerton 1979, p. 49.

11. The *compagnia* was founded in 1343. The Roman equivalent, from whose church the illustrations for this section are drawn, was the Archconfraternity of San Giovanni Decollato, founded in 1488. See J. S. Weisz, "Pittura e Misericordia: The Oratory of San Giovanni Decollato in Rome," (Ph.D. diss., Harvard University, 1982).

12. This translation slightly adapted from Edgerton 1985, p. 182. Edgerton takes as his base the *Instruzione universale per la compagnia de'Neri in occasione del esecusione di condannato in morte,* 2. 1. 138, fols. 173 v–174 (Florence, Biblioteca Nazionale).

13. Translation from J. Ross, *Florentine Palaces and Their Stories* (London, 1905), p. 230, reproduced and well discussed by Edgerton 1979, pp. 49–50. See also the good account of the life and death of Boscoli in Trexler 1980, pp. 197–205.

14. Edgerton 1979, pp. 53–57.

15. Cited in Freedberg 1985 (which contains a more extended discussion of the issues raised in these paragraphs), p. 6; see also chapter 14 below.

16. Dominici 1860, pp. 132–23; translation very slightly adapted from Gilbert 1980, p. 146. Cf. chapter 14, section 6, below. For similar fears from Saint Bernard to Martin Luther and after, see Freedberg 1982, p. 149, n. 56; and Freedberg 1986, pp. 69–70.

17. Dominici 1860, p. 133.

18. Ibid.

19. See Steinberg 1983. Also see, for example, C. Hope, "Ostentatio Genitalium," *London Review of Books* (15 November–6 December 1984), pp. 19–20: "There is nothing special about the fact that Christ's genitals are depicted in so many paintings of the Madonna. . . . The genitals are in a sense the attributes of babyhood, and for many people they are also rather cute. [In Baldung's *Holy Family with Saint Anne*] the gesture [of fondling the genitals] is at the very least ambiguous, in that the fingers could well be behind the penis, and not touching it at all. . . . If they had initially supposed that St. Anne was fondling Christ's penis, they would surely . . . have noticed not only the position of the other fingers, but would also have observed that her right hand is under the child's back . . . and that she is bending forward to take him from her daughter." (This is the one thing anyone might claim she is not doing).

20. Or there are analyses like Gould's: "The treatment of the body is generalized both in its outlines and its modelling, and in this way maintains a certain classical feeling, for all its realistic trappings" (C. Gould, *Titian* [London, 1969], p. 36). Perhaps there is nothing very wrong with this; it is simply evasive, given the absence of any further remark about the subject of the picture. In this sense it is both wrong and spurious.

21. See, for example, Reff 1963, p. 361: "The robe held by one of the maids is probably, as Wind suggests, 'the cosmic mantle designed to cover the celestial Venus,' . . . but 'reduced to a comfortable domestic apparel.' . . . The maids may allude to the Horae, the Hours or Seasons who clothe Venus with the heavenly mantle and bring her to the assembled Gods after her birth in the sea. Now it was just this celestial Venus, or Venus Urania, who was considered in classical and renaissance mythology as the goddess of noble love, culminating in marriage, in contrast to the common Venus, or Venus Pandemos, whose dominion was purely carnal love."

The view was widely shared. Compare the standard monograph on Titian by Wethey: "The interpretation of the Venus as symbolizing marital love and fidelity is doubtless nearer to the truth than the Victorian tradition, still maintained by Tietze and later writers, that she is merely a hymn to voluptuous carnality, and that the model was a Venetian courtesan" (1969–75, 3:203). The "merely" in this extraordinary passage should be compared with the similar phrases by Hope cited in the following note. For a firm revival not only of the "Victorian" view, but also the eighteenth-century one, see H. Ost, "Tizian's sogenannte 'Venus von Urbino' und andere Buhlerinnen," in *Festschrift für Eduard Trier,* ed. J. Müller Hofstede and W. Spies (Berlin, 1981), pp. 129–48. Ost also sets out the considerable circumstantial arguments in favor of treating this and a variety of related works as pictures of courtesans intended to arouse male sexual interest.

22. Reff had claimed that Giorgione's picture was "an almost religious celebration of serene and utterly chaste feminine beauty" (1963, p. 361), but it has now been demonstrated that the picture has little to do with chastity. Compare the convincing epithalamic interpretation offered by J. Anderson, "Giorgione, Titian, and the Sleep-

ing Venus," in *Tiziano e Venezia,* pp. 337–42). Here, as in Titian's picture, it is "hard to escape the feeling that the sexual invitation . . . is entirely explicit," as Charles Hope has recently observed (Hope 1976, p. 118). But Hope impairs the strength of his suggestion by going on to maintain that "these pictures were for the most part mere pin-ups, and were seen as little more than sex objects" (p. 119). "Mere" and "little more than" define the matter a little too simplistically.

23. Hope 1976, p. 118; cf. note 22. For a good account of the traditional problems encountered in interpreting these pictures, see D. Rosand, "Ermeneutica Amorosa: Observations on the Interpretation of Titian's Venuses," in *Tiziano e Venezia,* pp. 375–83, with full bibliographical references and a number of particularly relevant passages from the fourth book of Castiglione's *Courtier,* of 1528.

24. This is what Eddy de Jongh called the *schaamtegrens* in a profound appendix to his 1968–69 article on erotic symbolism in Holland in the seventeenth century.

25. This does not, of course, preclude acknowledging that the fact of the canonicity of certain images may itself condition response across all classes.

26. Benjamin 1985, p. 42, citing and criticizing R. M. Meyer, "Über das Verstandis von Kunstwerken," *Neue Jahrbücher für das Klassische Altertum, Geschichte, und Deutsche Literatur* 4 (1901):378.

27. Goodman 1976, pp. 247–48.

28. Ibid., p. 259.

2. THE GOD IN THE IMAGE

1. Mansi 13, cols. 80e–85c

2. Ibid., col. 85c

3. Kitzinger 1954, p. 147.

4. For a fuller rejection of notions of animism, see chapters 4 and 10, and—especially—the introductory section of chapter 11.

5. For stronger but less radical statements, see Gordon 1979, pp. 7–20—less radical because for him the issue is too starkly reduced to its linguistic and semantic features.

6. See Nadel [1954] 1970, pp. 190–91, 198–201, and 208–23 on this and on the important related cults among the Hausa and the Yoruba

7. Ibid., p. 190.

8. Ibid., pp. 190–91.

9. It is worth recalling, however, how frequently it turns out that images in the West which seem to be supernaturally animated are in fact literally animated by those who stand to gain—whether spiritually, socially, materially, or all three—from such appearances. Especially abundant examples are found in late antiquity (as in Lucian's splendidly satirical *Alexander*) and, with Christian images, in the Middle Ages and Reformation (although with Christian images the exmaples are often—but by no means always—no more than allegations by critics of the established use of images).

10. Consecration or investiture of this kind may, of course, derive from the artistic skill or craftsmanship of the maker of the image. This in turn accounts for the holy (or near-divine) qualities assigned to many artist and artisans, and (on the other hand) for the frequent requirements of good and pure behavior and morality on the part of the artist (but see also chapter 13, section 3, below).

11. For a description see Nadel [1954] 1970, pp. 197–201.

12. On the nineteenth- and twentieth-century discussions of animism, see the introductory section of chapter 11.

13. *Bretas* is now understood to be a non-Greek, non–Indo European word that was taken into the Greek vocabulary; see P. Chantraine, *Études sur le vocabulaire grec,* (Paris, 1956), p. 9. But the excellent articles in the *Dictionnaire des antiquités grecques et romaines* by E. Saglio (s.v. *argoi lithoi,* in *DA* 1:413–14) and F. Lenormant (s.v. *baetylia,* in *DA* 1:642–47) still provide an extraordinary fund of basic and useful references—better than the articles by E. Reisch and K. Tümpel on these subjects in Pauly's encyclopedia (*RE* 3, cols. 723–28, and *RE* 5, cols. 2779–81, respectively).

14. Arnobius, *Adversus nationes,* 1.39. All such references are, of course, to be seen as polemical, in the light of the arguments about idolatry and pagan image-worship around A.D. 300. Indeed, as Clerc noted (1915, p. 11), this particular passage is a close translation of Lucian, *Alexander,* 30 (about the religious enthusiast Rutilianus).

15. This is the *aition* provided by Menodotos of Samos, as cited in Athenaeus, *Deipnosophistai,* 15. 11–15 (= F. Gr. Hist. 541 F1). See also Meuli 1975, pp. 1060–62. From the statues of Daedalus which had to be chained in order to prevent them from walking or running away, to those many protectors of cities that had to be kept on the spot, the classical stories of restraints upon things one would have thought to be immobile are legion. For useful summaries, see the works by Meuli (1975) and Merkelbach (1971), as well as chapter 4, section 6.

16. Plutarch, *Life of Aratos,* 32.

17. It is not hard to understand this when we consider our own unease in the presence of the rudimentarily shaped African sculpture with the turquoise eyes that stare, disquieting and coldly piercing.

18. The matter has been exhausted with little descent from the merely speculative in the discussions of tree cults, whether by anthropologists or classical scholars.

19. For other examples of this particular form, see also May 1950, plate 10, nos. 437–58. A particularly good illustration, which also gives some hint of the rudimentary markings on the stock itself, see G. K. Jenkins, *Ancient Greek Coins* (London, 1972), plate 277.

20. I am not here referring to the case of Cycladic idols, although their relevance to the present discussion is clear.

21. Johannes Tzetzes, *Chiliades,* 1.19; Clerc 1915, p. 22.

22. On *xoana* see, in addition to Frazer's commentary on Pausanias 1.22.4, F. M. Bennett, "A Study of the Word XOANON," *American Journal of Archaeology* 21 (1917):8–21, and "Primitive Wooden Statues which Pausanias saw in Greece," *Classical Weekly* 10 (1917): 82–86; J. Papadopoulos, *Xoana e sphyrelata,* Studia Archaeologia, 24 (Rome, 1980); and the very thorough thesis by Donohue (1984). It should perhaps be noted here that the use of the term *xoanon* varies very widely, and that it is often used in the context of idolatry (*xoanon* often being more or less synonymous with *eidōlon*), in authors who range from Clement of Alexandria to Philo Judaeus and even Flavius Josephus. The possibility that Pausanias's *xoana* were in fact fully figural, or were not even of great age, as some authorities claim (cf. Donohue 1984, p. 151), does not diminish the implications of the issues of inherence and identity raised in this chapter and in chapter 4.

23. "Xenēn kai epi theois Hellēnikois ou kathestatōsan" (Pausanias 10.19.2).

24. Pausanias 10.19.3.

25. F. Junius, *On the Painting of the Ancients* (London, 1638), p. 351. The work is Junius's own translation of his treatise *De pictura veterum,* which first appeared in Amsterdam a year earlier. The related term in Porphyry, *De abstinentia,* 2.18, is *theia.*

26. Porphyry, *De abstinentia,* 2.18.

27. See the passage from Diodorus Siculus quoted in the following paragraph, as

well as the scholion on the immensely important passage in Plato, where he speaks of the way in which Daedalus, having marked the limbs, enabled statues to move (note 29 below; cf. also chapter 4, section 6).

28. Pausanias 2.4.5.

29. Diodorus Siculus, 4.76.1–3; translated in Pollitt 1965, p. 5. Cf. the scholion on Plato, *Meno,* 97d: "In ancient times craftsmen shaped *zoia* that had closed eyes and feet that were not separated. . . . Daedalus . . . was the first who spread apart their eyelids, so that they seemed to see, and set their feet apart so that were held to walk; and because of this they were tied, so that they did not flee; since in truth they had now become alive" (text in W. C. Greene, ed., *Scholia Platonica* [Haverford, 1938]). It would be a mistake to see this as *just* a manner of speaking.

30. On the implications of commonplaces about lively and active images for the analysis of classical views, see Gordon 1979, pp. 6–21. See also chapter 3 and chapter 11, section 3.

31. For a still more forceful statement of the need to take writers like Pausanias more seriously than art historians usually do—and not just as an eager and useful *cicerone,* see Gordon 1979, pp. 7–17. See, too, Jane Harrison's splendidly straightforward observation on Pausanias that "a more able man might often have been a less trutstworthy guide. If we are conscious . . . that in the view taken by Pausanias of the monuments of Greece there is a certain want of perspective, a lack of grouping, an inability to see the relative proportion of things, we feel at least that we get our facts undistorted by the medium of a powerful personality, untinged by any colouring of formative theory" (Jane Harrison, ed., *Mythology and Monuments of Ancient Athens, Being a Translation of a Portion of the "Attica" of Pausanias,* by M. de G. Verrall [London, 1890], pp. ix–x).

32. Clerc 1915, p. 2. Emphasis added.

3. THE VALUE OF THE COMMONPLACE

1. Nathaniel Hawthorne, "The Prophetic Pictures," in *The Complete Works of Nathaniel Hawthorne,* 1: *Twice Told Tales,* Wayside Edition (Boston and New York, 1882), p. 195.

2. See Skorupski 1976, pp. 2–3 and passim, for an outline, critique, and advocacy of the so-called intellectualist position.

3. Dio Chrysostom, *The Olympic Discourse; or, On Man's First Conception of God,* 51 ad finem. The translation is that of J. W. Cohoon in the Loeb Classical Library edition, *Dio Chrysostom* (London and Cambridge, Mass., 1939), 2:57. For more on this passage and a longer citation, see chapter 8, section 4.

4. L. B. Alberti, *On Painting and Sculpture: The Latin Texts of the De Pictura and De Statua,* edited by C. Grayson (London, 1972), pp. 60 and 61.

5. *Virtù* in the text.

6. Valerius Maximus, *Dictorum factorumque memorabilium,* lib. 9, cap. 4, *Externa* 1.

7. These passages are from Evelyn Gendel's translation of the trial of Madame Bovary in the edition of *Madame Bovary* published by the New American Library in 1964, pp. 323–403.

8. "Segnius irritant animos demissa per aurem,/ Quam quae sunt oculis subiecta fidelibus, et quae/ Ipse sibi tradit spectator" (Horace, *Ars poetica,* lines 180–82). For the whole issue of censorship and the implications for it of the parallel between painting and poetry, see chapter 13, especially section 7.

9. "Multoque loquacior est pictura, quam oratio; et frequenter altius descendit in

pectus hominis" (*Desiderii Erasmi opera omnia,* edited by J. Clericus (recte Leclerc), [Leiden, 1703–6], 5, col. 696e. For the Aristotelian view, see *Politics,* 7. 17.9–10 (1336b). For Erasmus's use of Aristotle, see Freedberg 1971, pp. 234–35 and 239–41.

10. See Richter 1949, especially p. 64–65: "If the poet can kindle love in man, more so . . . , the painter, as he can place the true image of the beloved before the lover, who often kisses it and speaks to it. . . . *Muove più presto i sensi la pittura, che la poesia*" (Cod. Urbinas 1270, Trat. 25); cf. also chapter 12, section 3, on some further consquences of lovers' discourse with pictures.

11. Nicholas of Cusa, *De visione Dei,* Praefatio, in Nikolaus von Kues, *Philosophisch-Theologisch Schriften,* ed. L. Gabriel, (Vienna, 1967), 3:94–6.

12. Characteristically, most (but not all) art historical interest in this remarkable and moving passage has been confined to its references to specific pictures. See, for further discussion of Nicholas and art, F. Hempel, "Nikolas von Cues in seiner Beziehungen zur Bildenden Kunst," in *Berichte über die Verhandlungen der sächsischen Akademie der Wissenschaften zu Leipzig, Philosophisch-Historische* Klasse, 100 (Leipzig, 1953), part 3.

13. *New York Times,* Sunday, 16 August 1987, p. 8. The attitudes of other villagers, reported here too, raise some of the further problems facing any analyst of response: "Imagination can also make something happen . . ." "You have to believe. It's not like a picture show. You can't just drop in and see it." I hope that my own position on qualifications on the grounds of belief and imagination (and the charming but misleading distinction with motion pictures) will become clear in the course of the rest of this book.

4. The Myth of Aniconism

1. R. Assunto, "Images and Iconoclasm," in *EWA* 7, cols. 145–46 (the original article was significantly entitled "Iconismo e Aniconismo").

2. The mistake is only explicable if by "aniconism" one refers solely to those cultures which refrain from figuring the supreme deity.

3. To say nothing of the figurative decorations in the Jewish catacombs in Rome, in the Vigna Rondanini, the Villa Torlonia, and the extraordinary painted stucco figures of the Jewish sepulchral chambers of Gamart near Carthage. E. R. Goodenough, *Jewish Symbols in the Greco-Roman period,* 13 vols. (New York and Princeton, 1953–68), is, of course, the fundamental work on Jewish symbolism, with volumes 9–11, *The Symbolism of the Dura Synagogue* (1964), dealing specifically with the imagery at Dura. The 1971 collection of essays edited by Gutmann (and, especially, his own essay in it) provides a good overview of the problem of Jewish attitudes.

4. For the Islamic strictures, see the basic articles by Marçais (1932) and Paret (1960), as well as K. A. C. Creswell, "The Lawfulness of Painting in Early Islam," *Ars Islamica* 11–12 (1946): 159–66; see also Creswell's *Bibliography of Painting in Islam,* Ars Islamica, 1 (Cairo, 1953), for the bibliography up to 1950 (esp. page 8: "On the Question of the Lawfulness of Painting in Islam"). For a more recent account, see the careful and nuanced pages in Grabar 1977, pp. 75–103, with a useful bibliographic discussion on pp. 222–23.

5. For good illustrations see *EWA* 7, plates 104–5, illustrating the article originally called "Iconismo e Aniconismo."

6. Cormack 1985, p. 105. See also Grabar 1977, pp. 93–95 and 225 for a slightly different view.

7. Compare the very similar colophon by Joseph the Frenchman in the Cervera Bible of 1299–1300 (which must have served as a model for the Kennicott Bible), Biblioteca Nacional de Lisboa, MS Hebr. 72, fol. 449; illustrated in color in J. Gutmann, *Hebrew Manuscript Illumination* (New York, 1978), plate 10.

8. On micrography and related Jewish practices, see the combined work by C. Sirat and L. Avrin, *La lettre hébraïque et sa signification/Micrography as Art* (Paris/Jerusalem, 1981); also L. Avrin, *Hebrew Micrography: One Thousand Years of Art in Script* (Jerusalem, 1981).

9. The examples here are from cultures in which the theoretical resistance to making visual images is very marked indeed, and in which there is no such resistance to the written word. But while their relevance to this chapter is clear, it may be as well to remind the reader of the long Western strain in which words and letters are turned into ornaments and pictures, from the *carmina figurata* of the Carolingian copies of antique models (such as the manuscripts of Aratus), to the manuscripts of writers like Venantius Fortunatus in the sixth century and Hrabanus Maurus in the ninth, through a huge variety of later examples, such as the more ordinarily written sequences of words that are turned into the delightful knotted verses of Hieronymus Wierix's 1607 psalm cycle. But in cases such as these, we must reckon that the factors of play and delight and the need to compel attention, are less mitigated—if at all—by moral or theoretical reservations about the status of the image itself. Rather, one might say, it is precisely because the letters and words do not seem enough that we turn them into pictures in order to make them more effective. None of this is to deny the possibility of the sheer delight (to return to the Hebrew cases) that the Masoretic text, once turned into micrographic form, may have given the commentators. But, as I have tried to suggest, there are always other issues at stake; and so "sheer" may not be the entirely accurate adjective.

10. In addition to the mask employed during the ritual of the *ndakó gboyá* discussed in chapter 2, there is also that of the *kuti-mamma,* as well as the nondangerous bronze figures used in the course of the *dzakó.* (Nadel [1954] 1970, pp. 190–92 and 90–94).

11. On Walbiri representations, see Munn's excellent and well-illustrated book on the role of images in Walbiri culture (Munn 1973).

12. "Figurative" is deliberately used in this and the following sentence, rather than "artistic." The issue may well be "figure and illusion" rather than "art and illusion"— unless we roughly mean that the art resides in making the figure the illusion.

13. Goodman 1976, p. 38.

14. The classic art historical expression of the implications of this view is, of course, to be found in A. Riegl, *Die Spätrömisches Kunstindustrie* (Vienna, 1901). But it reappears in critical and sophisticated form in Gombrich, notably in *The Sense of Order* (1979).

15. None of this is to deny the possibility that in some cultures the common Western distinction (now undermined both by Gombrich and Goodman) between the abstract and the representational is weak or absent, as Anthony Forge emphasized in his work on Abelam painting in Lowland New Guinea. Indeed, in a curious inversion of the misleading tendency identified here, Forge suggests that the need to identify a design as representational (or meaningful) is an ethnocentric one; and he shows the ways in which Abelam artists fail to distinguish or only reluctantly distinguish between the representational and the abstract (or the nonrepresentational). But Forge's insistence on this distinction as the subject of his research is itself ethnocentric— however much he may insist on the functional value of what he defines as abstract/

nonrepresentational/nonanthropomorphic. If he had forgotten about the distinction (or spent more time in listening to public responses rather than those of artists artificially brought together), his work might have yielded greater benefits in terms of the motives and needs that underlie image use in Abelam culture. See A. Forge, "Style and Meaning in Sepik Art," in his *Primitive Art and Society* (London and New York, 1973), pp. 169–92.

16. It would obviously, in these last sentences, be more appropriate to refer to "people" than to "man." But the old male terminology for all humankind is peculiarly useful here, in that it reflects, quite precisely, the male orientation of Judaeo-Christian thinking about the relationship between God and his creations. "Man" is all humanity, but it is also the specifically male embodiment of God. The double sense in which we used, until very recently, the term "man" is the most apt way of conveying the superiority of man in our tradition.

17. Plutarch, *Numa,* 7.7–8.

18. Taken from Clement of Alexandria, *Stromata,* 5.109.2 (Diels 1934–54, frag. 14; Kirk and Raven 1966, frag. 170). It should be noted, however, that this extract, just as that from Antisthenes, comes from someone who had many related axes to grind on the subject of pagan image worship. In another passage from Clement, Xenophanes raises an issue to be discussed at greater length later in this chapter: "The Ethiopians say that their gods are snub nosed and black, the Thracians that theirs have light blue eyes and red hair" (*Stromata,* 7.22.1; Diels frag. 16; Kirk and Raven frag. 171).

19. Aristocritus, *Theosophia,* 68 (Diels frag. 5, Kirk and Raven frag. 244). Marsilio Ficino, one hardly needs add, stands at the long end of the tradition outlined in this paragraph. When he insists on the greater veneration due to divine names than to divine statuary, he can do so on the basis of the claim that "the image of God is more expressively rendered by an artifice of the mind than by manual works" (*In Philebum,* 1.11, as translated by E. Wind, *Pagan Mysteries in the Renaissance,* enlarged and revised edition, [London, 1967], p. 127).

20. On Antisthenes see Clement of Alexandria, *Stromata,* 5.14.104.4; *Protrepticus,* 6.71.23. Cf. my comment on Clement in note 18 above. For Zeno, see *Stoicorum Veterum Fragmenta,* edited by H. von Arnim (Leipzig, 1903–5), 1:264.

21. Clement not only repeated the story of Numa's strictures on images, he also is the source for many of the Pre-Socratic views—especially in the long arguments in *Protrepticus,* 4.

22. As, for example, in Philo, *De confusione linguarum,* 27. 134–40.

23. Nicephoros, *Antirrheticus I,* in *PG* 100, col. 301C.

24. See Mansi 13, cols. 208–332D, for the full statement of the arguments as read out piecemeal at the Seventh Ecumenical Council of 787, as well as the discussion and summary by Anastos.

25. See Stirm 1977 and, for convenient summaries, Freedberg 1977, 1982, and 1986.

26. Augustine, *De civitate Dei,* 4.31.

27. Tertullian, *Apologeticus,* 25.12–13. Cf. Tertullian, *De idololatria,* 3.1–2.

28. Becatti 1951, pp. 35 and 286–88.

29. Strabo, *Geography,* 5.235.

30. Sallust, *Catiline,* 11.5–7.

31. This idea naturally percolated from the mainstream of Roman thought to Christianity—as in Lactantius's strong view that to admire a statue was to be "seduced

by beauty and to be forgetful of true [divine] majesty" (*Epitome*, 25.13), and in Augustine's formulations of the way in which true beauty resides in God alone (as most strongly in the *De ordine* and the *De vera religione*).

32. Plutarch, *Marcellus*, 21.1–5. "Plain and unadorned" is, of course, the chief characteristic of the virtuous and vigorous Attic style, the style which throughout the history of Roman rhetoric was opposed to the Asian.

33. Velleius Paterculus, *Historiae Romanae*, 1.13.5.

34. Livy 34.3–4.

35. Ibid., 45.27–28.

36. Pausanias 7.22–24.

37. In his important commentary on Pausanias 7.22–24 cited here, Frazer gives a variety of examples from other cultures of the worship of unworked stones. For all their mythographic and ethnoreligious biases, good compendia of classical information are provided by E. Saglio in *DA* 1:413–4 (s.v. *argoi lithoi*) and, especially, F. Lenormant in *DA* 1:642–46 (s.v. *baetylia*).

38. *Sanchoniathonis Fragmenta*, ed. J. C. Orellius (Leipzig, 1826), p. 30. "Itane vero? *lapides animatos?* O rem ridiculam, Cato, et iocosam!" exclaims Orellius in his commentary. He then goes on to explain that Syrian *phay* and *shin* must have been transposed in the original "Unde factum ut lapides uncti . . . mutarentur in animatos."

39. The Pausanian references are 7.22.4, 9.24.3, 9.27.1, and 9.38.1 respectively.

40. The stone is clearly reproduced in Nilsson 1967, plate 32, fig. 1.

41. The coins were previously said to come from Mallos. For the Carian provenance and dating, see E. S. G. Robinson, "A Find of Archaic Coins from South West Asia Minor," *Numismatic Chronicle*, 5th series, 16 (1936): 265–80.

42. See C. Lenormant in *Revue numismatique* (1843), pp. 273–80, as well as F. Lenormant in *DA* 1:644–45, with good further references to this and other "hysteroliths." The fact that Byzantine and other writers also noted this mark on the Black Stone of Mecca is not only an index of their prejudices; it demonstrates the propensity and need to search for anything that might help us make organic, anthropomorphic, or merely lively sense of what otherwise might seem a large, puzzling, all-too-mysterious block. The need is automatic, not cultivated.

43. Genesis 38.11–12.

44. Even a sophisticated writer like Ridgeway postulates a development from "presumably ill-shaped" wooden statues (*kolossoi*) to anthropomorphic figures whose lower parts were essentially columnar" (B. S. Ridgeway, *The Archaic Style in Greek Sculpture* [Princeton, 1977], p. 37). Cf. figs. 25 and 28.

45. Cf. Pausanias 2.9.6 and 8.48.4–6 (referring to the *agalma tetragōnon*); but see also Lucian, *De Dea Syriaca*, 16. See also Pausanias 3.22.1. For all these more-or-less shaped blocks that served as cult statues of Zeus, see Cook 1914–25, vol. 2, pt. 2, appendix M, *Zeus Meilichios*, especially pp. 1144 (Sikyon) and 1147–48 (Tegea). Cf. also ibid., pp. 160–66, on Agyieus pillars.

46. The Apollo Agyieus coins come from Epirus (mint of Ambracia) and Illyricum and date from the third century B.C. to the first century A.D.; that of Zeus Casios from Seleucia Pieria illustrated here dates from between A.D. 222 and 235. For these and the other examples mentioned here, see also Lenormant in *DA* 1:643. Nilsson has a useful assessment of the Apollo Agyieus type ("hieraus geht hervor, dass der stein selbst der Kultgegegenstand war, und dass der Anschluss an Apollon sekundär erfolgte") and a considerable list of references to the most famous of all the Apollonian holy stones, the Omphalos of Delphi (Nilsson 1967, pp. 203–4).

47. See Lenormant for further details (*DA* 1:643).

48. As Lenormant also commented (*DA* 1:642).

49. For the stone images and the occasional coins and vase paintings that may or may not preserve their form, see *DA* 1:1471–76, s.v. *statua*.

50. In addition to this example, there is a wide variety of ways in which the tree connection seems to be conveyed: for example, in the coin showing Eleuthera of Myra appearing out of a tree, or in the well-known bronze dish showing Artemis of Ephesus, or in the extraordinary ivory statuettes with a tall columnar projection from the head (Meuli 1975, p. 1051, suggests it is a tree trunk). For these and other illustrations, see the articles by Meuli (1975) and Merkelbach (1971), both of whom emphasize the link between the chaining of cult statues and statues that suggest arboreal origins. Unfortunately, in both cases the arguments are weakened by the obvious fact that visually it is by no means always clear whether the markings suggest chains or trees.

51. Cf. G. M. A. Richter, *Archaic Greek Art* (New York, 1949), p. 104: "Though the figure is as rigid as a tree . . . the fluid contours . . . give it an amazingly lifelike quality."

52. The case is recorded by a large number of writers, including Livy 29.10–11; Arnobius, *Adversus nationes,* 7.49; Herodian 1:2.1; Appian 7.56; Ammianus Marcellinus 22.22; Bloch, *Philologia,* 52.580. See Ovid (*Fasti,* 4.247–348) and Bloch for the possibility that the stone did not come from Pessinus. Several further details are supplied by E. Reisch in *RE* 3:726–27, s.v. *argoi lithoi.*

53. Literally, "a face too little expressed with imitation" (Arnobius, *Adversus nationes,* 7.49; cf. 6.11, where the Pessinuntans worshiped a piece of flint in place of the Mother of the Gods).

54. See Lenormant for further references (*DA* 1:645).

55. The statue is one of a series of busts in marble in the museum whose origin is extremely hard to pinpoint. Deonna's lines on them summarize and epitomize the difficulties: "On a supposé avec vraisemblance qu'il s'agit de divinités chthoniennes, dont on a omis le visage parce-que l'on redoutatit de le figurer. Un sanctuaire de divinités chthoniennes à Agrigente a fourni des representations analogues, sortes de colonnes creusées en terre cuite, avec chevelure et oreilles, mais sans autre organe humain" (1930, p. 324).

56. Or as we shall see in chapters 9 and 14, because the most vital of its organs, its eyes and mouth, are so awfully absent, so blankly away. Pictures which lack an eye—or sometimes worse, a mouth—are unexpectedly shocking and arresting. In addition to the examples caused by iconoclasm cited in chapter 14, see especially chapter 9, section 1, with notes 13 and 14 in particular.

57. May 1950, p. 272, citing a payprus discovered in 1934 at Tebtunis and quoted by E. Cahen in *Revue des Études Grecques* 48 (1935):308–10.

58. Pausanias 10.19.3; cf. chapter 2, section 3 for the full account.

59. As noted as well by May (1950, p. 272). For other coins of Ainos showing this Hermes Perpheraios, see May 1950, plate 10, nos. 436–58.

60. See Meuli 1975, plate 59, fig. 25, for a good illustration of the Eleuthera goddess-in-the-tree. See also note 50 above on the Ephesian goddess.

61. On Xenophanes, see note 18 above.

62. In addition to Frazer's wide-ranging examples in his comment on Pausanias 3.15.7, see also W. Crooke, "The Binding of a God: A Study in the Basis of Idolatry," *Folklore* 8 (1897): 325–55 (for many non-Greek examples), the recent general article by Merkelbach (1971), and the very thorough—if occasionally too hopefully speculative—prolegomenon by Meuli (1975).

63. Cf. Pausanias 3.15.7–8, 5.26.6, 9.38.5, etc. The first of these passages commences with his account of the Enyalios in fetters at Sparta: "The notion of the Lakonians about this statue is that, being held fast by fetters, the god of war will never run away from them; just as the Athenians believe about the Victory they call wingless" (3.15.7). See also Diodorus Siculus 17.41.7–8, and Plutarch, *Alexander,* 24.3–4, on the Tyrians, who tied the *xoanon*—or *kolossos*—of Apollo to its base with golden cords to prevent him from leaving the city. The most famous literary case, of course, is that of the maidens who in Aeschylus's *Seven against Thebes* cling to the feet of the *breteis* to prevent the gods from forsaking the city—although here they seem to know perfectly well that the idols will stay put. Several of these issues are covered—characteristically—in Bevan's neglected book of 1940, especially pp. 27–28)

64. Meuli 1975, pp. 1039–42.

65. In addition to the expected references in second- and third-century Greek writers like Plutarch and Pausanias, we also find them in Greek writing of a much earlier period, from Homer and Alkaios, through Aeschylus, Aristophanes, and Pindar.

66. *Scholia in Olympionicarum carmen,* 7.95a, in *Scholia vetera in Pindari carmina,* 1: *Scholia in Olympionicas,* rec. A. B. Drachmann (Leipzig, 1903), p. 221.

67. Meuli 1975, p. 1081.

68. Cf. Pausanias 3.16.7–11. For further and comparative references, Meuli's notes are again extremely useful (Meuli 1975, pp. 1044–47). See also chapter 5, section 2, for more on the danger of the gaze.

69. Fully presented in R. M. Dawkins, ed., *The Sanctuary of Artemis Orthia at Sparta, Excavated and Described by Members of the British School at Athens, 1906–10,* The Society for the Promotion of Hellenic Studies, Supplementary Paper 5 (London, 1929). It should be noted here, however, that it is not clear that what Meuli and others read as chains in the statues and statuettes of Artemis Orthia and other chained gods are definitely chains at all: fillets, serpents, and other kinds of patterns are also possibilities. The temptation to induce a chain reading from the archaeological evidence on the one hand and the literary evidence on the other ("bound with willow," for example) is great. In his note on the Enyalios in chains in Lakonia, Peter Levi (in his Penguin translation of Pausanias [Harmondsworth, 1979], 2:52, n. 123) cautions that one should bear in mind the possibility that the "chains" on statues may have been dedications (as in the pillar of Oinomaos at Olympia).

70. Pausanias 9.38.4–5. The story follows the reference to the worship of the stones that fell from heaven for Eteokles.

71. In this respect, therefore, the cautions offered by Peter Levi and myself in note 69 above do not hold—however valid it may be for the surviving archaeological evidence.

72. Plato, *Meno,* 97c–e. Cf. also *Euthryphro,* 11b–e: "Your statements, Euthyphro, are like the works of my ancestor Daedalus, and if I had made them you'd say that on account of my relationship to him my works in words run away and not want to stay where they were put."

73. By "differentiation" I broadly mean the ability to stand back from immediate responses based on the perception of an object—or its iconography—as real, or on the identity of sign and signified, and make aesthetic judgments and distinctions about formal qualities and categories.

74. Gadamer 1975, p. 126.

75. Ibid., p. 123.

76. Aside from anything else, the notion of magic is too much associated with ideas of "primitive" behavior to be used in a satisfactory and reasonably value-free way here.

But for an extended example of the misleading use of the term "magic" in relation to the identity between image and god—or human—so often encountered in ancient writing on images, see Pollitt 1974, p. 64. Here he comments on the observation by T. B. L. Webster, "that the Greek word *kolossos* meant a statue which was thought of as a magical substitute for a human being, and also that the custom of putting inscriptions on statues and paintings in the first person suggests a magical 'life' within the work" (Webster, "Greek Theories of Art and Literature down to 400 B.C.," *Classical Quarterly* 33 (1939): 166–79). We may well want to ask, Why "magical"? And why set off the word "life" in quotation marks? It is by no means clear what is really explained when writers like Pollitt and Webster describe the life of a work as "magical." Webster refers to a "magical substitute view"; Pollitt (in his footnote to this passage) refers to the "basic idea that works of art can have a magical life of their own" (Pollitt 1974, p. 87). The conjunction of "magic" and "life" does not explain; it elides explanation. See also section 8 of this chapter as well as chapter 10, sections 5 through 7 for further arguments against this kind of usage.

77. Augustine, *De civitate Dei,* 7.5.2. It is as well to note, as is not often the case, that this passage occurs precisely in the context of Augustine's reference to the pure "aniconism" of early Rome.

78. Sperber 1975, p. 26.

79. Ibid., p. 33.

80. Ibid., p. 49.

81. Ibid., p. 84.

82. Ibid., p. 112.

83. Ibid., p. xii

84. See chapter 10, section 7, for a further—positive—engagement of the Maussian position.

85. Nadel [1954] 1970, pp. 4–5. In the second part of the quote, Nadel is citing D. Bidney, "Meta-Anthropology," in *Ideological Differences and World Order,* ed. F. S. C. Northrop (1949).

5. CONSECRATION

1. Blackman 1924, p. 48, citing Zimmern, *Ritualtafeln* (1901), nos. 31–38, frag. 1.23–26.

2. Blackman 1924, p. 52.

3. The sixth-century version, for example, curiously omits the opening of the mouth. See Smith's publication of a small tablet in the British Museum for further details (Smith 1925).

4. Ibid., pp. 39 and 50 (for the text).

5. Ibid., pp. 40 and 51 (for the text).

6. Although we may still want to call it a ritualized activity, in the secondary more colloquial sense of the word noted by Mary Douglas, whose distinctions—chiefly in *Natural Symbols: Explorations in Cosmology,* Penguin Educational edition (London 1978; 1st ed., 1970)—between rite and ritualized act have informed my own, despite our differences on issues of ritual value. But in the end, it is the work of A. R. Radcliffe-Brown that remains the basic point of departure and of return in these matters. See, above all, "Taboo" and "Religion and Society," in *Structure and Function in Primitive Society: Essays and Addresses* (London, 1976; 1st ed., 1952), pp. 133–77.

7. A good selection of examples is given by E. Reisch, in *RE* 3:727, s.v. *argoi lithoi.*

8. As in Theophrastus, *Characters*, 16; Xenophon, *Memorabilia*, 1.1.14; Clement of Alexandria, *Stromata*, 7.4.26; as well—inevitably—in several places in Lucian, e.g., *Concilium Deorum*, 12. Still further examples can be found in E. Saglio, in *DA* 1:414; and Reisch, in *RE* 3:727.

9. In Euripides, *Iphigenia in Tauris*, 1358–59.

10. Meuli 1975, p. 1050.

11. Minucius Felix, *Octavius*, 24. Cf. the many similar texts in Tertullian (e.g., *Apologeticus*, 12; *De idololatria*, 15; *De spectaculis*, 13). Cf. also the remarks by Knox cited in the next section of this chapter and quoted in Gombrich 1966–67, p. 24.

12. See Bevan 1940, p. 31, on Hindu practices, after a slightly inconclusive rumination on "intermediate shades of belief" and on the fact that "we realize more today than before how the mind of man is on various levels."

13. The rite of opening the eyes of Buddha images in general is a very old one, as S. J. Tambiah and many earlier writers have noted. Instances are recorded as far back as the emperor Asoka, who is supposed, according to Buddhaghosa writing in the fifth century A.D., to have held a festival of *akkhipuja* (the Pali term for the eye ceremony). See in Tambiah 1984 the section entitled "The Process of Sacralizing Images and Amulets," especially pp. 255–57, with appropriate references to the earlier literature, including A. K Coomaraswamy, *Medieval Sinhalese Art* (New York, 1956; 1st ed., 1908), and A. Leclere, *Cambodge fêtes civiles et religieuses* (Paris, 1916). For reasons that I allude to in the final section of chapter 6, I am not certain that Tambiah's use of the notion of sacralization takes care of many of the isues that arise with consecration and contagion; and I have reservations about the emphasis he places on monks and holy men in these contexts (indeed, his chapter is subtitled "The Transfer of Power by Monks," which evades a whole variety of problems about the relations between effectiveness and representation).

14. Knox's *An Historical Relation of Ceylon* (1681), is thus cited in Gombrich 1966–67, p. 24.

15. Gombrich, 1966–67, p. 24.

16. Ibid., 24–25.

17. See S. Kramrisch, *The Hindu Temple* (Calcutta, 1946), 1:359.

18. E.g., in the *Biography of Ku K'ai chih*, translated by Chen Shih-Hsiang (Berkeley and Los Angeles, 1961), pp. 14–15. See also Acker 1974, pp. 14–15. The modern and popular equivalents are known to everyone who has attended Chinese festivities such as the celebration of the New Year. I quote from the *Times* (London) of 4 February 1984, p. 14: "At around 11:45 a dignitary from the Chinese Embassy, perhaps the ambassador himself, should arrive for the ceremonial dotting of the eyes of the exotic lions which are itching to dance around the Soho streets. The act has much significance for the Chinese but might seem dull to the rest of us, particularly those with small children in tow." The first part of this passage precisely catches the several implications of the ceremony; the second part is characteristically unimaginative.

19. Acker (1974, p. 174) has a slightly different and fuller version of the story about Chan-Seng-Yu's Four White Dragons in the temple in Chien-k'ang. Because people so persistently begged Chan to dot the pupils, he finally acquiesced—but only in the case of two of the dragons. Thunder and lightning tore the walls asunder and the two dragons flew up into the sky. But the other two, whose eyes he had not dotted, were still to be seen in the temple.

20. S. W. Bushell, *Chinese Art*, 2d revised ed. (London, 1909), 2:124. Cf. also Weynants-Ronday 1936, p. 124, and Meyer 1923, pp. 131, 260–61. Meyer relates the following extraordinarily inverse tale. Po-shih was painting a picture of a horse.

As soon as he finished it, the horse died. "It seems that all the vital force of the horse was taken out it by Po-shih's brush."

21. Gombrich 1966–67, p. 25.

22. On theurgy, see especially Bonner 1950 and Dodds 1956. Both have excellent further bibliographies. Dodds (pp. 283–85) succinctly discusses the significance of the probable founder of theurgy, one Julianus (who probably invented the term *theourgos* to distinguish himself from the *theologoi*), and the key source known as the *Chaldaean Oracles*. Dodds just as usefully discusses the relationship between theurgy and Neo-Platonism (pp. 285–89).

23. But like Maximus of Tyre and Dio Chrysostom, for example, Plutarch justified images on the grounds that man needed material symbols of God precisely because of his inability to ascend directly to the realm of the spiritual. Cf. chapter 8 below.

24. The phrase is Bonner's (1950, p. 15). See also G. Hock, *Griechische Weihegebrauche* (1905), pp. 65–70; and T. Hopfner, *Griechisch-ägyptischer Offenbarungszauber* (Leipzig, 1921), 1:808–12.

25. See Dodds 1956, pp. 292, 295–99. For the relationship between movement and prophetic powers, see Cyril Mango's succinct observation in his penetrating analysis of similar practices in Byzantium: "As every Byzantine knew, demons [such as those believed to inhabit statues] had the faculty of swift locomotion and were thus able to apprehend events that took place at a great distance. This faculty they often passed off as foreknowledge" (Mango 1963, p. 59).

26. Dodds 1956, p. 292.

27. The key writers on the subject, from Iamblichus to Proclus, combined their knowledge of these with what they had learned from the Neo-Platonists, especially (and inevitably) from Plotinus—though Dodds (ibid., pp. 285–89) takes pains to point out how mistaken it would be to regard Plotinus as anything like a theurgist.

28. Text and this translation supplied by Bonner (1950, p. 15), citing Proclus, *In Timaeum*, 37c–d, marg. pag. 240a (Kroll ed., 3.6.8–15).

29. Proclus, *In Timaeum*, 3.155.18. Text in Dodds 1956, p. 292.

30. Dodds 1956, pp. 62–63.

31. Or, as a scholion on Plato's *Phaedrus* observed: "We have told how the soul is inspired. But how can an image also be said to be inspired? Perhaps the thing itself cannot respond actively to the divine, inasmuch as it is without life; but the act of consecration purifies its matter, and by attaching certain marks and symbols to the image, first gives it a soul by these means and makes it capable of receiving a kind of life from the universe, thereafter preparing it to receive illumination from Divinity." Text and this translation in Bonner 1950, p. 16, citing Hermias Alexandrinus, *Scholia in Platonis Phaedrum*, ed. P. Couvreur (Paris, 1901), p. 87.

32. *Rituale Romanum*, tit. 8, cap. 25 (sub "Benedictiones ab Episcopis"). With a few minor variations, the wording is basically the same both before and after the Council of Trent.

33. "Qui Sanctorum tuorum imagines sive effigies sculpi, aut pingi non reprobas" (*Rituale Romanum*, tit. 8, cap. 25). Cf. the final Tridentine decree itself: "Non quod credatur inesse aliqua in iis divinitas vel virtus, propter quam sint colendae, vel quod ab eis sit aliquid petendum, vel quod fiducia in imaginibus sit figenda . . ." (Sessio 25, *De invocatione veneratione et reliquiis sanctorum, et de sanctorum imaginibus*, in COD, p. 750).

34. "Quoties illas oculis corporis intuemur, toties eorum actus et sanctitatem ad imitandum memoriae oculis meditemur" (*Rituale Romanum*, tit. 8, cap. 25).

35. The same applies to images attached to the doors and other parts of houses.

See, for example, the *Manuale,* pp. 102–11. Cf. chapter 6, section 3, for a more extended discussion of the problem of apotropaism.

36. *Poetae Latini* 5 (MGH) edited by K. Strecker (1937–39), pp. 465–66; and P. Fabre and L. Duchesne, *Le Liber Censuum de l'église romaine* (Paris 1905–10), 2:158–59; details in Kitzinger, "A Virgin's Face," p. 12.

37. "Quaerens oracula matris," Kitzinger 1980b, p. 19, citing *Poetae Latini* V:467. For his suggestion about the encounter with the famous icon of the Virgin at Santa Maria Nova, based partly on the basis of the sixteenth-century encounter of the Lateran Christ with the Virgin of Santa Maria Maggiore on the steps of that church, see ibid., pp. 17–18.

38. See, for example, Freedberg 1981.

39. *PL* 118, col. 1265.

40. Schrade 1958, p. 82.

41. Ibid.

42. Mango 1963.

43. In addition to the material provided by Mango (ibid., p. 55–64), see now the 1984 edition by Cameron and Herrin of what Mango himself called "the richest source of statue lore"—"the confusing little" *Parastaseis syntomoi chronikai,* which was compiled in the middle of the eighth century and reworked in Solinus's *Patria Konstantinoupoleos.*

44. Mango 1963, p. 61

45. He certainly knew of Apollonius of Tyana, who endowed statues with miraculous powers both at Antioch and Constantinople.

46. In particular for a spirit attached to a specific place. For all this, see Mango 1963, p. 63.

47. *PL* 16, ep. 21, col. 1019. Cf. Bede, *Historia ecclesiastica,* 1.29. Sumption (1975, p. 29 and note) has a good survey of this issue.

48. Hugh of Poitiers, *Historia Vizeliacensis Monasterii* 4, in *PL* 194, cols. 1659–61. Text also in Forsyth 1972, pp. 32–33, with the translation on which mine is based on pp. 33–34.

49. This is how the modern commentator immediately reflects on the passage: "A more explicit confirmation of the existence in the twelfth century of reliquaries fashioned as images of the Virgin and Child could hardly be found"; but at the same time she notes that "it is curious that the presence of relics in the Vézelay statue had been completely forgotten. . . . The passage demonstrates further that in the 1160s it was not considered necessary for statues of Mary to be reliquaries" (Forsyth, pp. 34–5). Of course the question that remains is precisely the one that has been posed here: Was it necessary for them to contain relics in order to work miraculously?

50. Gombrich 1966–67, p. 25.

51. The fact that there are, of course, certain images that may themselves be regarded as relics (by virtue, for example, of their having been in direct contact with a deity or saint) is not to be seen as especially problematic here. In a sense they constitute a fusion of the two possibilities and therefore are not, in this context, of great heuristic significance.

52. Forsyth 1972, p. 80 (my emphasis). In insisting on the legitimizing aspect of the insertion of relics, Forsyth thus takes a stand against the variety of positions which associate the revival of medieval sculpture in the round with the use of such sculptures as liturgical containers, in the broadest sense, or as reliquaries. See H. Keller, "Zur Entstehung der sakralen Vollskulptur in der ottonischen Zeit," *Festschrift für Hans Jantzen* (Berlin, 1951), pp. 71–90, as well as the variety of works cited by Forsyth on

pp. 79–82. For the argument that associates the rise of the cult of relics with that of images in the sixth century, see Grabar [1946] 1972, 2:343–52.

53. Peripatetic images feature largely in the Byzantine guidebooks (like the *Parastaseis syntomoi chronikai*), and in the great medieval compilations of miracle legends (such as those by Caesarius of Heisterbach and Gautier de Coinci), as well as in any one of the many etiological poems about pilgrimage images—all of which will be discussed in chapters 6 and 11.

54. Gadamer 1975, p. 137.

55. See especially Grabar [1946] 1972, 2:343–52.

6. IMAGE AND PILGRIMAGE

1. The best guide to the history and analysis of pilgrimage phenomena in the Christian West is now provided by the excellent essays and bibliographic material in Kriss-Rettenbeck and Möhler 1984. A much less useful survey is that edited by L. Sartori, *Pellegrinaggio e religiosità popolare,* Atti del convegno di studio organizzato dal Santuario di Santa Rita, Cascia, 1981 (Padua, 1983).

2. Turner and Turner 1978, p. 1.

3. There is, additionally, one category of pilgrimage to which this and the preceding paragraph apply only weakly; although even here the element of hope may be strong, and grow still stronger in the process. I refer to judicially imposed pilgrimages and to the whole class of what are sometimes called penitential pilgrimages. A good sketch is provided by Sumption (1975, pp. 98–113); but see also the excellent details in J. van Herwaarden, *Opgelegde Bedevaarten: Een studie over de Praktijk van Opleggen van Bedevaarten, met name in de stedelijke Rechtspraktijk in de Nederlanden gedurende de late middeleeuwen, ca. 1300–ca. 1500* (Assen and Amsterdam, 1978); and the useful overview of the legal spects of pilgrimage in general by L. Carlen, "Wallfahrt und Recht," in Kris-Rettenbeck and Möhler 1984, pp. 87–100.

4. This passage, as well as my subsequent citations about the Regensburg shrine and pilgrimage, are taken from the wonderfully trenchant account in Baxandall 1980, pp. 83–84.

5. The matter of what image exactly was set up on the marble altar in 1519 has been much discussed; for an overview with sources, see Hubel 1977, pp. 209–19.

6. The synagogue is also recorded in the poignant prints by Altdorfer of its interior (B. 63–64).

7. See Köster 1984, p. 206, for discussion of the *Schöne Maria* and other telling figures.

8. Baxandall 1980, p. 84.

9. See Köster 1984, p. 206. The best general account of these matters is now provided by Hubel 1977, pp. 199–237, with good illustrations and further references.

10. Ibid., p. 207. On Regensburg tokens in greater detail, see also W. Schratz, "Die Wallfahrtzeichen zur Schönen Maria Regensburg und die sonstigen Regensburger Marien-münzen," *Mittheilungen der Bayerischen Numismatischen Gesellschaft* 6 (1887):41–75. The whole of Köster's 1984 study, entitled "Mittelalterlicher Pilgerzeichen," provides an extremely useful and up-to-date summary of this important topic. For further examples of badges and tokens see the catalog *Wallfahrt kennt keine Grenzen,* pp. 41–51, with illustrations (catalog numbers 38–58) and several other examples passim. Although often illustrated, the remarkable pages showing pilgrimage badges in fifteenth-century Books of Hours deserve considerably further analysis.

11. See, for ex-votos, chapter 7, with further figures in section 3 there.

12. Characteristically, the literature on the history and cult of the shrine of the Madonna dell'Arco has grown very fast in recent years; but a good summary is provided by the local handbook by P. Raimondo Sorrentino, O.P., *La Madonna dell'Arco: Storia dell'immagine e del suo santuario,* 5th ed. (Naples, 1985; 1t ed., 1931). The older incidental literature is also substantial, and sometimes very entertaining.

13. For example, the picture *Pilgrims Returning from the Feast Day of the Madonna dell'Arco* of 1827 in the Louvre.

14. See, for example, P. Toschi and R. Penna, *Le tavolette votive del Madonna dell'Arco* (Naples, 1971), and A. E. Giardino and M. Rak, *Per grazia ricevuta: Le tavolette dipinte ex voto per la Madonna dell'Arco* (Naples, 1983).

15. A similar kind of enthusiastic salesmanship is represented by the vendors of popular devotional prints in the etchings and engravings after Annibale Carracci known as the *Arti di Bologna,* published in 1646, 1740, and 1776 and in those by G. M. Mitelli of 1660.

16. Nor, indeed, the many standards showing her in one form or another which have become so important an aspect of the celebration of her cult.

17. On the Madonna of Impruneta and attitudes toward her, see now the excellent article by Trexler, 1972. Trexler's piece has the additional merit of locating her cult in the broader context of quattrocento attitudes towards images, and in so doing adumbrates several of the main themes of this book.

18. The phrase is Trexler's 1972, p. 14

19. How these could be yoked to specifically religious factors appears most prominently in the case of the ravishingly situated *sacri monti* of Northern Italy (see chap. 9 below).

20. The Nahuatl convert Juan Diego took his mantle full of roses (specially collected at the behest of the Virgin) to his local—and skeptical—bishop. When he opened it, the roses fell out, and the *tilma* was found, inexplicably, to have imprinted on it the image of our Lady. It was then enshrined and became our Lady of Guadalupe, the chief Christian image of Mexico. During the Mexican Revolution, the independent armies marched under her banner against the Royalists, who in their turn carried yet another miraculous image to protect them—the "Virgen de los Remedios," under whose aegis none other than Cortes himself had conquered Mexico. On the complex relationship between the Mexican Virgin of Guadalupe and earlier native cults, see Turner and Turner 1978 (especially chapter 2 on Mexican pilgrimages, pp. 41–104), with pointers to the extensive bibliographic material on this issue. Just a year or so before the supposed discovery of the image on the *tilma,* the Dominican monks of Soriano in Calabria received their *acheiropoieta* of Saint Dominic from the hands of the Virgin herself, who, in the company of the Magdalen and Saint Catherine of Alexandria, mysteriously found her way into the closed church there. A useful compilation of the material is A. Barilaro, O.P., *San Domenico in Soriano* (Soriano-Calabro, 1968). The miracle thereby established and gave authority to the Dominican shrine at Soriano, and was especially commemorated in Spanish Dominican circles—hence the large number of Spanish pictures of this subject.

21. Warner (1976, pp. 310–11) has some thoughtful and perceptive lines on the issue of commercialism and spirituality.

22. For an example—one of many possible—of the kinds of complications to which the attempt at rigorous classification in these terms can lead, see V. Lasareff, "Studies in the Iconography of the Virgin," *AB* 20 (1938):26–65.

23. Further details in Walter Pötzl, "Santa-Casa-Kult in Loreto und Bayern," in

Kriss-Rettenbeck and Möhler 1984, pp. 368–82, esp. p. 378. See also the catalog *Wallfahrt kennt kein Grenzen,* pp. 206–24.

24. Gumppenberg's book, incidentally, concludes with a magnificent index of the varieties of these images, their behavior and the miracles attributed to them. He devotes chapter 1 of the index to the discovery—the *Inventio*—of miraculous images of the Virgin. Index 1 of this chapter classifies the finders themselves. Index 2 (of this chapter 1 of the main index) has the locations in which the images were found—in trees, on the earth, above the earth, in the sea, rivers, streams, and brooks, in heaven before Christ and after Christ. Each of these indexes is in turn divided into several catalogs, each having yet further subdivisions. The second chapter of the general index is devoted to the materials from which the images are made. The subindices here give: (1) the material substance, (2) the type of artist involved, (3) the varieties of pose and gesture, (4) the varieties of honor paid, (5) the ways in which they were attacked. Here Gumppenberg actually lists the weapons used, the parts affected, the feelings evinced by the images themselves (*ejularunt, fleverunt, mutarunt gestum,* etc.). Subindex 6 gives the victorious achievements of such images, and so on through subdivision after subdivision, including their powers and effects, whether consoling, miraculous, or hortatory. Like the index to the *Patrologia Latina,* and possibly even more revealing, this is one of the great examples of the indexical genre.

25. P. Samperi, S.J., *Iconologia della Gloriosa Vergine Madre di Dio Maria Prottetrice di Messina . . . ove si ragiona delle imagini di Nostra Signora che si riveriscono ne' Tempij, e Cappelle famose della Città,* (Messina, 1644).

26. [F. Corner], *Apparitionum et celebriorum imaginum deiparae Virginis Mariae in Civitate et Dominio Venetiarum enarrationes historicae* (Venice, 1760).

27. Steiner 1977, pp. 52–53. See also *Wallfahrt kennt keine Grenzen,* pp. 257–62.

28. See especially Gugitz 1955 and Aurenhammer 1955, but also more recent, entirely typical works such as H. Pfungstein, *Marianisches Wien: Eine Geschichte der Marienverehrung in Wien* (Vienna, 1963).

29. The plain, schematic, and rudimentary ones are undoubtedly in the majority; but there are, of course, exceptions. Most of these are the avowedly or recognizably artistic ones, made by good artists, like the Regensburg picture by Altdorfer, or Jacopo Sansovino's *Madonna del Parto* in Sant'Agostino in Rome.

30. For these examples and others, see Sumption 1975, pp. 50–51, citing *Mirac. S. Mariae Carnotensis* 18, in *Bibliothèque de l'école des Chartes* 42 (1881):537–38; John of Coutances, *Mirac. Eccl. Constatiensis* 6, in E. A. Pigeon, ed., *Histoire de la cathedrale de Coutances* (Coutances, 1876), pp. 370–72; Thomas More, *A Dyalogue of the veneration and worshyp of ymages and relyques, praying to saints and goyng on pylgrymage,* (London, 1529), fol. 22. See also ibid., p. 312, for further sources and examples.

31. On the whole issue of derivatives and their comparative effectiveness, see H. Dünninger, "Wahres Abbild: Bildwallfahrt und Gnadenbildkopie," in Kriss-Rettenbeck and Möhler 1984, pp. 274–83. Perhaps the most striking instance is that of the small paper images, ultimately derived from the Scherpenheuvel (Montaigu) Madonna (via its chief representative in Luxembourg), which forms the focus of the great pilgrimage center of Kevelaer. Dünninger also rightly stresses that "even in cases where the pilgrimage has originated from experiences of a purely visionary nature, these are translated in visual form, being reproduced and propagated as pictures or statues," as at La Salette, Lourdes, Fatima, and so on.

32. Cf. Freedberg 1983 on these kinds of stylistic adaptation in the case of printed examples from Flanders in the seventeenth century.

33. Steiner 1977, p. 47. But see also note 31 above.

34. Steiner 1977, p. 51.

35. "Si fuerit parva imago addatur. *Si quis vero infirmus aut moribundus eamden in manua sua tenuerit, aut supra pectus suum impositam haburerit, ad eum non audeant appropinquare hostes maligni, nec ei tentationibus suis nocere, aut spectris suis pavorem noxium immittere. Sed virtue hujus imaginis benedictae, & meritis beatae Virginis gloriosae, ab infestationibus daemonum liberatus Jesu Christo Filio ejus laudes & gratiarum actiones persolvat*" (*Manuale,* pp. 105–6).

36. See especially Van Heurck 1922, Van der Linden 1958, and Philippen 1968.

37. For further discussion and analysis of this and other aspects of the *bedevaartvaantjes* referred to in this paragraph, see Freedberg 1983, pp. 40–45.

38. "Geraeckt aan de Reliquien van de H. Elisabeth"; "Dit vaentje is aengeraekt aen het Miraculeus Beeld van Onse Lieve Vrouwe van Halle"; "Image de N.D. de hal, il delivre miraculeusement les ames du purgatoire comme on peu voir dans son histoire"—all cited in Philippen 1968, p. 26. The final example is to be found in the small but interesting collection of pennants in the Rijksmuseum Het Catherijne Convent, Utrecht.

39. The classic study is Spamer 1930, but see also Gugitz 1950. For the Netherlands, E. H. van Heurck, *Les images de devotion anversoises du XVIe au XIXe siècle: Sanctjes, Bidprentjes en Suffragien* (Antwerp, 1930), is the basic work; while good—and often entertaining—examples are provided by works such as K. van den Bergh, *Bidprentjes in de Zuidelijke Nederlanden,* Aureliae Folklorica, 20 (Brussels, 1975), and the splendidly Saint Sulpician survey by J. A. J. M. Verspaandonk, *Het Hemels Prentenboek: Devotie en bidprentjes vanaf de 17de tot het begin van de 20de eeuw* (Hilversum, 1975). The bibliography on the Italian *santini* has become too substantial to enumerate here; but the "Catalogo Descrittivo" by P. Arrigoni and A. Bertarelli, *Rappresentazione popolari d'immagini venerate nelle chiese della Lombardia conservate nella raccolta della stampe di Milano* (Milan, 1936), provides an excellent early example of awareness of the whole problem of downward adaptation and transformation.

40. *Gregorii Turonensis opera,* lib. 1: *De virtutibus S. Martini* (MGH, *Scriptores rerum Merovingiarum,* 1:585).

41. Ibid., 27:601.

42. Ibid., 28:601.

43. Ibid.

44. "Sed haec omnia fides strenua operatur, dicente Domine, Fides tua te salvum fecit," are Gregory's final words in this section.

45. Johannes Chrysostomos, *In martyres homilia,* in *PG* 50, col. 664. An extremely useful recent survey of the material, with abundant illustrations from the Louvre collections is provided by Metzger 1981; but the basic guideline, as so often, remains H. Leclercq, in *DACL* 1:2, cols. 1722–47, s.v. *ampoules.*

46. For fuller details of each of these, see the classic work by Grabar (1958).

47. Cf. chapter 5, section O, above.

48. Cf. Kitzinger 1980a, p. 152; and Engemann 1973, pp. 5–27, especially pp. 9–13, for a discussion of the significance of the EMMANOYHΛ inscription on all such eulogia, especially in the context of their presence on amulets.

49. Grabar (1958, pp. 63–67) has a brilliantly succinct account of just these problems of the relations between prophylaxis, figuration, and inscription; but his emphasis seems to be too much on iconography rather than on decoration and figuration itself.

50. British Library Add. MS. 37049, fol. 46 r. But compare the similar shield showing the *Arma Christi* above a nun in British Library MS. Cotton Faust. b.6,

illustrated in Suckale 1977, p. 185, fig. 7, who uses the page to illustrate his observation that "ein andere Nuance, die arma als Schutzwaffen, deutet die Amulettfunktion vieler Bilder an, bildlich ausgedruckt oft durch die Darstellung als Schild"—though here there are no demons even to corroborate the hypothesis.

51. Gregorius Nazianzenus, *Carmina,* lib. 2, sec. 1: *Apostrophe,* in *PG* 37, col. 1399. Text with French translation given by Leclercq, in *DACL* 1:2, col. 1801, s.v. *Amulettes.* The encolpium is also drawn and discussed in Leclercq, *DACL* 1:2, col. 1743, s.v. *Ampoules.*

52. Theodoret, *Historia religiosa,* 16, in *PG* 82, col. 1473A; Mansi 13, col. 73B. See also the discussion in Holl's justly well-known article on the role of the Stylites in the rise of the cult of images (1907, esp. p. 390). Further evidence of the attribution of this kind of apotropaic use or possibility is also provided by the varieties of benediction for images attached to houses and put beside doors, of the order cited in note 35 of the previous chapter. The difference, of course, is that the Theodoretan passage dates from the very lifetime of the Stylite; and that issues of contact and the transference of living power are thus more crucial than with other kinds of domestic or professional apotropaia and talismans.

53. As, for example, in the case of inscriptions like CTAURE BOHTHI ABAMOYN ("Cross protect Abamoun" [= "Son of Ammon"?]) on an early Christian amulet from Egypt (illustrated by Leclercq in *DACL* 1:2, col. 1821, and in Engemann 1973, p. 9, with an interesting discussion on this and other amuletic inscriptions on medallions, ampullae, gems, and crosses), and as in a whole variety of Gnostic amulets, such as a third-century charm from Cyzicus, which appears to have been intended to protect against nose-bleeding (illustrated and discussed by Leclercq in *DACL* 1:2, cols. 1847–48). But even in the latter case the evidently apotropaic and magical inscriptions are accompanied by representations that emphasize, clarify, and (presumably) enable the apotropaic message—sun, moon, eye, and large-jawed beast, inter alia, on the obverse; an aureoled cavalier on a rearing horse and an angel with significantly disposed wings on the reverse; and in others, the reclining woman naked to the breast on both faces. The whole problem of the significance of magical names, or names which by their very sound suggest magical powers of one kind or another, is one that should be borne in mind in this context; but to deal with it at greater length here would be to take this discussion well beyond its intended scope and its avowed concentration on the implications of the figurative.

54. Cf. chapter 5, section 4, and note 52 above.

55. Cf. A. A. Barb, "The Survival of the Magic Arts," in *The Conflict between Paganism and Christianity in the Fourth Century,* ed. A. Momigliano (Oxford, 1963), p. 120. For these and related examples, see also Wünsch 1898, pp. 6, 13, 16, 20, 23 et passim; and Audollent 1904, pp. lxxv–lxxvii, and lvi–vi.

56. The most famous case was perhaps that of the murder of Germanicus. For the fullest range of material still see Audollent 1904.

57. Needless to say, the issue has arisen even with the famous "gruppi di corde" referred to by Vasari in his life of Leonardo, and copied by Dürer, who called them "Die sechs Knoten" (B. 140–45). But the possibility of entrapping or warding-off demons is much more clearly suggested by the beautiful pulpit of Gropina near Arezzo—though even here the manner is not wholly clear. Plenty of further examples are provided by the excellent compendium by Hansmann and Kriss-Rettenbeck (1966), which should in any case be consulted for the problem of amuletic and apotropaic function generally. For more on knots and chains, see—as early but important studies—P. Wolters, "Faden und Knoten als Amulett," *Archiv für Religionswissenschaft*

8 (1905):1–22, and the immediately following article by Von Bissing on Egyptian examples. For reflections on the relation between what is regarded, putatively, as "purely" decorative and the possibility of functions that go beyond the "purely" aesthetic, see both chapter 4, section 1, and the final paragraph of this chapter.

58. Cf. Tambiah's reference to the "objectification of power in objects—of the sedimentation of charisma in gifts, valuables and amulets," in his discussion of the relations between Maussian mana and such objects as "vehicles of social exchanges" (1984, p. 339)

59. Ibid., p. 243.

60. Ibid., part 3, pp. 193–289. The problem arises largely because Tambiah's position is predicated on Max Weber's view of charisma, although he goes on to be critical of it. In other words, he sees charisma in terms of the exceptional individual, specifically the holy man. This concentration on the role of individuals with regard to the effectiveness of objects leaves out precisely those factors which are too often neglected in such discussions: viz., the visual, material, created factors. The same shortcoming is apparent in the well-known essay by Peter Brown on Byzantine iconoclasm, where—once again—the role of holy men seems a little exaggerated with respect to the problem at stake (Brown 1973).

61. Cf. the references to Gregory of Tours above, as well as *DACL* 2:1, cols. 1132–37, s.v. *brandeum;* but see also pp. 116–20 in Kitzinger's 1954 article on the cult of images before iconoclasm—my chief inspiration in this area as well as in many others.

7. THE VOTIVE IMAGE

1. On these and on the finds at Chamalières, see the useful summary in R. Martin, "Wooden Figures from the Source of the Seine," *Antiquity* 39 (1965): 247–52; as well as C. Vatin, "Circonscription d'Auvergne et Limousin," *Gallia* 27 (1969): 320–30; and J. C. Poursat, "Circonscription d'Auvergne," *Gallia* 31 (1973): 439–44. See also T. W. Potter (with an appendix by Calvin Wells), "A Republican Healing-Sanctuary at Ponte di Nona near Rome and the Classical Tradition of Votive Medicine," *Journal of the British Archaeological Association* 138 (1985): 23–47.

2. E.g., in Gregory of Tours, *Vitae SS. Patrum,* cap. 6: *De Sancto Gallo Episcopo* (in *PL* 71, col. 1031): "Erat ibi [i.e., Trevericae] fanum . . . ibi et simulacra ut deum adorans, membra secundum quod unumquemque dolor attigisset, sculpebat in ligno." Cf. also Gregory of Tours, *Miraculorum,* lib. 1: *De gloria martyrum,* cap. 97: *De glorioso martyre Sergio* (in *PL* 81, col. 790); and *De rege Gallicae populoque conversis, sive De Suevis* (in *PL* 71, col. 924).

3. MGH, *Leges,* 3.1, p. 61 (cap. 12). Cf. Kriss-Rettenbeck 1972, p. 107.

4. "Non licet . . . aut ad arbores sacrivos vel ad fontes vota dissolvere, nisi quicumque votum habuerit, in ecclesia vigilet et matricole ipsum votum aut pauperibus reddat, nec suptilia aut pede aut homine ligneo fieri penitus praesumat" (MGH, *Leges,* 3.1, p. 179; cited in Kriss-Rettenbeck 1972 p. 108).

5. "Fontes vel arbores, quos sacrivos vocant succidite, pe(cu)dum similitudines, quas per bivios ponunt, fieri vetate, et ubi in veneritis igne cremate" (MGH, *Scriptores rerum Merovingiarum,* 4. 705–7). Cf. the *Dicta Abbatis Pirmini* (Pirminius died in 753), which also forbade the making of "membra ex ligno facta," cited in Kriss-Rettenbeck 1972, pp. 107 and 108, notes 117 and 123. These pages and the accompanying notes in Kriss-Rettenbeck also provide a series of related texts about the use and prohibition of votive imagery. His material in turn derives from W. Boudriot, *Die altgermanische*

Religion in der amtlichen kirchlichen Literatur des Abendlandes vom 5 bis 11 Jahrhunderts (1928), esp. pp. 25–28, 70.

6. The 1980s have seen an extraordinary efflorescence of such publications, especially from Italy and Germany, but also from France. They now provide the researcher with more than adequate visual material, but it would be otiose and a lengthy business to list them here. More general books and articles have also begun to appear; but the significance and problematic of votive imagery are well set out in Kriss-Rettenbeck 1972, Brückner 1963, and in the short but general survey of the historical and the psychological dimensions of the phenomenon by A. Vecchi, "Per la Lettura delle Tavolette Votive," *Studia Patavina* 21 (1974): 602–21.

7. The original text is so representative, both in language and style, that it is perhaps worth recording here: "Haben uns alle in der stumb verspört und haben uns hernach auf Alten Oetting versprochen zu Unser L. Frawn, mit ainem tafel und kherzen, wan Gott behiete und das haus niet abprindt. Nach diesem vespröchen hat der kalch aufgehört zu prinen ien einem augenblick und nimer gerochen. Zu lob und dancksagung gott und U. L. Frawn opfern wir die khörzen sambt dem täfel" (Kriss-Rettenbeck 1972, p. 161, citing the *Mirakelbuch* of 1620ff. of Altötting).

8. The best account of these events is provided by the exactly contemporary anonymous *Historia della Madonna dei Bagni* preserved in the Archivio di San Pietro in Perugia, and presented by G. Guaitini and T. Seppilli in *Madonna dei Bagni*, pp. 9–10.

9. For the text of the *processo,* see U. Nicolini in *Madonna dei Bagni*, pp. 50–53. Interestingly, the old connection between water and tree and votive function emerges in some of the very earliest miracles. By the summer of 1657, when the local water supply dried up, a health-giving source had already sprung up from right beneath the Madonna of the Oak (Guaitini and Seppilli in *Madonna dei Bagni,* pp. 13–14, citing the anonymous *Historia* mentioned in note 8 above).

10. On the church and its building history, see P. Zucconi in *Madonna dei Bagni,* pp. 55–62.

11. The ex-votos of the Madonna dei Bagni have recently been subjected to intensive analysis and investigation. For example, Guaitini and Seppili in *Madonna dei Bagni* classified the miracles into no less than twenty-two major groups, with ver many subdivisions.

12. See also the examples in chapter 6, section 2.

13. For all these variations on Altdorfer's picture, and several others, see Hubel 1977, esp. pp. 217–37 and figs. 26–80.

14. Two panels, each 38.8 by 33.4 cm., with an inscription panel of 1643, now in the Museum der Stadt Regensburg (Winzinger 1975, nos. 101/102).

15. For good illustrations of these and other book illustrations showing the Regensburg Virgin, see Hubel 1977, figs. 13–16.

16. The best general account, with a generous corpus of illustrations, is provided by Hubel (ibid., 197–237), with further references, especially to G. Stahl, "Die Wallfahrt zur Schönen Maria in Regensburg," in *Beiträge zur Geschichte des Bistums Regensburgs* (Regensburg, 1968), 2:35–282. Hubel excellently covers in greater detail several of the issues touched on here, including that of the expulsion of the Jews and the many variations of the *Schöne Maria.*

17. See A. Nero, "Pietà liturgica e pietà popolare nel *Vesperbild* di Tiziano," in *Interpretazioni Veneziane: Studi di Storia dell'Arte in Onore di Michelangelo Muraro,* ed. D. Rosand (Venice, 1984), pp. 323–29, noting—but without any further substantive

discussion—that "la tavoletta votiva o ex-voto rientra dunque nel vasto alveo della pietà popolare" (p. 327).

18. On these events see Settis 1981, 712–22. The basic documentary evidence for this and the next paragraph is still provided by the transcriptions—with reference to the important earlier literature—by Kristeller (1902, 558–63). For similar previous cases—which almost certainly served as "suitable" precedents for the Mantuan events and allegations—involving Jews in Gubbio and Pisa in 1471 and 1491–92, see M. Luzzatti, *La Casa dell'Ebreo: Saggi sugli Ebrei a Pisa e in Toscana nel Medioevo en nel Rinascimento* (Pisa, 1985).

19. Kristeller 1902, doc. 141, pp. 561–62. This translation is by Caroline Elam, to whom I am grateful for drawing my attention to the relevance of this case.

20. All this is corroborated by several further letters, including one from Isabella d'Este herself to Francesco Gonzaga (Kristeller 1972, doc. 142, p. 562), in which she too comments on the sermon and the throngs that went to the Madonna della Vittoria in the tumultuous days following the construction of the new chapel. In these letters may be found the full array of the complex relations between artistic skill and perceived efficacity, between orchestrated devotion and local popularity (ibid., pp. 558–62, esp. docs. 134–44).

21. "Ita vovet ex toto suo, hoc est Mariano corde, tuus cliens Maximilianus Josephus."

22. Kriss-Rettenbeck 1972, p. 169, 114. Compare the figures for Regensburg given in chapter 6, section 1.

23. Cf. Warburg 1932, 1:99, 118–19, and 349–50, as well as Schlosser 1911, pp. 214–15. See also chapter 9, sections 4 and 6, for further discussion of the imagery in Santissima Annunziata.

24. For good photographs of the votive interiors of Heiligwasser and Tuntenhausen, see Kriss-Rettenbeck 1972, plates 24 and 14 respectively.

25. See D. Redig de Campos, "L'Ex Voto dell'Inghirami al Laterano," *Atti della Pontifica Accademia Romana di Archeologica,* ser. 3, *Rendiconti* 29, fasc. 1–4 (1956–57): 171–79; and P. Künzle, "Raffaels Denkmal für Fedra Inghirami auf dem letzten Arazzo," in *Mélanges Eugène Tisserant* (Rome 1964), 6:499–548; and Settis 1981, pp. 701–8.

26. On Figiovanni, see G. Corti, "Una ricordanza di Giovanni Battista Figiovanni," *Paragone* 15, no. 175 (1964): 24–31, and A. Parronchi, "Una ricordanza inedita del Figiovanni sui lavori della Cappella e della Libreria Medicea," in *Atti del convegno di studi Michelangeloleschi, Firenze Rome 1964* (Città di Castello, 1966), p. 341. On the votive picture, see G. Richa, *Notizie istoriche delle Chiese fiorentine* (Florence, 1757), 5:100, and D. Moreni, *Continuazione delle memorie istoriche della basilica di S. Lorenzo* (Florence, 1816), p. 294.

27. Kriss-Rettenbeck 1972, p. 164.

28. Ibid., p. 155.

29. Discussed fully ibid., pp. 273–306, 347–59.

30. The legal terminology used by Kriss-Rettenbeck is appropriate not least because of the fact that very often votive images do provide evidence to be used in the context of the law. For a brief summary of some of the juridical aspects of this usage, see L. Clausen, "Wallfahrt und Recht," in Kriss-Rettenbeck and Möhler 1984; pp. 87–100, esp. pp. 92–96.

31. Kriss-Rettenbeck 1972, p. 164, citing E. Baumann, "Die Votivbilder von Mariastein: Ihre Geschichte und Beschreibung," in *Die Glocken von Mariastein* (Laufen,

1946), p. 9. Here Kriss-Rettenbeck also gives several other instances of such stipulations on wood or on card.

32. It is perhaps worth recalling here that it is not always necessary, in the ex-voto, to show the illness itself. There are other ways of conveying the specificity of the cure—as in the kinds of ex-voto which show figures praying before a church wall covered with eyes (cf. Kriss-Rettenbeck 1972, plate 111, from Mühldorf). In such ways the picture makes abundantly plain both the substance of the thanksgiving and the specific efficacy for which the shrine was known.

33. With figure 91 one might compare, for example, the remarkable photograph by Michael Coyne in *Harper's Magazine* January 1988, p. 441, showing a stark assemblage of crutches and artificial limbs arrayed in front of a picture of the Ayatollah Khomeini and a text from the Koran—somewhere, presumably, in Teheran.

34. I am aware of the sense in which all representation is schematic, but here I use the term in its popular and nonphilosophical sense to mean a mode of representation where the components appears to be less naturalistic than they could be—to the eyes of most beholders from the relevant context.

35. In this respect the claims here are closer to those of Gombrich in *The Sense of Order* (1979) than in *Art and Illusion* (1960).

36. Aside from the evident resistance of iron to modeling, the usual need to make the body lifelike seems, therefore, to be allowed to lapse somewhat.

37. For the ways in which accuracy turns to verisimilitude, see chapter 9.

8. Invisibilia per visibilia

The original passage from which the epigraph to this chapter is taken reads as follows: "Das grosse gemeinsame ist das Verlangen nach Schau. Hier treffen sich Hesychasmus und Ikonenkult zu einer letzten gemeinsamen Haltung: Schau als Ausgangspunkt und Ziel-punkt für jegliche Erhebung des Geistes und Quelle jeglichen religiösen Affekts, verwandt der Bedeutungsentwicklung des lateinischen Wortes *contemplatio* und erst recht der des griechischen *theōria*" (Beck, 1975, p. 41). The chief difficulty in translating this passage revolves round *Schau.* It carries with it both a sense of the actual and external (as in "display" or—as Ernst Gombrich pointed out to me—the sense of the face to face) and of the internal (as in visionary experience). In discussing the matter with me, Nicolai Rubinstein observed that *Schau* could also be used in a further sense, one that embraces both the notions of internal and external vision, as used in the circle of Stefan George (e.g., in Friedrich Wolters and the early work of Ernst Kantorowicz) to convey the idea of the historian's grasp of a particular period based on inductive vision but developed from fact. Hans Belting, on the other hand, reminded me of the song of Lynceus the Watchman in *Faust,* part 2, where the relationship between seeing, *Sehen,* and the kind of vision represented by *Schau* is set out in the marvelous lines, sung at the dead of night: "Zum Sehen geboren/ Zum Schauen bestellt."

1. Methodios of Olympos reversed the metaphor in this way: Christ assumed a human body as if he had painted his picture for us, so that we might imitate him, its painter (Methodios of Olympios, *Symposium,* 1.4.24; in *GCS, Methodios* [Leipzig, 1917], p. 13). See Ladner 1953, pp. 10–11, for the dogmatic and theoretical context. Cf. also Methodius, *De Resurrectione,* 1.35.3–4; 2.10.7–17; and 3.6. Sister C. Murray, "Art and the Early Church," *Journal of Theological Studies,* n.s. 28, pt. 2 (1977): 321,

n. 1, also refers to the important passage from Origen where man, the image of God, is a painting painted by Christ the best painter (Origen, *In generatione hominis,* 13.4.119; in *GCS* 6:119–20).

2. Although elsewhere he was to concern himself with the ontology of images and the psychological aspects of the perception of material representation, in the commentary on Peter Lombard, Aquinas was explicitly concerned with the relations between the institutional status of images and practice.

3. The translation is my own from *Commentarium super libros sententiarum: Commentum in librum III,* dist. 9, art. 2, qu. 2—a passage that is rarely correctly cited and hardly ever actually quoted. For the Latin text see Freedberg 1982, p. 149, n. 53.

4. Horace, *Ars poetica,* lines 180–82; cf. also chapter 3 for a further discussion of the implications of this traditional parallelism.

5. The Latin text of the *Expositio in quatuor libros sententiarum,* lib. 3, dist. 9, qu. 2, from which this translation is made, is based—like the one above—on a recension of the fifteenth-century editions in the British Library. It is also available in Freedberg 1982, p. 149, n. 53.

6. Gregory the Great, *Lib. IX, Epistola IX Ad Serenum Episcopum Massiliensem,* in *PL* 77, cols. 1128–29. Almost exactly the same sentiments are outlined and expanded in another letter from Gregory to Serenus, *Lib. IX, Epistola XIII Ad Serenum Episcopum Massiliensem* in *PL* 77, cols. 1027–28.

7. And in several other early Christian writers—see Clerc 1915, p. 234; Elliger 1934, pp. 61–86; and Kitzinger 1954, p. 136. For Gregory of Nyssa, see the important *Oratio laudatoria Sancti ac Magni Martyris Theodori* (in *PG* 46, col. 757D).

8. It is already to be discerned in Gregory of Nyssa's account of how he could not pass by a picture of Abraham about to sacrifice Isaac—*miserabilis huius rei imaginem*—without crying at the sight of it (*Oratio de deitate filii et spiritus sancti,* in *PG* 46, col. 572).

9. Gregory the Great, *Lib. IX, Epistola LII Ad Secundinum,* in *PL* 77, cols. 990–91.

10. It also happens to put into words the basis for the expansion of the use of images outside churches and holy places; but that is another question.

11. Clerc 1915, p. 230.

12. Ibid., pp. 166–67.

13. Dionysius Areopagiticus, *De ecclesia hierarchia,* 1.2 (*PG* 3, col. 373). The translation is that of Kitzinger 1952, pp. 137–38.

14. Kitzinger 1954, p. 138.

15. Bonaventure, *Itinerarium mentis ad Deum,* 2.11. Cf. Chydenius 1960, pp. 11–12, for the place of this text in medieval symbolic theories. See also Bonaventure's own rather briefer statement that "omnis creatura est signum, cum ducat in deum" (*In Sententiarum,* dist. 1, dub. 3 [*QR* 1.42]).

16. Chydenius 1960, p. 9.

17. This even applies to Christ himself, as emerges from the passages by Methodius referred to in note 1 above.

18. It is worth recalling that although *signum* (*sēma*) originally simply meant a sign (in the sense that Augustine was also to use it), already in Roman republican times it had come to be used for statues, especially statues of the gods, and somewhat less frequently for other images (particularly the figural works of great and famous artists). Cf. W. Paatz, *Von der Gattungen und vom Sinn der gotischen Rundfigur,* Sitzungsberichte der Heidelberger Akademie der Wissenschaften, Philosophisch-Historische Klasse, 3 (1951), pp. 18–19.

19. Aelred of Rievaulx, *Tractatus de Jesu puero duodenni,* in *Oeuvres complètes de Saint Bernard* (Paris, 1865–67), 6:369–70; also cited in Ringbom 1965, p. 16.

20. Baxandall 1972, p. 45

21. It was copied and recopied for several centuries (over two hundred manuscripts exist) and its influence can be traced in practically every one of the many meditational tracts put together in the next three hundred years. By the sixteenth century, they had acquired new significance, because they in turn were adapted in the new forms of spiritual exercises.

22. Evidently a suitable reminder for the Poor Clares, or any member of the Franciscan order!

23. Pseudo-Bonaventure, *Meditations* (1961 ed., pp. 68–72).

24. With the intensification here culminating in the references to the injuries done to strangers whose helplessness, humility, and simplicity have just been so meticulously described.

25. Cf. Baxandall (1972, pp. 46–49) on meditative practices and on the implications of response; as well as his cautions—although it is hard to follow him altogether in his claims about general and unparticular representation. He suggests that painters like Perugino who painted "general unparticularized interchangeable types" thereby "provided a base—firmly concrete and very evocative in its patterns of people—on which the pious beholder could impose his personal detail, more particular but less structured than what the painter offered" (pp. 46–47). It is not clear that this characterization of Perugino is entirely right; nor that the claims about the relations between art and cognition, especially in the last sentence quoted here, are at all strong. They are no more than debatable.

26. Pseudo-Bonaventure, *Meditations* (1961 ed., pp. 331–32).

27. Ignatius Loyola, *Exercitia spiritualia,* 1: *Hebdomada quintum exercitium.*

28. And as one thinks about how such pictures may have worked, one should perhaps recall Pliny's comment on the statue by Pythagoras of Rhegion at Syracuse. It showed a man limping, "the pain of whose ulcer even the spectators seem to feel" (Pliny, *Historia naturalis,* 34.59).

29. *De meditatione passionis Christi per septem diei horas libellus,* in *PL* 94, cols. 561–68. Once again, this dates from the mid or the late thirteenth century.

30. *PL* 94, cols. 561–62; also cited in Marrow 1979, note 43.

31. *PL* 94, col. 564; also cited in Marrow 1979, note 44.

32. Excellent summaries of the way in which these details appear in the Netherlandish and German Passion tracts are provided by Marrow 1979, pp. 33–170.

33. For the text see Marrow (ibid., p. 54), citing Ludolphine manuscripts in the Hague and Brussels. Marrow gives even more melodramatic instances of the ways in which the Passion tracts spoke of Christ's sufferings: his tormentors did things like force his mouth open with a stick before spitting intemperately into it, or "they gathered foul thick matter in their throats and belched and spat it at Him" (p. 133).

34. Ibid., p. 14. For more on visions, reality, and dreams, see chapter 11, especially section 4.

35. Heinrich Suso (Seuse), *Deutsche Schriften,* ed. K. Bihlmeyer (Stuttgart, 1907; reprinted, Frankfurt, 1961), p. 103.

36. A good summary of the literature on the *devotio moderna,* of its influence, and of the meditational and imitative aspect of its religiosity is provided by Marrow 1979, pp. 20–27, with notes 65–79.

37. For a text that conveys these elements with remarkable procedural purity, see the passage from the Venetian *Zardino de oration* of 1454 quoted at the beginning of

the following chapter. Although the first part of these instructions (the specific recommendation to imagine Jerusalem and the actors in the Passion in known terms) carries obvious risks and was not often to be so explicitly formulated, and although it seems to have been written specifically for young girls, and although it is free of the practical imitational aspects that emerge so strongly in the *devotio moderna* that we have just analyzed, it demonstrates the range of potential practitioners and sets out the main procedures with marvelous clarity and coolness. It is by no means as melodramatic as usual; but the way it was meant to work could not be more explicit.

38. On the difficulties of and the need for recognition, see the extended discussion in chapter 9 below.

39. O. Clemen, *Die Volksfrömmigkeit des ausgehenden Mittelalters,* Studien zur Religiösen Volkskunde, 3 (Dresden and Leipzig, 1937), p. 14, translated by Ringbom 1965, p. 29, n. 40.

40. The need to color the plain object is another aspect of impulsiveness with figuration (or indeed with blankness) that has not received the attention it should have.

41. With "archetype" or "original" here, I refer to the image that is the archetype or original of the printed image; I am not yet, however, entering into the problem of fusion between the image and what is represented on it.

42. Ignatius Loyola, *Exercitia spiritualia,* 1: *Hebdomada, primum exercitium.* My translation here is made from Ignatius's original Spanish version. Such recommendations are abundantly exemplified by passages such as that from the Venetian *Zardino de oration* quoted at the beginning of chapter 9, as well as by, in almost literal terms, the *sacri monti* of Northern Italy discussed in the same chapter.

43. Costerus 1588, p. 15.

44. Freedberg 1978, pp. 436–40, has more specific details of the contents and procedures of Coster's book.

45. On Nadal, see Nicolau 1949 and Freedberg 1978 for the later literature.

46. Nicolau 1949, p. 169.

47. For the editions and the publishing history of the book, see ibid., pp. 114–16. The text I comment upon here is that of 1607, since it is not only a corrected and revised edition of that of 1595, but also contains an important additional preface. For the genesis of the book, published so many years after Nadal's death, see not only Nicolau but also the succinct account in T. Buser, "Jerome Nadal and Early Jesuit Art in Rome," *AB* 58 (1976): 424–25. Buser's article also gives an excellent overview of the influence of the kinds of ideas exemplified by Nadal's book.

48. These longer *adnotationes* were only added in the 1607 edition; they were not present earlier. For suggestions about the way in which these directions provide a fine index of how the scenes—no less than 153 from the Life of Christ—might have affected the contemporary beholder and what sorts of associations were open to him or her, see Freedberg 1978.

49. Noted in the unpaginated first preface to the 1607 edition.

50. Cf. Costerus 1588, *Praefatio,* esp. p. 23.

51. The wording of the passage is very telling: "Ne autem ipsarum imaginum multitudo satietatem cuipiam pareret, unde suo fine, spirituali scilicet animarum fructu, opus ipsum frustraretur si in aes incideretur parum eleganti manu; sed potius ut opificii elegantia ac pulchritudo, simul cum maxima ipsius argumenti sanctitate atque excellentia, operisque pietate coniuncta, omnes ad illud evoluendum, adsiduaque meditatione invitaret, necessarium omnino fuit, ut excellentissimum quique

artifices operi tam eximio, quod ipsius Evangelii nova ac pene spirans imago est, adhiberentur" Nadal 1607, *Praefatio* (signed Jacobus Ximenez) to Clement VIII, n.p.

52. The Latin edition appeared in 1601; the Dutch in 1603, as *De Christelijcke Waerseggher.* A catechetical outline in verse had been written several years earlier in the vernacular, as David himself notes in the *Praefatio/Veurreden* of the illustrated versions in prose discussed here. He also notes that the illustrations were commissioned not only to enhance the text but also so that the illiterate might "read by looking." For the other—equally interesting—illustrated books by David, see Landwehr 1962, nos. 52–55, as well as F. A. Snellaert, in *Biographie nationale de Belgique* (Brussels, 1873), 4, cols. 721–32.

53. "Ut debitis eum coloribus adumbrent," David notes on p. 45, in the section marked in the margin as "Christiani ut pictores, Christi imitatores."

54. He is the one, it was earlier noted by David, who even while contemplating Christ has the devil in the "painting of his heart," *in cordis sui tabella* (David 1601, p. 45).

55. Ibid., p. 353. "Ad vivum" is the entirely appropriate term David uses for what I here translate as "after the life."

56. Ibid., p. 45.

57. Ibid., p. 353.

58. It ran to at least twelve editions in Latin, Dutch, and French between 1620 and 1649. Cf. Landwehr 1962, nos. 221–22. I have used the seventh edition of 1630 (*editio auctior, castigatior et novissima,* Landwehr's 221c). But a better survey of the editions (and a good account of his life) is provided by A. Poncelet in *Biographie nationale de Belgique* (Brussels, 1926–29), 34, cols. 237–41.

59. Sucquet 1630, p. 501.

60. This particular illustration precedes another (in the 1630 edition, plate 16, facing p. 548), where the painter strives desperately to reach out to Christ, but is held back by the world (a chain attached to the orb) and—as the text explains—the weight of his human nature. It should, however, be noted that by this time the metaphor of the painting of the heart had become a common conceit both in word and image, in which the notion of imitation and painting was quite variously used. See, for example, the charming engraving by A. Wierix in the *Cor Iesu amanti sacrum* series (used from 1626 on in the many versions of E. Luzvic's *Le coeur devot* / *Cor Deo devotum/ Het Godt-vruchtighe Herte*) showing the infant Christ painting the human heart, as well as Goltzius's early print of 1578 showing the Magdalen painting a heart according to the model of the heart held out for her by Christ himself (B. 64).

61. Right at the end of the century a work like Nuñez de Cepeda's *Idea de el buen Pastor* reformulates these by now widespread ideas as follows: "Just as when painters paint one image of another (*imaginem ex imagine pingunt*), constantly keeping an eye on the exemplar, and try with great diligence to transfer its strokes and features to their own work, so he who meditates to make himself perfect in every virtue ought to reflect on the actual lives of the saints, and their good deeds, by imitating them, as if living *simulacra*" (Francisco Nuñez de Cepeda, *Idea de el Buen Pastor* [Leon, 1682], p. 259, *in margine*). The fact that the last part of this passage derives from Saint Basil's seventh oration on virtue and vice reminds us of the antiquity of a notion that bears such abundant fruit in the seventeenth century.

62. *De meditandi methodo qua anima a terrenis elevatur in Deum* (Suquet 1630, book 2, part 2, chap. 35, p. 498).

63. J. Andries, *Necessaria ad salutem scientia, partim necessitate medii, partim necessitate*

praecepti, per iconas quinquaginta duas repraesentata (Antwerp, 1654), p. 3. For the other important works by Andries—especially his *Perpetua crux . . . iconibus quadragensi explicata,* see C. Sommervogel and A. de Backer, *Bibliothèque des ecrivains de la Compagnie de Jésus* (Liége and Lyons, 1869–76), 1:18–20, 7:24. For a summary of the significance of all such illustrations in terms of their relations with canonical art and the status of images in Flanders, see also Freedberg 1983.

64. Indeed, one of the reasons we so often perceive natural objects and phenomena in terms of made images we know must be because we order natural phenomena in terms of our experience of conventionalized, ordered forms of representation.

65. The Greek original of this passage is given by Clerc 1915, p. 255, referring somewhat puzzlingly to Olympiodorus, *Praxis,* 46.74–76. For the relationship of this view with those in Porphry's important treatise *Peri Agalmatōn,* see Clerc, pp. 253–54.

66. Dio Chrysostom, *Oratio XII,* 52.

67. Cf. the passage from Xenophanes cited in chapter 4, note 18.

68. Dio Chrysostom, *Oratio XII,* 53.

69. Ibid., 55, 59, 60–61.

70. David Hume, *The Natural History of Religion,* in *Essays Moral, Political, and Literary,* ed. T. H. Green and T. H. Grose (London, 1889), vol. 2, sec. 3, p. 317; cited by Freud {1913} 1960, p. 77. Cf. also the introductory section of chapter 11 for a further discussion of some of the problems involved in talk about animism.

71. As suggested by Nelson Goodman, not only in *Languages of Art* but also in "Seven Strictures on Similarity," in *Problems and Projects* (1972), pp. 437–46.

9. VERISIMILITUDE AND RESEMBLANCE

1. The first historical work on Varallo to give the full details of Caimi's aims was G. B. Fassola, *La Nuova Gerusalemme osia il Santo Sepolcro di Varallo* (Milan, 1671). The fundamental modern work is P. Galloni, *Il Sacro Monte di Varallo* (Varallo, 1909 and 1914). But see also subsequent works like M. Bernardi, *Il Sacro Monte di Varallo* (Turin, 1960), and the very good general survey by Langé (1967, pp. 4–8 and 13–19). Further bibliographic references can be found in the stimulating review by W. Hood of the work cited in note 5 below, in *AB* 67 (1985): 333–37.

2. Baxandall 1972, p. 46.

3. In addition to Langé 1967, pp. 13–19, see also G. Testori, "Gaudenzio e il Sacro Monte," in *Gaudenzio Ferrari,* Exhibition Catalog, Vercelli, Museo Borgogna (Milan, 1956).

4. A good overview of these and other *sacri monti*—on which the literature is now burgeoning—is provided by Langé 1967, as well as by R. Wittkower, "Sacri Monti in the Italian Alps," in *Idea and Image* (London, 1978), pp. 175–83. The regional red guides of the *Touring Club Italiano* provide characteristically useful and generally sound information.

5. On Varese see P. Bianconi, S. Colombo, A. Lozito, and L. Zanzi, *Il Sacro Monte Sopra Varese* (Milan 1981).

6. S. Butler, *Alps and Sanctuaries* (London, 1986; 1st ed., 1881), pp. 249–51. The fact that Butler refers to "the peasant," ignoring the basic implications even for one as cultivated as himself is an illustration of just the kind of repression I have set out to expose and combat. But this does not diminish the richly and engagingly illustrative worth of both these extracts. Butler's *Ex-Voto* of 1888 is almost wholly devoted to the Sacro Monte of Varallo.

7. On flat images versus modeled sculpture in the round, see both chapter 3 and the conclusion of section 6 in this chapter.

8. See E. Sapir, "Symbolism," in *Culture, Language, and Personality: Selected Essays,* ed. D. Mandelbaum (Berkeley, 1949), pp. 564–66.

9. Cf. chapter 4, section 1, as well as chapter 15.

10. Kris and Kurz 1979, p. 76. It is significant that the title of the English adaptation of the original version of *Die Legende vom Künstler* is *Legend, Myth, and Magic in the Image of the Artist.*

11. Kris and Kurz 1979, pp. 76–77.

12. Ibid., p. 83.

13. The great fictional example is of course the man with the terribly wracked eye-sockets who torments Emma Bovary on her coach journeys to and from Rouen; but one also thinks of the troubling effect produced by portraits such as that of a one-eyed flautist from the school of Fontainebleau in the Louvre.

14. See chapter 5, section 2, for the insertion of the eyes, as well as chapter 4, section 6, for the danger of the gaze. The same applies, perhaps to a slightly lesser extent, to the mouth. The case may be tested by considering the always perplexed and sometimes terrified response evoked by images without eyes or deprived of their mouths. We see the image, it seems almost alive, but it lacks those marks, those final proofs of liveliness; and it thus disturbs us profoundly. Cf. also chapter 14, section 8, as well as figs. 27 and 187.

15. Kris and Kurz 1979, p. 77.

16. Ibid.

17. Ibid. See also H. Gomperz, "Über einige psychologische Voraussetzungen der naturalistischen Kunst," *Allgemeine Zeitung* (Munich, 1905), suppl. 160–61—an article which Schlosser also greatly praises in his study of waxworks cited in this chapter below.

18. Kris and Kurz 1979, p. 79.

19. As in Weynants-Ronday 1936, pp. 9, 133–73; and G. Maspero, "Le Double et les statues prophétiques," in *Études de mythologie et d'architecture égyptienne* (Paris 1893), pp. 82–89.

20. Euripides, *Alcestis,* 348–54. Gombrich refers to these same lines in Euripides, but makes something rather different of them: "What Admetus seeks is not a spell, not even assurance, only a dream for those who are awake; in other words, precisely that state of mind to which Plato . . . objected" ([1960] 1968, p. 107).

21. Cf. Nicephorus, *Antirrhetici,* in *PG* 100, col. 461, using the assertion to justify pictures at the time of the outbreak of the second great wave of Byzantine iconoclasm in 815. Naturally he was expelled from office. See also John of Damascus, *Oratio,* 1.33, in *PG* 94, col. 1261, for similar sentiments.

22. Such as those at the Quinisext Council of 692 and then at the Councils of 787 and 815.

23. For a good discussion around this problem see Cormack 1985, pp. 99–109.

24. As canon 82 of the Trullan or Quinisext Council of 692 fully recognized (Mansi 11, cols. 977–80, and 13, cols. 40–41).

25. For the problem of the image of Buddha see, for example—and inter multa alia—the good account in D. Seckel, *The Art of Buddhism* (New York, 1964).

26. Eusebius, *Historia ecclesiastica,* 7.18.

27. Ibid., 7.18.4; from G. A. Williamson's translation, *The History of the Church* (Baltimore, 1965), p. 302.

28. Macarius of Magnesia, *Apocriticus,* ed. C. Blondel (Paris, 1876), p. 1; cf. Koch 1917, pp. 41–42.

29. Roberts and Donaldson, vol. 16: *Apocryphal Gospels, Acts and Revelations: The Death of Pilate,* translated by A. Walker (Edinburgh: 1870) pp. 234–35.

30. Dobschütz 1899, p. 285*, citing Petrus Mallius, *Historia basilicae Vaticanae antiquae,* 25; cf. Mabillon, *Iter Italicum* (1724), p. 86.

31. This version of the legend is in fact rather later than commonly supposed, and cannot really be dated back prior to the twelfth century. The basic account of the whole Veronica tradition remains Dobschütz 1899, chap. 5, pp. 197–262 (including the Paneas legend, pp. 197–218), with a splendid array of the relevant texts on pp. 250*–335*.

32. Here too Dobschütz has the basic account and the fundamental texts (ibid., chap. 5, pp. 102–96 and 158*–249*).

33. Eusebius, *Historia ecclesiastica,* 1.13; cf. Dobschütz 1899, p. 164* for the relevant passage from the Syriac Acts of Thaddeus.

34. Cf. Dobschütz 1899, pp. 113, 171* (*Doctrina Addai*).

35. Roberts and Donaldson, vol. 8: *Acts of Thaddaeus,* pp. 558–59. But see, for the whole Edessene story, the *Narratio de imagine Edessena* from the court of Constantine Porphyrogenitus, in *PG* 113, cols. 423–54.

36. Evagrius, *Historia ecclesiastica,* 4.27, in *PG* 86.2, cols. 2748–49; but for a discussion of its exact role and the difficulties with the stories about its miraculous intercession on behalf of Edessa against the Persians in 544, see Kitzinger 1954, p. 103.

37. A recent and readable discussion in favor is I. Wilson's *The Turin Shroud,* revised edition (London, 1979). For the scholarly and skeptical view, see the King's College Inaugural Lecture by A. Cameron, *The Sceptic and the Shroud* (London, 1980).

38. For the whole cult of the Veronica, see K. Pearson, *Die Fronica* (Strasbourg, 1887), as well as Dobschütz 1899, pp. 218–30.

39. Translation from James 1924, pp. 477–78. For the textual history and other earlier versions of the Lentulus description, see Dobschütz 1899, p. 308**–30**.

40. James 1924, p. 477.

41. Both examples in Rijksmuseum Het Catherijne Convent, Utrecht.

42. Justin Martyr, *Dialogus cum Tryphone,* 14, 36, 85, 88.

43. E.g., in Clement of Alexandria, *Paedagogus,* 3.1.

44. Theodorus Lector, *Historia ecclesiastica,* 1.15, in *PG* 86, col. 173; cf. col. 221a. There is no need to enter into the early Christian and Byzantine arguments about whether Christ had a beard or not, since the issues remain the same.

45. H. Cardanus, *Opera* (Lyon, 1663), 3.661 (*De subtilitate,* 18) and Schlosser 1910–11, pp. 193–94. Cardanus presumably describes the stage prior to the final product in wax; cf. Giesey 1960, p. 4. On death masks in general see also E. Benkard, *Das Ewige Antlitz: Eine Sammlung von Totenmasken* (Berlin, 1927).

46. De Laborde 1850, p. 561 (Table alphabétique, s.v. *representation*).

47. "Ius imaginis ad memoriam posteritatemque prodendam," as Cicero succinctly put it in the fifth Verrine oration (*In Verrem,* 5.14).

48. Schlosser 1910–11, pp. 177–78, still remains one of the best concise accounts of this custom ever written; but see also Benkard as cited in note 45 above and J. D. Breckenridge, *Likeness: A Conceptual History of Ancient Portraiture* (Evanston, 1968), for a discussion of some of the issues raised in this chapter. The relation between verisimilitude and the need to ensure such a record is also suggested by the "matter-of-fact-realism," as John Rosenfield has put it, of commemorative portrait statues of the mid-

Kamakura period and later in Japan—of which the most stupendous example is the extraordinarily beautiful statue from Todai-ji of the monk Chogen. It is said to have been carved immediately after Shunjobo Chogen's death in 1206, and then used in his funerary ceremonies. See J. M. Rosenfield, in Y. Mino et al., *The Great Eastern Temple: Treasures of Japanese Buddhist Art from Todai Ji,* Exhibition Catalog, The Art Institute of Chicago (Chicago, 1986), esp. pp. 108–11.

49. Polybius, 6.53–54.

50. Schlosser 1910–11, p. 179.

51. See Ibid.: "Die Magie des Bildnisses tritt in Wirksamkeit durch möglichst Lebestreue."

52. Brückner 1966, p. 20.

53. Pliny, *Historia naturalis,* 35.153.

54. From Appian through Dio Cassius, Herodian, Ammianus Marcellinus, and *The Greek Anthology,* the sources are given and excellently translated in Schlosser 1910–11, pp. 180–85.

55. Appian 2.147.

56. Polybius, 6.53.

57. Schlosser 1910–11, p. 189. This kind of deception—whether deliberate or not—is very common indeed, and is to be related to the many medieval and Reformation instances, sometimes alleged, sometimes genuine, of using mechanical or manual devices in an image to give the impression of, say, miraculous movement, distillation, nictitation, or lachrymation. See also chapter 11, section 1 and note 7 there.

58. Brückner 1966, p. 107.

59. Schlosser 1910–11, p. 103. Giesey 1960 has a brief discussion on pp. 103–4 ("very little is noteworthy beside the simple fact that it was a replacement for the body") On pp. 197–201, he also gives a transcript of the chief manuscript sources, while on p. 203 he insists that Charles VI's effigy was a funeral effigy and not a death mask.

60. Details in ibid., pp. 105–6, with a discussion of the problems posed by Fouquet's temporary absence from Paris at just this point. Giesey's account thus supersedes the confusing one in P. Wescher, *Jean Fouquet and His Time* (New York, 1947), p. 30, and Schlosser 1910–11, p. 193.

61. After Fouquet, the roll call of distinguished artists continues: in 1515 it was the effigy of Louis XII—called a "visaige . . . après du vif," with a "perruqe selon la sienne"—prepared by Jean Perréal that was carried in front of the actual corpse of the king in the procession to Saint Denis (Schlosser 1910–11, p. 193; Giesey 1960, 115; Brückner 1966, p. 108). François Clouet himself made the effigies of François Ier (d. 1547) and Henri II (d. 1559); and the practice continues through Charles IX (d. 1574) and Henri IV (d. 1610). See Schlosser 1910–11, pp. 193–96, and Giesey 1960, pp. 115–92.

62. See Kathleen Cohen, *Metamorphosis of a Death Symbol: The Transi Tomb in the Late Middle Ages and the Renaissance,* for the relationship between the development of sculptures like these (in Cohen plates 72–77 discussed on pp. 120–24) and the extraordinarily realistic sculptures of decaying or decayed bodies that lay beneath, instead of on or in close proximity to them, usually on the same monument.

63. Schlosser 1910–11, p. 194; cf. Giesey 1960, p. 173, for another, though similar, account.

64. Giesey 1960, pp. 156–57, has the important Byzantine precedents.

65. Brückner rightly noted of the Vendome funeral that this was a "Nachwirkung

der königliche Quarantaine aus der Zeit des Effigiesbrauchs und keine Urmenschliche oder indogermanische Tradition" (Brückner 1966, p. 121).

66. Leather was used for the effigy of Henry V of England (d. Vincennes, 1422); cf. the passage from Monstrelet cited by Schlosser 1910–11, p. 200, referring to "sa ressemblance et représentation de cuyre bouilli painct moult gentillement."

67. On the Westminster effigies, see W. H. St. John Hope, "On the Funeral Effigies of the Kings and Queens of England," *Archaeologia* 60 (1907):517–70; L. E. Tanner and T. L. Nicholson, "On Some Late Funeral Effigies," *Archaeologia* 85 (1936):160–202 and plates; R. P. Howgrave-Graham, "The Earlier Royal Funeral Effigies," *Archaeologia* 98 (1961):160–69 and plates. St. John Hope has the basic survey of the documents; while Howgrave-Graham has good comments on the extreme accuracy and great subtleties of the early portraits. Of the bust of Ann of Denmark he notes that "the veins almost seem to lie just beneath the semi-transparent skin" (p. 167).

68. Vasari-Milanesi 3:372–73; from the translation by A. B. Hinds in the Everyman Library edition (London, 1927).

69. Schlosser 1910–11, pp. 176 and 217.

70. As noted by Bottari in Vasari-Milanesi 3:373, n. 2.

71. Baldinucci [1681] 1945–47, 4:99.

72. Cf. notes 13 and 14 above, as well as chapter 5, section 2 and figs. 27 and 187.

73. The terror aroused by such images therefore has nothing to do with magic; it has an empirically testable cognitive basis.

74. Nevertheless, no one will deny the possibility of reactions such as that wonderfully described by Julian Barnes (in a novel full of striking ruminations on eyes and eyelessness) upon seeing a preserved head "re-equipped with a coarse black wig and a pair of glass eyes. . . . This attempt to make the head more realistic had the opposite effect: it looked like a child's horror mask, a trick-or-treat face from a joke shop window" (*Flaubert's Parrot,* 1985], p. 208). But a moment's reflection gives one to realize the full ambivalence of this kind of reaction. In any event, the situation is rather different from that of the waxworks. The presence of an old but human object makes the artificiality of the attached components all too plain and inevitably confounds whatever degree of illusion is sought.

75. Sandrart's comments about the sculptures are worth noting too in their present context: "Neben dem aber erfunde er auch die Art, sein Wachs auf allerley Weiss, wie es die natur erforderte, zu coloriren, dass es dem abgebildeten Menschen ganz und gar in allem ähnlich wäre, auch sogar die metall und Edelgestein mit ihrer Farb, Schein und Glanz repaesentirte, dass man es oft fur warhafte Stein selbsten gehalten, wie dann viel Potentaten und Künstler solche für warhafte angesehen und probiret, ja sogar in eben dem Gewischt befunden" (R. A. Peltzer, ed., *Joachim von Sandrarts Academie der Bau-, Bild-, und Mahlerey-Künste von 1675; Leben der berühmten Maler, Bildhauer, und Baumeister* [Munich, 1925], p. 235). How often the reconstruction of convincing reality tails off into showmanship or high curiosity.

76. Ibid., p. 235. Brückner comments absolutely justly, "Wie sehr eine solche Konstruktion als Kunstwerk geschätzt wurde und noch nicht als technische Abnormität deklassiert war, beweist Sandrarts Hochschätzung" (1966, p. 158). For the commercial exploitation of automata in the Amsterdam *Doolhof,* see ibid., pp. 159–60, as well as note 81 below.

77. This extraordinary and delightful anecdote curiously reminds one not only of the famous passage from Nicholas of Cusa cited at the end of chapter 3, but also of the

kinds of trickery mentioned in connection with the mechanical statue of Julius Caesar mentioned by Appian and discussed in this section, with citation in note 55 above. On the further instances of trickery and other mechnical effects used to give the impression of liveliness, see both note 57 above, and chapter 11, section 1 and note 7.

78. Or some less dignified reaction: say mockery or disdain. Cf. the passage by Julian Barnes quoted in note 74 above.

79. Schlosser 1910–11, pp. 235–36; on p. 205, Schlosser gives details of other busts of Henri IV by Bourdin, as well as those by his competitors Dupré and Jacquet.

80. But this is not to suggest any causal connection between Bosse's eulogy and the royal appointment. Schlosser 1910–11, pp. 231–32 and 234–35, gives the references for Benoist. Further sources in S. Blondel, *Gazette des Beaux-Arts* 26 (1882): 429–30.

81. In addition to the good summary in Brückner 1966, pp. 159–60, see also the various booklets published and illustrated by Crispin de Passe in Amsterdam between the mid-1640s and the mid-1670s.

82. Schlosser 1910–11, p. 243.

83. Vasari-Milanesi 3:373–74.

84. Ibid., 3:375.

85. The same applies, by extension, to the commoner kinds of ex-votos, like representations of specific limbs or parts of the body preserved by miraculous intervention.

86. Though Schlosser 1910–11, p. 212, notes the possibility that this information, derived from Richa, *Chiese fiorentine* (1759), 8:7–8, may not be entirely reliable.

87. Warburg 1932, p. 116.

88. Cited ibid.

89. Ibid., p. 118.

90. Baldinucci, [1681] 1945–47, 3:276.

91. Warburg (1932, pp. 348–49) has the original text from Buchelius's *Iter Italicum* (ed. R. Lanciani), in *Archivio della Reale Società di Storia della Patria* 25 (1902).

92. Warburg 1932, p. 119, citing Andreucci 1858, p. 249.

93. On the collection in Bologna, see M. Armaroli, ed., *Le Cere Anatomiche Bolognesi del Settecento, Catalogo della Mostra organizzata dall'Universita degli Studi di Bologna nell'Accademia delle Scienze, 1981* (Bologna, 1981). The fullest survey of the Zoological Museum, along with good illustrations of the works of Zumbo and Susini, is now provided by *La Ceroplastica nella Scienza e nell'arte,* Atti del I Congresso Internazionale, 3–7 Giugno, 1975, 2 vols. (Florence, 1977). For all these phenomena, see now also T. Gantner, *Geformtes Wachs,* Catalog Exhibition, Schweizerisches Museum für Volkskunde (Basle, 1980).

94. Benjamin [1936] 1973, p. 226.

95. Ibid., p. 227.

96. Ibid., p. 228.

97. Ibid., p. 231.

98. Cf. my comments on reproduction at the end of chapter 15.

99. Benjamin [1936] 1973, p. 235.

100. Warburg 1932, p. 119, citing Andreucci 1858, p. 287.

101. This observation is not only tenable for Varallo, where the seventeenth-century contracts specify that artists were to conform to the style of the chapels dating before Gaudenzio's death in 1546.

102. Although to those who look for signs of it, idiosyncrasy will appear all the more easily when all else appears conventional or constant—just as the principles of Morellian connoisseurship demand.

103. Seymour 1966, p. 186. See also K. Weil Garris, "'Were This Clay but Marble': A Reassessment of Emilian Terra Cotta Group Sculpture," in *Atti del XXIV Congresso del Comitato Internazionale di Storia dell Art, 4: Le Arti a Bologna e in Emilia dal XVI al XVII Secolo* (Bologna, 1983), pp. 61–79, for an approach to these sculptures that is contextualized in a way that is not, broadly speaking, dissimilar to this chapter; but the conclusions, especially with regard to the differences from the "higher" kinds of Renaissance sculpture—are at complete odds with the arguments of this book.

104. Seymour 1966, pp. 186–87.

105. When Francisco Pacheco signed the contract for the polychromy of a small *retablo* by Montañes in 1610, he minutely described the manner in which he was going to paint the Saint Albert to make it seem alive. He would use his special method of "painting the flesh tones, delineating the eyes, mouth, beard and hair with the greatest possible accuracy . . . the veins would be coloured so as to be both lifelike and harmonious, and the habit painted to imitate a heavy coarse cloth" (Proske 1967, p. 51).

106. Ibid., p. 40 and nn. 153–55.

107. Ibid., p. 13.

108. Cf. note 105 above.

109. Cf. the comments in section 3 of this chapter, as well as in notes 74–77. But see also chapter 11, section 1 and notes.

110. Proske 1967, p. 13.

10. INFAMY, JUSTICE, AND WITCHCRAFT

1. Aeneae Sylvii Piccolomini, *Commentarii*, 7.185. This translation slightly adapted from *The Commentaries of Pius II*, translated by F. A. Gragg, Smith College Studies in History 22, nos. 1–2 (Northampton, Mass., 1937), p. 505, and *Pio II (Enea Silvio Piccolomini), I Commentari*, ed. G. Bernetti (Siena, 1973), 3:59–60.

2. It is referred to by Burckhardt, Huizinga, and Schlosser; and is further commented upon by Brückner 1966, pp. 203–4.

3. Or, as is most common—following Keller—to cite the case as some kind of evidence for the increased realism of Italian portraiture. But this is not an issue that I wish to enter into here, largely because I believe it (and the related question of the expansion of subject matter) has received undue emphasis in the literature. Cf. Keller 1939, esp. pp. 286–95; and Davidsohn 1866–1927, 4:329–30 and 4:222–23.

4. With the exception, now, of Edgerton 1985.

5. The use of *Schandbilder* as a means of defaming Jews is slightly different. While they were sometimes used wholly outside the legal and practical contexts outlined here, they could still not be categorized in terms of witchcraft. In any event, it is as well to remember how widespread the usage was.

6. On the classical forms, see both H. Kruse, *Studien zur offiziellen Geltung des Kaiserbildes im römischen Reiche* (Paderborn, 1934); and F. Vittinghoff, *Der Staatsfeind in der römischen Kaiserzeit: Untersuchungen zur "damnatio memoriae"* (Berlin, 1936). The date of the appearance of both these fundamental works cannot be wholly without further contemporary implication.

7. *Statuta communis Parmae digesta anno MCCLV,* ed. A. Ronchini, Monumenta historica ad provincias Parmensem et Placentinam pertinentia, 1 (Parma, 1855), p. 441; also cited in Ortalli, 1979, p. 61, n. 82.

8. Ortalli, 1979, pp. 33–34. Ortalli's book provides an excellent account of all

these distinctions, and is especially good on the legal aspects of the various forms of the *pittura infamante*.

9. The situation, however, is rapidly changing. This chapter was drafted in the year of the appearance of Ortalli's book, while Edgerton's is an important art historical addition to the literature.

10. Ortalli 1979, p. 132.

11. Ibid., p. 58, citing Davidsohn 1866–1927, 2:184, no. 1290.

12. As is implied in the fundamental article by Masi (1931).

13. Ortalli 1979, pp. 54–55 and note 6, citing the Bologna *Libri matriculorum*, cartella 1.

14. Ibid., p. 55.

15. Ibid., pp. 87–88.

16. Davidsohn 1866–1927, 2:443; see also 4:329–30. Vasari-Milanesi 1:625–26.

17. See G. Milanesi, "Di Andrea del Castagno e di Domenico Veneziano," *Giornale Storico del Archivi Toscani* 6 (1862): 3–10, esp. p. 5; also Vasari-Milanesi 1:681.

18. Vasari-Milanesi 5:53–54. Cf. J. Shearman, *Andrea del Sarto* (Oxford, 1965), 1:160–62 and 2:320–21 (noting not only Tribolo's wax models, but also that "Vasari's description of the deceptively living appearance of these figures may have been based on intimate experience of them" (2:402).

19. Ortalli 1979, p. 89 and note 147—though this is not what is implied by Shearman 1965, 2:320.

20. Ortalli 1979, pp. 36, and 76, citing *Matthaei de Griffonibus memoriale hisotricum de rebus Bononiensium,* eds. L. Frati and A. Sorbelli, Rerum Italicum Scriptores² 18.2 (Citta di Castello, 1902), p. 83.

21. Masi 1931, p. 655.

22. Ortalli 1979, pp. 52–53, citing the *Statuta civitatis Mediolani* (Milan 1480), fol. 90 r.

23. H. Wieruszowski, "Art and the Commune in the Time of Dante," *Speculum* 19 (1944):487.

24. For the Bartolomeo di Maestro Gerardino document, see F. Filippini and G. Zucchini, *Miniatori e pittori a Bologna: Documenti dei Secoli XIII e XIV* (Florence, 1947), p. 19.

25. Ortalli 1979, pp. 99–100.

26. J. Ficker, *Forschungen zur Reichs- und Rechtsgeschichte Italiens* (Innsbruck, 1874), 4:513–14. Cf. also Ortalli 1979, pp. 39–40, for discussion and further reference.

27. The rise and fall of the duke of Athens is fully told in book 12 of Giovanni Villani's contemporary *Cronica*. See also C. Paoli, *Della Signoria di Gualtiero Duca d'Atene* (Florence, 1862), and Egerton 1985, pp. 78–85.

28. Vasari-Milanesi 1:625–26.

29. It has been pointed out more than once that strictly speaking this painting does not fall within the category of juridical images; but it is rightly aligned with them, on the grounds that its function was the post-facto condemnation of a figure and of deeds that were construed as being against the commonweal. The picture does not appear within a statutory framework, like that of the Reggian example of 1301, but its form and function are evidently similar (except that here the figure of Saint Anne gives a more obviously ideological and propagandistic twist). To claim that it was merely commemorative is to overlook the context of shame in which all images like these were perceived.

30. A. Gherardi, ed., *Diario d'Anonimo Fiorentino dal 1358 al 1389,* in *Cronache dei secoli XIII e XIV,* Documenti di Storia Italiana, 6 (Florence, 1876), p. 340 (cf. also

ibid., pp. 232–33; Ortalli 1979, pp. 40–41; and now also Edgerton 1985, pp. 85–86).

31. G. B. Uccelli, *Il Palazzo del Podestà: Illustrazione storica* (Florence, 1865), p. 169 and Masi 1931, p. 645. Edgerton, however, reproduces a trecento account by the anonymous chronicler known as the Pseudo-Minerbetti which has Bonaccorso standing up, feet in water, with a variety of insulting animals and a defamatory inscription in large letters (Edgerton 1985, pp. 88–89).

32. Since the preceding account has dealt largely with Italian examples, I have omitted the few French ones, notably the 1477 commission to Gabriel le Fèvre of Evreux to paint five portraits of Jean, Prince of Orange: "est paint et pourtrait la stature et epitaffe de messire Jehan de Chaalon, prince d'Orange, pendu la teste en bas et les pies en halt" (Laborde 1850, 1:50–51; see Keller 1939, p. 289, and Edgerton 1985, p. 92, for further details).

33. *Scriptores historiae Augustae,* Trebellius Pollio, *Triginta tyranni,* De Celso, 29.4; discussed in Schlosser 1910–11, p. 184.

34. Brückner 1966, p. 192.

35. J. Hofer and K. Rahner, eds., *Lexikon für Theologie und Kirche,* 2d ed. (Freiburg im Breisgau, 1957–65), 4:214; and H. von Hentig, *Die Strafe,* 1: *Frühformen und kulturgeschichtliche Zusammenhänge* (Berlin, 1954), p. 20.

36. Brückner 1966, pp. 245–46.

37. "Ehrenrührige Zwangsmitteln," Brückner summarizingly calls them.

38. L. T. Maes, *Vijf Eeuwen Stedelijk Strafrecht: Bijdrage tot de Rechts-en Cultuurgeschiedenis der Nederlanden* (Antwerp and The Hague, 1945), p. 465.

39. Brückner 1966, p. 224.

40. Ibid., p. 249, citing P. Ayrault (Aerodius), *L'ordre formalité et instruction iudiciaire, dont les Grecs et Romains ont usé ès accusations publics: Conferé au stil et usage de nostre France* (Lyon, 1642; 1st ed., 1575/6), pp. 437–38.

41. Cf. Brückner 1966, pp. 234–35.

42. Ibid., pp. 246–49.

43. Ibid., p. 290, with several further sources.

44. Ibid., pp. 294–95, citing J. Döpler, *Theatrum poenarum suppliciorum et executionum criminalium oder Schauplatz derer Leibes und Lebens-Straffen* (Leipzig, 1697), 2:629ff. (vol. 1 published 1693).

45. Grøn 1934, pp. 329–32.

46. Brückner 1966, p. 304.

47. Grøn 1934, pp. 332–33. Throughout this century, wax modelers continued to make heads and hands in wax (to say nothing of the efflorescence of anatomical models in wax). But here we may also be reminded of how in the Netherlands from the fifteenth century on, those found guilty of certain crimes like physical assault were expected to have limbs of metal, even of gold, made for public display, and as a penitential reminder of their offence. The basic work is J. B. Cannaert, *Bijdragen tot de Kennis van het Oude Strafrecht in Vlaenderen,* 3d expanded edition (Ghent, 1835).

48. Brückner 1966, pp. 306–7 with texts.

49. Ioannes Saresberiensis, *Policraticus sive de nugis curialium et vestigiis philosophorum,* lib. 1, cap. 12 (ed. C. C. I. Webb [Oxford, 1909] 1:51–52).

50. For a splendidly wide-ranging bibliographical note on the subject, see Kittredge 1928, pp. 412–13, n. 4.

51. For another wide range of references, from Virgil to Gerald of Wales, see ibid., p. 75.

52. Ovid, *Heroides,* 6.91–92.

53. Acker 1974, p. 43. Cf. Kittredge 1928, p. 93, on portraits of faithless lovers who have their eyes pricked out.

54. Audollent 194, pp. xlix–liii, lv–lvi, and lxxvi–lxxvii; and Wünsch 1898, pp. 6–13, 16, 20, 23ff. for figures on tablets.

55. Wünsch 1902, p. 27.

56. Ibid., pp. 26–27, citing Sophronios, *De Theophilo* (i.e. Saint Sophronios, *SS. Cyri et Joannis miracula,* 35:, *De Theophilo qui a magia manibus et pedibus vinctus est,* in *PG* 883, cols. 3541–48.

57. The figure came from Antinooupolis and may originally have been pierced by more than eleven needles; for further details see the article cited in the following note.

58. S. Kambitsis, "Une nouvelle tablette magique d'Egypte. Musee du Louvre Inv. E. 2714–IIIe/IVe siècle," *Bulletin de l'Institut Française d'Archéologie Orientale* 76 (1976): 213–23.

59. See L. Preisendanz, *Papyri Graecae Magicae* (Leipzig, 1973), I², no. IV, and Kambitsis 1976 (see note 60), p. 216, for these and further texts.

60. Consider for example, the many entries in Hansen's index, s.vv. *Zauberei (mit) Bilder/Bleibilder/Wachsbilder (Atzmänner).* See also Kieckhefer 1976, pp. 50–55, for a good survey and selection of examples.

61. C. Sommer, *Die Anklage der Idolatrie gegen der Papst Bonifaz VIII und seine Porträtstatuen* Inaug. Diss. (Freiburg-im-Breisgau, 1920), p. 5.

62. Ibid., pp. 60–62.

63. K. Eubel, "Vom Zaubereienwesen anfangs des 14. Jahrhunderts," *Historisches Jahrbuch* 18 (1897): 608–31, esp. pp. 609–25, for documentation; R. Michel "Le procès de Matteo et de Galeazzo Visconti," *Mélanges d'Archéologie et d'Histoire* 29 (1909): esp. pp. 307–27; Kieckhefer (1976, p. 52) notes too that prior to the exposure of the statuette "complete with genitalia," it was censed for nine nights and equipped not only with John's name, but also with the names and symbols of evil demons. John's favorite nephew had already been killed by the maleficent use of wax images (Kieckhefer 1976, p. 53 and note 28).

64. Hansen 1901, doc. 19, p. 11.

65. Ibid., doc. 3, pp. 42–44.

66. Ibid., doc. 5, p. 49.

67. Ibid., p. 51.

68. Much evidence in ibid., pp. 91–93 and chapter 3 generally. See also C. L. Ewen, *Witchcraft and Demonianism: A Concise Account Derived from Sworn Depositions and Confessions Obtained in the Courts of England* (1933). All the evidence can easily be extended.

70. Hansen 1901, doc. 22, pp. 14–15.

71. Or the nail may be used to damage the spirit believed to inhere in the "fetish." See also W. Muensterberger, "Roots of Primitive Art," in *Anthropology and Art: Readings in Cross Cultural Aesthetics,* ed. C. M. Otten (Garden City, 1971), pp. 115–18, for examples.

72. G. Brucker, ed., *The Society of Renaissance Florence: A Documentary Study* (New York, 1971), p. 260. Text in Archivio di Stato Firenze, *Atti del Esecutore,* 751, fols. 25 r–26 r, 5 Nov. 1375.

73. Ibid., p. 261. Cf. also the story about Ku K'ai-chi'h noted above, and Kris and Kurz 1979, pp. 73–74.

74. P. Fredericq, ed., *Corpus Documentorum Inquisitionis Haereticae Pravitatis Neerlan-*

dicae (Ghent and The Hague, 1889), 1, no. 351:428–29. For examples of antique *envoûtement* for the purpose of winning the heart of a woman, see Clerc, 1915, p. 78.

75. Brückner 1966, p. 309.

76. Ibid., p. 315.

77. Ibid., pp. 188–89.

78. Kittredge 1928, p. 73. Emphasis mine.

79. Wünsch 1902, pp. 27–28.

80. Frazer 1913, 1:52.

81. Ibid., p. 55.

82. Ibid., p. 53.

83. Ibid.

84. Skorupski 1976, p. 138.

85. Ibid., p. 139. Again the view is identical with Nelson Goodman's general view of similarity.

86. Skorupski 1976, p. 139.

87. Mauss 1972, p. 68.

88. Skorupski 1976, pp. 141ff. and 159.

89. Ibid., p. 143.

90. Similar caveats to the ones entered here may be taken to apply to traditional notions of contagion in the context of the efficacy of visual objects that reproduce the potent and divine prototype. See also chapter 6, sections 2 and 3.

91. A. G[allan]d, *Tableau de l'Égypte pendant le séjour de l'armée française* (Paris, 1800), 1:120–21. The Chinese legendary parallel is perhaps this, among several possibilities: Po-shih's subjects are supposed to have died once the brush was removed from their portraits; they had lost their vital force (Meyer 1923, pp. 131 and 260–61). As with Alberti, theory and commonplace seem to approach a fact of cognition.

92. A good Byzantine manifestation of just this belief is provided by the early seventh-century life of Saint Theodore of Sykeon now available in the two-volume edition by A. J. Festugière, *Vie de Théodore de Sykéon,* Subsidia Hagiographica, 48 (Brussels, 1970). Chapter 139 tells of how Theodore's fellow monks wanted to have a portrait of him, but it had to be made without his knowledge. The painter thus had to peer surreptitiously through a small opening in the wall in order to make a good likeness. When it was finished, the monks took it to Theodore to have it blessed: "The saint made a joke to the effect that the painter was a thief. . . . Theodore blessed the painting, but with his remark he betrayed a belief that an icon which copied a person could somehow take away something of the original and have a reality of its own" (Cormack 1985, p. 39).

93. Frazer 1913, 2:96.

94. For bibliographic references to this kind of fear, see Kittredge 1928, p. 423, n. 123.

95. Frazer 1913, 2:96–98.

96. I remain skeptical about this phenomenon, however. It may slightly be a case of how we want or prefer "primitives" to be. In any event, it often leads to overstatement, as when Aaron Scharf (1974) says that the alleged difficulty is both protracted and occurs "in all cases that I have been able to discover" (i.e., among humans, as opposed to Kohler's apes). The sources Scharf gives are Sir John Lubbock's 1870 *Origins of Civilization,* and the work of J. D. Lajoux in the Moi Uplands of South Vietnam, as described by M. Braive (*The Open University: Introduction to Art,* An Arts Foundation Course, units 16–18, prepared by A. Scharf and S. Bayley [Milton Keynes, 1978], p. 19).

97. Frazer 1913, 2:97–99.
98. Mauss 1972, p. 120.
99. Ibid., p. 121.

11. LIVE IMAGES

1. Lactantius, *Divinae institutiones,* 1.22.13, in E. H. Warmington, *Vetera Latina,* Loeb Classical Library (1935), 3:166, nos. 524–29.

2. Even when the term was avoided it seemed possible to explain the living powers attributed to images on the grounds of some notion of metempsychosis, as in the case of the transference of the dead Egyptian's disincarnate *ka* to an image of him.

3. Herein lies the paradox inherent in many of the accounts: it is precisely by transcending their earthbound quality that the images seem to be miraculous; but the way in which they most often do so is by behaving in ways that are familiar to even the simplest beholder: the more familiarly the image behaves, the more miraculous it may often seem. For a brief account of all these phenomena, with sources from the *Acta Sanctorum* and the *Analecta Bollandiana* (the point of departure for all such researches), see C. G. Loomis, *White Magic: An Introduction to the Folklore of Christian Legend* (Cambridge, Mass., 1948). For another and even broader ethnographic survey of the varieties of animated images, see P. Sebillot in *Revue des Traditions Populaires* 2 (1887):16–23.

4. Caesarius, *Dialogus,* dist. 7, cap. 45.

5. Taubert and Taubert 1969, pp. 80–91.

6. See the fine example from Döbeln in Saxony illustrated in ibid., fig. 3 (no. 3, pp. 80–81). Compare also the crucifixes at Altheim and Memmingen (in ibid., cat. nos. 2 and 17, with illustrations on plates 1 and 2 respectively).

7. As in the frequently deceitful and allegedly deceitful use of similar mechanical devices to give the impression of a miraculous event. One example out of many is the famous statue of the Virgin in Berne which was made to weep and speak in order to fool the pious. The hidden pipes by means of which it did so were discovered after its most famous performance in 1508 (cf. Baxandall 1980, pp. 59–60). See also chapter 9, section 3, with notes, for examples of trickery by image.

8. The classic book is Young 1933, but see also N. C. Brooks, *The Sepulchre of Christ in Art and Liturgy,* University of Illinois Studies in Language and Literature, 7:2 (Urbana, 1921).

9. Taubert and Taubert 1969, pp. 92–96, on Prüfening; pp. 96–98 on Barking.

10. Cf. the remarkable painting by Gaspar de Crayer of Christ embracing Saint Lutgard (fig. 148); or Gregorio Fernández's sculpture for the High Altar of Las Huelgas in Valladolid, which may have influenced Ribalta; as well as many earlier German representations.

11. Other Spanish representations of this subject include the well-known paintings by Roelas of 1611 (Seville, Hospital of San Bernardo) and Murillo of 1650–55 (Prado)—but there are many more from both Mediterranean and Northern countries.

12. For the source, see notes 44 and 45 below.

13. Forsyth 1972, p. 49; but see also the earlier article by Forsyth, with further details of these dramas: "Magi and Majesty: A Study of Romanesque Sculpture and Liturgical Drama," *AB* 50 (1968): 215–22.

14. Forsyth 1972, p. 12.

15. For an extraordinarily good survey of this kind of material, with particular reference to portraits which are so good that they seem to speak—or so deficient that

they lack speech, or so much less good than reality because they want speech, etc.—see J. Emmens, "Ay Rembrant, Maal *Cornelis* Stem," *Nederlands Kunsthistorisch Jaarboek* 7 (1956): 133–65. The article takes as its starting point the well-known portraits of the Mennonite preacher Cornelis Anslo by Rembrandt, but provides an excellent overview of the classical material. For the speaking statues of Egypt, see G. C. Maspero, "Les statues parlantes dans l'Egypte antique," in *Causeries d'Egypte* (Paris, 1907).

16. It originally stood in the Athenian Agora but was transferred to the Temple of Peace in Rome. For this group of epigrams, see *The Greek Anthology,* book 9, translated by W. R. Paton (Loeb Classical Library ed., 1917), 3, nos. 713–42.

17. Ibid., no. 724 (Antipater).

18. Ibid., no. 721 (also Antipater).

19. *The Greek Anthology;,* book 1 (1916 Paton translation), no. 82.

20. See especially the article by Emmens cited in note 15 above.

21. Pliny, *Historia naturalis,* 45.120.

22. See O. Rossbach in *RE* 6, col. 1985.

23. But when Myron's statue of the athlete Ladas is said to be *empnoos,* filled with breath, alive, the asyndeton used in translating that term is deliberate and altogether fitting, since it involves no great semantic leap from "filled with breath" to "alive" (*Anthologia Planudea,* translated by W. R. Paton [Loeb Classical Library ed., 1918], 5:54 and 54a; cf. the comments by Gordon 1979, p. 10).

24. For a sophisticated discussion, slightly divergent from mine, of the way in which these words become catachrestic, see Gordon 1979, pp. 5–17. Gordon here also provides a perceptive survey of the implications of the classical material for art history.

25. Similar scenes can be found, though less frequently, in the earlier Khludov and Barberini Psalters. I am aware that in most of the marginal psalters the illustration of iconoclastic actions plays an important role, and that for this reason alone it may have been felt necessary to show the images as explicit embodiments of Christ (he suffered in/as did his images; to assault Christ's pictures is to assault him; etc.). I suppose that it could be argued that to put Christ into a medallion, or even a square picture, is simply one way of representing him. But that elision is itself significant. If it is a conventionalized thing to show Christ as if in a picture, then one must assume the sense in which pictures do have the living Christ in them. These medallions—and the occasional square or rectangle—are not *just* ways of showing Christ. They are evidently real images—as, precisely, in the various iconoclastic scenes.

26. For this last example, see note 50 below. Visitors to Canterbury will recall the glass showing Saint Thomas Becket climbing out of his shrine to appear to a sleeping monk—though here it may seem easier to argue that the saint is in the shrine because a piece of him is so evidently there.

27. The problem of the relations between devotion before real image and devotion before vision—discussed at greater length later in this chapter—is almost perfectly exemplified by the pages from the prayer book of James IV of Scotland (in the Öster-reichisches Nationalbibliothek, Col. 1897) where James is shown in prayer before a triptych showing the blessing Christ and his wife Margaret in prayer before what is clearly a vision of the Madonna and Child. Illustrated in the characteristically brilliant article by Ringbom (1969, figs. 6–7). See also his pages 164–66.

28. See R. W. Southern, "The English Origins of the 'Miracles of the Virgin,'" *Medieval and Renaissance Studies* 4 (1958): 176–216. The fundamental work on these issues, however, are the great studies by Mussafia, who surveyed an extraordinary amount of the very substantial manuscript material; but see also the useful edition by T. F. Crane of the *Liber de Miraculis Sanctae Dei Mariae, published at Vienna, in 1731 by*

Bernard Pez, O.S.B. (Ithaca and London, 1925). Mussafia based much of his work on that 1731 edition by Pez.

29. On Caesarius see below; many of the important texts by Gautier were edited piecemeal in the *Annales Academiae Scientiarum Fennicae* (Helsinki) between 1932 and 1963, and collected in the critical edition by Koenig of 1955–70.

30. For more, see Mussafia, *Studien,* 1: 918–36, and E. Levi, "I Miracoli della Vergine nell'arte del medioevo," *Bolletino d'Arte* 12 (1919): 1–30. I omit the many further-flung collections, such as the Ethiopic ones assembled by Wallis Budge in 1923 in *One Hundred and Ten Miracles of Our Lady, translated from Ethiopic Manuscripts for the most part in the British Museum, with extracts from ancient European versions. . . .* (London, Liverpool, and Boston, 1923).

31. With Wichmans's book one should compare even more local works, such as Samperi's detailed study of the Madonnas of Messina, cited in note 25 of chapter 6.

32. See the penultimate paragraph of chapter 3 on the Sri Lankan Virgin. On the Chicago Madonna, see the *New York Times,* 22 December 1986: "The Greek Orthodox Church has no plans to analyze the moisture which Father Koufos described as 'a very thin oily sweet substance very similar to the chrism we use to baptize children or unction for the sick. To further analyze it would be almost blasphemy,' he said. 'The Archdiocese thinks they should not subject it to scientific analysis which is not a very religious procedure.'"

33. *Apologia ad Guillelmum Sancti Theoderici Abbatem,* in *PL* 192, cols. 915–17.

34. M. Schapiro, "On the Aesthetic Attitude in Romanesque Art," in *Romanesque Art: Selected Papers* (New York, 1977), 1:1–27 (esp. pp. 6–10).

35. In addition to the edition of the *Dialogus miraculorum* by Strange (Caesarius 1851) and the translation by Scott and Bland (Caesarius 1929), see also Meister's edition of the fragments of the *Libri miraculorum* (Caesarius 1901) and the editions of the first two books, on the miracles and the exempla, by A. Hilka, *Die Wundergeschichte des Caesarius von Heisterbach,* 1: *Einleitung Exempla und Auszüge aus den Predigten,* and 3: *Die Beiden ersten Bücher der Libri VIII miraculorum,* Publikationen der Gesellschaft für Rheinischen Geschichtskunde, 43, 1, 3 (Bonn, 1937).

36. A slender exception is E. Beitz, *Caesarius von Heisterbach und die bildende Kunst* (Augsburg, 1926), with some interesting material on Cistercian attitudes on pp. 8–12.

37. The selection by A. Kaufmann, *Wunderbare und Denkwürdige Geschichten aus den Werken des Cäsarius von Heisterbach* (Cologne, 1888), is usefully divided according to place of miracle. It also has a substantial amount of interesting comparative material.

38. Caesarius, *Dialogus,* dist. 8, cap. 76. The translation here is based on Scott and Bland's.

39. Caesarius, *Dialogus,* dist. 8, cap. 83; the translation from Scott and Bland.

40. Caesarius, *Dialogus,* dist. 8, cap. 21, and *Libri VIII miraculorum,* lib. 2, cap. 35. Cf. *AA.SS.* (September), 2:277, col. 1.

41. See Thomas of Celano, *Legenda antiqua,* cap. 5, and *Tractatus secundus super Vitam Santi Francisci de Assisi cum miraculis,* cap. 6: *De ymagine crucifixi, que sibi locuta fuit et honore quem ei impendit,* available in the edition of Thomas of Celano's lives of Saint Francis by H. G. Rosedale, *Legenda Antiqua,* p. 13, *Tractatus secundus,* p. 11 (London, 1904). See too illustrations such as that showing the Vision of Saint Catherine of Siena, in *Dialogo della divina providentia* (Venice 1494), fol. x₇.

42. As in H. Varnhagen, *Zur Geschichte der Legende von Katharina von Alexandrien: Nebst lateinischen Texten nach Handschriften* (Erlangen, 1891), pp. 20–23. For an unusually particularized and sensitive description of the image which stimulated the

vision, see H. Knust, *Geschichte der Legenden der h. Katharina von Alexandria und der h. Maria Aegyptiaca* (Halle, 1890) p. 27: "Dedanz sa capelle est assise/ sor un alter de marbre bisse/Un ymage estrainiement fine/ E a forme d'un raine/ Qui en ses braiz teint un enfant,/ Colore vermeil et riant . . ."

43. The basic source is the *De vita et gestis Bernardi,* lib. 7, cap. 7 (*Exordium magnum Cisterciense,* lib. 7, cap. 7). For examples from Caesarius of Christ descending from the cross to embrace a devotee, see—in addition to the other examples referred to in this chapter—*Dialogus,* dist. 8, caps. 13 and 16.

44. See *AA.SS.* (August), 4:206–7. The theme is a late one and is evidently derived from the many references in Bernard's own work to the sweetness and milk of the Virgin (e.g., "omnibus flerens lac et lanam," in *PL* 183, col. 430, as well as the refrain "monstra te esse matrem"). See also L. Dewez and A. van Iterson, "La lactation de Saint Bernard: légende et iconographie," *Citeaux in de Nederlanden* 7 (1956): 165–89. For the relationship to the very many instances of the breast-revealing or lactating Virgin in other contexts of conversion, compassion, intercession, and beneficence, see, for example, the pages on the subject in Knipping 1974, esp. 2:264–73. See also A. Poncelet, "Index Miraculorum B.V. Mariae quae saecula VI–XV latine conscripta sunt," *Analecta Bollandiana* 21 (1902):359, lists still further instances.

45. Mussafia 1896, p. 37; cf. also Ringbom 1965, p. 14; 1968, p. 160. In Paris, Bibliothèque Nationale, MS fr. 2593, no. 31, the breasts that appeared on the image are even more explicitly described as *carneae mamillae* (Mussafia, *Studien,* 1:963). A very similar event also takes place in the various versions of the Miracle of Sardenai. See Gautier 1959, pp. 23–24 (Latin source) and lines 457–86 (Gautier's verses).

46. Even more extravagant is the tale in the *Libri VIII miraculorum,* lib. 3, cap. 23, of an unlearned monk who became very learned upon sucking from the breasts of the Virgin. While praying he saw "pulcherrimam virginem ante altare stantem, quae eum blande leniterque vocavit et sacratissima sua ubera ad sugendum dulciter porrexit."

47. Caesarius, *Dialogus,* dist. 8, cap. 16.

48. Ibid., dist. 8, cap. 13.

49. Taubert and Taubert 1969, p. 120. On the Regensburg ceremony see Young 1933, 1:505.

50. Oxford, Bodleian Library, MS Douce 374, fols. 92 v–93 r (*Miracles de Nostre Dame,* no. 64, illustrated; Miélot 1885 ed., p. xxxiv); Paris, Bibliothèque Nationale, MS fr. 9199, fol. 95 v (illustrated). For another good illustration, see also the page from the *Cántigas* of Alfonso X reproduced in V. W. Egbert, *The Medieval Artist at Work* (Princeton, 1967), p. 49 (reproducing Escorial, MS T.1.1., fol. 109 r). Vincent of Beauvais, *Speculum historiale,* lib. 7, cap. 104, has an almost identical account to Gautier's. Cf. also Caesarius, *Libri VIII miraculorum,* lib. 3, cap. 43 (where the Devil attempts to throw him into the sea).

51. As in Oxford, Bodleian Library, MS Douce 374, fol. 12 (Miélot 1885 ed., p. xii).

52. Oxford, Bodleian Library, MS Douce 374, fol. 59 (Miélot 1885 ed., p. xxviii); Paris, Bibliothèque Nationale, MS fr. 9199, fols. 61r–61 v (Miélot 1828–29 ed., pp. 185–86). Cf. Rickert 1965, p. 86, for the version from the *Altes Passional* and Caesarius, *Libri VIII miraculorum,* lib.3, cap. 37.

53. Caesarius, *Dialogus,* dist. 7, cap. 46.

54. Ibid., dist. 7, cap. 33; cf. Mussafia 1896, p. 53, for the source of the similar tale in Gautier de Coinci 1.35).

55. Mussafia, *Studien,* 1:965, citing Bibliothèque Nationale, MS fr. 12593, no. 56. This ability of particular statues to move in order to reclaim their rightful places

is common enough; a far-flung one is provided by the Virgin of Ocatlán. Upon its discovery this image was placed in the chapel of San Lorenzo outside Tlaxcala, but it had to replace a favored image of the saint. The sacristan removed the Virgin and put the saint back in its old place. The next morning the Virgin was back in its new place, with the saint to its side. The same thing happened three times in a row. Cf. Turner and Turner 1978, p. 59.

56. A charming and rather less known legend of a flying image is that of Genazzano near Rome. It is said that this picture (now ascribed to Antonio Vivarini) was carried there by angels from Albania in April 1467. A crowd of marketgoers are reported to have seen it arrive through the air and land on the Augustinian church in the town (G. Sangiorgi, "Discovery at Genazzano," *Augustinia* 25 [1975]:43–47). For an unsurprising modern development at Loreto, see F. Grimaldi, "La Madonna di Loreto patrona degli aeronauti," in Kriss-Rettenbeck and Möhler 1984, pp. 300–5.

57. Mussafia, *Studien,* 1:965.

58. *PL* 71, cap. 21 (*De iudaeo qui iconicam Christi furavit et transfodit*), p. 724; cf. Caesarius, *Libri VIII miraculorum,* lib. 2, cap. 39.

59. Caesarius, *Libri VIII miraculorum,* lib. 2, cap. 39 (1901 ed., p. 117).

60. See Gautier 1959 ed., lines 640–50. For a long Chateauroux account, see Mussafia, *Studien,* 5:21–23. For Byzantine instances of bleeding images, see the several cases in the *Letter of the Patriarchs of Alexandria, Antioch, and Jerusalem to the Emperor Theophilus in 836,* published in L. Duchesne, "L'iconographie byzantine dans un document grec du IXe siècle," *Roma e l'Oriente* 5 (1912–13): 222–39, 273–85, and 349–66; discussed in Cormack 1985, esp. pp. 126–27.

61. Kretzenbacher 1977 provides an excellent and thoughtful survey on this whole congeries of stories and legends.

62. Vincent of Beauvais, *Speculum historiale,* lib. 7, cap. 110a; cf. Mussafia, *Studien,* 2:55.

63. Caesarius, *Dialogus,* dist. 7, cap. 2.

64. As, for example, in the case of the image of Sardenai (Gautier 1959 ed., pp. 23–25 and lines 457–86).

65. Miélot 1928–29 ed., pp. 126–27 (Paris, Bibliothèque Nationale MS fr. 9198, fol. 124). Cf. Caesarius, *Libri VIII miraculorum,* lib. 3, cap. 23.

66. Caesarius, *Dialogus,* dist. 7, cap. 44.

67. Ibid., "non quidem per opus bene formata, sed multa virtue dotata."

68. Barthes, 1981, p. 100.

12. AROUSAL BY IMAGE

Epigraph: see Charles Rosen in the *New York Review of Books,* 17 December 1987, for a brilliant discussion of the implications of this and other changes in the various versions and editions of Balzac's story; and on the problem of Romantic revision in general.

1. For this reason little would be served by outlining the long history of the use of pictures in private erotic contexts. From Tiberius's use of "the most lascivious pictures" in the rooms in which he held his orgies and his installation of Parrhasius's painting of Atlanta "gratifying Meleager with her mouth" (Suetonius, *Tiberius,* 43–44), the cases of the suggestive, therapeutic, and auxiliary use of images, both high and low, extend abundantly into the present—and everyone knows of them.

2. See, for example, the text attributed to Germanos of Constantinople in *PG* 98, col. 3999, and that by Arnaldus of Chartres, in ibid., 199, cols. 1725–26 (adapted

in the *Speculum humanae salvationis,* cap. 12). Knipping 1974, pp. 263–75 provides an extremely illuminating overview of the later material derived from basic texts like these.

3. Illustrated, perhaps, by stories about monks and novices such as those discussed chapter 11, section 4, and in section 2 of this chapter.

4. M. Gorky, *My Apprenticeship,* translated by M. Wettlin (Moscow, 1932), pp. 161–64.

5. Caesarius, *Dialogus,* dist. 8, cap. 16. Cf. chapter 11, section 4.

6. Vasari-Milanesi 4:535–36 (in the *Life of the Ghirlandai*)

7. *The Travels and Controversies of Friar Domingo Navarrete, 1618–1686,* ed. J. S. Cummins (Cambridge, 1962), 1:162, n. 1. Cf. G. de Magalhaes, *A New History of China* (London, 1688), p. 103.

8. See P. Schwarz, *Iran in Mittelalter nach den arabischen Geographen* (Leipzig, 1921), 4:488, citing Kazwini and Ibn Rusta. For more on these Sassanid sculptures and their location, see W. Barthold, *An Historical Geography of Iran,* translated by S. Soucek and ed. by C. E. Bosworth (Princeton, 1984), pp. 195–97. The story is also briefly referred to in Kris and Kurz 1979, p. 72. Cf. the 1972 attack on Michelangelo's *Pietà* (discussed in chapter 14, section 6), where the nose seems to have been one of the particular targets.

9. Cited in C. Koch, "Über drei bildnisse Baldungs als künstlerische Dockumente von Beginn seines Spätstils," *Zeitschrift für Kunstwissenschaft* 5 (1975):70, from H. Rott, *Quellen und Forschungen zur sudwestdeutschen und schweizerischen Kunstgeschichte, 3, 1: Der Oberrhein* (Stuttgart, 1935), p. 227.

10. Kris and Kurz 1979, p. 72.

11. As E. de Jongh did so brilliantly in his article on erotic symbolism and boundaries of shame in the Netherlands in the seventeenth century (De Jongh 1968–69).

12. *Morlini novellae,* Joan Pasquet de Sallo (Naples, 1520). The edition used here is *Hieronymi Morlini Parthenopei, Novellae, Fabulae, Comoediae: Editio tertia, emendata et aucta* (Paris, 1855). See the "Avant-propos" here for a useful summary of the earlier editions, piratical and otherwise.

13. Morlini 1855 ed., pp. 158–59.

14. Brantôme, *Vie des dames galantes,* in *Oeuvres,* ed. L. Lalanne (Paris, 1876) 9:580 (in the *Discours sur les femmes mariées, les vefves et les filles a sçavoir desquelles les unes sont plus chaudes a l'amour que les autres*).

15. Calcagnino's report was published in *Archivio Storico dell'Arte* 2 (1889): 377–78. See also S. Pressouyre, "Les fontes de Primatice à Fontainebleau," *Bulletin Monumental* 127 (1969): 230 for a brief reference.

16. For the sources see note 20 below.

17. The date of the life is extremely problematic. The arguments range from the fifth or sixth century to the late tenth century. For the latter, see L. Rydén, "The Life of Andreas Salos," *DOP* 32 (1978): 129–55.

18. Mango 1963, p. 60.

19. Mango (ibid., p. 56) notes that "whereas some Christian thinkers believed idols inanimate, the general opinion was that they were inhabited by maleficent demons" (while "conversely in the eyes of the fourth century Neo-Platonists, idols were animated with divine presence"). The fullest source for the varieties of statue behavior—and for attitudes to them—is the eighth-century Constantinopolitan guide known as the *Parastaseis syntomoi chronikai* (now republished in the excellent 1984 edition by A. Cameron and J. Herrin). Mango describes it as being "on a low intellectual level."

There may be some justice in the categorization, but its tone unmistakably reveals, yet again, a kind of devaluation of what is "low-level" and commonplace.

20. Overbeck 1868, nos. 1227–45 and 1263; and Pollitt 1965, pp. 128–31. When Pliny, *Historia naturalis,* 36.20, refers to the story, he notes that there was another nude by Praxiteles in Parium on the Propontis, which was equally famous and also roused youthful desire, in the same way.

21. "Samos, they say, has had a case like this;/ The poor chap fell in love with a marble miss,/ and locked himself in the temple." This is the charming translation of the passage from Alexis provided by J. M. Edmonds, *The Fragments of Attic Comedy* (Leiden, 1959), 2:393, and taken from the section in Athenaeus, *Deipnosophists,* 13.605ff. on falling in love with works of art. Athenaeus provides further details: the name of Alexis's play was *The Picture;* the young man was Cleisophus of Selymbria; and—according to Adaeus of Mitylene's book *On Sculptors*—the statue was the work of Ctesicles, possibly as Edmonds suggests, identical with the painter of Stratonice referred to in Pliny, *Historia naturalis,* 35.40.33. Cf. also Philemon 139, cited in Athenaeus *Deipnosophisti,* 13.606a (Edmonds 1961, 3:76–77); and Lucian, *Amores,* 13.

22. Aelian, *Variae historiae,* 9.39 (in the section *De ridiculis et absurdis amoribus*).

23. Miélot 1928–29 ed., pp. 126–27 (Paris, Bibliothèque Nationale, MS fr. 9198, fol. 124). Cf. Caesarius, *Libri VIII miraculorum,* lib. 3, cap. 23 (also discussed at the end of chapter 11, section 4).

24. It is no part of the aim of this book to make claims for the greater effectiveness of images over words, or vice versa. For the problematic of all such claims, see now the thoughtful analysis of the problem as a whole in Mitchell 1986.

25. The most useful compilation is still that provided by Baum (1919), who surveys both the primary and the secondary material; but some additional discussion is provided by Theodore Ziolkowski, *Disenchanted Images: A Literary Iconology* (Princeton, 1977).

26. Cf. Mussafia, *Studien,* 1:962 (Paris, Bibliothèque Nationale, MS fr. 12593, no. 29). See also H. Focillon, *Le peintre des Miracles de Notre Dame* (Paris, 1950), p. x and text (from Paris, Bibliothèque Nationale, MS nouv. acq. fr. 24541, dating from the first half of the fourteenth century). But the story may be found in several further places in Gautier and is discussed on several occasions by Mussafia in his analysis of the manuscripts of the miracle legends. See, for example, Mussafia 1896, pp. 35–37 (relating to Gautier book I, miracle 12).

27. Baum 1919, pp. 529–30. For the whole story see MGH, *Deutsche Chroniken,* 1:319–23.

28. Baum (1919, p. 562), has the text, which comes from Bartholomew of Trent but was earlier reproduced in A. Graf, *Roma nella memoria del medio evo* (Turin, 1883), 2:402, n. 69 (also in the chapter in the *Legenda Aurea* on Saint Agnes).

29. Eichendorff, *Das Marmorbild* (1817–19), *Julian* (1853); Merimée, *Venus d'Ille* (1837); William Morris, *The Earthly Paradise* (1870). For a more recent treatment of the whole theme, along with a full expansion of the postmedieval treatments of the subject, see the chapter entitled "Venus and the Ring," in Ziolkowski, 1977, pp. 18–77 (see note 25 above).

30. S. Thompson, *Motif Index of Folk Literature,* revised and enlarged ed. (Bloomington and London, 1975). See also Thompson's index in *Indiana University Studies* 21, nos. 103–6 (1934), and 22, nos. 108–10, s.v. "Love through sight of picture" (T.2.2) and "Love through sight of statue" (T.2.2.1).

31. Similar issues arise in the case of another, more overtly functional category of images. Everyone knows how before the advent of photography, portraits were used by those who could afford such luxuries to assist in the selection of spouses. In Rubens's Marie de'Medici cycle, Henri IV casts an assessing eye at the somewhat glamorized portrait of Marie (fig. 156), though Holbein's great portrait of Christina of Denmark apparently moved Henry VIII less. In each case, reasons of state probably played more of a role in the outcome than anything to do with the way the portrait looked. But the case must be different with the pictures of courtesans and prostitutes. Some of course, may simply have been intended to be the fond recording of the features of favorite mistresses, as, presumably, in the case of the well-known pictures by Palma Vecchio, Titian, and Paris Bordone (e.g., fig. 154), and the many instances in Andrea Vendramin's collection. But one can never be quite certain; nor can one be sure of the effects of the well-known Fontainebleau paintings supposedly of Diane de Poitiers had (e.g., fig. 153), or of the *Jocondes,* the half-length or partly nude versions of Leonard-esque prototypes that figure so prominently in the inventories of the seventh-century bourgeoisie in Paris (see G. Wildenstein, "Le goût pour la peinture dans la bourgeoisie parisienne au début de la règne de Louis XIII," *Gazette des Beaux-Arts* 37, ser. 6 [1950]: 153–273). Indeed, with the latter pictures as well as with the illustrated catalogs of courtesans by Crispin de Passe, for example, and many of the pictures of prostitutes in the sixteenth- and seventeenth-century inventories, one wonders whether they should not be assigned a specific erotic function, along the lines of the *libidinis fomenta* de-scribed by Thomas Peacham in *The Gentleman's Exercise* of 1612 (though those, signif-icantly, were in the round; cf. chapter 13, section 2, below). In any event, the poten-tiality of all such pictures seems to be perfectly illustrated by the theme "love through sight of picture," which I continue to discuss in the text. For further details of the kinds of courtesan picture discussed in this note, see the excellent brief review in A. Kettering, *The Dutch Arcadia: Pastoral Art and Its Audience in the Golden Age* (Montclair, N.J., 1983), esp. pp. 51–55 and notes.

32. Cf. chapter 3, note 10, for a specific parallel from Leonardo, as well as the discussion of the general problem in chapter 11.

33. L. Giustinian, "Dagli Strambotti," in *Il Fiore della lirica Veneziana,* ed. M. Dazzi (Venice, 1956), 1:99.

34. For the further implications of the notion that the lover's image could be treated idolatrously (as Julia insists in the very next stanza in the lines from Shakespeare), see also chapter 13, section 7, and note 70.

35. For others, see the useful but by no means complete survey by J. C. Bürgel, "'Dies Bildnis ist bezaubernd schön!' Zum Motiv 'Love through Sight of Picture' in der klassischen Literatur des islamischen Orients," in *Michael Stettler zum 70 Geburtstag . . . Porträtstudien* (Bern, 1983), pp. 31–39.

36. "The Tale of Ibrahim and Jamilah," in *The Book of the Thousand Nights and a Night,* translated by Richard Burton (New York, 1934), pp. 3415–40. What is sig-nificant about this tale is that Jamilah is hostile to men only because she had already fallen in love with Ibrahim—on the basis of *reports* about his beauty—and thus could not stand any other. Cf. my comments on Mitchell in chapter 13.

37. It is worth noting here Shapur's claim when he is first brought into the story: "When I draw a person's head," he asserts, "it moves; the bird whose wing I draw will fly" (cf. both chapter 5, section 1, and chapter 11, section 2; also chapter 10, note 91); and then follows the even greater cliché: "At portraiture Shapur excelled; he could capture not only the likeness but the subject's very soul." This translation from P. J.

Chelkowski, *Mirror of the Invisible World: Tales from the Khamseh of Nizami* (New York, 1975), pp. 22–23.

38. Ibid., pp. 23–24. On pp. 46–47, Chelkowski gives a very useful commentary on the earlier versions of the story of Khosrow and Shirin by Khalid ibn Fayyaz, Ferdowsi, and Quatran, and assesses special characteristics of Nizami's great retelling.

39. B. Berenson, *The Florentine Painters of the Renaissance* (New York and London, 1896), pp. 3–7.

40. P. Taylor, "How David Salle Mixes High Art and Trash," *New York Times Magazine*, 11 January 1987, p. 28.

41. One difficulty is that when we locate the kind of perception attributed to Phillip Johnson in the context of the wide availability of art works in New York in the 1980s, and see its origins in pure male ideologies, we mitigate the truth that it hides. So too it is easy to contextualize elsewhere, and thereby retrieve other forms of evasiveness. On the face of it, one may find something appealing about the effort to corroborate past reports with present experience in Theodor Birt's lecture, six years after Berenson's Florentine introduction, on lay judgments about art in antiquity (*Laienurtheil über bildende Kunst bei den Alten: Ein Capitel zur antiken Aesthetik*, Rektoratsrede [Marburg, 1907]). "He who knows the Southerner," comments Birt, also offhandedly, "knows just how impressionable is his erotic fantasy." The assertion is given a footnote, as follows: "I myself have observed this phenomenon among young Neapolitans, as they stand before the Venuses from Pompei in the Museo Borbonico." A good thing that they were young and Neapolitan! One could hardly wish for a clearer demonstration of the dangers of contextualization. Birt, being the rector of a German university, could naturally be more dispassionate in his responses; and one would not want to suspect his erotic fantasies of being too impressionable. In any case, they would not be relevant in this book at all. My reference to Foucault is, of course, to *Histoire de la sexualité*, vols. 1–3 (Paris, 1976–84).

42. For a parallel from the Persian *Book of Parrots*, in which four men share in the creation of a work of art which by their prayer becomes alive and then compels them all to fall in love with it, see Kris and Kurz 1979, p. 72, citing R. Schmidt's translation of the *Sukasaptati* (Munich, 1913), pp. 149ff.

43. Cf. the end of the opening section of Alberti, *De pictura*, book 2, which provides another kind of comment on the transforming power of art over precious substances. Cited and discussed in chapter 3.

44. Ovid, *Metamorphoses*, 10, lines 243–89. I have only slightly modified the translation by Mary M. Innes in the Penguin Classics series (1955 et seq.).

45. Paret 1960, especially pp. 38–41, has a number of the relevant texts from the Ḥadith.

46. A. Papodopoulo, *Islam and Muslim Art*, tr. R. E. Wolf (New York, 1979), pp. 55–58, discusses those aspects of the Ḥadith that concern portraiture as well as the resistance to the imitation of animate beings in general. See also Grabar 1977, pp. 75–104.

13. THE SENSES AND CENSORSHIP

1. *The Swinburne Letters*, ed. C. Y. Lang (London, 1959), 1:99, no. 55.

2. Mark Twain, *A Tramp Abroad* (1880); cited and discussed in Leo Steinberg, "Art and Science: Do They Need to be Yoked?" *Daedalus* (Summer 1986), p. 11.

3. Vasari-Milanesi 4:188.

4. Ibid.

5. Janet Cox-Rearick, "Fra Bartolomeo's St. Mark Evangelist and St. Sebastian with an Angel," *Mitteilungen des Kunsthistorischen Institutes in Florenz* 18 (1974):329–54.

6. Ibid., p. 345.

7. That the large-scale sculpture discussed might also have some of the effects ascribed to Fra Bartolomeo's picture is, of course, omitted altogether.

8. Vasari-Milanesi 4:178–79.

9. The fact that I say "what we define as" and "what we call" should make it clear that I hold to no absolute sense of either art or arousal.

10. For a good range of bibliographic references, as well as a useful brief discussion, see Scharf 1974, pp. 345–46.

11. Ibid., p. 345.

12. Ibid.

13. Though by no means always. It would have been hard to "improve" on—or make still more "artistic"—a photograph such as the well-known one (ca. 1854) given to Durieu and Delacroix, showing a seated model seen from behind with her torso bare, but with a cloth falling downward from the back of the chair and across her lap.

14. It is difficult not to reflect here, as Courbet endows the photographic model with extra fleshiness, on the way in which Rubens invested the taut model of his antique prototypes with exuberant carnality and luxuriant palpability, perfectly in keeping with the desire expressed in his lost treatise *De imitatione statuarum* that the painter should above all avoid the effect of stone: *omnino citra saxum*.

15. This, of course, also happened to be the position with which Courbet, both explicitly and implicitly, was himself consistently to take issue.

16. Scharf 1974, p. 96.

17. Of course the converse may also be the case, namely, that arousal may proceed from the habitual connection with a particular kind of image.

18. Scharf 1974, p. 130, citing *Le Moniteur de la Photographie* (October 1863), p. 111.

19. *Journal des Débats,* 21 March 1851, cited in Scharf 1974, p. 128.

20. Some instances of this kind of transmutation verge on the absurd, as in Richard Polak's ridiculous photographic realization of Vermeer's *Painter in His Studio,* illustrated in Scharf 1974, p. 240 (fig. 175). It dates from 1915, but it is an extreme example of a tendency already seen much earlier. The absurdity is highlighted, perhaps, by the use of a genre picture to make the potentially arousing image more domestic and comfortable.

21. Scharf 1974, p. 130 (his translation from *L'Art de la photographie* [Paris, 1862], p. 302).

22. Ibid., p. 134.

23. The same set of oppositions arises in the case of the other great development in reproductive imagemaking, the woodcuts, etchings and above all engravings of the fifteenth and sixteenth century. Cf. the introductory paragraph in section 4 of this chapter.

24. H. Peacham, *The Gentleman's Exercise* (London 1612), p. 9.

25. Plutarch, *Life of Marcellus,* 21—although the issue here is not of such blatant sensuality, but rather of a descent from pristine manliness: "Hitherto people had been accustomed to spend their time either in fighting or in agriculture. . . . Now they idled away the greater part of the day in clever and trivial chatter about aesthetics."

26. Clement of Alexandria, *Protrepticus,* 4.53P.

27. Duchesne 1920, p. 133; see also D. E. Kozanikov, *Stoglav* (St. Petersburg,

1863), p. 150, and G. Ostrogorsky, "Les decisions du "Stoglav" concernant la peinture d'images et les principes de l'iconographie," in *Byzanz und die Welt der Slawen: Beiträge sur Geschichte der Byzantinischen-Slawischen Beziehungen* (Darmstadt, 1974), pp. 122–40, esp. pp. 138–40.

28. Cf. Aristotle, *Politics,* 7.17 (1336b): "It should therefore be the duty of the government to prohibit all statuary and painting which portrays any sort of indecent action" (*The Politics of Aristotle,* translated E. Barker [New York, 1962]). Cf. Freedberg 1971, pp. 240–41, and Plato, *Republic,* 3.401: "We must also supervise craftsmen of every kind and forbid them to leave the stamp of baseness, licence, meanness, and unseemliness on painting and sculpture, or building or any other work of their hands. We would not have our Guardians grow up among representations of moral deformity, as in some foul pasture where day after day, feeding on every poisonous weed, they would little by little gather insensibly a mass of corruption in their very souls."

29. Quoted and discussed in chapter three.

30. Valerius Maximus, *Dictorum factorumque memorabilium,* lib. 9, cap. 4, *Externa* 1.

31. Poggio Bracciolini, *Epistolae,* ed. T. de Tonelli (Florence, 1832), 1:183; briefly discussed in Baxandall 1971, pp. 39–40.

32. Cf. the passage by Giulio Mancini cited and discussed in chapter 1, section 1.

33. Richter 1949, p. 65 (Codex Urbinas 1270, Trat. 25). Here too it is impossible not to recall the State's case against *Madame Bovary.* Just before embarking on the sustained description of the offending passages in the novel as paintings (cf. the citations and discussions in chapter 3, and in the previous section of this chapter), the prosecutor says, "It is for you to decide if this is not a mingling of the sacred and the profane, and if it could not be something worse, a mingling of the sacred and the sensual" (*The Trial of Madame Bovary,* translated by E. Gendel, in the New American Library edition of *Madame Bovary* [New York, 1964], p. 343). On the problematic consequences of the mixing of sacred and profane see also chapter 12, section 1.

34. On some of the consequences of Leo XII's rescript of 10 May 1823, ordering the destruction of obscene plates, see A. Rossi, "La Chalcographie Royale de Rome," *Byblis: Miroir des Arts du Livre et de l'Estampe* 6 (1927):119; as well as the excellent catalog by S. Massari, *Incisori Mantovani del '500: Giovan Battista, Adamo, Diana Scultori e Giorgio Ghisi dalle collezioni del Gabinetto Nazionale delle Stampe e della Calcografia Nazionale* (Rome, 1980–81), esp. pp. 32–33, 40, 142–43.

35. The same Aretino who in 1545 was to write a celebrated letter to Michelangelo in which he expresses the hope that Paul III would destroy the *Last Judgement,* just as Gregory the Great had stripped Rome of "the proud idolatrous statues which by their excellence had deprived the humble images of the saints of their due reverence" (G. Gaye, *Carteggio inedito d'artisti* [Florence, 1840], 2:322ff., as well as the good discussion in Buddensieg 1965, pp. 60–61).

36. Vasari-Milanesi 5:418; see also Aretino's interesting letter to Battista Zatti of Brescia (*Lettere: Il primo e il secondo libro,* ed. F. Flora [Milan, 1980], 1:399–400) and the general summary of the episode and some of the derivations of the series in G. Lise, *L'Incisione erotica del Rinascimento* (Milan, 1975), pp. 55–61. But see now also the book by Lawner cited in the following note.

37. For a discussion of the fate and *Nachleben* of the *Modi,* see L. Lawner, *I Modi nell'opera di Giulio Romano, Marcantoni Raimondi, Pietro Aretino e Jean-Frédéric-Maximilien de Waldeck* (*I Marmi,* 119) (Milan, 1984); for the later prints, see Lise 1975, pp. 54, 60, and 63–81 (cited note 35). Lawner also discusses the possibility of the survival of one complete engraving of the first of the *Modi* and, most important, publishes the book, probably dating to 1527, of fourteen woodcuts and sixteen sonnets

bound in a pornographic and scatological miscellany formerly in the collection of Walter Toscanini. On this material, and on the broader problem of sixteenth-century pornographic material, especially in Venice, see also H. Zerner, "L'Estampe erotique au temps de Titien," in *Tiziano e Venezia,* 1976, pp. 84–90.

38. Although it should be noted that already Hadrian VI had wished to destroy the Sistine ceiling "dicendo ch'ell' era una stufa d'ignudi" (Vasari-Milanesi 5:456). For the various attempts at destruction and covering-up, see E. Steinmann, *Die Sixtinische Kapelle* (Munich, 1905), 2:515–16, and now the excellent survey by P. de Vecchi, "Michelangelo's Last Judgment," in *The Sistine Chapel: The Art, the History, and the Restoration,* ed. C. Pietrangeli et al. (New York, 1986), esp. pp. 190–97 and notes.

39. See D. DeGrazia Bohlin, *Prints and Related Drawings by the Carracci Family,* National Gallery of Art, Washington, 1979), pp. 289–90, for a full discussion of the attitudes of both Clement VII and Clement VIII toward sixteenth-century erotic print-making—especially the *Lascivie.* In note 1 on p. 290, she reproduces Malvasia's account of Clement's VIII's wrath over Agostino's prints.

40. See note 33 above.

41. Or, at any rate, so it was alleged by critics ranging from Erasmus to the poet Anna Bijns—a criticism evidently based on the reality of pictures of the order now best known by those of the Cranachs and their school. For Erasmus's attack, see Freedberg 1971, pp. 240–43; for Anna Bijns's see Freedberg 1982, p. 135 and note 18.

42. For the Council's decree on religious images, see *COD,* pp. 775–76 (Sessio 25, 3–4 December 1563), especially from the section beginning "omnis denique lascivia vitetur ita, ut procaci venustate imagines non pingantur, nec ornentur, et Sanctorum celebratione, ac Reliquiarum visitatione homines ad commessationes atque ebrietates non abutantur . . ." For a longer discussion of this aspect of the Council's decree, see Freedberg 1982.

43. Either the nudities were downright immoral, or—as in Aretino's famous letter of 1545 (and in writers like Gilio da Fabriano)—they were far too full of style to be holy pictures. See notes 35 and 38 above.

44. For both the writers and their attempts, see Freedberg 1986, 1982, and 1976.

45. On Molanus and on the various editions of the book which first appeared as the *De picturis et imaginibus sacris liber unus, tractans de vitandis circa eas abusibus ac de earunden significationibus,* but then went through several editions under the title of *De historia sanctarum imaginum et picturarum, pro vero earum usu contra abusus libri quatuor,* and on his other publications, see Freedberg 1971, pp. 229–36.

46. Molanus, *De historia,* lib. 2, cap. 42: "In picturis cavendum esse quidquid ad libidinem provocat" (in the first edition of 1570 it occurs as chapter 33 of the only book; translated and discussed at length in Freedberg 1971).

47. From Catharinus's *Disputatio de cultu et adoratione imaginum* (Rome, 1552), col. 144, cited in Molanus, *De historia* (a few further details in Freedberg 1971, p. 238).

48. G. Durandus, *Rationale divinorum officiorum,* 1.3.2; cf. Freedberg 1971, pp. 239–40, for the use of the passage in Molanus.

49. See S. Axters, O.P., *Geschiedenis van de Vroomheid in de Nederlanden* (Antwerp, 1960), 4:264–65.

50. Kris and Kurz 1979, p. 72.

51. Mango 1963, p. 56, citing Marcus Diaconus, *Vita Porphyrii,* ed. H. Grégoire and M.-A. Kugener (Paris, 1930), pp. 47ff.

52. See the excellent summary of Gregory's iconoclasm by Buddensieg 1965, pp. 44–65.

53. Andreas Fulvius, *Antiquitates urbis* (Rome, 1527), fol. lxxxi r (for lxxvi), cited

in F. Haskell and N. Penny, *Taste and the Antique: The Lure of Classical Sculpture, 1500–1900* (New Haven and London, 1982), p. 14.

54. See P. A. Bargaeus, *De privatorum publicorum aedificiorum urbis Romae Eversoribus . . .* (Rome, 1589), in Graevius, *Thesaurus antiquitatum Romanorum* (Venice, 1732), col. 1887 (Buddensieg 1965, p. 62, and especially Pastor 1886–1933, 10:451 and note 6, with further contemporary bibliography).

55. A. Possevino, *Tractatio de poesi et pictura* (Lyons, 1595), cap. 27.

56. Lessing 1854, p. 66.

57. Ibid.

58. Mitchell 1986, p. 109.

59. The difference between Mitchell's reading of these matters and mine is that his avowed aim is to describe the political and ideological unconscious that sets in motion the distinction of genres, while my reading has more broadly cognitive aims. This is not, however, to disavow the possibility of the task Mitchell sets himself.

60. Lessing 1854, p. 140.

61. Mitchell's comment (1986, p. 102) that the propriety of space and time in painting and poetry is at bottom a matter of the economy of signs, the difference between cheap, easy labor and costly "pains and effort," is a little misleading here—not least because Lessing makes no claim about the cheapness of the labor associated with visual signs; and "costly" is Mitchell's own interpolation before Lessing's straightforward "pains and effort."

62. Lessing 1854, pp. 107–8.

63. Mitchell 1986, p. 106.

64. Lessing 1854, p. 107.

65. Mitchell 1986, p. 110.

66. "A Vision of the Last Judgment," cited in ibid., p. 110.

67. Lessing 1854, p. 66.

68. See chapter 3, note 6, for reference, as well as note 30 above.

69. Reference in note 31 above.

70. *Two Gentlemen of Verona,* act 4, scene 2. But when Julia sees Silvia's picture in the final scene of this act, the problem emerges in all its fullness: "O thou senseless form,/ Thou shal't be worshipp'd, kiss'd lov'd and ador'd!/ And were there sense in his idolatry/ My substance should be statue in thy stead./ I'll use these kindly for thy mistress' sake,/ That us'd me so; or else, by Jove I vow,/ I should have scratch'd out your unseeing eyes,/ To make my master out of love with thee."

71. Mitchell 1986, p. 113.

72. It is hard, again, not to recall the way in which Lucian satirized the superstitious Paphlagonians (and the throngs who subsequently poured in from Bithynia, Galatia, and Thrace) for being taken in by the way in which Alexander of Abonoteichos convinced them of the appearance of Asclepius of Pella by means first of a baby snake and then a very large one from Pella. Needless to say, the god's fame then spread from Asia Minor to Italy; and soon "icons, images and bronze and silver statuettes of the new god were on sale everywhere" (Lucian, *Alexander*).

73. The whole tendency is perfectly exemplified by Ghiberti's account of how the Sienese found a beautiful statue by Lysippus. Everyone marveled at it—at least for a time. Then a citizen arose and announced that ever since the statue had been found, the Sienese had only met with misfortune in their war with the Florentines. "Consider how idolatry is forbidden by our faith," he exhorted his fellow citizens. Thereupon the statue was smashed into pieces and sent to be buried on Florentine soil (L. Ghiberti, *Commentari,* ed. O. Morisani [Naples, 1947], book 3, p. 56). On the other hand, the

story may also be seen in the light of the old and persistent belief that the images or idols of another people bring fortune or misfortune. Possession of strange images may mean that one controls them; but the gods in them take their revenge too, for, say, their enforced banishment.

14. IDOLATRY AND ICONOCLASM

1. A. F. Blunt, *Nicolas Poussin* (New York 1967), p. 129. (The A. W. Mellon Lectures in the Fine Arts, 1958, Bollingen Series, 35.7).

2. In the bacchic picture in London (*Dance Round the Herm of Pan*, National Gallery; no. 62) of almost exactly the same date, the garments of a nymph drunkenly dancing round a herm of Pan are handled in almost the identical way.

3. C. van Mander, *Het Schilder-Boeck* (Haarlem, 1604), fol. 213 v.

4. Exactly how the first and second commandments were to be read was the subject of much dispute, especially during the Reformation of the sixteenth century. The prohibition against graven images could be taken in a hard or in a soft sense, according to where the distinction between first and second commandment was made. Thus for Luther (unlike Zwingli and Calvin), this key text from the Decalogue was to be understood as part of the first commandment, and was to be taken specifically in conjunction with the insistence "Thou shalt have no other God before me." On this much debated issue, see now the careful discussion, with sources, in Stirm 1977.

5. It is hard not to recall the Poussin in this context, for in the suggestive but restrained décolletage of the female figures on the left and the right, the painter has once more revealed his subtle and delicate attentiveness to the crucial aspects of a text.

6. For the sources of this aspect of the reformers' views, see now Stirm 1977.

7. The very opposite, in other words, of the other famous image of the Israelites in the wilderness, the Brazen Serpent, erected by Moses himself. That work was salvific and redemptive, the evident forerunner of Christ's own cross. It saved the Israelites in the wilderness from the plague, just as Christ on the cross had saved mankind from its sins. The problem in the sixteenth century, however, was that the subject was also appropriated as a specifically Protestant one (see D. Ehresmann, "The Brazen Serpent: A Reformation Motif in the Works of Lucas Cranach the Elder and His Workshop," *Marsyas* 13 [1967]: 32–47). But the complexities of the use of this example is pointed to by the varieties of reference to the subsequent Old Testament iconoclast kings. Hezekiah, for instance, could be regarded as an *exemplum* of justified iconoclasm (he broke the Brazen Serpent down when the Israelites burned incense to it); but Catholics might say that his deed (like Josiah's, say) could not justify iconoclasm, since it was only a case of the abuse of rightful images. See also Freedberg 1986, note 194.

8. As emphasized especially in Freedberg 1978 and 1986.

9. H. Jedin, "Entstehung und Tragweite des Trienter Dekrets über die Bilderverehrung," *Theologische Quartalschrift* 116 (1935): 142–82, 404–28; see also Freedberg 1986, p. 72.

10. Which continued in the Netherlands in the early 1580s and left the churches white.

11. A good overview can be found in P. Mack Crew, *Calvinist Preaching and Iconoclasm in the Netherlands, 1544–1569* (Cambridge, 1978).

12. For a summary of all these issues, see my general article of 1986, with more specific details in my Oxford D. Phil. thesis of 1973 entitled *Iconoclasm and Painting in the Revolt of the Netherlands, 1566–1609* (New York, 1987).

13. As in Freedberg 1985.

14. The relevance to the Byzantine ideas and episodes of Islam and Islamic ideas has been much discussed, from the famous edict of the Caliph Yazid on (see A. Vasiliev, "The Iconoclastic Edict of the Caliph Yazid II," *DOP* 9/10 [1956]: 23–47, and Beck 1975, pp. 13–14, n. 33, etc.).

15. *Apologia ad Guillelmum . . . Abbatem,* in *PL* 182, cols. 915–17. See also Freedberg 1982, n. 56 for the Reformation descendance of this view.

16. See J. Phillips, *The Reformation of Images: Destruction of Art in England, 1535–1660* (Berkeley and Los Angeles, 1973), p. 144. The event happened in 1600. Although Queen Elizabeth objected to the substitution, and immediately ordered the restitution of a cross, the city magnates demurred; but in the end agreed to her instructions. See Aylmer Vallance, *Old Crosses and Lychgates* (London and New York, 1920), pp. 102 and 106. It is worth noting that already in 1581 the Virgin had suffered greater indignities than the other sculptures on the cross, at least on its upper part (ibid., p. 102).

17. See the *Führer durch die Ausstellung Entarte Kunst* (reprinted with additional texts, Munich, 1937). More useful material is found in B. Hinz, *Die Malerei im deutschen Faschismus: Kunst und Konterrevolution* (Munich, 1974). See also the important debate that has arisen between Hinz in *Kritische Berichte* 14 (1986), Heft 4, and C. Frowein, *Kritische Berichte* 15 (1987): 70–71.

18. See V. Zinserling, "Das attische Grabluxusgesetz des frühe 5. Jahrhunderts," in *Kunst und Politik in der Antike,* Wissenschaftliches Zeitschrift Universitatis Jena, 14 (1965), with good references to earlier literature.

19. For a useful and interesting summary of the Greek and Roman instances—along with short accounts of the Egyptian, Islamic, and Jewish cases—see D. Metzler, "Bilderstürme und Bilderfeindlichkeit in der Antike," in Warnke 1973, pp. 14–29. K. Ch'en, "Economic Background of the Hui Ch'ang Persecution," *Harvard Journal of Asiatic Studies* 19 (1956): 67–105, sets out some of the economic issues underlying the Hui-Ch'ang events, though complex cultural and local political issues appear to have been significant motivating factors as well—as so often.

20. As Kitzinger noted: "For Christian as for pagan emperors their own portraits served to represent them wherever they were unable to be present in person. They were sent to distant provinces, to co-rulers and subordinates to receive obeisance on behalf of a new sovereign, and their acceptance or refusal meant acceptance or rejection of the sovereign himself. In the Law courts, market places, assembly rooms and theatres they served to represent the sacred person of the absent emperor, and to confirm the magistrates' acts. . . . Most striking of all perhaps was their recognized function as legal protectors of the individual citizen. *Ad statuas confugere* was a traditional right of any person seeking the protection of imperial law" (Kitzinger 1954, pp. 122–23, with sources). "Represent" at the beginning of this extract may be too weak a verb to convey the equivalence in power between Emperor and Emperor present in his image; and this sense of presence was emphatic in Byzantium.

21. The translation offered by the *Ancient and Modern Library of Theological Literature* (London, 1889), which is occasionally given for this passage, is perhaps a little too expansive and nonliteral; but it underscores the point: "The likeness of the Emperor is indelibly impressed upon the image." Although "indelibly impressed" is nowhere in the original text, it is not misleading; what is misleading in this translation is the use of "likeness" to translate both *eidos* and *homoiotēs.*

22. This section of the passage is doubly significant: first, because of its importation

of the notion of the speaking image; and second, because as Ladner notes (1953, p. 8), the words imputed to the image form an "obvious parallelism to the gospel of St. John 'I and the Father are one' and 'I am in the Father, and the Father in me.'"

23. *Oratio III contra Arianos* 5, in *PG* 26, col. 332A ff. Predictably quoted by John Damascene, *De imaginibus, Oratio III,* in *PG* 94, col. 1405A; translated and briefly discussed in Ladner 1953, p. 8.

24. Ladner 1953, p. 8.

25. See especially ibid., pp. 7–8 and notes 27–28; but also W. Dürig, *Imago: Ein Beitrag zur Terminologie und Theologie der Römischen Liturgie* (Munich, 1952), on the crucial texts in 1 Corinthians 15.49 and Colossians 3.9–10.

26. Saint Basil, *De spiritu sancto,* 18.45 (in *PG* 33, col. 149).

27. Kitzinger 1954, esp. p. 91, and Ladner 1953, p. 3.

28. John of Damascus, *Oratio III,* 26, and *Oratio I,* 21 (in *PG* 94, cols. 1345 and 1252).

29. As in the *horos* of the Council of 754, as known from the excerpts read out at the Seventh Ecumenical Council of 787 (Mansi 13:261–64. See also S. Gero, "The Eucharistic Doctrine of the Byzantine Iconoclasts and Its Sources," *Byzantinische Zeitschrift* 78 (1975):4–22.

30. Cf. John of Damascus, *Oratio III,* 18 (in *PG* 94, col. 1337); and Theodore the Studite, *Antirrheticus III,* (*PG* 99, cols. 341 and 426–27; see too Ladner 1953, pp. 16–18, and Beck 1975, pp. 20–21.

31. The chief document for the pro-image stance of Theodore is his third *Antirrheticus* (available in *PG* 99); on John there is much more, both primary and secondary. See B. Kotter's introduction to his edition of the three orations against the Iconoclasts, *Die Schriften des Johannes von Damaskos III, Contra Imaginum Calumniatores Orationes tres* (Berlin, 1975).

32. John of Damascus, *Oratio I* (*PG* 94, col. 1269A–B), citing Gregory of Nyssa, *De opificio hominis,* 5 (*PG* 44, col. 137A), as translated in Ladner 1953, p. 3. Cf. also Gregory of Nazianzus cited in *Oratio III* (*PG* 94, col. 1368). See the discussion in chapter 8, section 3, for the significance of such ideas for meditation and imitation.

33. *PG* 99, col. 405.

34. Ibid., cols. 357 and 405. On all these issues, see the excellent summary in Beck 1975, pp. 20–21.

35. Guided by the prudent patriarch Tarasios, the council simply emphasized that images were worthy of veneration, that they were of use for memory and devotion, but that *latreia*—adoration—was due to God alone. On Tarasios' role and his views, see the excellent observations by Beck 1975, pp. 27–28.

36. Almost exactly the same evasiveness about the nature of religious imagery characterizes the pronouncements on images by the Council of Trent almost eight hundred years later. The bulk of the Byzantine material in this and the preceding paragraph comes from the extraordinarily rich and suggestive study by Beck (ibid., esp. pp. 20–27).

37. Cf. also note 4 above.

38. Cf. Origen's exegesis of the *Magnificat* in the *Eighth Homily to Saint Luke,* in *GCS, Origenes,* 9.56, and *Contra Celsum,* 8.17–18.

39. See P. J. Alexander, "The Iconoclastic Council of Saint Sophia (815) and its Definition (*Horos*)," *DOP* 7 (1953): 35–36, on the use of Epiphanius's possibly spurious treatise; Mansi 13, cols. 292–309, and (on Epiphanius' treatise), K. Holl, "Die Schriften des Epiphanius gegen die Bilderverehrung," in *Gesammelte Aufsätze zur Kirchengeschichte,* 2: *Der Osten* (Tübingen, 1928), pp. 351–87.

40. *Eusebius ad Constantiam Reginam,* in Mansi 13, col. 313 (in the acts of the 787 Council). Cf. H. F. von Campenhausen, "Die Bilderfrage als theologisches Problem der alten Kirche," in *Tradition und Leben: Kräfte der Kirchengeschichte* (Tübingen, 1960), pp. 223–24.

41. Again, the issue is related to the much broader one of man's temerity in even trying to emulate the truly creative powers that belong to God alone.

42. Tertullian, *De cultu feminarum,* lib. I, cap. 8 (P. 44).

43. Ibid. (P. 44–45).

44. Gregory the Great, *Ad Serenum Episcopum Massiliensem,* ep. 11.10 (in *PL* 77, cols. 1027–28).

45. *COD,* pp. 774–75 (Sessio 25, 3–4 Dec. 1563: *Decretum de invocatione veneratione et reliquiis sanctorum et de sacris imagnibus*).

46. *Ita ut nullae falsae dogmatis imagines et rudibus periculosi erroris occasionem praebentes statuantur* (ibid., p. 775).

47. Quoted in *Miscellaneous Enquiries,* ed. F. Diekamp, in *Orientalia Christiana Analecta* 117 (1938): 127–29. This translation from P. J. Alexander, "Hypatius of Ephesus: A Note on Image Worship in the Sixth Century," *Harvard Theological Review* 44 (1952): pp. 178–81; see the slightly different translation in Mango 1972, p. 117.

48. On Nicephorus see especially P. J. Alexander, *The Patriarch Nicephoros of Constantinople* (Oxford, 1958).

49. Beck 1975, pp. 17–19.

50. A position like this was obviously capable of being used as a base for arguments which justified images on the grounds that they provided access to that which was absent (as in Theodore the Studite) (cf. Beck 1975, p. 18).

51. Leontios, bishop of Neapolis, quoted in *PG* 93, cols. 1605–8. Cf. John of Damascus, *De fide orthodoxa,* 4.16ff. in *PG* 94, cols. 1158ff. (also in Mango 1972, pp. 169–70).

52. John of Damascus, *Oratio I* (*PG* 94, col. 1248C–D). The translation is the excellent one in Bryer and Herrin, p. 183—although the reference there is incorrect.

53. Mansi 13, cols. 256A and 252A; translations from Mango 1972, p. 166.

54. The *horos* of the Council of 754 is known, as so often, from its piecemeal refutation at the Council of Nicaea in 787. The text is available in Mansi 13, cols. 208ff., but see also Anastos's excellent discussion (1954) of its contents and context.

55. *Oratio I,* (in *PG* 94, col. 1245A); translation from Bryer and Herrin 1977, p. 183.

56. *Oratio II* (in *PG* 94, col. 1300B–C); (cf. *Oratio I* (*PG* 94, col. 1245B–C).

57. *Oratio I* (*PG* 94, cols. 1237D–1240A), largely as translated in Bryer and Herrin 1977, pp. 183–84.

58. *PG* 94, cols. 1337–38, as translated by Mango 1972, p. 171.

59. C. Ginzburg, *Il Formaggio e i Vermi: Il mondo di un mugnaio del cinquecento* (Turin, 1976).

60. The most distinguished recent commentator on the problem of images in Byzantium (*Von der Fragwürdigkeit der Ikone,* significantly, is how Beck entitled his piece on what might be translated as the "dubiety of images") has sought to explain the disjunction between the sparseness of liturgical reference and the abundance of liturgical use of images in terms of factors like Byzantine hesychasm. This is the kind of mysticism that makes much of the need to grasp the unknowable by means of material made resplendent. The sensual gaze becomes a spiritual gaze. The resplendent is necessary because what is sought is the ultimate and fiery light of divine truth. But although indisputably instructive, it is not really mysticism, of any kind, that is at

stake here. It is the relations between representation in material form (on the one hand) and looking (on the other) that underlies mysticism, devotion to images, and iconoclasm—all three.

61. According to the *Neue Kronen Zeitung* of 11 October 1975. Cf. the immediate response of the Rijksmuseum curator who declared after the attack that "iedereen die de Nachtwacht aanvalt moet gestoord zijn" (*De Volkskrant*, 15 September 1975).

62. Since all criteria are normative, what are the criteria that are not normal? Is the tacit proposal here that we should judge abnormal behavior by abnormal standards? In which case, presumably, abnormality becomes normality. It is only by the standards of normality that abnormal appears abnormal, and so on.

63. In many of the cases from major museums mentioned here, I was allowed to consult the museum files on the relevant paintings; but by and large I have confined the references in the following notes to reports in the popular press.

64. *Het Leven*, 17 January 1911.

65. *De Telegraaf* and *Trouw*, 16 September 1975; also *Het Parool*, 15 and 16 September 1975.

66. Freedberg 1985, pp. 12–13 and notes, as well as p. 50, n. 83.

67. *De Telegraaf*, 16 September 1975, and *Neue Kronen Zeitung*, 11 October, 1975.

68. For all these cases see Freedberg 1985, p. 11.

69. Ibid., especially notes 33–34 for the assailant's history.

70. Cf. inter alia, Valerius Maximus 8.14.5; Aulus Gellius 20.6.18; Aelian 6.40; Strabo 14.1.22, as well as W. Alzinger in *RE*, supp. 12, sp. 1666, s.v. "Ephesos."

71. See *De Echo*, 17 January 1911, and *Die Welt*, 10 October 1977, as well as Freedberg 1985, especially note 103.

72. See the interview with Mary Richardson in the London *Star*, 22 February 1952. Cf. her comment in the *Times*, 11 March 1914: "I have tried to destroy the picture of the most beautiful woman in mythological history as a protest against the Government for destroying Mrs. Pankhurst, who is the most beautiful character in modern history."

73. London *Star*, 22 February 1952.

74. Freedberg 1985, p. 24, and notes 80–81, citing the *Times*, 11 March 1914, and *Het Leven*, 17 January 1911.

75. Details in Freedberg 1985, p. 17 and note 50.

76. For these cases, see the *Daily Sketch* (London), 16 March 1953, and the *New York Times*, 16 March 1953; also the *Times*, 14 September 1983.

77. The *Times*, 17 September 1981.

78. For a good array of practical juridical and legislative examples involving the most important earlier British case—that of the portraits of Elizabeth I—see R. Strong, *Portraits of Queen Elizabeth I* (Oxford, 1963), esp. pp. 5–11. It may be worth recalling here the frequent examples, particularly, it seems, in the fifteenth and sixteenth centuries, of the raising of hats to pictures of kings, queens, and others in positions of high authority.

79. As appears from the photographs of the painting in its stripped state made by William Suhr in 1959, immediately before he undertook restoration and repairs.

80. See the excellent article on the history and restoration of the altar, by C. J. de Bruyn Kops, "*De Zeven Werken van Barmhartigheid* van de Meester van Alkmaar gerestaureerd," *Bulletin van het Rijksmuseum* 23 (1975): 203–6.

81. On the vitality and power of the eyes, see chapter 4, section 6; chapter 5, section 2; and chapter 9, sections 1 and 3. For the effects of their removal, see especially chapter 9, notes 13 and 14. Details of the mutilation of the Rubens (of the

successful restoration as well) in U. Peter, "Zur Restaurierung des Rubens-Gemälde 'Erzherzog Albrecht van Österreich,'" *Maltechnik-Restauro* 84 (1978): 178–81.

82. See the good brief discussion in Gamboni 1983, pp. 19–20.

83. Personal communication, F. Leeman, Groningen, October 1983; cf. *NRC Handelsblad,* 2 September 1983.

84. Exactly this applies to the case of the man who made the horrific acid attacks on three paintings by Dürer in the Alte Pinakothek in Munich in May 1988. He was the same man who in 1977 had thrown acid on paintings in Kassel, Hamburg, Düsseldorf, and elsewhere in Germany. Apparently further embittered by the court's judgment that his pension be reduced in order to pay for some of the damage, he decided to do a similar deed again. When the security guard who held him until the police arrived declared to his superiors: "This man destroyed the paintings," the man responded, "No, I destroyed three Dürers."

85. *Daily Telegraph,* 20 June 1978; *Sheffield Star,* 19 June 1978 (on pleading guilty); cf. "Die Zerstörung der Gemälde hat mich befriedigt," in the Munich *Abendzeitung* of 10 October 1977.

86. *Liverpool Daily Post,* 4 April 1978.

87. *Evening Standard,* 3 April 1978.

88. This is why many authorities think they are justifying images when all they are doing is defining and prohibiting misuse.

89. So, for example, when the Burlington House cartoon by Leonardo da Vinci (National Gallery, London) was attacked with a shotgun in July 1987 (a bottle of ink had already been thrown at it in 1962), newspaper coverage was extraordinarily attentive and extensive; and as in some of the other assaults of the last decade or so, brief surveys of iconoclasm were also provided. For other instances of the pleasure in this kind of reportage, see Freedberg 1985, pp. 24–25 and notes.

90. This claim was made to me several times in the course of my investigation of modern iconoclasm, and sometimes led to the reluctance of the officials concerned to let me examine relevant documents and clippings.

91. The conjunction of William of Aquitaine's *vers* about nothing with the apparent nonreferentiality of Jackson Pollock—and the elitist implications of such positions— was first made (as far as I know) in a lecture on Pollock by T. J. Clark in 1986.

92. "Restat igitur ut ea sola pingantur ac sculpantur, quorum sint capaces oculi: Dei maiestas, quae oculorum sensu longe superior est, ne indecoris spectris corrumpantur" (Calvin, *Institutio Christianae religionis,* 1.12.6)

93. There can be little surprise at the project of a treatise on the power of images by a Jewish writer brought up in the awareness of the prohibition on graven images and schooled in the Calvinist tradition that proclaimed the possibility of picturing the world about one, but not—as both doctrines agreed—the unknowable God.

15. REPRESENTATION AND REALITY

1. Barthes 1981, p. 76. The remarkable grace of Barthes's essay, it seems to me, is only vitiated by two lapses: the grotesque aestheticization of Koen Wessing's photographs of death scenes in Nicaragua (pp. 23–24); and the overintellectualization of the difference between contrived and inadvertent charm (p. 47, referring to a photograph by Bruce Gilden of nuns and drag queens in New Orleans, and referring back, implicitly, to William Klein's photograph of children in Little Italy).

2. Ibid., p. 119.

3. Ibid., p. 117.

4. Especially in Goodman 1976, pp. 248–51, where he sets out his brilliant critique of the domineering dichotomy between the cognitive and the emotive "which pretty effectively keeps us from seeing that in aesthetic experience, the emotions function cognitively." It is important to note that Goodman emphasizes that "emotions are not so self-contained as to be untouched by their environemnt, but cognitive use neither creates new emotions nor imparts to ordinary emotions some magic additive." He then goes on to observe, "I am not resting anything on the distinction between emotion and other elements in knowing, but rather insisting that emotion belongs with them. What does matter is that the comparisons, contrasts and organizations involved in the cognitive process often affect the particular emotions"—and he thus moves off on a different tack.

5. The process is brilliantly but irritably set out by Michael Baxandall in "The Language of Art History," *New Literary History* 10 (1979): 453–65, and exemplified by his works on the Italian Renaissance (1971, 1972) and on German Limewood sculpture (1980).

6. One supposes that avoidance is claimed as a virtue in the remarkable—and wholly misleading—declarations by Baxandall that "forms may manifest circumstances, but circumstances do not coerce forms. Precisely this gives the best works of art their curious authority as historical documents; the superior craftsman, and only the superior one, is so organized that he can register within his medium an individual awareness of a period predicament" (Baxandall 1980, p. 164). Cf. the comments by Jane Harrison on Pausanias cited in chapter 2, note 31.

7. For the notion of repleteness, see Goodman 1976, pp. 252–54.

8. Ibid., p. 262.

9. R. F. Thompson's "Yoruba Artistic Criticism," in *The Traditional Artist in African Societies,* ed. W. L. d'Azevedo (Bloomington and London, 1973), pp. 19–61, is perhaps the best known of the now many articles attempting, sometimes rather naively, to demonstrate the aesthetic and critical refinement of societies notionally held to be not so refined.

10. Petrarch's will was straightforward enough: it referred to a panel by Giotto, whose beauty the ignorant do not understand, but at which the *magistri artis* are amazed (Baxandall 1971, p. 60, with more examples of this position on p. 61).

11. Though it must be admitted that sophisticated formalism does, by and large, involve a little more acknowledgment of responses to line, shape, color, form, and ponderosity, and a little less emphasis on the need for recognition and knowing).

12. When Plato says that "there are few who going to images behold in them that which the images express" (*Phaedrus,* 250b), the implication is "that so-called real things are only images of their truly real forms or ideas" (Ladner 1953, p. 6). Although this position is directly relevant to what follows here, my concerns lie strictly with visual imagery (and the point should be made strongly, in order to avoid misunderstanding). Here and elsewhere, especially in his earlier work, Plato makes much of the view that art is merely a low-level imitation of nature—which itself is at some stage below the highest level of truth. These are the views, especially the first one, against which I have set myself in this book.

13. Puttfarken 1985, p. ix. The other two problems, that of "liberating the theory of painting from the dominance of literary theory [which] had been an almost permanent feature of traditional theory" and "of defining the visual interest we have in pictures in contrast to our intellectual, moral or religious interest in the picture's subject matter" are, of course, absolutely germane to my discussion in this book.

14. Ibid., p. x.

15. Ibid.

16. What does this imply? Either we now have some kind of picture theory of reality or we are forced to renounce the metaphoric and metonymic status of representation. At least one then resolves the old and absurdly inflated problem of the ways in which we see nature through art; but the concept of representation (picturing, etc.) remains clumsy, and one begins to doubt its serviceability.

17. Barthes 1981, p. 82.

18. Ibid., p. 99.

19. Ibid., p. 100.

20. Cf. ibid., pp. 118–19: "The other means of taming the Photograph is to generalize, to gregarize, banalize it until it is no longer confronted by any image in relation to which it can mark itself, assert its special character, its scandal, its madness."

Bibliography

This is not intended to be a comprehensive bibliography. To have provided one would have been unduly and impractically cumbersome. I have not listed works cited only once in the notes to the text, nor have I listed any of the classical and patristic writers I use. References to standard editions are taken to be sufficient. Only nonclassical and nonpatristic works referred to more than once are listed below, as well as a very few which are not cited in the notes but which I found especially useful.

Acker, W. R. B. 1974. *Some T'ang and Pre-T'ang Texts on Chinese Painting,* vol. 2, part 1. Sinica Leidensia 12. Leiden.

Anastos, M. V. 1954. "The Argument for Iconoclasm as presented to the Iconoclastic Council of 754." In *Late Classical and Medieval Studies in Honour of A. M. Friend, Jr.,* pp. 177–88 Princeton.

Andreucci, A. *Il fiorentino istruito nella Chiesa della Nunziata.* Florence. 1858.

Appuhn, H., and C. von Heusinger. 1965. "Der Fund kleiner Andachtsbilder des 13. bis 17. Jahrhunderts im Kloster Wienhausen." *Niederdeutsche Beiträge zur Kunstgeschichte* 4:157–238.

Audollent, A. 1904. *Defixionum Tabellae.* Paris.

Aurenhammer, H. 1955. "Marienikone und Marienandachtsbild: Zur Entstehung des halbfigurigen Marienbildes nördlich der Alpen." *Jahrbuch der Österreichischen Byzantinischen Gesellschaft* 5:135–57.

Baldinucci, F. [1681] 1845–47. *Notizie dei professori di disegno da Cimabue . . .* Edited by F. Ranalli. 5 vols. Florence. Reprinted in 7 volumes with an appendix, critical note, and supplements by P. Barocchi (Florence, 1974–75).

Barthes, R. 1981. *Camera Lucida: Reflections on Photography.* Translated by

R. Howard. New York. Originally published as *La chambre clair* (Paris, 1980).

Bauch, K. 1960. "Imago." In *Beiträge zu Philosophie und Wissenschaft: Wilhelm Szilasi zum 70 Geburtstag,* pp. 9–28. Munich.

Baum, P. F. 1919. "The Young Man Betrothed to a Statue." *Publications of the Modern Language Association* 34, 4 (n.s. 27, 4): 523–79.

Baxandall, M. 1971. *Giotto and the Orators: Humanist Observers of Painting in Italy and the Discovery of Pictorial Composition, 1350–1450.* Oxford (corrected edition, 1986).

———. 1972. *Painting and Experience in Fifteenth-century Italy: A Primer in the Social History of Pictorial Style.* Oxford.

———. 1980. *The Limewood Sculptors of Renaissance Germany.* New Haven and London.

Becatti, G. 1951. *Arte e gusto negli scrittori Latini.* Florence.

Beck. H.-G. 1975. *Von der Fragwürdigkeit der Ikone.* Bayerische Akademie der Wissenschaften, Philosophisch-Historische Klasse, Sitzungsberichte, Heft 7. Munich.

Beitz, E. 1924. "Die Quelle der Kruzifixe aus Neumünster zu Würzburg und aus Heinrich." *Der Cicerone* 16:722–23.

Belting, H. 1981. *Das Bild und sein Publikum im Mittelalter: Form und Funktion früher Bildtafeln der Passion.* Berlin.

Benjamin, W. [1936] 1973. "The Work of Art in the Age of Mechanical Reproduction." In *Illuminations,* pp. 219–53. London.

———. 1985. *The Origins of German Tragic Drama.* Translated by J. Osborne. London. Originally published as *Ursprung des deutschen Trauerspiels* (Frankfurt, 1963).

Bevan, E. 1940. *Holy Images: An Inquiry into Idolatry and Image-Worship in Ancient Paganism and in Christianity.* London.

Bielefeld, E. 1953–54. "Aphrodite *anadoumenē parastheisa.*" *Wissenschaftliche Zeitschrift der Universität Greifswald,* 3: *Gesellschafts- und sprach wissenschaftlich Reihe,* 2:107–112.

Blackman, A. M. 1924. "The Rite of Opening the Mouth in Ancient Egypt and Babylonia." *Journal of Egyptian Archaeology* 10:47–59.

Bonner, C. 1950. *Studies in Magical Amulets Chiefly Graeco-Egyptian.* Ann Arbor and London.

Bourdieu, P. 1979. *La distinction: Critique sociale du jugement.* Paris.

Bourdieu, P., with A. Darbel and D. Schnapper. 1969. *L'Amour de l'art: Les musées d'art européens et leur public.* 2d ed., revised and enlarged. Paris.

Breckenridge, J. D. 1968. *Likeness: A Conceptual History of Ancient Portraiture.* Evanston.

Brown, P. 1973. "A Dark-Age Crisis: Aspects of the Iconoclastic Controversy." *English Historical Review* 346:1–34. Reprinted in *Society and the Holy in Late Antiquity,* pp. 251–301 (London, 1982).

————. 1981. *The Cult of the Saints: Its Rise and Function in Latin Christianity.* Chicago.

Brückner, W. 1963. "Volkstümliche Denkstrukturen und hochschichtliches Weltbild in Votivwesen: Zur Forschungssituation und Theorie des bildlichen Opferkultes." *Schweizerisches Archiv für Volkskunde* 3–4:186–203.

————. 1966. *Bildnis und Brauch: Studien zur Bildfunktion der Effigies.* Berlin.

Bryer, A., and J. Herrin, eds. 1977. *Iconoclasm* (Papers given at the Ninth Spring Symposium of Byzantine Studies, University of Birmingham, 1975). Birmingham.

Buddensieg, T. 1965. "Gregory the Great, the Destroyer of Pagan Idols: The History of a Medieval Legend Concerning the Decline of Ancient Art and Literature." *Journal of the Warburg and Courtauld Institutes* 28:44–65.

Caesarius of Heisterbach. 1851. *Dialogus miraculorum.* Ed. J. Strange. 2 vols. Cologne, Bonn, and Brussels.

————. 1901. *Die Fragmente der Libri VIII miraculorum.* Ed. A. Meister. Römisches Quartalschrift für christliche Altertumskunde und für Kirchengeschichte, Supplementheft 14. Rome.

————. 1929. *The Dialogue on Miracles.* Translated by H. von E. Scott and C. C. Swinton Bland, with an introduction by G. G. Coulton. 2 vols. London.

Cameron, A., and J. Herrin, eds. 1984. *Constantinople in the Early Eighth Century: The Parastaseis Syntomoi Chronikai.* Columbia Studies in the Classical Tradition, 10. Leiden.

Chydenius, J. 1960. *The Theory of Medieval Symbolism.* Commentationes humanarum litterarum 27/2. Helsinki.

Clerc, C. 1915. *Les théories relative au culte des images chez les auteurs grecs du II^me siècle après J.-C.* Paris.

Collin de Plancy, J. A. S. 1821–22. *Dictionnaire critique des reliques et images miraculeuses.* 3 vols. Paris.

Cook, A. B. 1914–25. *Zeus.* 2 vols. in 4. Cambridge.

Cormack, R. 1985. *Writing in Gold: Byzantine Society and Its Icons.* London.

Costerus, F. 1588. *De vita et laudibus deiparae Mariae Virginis meditationes quinquaginta.* Ingolstadt (Antwerp *approbatio* of 1587).

David, J. 1601. *Veridicus Christianus.* Antwerp.

Davidsohn, R. 1896–1927. *Geschichte von Florenz.* 9 parts. Berlin.

De Jongh, E. 1968–69. "Erotica in Vogelperspectief: De Dubbelzinnigheid van een reeks 17de eeuwse Genrevoorstellingen." *Simiolus* 3:22–74.

Deonna, W. 1930. "L'Image incomplète ou mutilée." *Revue des Etudes Anciennes* 32:321–32.

Diels, H. 1934–54. *Die Fragmente der Vorsokratiker,* 5th, 6th, and 7th eds. Edited with additions by W. Kranz. Berlin.

Dodds, E. R. 1956. *The Greeks and the Irrational*. Sather Classical Lectures, 25. Berkeley.

Dominici, G. 1860. *Regola del governo di cura familiare*. Edited and annotated by D. Salvi. Florence.

Donohue, A. 1984. "Xoana." Ph.D. diss., New York University.

Dobschütz, E. von. 1899. *Christusbilder: Untersuchungen zur christlichen Legende*. Texte und Untersuchungen zur Geschichte der altchristlichen Literatur, n.f. 3.18. Leipzig.

Duchesne, E. 1920. *Le Stoglav ou les cent chapitres*. Paris.

Dumoutet, E. 1926. *Le désir de voir l'hostie et les origines de la dévotion au saint-sacrement*. Paris.

Edgerton, S. Y., Jr. 1979. "A Little-known 'Purpose of Art' in the Italian Renaissance." *Art History* 2:45–61.

————. 1985. *Pictures and Punishment: Art and Criminal Prosecution during the Florentine Renaissance*. Ithaca.

Elliger, W. 1934. *Die Stellung der alten Christen zu den Bildern in den ersten vier Jahrhunderten*, Part 2: *Zur Entstehung und frühen Entwicklung der altchristlichen Bildkunst*. Leipzig.

Engemann, J. 1973. "Palästinesische Pilgerampullen im F. J. Dölger Institut in Bonn." *Jahrbuch für Antike und Christentum* 16:5–27.

Fazzo, V. 1977. *La giustificazione delle immagini religionse*, 1: *La tarda antichità*. Naples.

Forsyth, I. 1972. *The Throne of Wisdom: Wood Sculptures of the Madonna in Romanesque France*. Princeton.

Frazer, J. G. 1913. *The Golden Bough*, Part 1: *The Magic Art and the Evolution of Kings;* Part 2: *Taboo and the Perils of the Soul*. London.

————., ed. and trans. 1898–1913. *Pausanias' Description of Greece*. 6 vols. London.

Freedberg, D. 1971. "Johannes Molanus on Provocative Paintings." *Journal of the Warburg and Courtauld Institutes* 34:229–45.

————. 1976. "The Problem of Images in Northern Europe and Its Repercussions in the Netherlands." *Hafnia, Copenhagen Papers in the History of Art*, pp. 25–45.

————. 1977. "The Structure of Byzantine and European Iconoclasm." In Bryer and Herrin 1977, pp. 165–77.

————. 1978. "A Source for Rubens's Modello of the Assumption and Coronation of the Virgin: A Case Study in the Response to Images. *BM* 120:432–441.

————. 1981. "The Origins and Rise of the Flemish Madonnas in Flower Garlands: Decoration and Devotion." *Münchner Jahrbuch der Bildenden Kunst* 32:115–50.

————. 1982. "The Hidden God: Image and Interdiction in the Netherlands in the Sixteenth Century." *Art History* 5:133–53.

————. 1983. "Prints and the Status of Images in Flanders." In *Le stampe e la diffusione delle immagini e degli stili,* ed. H. Zerner, pp. 39–54. Atti del 24 Congresso C.I.H.A., 1979. Bologna.

————. 1985. *Iconoclasts and Their Motives.* Maarssen.

————. 1986. "Art and Iconoclasm, 1525–1580: The Case of the Northern Netherlands." In *Kunst voor de Beeldenstorm: Noordnederlandse Kunst, 1525–1580,* ed. J. P. Filedt Kok, W. Halsema Kubes, and W. T. Kloek, pp. 39–84. Amsterdam, Rijksmuseum.

Freud, S. [1913] 1960. *Totem and Taboo: Some Points of Agreement between the Mental Lives of Savages and Neurotics.* London.

Gadamer, H.-G. 1975. *Truth and Method.* Translated and edited by G. Barden and J. Cumming. New York (translated from the 1965 edition of *Wahrheit und Methode,* originally published in Tübingen, 1960).

Gamboni, D. 1983. *Un iconoclasme moderne: Theorie et pratiques contemporaineds du vandalisme artistique.* Institut Suisse pour l'histoire de l'art, Annuaire, 1982–83. Lausanne.

Gautier de Coinci. 1955–70. *Les miracles de Nostre Dame.* Edited by V. F. Koenig. 4 vols. Textes Littéraires Français, 64. Geneva.

————. 1959a. *Les chansons à la Vierge.* Edited by Jacques Chailley. Paris.

————. 1959b. *C'est d'un moine qui vout retolir a une nonne une ymage de Nostre Dame que il li avoit aportée de Jherusalem.* Edited by P. Jonas. Annales Academiae Scientiarum Finnicae, ser. B, t. 113.2. Helsinki.

Gebhard, T. 1954. "Die Marianischen Gnadenbilder in Bayern: Beobachtungen zur Chronologie und Typologie." In *Kultur und Volk, Beiträge zur volkskunde aus Österreich, Bayern, und der Schweiz: Festschrift für Gustav Gugitz zum 80. Geburstag,* pp. 93–117. Veröffentlichungen des Österreiches Museums für Volkskunde, 5. Vienna.

Gero, S. 1973. "The *Libri Carolini* and the Image Controversy." *Greek Orthodox Theological Review* 18:7–34.

Giesey, R. E. 1960. *The Royal Funeral Ceremony in Renaissance France.* Travaux d'Humanisme et Renaissance, 37. Geneva.

Gilbert, C. 1980. *Italian Art, 1400–1500.* Sources and Documents in the History of Art. Englewood Cliffs, N.J.

Gombrich, E. H. 1968. *Art and Illusion: A Study in the Psychology of Pictorial Representation.* 3d ed. London.

————. 1979. *The Sense of Order: A Study in the Psychology of Decorative Art.* Oxford.

————. 1981. "Image and Code: Scope and Limits of Conventionalism." In *Image and Code,* ed. W. Steiner, pp. 11–41. Ann Arbor.

Gombrich. R. F. 1966–67. "The Consecration of a Buddhist Image." *Journal of Asian Studies* 26:23–26.

————. 1971. *Precept and Practice: Traditional Buddhism in the Rural Highlands of Ceylon.* Oxford.

Goodman, N. 1976. *Languages of Art: An Approach to a Theory of Symbols.* 2d ed. Indianapolis.

Gordon, R. L. 1979. "The Real and the Imaginary: Production and Religon in the Graeco-Roman World." *Art History* 2:5–34.

Grabar, A. 1958. *Ampoules de Terre Sainte (Monza-Bobbio).* Paris.

———. [1946] 1972. *Martyrium: Recherches sur le culte des reliques et l'art chrétien antique.* 2 vols. Paris.

Grabar, O. 1977. *The Formation of Islamic Art.* New Haven and London.

Grøn, F. 1934. "Über den Ursprung der Bestrafung in Effigie." *Tijdschrift voor Rechtsgeschiedenis/Revue d'Histoire du Droit* 13:320–81.

Gugitz, G. 1950. *Das kleine Andachtsbild in den österreichischen Gnadenstätten in Darstellung, Verbreitung, und Brauchtum.* Vienna.

———. 1955. *Österreichs Gnadenstätten in Kult und Brauch.* Vol. 1. Vienna.

Gumppenberg, W. 1659. *Atlas Marianus sive de imaginibus deiparae per orbem Christianum miraculosis.* 2 vols. Ingolstadt.

Gutmann, J., ed. 1971. *No Graven Images: Studies in Art and the Hebrew Bible.* New York.

Hansen, J. 1901. *Quellen und Untersuchungen zur Geschichte des Hexenwahns und der Hexenverfolgung im Mittelalter.* Bonn.

Hansmann, L., and L. Kriss-Rettenbeck. 1966. *Amulett und Talisman: Erscheinungsform und Geschichte.* Munich.

Hope, C. 1976. "Problems of Interpretation in Titian's Erotic Paintings." In *Tiziano e Venezia: Convegno Internazionale di Studi Venezia 1976,* pp. 111–24. Università degli Studi di Venezia. Vicenza.

Holl, K. 1907. "Der Anteil der Styliten am Aufkommen der Bilderverehrung." In *Philotesia für Paul Kleinert,* pp. 51–66. Reprinted in *Gesammelte Aufsätze zur Kirchengeschichte,* 2: *Der Osten,* pp. 388–98 (Tübingen, 1928).

Horn, H. J. 1979. "Lügt die Kunst? Ein Kunsttheoretischer Gedankengang des Augustinus." *Jahrbuch für Antike und Christentum* 22:50–60.

Hubel, A. 1977. "Die Schöne Maria von Regensburg: Wallfahrten, Gnadenbilder, Ikonographie." In Mai 1977, pp. 199–237.

James, M. R., ed. 1924. *The Apocryphal New Testament.* Oxford.

Keller, H. 1939. "Die Entstehung des Bildnisses am Ende des Hochmittelalters." *Römisches Jahrbuch für Kunstgeschichte* 3:227–356.

Kieckhefer, R. 1976. *European Witch Trials: Their Foundations in Popular and Learned Culture, 1300–1500.* Berkeley and Los Angeles.

Kirk, G. S., and J. E. Raven. 1966. *The Presocratic Philosophers.* Corrected edition. Cambridge.

Kittredge, G. L. 1928. *Witchcraft in Old and New England.* Cambridge, Mass.

Kitzinger, E. 1954. "The Cult of Images in the Age before Iconoclasm." *DOP* 8:83–150.

————. 1980a. "Christian Imagery: Growth and Impact." In *Age of Spirituality: A Symposium,* ed. K. Weitzmann, pp. 141–63. New York and Princeton.

————. 1980b. "A Virgin's Face: Antiquarianism in Twelfth-Century Art." *AB* 62:6–19.

Knipping, J. B. 1974. *Iconography of the Counter-Reformation in the Netherlands.* 2 vols. Nieuwkoop and Leiden.

Koch, H. 1917. *Die altchristliche Bilderfrage nach den literarischen Quellen.* Göttingen.

Köster, K. 1963. "Pilgerzeichen-Studien: Neue Beiträge zur Kenntnis eines mittelalterlichen Massenartikels und seiner Überlieferungsformen." In *Bibliotheca docet: Festgabe für Karl Wehmer,* pp. 77–97. Amsterdam.

————. 1984. "Mittelalterlicher Pilgerzeichen." In Kriss-Rettenbeck and Möhler 1984, pp. 203–25.

Kötting, B. 1950. *Peregrinatio religiosa: Wallfahrten in der Antike und das Pilgerwesen in der alten Kirche.*

Kretzenbacher, L. 1977. *Das Verletzte Kultbild: Voraussetzungen, Zeitschichten, und Aussagewandel eines abendländischen Legendentypus.* Bayerische Akademie der Wissenschaften, Philologisch-Historische Klasse, Sitzungsberichte, Heft 1. Munich.

Kris, E., and O. Kurz. 1929. *Legend, Myth, and Magic in the Image of the Artist: A Historical Experiment,* with a preface by E. H. Gombrich. New Haven and London.

Kriss-Rettenbeck, L. 1972. *Ex Voto: Zeichen Bild und Abbild im christlichen Votivbrauchtum.* Zurich and Freiburg-im-Breisgau.

Kriss-Rettenbeck, L., and G. Möhler, eds. 1984. *Wallfahrt kennt keine Grenzen: Themen zu einer Ausstellung des Bayerischen Nationalmuseums und des Adalbert Stifter Vereins.* Munich and Zurich.

Kristeller, P. 1902. *Andrea Mantegna.* Berlin and Leipzig.

Laborde, L. de. 1850. *La Renaissance des arts à la cour de France: Etudes sur le seizième siècle.* Paris.

Ladner, G. B. 1953. "The Concept of the Image in Greek Fathers and the Byzantine Iconoclastic Controversy." *DOP* 7:3–33.

Landwehr, J. 1962. *Dutch Emblem Books: A Bibliography.* Utrecht.

Langé, S. 1967. *Sacri Monti Piemontesi e Lombardi.* Collana Italiana, 7. Milan.

Lessing, G. E. 1874. *Laocoon.* Translated by R. Phillimore. London.

Mai, P., ed. 1977. *850 Jahre Kollegiatstift zu den heiligen Johannes Baptist und Johannes Evangelist in Regensburg, 1127–1977.* Festschrift herausgegeben im Auftrag des Stiftskapital. Munich and Zurich.

Mâle, E. 1951. *L'Art religieux de la fin du XVIᵉ siècle, du XVIIᵉ siècle, et du XVIIIᵉ siècle: Etude sur l'iconographie après le Concile de Trente.* Paris.

Mango, C. 1963. "Antique Statuary and the Byzantine Beholder." *DOP* 17:53–77.

Mango, C., ed. and trans. 1972. *The Art of the Byzantine Empire, 312–1453*. Sources and Documents in the History of Art. Englewood Cliffs.

Marçais, G. 1932. "La question des images dans l'art musulman." *Byzantion* 7:161–83.

Marrow, J. H. 1979. *Passion Iconography in Northern European Art of the Late Middle Ages and Early Renaissance: A Study of the Transformation of Sacred Metaphor into Descriptive Narrative*. Ars Neerlandica, 1. Kortrijk.

Masi, G. 1931. "La pittura infamante nella legislazione e nella vita del Comune fiorentino." In *Studi di diritto commerciale in onore di Cesare viviante*, 2:3–33. Rome.

Mauss, M. 1972. *A General Theory of Magic*. Translated by R. Brain. London.

May, J. M. F. 1950. *Ainos: Its History and Coinage, 474–341* B.C. Oxford and London.

Meiss, M. 1964. *Painting in Florence and Siena after the Black Death: The Arts, Religion, and Society in the Mid Fourteenth Century*. New York.

Merkelbach, R. "Gefesselte Götter." *Antaios* 12:549–65.

Metzger, C. 1981. *Les ampoules à eulogie du musée du Louvre*. Notes et Documents des Musées de France, 3. Paris.

Meuli, K. 1975. "Die Gefesselte Götter." In *Gesammelte Schriften*, edited by T. Gelzer, 2:1035–1197. Basel-Stuttgart.

Meyer, A. E. 1923. *Chinese Painting as Reflected in the Thought and Art of Li Lung-Mien, 1070–1106*. New York.

Miélot, J. 1885. *Miracles de Nostre Dame, . . . reproduced in facsimile from Douce Manuscript 374*. Ed. G. F. Warner. London.

————. 1928–29. *Miracles de Nostre Dame . . . (Étude concernant trois manuscrits du XVᵉ siècle ornés de grisailles)*. Ed. A. De Laborde. Publications de la Société Française de Reproductions de Mss. à Peintures, 12. Paris.

Mitchell, W. J. T. 1986. *Iconology: Image, Text, Ideology*. Chicago and London.

Molanus, J. [1570] 1770. *De historia sanctarum imaginum et picturarum, pro vero earum usu contra abusus libri quatuor*. Ed. J. N. Paquot. Louvain.

Munn, N. D. 1973. *Walbiri Iconography: Graphic Representation and Cultural Symbolism in a Central Australian Society*. Ithaca and London.

Mussafia, A. 1896. *Über die von Gautier de Coincy benützte Quellen*. Denkschriften der Kaiserliche Akademie der Wissenschaften, Philosophisch-Historische Klasse, 44.1, Abh. 1.

————. 1886–98. *Studien zu den mittelalterlichen Marienlegenden, 1–5*. Sitzungsberichte der Kaiserliche Akademie der Wissenschaften in Wien, Philosophisch-Historische Klasse, 113 (1886): 917–94; 115 (1888):5–92; 119 (1889), Abh. 9; 123 (1891), Abh. 7; 139 (1898), Abh. 8.

[Nadal, J.] Natalis, H. 1607. *Adnotationes et meditationes in Evangelia . . . Editio ultima*. Antwerp.

Nadel, S. F. [1954] 1970. *Nupe Religion: Traditional Beliefs and the Influence of Islam in a West African Chiefdom*. New York.

Nersessian, S. der. 1944–45. "Une apologie des images du septième siècle." *Byzantion* 17:55–88.

Nicolau, M. 1949. *Jerónimo Nadal, S.I. (1507–1580): Sus obras y doctrinas espirituales*. Madrid.

Nilsson, M. P. 1967. *Geschichte der griechischen Religion*. Vol. 1, 2d ed. Munich.

Ortalli, G. 1979. *Pingatur in palatio: La pittura infamante nei secoli XIII–XVI*. Rome.

Overbeck, J. 1868. *Die antike Schriftquellen zur Geschichte der bildenden Künste bei den Griechen*. Leipzig.

Pächt, O. 1961. "The 'Avignon Diptych' and Its Eastern Ancestry." In *De Artibus Opuscula XL: Essays in Honor of Erwin Panofsky*, pp. 402–21. New York.

Pastor, L. von. 1886–1933. *Geschichte der Päpste seit dem Ausgang des Mittelalters*. 16 vols. in 21. Freiburg-im-Breisgau.

Paret, R. 1960. "Textbelege zum islamischen Bilderverbot." In *Das Werk des Künstlers: Studien zur Ikonographie und Formengeschichte, Hubert Schrade zum 60 Geburtstag*, pp. 36–48. Stuttgart.

———. 1968. "Das islamischen Bilderverbot und die Schia." In *Festschrift für Werner Caskel zum 70 Geburstag*, ed. E. Graf. Leiden.

Philippen, J. 1968. *De Oude Vlaamse Bedevaartvaantjes: Hun Volkskundige en Cultuurhistorische Betekenis*. Diest.

Pollitt, J. T. 1965. *The Art of Greece, 1400–1431 B.C.* Sources and Documents in the History of Art. Englewood Clifs, N.J.

———. 1974. *The Ancient View of Greek Art: Criticism, History, and Terminology*. Yale Publications in the History of Art, 26. New Haven and London.

Proske, B. G. 1967. *Juan Martinez Montañes, Sevillian Sculptor*. New York.

Pseudo-Bonaventure. 1961. *Meditations on the Life of Christ: An Illustrated Manuscript of the Fourteenth Century*. Translated from the Paris Bibliothèque Nationale manuscript (Ital.) by I. Ragusa. Completed from the Latin and edited by I. Ragusa and R. B. Green. Princeton.

Puttfarken, T. 1985. *Roger de Piles' Theory of Art*. New Haven and London.

Reff, T. 1963. "The Meaning of Titian's *Venus of Urbino*." *Pantheon* 21:359–66.

Richter, I. A. 1949. *Paragone: A Comparison of the Arts by Leonardo da Vinci*. London.

Rickert, H.-G., ed. 1965. *Marienlegenden aus dem Alten Passional*. Altdeutsche Textbibliothek, no. 64. Tübingen.

Ringbom, S. 1965. *Icon to Narrative: The Rise of the Dramatic Close-Up in Fifteenth-Century Devotional Painting.* Acta Academiae Aboensis, ser. A., Humaniora 31, 2. Åbo.

—————. 1969. "Devotional Images and Imaginative Devotions: Notes on the Place of Art in Late Medieval Private Piety." *Gazette des Beaux-Arts,* ser. 6, 73:159–70.

Roberts, A., and J. Donaldson, eds. 1868–72. *The Ante-Nicene Christian Library: Translations of the Writings of the Fathers down to A.D. 325.* Edinburgh.

Rohault de Fleury. 1878. *La Sainte Vierge.* 2 vols. Paris.

Rosenberg, A. 1975. *Christliche Bildmeditation.* Munich (originally published as *Die Christliche Bildmeditation,* 1955).

Scharf, A. 1974. *Art and Photography.* Harmondsworth.

Schlosser, J. von. 1910–11. "Geschichte der Porträtbildnerei in Wachs," *Jahrbuch der kunsthistorischen Sammlungen des Allerhöchsten Kaiserhauses* 29:171–258.

Schrade, H. 1958. *Vor- und frühromanische Malerei: Die karolingische, ottonische, und frühsalische Zeit.* Cologne.

Seymour, C. 1986. *Sculpture in Italy, 1400–1500.* Pelican History of Art. Harmondsworth.

Settis, S. 1981. "Artisti e committenti fra Quattro e Cinquecento." In *Storia d'Italia,* Annali 4: *Intelletuali e potere.* Turin.

Skorupski, J. 1976. *Symbol and Theory: A Philosophical Study of Theories of Religion in Social Anthropology.* Cambridge.

Smith, S. 1925. "The Babylonian Ritual for the Consecration and Induction of a Divine Statue." *Journal of the Royal Asiatic Society,* pp. 37–60.

Spamer, A. 1930. *Das kleine Andachtsbild vom 14. bis zum 20. Jahrhundert.* Munich.

Sperber, D. 1975. *Rethinking Symbolism.* Cambridge.

Steinberg, L. 1983. *The Sexuality of Christ in Renaissance Art and in Modern Oblivion.* New York.

Steiner, P. 1977. *Altmünchner Gnadestätten: Wallfahrt und Volksfrömmigkeit im Kurfürstlichen München.* Munich and Zurich.

Stirm, M. 1977. *Die Bilderfrage in der Reformation.* Quellen und Forschungen zur Reformationgeschichte, 45. Gutersloh.

Suckale, R. 1977. "Arma Christi: Überlegungen zur Zeichenhaftigkeit Mittelalterlicher Andachtsbilder," *Städel-Jahrbuch* 6:177–208.

Sucquet, A. 1630. *Via vitae aeternae: Iconibus illustrata per Boetius a Bolswert.* Editio septima, auctior et castigatior et novissima. Antwerp.

Sumption, J. 1975. *Pilgrimage: An Image of Mediaeval Religion.* London.

Tambiah, S. J. 1984. *The Buddhist Saints of the Forest and the Cult of Amulets: A Study in Charisma, Hagiography, Sectarianism, and Millennial Buddhism.* Cambridge Studies in Social Anthropology, 49. Cambridge.

Taubert, G., and J. Taubert. 1969. "Mittelalterliche Kruzifixe mit schwenkbaren Armen: Ein Beitrag zur Verwendung von bildwerken in der Liturgie." *Zeitschrift des Deutschen Vereins für Kunstwissenschaft* 23:79–121.

Tiziano e Venezia: Convegno Internazionale di Studi Venezia 1976. Università degli Studi di Venezia. Vicenza.

Turner, V., and E. Turner. 1978. *Image and Pilgrimage in Christian Culture: Anthropological Perspectives.* New York.

Trexler, R. C. 1972. "Florentine Religious Experience: The Sacred Image." *Studies in the Renaissance* 19:7–41.

———. 1980. *Public Life in Renaissance Florence.* New York.

Van der Linden, R. 1958. *Bedevaartvaantjes in Oost-Vlaanderen: Bijdragen tot de Studie van de Legenden, de Ikonografie, de Volksgebruiken.* Ledeberg and Gent.

Van Heurck, E. H. 1922. *Les drapelets de pèlerinage en Belgique et dans les pays voisins: Contribution a l'iconographie et l'histoire des pèlerinages.* Antwerp.

Vincent of Beauvais. 1624. *Bibliotheca mundi seu speculi maioris, 4: Speculum historiale.* Douai.

Wallfahrt kennt keine Grenzen. 1984. Catalog of an exhibition held in the Bayerisches Nationalmuseum, Munich. See also Kriss-Rettenbeck and Möhler 1984.

Warburg, A. 1932. *Gesammelte Schriften.* 2 vols. Leipzig and Berlin.

Warner, M. 1976. *Alone of All Her Sex: The Myth and the Cult of the Virgin Mary.* London.

Warnke, M., ed. 1973. *Bildersturm: Die Zerstörung des Kunstwerks.* Kunstwissenschaftliche Untersuchungen des Ulmer Vereins für Kunstwissenschaft, 1. Munich.

Wethey, H. E. 1969–75. *The Paintings of Titian.* 3 vols. London and New York.

Weynants-Ronday, M. 1936. *Les statues vivantes: Introduction a l'étude des statues égyptiennes.* Brussels.

Winzinger, F. 1975. *Albrecht Altdorfer—die Gemälde, Gesamtausgabe.* Munich and Zurich.

Wünsch, R. 1898. *Sethianische Verfluchtungstafeln aus Rom.* Leipzig.

———. 1902. "Ein antike Rachepuppe." *Philologus* 61:26–31.

Young, K. 1933. *The Drama of the Medieval Church.* 2 vols. Oxford.

Index

Abelam painting, 452 n. 15
Abgar V, king of Edessa, 207–9
Abondio, Alessandro, 121
Acciaiuolo, Agnolo, 255
Accuracy. *See also* Verisimilitude
 distinguished from verisimilitude, 206–
 12, 215
 of images of Christ, 205, 211–12
 in images of infamy, 254
 in votive images, 159
Acheiropoietai, 66, 90–91, 100, 110, 212,
 395–96, 440, 462 n. 20
Acker, W. R. B., 458 n. 19
Acts of Thaddeus: and imagery of Christ, 209
Aelian, 37, 331
Aelred of Rievaulx: and images of Jesus,
 167–68
Aerodius. *See* Ayrault, Pierre
Aesthetic differentiation, 76, 167, 204, 231,
 237, 274, 276, 281, 458 n. 73
Aesthetics. *See also* Benjamin, Walter;
 Gadamer, Hans-Georg; Goodman, Nel-
 son; Platonism and Neoplatonism
 and emotional response, 358, 431–33
 popular expectations, 121
 and pornography, 349–50
 and problem of aesthetic judgment, 74,
 76, 112, 115, 236
 problem with categories of, 24
 and realism, 352–53
 relation to religion and values, 77
 and repression, 376
 transcended, 245
 and verisimilitude, 215
African art, 434. *See also* Nail fetishes; Pres-
ence and representation: in masks of
 Nupe; Yoruba critical categories
Agostino, Monna Caterina di, 269
Ainos. *See Hermes Perpheraios* of Ainos
Akhenaten. *See* Iconoclasm: various episodes
 of
Alberti, Leone Battista, 44–47, 49,
 493 n. 43
Alexander IV, Pope: votive image of, at San-
 tissima Annunziata, 227
Alfonso X of Castile, 299
Altdorfer, Albrecht: and the *Schöne Maria* at
 Regensburg, 100–101, 112, 121, 141–
 42
Altes Passional, 308
Altötting, Bavaria (pilgrimage shrine), 137–
 38, 146–48, 155–56
Ambivalence, 388, 395, 401, 405–6
Amiens, Colas d'. *See* Charles VII: exequies
 of
Amulets, 124, 128–29, 132–35, 307, 396,
 465 n. 53. *See also* Consecration
Ampullae 128, 130, 134–35, 159, 396
Anagogical view of images, 162, 164–66,
 188–89, 404–5
Anderson, Jaynie, 447 n. 22
Andrea, Zoan, *Couple Embracing,* 362
Andries, Judocus, 187
Angelico, Fra, *Lamentation,* 9
Aniconism. *See also* Augustine, Saint; Hera-
 clitus; Iconoclasm; Plutarch; Xeno-
 phanes
 and aesthetic differentiation, 76
 and anthropomorphic imagery in mono-
 theism, 54–56

Aniconism (*continued*)
 critique of Western views of, 59–60, 73–74
 in early Greek and Judaeo-Christian culture, 60–63
 as false justification for cultural superiority, 60, 74
 and iconoclastic movements, 29, 62
 and spirituality, 65
Animism, concept of, 29–30, 32, 190–91, 284–85
Animation of images, 49, 86–87, 96, 241, 297, 448 n. 9. *See also* Eyes; Greek images; Images, coming alive of; Inherence: and animation
Antisthenes the Cynic, 61
Anselm, Saint, 299
Anthropomorphization of images, 70, 72–74, 76. *See also* Aniconism
Anti-Semitism, 100, 103, 145–46, 388, 468 n. 18, 480 n. 5
Aphrodite
 of Cnidos, 330–31
 nude statue of, in the *Marneion*, 370
Apollonios of Tyana, 460 n. 45
Apotropaia, 90, 124–30, 145, 396, 465 nn. 52–53, 57
Appian. *See* Julius Caesar: exequies of
Arboreal origins of images, 70, 73, 455 nn. 50–51
Archaic qualities in images, 35–36
Aretino, 362, 495 nn. 35–36, 496 n. 43
Armenini, G. B., 2
Arnobius, 37, 71
Argoi lithoi, 66–68, 83, 449 n. 13
Aristophanes, *Daedalus*, 76
Aristotle, 50, 495 n. 28
Arousal. *See* Iconoclasm: and fear of sexual arousal; Images, looking at
Art and morality, 63–65, 250, 350–52, 358–59
Artemis, images of, 70, 71, 73–76, 83–84
Artemis of Ephesus. *See* Chaining of images; Greek images
Artemis Orthia, 70, 456 n. 69. *See also* Chaining of images
Artist
 creativity of, 166
 and emulation of the divine, 42, 86, 203–4, 344, 359, 397, 438, 501 n. 41
 fame of the, and artistic worth, 236
 and moral stature, 250, 359, 388–89, 448 n. 10
Atget, Eugène, 233

Athanasius, Saint, 392–93
Attentiveness, 166–67. *See also* Images, looking at
Augustine, Saint, 2, 62, 78, 164, 166, 479 n. 18. *See also* Presence and representation
Auxerre, Council of, 136
Ayrault, Pierre, 259

Baitulia, 33–34, 36, 66–71
Bajazid II. *See* Innocent VIII
Baldinucci, Filippo. *See* Cardi, Ludovico, il Cigoli; Tacca, Pietro
Baldung Grien, Hans, *Holy Family with Saint Anne*, 12–13, 318
Balzac, Honoré de, *Le chef-d'oeuvre inconnu*, 317, 342
Barnes, Julian, *Flaubert's Parrot*, 478 n. 74
Barthes, Roland, 315, 430, 440–41, 503 n. 1, 505 n. 20
Bartolomeo di Maestro Gerardino, 254
Bartolomeo, Fra, *Saint Sebastian*, 346–48, 353
Basil, Saint, 393, 415
Baxandall, Michael, 100–101, 103, 168, 471 n. 25, 504 nn. 5, 6
Beauty and art, 63–64, 189–90, 353–55, 373–74, 376, 397–98
Beck, H.-G., 161, 396, 469, 500 nn. 35–36, 501 n. 60
Bede, Pseudo-, *Little book on the meditation on the Passion of Christ*, 171
Bedrooms, pictures in, 2–3, 357–58
Beham, Hans Sebald and Barthel, prints by, 21, 360
Benedict XII, Pope: investigation into magical practices, 267–68
Benedict XIV, his collection of prints, 368
Benintendi (family of waxworkers), 225–26
Benjamin, Walter, 23–24, 126, 232–35
Benoist, Antoine, wax portraits by, 224
Berenson, Bernard, 339–40, 358
Bernard of Angers, his description of *Majesty of Saint Gerald*, 291
Bernard, Saint. *See also* Images, coming alive of
 criticism of images, 301–2, 387
 vision of, 288, 305–7, 312, 319, 332, 368, 488 n. 44
Bernardi, Gerardino, 250
Bernascone, Giuseppe, 197
Bernini, Gianlorenzo, 323
Betrothal to statues, 333–38, 491 n. 29
Bianco, Maso di. *See* Giottino

Birt, Theodor, 493n.41
Bleeding images, 310–11, 313, 489n.60
Body and embodiment. *See* Fusion; Inherence; Possession and gender ideology; Presence and representation; Reconstitution; Sexual responses to images
Bonaventure, Pseudo-: and meditation, 168–69, 171, 174, 180
Bonaventure, Saint, 162–63, 165–66, 470n.15
Boniface VIII, Pope: trial of, 266
Book of Parrots, 493n.42
Borromeo, Carlo, 193
 tomb of, 148
Bosse, Abraham: on Antoine Benoist, 224
Boti. See Churches: Or San Michele; Churches: Santissima Annunziata
Bourdieu, Pierre, 40
Bourdin, Michel, wax bust of Henri IV, 224
Bracciolini, Poggio, 360–61, 376
Bradshaw, John, 261
Brandea, 135
Brantôme, Pierre de Bourdeille, Sieur de, 327
Brazen Serpent, significance of, 498n.7
Bretades, 33–34, 36, 66–70, 73, 83, 449n.13
Brown, Peter, 445n.1
Brückner, Wolfgang, 214, 216, 259, 261–62, 270–71, 478n.76
Bruegel, Pieter the Elder, *Saint George's Day Fair,* 108–24
Bruni, Pietro, Friar Minor: and Madonna of the Oak, 138
Buchell, Arnout van, 228–29
Buda, Bernardo del, 250–51
Buddhism and images, 56, 60, 84–86, 95, 207, 389
Butler, Samuel, *Alps and Sanctuaries,* 199–200, 474n.6

Caesarius of Heisterbach, 299, 301–9, 312–13, 322, 487–88nn.35–44
Caimi, Bernardino, Friar Minor, 192–93
Calligrams, 56
Callot, Jacques, *The Fair at Impruneta,* 107
Calvin, John, 62, 349, 399, 427, 498n.4
Canonicity, 1, 22–23, 215, 245, 281, 314, 316, 349, 355, 373–74, 376, 429, 432–35, 437–38, 448n.25
 and the shocking, 425
Captial punishment and images, 5–6, 8–9
Cardanus, Hieronymus, 213
Cardi, Ludovico, il Cigoli, 228

Carmina Figurata, 452n.9
Carracci, Agostino, *Lascivie,* 21, 356, 368
Carracci, Annibale, after, *Arti di Bologna,* 462n.15
Castagno, Andrea del, 250
Catacombs, Jewish, 451n.3
Catharinus, Ambrosius, 369
Catherine, vision of Saint, 305
Cato "the Censor," Marcus Porcius, 64–65
Celsus: punishment of, 259
Censorship. *See also* Durandus, William; Molanus, Johannes; Trent, Council of; Verisimilitude of images: and censorship
 by covering or hiding parts of the body, 344, 354, 360–61, 363–70, 376
 vs. destruction of images, 349
 of images, 346, 356, 358, 361
 and 16th-century Christianity, 368
 of 16th-century prints, 361–68
Cervera Bible, 452n.7
Chaining of images, 33, 74–76, 449n.15, 456nn.63, 69
Chalcografia Camerale, 362
Champaigne, Phillipe de: *Ex-voto of 1662,* 142–45
Chan-Seng-Yu, 458n.19
Charisma, 135, 466nn.58, 60
Charles VI: exequies of, 216–17
Charles VII: exequies of, 216–17
Charles IX: exequies of, 217–18
Children and images, 3–5, 169, 320–21, 353, 361, 369, 424, 458n.18
Child-rearing and images, 4–5, 11–12
Christ, Passion of. *See* Passion of Christ
Christian imagery. *See also* Abgar V, king of Edessa; *Acheiropoietai;* Aelred of Rievaulx; Altdorfer, Albrecht; Capital punishment and images; Catharinus, Ambrosius; Child-rearing and images; Churches; Consecration: of Christian Imagery; Dell'Arca, Niccolò; Dyck, Anthony van; Eusebius of Caesarea; Fernández, Gregorio; Fusion of image and prototype; Gregory I, Saint, Pope; Ignatius of Loyola, Saint; Juní, Juan de, *Lamentation;* Madonnas; Manuscript illumination; Manzoni, Guido; Meña, Pedro da; Michelangelo; Passion of Christ; Relics; Shrines; *Tavolette;* Veronica
Christ embracing saints and others from cross, 287, 294, 305–6
 and claims for verisimilitude, 205–6, 209–10

Christian imagery (*continued*)
consecration of, 89
and description of Christ by Lentulus,
210–11
and empathy, 164, 169–74
and the Hemorrhoissa, 207, 212
and nudity of Christ, 369–70
purpose of, 163
as replacement for relics, 93
and sacred vessels, 92
Theodore the Studite on, 394–95
at Varallo, 193–96
at Varese, 196–200
Christodorus of Thebes, 292
Chrysostom, Dio. *See* Dio Chrysostom
Chrysostom, John. *See* John Chrysostom
Churches. *See also* Shrines
Heiligwasser (Tyrol), 148
Madonna dei Bagni (Casalina near De-
ruta), 139, 156
Madonna delle Carceri (Prato), 149
Montaigu (Dutch: Scherpenheuvel),
110
Nosse Senhor do Bonfim (Salvador, Bra-
zil), 148
Or San Michele (Florence), 227–48
Peterskirche (Munich), 117, 121
Saint Catherine (Boulbonne), 268
Sanctuary of the Madonna dell'Arco, 105,
148
Sankt Wolfgang am Abersee (Salzkammer-
gut), 229
Santa Maria delle Grazie (Mantua), 148,
158, 225, 229
Santissima Annunziata, 226–29, 235
Tuntenhausen (Upper Bavaria), 148
Vierzehnheiligen (Franconia), 148, 229
Cicogna. *See* Rolando, Antonio di
Circumscription of divine in material form:
29, 62, 298, 402–5
Cimon and Pero (*Caritas Romana*), 47–48,
359–60, 368, 375
Clement of Alexandria, 62, 211, 358–59,
453n.18
Clement VIII, Pope, and censorship, 362,
365, 368
Clerc, Charly, 38–40
Clouet, François, 477n.61
Clouet, Jean, 231
Cohen, Kathleen, 477n.62
Coins
Carian, 67
Greek, 34–35, 72–73, 454n.46,
455n.50
Roman, 69

Color and allurement, 384, 397–99,
472n.40. *See also* Women
Colossus. *See Kolossos*
Commonplaces and critical conventions: sig-
nificance of, 10, 37–40, 46–47, 49,
51–53, 86, 112, 156, 285, 291, 293–
94, 297, 305, 313, 323–27, 484n.91
Consecration, 31–32, 448n.10. See also *En-
voûtement;* Eyes: painting in or opening
of; Relics; *Stoicheiosis*
and amulets, 133–34
of *argoi lithoi,* 83
of Christian images, 85, 89–91
Egyptian, 82
and footwashing, 91
opening of the mouth, 82, 84
opinion of Sinhalese monks, 86
realized in washing, anointing, crowning,
or garlanding, 96, 276
related to pilgrimages, 100, 110
of shrines, 109
of votive images, 153–54
Context and contextual pressures, xix–xx,
22–23, 171, 431–32, 439–40
Convention. *See* Commonplaces and critical
conventions: significance of
Convention in representation. *See* Gombrich,
E. H.; Goodman, Nelson; Schematiza-
tion
Copulation with statues. *See* Morlini, Giro-
lamo; Sexual responses to images
Coster, Francis, *Fifty Meditations,* 180, 182
Council and Synods. *See* Auxerre, Council of;
Iconoclastic Council of 754; Iconoclastic
Council of 815; Nicaea, Coucil of; Or-
leans, Synod of; Quinisext Council; Sto-
glav; Trent, Council of
Courbet, Gustave, 350, 352–53
Courtesans, pictures of, 357, 492n.31
Cranach, Lucas, 21, 297–98
Credi, Lorenzo di: and Fra Bartolomeo, 348
Cromwell, Oliver: mock execution of, 261
Crucifixes with movable arms, 286–87, 313

Daedalus, 36–37, 75–76, 291, 449n.15,
449–50nn.23–29
Damian, Peter, 299
Damnatio Memoriae, 248, 389
David, Johannes, *Veridicus Christianus,* 183–
84
Dawkins, R. M., 456n.69
De Crayer, Gaspar, *The Crucified Christ Em-
bracing Saint Lutgard,* 294, 296,
485n.10
Decorative: category of the, 59–60, 135

Defacing of images
besmirching of images in order to shame, 247, 255
"Burlington House Cartoon" (Leonardo), 1962 and 1987 attacks on, 503 n. 89
Dance Round the Golden Calf (Poussin), 1978 mutililation of, 421–22
Dürer, 1988 acid attacks on paintings by, 503 n. 84
eyes, mutilation of, 415–16
Fall of the Damned (Rubens), 1959 acid attack on, 409, 419
and fetishism, 419–20
individual acts and group iconoclasm, 386, 416–17
by jealous artists, 412, 418
Juno (?R. Verhulst), removal or mirror, 412
Leda and the Swan (Correggio), mutilation by Louis of Orleans, 410
Martyrdom of Saint James (Mantegna), attack on eyes, 415
Massacre of the Innocents (Matteo di Giovanni), gouging of eyes, 415
The Nightwatch (Rembrandt), slashings of, 407–9, 419
Pietà (Michelangelo), 1972 hammer attack on, 409, 420
Portrait of Archduke Albert (Rubens), 1977 acid attack on, 416
Portrait of Jacob Cornelisz. van Oostsanen and his wife (Jacobsz.), knifing of eyes, 415
Portrait of Princess Diana of Wales (Organ), 1981 slashing of, 414
predicated on attribution of life to image, 415
President Marcos of the Phillipines, 1983 desctruction of portraits of, 413
psychopathology and sublimation of destructive desires, 419
public curiosity about, 423–24
Richardson, Mary ("Slasher Mary"), 409–10, 502 n. 72
Rokeby Venus (Velazquez), 1914 slashing by suffragette, 409–10, 412
Self-Portrait (Dürer), attack on eyes, 415
Seven Works of Mercy (Master of Alkmaar), 16th-century attack on, 415–16
slashings of nudes, 410, 420
Strobos, Evert, 1983 destruction of sculptures by, 418–19
Unknown Political Prisoner (Butler), 1953 attack on, 412
Who's Afraid of Red, Yellow and Blue (Newman), 1982 attack on, 418

Defixio. See *Envoûtement*
Defixionum tabellae, 134
De Jongh, Eddy, 448 n. 24
Delacroix, Eugène, 350
Délécluze, Etienne Jean, 352
Dell'Arca, Niccolò, *Lamentation* group, 237
Demons and Spirits, 370, 459 n. 25, 490 n. 19. See also Mango, Cyril; *Stoicheiosis;* Theurgy
Denotation and connotation, 78–79, 155
Dente, Marco. See Raimondi, Marcantonio, *Pan and Syrinx*
Deonna, W., 455 n. 55
De Passe, Crispin, 479 n. 81, 492 n. 31
Destruction of images. See Censorship; Defacing of images; Iconoclasm; Gregory I, Saint, Pope
Devotio moderna, 174, 471 n. 37
Differentiation. See Aesthetic differentiation
Dio Chryosostom, 43–44, 164, 189
Diodorus Siculus, 36–37
Dionysius the Areopagite, 164–66
Divine, emulation of. See Artist: and emulation of the divine
Divine, perception of, 166. See also Aniconism; Iconoclasm
through human attributes, 60, 65, 190–91, 206–7, 298, 321–23
in visions and dreams, 304
Dolls, Holy, 446 n. 7
Dominici, Cardinal. See Child-rearing and images
Dominis, Marcantonio de: posthumous execution of, 261
Douglas, Mary, 457 n. 6
Downward transformation of canonical forms, 121–27. See also Secondary images
Dreams and visions: images in, 297, 303–4, 312, 486 n. 27
Duns Scotus, 166
Durandus, Abbot of Boulbonne, 268
Durandus, William, bishop of Mende, 369
Dürer, Albrecht, *Self-Portrait,* 415. See also Defacing of images
Dyck, Anthony van
Lamentation, 121
Madonna del Rosario, 142

Edgerton, Samuel Y., Jr., 8, 482 n. 31
Edessa, image of Christ at, 207–10, 476 n. 35
Effigies. See also Ayrault, Pierre; Charles VI: exequies of; Charles VII: exequies of; Churches: Santissima Annunziata; Fran-

Effigies (*continued*)

çois I; Julius Caesar: exequies of; Lykke, Kai; Meit, Conrad; Montbas, Jean Barton de; Pius II, Pope; Pliny the Elder; Tacca, Pietro; Tussaud, Madame; Uhlfeldt, Count Cortiz; Westminster Abbey, Undercroft Museum; Witchcraft

and punishment, 259–61

wax, evolution of, 229–30, 482 n. 47

Egyptian art, 204, 265, 277, 389, 393. *See also* Consecration; Iconoclasm

Egyptian attitudes to the soul, 204, 218, 277, 393, 485 n. 2

Eligius, Saint, 137

Elision of image and prototype, 276–77, 281, 486 n. 25. *See also* Fusion of image and prototype

Emotion and responses to images, 162–63, 166, 169, 184, 200, 282, 432

Empathy, 25, 161, 164, 167, 169–74, 193–96, 200, 231, 241, 245

Emperor in the image: in Byzantine theory, 392–93, 414, 499 nn. 20–21, 502 n. 78

Emulation of the divine. *See* Artist: emulation of the divine

Encolpia, 128, 132

Enrico, Giovanni d', 196

Enshrinement of images, 100, 117–19, 126

Envoûtement, 263–71

Epigrams, Greek. *See* Myron

Epiphanius of Salamis, 396, 500 n. 39

Epiphany dramas. *See* Liturgical dramas

Erasmus, 50, 496 n. 41

Eratostratos, 409

Etienne de Bourbon, 299

Etienne, Robert: punishment of, 260–61

Eucharist. *See* Christian imagery

Euripides, *Alcestis*, 204–5, 212, 475 n. 20

Eusebius of Caesarea, 164, 207–9

Letter to the Empress Constantia, 397

Evagrius, 209

Execution *par figure*, 260–61

Executio in effigie, 246–63

Ex-votos, 136–60, 466 n. 1, 467 n. 6

Eyck, Jan van (followers of), *Head of Christ*, 53, 211

Eyes. *See also* Barnes, Julian, *Flaubert's Parrot*; Defacing of images; Famulus; Flaubert, Gustave, *Madame Bovary*; Greek images

absence of, in images, 34, 202, 220, 415–17, 455 n. 56, 475 nn. 13, 14

and animation and enlivening of images, 10, 47, 51–52, 202, 205, 220, 242–44, 284, 292, 389, 415

painting in or opening of, 51, 82, 84–86, 202, 458 nn. 13, 19

related to danger, 33, 86, 220

removal of, 389, 415, 483 n. 53

Familiarity and perception, 65, 190–91, 298, 485 n. 3. *See also* Divine, perception of: through human attributes

Famulus: eyes of his painted Athena, 292–93

Fearful responses to images, 231, 281, 354, 356. *See also* Defacing of images; Eyes; Iconoclasm; Senses, fear and suspicion of

being portrayed, 278–79

and destruction, 376

and effects of foreign art, 357

Ferdinand III, wax image of. *See* Sandrart, Joachim von

Fernández, Gregorio, 239–41

Ferrari, Gaudenzio, 193

Fetishism, 60, 112, 120, 124, 159, 178, 306–7, 317–20, 327–29, 352–55, 360, 371–73, 376. See also *Envoûtement*; Images, looking at; Sexual responses to images

Ficino, Marsilio, 453 n. 19

Figiovanni, Battista, 149

Figuration, efficiency of, 129–32, 134, 146, 156, 167, 170–71, 253, 307, 320

Flaubert, Gustave, *Madame Bovary*

eyes in, 475 n. 13

trial of, 50, 350, 495 n. 33

Flying images, 309–10

Forge, Andrew, 452 n. 15

Form, consequences of pleasure in, 178, 186–88, 190. *See also* Beauty and art; Platonism and Neo-Platonism; Senses, fear and suspicion of

Forsyth, Ilene, 460 nn. 49, 52

Fouquet, Jean. *See* Charles VII: exequies of

Foreign art: corrupting effects of, 63–65, 357

Francis, Saint, 305

François Ier, 260, 327–29, 346

Frazer, Sir James George, 264, 272–74, 278

Frederick, Count Palatine. See *Goldenes Rössl*

Freud, Sigmund, 190–91, 343, 372

Fulvio, Andrea, 37

Funerary images, 45, 213–20, 236, 477 n. 62

Fusion of image and prototype, 29–30, 32, 65, 79, 90, 188, 200–201, 245, 276–77, 279, 281, 308, 311, 313, 392, 402, 406, 414. *See also* Inherence

criticism of, by Lucilius, 283–84

distinguished from reconstruction, 314

and dreams, 331
and the Eucharist, 393
Pauline views of Christ, 393
rationalized to magical explanation, 330–31
realism and the desire to possess, 352
in Saint Basil, 393
and sympathy, 271

Gadamer, Hans-Georg, 76–77, 80, 96–97, 338
Galland, Antoine, 278
Galluzzi, Alberto. *See* Griffoni, Matteo
Gautier de Coinci, 299, 307–8, 311–12
Gautier of Cluny, 299
Gaze of the observer. *See* Fetishism; Images, looking at
Gérard, Baron François-Pascal-Simon: engravings of the *Modi*, 362
Geiler von Kaysersberg, 177–78
Gender ideology, 13–17, 63, 317–19, 321–24, 348, 375–77, 397–99, 409–10, 424, 453 n. 16
Genitalia in images, 13, 17, 67, 327, 355–56. *See also Linga;* Morlini, Girolamo; Sexual responses to images
Germanos of Constantinople, 489 n. 2
Ghiberti, Lorenzo, 497 n. 73
Ghisi, Giorgio, *Venus and Adonis,* 365–68
Gigante, Gaetano, *Feast of the Madonna dell'Arco,* 105–7
Giorgione, *Venus,* 13, 21, 447 n. 20
Giottino, *Expulsion of the Duke of Athens,* 250, 255
Giovanni, Bonaccorso di Lapo di. *See* Images of infamy
Giustinian, Leonardo, 335
Gnostic amulets, 465 n. 53
God, creative activity of, 166, 396, 469 n. 1. *See also* Artist: and emulation of the divine
Goethe, *Die Wahlverwandschaften,* 446 n. 4
Goldenes Rössl, 146–48
Gombrich, E. H., 59, 201, 427, 469 n. 35
Gombrich, Richard, 84–86
Gomperz, Heinrich, 203
Gonzaga, Francesco, 145
Goodman, Nelson, 25, 59, 201, 274, 427, 430, 504 n. 4
Gorky, Maxim, 320–21, 361
Gould, Cecil, 447 n. 20
Grabar, André, 97
Greek Anthology, 292
Greek images. See also *Argoi lithoi;* Artemis, images of; *Baitulia; Bretades;* Coins;

Daedalus; Eusebius of Caesarea; *Kolossos;* Pausanius; Pessinus, sacred stone of; Porphyry; Tertullian
arboreal origins of, supposed, 70, 73, 76, 455 nn. 50–51
compared with early Roman, 64
consecration of cult statues, 34–35
divine representation, views of, 61
eyes of primitive images, 71
pagan and Christian writers on, 37, 72
sexual scenes on vases, 356
teleology of, supposed, 66–68, 70, 73, 76
Gregory I, Saint, Pope. *See also* Mystic Mass of Saint Gregory
and cult of images, 164
and destruction of images, 370
images as books of the illiterate, 163, 398
Letter to Secundinus, 164–65
Letter to Serenus, 398–99
and Monza *ampullae,* 130
Gregory Nazianzenus, 132, 500 n. 32
Gregory of Nyssa, 163
Gregory of Tours, 129–30, 136, 310
Griffoni, Matteo, 251
Groff, Wilhelm de, statue of Crown Prince Max-Joseph, 146–48
Grünewald, Mathias, 170
Guibert of Nogent, 299
Gumppenberg, Wilhelm von, *Atlas Marianus,* 113–15, 301, 463 n. 24

Hadrian I, Pope, 91–92
Hadrian, VI, Pope, 369, 496 n. 38
Hawthorne, Nathaniel, *The Prophetic Pictures,* 41–42
Heart, painting of the, 185, 473 n. 60
Heliodorus, *Aethiopica,* 2
Hennes, Pierre de. *See* Charles VII: exequies of
Henri IV, 224, 477 n. 61, 479 n. 79, 492 n. 31
Henry VIII, 492 n. 31
monasteries, dissolution of, 385
Hera of Samos, 70, 73
Heraclitus, 61
Hermes Perpheraios of Ainos, 34–35, 72
Herolt, Johannes, 300, 308
Hesychasm, 161, 501 n. 60. *See also* Mysticism
Heydenreich, Erhard, master of works at Regensberg, 101
High and low images. *See* Canonicity
Homer. *See* Christodorus of Thebes
Honorius Augustodunensis, 299

Hope, Charles, 447 n. 19, 447–48 nn. 22–23
Horace, 50, 163, 175, 360–61
Hostility, Christian, to pagan statues. See Pagan statues, Christian hostility to
Hugh of Poitiers, on discovery of relics in image at Vézelay, 94
Hume, David. See Freud, Sigmund
Hypatios of Ephesus, 399–400

Iconoclasm. See also Aniconism; Censorship; Defacing of images; Gregory I, Saint, Pope; Leo V, Byzantine emperor; Nicaea, Council of
and the Brazen Serpent, 498 n. 7
in Britain, xxv, 385, 387, 499 n. 16
Byzantine, 29, 387, 393–405, 486 n. 25
Chinese, 389, 499 n. 19
Egyptian, 389
failure of, 422–23
and fear of sexual arousal, 323–24, 370, 410, 420
and the first and second commandments, 379, 396, 498 n. 4
groups and individual spontaneous action of, 261–62, 386
iconodules and iconoclasts, inseparability of, 427
against magical powers of images, 396
messianic feelings of iconoclasts, 408–9
and Muhammad, 389
and Nazi Germany, 388
outgrowth of censorship, 362
and repression, 10–11, 376–77
in 16th-century Europe, 349, 385–87, 390, 405
and superior status of words, 400–401, 405–6, 452 n. 9
and symbolism, 390
and use of pagan replacements, 387
various episodes of, 385, 387–89, 497 n. 73
Iconoclastic Council of 754, 29, 62, 403, 500 n. 29
Iconoclastic Council of 815, 396
Idolatry, 374, 376, 379–81, 384–85, 396, 497 n. 73. See also Child-rearing and images; Eusebius of Caesarea; Iconoclasm; Leyden, Lucan van; Mitchell, W. J. T.; Poussin, Nicolas; Tertullian
Ignatius of Loyola, Saint, Spiritual Exercises, 170, 179–81, 183, 472 n. 42. See also Sucquet, Antonius
Image magic: distinguished from juridical uses of images, 270–71. See also

Envoûtement; Kittredge, George L.; Witchcraft
Image-assisted meditation. See Meditation, image-assisted
Images, anagogical view of. See Anagogical view of images
Images as means of expressing gratitude, 138, 225–27. See also Ex-votos
Images, chaining of. See Chaining of images
Images, coming alive of, 36, 285, 291, 297, 319. See also Bernard, Saint, vision of; Caesarius of Heisterbach; Christodorus of Thebes; Crucifixes with movable arms; Divine, perception of; Images, moving and self-transportation; Lactating Madonnas; Myron; Mystic Mass of Saint Gregory; Parastaseis syntomoi chronikai
beautiful images and sexual arousal, 333, 338
and blurring of signified and signifier, 325, 359
etymologies, 293
in manuscript illuminations, 294
and sexual desire of viewer, 319, 339–40, 359
in Spanish paintings, 287–88
and superhuman feats, 310–11
Images, looking at. See also Eyes; Fetishism; Iconoclasm: John of Damascus; Reconstitution
and arousal, 50, 329, 332–33, 339–40, 349, 352, 354, 357–59
and attentiveness, 166–67
and beauty, 373
and idolatry, 376
and the power to enliven, 50, 74–76, 308, 360, 376
relationship of sight to the other senses, 358, 384
and seductiveness, 375, 376, 397–98
Images, moving and self-transportation, 81, 309–10, 459 n. 25, 488 n. 55, 489 n. 56. See also Flying images
Images of infamy, 250–57, 480 n. 5. See also Effigies: and punishment
and the family dalla Palude, 254–55
and implication for the artist, 250–51
and the issue of resemblance, 254
painting of Bonaccorso di Lapo di Giovanni, 257
painting of Jean de Châlon, Prince of Orange, 482 n. 32
painting of Rodolfo da Varano, 256–57

and the trial of Sigismondo Malatesta, 246–47

The Expulsion of the Duke of Athens, 255

Images, ontology of. *See* Ontology of images

Images, perspiring. *See* Secreting images

Images, secreting. *See* Secreting images

Imagination: activation by images, 49, 90, 170, 191. *See also* Anagogical view of images; Meditation: image-assisted

Imagination: restrained by images, 162, 169, 175, 184–86. *See also* Meditation: image-assisted

Immagini infamanti. See Images of infamy

Imitation
 and relation to meditation, 162, 168–71, 174, 179, 181, 185, 192–93. *See also* Heart, painting of the
 and representation, 437–38

Incarnation of Christ, 162, 164, 206, 210, 212, 221, 298, 309, 395, 402

Indifference to images, 106–9

Infamy. *See* Images of infamy

Inferential criticism, 431

Inghirami, Tommaso Fedra, 149

Ingres, Jean-Auguste-Dominique. *Odalisques* and *Baigneuses,* 353

Inherence, 29–31, 71–72, 404, 459 n. 33
 and animation, 74
 and cult images, 406
 and denotation, 78
 and fusion through consecration, 32
 in John of Damascus, 404
 and living images, 315–16, 319
 material form and the divine, 403
 and sympathy, 88

Innocent VIII, Pope, 210

Inscriptions on images, 149, 155, 254, 465 n. 53

Islam and images, 42, 55, 68, 86, 203–4, 250, 344, 359, 389, 451 n. 4, 493 n. 46, 499 n. 14

Irmgard of Zutphen, Saint, 304

Ius imaginum, 213

Jacobus de Voragine, 300

Jacobsz., Dirk, *Portrait of Jacob Cornelisz. van Oostsanen and his Wife,* 415–16

James, M. R., 211

Japanese portrait statues, 476 n. 48

Jean de Châlons, prince of Orange. *See* Images of infamy

Jewish attitudes to images. *See* Judaism and images

Jiménez, Diego, 183

John Chrysostom, 130

John of Damascus, 394, 401–5, 475 n. 21.
 See also Fusion of image and prototype: Pauline views of Christ

John of Salisbury, *Policraticus,* 263

John the Faster, Saint, 30

John XXII, Pope, 266–67

Johnson, Philip, 340, 493 n. 41

Judaism and images, 55–56, 60, 389, 451 n. 53

Julius Caesar: exequies of, 215–16

Juní, Juan de, *Lamentation,* 241

Junius, Franciscus, 35

Juridical use of images, 247–63, 461 n. 3, 468 n. 30, 481 n. 29, 482 n. 47, 502 n. 78
 distinguished from image magic, 270–71

Justin Martyr, 211

Kaiserchronik, 333

Kennicott Bible, 56

Key, Willem, *Pietà,* 121

Kittredge, George L., *Witchcraft in Old and New England,* 271

Kitzinger, Ernst, 29–30, 165, 396, 466 n. 61, 499 n. 20

Klapisch-Zuber, Christiane, 446 n. 7

Kleine Andachtsbilder, 113–17, 121–26, 464 n. 39

Knots as *apotropaia,* 465 n. 57

Knox, Ronald, 84–85

Köster, K., 461 n. 10

Kolossos, 456 nn. 63, 67

Kris, Ernst, and Kurz, Otto, 201–3, 205, 370

Kriss-Rettenbeck, Lenz, 153–54

Ku K'ai-chih, 86, 264

La Bruyère, Jean de: on Antoine Benoist, 224

Lactantius, 283

Lactating Madonnas, 288, 305–6, 312, 319, 332, 368, 488 nn. 44–46
 and male sexuality, 312, 319, 488 n. 46

Ladner, Gerhard B., 392

Law and images. *See* Juridical use of images

Le Beau, Philibert, tomb of. *See* Meit, Conrad

Lentulus: description of Christ, 210–11

Leo V, Byzantine emperor, 400–401

Leo XIII, Pope: censorship of prints, 362

Leonardo da Vinci, *Paragone,* 50, 361

Leontios, Bishop of Neapolis (Cyprus), 401

Lessing, Gotthold Ephraim, 372–75
Leyden, Lucas van, *Dance Round the Golden Calf,* 378–79, 384
Libri Carolini, 91–92
Life and liveliness in images. *See* Images, coming alive of
Lifelike, fear of the, 231. *See also* Fearful responses to images; Images, coming alive of; Inherence; Reconstitution
Linga, 67, 70
Lithoi empsychoi, 33, 66
Litholatry, 33–36, 66–73, 77–79
Liturgical dramas, 286–88, 306–7
Lomazzo, Giovanni Paolo, 1
Lorenzo de' Medici, images of, 225–27
Lourdes. *See* Shrines
Love by sight of image, 50, 333–38, 361, 375, 492 n. 31, 493 n. 42
Ludolph of Saxony, 171, 173
Lucian of Samosata
 Alexander, 448 n. 9, 449 n. 14, 497 n. 72
 on the Venus of Cnidos, 330–31
Luke, Saint: images purportedly painted by, 108–10, 141, 205–6, 210–11, 395
Luther, Martin, 62, 368–69, 384, 399
Lykke, Kai: *executio in effigie,* 261–62
Lysistratos: as maker of casts from the face, 220

Macarius of Magnesia, 207
Madame Bovary (Gustave Flaubert), trial of. *See* Flaubert, Gustave
Madonnas, 4, 29–30, 110–20, 126–28, 288, 305–6, 312, 319–23, 332, 368
 See also Shrines
 Madonna of Albanian Church in Chicago, 301, 487 n. 32
 Madonna of Altötting, 137–38, 146–48, 155–56
 Madonna dell' Arco, 105–7, 148, 462 n. 12
 Madonna di Foligno (Raphael), 142
 Madonna of Guadalupe, 110, 113, 128, 462 n. 20
 Madonna of Impruneta, 107–8, 462 n. 17
 Madonna of Loreto, 110, 113, 120, 128
 Madonna of Monte Berico, 118
 Madonna of Ocatlán, 488–89 n. 55
 Madonna of Paraskevi, 149
 Madonna of Rocamadour, 27–28, 110, 114–15
 Madonna del Rosario (van Dyck), 142
 Madonna della Vittoria (Mantegna), 145–46, 156, 158, 468 n. 20
 Maria-Hilf Madonnas, 117, 121
 Our Lady of Vladimir, 321

Santa Maria Maggiore, 91, 109, 112, 141
Schöne Maria at Regensburg, 100–104, 109, 112, 121, 141–42
 sexual appeal of, 321–23
Virgén de los Remedios (Cordoba), 115
Virgin of Mutwal (Sri Lanka), 52
Magic Flute, The (Mozart), 337–38, 352
Magic, xx–xxii, 44, 80, 92, 167, 201–3, 268, 272–76, 396, 423, 456 n. 76. *See also* Brückner, Wolfgang; *Envoûtement;* Frazer, Sir James George; Fusion of image and prototype; Iconoclasm; Image magic; Images of infamy; Mauss, Marcel; Sexual responses to images; Skorupski, John
 in images versus other objects, 167
 magical inscriptions, 465 n. 53
 magical papyri, 88, 265
Majolus, Simon, *Dies Caniculares,* 446 n. 3
Malatesta, Sigismondo, trial of, 246–47
Man as image of God, 60, 162, 385, 394, 401. *See also* Divine, perception of: through human attributes
Mana. *See* Charisma
Mancini, Giulio, 3
Mander, Carel van, 379
Manet, Edouard, *Olympia,* 19, 353
Mango, Cyril, 92, 331, 370, 459 n. 25, 490 n. 19
Mandylion, 207–9, 476 n. 35
Mantegna, Andrea,
 Madonna della Vittoria, 145–46, 156, 158
 Martyrdom of Saint James, 415
Manuscript illumination
 Byzantine marginal psalters, 294, 486 n. 25
 15th-century *Miracles of the Virgin,* 294, 301, 307
Manzoni, Guido, 237–39
Marguerite of Austria. *See* Meit, Conrad
Mariette, P.-J., and the *Modi,* 362
Marrow, James H., 170–71, 173, 471 n. 33
Masks, 31–33, 56
Master of Alkmaar, *The Seven Works of Mercy* (polyptych), 415, 417
Master of the Die, *Sacrifice to Priapus,* 365
Matteo di Giovanni, *Massacre of the Innocents,* 415
Mauss, Marcel, 80, 92, 272, 275–76, 280
Max-Joseph of Bavaria, Crown Prince. *See* Groff, Wilhelm de
Maximus of Tyre, 164
Mechanical devices in images, 215, 222–24, 235, 286, 478 n. 76. *See also* Crucifixes with movable arms; Trickery and images

Meditation, image-assisted, 161, 168–69, 171, 174, 180, 236, 308, 464 n. 39. *See also* Imitation: and relation to meditation
 and bleeding crucifixes, 310
 and concentration, 162, 166
 and internal representation or visualization, 168, 179, 184–85, 188–89
 Saint Catherine and icon of the Madonna, 305
 Saint Francis and speaking crucifix, 305
 and response, 166, 175, 191
Meditations on the Life of Christ, 168–71
Meit, Conrad, 217
Memory, 49, 90, 162–63, 213, 387, 399
Meña, Pedro da, 241
Menodotos of Samos, 449 n. 15
Methodios of Olympos, 469 n. 1
Michelangelo
 Last Judgment, attempts to censor, 365, 369
 Pietà, attack on, 409–10, 420
 Sistine Ceiling, attempts to censor, 496 n. 38
Micrography, 56, 456 n. 9
Miélot, Jean, 294–95, 301, 307–8, 312
Migliore, del: on removal of images at Santissima Annunziata, 235
Minucius Felix, 61–62, 84, 283
Miracle legends involving images of Virgin and Christ, 284–85, 299–314
Miracles, 103, 105–8, 110, 112, 120–21, 166–67, 298–99, 485 n. 3. *See also* Caesarius of Heisterbach; Flying images; Gautier de Coinci; Images, moving and self-transportation; Madonnas
 establishment of legendary genres, 300–301
 and images in medieval legends, 299–300, 310–11
 and the Madonna of the Oak, 138–40
 and religiosity of the poor and simple, 399
 secreted oil from Sardenai image, 311
 and shrine at Altötting, 138
 and shrine of Saint Martin at Tours, 129–30
Mitchell, W. J. T., 372–76, 491 n. 24, 497 nn. 59, 61
Mobility of images. *See* Flying images; Images, coming alive of; Images, moving and self-transportation
Modi. See Romano, Giulio; Raimondi, Marcantonio
Molanus, Johannes, 3, 369, 371, 496 nn. 45–46

Montañés, Juan Martínez
 Cristo de la Clemencia, 241–42
 Jesus de la Pasión, 244–45
 realism of, 239–45
Montbas, Jean Barton de: *executio in effigie,* 262
Morality. *See* Art and morality; Artist, and moral stature; Foreign art, corrupting effects of
Morandi, Anna, 229
Morlini, Girolamo, 326–27, 330–31
Mozart, Wolfgang Amadeus, *The Magic Flute,* 337–38, 352
Muhammad, 55, 344, 389
Murillo, Bartolomé Esteban, *Saint Francis Embracing the Crucifed Christ,* 287
Mussafia, Adolfo, 486 n. 28, 491 n. 26
Myron: epigrams on works by, 292, 486 n. 23
Mystic Mass of Saint Gregory, 294, 297, 313
Mysticism, 65, 161–62, 173, 358. *See also* Hesychasm

Nadal, Jerome, 181–82, 185, 472–73 nn. 47–59
Nail fetishes, 268–69
Nature
 realism and art: bourgeois views of, 350–54, 361, 437, 439
 and referentiality: bourgeois views of, 425–26, 437, 505 n. 16
Neo-Platonism. *See* Platonism and Neo-Platonism
Netra moksa, 86
Netra pinkama, 84–85
Neuberger, Daniel, 222–23
Neurotic acts and behavior, signficance of, 10–11, 201–2, 205, 390, 407, 416, 418, 421, 423–25
Newman, Barnett
 Vir Heroicus Sublimis, 425–26
 Who's Afraid of Red, Yellow and Blue, 418
Nicaea, Council of, 29, 91–92, 395–96
Nicholas of Cusa, 51–52
Nicephorus, Patriarch of Constantinople, 400–401, 475 n. 21
Nizami, 336, 337
Notingham, Master John de: case of *envoûtement,* 267
Numa Pompilius, 61
Nuñez de Cepeda, Francisco, *Idea de el Buen Pastor,* 473 n. 61
Nunziata, Toto del, 322, 324, 361

Ontology of images, 77–80, 110, 166, 394–
 95. *See also* Presence and representation;
 Inherence
Orestes, myth of, 83
Origen, 396, 469–70 n. 1, 500 n. 38
Orleans, François d'. *See* Charles VI: exequies
 of
Orleans, Synod of, 136
Ornament, 59–60, 135
Ostendorfer, Michael, 101–4, 142–43, 157
Ovid
 Heroides, 264
 Metamorphoses. See Pygmalion

Pacheco, Francisco, 480 n. 105
Pagan statues, Christian hostility to, 358,
 369–71
Paintings as books of the illiterate, 163,
 398–401
Palude. *See* Images of infamy: and the family
 dalla Palude
Palladia, 209. See also *Apotropaia*
Parastaseis syntomoi chronikai, 92–93, 298,
 460 n. 43, 461 n. 53, 490 n. 19
Particularization and formal specificity, 112,
 117–18, 134, 146, 148, 155, 167,
 178, 218, 254, 276–77, 302, 469 n. 32
Passion of Christ, 170–71, 176–77
Paterculus, Velleius. *See* Valleius Paterculus
Pausanias, 35, 37, 66, 72, 75, 450 n. 31,
 454 nn. 37, 45, 455 n. 62, 456 nn. 63,
 69
Pay, Johann de, *Pietà,* 121
Peacham, Henry, *The Gentlemen's Exercise,*
 357
Penitential pilgrimages, 461 n. 3
Peter Lombard, *Sentences,* 162–63, 166
Petrarch, 504 n. 10
Pessinus, sacred stone of, 70–72
Phidias, 44–45, 189–90
Philip the Fair: and Boniface VIII, 266
Philo Judaeus, 62, 449 n. 22
Photography. *See also* Atget, Eugène;
 Barthes, Roland; Benjamin, Walter;
 Courbet, Gustave; Delacroix, Eugène;
 Portraiture; Scharf, Aaron; Villeneuve,
 Julien Vallou de
 and art, 350, 354–55
 and fear of portrayal, 279
 portraiture, 233–34
 and realism, 350–55
 and verisimilitude, 231–35
Photinus, *Life of Saint John the Faster,* 29–30
Piccolomini, Aeneas Sylvius. *See* Pius II,
 Pope

Piles, Roger de, 436–37
Pilgrimage badges, 103, 121, 126, 135,
 461 n. 10
Pilgrimage pennants and banners, 124–26,
 135
Pius II, Pope: and trial of Sigismondo Mala-
 testa, 246–47
Pius V, Pope, 371
Plato. *See also* Platonism and Neo-Platonism;
 Proclus
 Euthyphro, 456 n. 72
 Meno, 75–76
 Phaedrus, 504 n. 12
 Republic, 495 n. 28
Platonism and Neo-Platonism 61, 63, 87,
 164, 189, 358, 387, 396, 459 nn. 22–
 31. *See also* Proclus: Theurgy
Pliny the Elder, 312
 on Famulus, 292–93
 on Lysistratos, 220
 on Pythagoras of Rhegion, 241, 471 n. 28
 on wax images, 215
Plutarch, 33, 87, 312, 459 n. 23
 Numa, 61, 63
 Marcellus, 64, 357, 454 n. 32, 494 n. 25
Po-shih, 458 n. 20, 484 n. 91
Pollio, Trebellius: on punishment of Celsus,
 259
Pollitt, J. J., 456 n. 76
Pollock, Jackson, 425, 427–28
Polybius: on images of the dead, 213–16
Popular vs. sophisticated response, xx–xxi,
 1, 17–19, 37–39, 41–43, 52, 74, 199,
 201, 281, 349–50, 355–56, 361, 368,
 396, 399, 400, 406, 424–26
Pornography
 and art, 349–50, 355, 362–65, 489 n. 1
 and boundaries of shame, 21–22, 352
 problem of definition, 21–22, 352, 356
 and reproduction, 19, 355–56, 361
Porphyry, 35–36, 474 n. 65
Portraiture
 of Christ, 207–9
 of the dead, 213–20
 fear of, 278–80
 and photography, 232–33, 280
 rise in Italy, 480 n. 3
 and the soul, 492 n. 37
 speaking, 51, 485 n. 15
Possession: related to gender ideology, 317–
 22, 324, 326, 337–38, 352, 360
Possevino, Andrea, 376
Poussin, Nicolas, *Dance Round the Golden
 Calf,* 378, 381–84
Presence and representation, 27–28, 60,

245, 281. *See also* Animism, concept of; Animation of images; Fusion of image and prototype; Images, coming alive of; Inherence
aura of living presence, 234–35
in *baitulia* and *lithoi empsychoi*, 66–67, 71
in a Byzantine image of the Virgin, 29–30
in Byzantine images of Christ, 486 n. 25
in Egyptian images, 204
and eyes, 242–44
in film, 231, 234
illogicality of, 188, 201
in images of Buddha, 84–85
in meditation, 171, 173–74
in Nupe *ndakó gboyá* cult, 31–33, 56
representation and reality, 437–39
in the standardization of images of Christ, 177
Varro in defence of pagan imagery (Augustine), 62, 78
versus substitution, 26
the Virgin in the image, 30
in *xoana*, 72–73
"Primitive" beliefs and categories, xx–xxi, 1, 32, 42–43, 60, 74, 76, 80, 201–3, 272–73, 281, 284–85, 429, 433–35
Procedures, and evaluation of, 18–19, 23, 40, 432–33
Proclus: on Plato's *Timaeus*, 88
Projection, 154–55, 327
Prototype and image. *See* Fusion of image and prototype
Psalters, Byzantine. *See* Manuscript illumination
Psellus, Michael, 92–93
Pseudo-Bede. *See* Bede, Pseudo-
Pseudo-Bonaventure. *See* Bonaventure, Pseudo-
Pseudo-Dionysius. *See* Dionysius the Areopagite
Public display of images. *See also* Images of infamy
and shame, 253
versus form, 253
Puttfarken, Thomas, 436–37, 504 n. 13
Pygmalion, story of, 341–44, 352, 359
Pythagoras of Rhegion, 241, 471 n. 28

Quinisext Council, 475 nn. 22, 24

Radcliffe-Brown, A. R., 457 n. 6
Raimondi, Marcantonio
Modi, 21, 356, 362, 495 n. 37
Pan and Syrinx, 362

Raphael, *Madonna di Foligno*, 142
Realism. *See also* Flaubert, Gustave, *Madame Bovary*: trial of; Photography; Resemblance; Schematization; Verisimilitude
nature and vulgarity, 350–54
and provocation of the senses, 350, 379
relativity of, 59, 201, 237, 245, 427, 438, 440
and stylistic change, 237
Reconstitution, 48, 159–60, 188, 201, 242, 245, 281, 314–15, 325, 420, 436
Reff, Theodore, 447 nn. 21, 22
Regensburg, pilgrimage to. *See* Shrines
Relics, 28, 93–98, 461 nn. 49, 51–52. *See also* Consecration; Grabar, André; Gregory of Tours; *Stoicheosis*
Rembrandt, *Nightwatch*, 407–9
Remondini (publishers), *Apparitionum et celebrium imaginum deiparae Virginis in Civitate et Dominio Venetiarum enarrationes historicae*, 115–18
Repression, 11–13, 18–19, 42–43, 86–87, 281, 330, 358, 375–76, 378, 388, 425, 429–30, 435. *See also* Aesthetics; Iconoclasm; Sexual responses to images
Reproduction, consequences of, 19, 21, 124, 126, 145, 174–75, 177–78, 355–56, 361–62, 440. *See also* Secondary images
Resemblance, 157–59, 201, 212, 234–35, 245, 254, 274. *See also* Similitude and similarity; Verisimilitude
Ribalta, Juan, *Christ Embracing Saint Bernard*, 287–88
Ridgway, Brunhilde Sismondo, 454 n. 44
Riegl, Alois, 452 n. 14
Rituale Romanum, 89–90
Robert, Leopold, *Procession to the Madonna dell' Arco*, 106
Rodolfo da Varano, lord of Camerino. *See* Images of infamy
Rolando, Antonio di (called Cicogna), 250
Romano, Giulio: and the *Modi*, 21, 356, 362, 495 n. 37
Rondinelli, Vieri di Michele. *See* Agostino, Monna Caterina di
Rosand, David, 448 n. 23
Rosenfield, John, 476 n. 48
Rubens, Peter Paul, 494 n. 14
Portrait of the Archduke Albert, 416
Cimon and Pero (Caritas Romana), 47–48, 360
Fall of the Damned, 409, 411
Marie de' Medici cycle, 492 n. 31
Saint Teresa Interceding for Bernardino da Mendoza, 126

Sacchetti, Francesco: on wax images, 228
Sacred and sensual, separation of, 62, 190–
91, 211, 298, 321–23, 368–69,
495 n. 33. *See also* Anagogical views of
images; Censorship; Platonism and
Neo-Plantonism; Senses, the: fear and
suspicion of; Sexual responses to images
Sacri monti, 192–200, 236–37, 474 nn. 1, 4
Sallust, 63–64, 357
Samperi, Placido, *Iconologia,* 115
Sandrart, Joachim von: on sculpture by Dan-
iel Neuberger, 222–24, 478 n. 75
Santa Maria delle Grazie, 148, 158
Santa Maria Maggiore Madonna. *See* Madon-
nas
Santini, santjes. See Kleine Andachtsbilder; Sec-
ondary images
Sardenai, image of. *See* Miracles
Sarto, Andrea del, 250–51
Savonarola, Girolamo, 348–49
Scharf, Aaron, 350, 354, 484 n. 96
Schematization, 59, 110, 121, 126, 157–
59, 218, 236–37, 274–76
Schlosser, Julius von, 213, 215–16, 220,
225, 229, 259, 271
Sculpture and painting, 49, 200, 204, 237,
389, 393, 437. *See also* Leonardo da
Vinci
Scultori, Adamo
Hercules and Antaeus, 362
Venus Combing Her Hair, 362
Schöne Maria. See Shrines: of the *Schöne Maria*
at Regensburg
Secondary images
power of, 124–26, 135–39, 178
reproductions and souvenirs, 103, 112–
13, 115, 117, 126–27, 142, 145, 157,
177–78, 276, 463 n. 31, 464 n. 39
simplified reproductions, 120–21, 126
Secreting images. *See also* Images, coming
alive of; Lactating Madonnas; Medita-
tion; Miracles
issuing oil, 301, 306, 311–12, 487 n. 32
perspiring, 312
Senses, the,
arousal by imagery, 339, 349, 358–59,
368–69, 379, 384–85, 425. *See also*
Censorship; Sexual responses to images
fear and suspicion of, 62–63, 65, 201,
358–59, 396, 412, 424, 453 n. 31. *See
also* Anagogical views of images; Platon-
ism and Neo-Platonism; Women: atti-
tudes to, in relation to ideols and im-
ages
Sexual responses to images. *See also* Betrothal

to statues; Censorship; Fetishism; Gius-
tinian, Leonardo; Images, looking at;
Morlini, Girolamo; Pornography; Real-
ism: and provocation of the senses;
Shakespeare, William; Shame, bounda-
ries of
in Alexia and Philemon, 331
in Arabic poetry, 336–37
arousal, 1, 281, 324, 329–30, 350–53,
355–56, 358–59
in Saint Augustine, 2
the body in the image and repression, 12–
13, 18, 329–30, 346, 348, 349, 353
and the body perceived as present and real,
325
and convention, 323–26
desire and perception, 317, 329
female arousal, 321–26, 331, 337, 346–
47
frequency of male and female nudes, 324,
355
gender roles, 375
in Giulio Mancini, 3
and Greek vases, 356
in Heliodorus, *Aethiopica,* 2
in Leonardo, 50, 361
and "Love by sight of image," 334–38,
361, 375
in Lucian, 330–31
and magic, 330–31
male arousal and the desire to possess,
317–22, 326, 337–38
male fetishism at the Fontainebleau court,
327–28
in Ovid's Pygmalion story, 342–44
rationalization of, 330–32
shame and convention, 326–27
supposed effect of images on human con-
ception, 2–4
and Titian, *Venus of Urbino,* 13–14, 318,
345–46, 350
statues of Venus and arousal, 328, 330,
333
wedding rings placed on female statues,
333–34
Shakespeare, William, *The Two Gentlemen of
Verona:* and idols, 332, 372, 376,
497 n. 70
Shame, boundaries of, 21–22, 349–52,
355–56. *See also* Pornography; Sexual
responses to images
Shirin, paintings of, 338–39
Shirin, sculptures of, 323–24, 370, 420
Shrines. *See also* Churches; Consecration: of
shrines; Madonnas; Miracles

Altötting, 137–38, 146–48, 155–56
Fatima, 108
Lourdes, 112
Madonna dell'Arco, 105–7, 148
Madonna dei Bagni, 139–41, 156
Madonna of Guadalupe, 110, 113, 128, 462 n. 20
Madonna of Imprunета, 107–8, 462 n. 17
Madonna of Loreto, 110, 113, 120, 128
Madonna of Rocamadour, 27–28, 110, 114–15
Montaigu (Dutch: Scherpenheuvel), 110, 463 n. 31
Nosse Senhor do Bonfim in Salvador, 148
origins justified by miracle legends, 299–300
Saint Martin at Tours, 129
Santuario de los Remedios in Mexico City, 148
of the Schöne Maria at Regensburg, 100–104, 109, 112, 121, 128, 141–42
the Virgin of Monte Berico, 118
Shroud of Turin, 209
Sigebert of Gembloux, 299
Sign and signified, relationship between, 59, 78–79, 96–97, 165–66, 188, 245, 281, 285, 325, 425. See also Elision; Fusion of image and prototype; Images, coming alive of
Similitude and similarity, 159, 191, 201–3, 205–6, 212, 214–15, 221, 226, 274, 393. See also Realism: relativity of; Schematization; Verisimilitude
Simonides of Ceos, 377
Sixtus V, Pope, 372
Skorupski, John, 42, 274–77
Soriano, Miracle of, 110, 462 n. 20
Soranus of Ephesus, 2–3
Souvenirs. See Pilgrimage pennants; Secondary images
Sowe, Richard de, 267
Speaking images. See Images, coming alive of; Portraiture, speaking
Sperber, Dan, 79
Steinberg, Leo, 13
Stephen IV, Pope: and the trial of Formosus, 259
Stoglav, 250, 359
Stoicheiosis, 92–93, 330, 333
Stones, worship of. See Litholatry
Stylites, 465 n. 52
Strabo, 63
Sucquet, Antonius, 184–86
Sudarium. See Veronica
Suetonius, Tiberius, 446 n. 6, 489 n. 1

Supernatural
and mobility, 81
problem of defining, 80–81
Suso, Heinrich, 173–74, 300, 308
Swinburne, Algernon Charles: on Titian, Venus of Urbino, 345
Symbolism. See also Anagogical view of images; Skorupski, John; Sperber, Dan
as commemoration, 201
and the divine, 166, 189–90, 206
and executio in effigie, 260
and iconoclastic acts, 390
and power, 132
and religious imagery, 206, 370, 374
and shape, 68–70, 78
and signs, 78–79
and the transcendent, 165
and verisimilitude, 206
Sympathetic magic, 264, 271–77. See also Frazer, Sir James George; Magic

Tacca, Pietro: wax bust of Cosimo de' Medici, 220
Talismans, 124, 128–35, 149, 307, 396
Tambiah, S. J., 134–35, 458 n. 13, 466 n. 60
Tarasios, Patriarch of Constantinople, 500 n. 35
Tavolette, 5–6, 8–9
Tedaldo, Fino di, 250
Tertullian, 62–63, 211, 403
De cultu feminarum, 397–98
De idololatria, 396–97
Theodore the Lector: on the physical appearance of Christ, 211–12, 476 n. 44
Theodore the Studite, 394–95, 501 n. 50
Theodore of Sykeon, Saint, 484 n. 92
Theodoret, Bishop of Cyrrhus, 132, 465 n. 52
Theurgy, 87–88, 93–95, 459 n. 22
Thomas à Kempis, 174
Thomas Aquinas, 162–63, 387, 392, 399
Thomas, James: on the Wateita, 279
Thousand and One Nights, 337, 492 n. 36
"Throne of Wisdom" sculptures, 93–94, 96, 288
Tiberius, and pornography, 446 n. 6, 489 n. 1
Titian. See also Sexual responses to images; Villeneuve, Julien Vallou de
Pietà, 142
Venus and the Organ Player, 17, 448 n. 23
Venus of Urbino, 13–17, 19–21, 318, 322, 345–46, 350, 353, 448 n. 23
Trent, Council of, 3, 301, 362, 368–69, 459 n. 33, 496 n. 42. See also Censorship
Trickery and images, 242, 292, 312,

Trickery and images (*continued*)
448 n. 9, 485 n. 7. *See also* Mechanical devices in images
Tussaud, Madame, 224, 229–30
Twain, Mark: on Titian, *Venus of Urbino,* 345–46
Tzetzes, Johannes, 34

Uhlfeldt, Count Cortiz, execution of, 262
Urban VIII, Pope: and heresy trial of Marcantonio de Dominis, 261

Vázquez de Leca, Mateo, 241
Valerius Maximus on painting of Cimon and Pero, 47–48, 359–60, 368, 375
Varro, Marcus Terentius, 62, 78
Vasari, Giorgio
 on Andrea da Verrochio, 218–20, 225–26, 238
 on Andrea del Castagno, 250
 on Andrea del Sarto, 250–51, 481 n. 18
 on Fra Bartolomeo, 346–48, 353
 on Giottino, 250, 255
 on the painting of nudes, 346–48, 353
 on Toto del Nunziata, 322, 324, 361
Velazquez, *Rokeby Venus,* 353, 409–10, 412
Velleius Paterculus, 64, 357
Venus in art. *See* Aphrodite; Giorgione; Sexual responses to images; Vico, Enea
Verisimilitude. *See also* Accuracy; Brückner, Wolfgang; Christian imagery: and claims for verisimilitude; Fernández, Gregorio; Manzoni, Guido; Montáñes, Juan Martínez; Realism; Similitude and similarity
 and aesthetic differentiation, 230–31, 237
 and arousal, 353, 361
 and censorship, 350, 353
 fear of, 354
 and live images, 291–94
 the need for, 157–59, 201, 203–5, 209–10, 213–16, 395, 403, 476 n. 48
 and photography, 231–32, 234, 350, 352
 as prerequisite for the substitute body in funerary images, 215, 218
 and shame, 262
 and wax as a medium, 226–27
Veronica: and image of Christ, 207–9, 212, 440
Verrochio, Andrea da, 218, 220, 225–26, 238

Vico, Enea, *Mars, Venus and Vulcan,* 362–67
Villeneuve, Julien Vallou de, 350–53
Vincent of Beauvais, 299–300, 307, 311, 488 n. 50
Visconti, Gian Galeazzo, 251
Visconti, Matteo and Galeazzo: and John XXII, 266–67
Visions. *See* Dreams and visions
Voodoo. *See* Envoûtement
Votive images. *See* Ex-votos

Walbiri drawings, 56–57, 79, 452 n. 11
Webster, T. B. L., 457 n. 76
Wethey, Harold E., 447 n. 21
Walter of Brienne, duke of Athens, 255–57
Warburg, Aby, 228
Westminster Abbey, Undercroft Museum, 218, 229–30, 478 nn. 66–67
Wierix, Antoine, 473 n. 60
Wierix, Hieronymus, 452 n. 9
Wieruszowski, Helene, 253
William of Malmesbury, 299
Witchcraft. *See also* Envoûtement; Kittredge, George L.
 and relationship to images of infamy, 247, 249, 262–63
 and use of imagery, 247
Women. *See also* Gender ideology; Sexual responses to images
 attitudes to, in relation to idols and images, 63, 321–23, 375–77, 397–99, 424
Words. *See also* Horace; Mitchell, W. J. T.; Paintings as books of the illiterate
 images more effective than, 49–50, 163, 211, 360–61, 375, 399–401, 405, 452 n. 9, 491 n. 24
 superior spiritual status of, 211, 400, 405–6, 452 n. 9
Wünsch, R., 264, 271

Xenophanes, 61, 73–74
Xoana, 34–35, 68, 70, 72–73, 83, 449 n. 22

Yoruba critical categories, 434

Zardino de Oration, 192, 471 n. 37
Zeno the Stoic, 61
Zerner, Henri, 495 n. 37
Zwingli, Ulrich, 62, 368–69, 384, 498 n. 4